IN THE MUSEUM OF MAN

IN THE MUSEUM OF MAN

Race, Anthropology, and Empire in France, 1850–1950

ALICE L. CONKLIN

Cornell University Press
Ithaca and London

First published 2013 by Cornell University Press
First printing, Cornell Paperbacks, 2013

Printed in the United States of America

Library of Congress Cataloging-in-Publication Data

Conklin, Alice L., author.
 In the museum of man : race, anthropology, and empire in France, 1850–1950 / Alice L. Conklin.
 pages cm
 Includes bibliographical references and index.
 ISBN 978-0-8014-3755-7 (cloth : alk. paper)
 ISBN 978-0-8014-7878-9 (pbk. : alk. paper)
 1. Anthropology—France—History. 2. Ethnology—France—
History. 3. Imperialism—Social aspects—France—History.
4. Race—Social aspects. I. Title.
 GN17.3.F8C66 2013
 301.0944—dc23 2013009576

Cornell University Press strives to use environmentally responsible suppliers and materials to the fullest extent possible in the publishing of its books. Such materials include vegetable-based, low-VOC inks and acid-free papers that are recycled, totally chlorine-free, or partly composed of nonwood fibers. For further information visit our website at www.cornellpress.cornell.edu.

Cloth printing 10 9 8 7 6 5 4 3 2 1
Paperback printing 10 9 8 7 6 5 4 3 2 1

For my parents

Contents

ACKNOWLEDGMENTS

This book grew out of my earlier study of French colonial administration in West Africa between 1895 and 1930. In that work, I was struck by the ways in which high-level officials in the 1920s began to claim that the very African peoples whom the French were exploiting had "cultures" and "civilizations" worth preserving. I concluded then that this newfound French "respect" for an "authentic" African way of life was largely a political response designed to contain demands by young educated Africans for equal rights, but later I began to wonder how the best anthropologists of the day were talking about these same African societies. This question led me to the Musée de l'Homme in Paris, and through it, to a labyrinthine world of ideas, networks, and scientific practices not only unfamiliar to me, but also to many historians of modern France and to anthropologists everywhere. The result of my intellectual foray into this world, I hope, is a story that will interest historians and anthropologists equally.

In the course of writing this book, I have accrued perhaps more than the usual quota of debts. I would like to acknowledge the John Simon Guggenheim Foundation, the German Marshall Fund, and the Fulbright Commission for providing critical support for much of my research. At Ohio State, grants from the Mershon Center and the Arts and Humanities division of the College of Arts and Sciences, and research support from the History Department, helped me to complete the manuscript.

I have received essential help from numerous archivists, librarians, and scholars at every step of the way. I began working on this book when Christine Laurière was cataloging the archives of Paul Rivet, as well as those of

the Musée de l'Homme (the former Musée d'Ethnographie du Trocadéro).
It is a true pleasure to thank her for her unflagging assistance and sharing of
her "insider" knowledge of French anthropology. Christine Barthe, a curator
of the Musée de l'Homme Phototèque, moved with the collection when it
was transferred to the Musée du Quai Branly in 2005. There she continued
to guide me through the vast photographic records, now almost completely
digitized and recataloged. Abdoulay Camara facilitated my access to the ar-
chives of the former Institut Français de l'Afrique Noire in Dakar. Julie Mc-
Master at the Toledo Museum of Art located a key set of documents there for
me. I would like to thank the staff at both the Institut Mémoires de l'Édition
Contemporaine, who helped orient me in the Marcel Mauss archives, and
the International African Institute Archives in London. I am also grateful to
Alice Lemaire, librarian and archivist at the Muséum National d'Histoire Na-
turelle, for her help in navigating the archives of the Musée de l'Homme after
they were moved there in 2005. Amy Buono graciously gave me copies of the
correspondence of Alfred Métraux that she had collected in archives in Go-
thenburg. Several French ethnologists agreed to meet with me—a historian
with no background in anthropology—in order to share their own forma-
tive experiences. These conversations provided crucial insights into the field's
trajectory, especially in the interwar years. For their time and generosity, I
thank Georges Balandier, Geneviève Calame-Griaule, Georges Condominas,
Françoise Cousin, Bernard Dupeigne, Jacques Faublée, Jean Jamin, and Serge
Tornay.

Over the past twelve years, I have had the opportunity to present my
work in a number of workshops, history departments, conferences, and ar-
ticles. I thank my many hosts and audiences for their stimulating comments
and engagement with the slippery questions about how "we know what we
know" that continue to consume me, and their generosity in opening their
doors to me. Several wonderful colleagues have read and provided invalu-
able feedback on chapters or parts of chapters of my manuscript-in-progress.
I would like to thank Dan Borus, Vicki Caron, John Carson, Josh Cole,
Steven Conn, Nélia Dias, Sarah Fishman, David Horn, Suzanne Marchand,
Philip Nord, Dorothy Noyes, Kapil Raj, Daniel Sherman, Émmanuelle Si-
beud, Todd Shepard, Tracy Teslow, Helen Tilley, Robert Westbrook, Owen
White, and Sarah Van Beurden. For their critical reading of the entire man-
uscript, I am extraordinarily grateful to four scholars: Jean Pedersen, Eric
Jennings, Harry Liebersohn, and Geoffrey Parker. Each in his or her way
has left a distinctive mark on this book, even if I have not taken on board all
their suggestions. Last but not least, a number of individuals kindly offered
critical insights and advice in the final stages of writing and editing: Claude
Blanckaert, Johan Heilbron, Julie Fette, André Burguière, Émmanuelle

Loyer, Éric Jolly, and Marianne Lemaire. Needless to say, any errors are entirely my own.

Thanks also go to all students in the different versions of the seminar "History of the Idea of Race" that I have taught over the years. Each time, they have helped me to think about the core ideas at the heart of this book in new ways. I also wish to acknowledge Peter Vanderpuy for his invaluable assistance in interpreting the German-language documents cited in chapter 7, and Timothy Nassau for his help in translating the many French quotations throughout the book. I owe a very special debt to Mircea Platon. As Dale Van Kley, my colleague in the History Department at Ohio State, elegantly put it, Mircea came to us as a graduate student in French history; by the time he left us, he had taught us more than we had taught him. My conversations with Mircea, and his research help, have transformed and enriched this book in ways I could not have imagined when I started.

I gratefully acknowledge the following for granting permission to cite various materials: Edgar Krebs and Daniel Métraux for permission to cite from the correspondence of Alfred Métraux; Robert Mauss for permission to cite from the correspondence of Marcel Mauss; Charles Le Coeur for permission to cite from the correspondence of his uncle Charles Le Coeur; Alexis Adandé to cite from the correspondence of, Alexandre Adandé; François Léon for permission to cite from the correspondence of Lucien Lévy-Bruhl; Tzvetan Todorov for permission to cite from the correspondence of Germaine Tillion; and the association Conseil International de la Langue Française for permission to cite from the correspondence of Bernard Maupoil.

Earlier drafts of parts of this work have been previously published as follows: sections of chapter 3 as "Civil Society, Science, and Empire in Late Republican France: The Foundation of Paris' Museum of Man," *Osiris* 17 (July 2002), © 2002 The History of Science Society; sections of chapter 4 as "Skulls on Display: Scientific Racism in Paris' Museum of Man, 1920–1950," in Daniel J. Sherman, ed., *Museums and Difference* (Bloomington: Indiana University Press, 2007), © 2007 The Board of Regents of the University of Wisconsin System; portions of chapter 5 as "The New 'Ethnology' and 'la situation coloniale,'" *French Politics, Culture, and Society* 20:2 (Summer 2002), © 2002 The Institute of French Studies at New York University and the Minda de Gunzburg Center for European Studies at Harvard University, and "The Making of a Colonial Science: *Ethnologie* and Empire in Interwar France," *Ab Imperio* 3 (2009) [translated into Russian], © 2009; and portions of chapter 6 as "L'ethnologie combattante de l'entre-deux-guerres," in Tzvetan Todorov, ed., *Le siècle de Germaine Tillion* (Paris: Seuil, 2007), © 2007 Éditions du Seuil.

I have been exceptionally lucky in my editor at Cornell University Press, John Ackerman. His enthusiasm for this book has sustained this project over

its long gestation, and it is a pleasure to acknowledge his help. I would also like to thank Marian Rogers and Karen Laun for shepherding the manuscript so expertly through the production process.

Last but not least, I wish to thank my friends and family. Celia Applegate, Kevin Boyle, Theodora Dragostinova, Marie Gardère, Vicky Getis, Marjan Groot, Laurence and Pascale Gouy, Alex Heron, Robin Judd, Debra Rahn-Oakes, Birgitte Søland, Susan Voci, and Stewart Weaver, have helped keep me together, body and soul, in Rochester, Columbus, and Paris. My father and mother, my sons, Timothy and David, and my siblings and their families have always been there for me, no one more so than my twin, Margaret. The love and example of my partner, Geoffrey Parker, made it possible for me to complete this book. All have taught me the true meaning of reciprocity.

Abbreviations

AMAAO	Archives du Musée d'Arts d'Afrique et d'Océanie
AMH	Archives du Musée de l'Homme
ANF	Archives Nationales de France
ARP	Archives du Rectorat de l'Académie de Paris
AS	*Année Sociologique*
BMSAP	*Bulletins et Mémoires de la Société d'Anthropologie de Paris*
CDJC	Centre de Documentation Juive Contemporaine
CNRS	Conseil National de la Recherche Scientifique
IAIA	International African Institute Archives
IE	Institut d'Ethnologie
IFAN	Institut Français de l'Afrique Noire
IMEC	Institut Mémoires de l'Édition Contemporaine
MNHN	Muséum National d'Histoire Naturelle
PH	Phototèque (at the Musée de l'Homme)

INTRODUCTION

In 1930s France, the biological study and ranking of the human races was still considered a fully legitimate branch of the human sciences. By the late 1940s, in contrast, a group of Parisian anthropologists had taken the lead in warning the public about the political dangers of such inquiries. With the help of Alfred Métraux (Swiss-born but French-trained), the United Nations Educational, Scientific and Cultural Organization (UNESCO) issued in 1950 the first condemnation of scientific racism by an international organization. This condemnation ended with the radical claim that "race was less a biological fact than a social myth."[1] Shortly afterward, Claude Lévi-Strauss and Michel Leiris, colleagues who had worked with Métraux, published pamphlets for UNESCO advocating the need for cultural pluralism and underscoring the irrelevance of race as a determinant of civilization.[2]

What was the background for this dramatic change? How exactly did anthropologists think about racial and sociocultural difference at the high-water mark of French imperialism in the 1920s and 1930s, and how did France's experience of defeat during World War II change their views? These questions lie at the heart of this study, and the answers take us, first, into the formative years of anthropology and social theory between 1850 and 1900; then deep into the renewal of anthropology, under the name of ethnology, both in Paris

[1] *New York Times,* 18 July 1950. See also Elazar Barkan, *The Retreat of Scientific Racism: Changing Concepts of Race in Britain and* the *United States between the World Wars* (Cambridge, 1992), 341.
[2] Michel Leiris, *Race and Culture* (Paris, 1951); Claude Lévi-Strauss, *Race and History* (Paris, 1952).

and in the empire before and especially after World War I; and finally, into the fate of the discipline and its practitioners under the German Occupation and its immediate aftermath.

In the second half of the nineteenth century, scholars around the Western world aimed to found a general science of man, or "anthropology." Armchair theorists in industrializing—and especially colonizing—nations compared, classified, and ranked data (physical and cultural) about "primitive" peoples and "races" believed to be at an earlier evolutionary stage of political, social, and technological development. Many thinkers insisted that members of "backward" societies lacked the cognitive capacity of "advanced" Westerners, and that these societies would "progress" only when each member acquired the ability for abstract thought—a process that imperialism was supposed to accelerate. At the same time, "race" was understood to correlate with civilizational levels, and it was assumed that all groups followed the same upward trajectory from ape to human, just not at the same speed or with the same ultimate outcome. Hence the principal reason for anthropologists to study "primitives" was to reveal new information about the supposedly similar Stone Age predecessors of their own societies.

As part of their quest for a general human science, these nineteenth-century scholars began to develop specialties within their common field of inquiry. Some concentrated on studying the physical types of humankind, for example the American Josiah Nott (1804–73); others, such as the Englishman John Lubbock (1834–1913) and the American Frederick Ward Putnam (1839–1915), focused on identifying the stages of evolution in human prehistory. Still others sought to discover the universal laws of cultural evolution and origins of such human traits as marriage, religion, law, language, and art, along the lines of Henry Lewis Morgan (1818–81) in the United States and E. B. Tylor (1832–1917) in Britain. In France, too, self-styled anthropologists began to develop different subfields, but they made their greatest mark internationally in racial classification. France's most famous anthropologist in the nineteenth century was Paul Broca (1824–80), whose pioneering methods made his school the world leader in the measurement of skull and brain capacities of different races. After his death, physical anthropology remained the dominant branch of the professional discipline in France, and Broca's precocious attention to race helped to place the concept of fixed racial differences at the heart of French anthropological studies.

In the early decades of the twentieth century, however, French anthropology began to change in methodology, organization, and orientation. In particular, a new cluster of ambitious scientists sought to renew and expand the study of human cultural diversity, at a time when British and American anthropologists were challenging earlier theories of unilinear evolution, and

working their way toward the pluralistic idea that every human society was historically rooted and environmentally conditioned. This perspective recognized that societies develop not as a result of each member's acquisition of "abstract reasoning" but rather through the interactions of all members, and their collective adaptation to different modes of subsistence. In France, these new students of the social consciously chose the name "ethnologists" to distinguish themselves from physical "anthropologists," whom they considered too preoccupied with the racial classification of humans, past and present, and too attached to the idea of universal and inflexible stages of evolution for races and civilizations. This same group of ethnologists also introduced a new scientific method that was gaining ground internationally: *in situ* contact with so-called primitive societies, especially those close at hand in France's colonies, rather than armchair theorizing exclusively from ethnographies and artifacts collected by others. In 1925 the sociologist Marcel Mauss and the physical anthropologist Paul Rivet organized France's first university training in ethnology: the Institut d'Ethnologie at the Sorbonne (University of Paris), whose funding came from taxes levied in France's empire, which this new science was also supposed to serve. In 1938 the Institut d'Ethnologie moved into the Musée de l'Homme, or Museum of Man, which Rivet had directed since 1928. An energetic reformer, Rivet had transformed the museum into what critics at the time deemed the most modern of the world's institutions devoted to the display and study of humankind's racial and cultural diversity.

Under the combined impetus of Mauss and Rivet, a reformed science of man swiftly took shape in France, with the Musée de l'Homme and the Institut d'Ethnologie as its institutional and public homes, absent any dedicated university professorships in the new discipline. Mauss's doctoral students became ethnology's pioneering foot soldiers, testing empirically in the field certain anthropological constants that Mauss had formulated for understanding the different lifeways of "primitive" peoples, and working collaboratively as a group to synthesize their results in order to found a genuinely new "Maussian" school. Active Socialists both, Mauss and Rivet fostered a strong sense of solidarity in their young community as well as a deep commitment to antiracism and cultural pluralism: a lived humanism and openness to the world, in an age of intensifying racism, individualism, and rise of authoritarianism on the Right and the Left. Many of these students worked throughout the 1930s in the Musée de l'Homme trying to modernize it, and to bring this message of tolerance to the wider public through their exhibits.

Nevertheless, this humanism did not lead Mauss and Rivet to reject all racial theories, in a France still deeply embroiled in the violent and exclusionary practices of empire, and in a scientific world where the epistemological

foundations of racial thought were just beginning to be challenged. Socio-cultural explanations of human diversity did not definitively triumph over a racialized conception of difference among ethnologists in the interwar years. Rivet, for example, was a physical anthropologist by training who defined ethnology as the study of languages, civilizations, and races. Yet he also saw race as malleable and therefore meaningless for determining capabilities at the level of any particular group. Here he had much in common with the American antiracist anthropologist Franz Boas, whom Rivet knew personally and admired. Rivet's balancing of racialist and cultural-ist anthropology, ironically, meant that he appeared to share some of the same slippery conceptual terrain as a group of biological determinists who resurfaced in the wake of the global Depression and the rise of the Nazis to power. The most extreme of these scientific racists among professional ethnologists in interwar France was Mauss and Rivet's contemporary, George Montandon, whose racism dressed up in the guise of the science of humanity went uncriticized by his peers in the field, in France and abroad. Montandon would become a highly visible collaborator during the German Occupation.

Despite certain continuities with nineteenth-century racial science, the emergence of a university-based ethnology in the 1920s, 1930s, and 1940s represented a turning point in the human sciences in France institutionally and epistemologically—but not in a way that either historians or anthropologists have previously recognized. The experience of conducting intensive fieldwork in one of France's colonies often relativized younger ethnologists' under-standings of race and culture. Mauss's and Rivet's students, as scientists, be-came detached from the very colonial state that supported them. Mauss, who did the majority of the teaching at the Institut d'Ethnologie, trained future fieldworkers to look at every society holistically and to historicize cultures, rather than to search for a general law of cultural or biological development. Mauss also insisted that, because of the denser ties of reciprocity they fostered among their members, "archaic" societies were "wiser" than modern indus-trial and liberal ones. Armed with these insights, Mauss's students were quick to register the shock that colonial capitalism represented for the peoples of Africa, Asia, and Oceania. The most talented among them began to analyze the ravages of empire in their ethnographies and to challenge long-standing and insidious forms of racial prejudice. In their works, racial science not only disappeared but was replaced by an alternative sociologically grounded un-derstanding of difference based on such innovative universal concepts as the gift, the person, and historical contact between societies. For these ethnolo-gists, there were no "primitives" without history or culture, living "more sim-ply" and "authentically" than people in the modern West.

Many of these "Maussians" then risked and lost their lives during World War II. Trained to work cooperatively and to synthesize their conclusions as a group, they were drawn to fight fascism in part for ideological reasons (although none had followed their mentors into traditional party politics), in part because successful resistance required the skills and empathy that they had honed in their work as ethnologists. The Resistance also represented the best hope of defeating the unprecedented degree of politicization of racial science during World War II—whose atrocities in the name of science, at least in Europe, had been unthinkable before the Holocaust. The French contribution to the 1950 UNESCO statement that "race was less biological fact than social myth" was, in this sense, a public rebuke by ethnologists and physical anthropologists alike to those, including members of their own academic community, who had allowed the science of man to be harnessed to a lethal political discourse. Before 1940, many French intellectuals still accepted that "true facts" displayed in a museum would suffice to combat scientific racism; the war helped to change all that. To put it another way, the UNESCO statement offered the opportunity for a specific community of intellectuals to make a political response to racism, a problem that society had created and that science could not resolve alone. By taking advantage of this opportunity, these scientists revealed that their idea of the proper relationship between politics and science had changed dramatically since the late nineteenth century.

At this point it may be useful to clarify certain questions of terminology, for when it comes to studying concepts as confused and as heterogeneous as those associated with "race," there is always a danger of applying contemporary meanings to notions that were understood differently in the past. In this book, I use the term "racial science" to designate the field of inquiry that developed around the study of race in the nineteenth century, particularly by anthropologists seeking to professionalize the field. These scientists tried to sort humans neatly into racial categories in which intelligence correlated with skin color, on the basis of increasingly precise measurements of body parts, usually skulls. Racial science, in short, defined what it meant to be human in the most rigid, harmful, and dehumanizing terms imaginable. It nevertheless conformed to the best scientific standards of its times, at least as practiced by Broca, his school, and their successors in the first half of the twentieth century.[3] Although their hypotheses were racist, in the sense that

[3] On the concept of normal science, see Thomas S. Kuhn, *The Structure of Scientific Revolutions*, 2nd enl. ed. (1962; Chicago, 1970). The question of how the Kuhnian paradigm of scientific development fits the human sciences is unsettled; Kuhn himself developed his model with the hard sciences in mind. See Steve Fuller, *Thomas Kuhn: A Philosophical History for Our Times* (Chicago, 2000).

anthropologists assumed from the outset that a hierarchy of races with different mental capacities existed, these same scholars established professional norms for testing their hypotheses, and institutions that supported these norms (peer review, journals, learned societies, museums, laboratories, and schools). Over time, many of these scientists came to realize that their original hypothesis was flawed, and although they continued to study races, they no longer ranked them or assumed that race correlated in any way with intelligence. They were, in short, no longer racist in the ways their predecessors had been, or in the way that some of their successors would be again.

In contrast, I use the term "scientific racism" to designate the efforts of individual anthropologists to publicize the findings of their science for racist political ends, particularly in two charged moments in recent French history: at the height of the Dreyfus affair (between 1898 and 1906), and then again in the 1930s. The distinction between racial science and scientific racism is to some extent heuristic. Scientific racism had roots in the racial science that developed in the nineteenth century everywhere, and scientific racism surfaced in France in many additional contexts besides the two listed above. But to label all racial science as scientific racism undermines any serious attempt to explain how and why this science became politicized only at certain moments and not at others; it also obscures the complicated ways in which antiracist anthropologists viewed bodies in racialized and sociocultural ways simultaneously. To state the obvious: not all racisms (or for that matter, antiracisms) are the same, and it is essential to examine the past range of practices mobilized by racial science (including scientific racism)—as well as its relation to the society in which it was produced—in order to better understand its persistence down to the present. As Tracy Teslow has argued in the case of American anthropology, "recapturing the fullest possible picture of how science and scientists functioned within society serves an epistemological and historical purpose in counter-acting the powerful ideological and rhetorical force of science itself."[4]

The use of the term "primitives" in the past to designate the object of study of sociocultural anthropologists poses a slightly different problem. Here, I retain quotation marks or write "so-called primitives" to make clear that such a designation was an earlier usage that has passed from our current vocabulary (unlike the term "race," which has survived while changing in meaning). It is noteworthy that no satisfactory term has been devised to describe the various groups of people who interested ethnologists in the late nineteenth and early twentieth centuries. A number of substitute terms have come and gone in the academy

[4] Tracy Lang Teslow, *Anthropology and the Science of Race in America, 1900–1960* (Cambridge, forthcoming), introduction.

and beyond: "traditional," "simple," "tribal," "preindustrial," "peoples without writing," "peoples without machines," "technologically simple peoples," "indigenous," "autochthonous," "vanishing," "vanished," "native," "premodern"—and the list goes on. I have sought to respect the usage that seems to have become most common among specialists for different parts of the world: Amerindians for the peoples of the pre-Columbian Americas, Oceanians for the peoples of the South Pacific, Africans and Asians for the peoples of those continents. Since Mauss used the word "archaic," I use this term as well, without quotation marks, when discussing him and his school; often I resort to the qualifiers I find the least demeaning: premodern, vanishing or vanished (although given that we are talking about colonized peoples, "vanquished" would be even more accurate). The problem is not only a semantic one. The supposedly more neutral terms that we have introduced to replace the older terms "primitive" and "savage" continue to designate a foundational difference that our society still finds meaningful: that between the industrialized West that purportedly led the way into modernity, and those groups who ostensibly failed to follow. One aim of this book is to understand how anthropologists' discourse contributed to constructing this demarcation in France, and in so doing to demonstrate that an earlier generation, now largely forgotten, also struggled, with a certain amount of success, to replace it with a genuinely pluralist understanding of human differences.[5]

In taking up the story of the struggle to turn an older French anthropological tradition into a humanist science that studied peoples for the values each society creates, rather than one that ranked them on charts or graphs relative to other races, this book joins a field of sociological and historical inquiry into the origins, institutions, and ideas of the nascent human sciences, as well as into the history of the idea of the proper relationship between science and politics in modern France and its empire. The emergence of this scholarship owes much to Pierre Bourdieu's call in the 1970s for a social history of the social sciences based on his idea of "fields"—which he defined as a particular

[5] Here Joan Scott's insights into the persistence of sexual difference as fundamental in modern French republicanism are pertinent. As she puts it, "Placing equality and difference in antithetical relationship has, then, a double effect. It denies the way in which difference has long figured in political notions of equality and it suggests that sameness is the only ground on which equality can be claimed. It thus puts feminists in an impossible position, for as long as we argue within the terms of discourse set up by this opposition we grant the current conservative premise that since women cannot be identical to men in all respects, they cannot expect to be equal to them. The only alternative, it seems to me, is to refuse to oppose equality to difference and insist continually on differences—differences as the condition of individual and collective identities, differences as the constant challenge to the fixing of those identities, history as the repeated illustration of the play of differences, differences as the very meaning of equality itself." Joan W. Scott, *Gender and the Politics of History*, rev. ed. (New York, 1999), 174–75; see also Scott, *Only Paradoxes to Offer: French Feminists and the Rights of Man* (Cambridge, MA, 1997).

structured space with its own criteria, rules, and hierarchies that determine entry, success, and the degree of autonomy of its competing members and the knowledge they produce.[6] Scholars interested in the human sciences have paid increasing attention to the networks, institutions, and journals that underpin and inform scientific production and help explain how and why certain scientific ideas are formulated, and eventually overturned.[7] Michel Foucault's studies of how professional disciplines emerge in liberal polities, and how their forms of knowledge operate independently of any particular progenitor, have been similarly provocative and productive—although perhaps more outside France than within it. Foucault's insights have encouraged careful historical research into particular kinds of "experts" who came to "embody" power, as well as into the institutional regimes, including museums, that organized the production of social scientific knowledge along disciplinary lines.[8] In the wake of these and related theoretical developments, scholars of the human sciences have increasingly been placing texts in their political and social contexts.[9]

[6] Pierre Bourdieu, "Le champ scientifique," *Actes de la Recherche en Sciences Sociales* 2:2 (1976): 88–104, esp. 89.

[7] In France, the epicenter of this new interest in writing the history of the human sciences is the Société Française pour l'Histoire des Sciences de l'Homme, created in 1986, and its journal, the *Revue d'Histoire des Sciences de l'Homme,* launched in 1999. For its program, see Claude Blanckaert, "Pour une histoire des sciences de l'homme," *Bulletin de la Société Française pour l'Histoire des Sciences de l'Homme* 4 (April 1991). The historian Christophe Charle's work on intellectual networks has also been extremely influential: Charle, *Les élites de la République* (Paris, 1987); with Éva Telkes, *Les professeurs du Collège de France, dictionnaire biographique (1901–1939)* (Paris, 1988); *Naissance des "intellectuels"(1880–1900)* (Paris, 1990); and *La République des universitaires* (Paris, 1994). An earlier generation of American and French scholars also made decisive contributions to the sociology of knowledge, through their work on the Durkheimians. Among book-length studies, see Terry N. Clark, *Prophets and Patrons: The French University and the Emergence of the Social Sciences* (Cambridge, MA, 1973); Steven Lukes, *Émile Durkheim: His Life and Work; A Historical and Critical Study* (New York, 1973).

[8] See especially Michel Foucault, *L'ordre du discours* (Paris, 1971) and *Surveiller et punir. Naissance de la prison* (Paris, 1975). For a trenchant analysis of Foucault's contribution to thinking about professionalization in the human sciences, see Jan Goldstein, "Foucault among the Sociologists: The 'Disciplines' and the History of the Professions," *History and Theory* 23:2 (May 1984): 170–92 and Goldstein, *Console and Classify: The French Psychiatric Profession in the Nineteenth Century* (1987; Chicago, 2002). Other influential calls for overcoming the kind of cleavage between science and society that a traditional history of ideas tended to engender include David Bloor, *Knowledge and Social Imagery* (London, 1976) and Bruno Latour, *Science in Action: How to Follow Scientists and Engineers in Society* (Cambridge, MA, 1988).

[9] In writing about the history of primitivism in postwar France, Daniel Sherman has rightly warned about the need to avoid "a simple dichotomy between text and context, which tends to privilege or attribute explanatory value to one domain over another." Daniel J. Sherman, *French Primitivism and the Ends of Empire* (Chicago, 2011), 7. In what follows, I nevertheless draw a fairly clear line between texts and contexts because I believe that political change in the 1930s and 1940s did decisively shape certain discursive shifts in the French human sciences. On this point, see also Patrick Wolfe, *Settler Colonialism and the Transformation of Anthropology: The Politics and Poetics of an Ethnographic Event* (London, 1999), 5–7.

One result of this interest in the history of the human sciences has been new attention paid to the specific contributions of anthropologists to the larger domain of racial science, in France and overseas. Thanks to such scholars as Nélia Dias, Martin Staum, Laurent Mucchielli, and Claude Blanckaert, we now have a variety of rich and nuanced studies regarding the content, practices, and political implications of nineteenth-century anthropology; these works also examine how certain physical anthropologists and the Durkheimian sociologists broke with biological determinism before World War I, as part of an alternative view that human behavior is socially determined.[10] The contributions that individual colonial administrators, missionaries, travelers, and explorers made to the emergence of a separate branch of sociocultural anthropology and a modern ethnographic method in France from 1900 onward are coming into focus as well.[11] Other works have opened up new approaches to thinking about how specialized knowledge of human groups, whether in the form of discourses (missionary, administrative, or legal) or objects (bones and artifacts), emerged and circulated among colonies and between colonies and metropoles between 1850 and 1950.[12] Finally, new scholarship on shifting definitions of the nation under the Third Republic (1870–1940) and Vichy (1940–44) has produced a substantial body of work on race experts who were

[10] The key works here are Claude Blanckaert, *De la race à l'évolution. Paul Broca et l'anthropologie française, 1850–1900* (Paris, 2009); Nélia Dias, *Le Musée d'ethnographie du Trocadéro (1878–1908). Anthropologie et muséologie en France* (Paris, 1991); Martin Staum, *Nature and Nurture in French Social Sciences, 1859–1914 and Beyond* (Montreal, 2011); Laurent Mucchielli, *La découverte du social. Naissance de la sociologie en France (1870–1914)* (Paris, 1998); and Jennifer Michael Hecht, *The End of the Soul: Scientific Modernity, Atheism, and Anthropology in France* (New York, 2003).

[11] For example, James Clifford, *Person and Myth: Maurice Leenhardt in the Melanesian World* (Berkeley, 1982); Patricia Lorcin, *Imperial Identities: Stereotyping, Prejudice, and Race in Colonial Algeria* (London, 1995); Owen White, *Children of the French Empire: Miscegenation and Colonial Society in French West Africa, 1895–1960* (Oxford, 1999); Émmanuelle Sibeud, *Une science impériale pour l'Afrique? La construction des savoirs africanistes en France 1878–1930* (Paris, 2002); Oscar Salemink, *The Ethnography of Vietnam's Central Highlanders: A Historical Contextualization, 1850–1990* (Honolulu, 2003); George Trumbull IV, *An Empire of Facts: Colonial Power, Cultural Knowledge, and Islam in Algeria, 1870–1914* (Cambridge, 2009).

[12] See, among others, Paul Rabinow, *French Modern: Norms and Forms of the Social Environment* (Cambridge, MA, 1989); Herman Lebovics, *True France: The Wars over Cultural Identity, 1900–1945* (Ithaca, NY, 1992); Ann Laura Stoler, *Carnal Knowledge and Imperial Power: Race and the Intimate in Colonial Rule, with a New Preface* (Berkeley, 2010); Richard Keller, *Colonial Madness: Psychiatry in French North Africa* (Chicago, 2007); Gary Wilder, *The French Imperial Nation-State: Colonial Humanism, Negritude, and Interwar Political Rationality* (Chicago, 2006); Bruce S. Hall, *A History of Race in Muslim West Africa* (Cambridge, 2011); Pierre Singaravélou, *Professer l'empire. Les "sciences coloniales" en France sous la IIIe République* (Paris, 2011); Émmanuelle Saada, *Les enfants de la colonie. Les métis de l'Empire français entre sujétion et citoyenneté* (Paris, 2007); Nicholas Thomas, *Colonialism's Culture: Anthropology, Travel, and Government* (Princeton, NJ, 1994); and Sherman, *French Primitivism*.

not trained as physical anthropologists but who were deeply influenced by them.[13]

Despite the growing number of studies on different aspects of the history of sociology and anthropology in France, the shifting intersections of ideas about race, society, and culture among professionalizing academic scientists in the first half of the twentieth century, and their relationship to the political, social, and imperialist trends of the time, remain poorly understood.[14] The few general histories of French anthropology tend either to slight these years or to stop in 1930.[15] This neglect is beginning to change, however. Three excellent recent biographies—those of Filippo Zerilli and Christine Laurière on Paul Rivet, and of Marcel Fournier on Marcel Mauss—along with Harry Liebersohn's erudite study of the long genesis of Mauss's concept of the gift have brought part of the story I wish to tell to the fore, and I draw from all of them.[16] Another exciting vein of scholarship is emerging on museums and the other, scientific displays at colonial exhibits and world fairs, and the intertwined worlds of interwar scientific ethnographic writing and

[13] William Schneider, Gérard Noiriel, and Patrick Weil have explored the science and politics of the geographer Georges Mauco and the immigration specialist René Martial before and during World War II. William H. Schneider, *Quality and Quantity: The Quest for Biological Regeneration in Twentieth-Century France* (Cambridge, 1990); Gérard Noiriel, *Immigration, antisémitisme et racisme en France* (Paris, 2007); Patrick Weil, "Georges Mauco, expert en immigration. Ethnoracisme pratique et antisémitisme fielleux," in Pierre-André Taguieff, ed., *L'antisémitisme de plume 1940–1944. Études et documents* (Paris, 1999), 267–76; Patrick Weil, *How to Be French: French Nationality in the Making since 1789*, trans. Catherine Porter (Durham, NC, 2008). In his work on the republican origins of Vichy, Noiriel usefully distinguishes between "experts" located outside the university (statisticians, doctors, lawyers, physical anthropologists) and academic "savants." He argues that throughout the life of the Third Republic and Vichy, politicians enamored of science turned to experts rather than more independent-minded university professors to draft policies designed to improve the French race. Noiriel explicitly (and rightly) exonerates the savants Mauss and Rivet from direct complicity in exclusionary practices toward foreigners; but he has not studied these ethnologists in any depth and fails to consider their close relationship to the empire. Gérard Noiriel, *Les origines républicaines de Vichy* (Paris, 1999), esp. chap 5.
[14] On the collective inability in France to name race, much less remember its place in their history, see Ann Laura Stoler's incisive article, "Colonial Aphasia: Race and Disabled Histories in France," in Janet Roitman, ed., "Racial France," a special issue of *Public Culture* 23:1 (2011): 121–56.
[15] See the otherwise exemplary essay on France by Robert Parkin, in Frederick Barth et al., *One Discipline, Four Ways: British, German, French, and American Anthropology* (Chicago, 2005); Li-Chuan Tai, *L'anthropologie française entre sciences coloniales et décolonisation (1880–1960)* (Paris, 2010); and Henrika Kuklick, ed., *A New History of Anthropology* (Oxford, 2008). Part of the challenge is that there is no definitive list of Mauss's students in ethnology, since he taught in many different disciplines simultaneously at a time when their content was still in flux. For a list of many of those he taught, see Marcel Fournier, *Marcel Mauss* (Paris, 1994), 602.
[16] Christine Laurière, *Paul Rivet. Le savant et le politique* (Paris, 2008); Filippo M. Zerilli, *Il lato oscuro dell' etnologia. Il contributo dell' antropologia naturalista al proceso di istituzionalizzazione degli studi etnologici in Francia* (Rome, 1998); Fournier, *Marcel Mauss;* and Harry Liebersohn, *The Return of the Gift: European History of a Global Idea* (Cambridge, 2011).

literature.[17] The persistence of nineteenth-century racial science into the twentieth century and its influence on political elites have also come under scrutiny.[18] Yet a focus on particular individuals and institutions, or ideas and practices, misses how Mauss, Rivet, and their colleagues and students *collectively* forged innovative anthropological theories and institutions after 1900 that helped the younger generation to mobilize politically and intellectually in new ways against a resurgent misuse of science. Although much more work remains to be done to bring all facets of the scientific study of humanity in modern France to light, this book represents one step in that direction, by considering together the history of physical and sociocultural anthropology across a century of traumatic political change and rapid imperial expansion.[19]

The relative lack of scholarly attention to the emergence of ethnology in France and its empire, and the role it played in the history of the Third Republic and Vichy, remains all the more striking when compared with the rich tradition of writing about English- and German-language anthropology for the same period. For a long time, reconstructions of Anglo-American physical and cultural anthropology proceeded separately and teleologically. The dominant narrative was that progressive scientists who boasted a cultural understanding of human variation "won out" over physical anthropologists with pernicious essentialist and racist ideas. In this context, George W. Stocking, Jr.'s work in the 1960s and 1970s, which portrayed Franz Boas as a transitional figure between an older racial science and a newer cultural anthropology, was an early and crucial exception.[20] Several scholars have since followed Stocking's lead in

[17] Benoît de l'Estoile, *Le goût des autres. De l'exposition coloniale aux arts premiers* (Paris, 2007); Fabrice Grognet, "Le concept de musée. La patrimonisalition de la culture 'des Autres' d'une rive à l'autre, du Trocadéro à Branly. Histoire de métamorphoses" (Thèse de doctorat, École des Hautes Études en Sciences Sociales, 2009); Julien Bondaz, "L'exposition postcoloniale. Formes et usages des musées et des zoos en Afrique de l'Ouest (Niger, Mali, Burkina Faso)" (Thèse de doctorat, Université Lumière Lyon 2, 2009); and Vincent Debaene, *Adieu au voyage. L'ethnologie française entre science et littérature* (Paris, 2010).
[18] Carole Reynaud-Paligot, *La République raciale. Paradigme racial et idéologie républicaine* (Paris, 2006); Reynaud-Paligot, *Races, racisme et antiracisme dans les années 1930* (Paris, 2007).
[19] On the importance of analyzing past ideas about race and culture together, see Émmanuelle Saada, "Race and Sociological Reason in the Republic: Inquiries on the Métis in the French Empire (1908–1937)," *International Sociology* 17:3 (Sept. 2002): 361–91, esp. 385–86; and Ann Laura Stoler, "Racial Histories and Their Regimes of Truth," *Political Power and Social Theory*, vol. 11 (1997): 183–206.
[20] George W. Stocking, Jr., "Franz Boas and the Culture Concept in Historical Perspective," *American Anthropologist*, n.s., 68:4 (Aug. 1966): 867–82; Stocking, "Racial Capacity and Cultural Determinism," in George W. Stocking, Jr., ed., *A Franz Boas Reader: The Shaping of American Anthropology, 1883–1911* (1974; Chicago, 1989), 219–54. See also Regna Darnell, *And Along Came Boas: Continuity and Revolution in Americanist Anthropology* (Amsterdam, 1998); and Douglas Cole, *Franz Boas: The Early Years, 1858–1906* (Vancouver, 1999), esp. chap. 15. It is difficult to exaggerate the importance of George W. Stocking's impact on the writing of the history of English-language anthropology by anthropologists and historians. The multivolume History of Anthropology series that he edited, published by the University of Wisconsin Press starting in 1983, has become an obligatory reference for anyone working in the larger field of the human sciences.

providing more nuanced accounts of Boas's career and the larger trajectory of American anthropology, including the "retreat of scientific racism."[21]

In the case of British anthropology, the persistence of racism in the postcolonial era has also led historians and anthropologists alike since the early 1990s to reconsider traditional ideas about their discipline's history, and more particularly to examine the relationship between its growth and that of the empire. The literature on colonialism and anthropology is now extensive, and some of the earlier assumptions about how anthropological knowledge served empire's racist ends are being revised.[22] Although there is no question that anthropologists used the empire to their own professional advantage, as Helen Tilley has argued in her study of British human scientists in Africa in the 1930s, this colonial imbrication had unintended consequences. When it came to "selling" their respective expertise to colonial officials in the interwar years, anthropologists interested in analyzing social change were more successful than psychiatrists who sought to conduct racial intelligence testing on the local populations. In Tilley's words, "anthropologists, who had worked for so long to stake out a claim to be included among the empire's experts" then used their tools to chip away at colonialism from within.[23]

[21] Barkan, *Retreat of Scientific Racism*. Yet even in Barkan, there is an underlying teleology that implies that racial science disappeared for good after 1945, which is clearly not the case. Since the appearance of Barkan's book in the early 1990s, scholars have begun looking more closely at the role of anthropologists in the constructions of race in the United States at different moments since World War II. See Teslow, *Anthropology and the Science of Race*; Michelle Brattain, "Race, Racism, and Antiracism: UNESCO and the Politics of Presenting Science to the Postwar Public," *American Historical Review* 112:5 (Dec. 2007): 1386–1413; and Lee D. Baker, *From Savage to Negro: Anthropology and the Construction of Race, 1896–1954* (Berkeley, 1998).

[22] The literature on the relationship between colonialism and the human sciences is especially rich for Britain and its empire, but work is now emerging on other empires. See among other works Talal Asad, *Anthropology and the Colonial Encounter* (New York, 1973); George W. Stocking, Jr., ed., *Colonial Situations: Essays on the Contextualization of Ethnographic Knowledge* (Madison, WI, 1991); Henrika Kuklick, *The Savage Within: The Social History of British Anthropology, 1885–1945* (Cambridge, 1991); Nicholas Dirks, ed., *Colonialism and Culture* (Ann Arbor, MI, 1992); Jean Comaroff and John Comaroff, *Ethnography and the Historical Imagination* (Boulder, CO, 1992); Thomas, *Colonialism's Culture*; Bernard Cohn, *Colonialism and Its Forms of Knowledge* (Princeton, NJ, 1996); Peter Pels and Oscar Salemink, eds., *Colonial Subjects: Essays on the Practical History of Anthropology* (Ann Arbor, MI, 2000); Wolfe, *Settler Colonialism and the Transformation of Anthropology*; Helen Tilley with Robert J. Gordon, eds., *Ordering Africa: Anthropology, European Imperialism, and the Politics of Knowledge* (Manchester, UK, 2007); Kapil Raj, *Relocating Modern Science: Circulation and the Construction of Knowledge in South Asia and Europe, 1650–1900* (London, 2007); Omnia El-Shakry, *The Great Social Laboratory: Subjects of Knowledge in Colonial and Postcolonial Egypt* (Stanford, CA, 2007); Lynn Schumaker, *Africanizing Anthropology: Fieldwork, Networks, and the Making of Cultural Knowledge in Central Africa* (Durham, NC, 2001); Florence Bernault, "l'Afrique et la modernité des sciences sociales," *Vingtième Siècle* 70 (2001): 127–38; and Helen Tilley, *Africa as a Living Laboratory: Empire, Development, and the Problem of Scientific Knowledge, 1870–1950* (Chicago, 2011). See also above, note 10 and below, note 29.

[23] Tilley, *Africa as a Living Laboratory*, 311.

While once as little studied as the French tradition, the political, cultural, and social history of the German-language anthropological tradition is coming into its own, in part once again thanks to the work of George W. Stocking, Jr. His interest in Boas's German years helped to launch a new wave of scholarship on the genesis and evolution of the German tradition considered on its own terms. It is, of course, impossible here to escape the specter of 1933–45, and one of the major questions informing much of this scholarship is whether or not German-language anthropology overall changed in direction from a liberal to a racist science between the late nineteenth and early twentieth centuries. This question, with its implicit or explicit engagement with the *Sonderweg* thesis, has produced several new studies examining nineteenth-century anthropology and its connections (or not) to colonialism.[24] While the debate continues over how rooted first colonial, then Nazi scientific racism was in the anthropology of imperial Germany, there seems to be a growing consensus that in the years leading up to World War I, Germany still boasted a liberal cultural anthropology, side by side with a Darwinian-inflected essentialist one. By the mid-1920s, however, a new generation of biological determinists came to the fore, radicalized by events inside and outside the profession, including the deaths of the "founding" fathers, defeat in the Great War and the Treaty of Versailles, and the advance of genetics.[25] Many among this new generation would collaborate with the Nazis.[26]

[24] On nineteenth-century anthropology, see Suzanne Zantop, *Colonial Fantasies: Conquest, Family, and Nation in Precolonial Germany, 1770–1870,* Post-Contemporary Interventions series (Durham, NC, 1997); H. Glenn Penny, *Objects of Culture: Ethnology and Ethnographic Museums in Imperial Germany* (Chapel Hill, NC, 2001); Andrew Zimmerman, *Anthropology and Antihumanism in Imperial Germany* (Chicago, 2001); H. Glenn Penny and Matti Bunzl, eds., *Worldly Provincialism: German Anthropology in the Age of Empire* (Ann Arbor, MI, 2003); and George Steinmetz, *The Devil's Handwriting: Precoloniality and the German Colonial State in Qingdao, Samoa, and Southwest Africa* (Chicago, 2008).

[25] The continuity between Weimar racial science and Nazi *Rassenkunde* is now well established. See Robert Proctor, "From *Anthropologie* to *Rassenkunde* in the German Anthropological Tradition," in George W. Stocking, Jr., ed., *Bones, Bodies, Behavior: Essays in Biological Anthropology* (Madison, WI, 1988), 138–79; Benoît Massin, "From Virchow to Fischer: Physical Anthropology and 'Modern Race Theories' in Wilhelmine Germany (1890–1914)," in George W. Stocking, Jr., ed., *Volksgeist as Method and Ethic: Essays on Boasian Ethnography and the German Anthropological Tradition* (Madison, WI, 1996), 79–154; and Massin, "Anthropologie raciale et national-socialisme. Heurs et malheurs du paradigme de la 'race,'" in J. Olff-Nathan, ed., *La science sous le Troisième Reich* (Paris, 1993), 197–262; Thomas Hauschild, *Lebenslust und Fremdenfurcht. Ethnologie im Dritten Reich* (Berlin, 1995); Paul Weindling, *Health, Race, and German Politics from National Unification to Nazism* (Cambridge, 1989); Christopher M. Hutton, *Race and the Third Reich: Linguistics, Racial Anthropology, and Genetics in the Dialectic of the Volk* (London, 2005); Gretchen E. Schafft, *From Racism to Genocide: Anthropology in the Third Reich* (Urbana, IL, 2004); Hans-Walter Schmuhl, *The Kaiser Wilhelm Institute for Anthropology, Human Heredity, and Eugenics, 1927–1945* (Dordrecht, 2008); and the articles in Carol Sachse and Mark Walker, eds., *Politics and Science in Wartime: Comparative International Perspectives on the Kaiser Wilhelm Institute,* Osiris 20 (Chicago, 2005).

[26] Andrew Evans has recently shown how a younger nationalist generation of physical anthropologists carried out measurements on POWs from across Central Europe between 1914 and 1918,

In the face of this strong interest in English-language and German-language anthropology for the period after 1900, why has the history of the discipline in France so far been neglected? Several factors can be cited. One has to do with the selective memory of anthropologists themselves. As suggested above, it has long been assumed that there was not much of a story to tell. Racial science, according to conventional wisdom, was an embarrassing "error," on its way out after 1900, and sociocultural anthropology took off immediately after World War II. From this vantage point, the years in between saw only institutional organization, not new theories or methods—or none worth remembering. Among these new theories were certain cultural-racist ones that today are as discomfiting as those of racial science. Mauss and Rivet did not, in fact, have a monopoly on thinking about culture in innovative ways. The pessimistic ideas of the nineteenth-century essayist and diplomat Joseph-Arthur (Comte de) Gobineau about the inequality and future degeneration of the races and superiority of Indo-European civilization resurfaced in altered form in the 1930s, especially in theories that ranked civilizations in hierarchies similar to those used by physical anthropologists for the human races. Like racial science, this dark side of anthropology has been more convenient to forget than address. The painful question of colonial and wartime accommodation and collaboration by anthropologists has played its part, too, in making much of the ethnological production of the fraught 1930s and 1940s seem better left alone.[27]

A second reason for the neglect of pre-1950 French ethnology has to do with the "unusual" way in which it was established professionally. In hindsight, ethnology appeared to lack a charismatic leader (comparable, for example, to Durkheim for sociology) who might have negotiated the discipline's entry earlier into what is often referred to as the new (or reformed) university in late nineteenth-century France.[28] This absence posed a problem for a discipline habituated to constructing its memory in genealogical and patriarchal

which helped to pave the way for a racist racial science again to become ascendant. Andrew D. Evans, *Anthropology at War: World War I and the Science of Race in Germany* (Chicago, 2010).

[27] This taboo is rapidly ending, as evidenced by the seminar in ethnology at the École des Hautes Études en Sciences Sociales in Paris, run jointly by Christine Laurière, Daniel Fabre, and André Méry. Its subject in 2010–2011 was "Questions d'histoire de l'anthropologie en Europe (1930–1960)," and in 2011–2012 and 2012–2013, "Les ethnologues et le fait colonial (1920–1960)."

[28] Paul Broca might have achieved this entry, had he not died in 1880. With the advent of the Third Republic, France's institutions of higher learning, and especially its universities, acquired greater autonomy in recruitment, areas of research, and decisions over new courses of study—hence the designation the "new" university. Specialized research and publication became more important for faculty promotion than the popularization of ideological concepts, which had been the norm earlier in the nineteenth century. George Weisz, *The Emergence of Modern Universities in France, 1863–1914* (Princeton, NJ, 1983), introduction and chap. 8.

terms. From this perspective, the death of several of Durkheim's most talent-
ed students in World War I marked the end of the glory years of sociology—
ethnology's "older sibling," so to speak. Durkheim's nephew, Marcel Mauss,
has often been remembered "only" as a brilliant precursor rather than a theo-
rist in his own right, because he never completed any books. This view, how-
ever, overlooks the fact that Mauss was a superb and dedicated teacher who
eschewed "leadership" in favor of guiding the collective scholarly enterprise
of his students. The fact that World War II decimated the already small ranks
of Mauss's followers made their achievements seem even more marginal.

Third, in the immediate postwar decades the dominant trend among an-
thropologists was again toward universalizing concepts, often either struc-
turalist or Marxist. These approaches reoriented the discipline away from
the historically grounded study of individual societies in which the 1930s
ethnologists had excelled, and which had taken into account the impact of
colonialism as well as the instrumentalization of anthropology by colonial
authorities. Fourth, the creation of university positions under Vichy and after
shifted the cutting edge of the discipline from the museum to the academy,
making it all the more tempting to ignore the phase of ethnology's consolida-
tion associated with the Institut d'Ethnologie and the Musée de l'Homme,
when no university chairs in ethnology existed in France. Finally, the crisis
of confidence and the self-reflexive turn that rocked the discipline of anthro-
pology more generally in the 1970s over its direct and indirect "complicity"
with empire and other forms of racial injustice seems—after a first burst
of scholarship—to have diverted attention away from the very history that
needed to be written.[29]

This book aims to rectify these imbalances in a variety of ways. In keeping
with recent trends in the larger history of anthropology, it seeks to provide
an analysis of texts in contexts.[30] To this end, it begins with a reconsideration
of nineteenth-century developments, before turning to the contested ground
and bitter confrontations that the renovating science of man generated

[29] Early works that explored the question of social scientists' complicity in empire include Gérard
Leclerc, *Anthropologie et colonialisme* (Paris, 1972); Jean Copans, ed., *Anthropologie et impérialisme*
(Paris, 1975); Philippe Lucas and Jean-Claude Vatin, *L'Algérie des anthropologues* (Paris, 1975);
Pierre Bourdieu, ed., *Le mal de voir. Ethnologie et orientalisme. Politique et epistémologie, critique
et autocritique* (Paris, 1976); Daniel Nordman and Jean-Pierre Raison, eds., *Sciences de l'homme
et conquête coloniale. Constitution et usage des sciences humaines en Afrique (XIX–XXe siècles)*
(Paris, 1980); Jean-Claude Vatin et al., *Connaissances du Maghreb. Sciences sociales et colonisation*
(Paris, 1984). For the self-reflexive turn in anthropology more generally, which began in the United
States, the key work is James Clifford and George E. Marcus, eds., *Writing Culture: The Poetics and
Politics of Ethnography* (Berkeley, 1986).
[30] I am using the term "text" here broadly to include museum objects, which also have to be "read"
by the historian.

between 1900 and 1950. A second goal is to replace a comforting narrative of the inevitable triumph of good sociocultural anthropology over bad physical anthropology with a more complex story of the gradual separation of racial science and ethnology from 1900 through to the end of World War II. More benign, but also more malign, outcomes were always possible. Rather than take as my analytical lens a single institution or individual or set of ideas, I focus on providing a multigenerational group portrait, and on examining their writings and their lives *in situ*. The material and professional structures and the changing political and imperial contexts that conditioned their intellectual output, their career options, their attempts to reach out to the public, and their wartime choices are especially emphasized.

The chapters that follow study the ideas, research practices, and colonial encounters of the ethnological school founded by Mauss and Rivet at the Institut d'Ethnologie more or less at the same time that Rivet acquired control of the most important ethnographic and osteological collections in Paris—collections that would in 1938 form the core of the Musée de l'Homme. The Institut d'Ethnologie and Musée de l'Homme were themselves part of an older constellation—what the French call a *nébuleuse*—of overlapping networks, people, museums, and schools in France and in the colonies, all with an interest and expertise in modernizing the science of humanity on the eve of World War I. Since some of these innovators were racial and racist scientists who were accepted as legitimate interlocutors in the wider intellectual field, they, too, are considered. In particular, I explore the strange career of the physical anthropologist and ethnographer George Montandon, which sheds new light on the murky world of scientific racism in 1930s France. Although a marginal figure in some ways, he was part of a larger group of physical anthropologists whose professional fortunes revived in the 1930s, and whose extreme biological anti-Semitism became scientific dogma in the new political context of Vichy and the Occupation. How this transformation became possible demands explanation.

Last but not least, making sense of certain intellectual, institutional, and political French trends requires the evocation of a broader context still in the pages that follow: that of comparable developments in the rest of Europe and the United States, at a time when anthropologists internationally were facing many of the same professional and political choices, constraints, and opportunities to reinvent themselves as those in France, and the discipline remained itself split institutionally between the museum and the university. Until the Occupation made international communication impossible, French ethnologists were cosmopolitans who paid close attention to what was happening in German, Soviet, American, British, and Scandinavian sociocultural and physical anthropology: they read their publications, visited their museums, and met each other at conferences. In the interwar era, many

human scientists in these countries lobbied their governments to recognize the practical implications of their science for governance and experimented with new ways to popularize their findings. Mauss was simultaneously admiring and critical of the towering "pioneer" of modern solo fieldwork, the Polish-born British anthropologist Bronislaw Malinowski, whose works Mauss's students had to read. And Mauss and Rivet regularly evoked "foreign" examples to try to squeeze more resources for their fledgling science out of a parsimonious state, financially strapped colonies, and a university system hostile to innovation. France, they argued, had once been a leader in this particular domain of the human sciences but now had fallen way behind.

This insistence that France was a laggard, that "France was different," has to be taken with a grain of salt. It is more accurate to see French ethnologists between 1900 and 1950 as full partners in an international science that was itself in flux, and then under siege everywhere, as war swept the globe for a second time. Certainly anthropology, physical and sociocultural, entered the university in France later than in its closest international rivals. Yet before and during World War II, ethnologists had considerable success in obtaining positions and appropriating funds and artifacts from the colonies for themselves. From the point of view of the development of new methods and new theories, French ethnologists and racial scientists made distinctive contributions, especially in terms of a Maussian sociological ethnography, but also in the revival of a biological determinism that essentialized the nation in racist terms. During the war years George Montandon, much like several of his counterparts across the Rhine, willingly used his expertise to further Hitler's murderous ends. In all these ways, French ethnology shared key features of the better-known cases of Anglo-American and German anthropology, while also retaining characteristics peculiar to its own time and place. This study therefore highlights the importance that underlying institutional and material structures and networks played and continue to play in the academic life of France, as well as the dangerous power of ideology to distort the most human of the human sciences.

In order to chart this complex history of ethnology, the chapters are ordered chronologically and thematically. Chapter 1 analyses the two major traditions—Paul Broca's physical anthropology and a more fragmented science of ethnography—that professionalized in the early Third Republic. Chapter 2 follows the careers of Paul Rivet, Marcel Mauss, and George Montandon in the period from the Dreyfus affair to the establishment of the Institut d'Ethnologie in the late 1920s. Chapters 3, 4, and 5 examine the newly organized discipline of ethnology from three different vantage points (the museum, racial science, and the empire) during the politically polarized 1930s. This was a period of dramatic growth but also perils for the renovated science of man, as ethnologists struggled to articulate, for themselves and

a broad public, a new concept of the human that remained entangled with biological notions of difference and the imperial cause. Chapter 6 provides a close reading of the field-based ethnographies produced by Mauss's students, to highlight the combined power of a brilliant mentor and contact with colonial realities to challenge the resurgent scientific racism of the era. Chapter 7 analyzes the wartime choices of an intellectual community whose science suddenly mattered, or was thought to matter, to new political actors: Vichy, the Resistance, and the German Occupation of France.

Historians of anthropology everywhere have tended to read backward into their profession a foundational division of the racial and physical from the cultural. This division did ultimately occur, but not easily; and what anthropologists learned to separate with difficulty, a wider public has often not grasped at all.[31] As in the interwar and Vichy years, contradictions continue to mark racial formation and cultural identity in France. The "discredited" assumptions of nineteenth-century racial science seem to resurface regularly in popular and elite discourse, no matter what scientists may say on the question. The assertion that "not all civilizations are of equal value," by the French minister of the interior Claude Guéant in a public speech on 4 February 2012, reveals the persistence of the discredited—but once "scientifically proven"—notion of a "natural" hierarchy of peoples, races, and cultures still in contemporary political discourse.[32] All too often, and not only in France, the concept of "civilization" or "culture" remains a code word for the older concept of "race," in which an underlying biological understanding of difference is implicit. Such conflations are deeply depressing, but they are neither new nor do they have to be permanent. As Andrew Zimmerman reminds us, anthropology since its birth has always had "multivalent and contradictory potentials": to essentialize but also to democratize, to objectify the other but also to empathize.[33] In this longer perspective, the era of the two world wars represented a moment of intensifying mobilization—scientific and then political—against racism, as part of a larger search for commonalities that could govern relations among peoples; and in this mobilization, French anthropologists' knowledge and actions played a crucial role.

[31] In the United States, pronouncements by scientists correlating intelligence with race or gender offer ample testimony that the notion that "science" can tell the "truth" about the "innate" capacities of different human groups is still deeply entrenched. See, for example, Richard J. Herrnstein and Charles A. Murray, *The Bell Curve: Intelligence and Class Structure in American Life* (New York, 1994); and Lawrence Summers's 2005 remarks while president of Harvard, http://www.pbs.org/newshour/updates/science/jan-june05/summersremarks_2–22.html. For an excellent historical analysis of the persistence of racism and its constant reinvention, see Thomas C. Holt, *The Problem of Race in the Twenty-First Century* (Cambridge, MA, 2000).

[32] http://tempsreel.nouvelobs.com/election-presidentielle-2012/20120204.OBS0607/claude-gueant-toutes-les-civilisations-ne-se-valent-pas.html.

[33] Zimmerman, *Anthropology and Antihumanism,*11.

Races, Bones, and Artifacts

A General Science of Man in the Nineteenth Century

> In France, anthropology took a course of development distinct from
> that in other countries. It was a Frenchman, Boucher de Perthes,
> who inaugurated the epoch-making advances of prehistory; and
> his continuators, from Lartet and de Mortillet to l'Abbé Breuil,
> have remained pre-eminent. Man as a biological organism has also
> stirred French enthusiasm for many decades, as the names of Broca,
> Topinard and Boule testify. But for some inscrutable reason the arts
> and manners of living peoples have attracted little interest. There
> were French colonies with Oceanian and Negro populations, but
> the accounts published of them long remained few in number and
> inferior in quality to the comparable reports of British and German
> officials. As for scholars trained to observe in the field—until lately
> there were none.
>
> —Robert Lowie, *The History of Ethnological Theory* (1937)

In the nineteenth century, physicians and naturalists began inventorying
the physical and racial variability of the human species on a much greater
scale than ever before. At the same time, a movement among writers, artists,
and linguists to study the spirit of vanishing peoples through their customs
and languages developed, originally in German-speaking lands but soon
throughout Europe and the Americas. Educated French men and women
and their governments participated fully in these new trends, by embarking
on a long path to professionalize the science that would come to be known
as anthropology—that is to say, the science of humanity in its physical and
sociocultural dimensions. These aspiring scholars created institutions for
collecting, defining, and dispensing their new knowledge, including learned
societies, peer-reviewed journals, private schools, and museums, at home and
in their new colonies. Indeed, by the 1870s, France boasted a rich proliferation

of all these structures, the most ambitious of which embraced the goal of building a "general anthropology," whose object was the human species in all its aspects: biological, linguistic, and civilizational.

Despite a number of partial successes, nineteenth-century anthropologists failed to develop this general science of their dreams, and no discipline of anthropology entered the university before the twentieth century. This was in contrast to the successful launching of Durkheimian sociology during the period of expansion of academic positions that took place between 1880 and 1910, when the early Third Republic modernized higher education.[1] While empirically minded French anthropologists were pioneers in the biological study of human traits, especially racial ones that ostensibly lent themselves to precise quantification, the scientific study of languages and civilizations of "primitive" peoples—what came to be called in France "ethnography" (*ethnographie*)—was particularly slow to gain traction. American and British universities established general anthropology departments from the 1890s onward; in Germany physical anthropology and sociocultural anthropology were recognized as sciences by the fin de siècle.[2] In contrast, only in 1925 did a combined discipline of physical and sociocultural anthropology enter the University of Paris, under the new (or rather "old"—as we shall see below) name of "ethnology" (*ethnologie*). The reasons for this slower French path to professionalization ranged from early divergences over how to define, much

[1] On this modernization, see the introduction, note 28. Durkheimian sociology secured four university chairs in Paris in these years. This success is often seen as one of the many factors delaying anthropology's establishment in France as a discipline with its own content and approach. Durkheim and his school were hostile to physical anthropology but also to ethnography, which they accused of lacking theoretical rigor. Rather than encourage the founding of an independent field called anthropology, the Durkheimians assumed that the study of cultures fell under the umbrella of their new sociology. Clark, *Prophets and Patrons*, chap. 6; Victor Karady, "Durkheim et les débuts de l'ethnologie universitaire," *Actes de la Recherche en Sciences Sociales* 74 (Sept. 1988): 23–32; Karady, "Le problème de la légitimité dans l'organisation historique de l'ethnologie française," *Revue Française de Sociologie* 23:1 (1982): 17–35; and Mucchielli, *La découverte du social,* chap. 13. Yet, as Johan Heilbron has demonstrated, even the success of sociology as a university discipline was relative in France. Institutionally, the new sociology remained under the umbrella of philosophy (most university teaching of sociology between 1910 and 1945 remained in the hands of philosophers), and no further academic posts were created until after World War II. Johan Heilbron, "Les métamorphoses du durkheimisme, 1920–1940," *Revue Française de Sociologie* 26:2 (1985): 202–37.
[2] In Great Britain, the Ethnological Society of London (1843) and the Anthropological Society of London (1863) amalgamated in 1871 as the Anthropological Institute of Great Britain and Ireland, which would become the Royal Anthropological Institute in 1907. A professorship in anthropology was established for E. B. Tylor at Oxford in 1896, and lectureships in anthropology were founded in 1900 at Cambridge and in 1904 at the London School of Economics. In the United States, the American Anthropological Association was created in 1902, although by the late 1920s it had once again divided, when the separate Association of Physical Anthropology was founded. Harvard created a general anthropology department in 1886, and Boas became the first professor of anthropology at Columbia University in 1899. In Germany, Rudolf Virchow and Johannes Ranke dominated physical anthropology, and Adolf Bastian cultural anthropology (or *Ethnologie,* as it was called there); the

less organize, the various branches of a new science of man in the age of Darwin, a lack of forceful personalities at the right moment, and the periodic politicization of scientific agendas because of persistent ideological division. One result of France's distinctive path to disciplinarization was that even when an interest in studying so-called primitive peoples scientifically developed, the old nineteenth-century ideal of a unified science—one that considered races, customs, and languages together—remained the unquestioned objective.

This chapter analyzes two of the most important clusters of scholars in Paris from the 1850s to the 1890s who sought to organize a general anthropology (*anthropologie générale*); both would leave their distinctive mark on the development of academic ethnology in the twentieth century. The first initiative was led by Paul Broca, who established an anthropological institute that became world famous in the 1860s and 1870s for the study of humanity in all its dimensions. In practice, however, the Brocan school saw anthropometry and racial science, and the pursuit of physical anthropology in general (including prehistory and paleoanthropology), as its essential vocation.[3] Most of Broca's followers never developed a serious interest in premodern societies; nor would they shed the notion that an understanding of race was fundamental to explaining human behavior. Brocan investigation of racial traits temporarily lost much of its original appeal and direction in the last two decades of the nineteenth century—especially in the wake of the Dreyfus affair—but his anthropological school would reemerge in the 1920s and 1930s as an influential center for the study of the natural history of humanity, including races.

The second cluster in general anthropology to develop in this period centered on Broca's contemporary and friendly rival, Jean Louis Armand de Quatrefages de Bréau, holder of the first chair in anthropology, established in 1856,

first academic chairs in anthropology (Munich, 1886; Berlin, 1908) went to anatomists. Cultural anthropologists, in contrast, were extremely successful in developing their science through another venue: ethnographic museums in Germany's leading cities, such as Berlin's Museum für Völkerkunde and those of Leipzig, Hamburg, and Munich. Because there were so many of these museums, *Ethnologie* was able to establish itself as the more prominent of the two disciplines by the turn of the century. Beyond their successful institutional strategies, German ethnologists also benefited from a rich intellectual heritage that promoted the idea of culture as something that people everywhere possessed. Here, Johann Gottfried von Herder and Alexander von Humbolt were particularly influential. For the history of European and American anthropological institutions, see Kuklick, *New History of Anthropology*.

[3] In fact, the term used at the time for the study of races was "ethnology"—the same term resurrected in the twentieth century with a related, but nevertheless quite different meaning. In the nineteenth century the anthropological domain was still far from fixed; as a result the terminology for studying "the human" was constantly shifting. Knowing which terms to use today for scholarly purposes is complicated by the fact of translation: a term like *ethnologie* might not correspond to what the English term "ethnology" designated at the same historical moment. To avoid confusion, I am substituting the term "racial science" for the nineteenth-century French term *ethnologie*. "Racial science" is itself a translation of the term *raciologie*, which French contemporary scholarship on nineteenth-century anthropology has tended to adopt, to avoid confusion with twentieth-century *ethnologie*.

at one of the most venerable research institutes in the natural sciences in Paris, the Muséum National d'Histoire Naturelle. This Muséum school subscribed to the same general definition of anthropology as the Brocan circle—but unlike Broca's acolytes, they practiced what they preached. Muséum denizens not only embraced paleoanthropology and racial science; they also studied the ethnographic (i.e., man-made) artifacts and customs of "primitive" civilizations. By the late 1870s, in a context of expanding colonization and new investments in improving a recently defeated French nation through science, the Third Republic created Paris's first public museum dedicated only to ethnography, the Musée d'Ethnographie du Trocadéro, and chose a young anthropologist from the Muséum to head it, Ernest-Théodore Hamy. The latter wished to use this institution to develop the study of premodern cultures into a serious science—one that could finally take its place alongside physical anthropology in a genuinely general science of man. Hamy, however, found little support in France's scientific community for his museum venture. Only with new actors, a new political context, and consolidation of empire in the early twentieth century would the conditions be right for a scientific field of ethnography to take off in France as part of a new academic discipline of ethnology—an ethnography that was a reaction against, but also heir to, the long and prestigious nineteenth-century tradition of privileging racial science over the study of languages and customs.

BROCAN ANTHROPOLOGY DEFINED: THE PRIMACY OF RACE, 1839–1879

The dubious "achievement" of one cluster of nineteenth-century anthropologists was the creation of a doctrine of race more scientific than any before it, in France and internationally. The epistemological origins of this doctrine can be traced back to the end of the eighteenth century, when certain geographers, naturalists, anatomists, phrenologists, and physiognomists first began to explore the observable differences, and particularly racial differences, among human groups and to hypothesize about racial influence on individual and group behavior and capacity.[4] At the time it was widely assumed that

[4] See Harry Liebersohn, "Anthropology before Anthropology," in Kuklick, *New History of Anthropology*, 17–32; Martin S. Staum, *Labeling People: French Scholars on Society, Race, and Empire, 1815–1848* (Montreal, 2003); Elizabeth A. Williams, *The Physical and the Moral: Anthropology, Physiology, and Philosophical Medicine, 1750–1850* (Cambridge, 1994); George W. Stocking, Jr., "French Anthropology in 1800," in Stocking, ed., *Race, Culture, and Evolution: Essays in the History of Anthropology* (Chicago, 1982), 13–41; Jean-Luc Chappey, *La Société des Observateurs de l'Homme (1799–1804). Des anthropologues au temps de Bonaparte* (Paris, 2002); Londa Schiebinger, "The Anatomy of Difference: Race and Sex in Eighteenth-Century Science," *Eighteenth-Century Studies* 23 (1990): 387–405.

humans sorted themselves into a natural hierarchy of distinct and stable races whose characteristics manifested themselves osteologically, particularly in the size of the skull, which could be measured; only a few voices argued for the possible equal endowment of the different races, but many were willing to believe that hereditarian inequality did not mean inability to progress, and that environmental influences rather than heredity (or some combination of the two) were responsible for the different races. Anthropometry and craniometry were invented as methods to try to demonstrate the biological reality of racial differences, although there was no scholarly agreement in this period on how to measure racial traits, much less on the proper methods to use to classify races.

The question of racial diversity, the reasons for it, and its implications for psychic capacity, were themselves part of a larger debate that riveted contemporaries, especially from the 1820s onward when Lamarckian transformism first began to win adherents: whether humanity at its origin was single (monogenesis), as stated in the Bible—with all races descending from the same first man and woman—or multiple (polygenesis)—that is to say, with each race constituting a different species from the outset.[5] This question became entangled in another, more political one unleashed by Anglo-American imperialism and the early nineteenth-century practice of slavery: whether certain "primitive" races were capable of improvement. Yet, while French scholars from a variety of fields contributed to this nascent racial science, the most famous controversies of the era pitted the American, pro-slavery craniologists Samuel Morton, George Glidden, and Josiah Nott against the British scientist and defender of slaves James Pritchard. After 1850 the center of racial science moved to France, in large part because a gifted and ambitious doctor, Paul Broca, had trained in the shadow of these earlier debates and become frustrated by what he saw as a fundamental lack of scientific rigor in his elders' approach to this "essential" aspect of human biology.

If we turn from the ideas that helped to launch the science of humanity in France as its own discipline to the key moments in its professional organization, the date 1839 stands out. In that year, a physiologist and antislavery advocate originally from Jamaica, the monogenist William Frédéric Edwards, founded the Société Ethnologique de Paris. Edwards is commonly recognized as the progenitor in France of a specifically racial science. Edwards's major accomplishments in the short term were twofold: he managed for the first time to bring rival groups of naturalists, historians, travelers, and geographers together in a single society; and second, he brought about this reconciliation by arguing that race was permanent and determinative in human

[5] Stocking, *Bones, Bodies, Behavior*, 3–9.

affairs, and by convincing the members of his new society that the proper object of "ethnological" studies should henceforth be the methodical study of the human races.[6] According to Edwards, pure races could be discovered beneath all the mixing of populations that had taken place over the past 6,000 years, principally through an examination of facial features (as opposed to the bone structures that so captivated craniologists).[7] Despite this emphasis on physical difference, Edwards's research program involved more than racial mapping; for Edwards, who was particularly interested in Celtic dialects, the peopling of Europe, and the original racial makeup of the French nation, ethnology included the study of not only the racial but also the intellectual, moral, and linguistic characteristics, and historical traditions and migrations, of each people.[8] His society immediately attracted a core of university-based academics and a large group of gentleman scholars.[9] The Société Ethnologique nevertheless foundered from Edwards's death in 1842 on, and the association disappeared for good in 1862.

By this time, however, an ambitious freethinking and polygenist professor of anatomy and surgeon at the Faculté de Médecine in Paris, Paul Broca, had already emerged with the energy and vision to take up Edwards's research program—but also to make it broader still, as well as more scientific.[10] Broca early on in his career became a convert to craniometry, and more particularly to the position staked out by the "Americans" versus James Pritchard in the debate over the fixity of racial traits: for Broca there was no fundamental unity of the species. One of Broca's primary specialties was the physical location of cerebral functions, the traditional preoccupation of phrenologists, from whom he nevertheless kept his distance.[11] Broca's expertise in brain

[6] On the founding of the Société Ethnologique de Paris, see Émmanuelle Sibeud, "The Metamorphosis of Ethnology in France, 1839–1930," in Kuklick, *New History of Anthropology,* 98; Claude Blanckaert, "On the Origins of French Ethnology: William Edwards and the Doctrine of Race," in Stocking, *Bones, Bodies, Behavior,* 18–55; Staum, *Labeling People,* 126, 132–33, and 158–59; Elizabeth A. Williams, "Anthropological Institutions in Nineteenth-Century France," *Isis* 76:3 (Sept. 1985): 331–38; Dias, *Le Musée d'ethnographie,* 17–31 and 47–49; and William B. Cohen, *The French Encounter with Africans: White Response to Blacks, 1530–1880* (Bloomington, IN, 1980), 218–21.

[7] Blanckaert, "Origins of French Ethnology," 38.

[8] Ibid., 41.

[9] Williams, "Anthropological Institutions," 333.

[10] On Paul Broca, see Blanckaert, *De la race à l'évolution*; John Carson, *The Measure of Merit: Talents, Intelligence, and Inequality in the French and American Republics, 1750–1940* (Princeton, NJ, 2007), chap. 3; Francis Schiller, *Paul Broca: Founder of French Anthropology, Explorer of the Brain* (Berkeley, 1979); Stephen Jay Gould, *The Mismeasure of Man* (New York, 1996), chap. 3; Clark, *Prophets and Patrons,*116–21.

[11] Phrenology was the study of external skull features as a guide to personality and cognitive function; pioneered by the German doctor Franz Joseph Gall (1758–1828), it was most popular in the period 1820–50. Phrenologists never managed to locate internal brain organs that correlated to specific faculties, and this failure served to discredit phrenologists' applications in the eyes of many scientists like Broca. Staum, *Labeling People,* chap. 3 and 175–76.

localization, too, would play a key role in his contribution to anthropology. In 1859, he and a small group of other dissident biologists, whose positivist inquiries into human origins and evolution were increasingly in conflict with what they perceived to be the old-fashioned teachings of the Catholic Church, helped to create a new society called the Société d'Anthropologie de Paris. The conservative government of Napoleon III, which remained suspicious of any science that smacked of materialism, reluctantly authorized its creation on the understanding that Broca keep religion and politics out of his association. The Société d'Anthropologie's mission, as defined by Broca, was nothing less than the study of "all matters dealing with the human race" "as a whole, in its details, and in relation to the rest of nature," in a climate scrupulously free from ideology.[12] In theory, this meant collecting and synthesizing information drawn from no fewer than twelve separate subfields relevant to the history of humanity, including prehistory, paleoanthropology, archaeology, comparative human anatomy, physical anthropology, medicine, linguistics, and finally what Edwards had called "ethnology," or "description of the races."[13] The name change from *ethnologie* to *anthropologie* was meant to emphasize this encyclopedic vocation, with the inclusion now of deep history and human evolution in the "study of humanity." From the outset, however, Broca significantly narrowed the scope of this general anthropology by focusing on those branches that could be placed on a quantifiable basis (physical anthropology, racial science) at the expense of those (archaeology, linguistics) that could not, in order to endow his new anthropology with the same status as such well-established *natural* sciences as biology, chemistry, and physics.

This quest for a place among the natural sciences would prove decisive in orienting Broca's subject and his method—and is part of what makes him such a troubling figure in the annals of the history of anthropology. Like the craniologists who had gone before him, Broca made the problem of human variability the central focus of his anthropological research. He also accepted that

[12] The first quotation is from Clark, *Prophets and Patrons,* 117; the second from Williams, *The Physical and the Moral,* 257. For a discussion of anthropology "au sens large" see Dias, *Le Musée d'ethnographie,* 13–47; also George W. Stocking, Jr., "Qu'est-ce qui est en jeu dans un nom? La 'Société d'Ethnographie' et l'historiographie de 'l'anthropologie en France,'" in Britta Rupp-Eisenreich, ed., *Histoires de l'anthropologie* (Paris, 1984), 421–31. On the founding of the Société d'Anthropologie de Paris, see Jean-Claude Wartelle, "La Société d'anthropologie de Paris de 1859 à 1920," *Revue d'Histoire des Sciences Humaines* 10:1 (2004): 125–71; Williams, "Anthropological Institutions"; Martin S. Staum, "Nature and Nurture in French Ethnography and Anthropology, 1859–1914," *Journal of the History of Ideas* 65:3 (2004): 475–95; Hecht, *End of the Soul,* 53–61; Joy Harvey, "Evolutionism Transformed: Positivists and Materialists in the Société d'Anthropologie de Paris from Second Empire to Third Republic," in David Oldroyd and Ian Langham, eds., *The Wider Domain of European Evolutionary Thought* (Dordrecht, 1983), 289–310; Donald Bender, "The Development of French Anthropology," *Journal of Behavioral Sciences* 1 (1965): 139–51.
[13] Wartelle, "La Société d'anthropologie," 128.

racial science by midcentury was sufficiently developed to have shown that
the races had been independently formed at the dawn of humanity, that skulls
were primordial racial traits that remained stable even as groups mixed, and
that intellectual capacities also had not changed over time and were directly
linked to brain size, which itself could be determined by measuring cranial
structures. Yet, where earlier scientists had taken this link between intel-
ligence and skull form for granted, Broca was determined to prove it em-
pirically by arguing that, in the words of Elizabeth Williams, "the races had
developed, and exerted their influence over intellectual and moral character-
istics, in accordance with established laws."[14] These laws of nature—akin to
the other laws governing the natural world and which were open to empirical
investigation—were not yet known. But Broca believed that with enough per-
severance he could find a lasting connection between some physical feature
of the brain (cranial volume, brain mass, brain convolution, and/or cephalic
index—i.e., the percentage of breadth to length in any skull) and intelligence
in a way that correlated to race. Broca thus set out to demonstrate the "natu-
ral" organization of human racial types into an intelligence-based hierar-
chy, with a degree of scientific accuracy and weight of empirical data that
had eluded those who had preceded him.[15] To this end he and his disciples
virtually reinvented the field of anthropometry, by measuring more care-
fully and more completely than any before them the cranial cavities of those
groups deemed inferior in intelligence (so-called primitives) as well as those
"known" to be superior (white European males). Far from discouraging this
approach, the great discoveries at midcentury of prehistoric human remains
seemed to prove the viability of Broca's assumptions. The first Neanderthal
skull to be identified as such in 1856, for example, only further confirmed
for many anthropologists that biological differences and correlative mental
differences between the races were long-standing, and thus open to empirical
investigation.[16]

Under Broca's dynamic leadership, the Société d'Anthropologie developed
into the most important anthropological organization in nineteenth-century
France and served as a model for the founding of similar societies interna-
tionally. Its membership climbed steeply in its first decade and reached its

[14] Williams, *The Physical and the Moral*, 259.
[15] Carson, *Measure of Merit*, 98. On Broca's craniometry, see also Blanckaert, *De la race à l'évolution*, 130–42 and chaps. 4, 5, and 6. For a succinct summary of the polygenist-monogenist debate, see Blanckaert, "Of Monstrous Métis? Hybridity, Fear of Miscegenation, and Patriotism from Buffon to Paul Broca," in Sue Peabody and Tyler Stovall, eds., *The Color of Liberty: Histories of Race in France* (Durham, NC, 2003), 42–70.
[16] For the place of craniometry in German anthropology in this same era, see Zimmerman, *Anthropology and Antihumanism*, chap. 3.

all-time high of 757 members in 1885. At a time when there were no pro-
fessional positions in the new science, many of these members were either
practicing doctors or medical school faculty, who shared Broca's secular-
ism, polygenism, and orientation toward anthropometry and comparative
anatomy.[17] Broca, moreover, was courteous and astute enough to include all
points of view and disciplinary perspectives in the Société d'Anthropologie—
for example, he admitted Clémence Royer, the first translator of Darwin in
France, at a time when women were typically banned from such associa-
tions.[18] In a period when the publication of *On the Origin of the Species* had
opened up new debates on humanity's nature and development that super-
seded the old monogenesis versus polygenesis quarrel, every major question
of the day—the single or multiple origin of the species, their transformation
or not through time, the perfectibility of the different races, the history of
human variation, the boundary between the animal and the human king-
doms, the "proof" of fossil man, the adaptability (acclimatization) of races to
new environments, the fecundity of "hybrids," and the problem of "civiliza-
tion"—was discussed with great civility and rigor within the society's erudite
walls, thanks to Broca's professionalism and political neutrality. Indeed, in
this respect he was not simply obeying the government's strictures; although
by conviction a moderate republican, Broca believed that objectivity required
a refusal to consider how science might be applied to the social and political
questions of the day.

Yet Broca gave an enormous impetus to racial science not only because
of the scienticity of his method and his personal probity. In addition to
leading the Société d'Anthropologie, he created several other institutions
that would also secure the future of his new anthropology: a set of presti-
gious publications of the society's proceedings intended for an international
audience—first the *Bulletins* and *Mémoires* of the Société d'Anthropologie,
and then the *Revue d'Anthropologie,* founded in 1872 (and lasting until 1889),
edited by Broca himself; a laboratory for training students, the Laboratoire
d'Anthropologie, which was attached to the IIIrd Section (natural sciences)
of the École Pratique des Hautes Études in 1867, a research "annex" of the
University of Paris; and, most importantly, a private school for dispens-
ing anthropology's increasingly specialized skills and knowledge, the École
d'Anthropologie, which opened in 1876 on the premises of the Faculté de
Médecine of the University of Paris (although it was not officially part of

[17] Wartelle, "La Société d'anthropologie, 153.
[18] Joy Harvey, *Almost a Man of Genius: Clémence Royer, Feminism, and Nineteenth-Century Science*
(New Brunswick, NJ, 1997).

the latter).[19] Faced with the difficulty of entering the conservative public university—which had a monopoly on granting degrees—Broca resolved to bypass it in the short term by establishing his own institution; his long-term ambition nevertheless remained the creation of an anthropology chair at the Paris Faculté de Médecine.

To fund his new school, Broca turned to philanthropists and the Paris city council; with the founding of the anti-clerical and pro-science Third Republic in 1870, both groups were happy to support his venture.[20] In the early 1870s, Broca successfully financed six teaching chairs, in anatomical (or general) anthropology, biological anthropology, ethnology (i.e., description of the races), linguistic anthropology, prehistoric anthropology, and demography. He occupied the chair in anatomical anthropology, and he filled the others with either other founding members of the Société d'Anthropologie, who shared his ambitions, or students whom he had trained in his laboratory. The Musée Broca, a museum for osteological specimens (most of which came from France and the rest of Europe), and a library were also attached to the school.[21] Broca baptized this impressive cluster of institutions (which now included the Société d'Anthropologie, the École d'Anthropologie, the Laboratory, and the Broca Museum) the "Institut d'Anthropologie de Paris."

With their institute in place, Brocan anthropologists consolidated their place as international leaders in the accurate measurement and comparison of crania, the calculation of racial averages, and the classification of races and their subgroups. In addition to his other innovations, Broca had been won over to the new science of statistics through his collaboration with the French demographer Louis-Adolphe Bertillon. Broca's instruments, which École d'Anthropologie faculty designed, and his statistical analyses of racial measurements set a high standard for physical anthropologists worldwide to try to emulate.[22] In France, anthropology proved a popular new science. At a time when the prestige of the medical profession in France was rising, doctors would remain prime recruits for Broca's science; anthropometry married well with their own training in anatomy, and medical students could afford

[19] On the Broca laboratory, see Denise Ferembach, "Le laboratoire d'anthropologie à l'École pratique des hautes études (Laboratoire Broca)," *BMSAP* 7: 7–4 (1980): 307–18. There is still no comprehensive history of the École d'Anthropologie. See Williams, "Anthropological Institutions," 339; Clark, *Prophets and Patrons,* 118–19; Wartelle, "La Société d'anthropologie," 133–34; and Hecht, *End of the Soul,* 137.

[20] On the Third Republic's embrace of science, see Weisz, *Emergence of the Modern University,* 10, 272–76.

[21] Nélia Dias, "Séries de crânes et armée de squelettes. Les collections anthropologiques en France dans la seconde moitié du XIXe siècle," *BMSAP* 1:3–4 (1989): 219–22.

[22] On Broca's use of statistics, see Blanckaert, *De la race à l'évolution,* 124–42.

the luxury of taking courses that led to no degree. Thousands of medical students flocked to École d'Anthropologie courses, and its faculty continued to expand.[23] Yet, for all his apparent dynamism, Broca did not have a monopoly on either the teaching of anthropology or the definition of its contents and methods in the second half of the nineteenth century. In these same years, another group of well-positioned anthropologists in Paris were following a slightly different path toward professionalization, one less focused on biology and race.

ANTHROPOLOGY AT THE MUSÉUM NATIONAL D'HISTOIRE NATURELLE, 1855–1878

In 1855, a naturalist trained in medicine and zoology, Armand de Quatrefages, was appointed to the chair in the "Anatomy and Natural History of Man" at the Muséum National d'Histoire Naturelle in Paris. Quatrefages was as caught up in the currents of his time regarding the origin, nature, and evolution of human variability as Broca, but on the monogenist side of the debate. He had thus moved from studying animal species to anthropoids and early humans. When he came to the Muséum, he decided to rename his chair as one in "Anthropology," which was more in keeping with his new interests, and he would occupy it until his death in 1892.[24] For Quatrefages, too, anthropology was primarily the natural history of the human species, and he would join forces with Broca to help found the Société d'Anthropologie, as well as make his own Muséum chair a center for the study of the human races. However, he insisted that the study of the artifacts of "primitive" peoples also constituted part of anthropology, and unlike Broca, he began developing methods for classifying objects—a pursuit he designated under the rubric of ethnography. Thanks to the existence of Quatrefages's chair in anthropology—the only one in a public institution of higher learning in France until 1942—the Muséum would become a second site for professionalizing anthropology, and for promoting a genuinely "general" science of humanity.

The Muséum was an important public research institution, but one whose position outside the university would make it more isolated as the nineteenth

[23] Mucchielli, *La découverte du social*, 78.
[24] The chair in the anatomy and natural history of man dated from 1838; before it had been a chair in human anatomy. On the renaming of the anthropology chair to include the natural history of evolution, see Claude Blanckaert, "La création de la chaire d'anthropologie du Muséum dans son contexte institutionnel et intellectuel (1832–1855)," in Blanckaert et al., eds., *Le Muséum au premier siècle de son histoire* (Paris, 1997), 85–124.

century advanced. Founded under the Old Regime and nationalized during the Revolution, it represented "official science" which for most of the early nineteenth century was allied with the Catholic Church and the conservative political establishment. The principal vocation of the Muséum had always been the collection and study of flora and fauna—to which the natural history of man had been added only in 1822. Each of the Muséum's chaired professors had a laboratory for housing specimens, as well as an assistant and a few ancillary personnel. Most of the objects in the Muséum's vast collections had come from scientific expeditions, whose sponsorship and oversight was one of the institution's *raisons d'être*—in conjunction with the state, which also sought to promote the reputation of French science throughout the nineteenth century. Given this primary research vocation, Muséum professors taught courses that were open to the public, but the institution did not grant degrees.[25] In contrast to Broca's many acolytes, Quatrefages had only one student whom he groomed as heir apparent, one, however, who would leave his distinctive stamp on French anthropology: Ernest-Théodore Hamy.

When Quatrefages took up his anthropology chair in an institution primarily dedicated to the natural sciences, he was an eager participant in the field of anthropometry then being developed by Broca—although when it came to studying the human races, the two men did not agree on all points. Quatrefages, like Broca, accepted the irreversibility of racial characteristics, the historic stability of human groups over the long term, and the fundamental inequality of the races. As a monogenist, however, he never gave up arguing that environmental influences had formed and continued to shape human varieties, and that underneath all the variety the species was fundamentally one, a position that always made his anthropology less biologistic than that of Broca and more open to questions regarding the historical development of cultures.[26] Quatrefages's greatest concern in the realm of physical anthropology was to understand the race characteristics of crania from the earliest humans forward, and with Hamy, he authored an enormous compendium

[25] Williams, "Anthropological Institutions," 340–43; and Dias, *Le Musée d'ethnographie*, 70–72. On the history of the Muséum see Camille Limoges, "The Development of the Muséum d'histoire naturelle of Paris, 1800–1914," in Robert Fox and Georges Weisz, eds., *The Organization of Science and Technology in France, 1808–1914* (Cambridge, 1980), 211–40.
[26] Staum, *Nature and Nurture*, 58. On Quatrefages's environmentalism, see Michael Osborne, *Nature, the Exotic, and the Science of French Colonialism* (Bloomington, IN, 1994), 74–78, 88–90. A practicing Catholic, Quatrefages simply could not swallow the "violation of the species barrier" that Darwinian evolution represented, even as he came to accept the principle of natural selection. Harvey, "Evolutionism Transformed," 297. Broca's and Quatrefages's spirited disagreements especially over the question of human origins, the unity of the species, and the principal reasons for why the races had evolved as they had, were part of what gave the Société d'Anthropologie de Paris such professional stature in the 1860s and 1870s.

on skull shapes based on French and foreign data, the *Crania ethnica* (2 vols., 1875–82); indeed, in this domain Quatrefages showed himself to be a gifted organizer in his own right. Committed to Broca's project of race classification based on ever more precise measurements, Quatrefages encouraged naturalists to bring back as many skulls as possible from their expeditions in order to extend and complete the cranial series necessary for the racial identification of different human types. The greatest number of crania in his laboratory, like those in Broca's collections, nevertheless remained ancient and modern ones from France, followed by skulls from other parts of Europe. He then created at the Muséum not only an anthropology laboratory, but also an anthropology gallery for the display of his growing collections. In the words of the American physical anthropologist Frederick Starr, touring Europe in 1892, Quatrefages's laboratory was "the best equipped and most convenient in the world"; it included "two large work rooms for students, a dark room and "rooms for modeling and casting in plaster" as well as a reference library. Starr was equally complimentary of the anthropology gallery at the Muséum, home to "probably the greatest collection in the world."[27]

Yet Quatrefages, for all his commitment to physical anthropology, was as interested in collecting and displaying ethnographic artifacts as he was osteological ones. The Muséum had long been a repository for such man-made objects acquired by scientists on voyages of exploration, but in this domain, too, Quatrefages rendered their collection more systematic. He insisted, for example, that naturalists always include artifacts alongside the skulls and bones they were sending to Paris, because the former were indispensable for identifying remains from tombs and cemeteries, and for establishing the specimen's place on a historic timeline. As a result, the Muséum's combined oseteological and material collections increased dramatically over the second half of the nineteenth century, from 5,000 to 24,000 specimens.[28] Quatrefages's own expertise was in ancient American artifacts—he had served on the scientific commission overseeing Napoleon III's ill-fated expedition to Mexico in the mid-1860s—and he would pass on his passion to his student, Hamy.[29] He was less curious about the material remains of contemporary "primitives," a prejudice shared by others who claimed the title of professional ethnographer.

[27] Frederick Starr, "Anthropological Work in Europe," *Popular Science Monthly*, May 1892, 67; Starr worked at the Field Museum in Chicago.

[28] Dias, *Le Musée d'ethnographie,* 216. According to Dias (106–7), the museum of the École d'Anthropologie also had an ethnographic collection, but the majority of its holdings were osteological.

[29] Pascal Riviale, "L'américanisme français à la veille de la fondation de la Société des Américanistes," *Journal de la Société des Américanistes* 81 (1995): 213; Riviale, *Un siècle d'archéologie française au Pérou (1821–1914)* (Paris, 1996), 285–86.

Quatrefages's interest in the material remains of early American civiliza-
tions would play an important if indirect role in the development of scientific
ethnography in France. Indeed he would exert a greater influence in the long
run than the founder of France's first ethnographic society, the linguist and
specialist in Asian texts Edmond de Rosny. Rosny was a religiously orthodox
social conservative who was not prepared to embrace Broca's anatomically
based anthropology, which in Rosny's view undervalued man's moral and
intellectual capacities. In 1859 he thus created his own society, named the
Société d'Ethnographie Orientale et Américaine (usually referred to as the So-
ciété d'Ethnographie de Paris) to counter Broca's heresies. Committed, or so he
and his supporters claimed, to the principle that all peoples were equal, these
ethnographers saw climate and milieu rather than heredity and race as the
decisive elements in the different levels of civilizations around the world. Yet
because the real point of the society was to defend religion against the godless
materialism of the Société d'Anthropologie, the Société d'Ethnographie from
the outset lacked the programmatic innovation and scientific coherence of Br-
oca's larger project. Many members limited their research to texts describing
the civilizations and religions of Asia, although some specialized in the codices
of the "partly" civilized Aztec and Inca empires; Africans and Amerindians,
in contrast, were considered "natural" peoples, that is, uncivilized, and there-
fore devoid of interest, except perhaps to physical anthropologists engaging
in racial typology. Although it did very well in the 1860s when its member-
ship outstripped that of the Société d'Anthropologie, after 1870 the Société
d'Ethnographie entered a period of slowly declining numbers and never did
manage to clarify what a science of civilization might entail, much less depart
from the traditional methods of textual analysis that had been developed for
studying the classical civilizations of Rome or Athens. Nor, as Martin Staum
has shown, were its denizens even capable of maintaining a consistent position
on the equality of all races.[30]

Ethnography at the Muséum, in contrast, was destined for a more brilliant
future, although less as a result of Quatrefages's own efforts than a fortu-
itous initiative by the French state: in 1878 the Ministry of Education cre-
ated a national ethnographic museum at the Trocadéro Palace, the Musée
d'Ethnographie, and appointed Ernest-Théodore Hamy its curator. This un-
expected "plum" combined with Hamy's own ambitions gave the study of the
customs of "primitives" an opportunity to develop in the orbit of the Muséum
anthropology chair, to which Hamy would be elected after Quatrefages's

[30] Staum, *Nature and Nurture*, chap. 2; Sibeud, "Metamorphosis of Ethnology," 99; L. Chailleu,
"Histoire de la Société d'ethnographie. La revue orientale et américaine (1858–1879). Ethnogra-
phie, orientalisme et américanisme au XIXe siècle," *L'Ethnographie* 86 (1990): 89–107; and Stocking,
"Qu'est-ce qui est en jeu?"

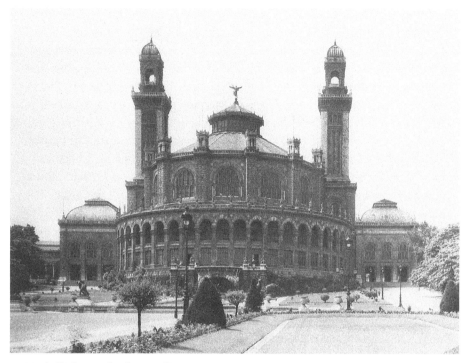

Musée d'Ethnographie du Trocadéro, Paris 1931. AMH/PH/1998–19074. Photo courtesy of the Musée du Quai Branly/Scala/Art Resource, NY.

death. A combination of ideological, practical, and political considerations lay behind the government's decision to create a public institution devoted to ethnography. The early leadership of Third Republic was committed to spreading science, and it accepted as fact the unequal endowment of the races (and of the sexes) that anthropologists were ostensibly demonstrating. The government had already allocated Broca 10,000 francs in 1872 to help set up his museum for crania, as well as a 20,000-franc subsidy for the École d'Anthropologie, renewable annually.[31] But like many anthropologists themselves, republican leaders were also neo-Lamarckian, and believed in the "natural" law of evolution and humans' ability to improve the fate of even "inferior" races and sexes. The new museum reflected all these principles. As its principal promoter put it, one of its purposes was to enlighten the public and savants about the efforts of "man" in general "to overcome the forces of nature, to better his situation, to attain progress." Far from displaying only "brilliant and valuable" luxury items, it would include the most ordinary objects if they "could serve to illustrate an aspect of human evolution."[32]

[31] Dias, *Le Musée d'ethnographie*, 68–69.
[32] Quoted in Dias, *Le Musée d'ethnographie*, 164.

A second reason for opening a museum was more prosaic. There was mounting pressure from various scientific explorers—many of whom had been financed by the government's *service des missions* in conjunction with the Muséum—to create a central public institution for the dispersed and often languishing ethnographic specimens that had been accumulating in the hands of private individuals and learned societies for over a century. The Ministry of Education had made this problem worse in 1874, when it expanded the *service* in order to sponsor even more voyages outside of France, including to Africa and Asia, which had recently been opened to "exploration."[33] Such missions, launched to increase the prestige of French culture abroad as well as to advance knowledge more generally, brought back artifacts yet had nowhere to display them.[34] The new museum was conceived to remedy this situation. Last but not least, the Third Republic's leaders were also responding to a broader development in this period: the emergence of a popular interest in "primitive" others internationally in the wake of the communications revolution, new forms of tourism, and the Third Republic's renewed colonialism. The bric-a-brac of informal and formal empire was filling bourgeois interiors as intrepid travelers sought ever more distant destinations. One of the most visible public signs of this movement was the creation of ethnographic museums in cities across Europe, as well as spectacular displays of *ethnographica* alongside crania at world fairs—exhibits that the viewing public loved.[35] Since Paris was hosting the 1878 World's Fair, the new republican elite sought to claim France's place in this rising ethnographic sun. Ironically—given their stated intentions—the public authorities refused

[33] The Ministry of Education founded the *service des missions* in 1842. It allocated grants for voyages by explorers, travelers, and "distinguished savants" in all branches of knowledge (artists, intellectuals, and writers, as well as scientists) and soon became the major source of funds for French research abroad. Its budget far outstripped those of France's many learned societies that also sponsored such fieldwork, particularly after 1874. Sibeud, *Une science impériale?* 23; Riviale, *Un siècle d'archéologie,* 69–86.

[34] Seventy percent of the expeditions still went to western Europe and the Mediterranean basin (mostly Algeria) after 1870; but voyages to sub-Saharan Africa, Southeast Asia, and South America, on the one hand, and to Germany, Russia, and the United States, on the other, increased with the advent of the Third Republic. Missions with an anthropological orientation increased from 16 (or 2.6 percent) in 1840–69 to 149 (or 8.6 percent) in 1870–1914. Michael J. Heffernan, "A State Scholarship: The Political Geography of French International Science during the Nineteenth Century," *Transactions of the Institute of British Geographers,* n.s., 19:1 (1994): 29–30.

[35] The Crystal Palace in 1854 had led the way for displaying ethnography at world's fairs; see George W. Stocking, Jr., *Victorian Anthropology* (London, 1887), 1–6. There would be ethnographic and anthropological displays at the 1878 and the 1889 World's Fair in Paris. The great age of ethnographic museums was the last third of the nineteenth century, and as Glenn Penny has shown in *Objects of Culture,* the German cities of Berlin, Hamburg, Leipzig, and Munich were particularly active in building them in the 1870s. Other famous museums from the era include Leiden's National Ethnographic Museum (1864), Harvard's Peabody Museum (1866), the Scandinavia Ethnographic Collection in Stockholm (1873), and the Pitt Rivers Museum at Oxford (1884). Following the older example

the curator an acquisitions budget that would have allowed the museum to plan its growth systematically.[36]

Yet despite its straitened circumstances almost from the outset, the Musée d'Ethnographie represented a key site in the long-term professionalization of the science of humanity in France. In the United States, Great Britain, and Germany as well as smaller countries, ethnographic museums were emerging in this period not only as venues to view exotica but also as centers of research and teaching. They were, in essence, laboratories that generated new methodologies for collecting material and other data from premodern societies; as such, they endowed their curators with the kind of legitimacy that attached to other sciences already inside the universities, and by the early twentieth century served as springboards for anthropologists to acquire academic chairs of their own. There can be no question that the Musée d'Ethnographie's first curator, Ernest-Théodore Hamy, aspired to make his museum such a research instrument, too; and while he failed in the short term, the institution itself would eventually prove a valuable asset for those wishing to merge the ethnographic and anthropological tradition in France into a single academic discipline in the 1920s.

ERNEST-THÉODORE HAMY AND THE MUSÉUM TRADITION OF SCIENTIFIC ETHNOGRAPHY

Thanks to the pioneering work of Elizabeth Williams, Nélia Dias, and Émmanuelle Sibeud we know a great deal about the history of the Musée d'Ethnographie and the ways in which Hamy sought to use it to professionalize

of the British Museum, a number of important natural history museums with ethnographic sections also opened: the American Museum of Natural History (1869), the Imperial Royal Museum of Natural History in Vienna (1876), and the Smithsonian Institution (1881)—to name but a few. It is difficult to give an overall picture of ethnographic collections in this period because scholars, and indeed contemporaries, do not define ethnographic museums in the same way; some include folklore museums under this rubric, while others include natural history museums with ethnographic sections. The historiography is rich in studies of individual museums, but few overviews exist. For one excellent but still incomplete list of prominent museums that opened between 1849 and 1931, including those outside Europe and the United States, see Anthony Alan Shelton, "Museums and Anthropologies: Practices and Narratives," in Sharon Macdonald, ed., *A Companion to Museum Studies* (Oxford, 2006), 65; see also the essays in Part II, "States of 'Nature' in the Museum: Natural History, Anthropology, Ethnology," in Bettina Messias Carbonell, ed., *Museum Studies: An Anthology of Contexts,* 2nd ed. (Chichester, UK, 2012); Dias, *Le Musée d'ethnographie,* 109–14; and Donna C. Mehos, "Colonial Commerce and Anthropological Knowledge: Dutch Ethnographic Museums in the European Context," in Kuklick, *New History of Anthropology,* 173–90.

[36] On the history of the Musée d'Ethnographie, see Dias's classic study, *Le Musée d'ethnographie*; and also Ernest-Théodore Hamy, *Les origines du Musée d'Ethnographie, histoire et documents* (1890; Paris, 1988). At the 1878 Paris World's Fair, the government asked the Société d'Anthropologie to organize its main exhibit, devoted mostly to physical anthropology. But a "provisional" ethnographic gallery for ancient American artifacts also opened at the fair and would form the core of the future Musée d'Ethnographie. Riviale, *Un siècle d'archéologie,* 298–302; Sibeud, *Une science impériale?* 38.

ethnography—a notoriously vague term in the nineteenth century.[37] When Hamy, a doctor enthralled by Broca's science, first came to the Muséum in 1870 as Quatrefages's assistant, the latter not only initiated the younger man into anthropometry. In keeping with his generalist approach to the study of humanity, Quatrefages also set him to work organizing the anthropological collections after a part of the building housing them had collapsed. Hamy proved a quick study, whose handiwork later elicited compliments from abroad. During his 1892 visit to Paris, the Chicago Field Museum anthropologist Frederick Starr noted with respect to the rebuilt anthropology gallery: "One room is devoted to fossil men, and here are many original pieces of great value and world-famous, such as the Cro-Magnon skulls and the Mentone skeleton."[38] Yet another American curator traveling in Europe seven years later, George Dorsey of the Smithsonian's Natural History Museum, wrote: "This collection . . . presents a very attractive appearance. The material is excellently mounted, well-labeled, and is supplemented by valuable maps and a full series of photographs of the different peoples represented. There is also in this museum a small series illustrating the range of variation in the human skeleton."[39] Hamy's experience in the anthropology gallery at the Muséum gave him—almost uniquely in Paris's growing anthropological community—the credentials of a museographer when the Trocadéro directorship opened up. Hamy was ambitious enough to seize the opportunity.[40] In a retrospective note on the state of the field in 1882, he chastised the physical anthropologists of his generation for their exclusive focus on skeletal measurements and the comparative study of "the first tools fashioned by human hand," at the expense of ethnography—and this at a time when the "characteristics" of "savage" peoples would soon be lost to science forever because of their "inevitable extinction" before the advances of the white races. Fortunately, he concluded, "osteology had sufficiently perfected its techniques" for anthropologists to move on to the study of humanity's "moral and intellectual characteristics."[41] As this quote suggests, Hamy made no automatic link between skull size and intelligence.

[37] Stocking, *Victorian Anthropology*, 47. As will be discussed in more depth in chapter 2, there were many individuals in France and its empire—missionaries, explorers, diplomats, colonial administrators, geographers, folklorists, naturalists—who claimed, if not the label ethnographer, at least to be doing ethnography. By this, they usually meant either collecting artifacts from, and/or writing firsthand accounts about, exotic or vanishing customs in France, the colonies, or other parts of the world.

[38] Starr, "Anthropological Work in Europe," 67.

[39] In contrast, the Broca Museum was "housed in the attic of an old building and most of the specimens are so covered with dust that it is impossible to determine whether they are labeled or not." George A. Dorsey, "Notes on the Anthropological Museums of Central Europe," *American Anthropologist*, n.s., 1:3 (July 1899): 463.

[40] Riviale, *Un siècle d'archéologie*, chap. 8.

[41] Ernest-Théodore Hamy, "Introduction," *Revue d'Ethnographie* 1 (1882): ii-iii.

At the time of Hamy's appointment, there were numerous collections of artifacts in private hands or scattered throughout museums in France, but there was no recognized method for how to gather information about them accurately, much less consensus on the boundaries of what "ethnography" included. This was not quite the case in other Western nations, where ethnographic museums with classificatory principles and collecting guidelines for amateurs—who provided curators with most of their objects and data—had been recently established. In Germany under the influence of Adolf Bastian, in Britain under the stewardship of Henry Christy, General Pitt Rivers, and E. B. Tylor, and in the United States—where the immediate proximity of Amerindians had led to a precocious interest in study of their cultures under Otis Mason, Lewis Henry Morgan, Daniel Garrison Brinton, Frederic Ward Putnam, and John Wesley Powell—professionalizing scholars had begun grappling with what constituted reliable ethnographic "facts," whether objects or customs.[42] Many had come to these questions as ambitious theorizers of culture in the wake of Darwin, in search either of universally valid laws that would explain why some peoples "progressed" and others "stagnated" (Tylor), or of proof of the psychic unity of humankind (Bastian). Without good empirical data for comparative purposes, these theorists realized that valid generalizations about the origin, nature, and distribution of cultures across the world could not be made.[43]

While he was not a theorist, Hamy's developing profile as an ethnographer was nevertheless in keeping with these trends. Like his counterparts abroad, he could not imagine future scholars achieving full scienticity if they did not have objects to hold, describe, compare, and classify in a laboratory designed for such a purpose. Not surprisingly, Hamy's model for developing a cultural science remained a natural history one, and he thus did not question that every significant aspect of a people's life was instantiated in material forms.

[42] Museums established in the older nineteenth-century European colonies, such as India, Algeria, Australia, and New Zealand, may have also embraced these trends. See, for example, Conal McCarthy, *Exhibiting Maori: A History of Colonial Cultures of Display* (New York, 2007).

[43] For an introduction to each of these national anthropological traditions and the place of the study of material culture within them, see Regna Darnell, "North American Traditions in Anthropology: The Historic Baseline"; Henrika Kuklick, "The British Tradition"; and H. Glenn Penny, "Traditions in the German Languages," in Kuklick, *New History of Anthropology*, 35–95. In Britain, to cite one example of Victorian anthropologists' concern to provide ever more precise instructions to collectors of ethnographic data, Tylor's 1874 *Notes and Queries* was regularly revised under the auspices of the Pitt Rivers Museum. Tylor also drew on material culture extensively. Alison Petch, "Notes and Queries and the Pitt Rivers Museum," *Museum Anthropology* 30 (Spring 2007): 21–39; Alison Brown, Jeremy Coote, and Chris Gooden, "Tylor's Tongue: Material Culture, Evidence, and Social Networks," *Journal of the Anthropological Society of Oxford* 31:3 (2000): 257–76. On questionnaires for travelers drawn up by armchair theorists in this period in France, see Dias, *Le Musée d'ethnographie*, 72–92.

A particular people's customs and perhaps its history could be most reliably "known" through its objects, rather than from other kinds of data, such as travelers' *in situ* descriptions of rituals and customs. The latter were also indispensable, but whereas accounts by amateurs might or might not be true, objects could not lie—especially to a trained eye inventorying them, and arranging them in series for the purpose of comparative study. And it was precisely a corpus of hard data and "trained eyes"—as well as a "laboratory" for storing and displaying objects—that he set out to build at the Musée d'Ethnographie.

Hamy soon proved himself a serious student of European museography. He had already visited the pioneering ethnographic museums of Scandinavia while curator of the Muséum anthropology gallery, and he now traveled to Berlin, the Netherlands, and Great Britain. The library that he built up contained documentation from every major ethnographic museum in the world.[44] Despite different national and individual approaches to the classification and display of material culture, a museographical consensus had emerged that individual objects were not in and of themselves meaningful. Rather, significance was established by placing the artifact in a documentary series that in turn predetermined its meaning.[45] Objects from all cultures were assumed to correspond to universal functions according to a gradation of human "natural" needs, such as food, shelter, and clothing. For some curators in the thrall of evolutionary thinking, the material forms of vanishing peoples were of particular interest because they were seen as missing links, or survivals, that could shed light on the long-term development of apes into "Europeans." These scholars—and no one more assiduously than Pitt Rivers at the Oxford museum—chose to create typological series of objects according to their morphological similarity, regardless of origin or intended function; artifacts were arranged from the simplest to the most complex to prove the necessary linear evolution of humanity. Yet for others, what mattered was the mode of life characteristic of a specific geographical region, represented through the distinctive objects of its peoples. In an era when notions of race, environment, culture, history, and evolution remained deeply entangled, many museums borrowed from both approaches, grouping together all objects of a given civilizational group—which might or might not be defined racially as well as geographically—but then ordering the objects in each civilization according to the same overarching categories.[46]

Hamy was a part of this latter trend, which was also consistent with the Muséum monogenist tradition of anthropology; nevertheless, he was also

[44] Dias, *Le Musée d'ethnographie*, 103.

[45] Ibid., 151–57.

[46] Nélia Dias, "Looking at Objects: Memory, Knowledge, in Nineteenth-Century Ethnographic Displays," in George Robertson, Melinda Mash, Lisa Tickner, Jon Bird, Barry Curtis, and Tim Putnam, eds., *Travellers' Tales: Narratives of Home and Displacement* (London, 1994), 164–77.

sensitive to aesthetic considerations, particularly in a space that had never been designed to be a museum. In the Musée d'Ethnographie the layout of the rooms was geographical. Within each geographical division, Hamy identified objects first by the ethnic/racial group to which they belonged (whose signifying physical features were always indicated), and then grouped these objects together by function according to a hierarchy of needs (from most basic to most complex: food production, then weapons, then housing, then clothing, followed by communications, industrial and commercial instruments, and ascending to artistic, spiritual, and social life). Since the museum had no acquisitions budget and depended on preexisting collections and ongoing donations, none of its functional series came anywhere close to completion. Two principal galleries were devoted to European (principally French) and ancient American ethnography (a small section of the latter was devoted to the "Red Skins" of North America); these collections were by far the largest, and the Americanist one was the most valuable. Smaller areas were set aside for Oceania, Asia, and Africa, whose collections and placement in the museum were clearly marginal.[47] Hamy introduced the use of wax models or mannequins to depict racial types as well as to display typical dress when available. Africans and Oceanians were represented mostly by masks and panoplies of spears placed vertically on the museum walls, while the large collection of ancient American ceramics and a striking series of ancient Peruvian mummies were displayed horizontally in glass cases.[48] As Frederick Starr noted in his 1892 visit, "The Trocadéro is a beautiful building, and the collections it contains are of great importance, but it is not adapted to their suitable display. Dr. Hamy has made the best of his circumstances, and his cases and wall trophies (usually an abomination in a museum, but here a necessity [for lack of space]) are true works of art."[49]

As curator of the Musée d'Ethnographie, however, Hamy was not content to identify, organize, and archive objects; as part of his larger ambition to align French ethnography's standards with international ones, he also sought permission to inaugurate a course at the museum in collecting practices for scientifically minded individuals departing for exotic locales. Such a course could expand the nation's ranks of professionals in the domain and also help fill the holes in the existing collections. The Ministry of Education nevertheless refused Hamy this right—arguing that such instruction already existed at the Muséum. Undaunted, with the help of Quatrefages Hamy decided in 1882 to found a peer-reviewed journal, the *Revue d'Ethnographie*, as an

[47] The Asian collections were removed from the museum altogether in 1890, for lack of space.
[48] On the layout of the museum, see Dias, *Le Musée d'ethnographie,* chap. 7
[49] Starr, "Anthropological Work in Europe," 66.

alternative forum for the community of scientific ethnographers that France still lacked. The journal was to publicize the work in progress at the Musée d'Ethnographie and open this work to peer review. In the end the journal failed to live up to Hamy's expectations, shutting down after seven years in part because Hamy ran out of energy to oversee its publication, and in part because he could not attract sufficient contributions.[50] Yet each year it lasted, and then later in *L'Anthropologie,* a new scientific journal devoted to physical anthropology and ethnography that he helped to found in 1892, Hamy published countless descriptive articles of his own, particularly on the American collections.[51]

In the international circulation of science, Hamy's descriptive ethnography was not pathbreaking in the way Broca's anthropometry and racial science had been. For Hamy the essence of good ethnography was the proper identification and classification of objects, which might or might not be collected by ethnographers themselves; his essays were always short and devoted to one artifact whose origins, function, and iconography interested him. He would then painstakingly comb through earlier textual sources for descriptions or references, in order to date and periodize the object in question, sometimes in comparison with others that could also be identified. Hamy did not entirely eschew larger conclusions; for example, in keeping with his belief that environmental factors and history shaped civilizations, he hazarded a hypothesis that similarities in American and Indian iconography suggested an Asian origin for the peopling of the continent. But overall he remained a cautious empiricist, dedicated to establishing the facts about an object. Well after Hamy disappeared and scientific ethnography shifted from the museum to the field, meticulous descriptions of the customs and objects of vanishing peoples remained one hallmark of French ethnology.

Hamy would leave his imprint on later French sociocultural anthropology in another way as well. Even at a moment of great imperial expansion in Africa and Asia, his armchair ethnography retained a distinctively Americanist orientation that future anthropologists, from Paul Rivet and Jacques Soustelle to Claude Lévi-Strauss and Philippe Descola, would continue.[52] Indeed, in 1895, Hamy

[50] Sibeud, *Une science impériale?* 55–56.
[51] Elizabeth A. Williams, "Art and Artifact at the Trocadéro: Ars Americana and the Primitivist Revolution," in George W. Stocking, Jr., ed., *Objects and Others: Essays on Museums and Material Culture* (Chicago, 1985), 146–66.
[52] J. P. Daughton has suggested that at the same time that the Third Republic was expanding its formal empire, it pursued a policy of "soft power" in South America. The long-standing French investment in Americanist ethnology might be analyzed in this light. J. P. Daughton, "When Argentina Was 'French': Rethinking Cultural Politics and European Imperialism in Belle-Époque Buenos Aires," *Journal of Modern History* 80 (December 2008): 831–64.

became the driving force behind the creation of a new learned society devoted to the languages, archaeology, and ethnography of the Americas in France, the Société des Américanistes, which, unlike his previous venture, was destined to have a long and illustrious career.[53] Hamy's preference for Americanist ethnography reflected the strength of the Trocadéro's collections in the domain; but how the material cultures of Mesoamerica and ancient Peru became the privileged objects of France's first scientific "ethnography" is a revealing story in itself—about the unstable nature of notions of civilizational achievement among nineteenth-century collectors. New World artifacts had first arrived in France in the seventeenth century but were soon lost from view; then, in the 1830s and 1840s, several new spectacular collections entered the country, initially to great excitement.[54] A museum for American antiquities had even been created in 1850 at the Louvre to display them—only, however, for the objects to once again disappear into the reserves in the following decades. Despite the inauguration of Mexican archaeology during France's ill-fated invasion of the country in 1862, no major exhibit of its findings took place.[55] The reason for this neglect stemmed in part from the fact that the Louvre's curators could not decide whether these American antiquities were works of art or not. Nineteenth-century European travelers and collectors "rediscovering" these artifacts initially marveled at the high level of American material civilization—especially since they appeared to owe nothing to the cradles of European creativity in the ancient world. But these same amateurs did not find most of the production (with the exception of ceramics) "beautiful," and therefore worthy of entering an art museum. With the creation of the Musée d'Ethnographie, the fate of French *Ars Americana* was finally resolved in 1887. The new museum would not only centralize existing American collections in Paris and the provinces but also house all future artifacts that subsequent scientific voyagers to the Americas brought back. *Ars Americana*, as Elizabeth Williams has argued, had by the late 1870s become *ethnographica*, of interest not for their aesthetic qualities, but for their scientific value as vestiges of extinct "primitive" civilizations and races.[56]

[53] Riviale, *Un siècle d'archéologie*, 214–16.

[54] The first American collections dated back perhaps to France's sixteenth-century expedition to Brazil; others included the Dombey Peruvian collections (1786); the d'Angeviller and d'Esclignac collections, confiscated during the Revolution; the Mexican Franck collection (1832); the Peruvian Angrand collection (1839); the Mexican Latour-Allard collection (1850); the Wiener Peruvian collection (1876–77); the Crévaux Amazonian collection (1876–80); the Cessac Peruvian collection (1882); and collections gathered by the botanist Édouard André in Colombia and Ecuador (1875–76). Jean Babelon, *La Revue de Paris* 5 (Sept.-Oct. 1935): 186. For a detailed history of these collections, see Riviale, *Un siècle d'archéologie*.

[55] On this expedition, see Paul N. Edison, "Conquest Unrequited: French Expeditionary Science in Mexico, 1864–1867," *French Historical Studies* 26:3 (Summer 2003): 459–95.

[56] Williams, "Art and Artifact," 148–52.

Beyond the sophistication of the techniques that the American artifacts displayed, the very depth of the collections—they had been accumulating in France for over three centuries, and Hamy thought them the best in the world—made them an obvious research project for Hamy. Equally appealing was their ample documentation: there were, after all, several well-known Spanish codices and missionary accounts ready at hand to help scientists study these objects. No other vanished or vanishing culture, and certainly not those of any part of Africa or Oceania, could claim as much written corroborating data—and without such written data, Hamy felt, he could not be sure of his conclusions. An additional advantage to launching a scientific ethnography with a concentration on the Americas was that Hamy could borrow the techniques of a more established discipline that overlapped with ethnography: archaeology. Archaeology had become an influential new science in midcentury Europe and was initially conceived as providing essential data in the attempt to solve the mystery of human origins.[57] By concentrating on American artifacts, scientific ethnography in its infancy could attach to itself some of its sister discipline's new luster. Last but not least, empires like that of the Incas posed particularly compelling questions for those nineteenth-century anthropologists open to thinking about human cultures historically. Where had the American races originated? Given the sophistication of Mesoamerican and Andean civilizations amid a sea of "savagery," how had these civilizations come about—through independent invention or contact with other peoples?[58] These questions, while not free from hierarchical and racist assumptions, implicitly challenged the idea that racial inheritance was the

[57] George Kubler, *The Art and Architecture of Ancient America: The Mexican "Maya" and Andean Peoples* (Harmondsworth, UK, 1962), 7–11.

[58] The questions of whether humanity was one, and whether humanity's diverse cultures could be explained better by an evolutionary model of independent invention or diffusionism, were much debated among museographers and anthropologists in the later nineteenth century. The first position held that because human beings everywhere shared the same psychological traits, they were likely to innovate in exactly the same way and thus evolve in parallel fashion everywhere; diffusionism, in contrast, held that the most important cultural traits had spread throughout the world from a few— or perhaps one—original center(s) of invention, and that all cultures, even premodern ones, had complex histories that needed unraveling. These views were not considered incompatible. In France, where the monogenist-polygenist division lingered longer than elsewhere, monogenists like Quatrefages and Hamy sought to use ethnographic data to prove that all human groups could be traced to a single root. Yet this did not preclude a belief that all peoples also followed the same evolutionary stages despite innumerable local variations; even such convinced socio-evolutionists as Tylor and Pitts Rivers argued for the existence of diffused traits in a people's historical development. And Bastian, who rejected biological transformism as unproven, accepted that there were uniform laws of growth through which simpler phenomena became higher and complex. See Stocking, *Victorian Anthropology;* also Robert H. Lowie, *The History of Ethnological Theory* (New York, 1937), chaps. 3, 4, and 7. Americanists were very engaged in the debate, because of the uncertain origins of early American civilizations. Kubler, *Art and Architecture,* 11–12.

key factor in explaining social and cultural development—at a time when Broca's heirs were arguing just the opposite.[59]

Hamy would remain an influential anthropologist on the Paris scene until his death in 1908. In 1892 he had finally succeeded to the prestigious Muséum chair in anthropology while retaining his directorship of the Musée d'Ethnographie. Despite his new teaching responsibilities in physical anthropology and the development of research projects in that domain, he continued his practice of Americanist ethnography, while remaining open to new developments and debates in the field. In 1906 he resigned from the Trocadéro to protest its paltry budget and inadequate personnel: with no room to grow and no budget to preserve artifacts, its rooms had become overstuffed as new donations arrived, while the objects themselves were deteriorating. On his 1899 visit to Paris, museum anthropologist George Dorsey had already complained that the Trocadéro "is not adapted to museum purposes; it is poorly lighted, and does not seem to be clean, while the cases are the poorest of any museum visited in Europe."[60]

Yet if the state of the Musée d'Ethnographie suggests that institutionally this branch of anthropology remained a fragile plant in the fin de siècle, the Institut d'Anthropologie founded by Broca was no longer thriving either. In 1880, at the height of his fame, Broca died unexpectedly. Without the physical presence of the founding father, the integrity and ultimately the reputation of his scientific edifice began to unravel, even as racial science remained a fixture on the French intellectual and institutional landscape. Broca's heirs launched new, divisive research and outreach programs, standards began to slip, and anthropometrists faced a growing inability to prove that any real biological differences between the races existed. Paradoxically, Brocan racial science and its assumption that a race hierarchy could be demonstrated empirically showed no signs of fading away even among those abandoning craniometry; instead this science found new, sometimes terrifyingly ugly, modes of expressing itself. In light of these many developments, the chances for a general anthropology to continue to emerge receded, at least for a while.

[59] Michael Hammond, "Anthropology as a Weapon of Social Combat in Late Nineteenth-Century France," *Journal of the History of the Behavioral Sciences* 16:2 (1980): 120; Staum, "Nature and Nurture," 483–85; Williams, "Anthropological Institutions," 337; and Laurent Mucchielli, "Sociologie *versus* anthropologie raciale. L'engagement des sociologues durkheimiens dans le contexte 'fin de siècle' (1885-1914)," *Gradhiva* 21 (1997): 79–80. Hamy's views here can be usefully compared with those of some of his counterparts abroad—for example, Tylor and Bastian were at this same time questioning the relevance of race (but not denying racial inequality) for the study of civilizations and languages.
[60] Dorsey, "Notes," 468.

New Directions after Broca: The Racial Evolutionist Paradigm

Broca had founded the École d'Anthropologie in 1876 as part of his larger institute, to further ensure that his science would take root in France, and it certainly did—but perhaps not in the manner Broca had envisioned. Although a moderate republican who was elected a senator for life in 1880, Broca always championed the concept of "pure science" and cautioned his followers to keep their knowledge and their politics separate. This proscription had been necessary in the 1860s for the survival of a science that so obviously objectified human nature, at a time when the conservative Catholic Church and the Second Empire were allied and ascendant. But after Broca's demise, and with the final consolidation of the Third Republic, several of Broca's fellow professors at the École d'Anthropologie—radical republicans all, who had originally allied with him to found the Société d'Anthropologie—abandoned his caution. These men were neo-Lamarckian "materialists" who had long believed that human phenomena were the result of material interactions alone, that physical and sociocultural evolution thus correlated, and that evolution was linear and progressive.[61] It was as materialists and freethinking republicans that they had been drawn to anthropology in the first place, seeing in this "new science" an opportunity to prove what they knew to be true about human development, and at the same to use this science to benefit humanity. These ideologically driven goals determined the materialists' research agenda, leading them to abandon anthropometry altogether and investigate aspects of the natural history of man that Broca had left to the side, and to popularize their findings. While some of their scientific achievements were incontestable, the political engagement of these scientists divided Broca's followers bitterly. At the same time their materialism, if anything, further entrenched the notion of a racial hierarchy that Broca had developed.

The two most prominent materialists at the École d'Anthropologie early on were the prehistorian Gabriel de Mortillet and the linguist Abel Hovelacque. In the wake of the translation of part of Herbert Spencer's *Principles of Sociology* in 1878 and 1879, a third chair in the history of civilizations was created in 1884 for another materialist, Charles Jean Marie Letourneau. Mortillet was one of the founders of prehistory in France, who with his son

[61] On the materialists at the Société d'Anthropologie, see Hecht, *End of the Soul*; Staum, *Nature and Nurture*, chap. 3; Blanckaert, *De la race à l'évolution*, 440–48; Hammond, "Anthropology as a Weapon"; Natalie Richard, "La revue *L'Homme* de Gabriel de Mortillet. Anthropologie et politique au début de la Troisième République," *BMSAP* 1:3–4 (1989): 231–56; and Wartelle, "La Société d'anthropologie," 136–55.

Adrien organized the collections at the Musée des Antiquités Françaises at St. Germain-en-Laye. He had chosen political exile after 1848, principally in Switzerland; there he discovered the work of Boucher de Perthes, Édouard Lartet, and other prehistorians and became interested in the study of flints and stone axes that proved the antiquity of man. When Mortillet returned to France in 1864, he joined the Société d'Anthropologie, as well as becoming an assistant curator at the St. Germain-en-Laye museum and launching a journal dedicated to prehistory entitled, provocatively, *Materials for a Positive and Philosophical History of Man*. Once ensconced in his chair at the École d'Anthropologie, Mortillet devoted his research efforts to tracking the upward march of Europeans through stages as revealed by their tools—first stone implements, then bronze, then iron—establishing the sequence of ages in which human prehistory is still conceived. He continued this project until his death in 1898, and he never deviated from his conviction that all physical and cultural evolution was unilinear and progressive.[62]

Hovelacque had begun his career as a student of Oriental languages but became a materialist, in the sense of seeking an explanation for all original language development within the structure of the brain—a quest that led him to tie the physical and cultural aspects of language acquisition in humanity's progenitors. Charles Letourneau had trained in medicine but converted to materialism, transformism, and socialism in the mid-1860s; he, too, became convinced that there was no break between animals and humans, just evolution of traits that then became species-specific. Exiled after the Commune, he returned to France in the late 1870s and began a monumental evolutionary sociology, which slotted every social, cultural, and moral institution known to man into a predetermined universal sequence of development.[63]

As Jennifer Hecht has persuasively shown, Mortillet, Letourneau, and Hovelacque's decision to see all human development as an ascending march was driven by a freethinking agenda: the possibility of a utopian future that they believed it was scientists' duty to hasten. As neo-Lamarckians and polygenists, they believed that humanity was a product of evolution, but not its puppet; anthropologists, by decoding nature's laws, could thus play a key role in aiding, in Hovelacque's words, "humanity to realize its own development . . . in the pursuit of the better and of the general good."[64] For example,

[62] Hammond, "Anthropology as a Weapon," 118–22; Philip Nord, *The Republican Moment: Struggles for Democracy in Nineteenth-Century France* (Cambridge, MA, 1995), 41–44; Richard, "La revue"; and Hecht, *End of the Soul*, 61–145 passim. For a more general history of prehistory, see Natalie Richard, *Inventer la préhistoire. Les débuts de l'archéologie préhistorique en France* (Paris, 2008).

[63] Hammond, "Anthropology as a Weapon," 123–25, Harvey, "Evolutionism Transformed," 292–303 passim; Nord, *Republican Moment,* 41–44; Hecht, *End of the Soul,* 61–145 passim.

[64] Quoted in Hammond, "Anthropology as a Weapon," 126.

anthropologists could usefully identify vestiges of an earlier stage (the Church) that should be removed so people could advance more quickly; they could also encourage less endowed groups (women, workers, premodern peoples) to catch up with those most biologically wired for greatness (European white males). Yet these same socially progressive scientists—not surprisingly, given their materialism and their training with Broca—did nothing to challenge the belief in the existence of a hierarchy of races, even if the assumption was that inherited inferior racial traits could be overcome in the future by the right social policies. Instead, Broca's acolytes simply grafted their study of social institutions or languages or prehistory on a bedrock of hereditarian assumptions in which race in the past and present (if not the future) always correlated with achievement. The result, as Laurent Mucchielli has argued, was a "racial evolutionist paradigm" that was science of the most dogmatic sort.[65] Among other pernicious consequences, the hold of this paradigm at the École d'Anthropologie prevented the study of cultures or languages— understood in historically specific rather than evolutionary terms—from developing within its walls, at a time when Hamy at the Musée d'Ethnographie was tentatively moving in this direction.

Letourneau's sociology was exemplary on this score, even though his interest in the social organization of "primitive" peoples was, like Hamy's, innovative for his time, given that most of his professional peers in France saw only "savages."[66] In his teaching and his writing, he combed any literature he could find on contemporary premodern societies for what it might reveal about Europeans' past and present trajectory upward. Historic peoples were slotted into their "natural" place according to their race (and there were only three "anatomically and sociologically": "black," "yellow," and "white"). Letourneau then found "evidence" that "proved" that a people's cultural achievements mirrored their physical development; people "known" to be racially inferior had inferior industrial arts and mental capacities, which correlated with their smaller brains—here he cited French anthropologists. Contemporary "black" and "yellow" peoples were of interest principally for illustrating a stage that Europeans had long left behind.[67]

Mortillet and Hovelaque's science operated in the same fashion, although Mortillet at least identified and described his prehistoric artifacts with care. His ranking of Stone Age tools in what he considered to be a universally valid evolutionary sequence correlated directly as well with biological

[65] Mucchielli, *La découverte du social,* 57.
[66] Blanckaert, *De la race à l'évolution,* chap. 13.
[67] Charles Letourneau, *La sociologie d'après l'ethnographie,* 2nd ed. (Paris, 1884); Staum, *Nature and Nurture,* 56.

transformations; he was particularly eager to link the cultural progress he saw in the archaeological record with the evolutionary stages being proposed by some biologists to cover the modern emergence of humans from the apes. As Peter Bowler has put it, "The makers of the most primitive stone tools were depicted as primitive ape-men, thus allowing both the Neanderthals and the modern peoples still using these tools to be cast as mentally inferior to the white race."[68] Hovelacque aspired to found a school of natural linguistics that appeared superficially close to the ideas of Joseph-Arthur (Comte) de Gobineau, who had conflated racial and linguistic hierarchies in his 1853–55 essay *On the Inequality of the Human Races* on purely speculative grounds.[69] Both Hovelacque and his student André Lefèvre, who also taught at the École d'Anthropologie, wished to attach the study of language to the natural sciences, seeing language acquisition and the stages of evolution as parallel.[70]

The materialist group's embrace of this racialized transformism and its direct impact on their research marked one new orientation in the Brocan tradition of anthropology after the founder's death. A second shift followed as well: certain other acolytes determined that they would actively seek out opportunities to place their specialized techniques at the service of the state, to help it to rationally manage the nation's population in an era of declining birthrates, aggressive nationalism, and imperial expansion.[71] For example, the École d'Anthropologie professor of demography Louis-Adolphe Bertillon and his sons Jacques and Alphonse pioneered new uses of statistics in studying France's population through the counting and measuring of bodies. They then sought and found a wide forum for their methods among the educated public and official authorities interested in disease control and lowering mortality rates. Jacques Bertillon helped to establish international statistical standards, while Alphonse Bertillon developed a system of criminal identification based on Brocan anthropometric techniques.[72]

[68] Peter J. Bowler, *Evolution: The History of an Idea*, 3rd ed. (Berkeley, 2003), 285–86.

[69] Only a few French anthropologists were in fact serious students of Gobineau in the second half of the nineteenth century. Most, including Hovelacque, did not share Gobineau's pessimistic vision of the eventual decline of the "superior" races as a result of intermixing with "inferior" ones; indeed, Gobineau's ideas were initially much more widely disseminated in Germany than in France. Blanckaert, *De la race à l'évolution*, 23, 94–107, 363, and 484.

[70] Piet Desmet, "Abel Hovelacque et l'école de linguistique naturaliste. De l'inégalité des langues à l'inégalité des races," in Claude Blanckaert, ed., *Les politiques de l'anthropologie. Discours et pratiques en France (1860–1940)* (Paris, 2001), 55–94.

[71] Claude Blanckaert, "La crise de l'anthropométrie. Des arts anthropotechniques aux dérives militantes (1860–1920)," in Blanckaert, *Les politiques*, 95–172.

[72] On the birth of statistics in France, see especially Joshua Cole, *The Power of Large Numbers: Population, Politics, and Gender in Nineteenth-Century France* (Berkeley, 2000); and Libby Schweber, *Disciplining Statistics: Demography and Vital Statistics in France and England, 1830–1885* (Chapel Hill, NC, 2006).

Scholars have seen in this turn toward a politicized racial evolutionism and applied anthropology in the 1880s and 1890s a growing epistemological impasse in Brocan science itself. Anthropometry was by definition an arid, exacting, and abstract science unlikely to capture the restless energies and ambitions of the likes of Mortillet and the Bertillon *père et fils* for long. To complicate matters, as anthropologists' measurements of human brains multiplied, the correlation of intelligence with specific racial types became ever more elusive, for the simple reason that the statistical series never added up sufficiently to group—much less rank—human varieties into distinct categories. The hope had been that specific characteristics of a group would vary consistently within certain limits across measurements. Crania, however, could be measured variously, and two sets of measurements on the same series did not necessarily produce the same range of variation when compared to another series.[73] Confronted with craniometry's failure to yield either neatly bounded races or classifications everyone could agree on, physical anthropologists' object of study—as originally defined by Broca—became increasingly uncertain. At this moment of confusion, many of his collaborators sought to give their research renewed purpose and direction by applying their specialized knowledge to social problems, in a political context that favored scientific solutions.

At the time of Broca's death in 1880, not all of the École d'Anthropologie's members shared either the outlook or the goals of Mortillet, Hovelacque, Letourneau, or the Bertillons. In particular, the anatomist Paul Topinard—the most orthodox of Broca's heirs and secretary-general of the Société d'Anthropologie in 1880—fought against any deviation from the founding father's "pure science" program or his anthropometry. A prolonged succession struggle for the leadership of the Société d'Anthropologie ensued, which paralyzed the society's proceedings and polarized its members until Topinard lost the struggle in 1886 (and three years later he was ousted from his École d'Anthropologie chair as well). Charles Letourneau replaced him as secretary-general, but by this time many members had left the society, thereby ending the era of genuine scientific debate that had obtained while Broca was still alive. The standards of scholarship within the society and anthropology more generally also began to decline. Within the discipline's journals, legions of articles in anthropometry dedicated to the project of race classification continued to appear, many by doctors who did anthropometry on the side. Rather, however, than comparing data on one set of skulls or other physical features with those of other groups—which was the essence of the Brocan

[73] Carson, *Measure of Merit*, 101; Schneider, *Quality and Quantity*, 218; Blanckaert, "La crise de l'anthropométrie."

scientific method—these articles tended to be purely descriptive, and limited to one sample set. In the face of conflicting anthropometric data, and the thicket of numbers, many Société d'Anthropologie members could see no way forward except by generating ever more numbers. Still other anthropologists began measuring, in addition to skulls and brains, such morphological traits as hair color and texture, eye color and shape, and skin color, in the hope of solidifying their shaky classifications. In a more sinister vein, any hypothesis about the permanent inferior intelligence of women, the nonwhite races, and criminals was becoming publishable in the profession's journals—as long as it carried some reference to skull shape and volume.

Perhaps the most famous, or infamous, barometer of these collapsing standards and growing politicization was the career of the hardline heredi-tarian Georges Vacher de Lapouge. Vacher de Lapouge was a Darwinist who had studied at the École d'Anthropologie in the early 1880s and joined the Société d'Anthropologie. He has become a well-known figure to contempo-rary historians of racism, because in the 1890s he helped to reintroduce the mid-nineteenth-century ideas of Gobineau on the inequality of races to a few scientists like himself and to nationalist intellectuals on the Far Right in France.[74] Vacher de Lapouge's scientific career never took off in Paris. In-stead, from a position in the provinces (he was a librarian in Rennes), he became the leader of a small group of "anthroposociologists" who selectively drew on Gobineau's corpus to theorize that race alone determined the psy-chological makeup of individuals and thus provided the key to social behav-ior.[75] According to Vacher de Lapouge, all of history was a struggle between

[74] For Vacher de Lapouge's use of Gobineau, see Georges Vacher de Lapouge *Les sélections sociales* (Paris, 1896). See also Hecht, *End of the Soul,* chap. 5; Massin, "L'anthropologie raciale," 269–336; Mucchielli, "Sociologie *versus* anthropologie raciale," 84–85; Pierre-André Taguieff, "Racisme aryaniste, socialisme et eugénisme chez Georges Vacher de Lapouge (1854–1936)," *Revue d'Histoire de la Shoah* 183 (2005): 69–134; and Taguieff, *La couleur et le sang. Doctrines racistes à la française* (Turin, 1998), chap. 1.

[75] Mucchielli, *La découverte du social,* 279. A second edition of Gobineau was brought out in France in 1884, but even then his ideas remained largely unknown until Vacher de Lapouge helped to popu-larize his version of Gobineau's writings. Without denying Gobineau's obvious racism, the literary scholar Jean Gaulmier argues that fin-de-siècle polemicists like Vacher de Lapouge and Houston Stewart Chamberlain distorted Gobineau's claims. For example, Gobineau never maintained that modern Germans were descended from Aryans; nor was he anti-Semitic. Gaulmier emphasizes the stylistic and "poetic" qualities of Gobineau's writings, which help to explain why, after his "rein-troduction" during the Dreyfus affair in France, Gobineau would continue to be read critically by French intellectuals across the political spectrum, especially in the interwar years. Jean Galumier, "Dossier Gobineau," *Romantisme* 37 (1982): 81–100, esp. 82–85. The anthropologist Wictor Stocz-kowski, in his work on Claude Lévi-Strauss, analyzes the latter's criticism of as well as his engage-ment with Gobineau, especially in the context of Lévi-Strauss's late-career fears regarding over-population. Wictor Stoczkowski, *Anthropologies rédemptrices. Le monde selon Lévi-Strauss* (Paris, 2008), chap. 9.

two unequally endowed races, whose moral and intellectual capacities could never be altered: the superior but dwindling Aryan doliochocephalic race, or long heads; and the inferior but proliferating Alpine brachiocephalic race, or round heads. He went on to attribute to each race certain fixed qualitative characteristics: doliochocephalics were fair-skinned, blue-eyed, and creative, while brachiocephalics were dark-skinned and of mediocre intelligence. He also combined this biological racism with one of the earliest calls in France for eugenic selection by the state to ensure that only "Aryans" reproduced.[76] Such selective breeding would guarantee the survival of the superior race and rescue the nation from the degeneration that modern race mixing had supposedly introduced. During the Dreyfus affair, Vacher de Lapouge's arguments became for the first time openly anti-Semitic, as he accused Jews of contributing directly to the decline of French civilization. Soon the right-wing author Édouard Drumont was pointing to Vacher de Lapouge's recently published works to claim that science had proven that Jews were a foreign, atavistic, and degenerate race.[77]

As this appropriation of Vacher de Lapouge's "science" suggests, he had succeeded in placing his tendentious anthroposociological theories in the 1890s in the major anthropological journals of his day, including the *Revue de l'École d'Anthropologie* and, more surprisingly, *L'Anthropologie*, which Hamy helped to edit.[78] This success, Laurent Mucchielli has argued, represented nothing less than a breakdown of normal science in the field of professional anthropology as a result of the years of internecine quarreling among Broca's heirs—including inadequate peer review, a loss of consensus over the domain's parameters, and a lack of control over scientific production more generally.[79] Yet if Vacher de Lapouge was able to take advantage of such a breakdown to publish his extreme ideas, the ground had been well prepared first by the hierarchical assumptions that physiological structures correlated

[76] Georges Vacher de Lapouge, *L'Aryen et son rôle social* (Paris, 1899).

[77] According to Mucchielli, Drumont cited the works of the anti-Semitic neuropsychologist Jules Soury as well as those of Vacher de Lapouge. Soury and Lapouge were part of a small group of extreme racial determinists in France who linked all cultural achievement to biology and heredity. Mucchielli, "Sociologie *versus* anthropologie raciale," 84–85. On Soury, see Toby Gelfand, "From Religious to Bio-medical Anti-Semitism: The Career of Jules Soury," in Ann Elizabeth Fowler La Berge and Mordechai Feingold, eds., *French Medical Culture in the Nineteenth Century* (Amsterdam, 1994), 248–79.

[78] Wartelle, "La Société d'anthropologie," 157–58; Benoît Massin, "L'anthropologie raciale comme fondement de la science politique. Vacher de Lapouge et l'échec de l' 'anthroposociologie' en France (1886–1936)," in Blanckaert, *Les politiques*, 299–304. After 1894, *L'Anthropologie* was jointly edited by Hamy, the prehistorian Émile Cartailhac, and the anthropometrist Paul Topinard, three figures who did not share the materialists' perspective and who might have been expected to question Vacher de Lapouge's methods and claims. Even the *AS* initially reviewed his works.

[79] Mucchielli, "Sociologie *versus* anthropologie raciale," 85.

with capacity, which had informed Brocan anthropometry, and then by the racial evolutionary paradigm adopted by several École d'Anthropologie denizens; indeed, intellectuals across the political spectrum shared these assumptions in the first half of the Third Republic.[80] Neither Broca nor his closest colleagues and students, however, crossed the line into hardened racism the way Vacher de Lapouge did; to the contrary they remained optimistic about the ways improved environments and social policy could help individual members of "inferior" races progress. Fortunately, by the late 1890s a new group of social scientists, the Durkheimians, were sufficiently well organized to recognize and counter scientifically the threat that Vacher de Lapouge's anthroposociology posed not only to all students of the "human," but to the founding principles of the Republic itself. The arrival of Durkheimians on the French academic scene more or less at the same time that the arrest of Dreyfus was escalating into a national crisis did not mean the end of racial science in France, but it did help spell the end of Vacher de Lapouge's anthroposociology.

BROCAN SCIENCE AT THE TURN OF THE TWENTIETH CENTURY

If the outlook for French anthropology looked particularly bleak in the fin de siècle, Drumont's politicization of Vacher de Lapouge's "bad" science to justify his anti-Semitism did not go unanswered in France's larger community of "human" scientists. As Laurent Mucchielli, Ivan Strenski, and Filippo Zerilli have shown, one group that responded with alacrity was made up of relative newcomers to the French academic milieu: Émile Durkheim and his disciples. Durkheim believed that society shaped individuals rather than the other way around, and that there were universal social laws that the rigorous sociologist could discover. As part of his social perspective on human civilization, he had begun by the 1890s to take an interest in primitive religion among the aborigines of Australia and North America.[81] This primitivist turn led him implicitly to reject the idea that the mental and psychological characteristics of any group of human beings could be attributed exclusively to race—as Vacher de Lapouge claimed. If Durkheim's new sociology had

[80] As Owen White has argued, mainstream republican intellectuals made use of this same Brocan science to warn of the "dangers" of miscegenation. One example is Alfred Fouillée, the founder of the ideology of solidarism. See his "Le caractère des races humaines et l'avenir de la race blanche," *Revue des Deux Mondes* (July 1894): 76–107; cited in White, *Children of the French Empire,* 105. Fouillée would nevertheless oppose Vacher de Lapouge's radical conclusions.

[81] For example, Émile Durkheim, "La prohibition de l'inceste et ses origines," *AS* 1 (1898): 1–70; Durkheim, "De la définition des phénomènes religieux," *AS* 2 (1899): 1–28.

been more established institutionally in the late 1890s, and if he and his disciples had not themselves been committed to the egalitarian principles of the Third Republic, they might not have taken on Vacher de Lapouge, leaving it to the anthropologists to prove how unsubstantiated the claims of anthroposociology were. But because Vacher de Lapouge was allowed a foothold in the intellectual field at a time when Durkheim was building his new networks, as well as being used by Durkheim's political enemies, the sociologist chose to attack. From 1900 to 1907, the *Année Sociologique* waged a steady battle against anthroposociology and its racist premises on scientific grounds, in which Durkheim's nephew and disciple, Marcel Mauss, played a key role.[82] In the wake of this assault, Vacher de Lapouge's "scholarly" production was not published in France again until the 1920s and especially the 1930s, when the resurgence of anti-Semitism and the Far Right in France made his ideas once again acceptable in certain scientific as well as political milieus.

It would be wrong, however, to imply that among France's human scientists, only the Durkheimians took on Vacher de Lapouge's assertions. Several members of the French physical anthropology establishment also reacted to his scientific racism, which threatened to tar their entire community with charges of a lack of rigor.[83] The most prominent dissenter was Léonce Manouvrier, professor of anthropology at the École d'Anthropologie and Broca's last student. According to Mucchielli, Manouvrier was the "first" physical anthropologist to have "if not understood, at least to have recognized and integrated into his work the fact that anthropology could no longer aspire to explain humanity in its fundamental essence [*fondamentalement*] by the study of his biological constitution."[84] Already in the 1890s, Manouvrier had distanced himself in print from the kind of crude racial determinism espoused by the crowd psychologist Gustav Le Bon and the anthropological criminologist Cesare Lombroso—both former students at the École d'Anthropologie.[85] But the Dreyfus affair encouraged him, too, to attack such reductionism head-on, and in 1899 he launched his own scientific refutation

[82] See Mucchielli, *La découverte du social,* chap. 1; Ivan Strenski, "Henri Hubert, Racial Science, and Political Myth," *Journal of the History of the Behavioral Sciences* 23:4 (1987): 353–67; and Zerilli, *Il lato oscuro,* 33–38.

[83] For a comparable rebuttal of biological essentialism among staunchly republican historians of the era, see André Burguière's study of the iconoclastic Paul Lacombe, whose sociohistorical approach to the "psychology of peoples" later inspired Marc Bloch and Lucien Febvre. André Burguière, "De la psychologie des peuples à l'histoire des mentalités. La controverse de Paul Lacombe et d'Alexandre Xenopol" (unpublished paper).

[84] Mucchielli, "Sociologie *versus* anthropologie raciale," 89.

[85] On Manouvrier's rejection of Lombroso, see Robert Nye, "Heredity or Milieu: The Foundations of Modern European Criminological Theory," *Isis* 67:3 (1976): 335–55.

of Vacher de Lapouge in the *Revue de l'École d'Anthropologie*.[86] Manouvrier did not challenge the skull-based theory of races; he did, however, try to persuade his readers that "aptitudes transmitted through heredity" were purely physiological and elementary ones that did not predict subsequent behavior in any way.[87] In a way that could and did comfort the Durkheimians, he called for an independent sociology that accounted for the full complexity of human phenomena.[88]

Manouvrier's rejection of anthroposociology helped to discredit extreme forms of racial determinism among the majority of French physical anthropologists, although neo-Lamarckian hereditary theory continued as before to prevail among their ranks. This said, at least some of the faculty at the École d'Anthropologie disagreed with Manouvrier about the limits of what the study and classification of humans by race might yield in terms of understanding the variety of human societies, languages, and civilizations, past and present. At stake was whether the social could legitimately be severed from the racial—a disciplinary and epistemological move that several École d'Anthropologie professors steadfastly resisted. Thus, although the latter rejected Vacher de Lapouge's unsubstantiated racist claims and distanced themselves from the political use to which they were being put by nationalists like Drumont, these anthropologists nevertheless clung to the racial evolutionist paradigm developed by the materialists a generation earlier, which had long subsumed the analysis of cultural and social traits within racial ones. Fairly typical in this regard were the following claims in 1907 by the holder of the chair in ethnology at the École d'Anthropologie and also one of Broca's later students, who had trained as a doctor, Georges Hervé: "The scientific objective of ethnology is to draw a profile of each race, and then order all the human races in an ascending series, that is to say from the simian point of departure to the most intellectually and socially endowed."[89]

For Hervé, ethnology (which he described as the science of the "description of the races") remained "the queen branch [*branche maîtresse*] in the natural history of man," which studies those "natural groups whose hereditary and fixed characteristics indicate their boundaries, and which are conventionally referred to as races." And as the queen branch, racial science could not only elucidate the origins of humanity but also explain "the causes behind the disappearance, or the transformation, or the maintenance of

[86] Léonce Manouvrier, "L'indice céphalique et la pseudo-sociologie," *Revue de l'École d'Anthropologie* 9 (1899): 233–59. On Manouvrier, see Hecht, *End of the Soul,* chap. 6; Zerilli, *Il lato oscuro,* 32–33 and 58–63; and Blanckaert, "Crise de l'anthropométrie."
[87] Schneider, *Quality and Quantity,* 217.
[88] Mucchielli, "Sociologie *versus* anthropologie raciale," 89.
[89] Quoted in Mucchielli, *La découverte du social,* 485.

these ethnic groups."[90] Another École d'Anthropologie professor, Georges Papillault—who inherited Letourneau's chair in sociology and who would later be responsible for the physical anthropology display at the Colonial Exposition of 1931—was openly critical of the Durkheimians for trying to study societies on the basis of "exterior forms" only, without "penetrating the living matter which constitutes their substance."[91] Papillault, an early advocate of eugenics in France like Vacher de Lapouge, authored several manifestos in favor of what he called "biosociology," which also rooted the social in the biological (and thus, implicitly, the racial): "The most widespread form of organization, the one most independent of environment and race, produces different results, yields profoundly different outcomes, according to the biological characteristics of the individuals that make it up."[92] At stake in these exchanges between certain denizens of the École d'Anthropologie and the Durkheimians was which science—the old physical anthropology or the new Durkheimian sociology—could *best* explain human social behavior.

The old-fashioned positions that Papillault and Hervé—as opposed to Manouvrier—carved out on the question of race and human capacity in the wake of the Dreyfus affair reflected a larger decline in the school compared to its tremendous popularity twenty years earlier. As a private school, the École d'Anthropologie suffered from certain innate disadvantages compared to disciplines housed within the university. Its funding remained precarious, and since it did not have the ability to grant degrees, the training it offered was of dubious value for students planning a career outside of medicine.[93] Medical students began deserting the École d'Anthropologie's once-popular courses. By then, evolutionism had largely been accepted in France, even by many clerics; the combative materialists of the founding years were also disappearing from the scene, and new, nonlinear interpretations of evolution were emerging, for example, in the paleoarchaeology of l'Abbé Breuil and the paleoanthropology of Marcellin Boule. Both initially had positions at the Muséum rather than the École d'Anthropologie, where they became leading critics of Mortillet's theory of a continuous single ascent of man on the basis of new finds. Because of their efforts the Société Préhistorique Française would be founded in 1904, followed by that of the Institut de Paléontologie Humaine in

[90] Quoted in Mucchielli, *La découverte du social*, 485.
[91] Quoted in Sibeud, *Une science impériale?* 71 n. 60.
[92] Quoted in Mucchielli, *La découverte du social*, 486. For a further discussion of Papillault, who actively championed a racist colonial sociology from 1900 onward, see Sibeud, *Une science impériale?* 67–73.
[93] Williams, "Anthropological Institutions," 345–47.

1910, which soon garnered an international reputation.[94] With the exception of Manouvrier—trained as an anatomist, and one of Broca's last students, who denounced the entire Brocan attempt to connect brain size to intelligence as ill conceived—a new generation of undistinguished faculty presided at the École d'Anthropologie in the early twentieth century. The most dramatic break-throughs in racial science would henceforth come from outside of France—for example, from the biometricians Francis Galton and Karl Pearson in Britain, from Franz Boas's investigations into the malleability of head forms in the United States, and from Eugen Fischer's application of Mendelian genetics to anthropology in Germany. In short, much like the Société d'Anthropologie, the École d'Anthropologie had lost its claim to be a leader in the fields that had made it famous since its founding: racial science and prehistory.

The history of the first half century of professional anthropology in France makes clear that the death of Broca helped to transform what had begun as a promising movement to inaugurate a general anthropology in France under the banner of the Société d'Anthropologie into a more fractured enterprise. Perhaps the most significant consequence of this fragmentation was the fail-ure of serious study of premodern cultures to take off in France at a time when it was being launched in other countries. Yet this failure was not due to a lack of trying. Broca, while not himself interested in developing a scientific study of sociocultural diversity, had placed the topic in his original program. The state's decision to found a scientific ethnographic museum was also proof that France was not a laggard in this domain. For Claude Blanckaert, much of the blame for the rise and fall of French anthropology can be attributed to the fact that, before and after Broca, it "lived closed in on itself," never moving beyond the study of anatomy and prehistory on which Broca and others first

[94] Both l'Abbé Breuil and Boule would move to the Institut de Paléontologie Française, funded by Prince Albert I of Monaco. Marcellin Boule began as a paleontologist at the Muséum in the 1880s, where he built a career around establishing the ancestry (branching, linear, or parallel but separate development) of fossil species. In the early 1900s he began applying the same methods to the study of hominin remains. He famously ejected Neanderthals from the human family tree, on the basis of an exhaustive reconstruction of the first relatively complete skeleton, which was discovered at La Chapelle-aux-Saints in 1908. His findings became dogma for several generations before being criti-cized in the 1950s. Michael Hammond, "The Expulsion of Neanderthals from Human Ancestry: Marcellin Boule and the Social Context of Scientific Research," *Social Studies of Science* 12:1 (1982): 1–36. Boule's friend and later colleague, l'Abbé Breuil, an ordained priest allowed by his church to pursue research, became one of the first experts in prehistoric ethnology, paleoarchaeology, and cave art; he later accurately dated the Aurignacian culture in the Middle Paleolithic on the basis of prehistoric finds and was a key innovator in the accurate dating of Paleolithic cultures. He would be elected to the Collège de France in 1925. Arnaud Hurel, *L'abbé Breuil. Un préhistorien dans le siècle* (Paris, 2011). On the history of these fields in France, see Hurel, *La France préhistorienne de 1789 à 1941* (Paris, 2007).

grafted it.[95] This same tendency helps to account for the fact that "the postu-
late of fixed and original races . . . endured . . . despite Lamarck and Darwin,
as an inert but paradoxically active element in the heart of the anthropologi-
cal paradigm well into the early twentieth century."[96]

When Hamy resigned from his ethnographic museum in protest over its
neglect, it might seem that the possibilities for the development of a science
of ethnography were as dim as those for any immediate return to prominence
of the École d'Anthropologie—and that the prospect for a unified science of
man that took up the questions of both the physical and the sociocultural
diversity of humans in the deep past and the present was even more remote.
Indeed, one of the best Durkheimian sociologists of primitive religion, Mar-
cel Mauss, complained in two articles published in 1913 in the *Revue de Paris*
under the title "Ethnography in France and Abroad" that even Switzerland
and Sweden had done better than France in this domain, despite the latter's
superior status as a great "scientific power and colonial power."[97] At the time,
Mauss had just returned from visiting the British Museum and the Museum
für Völkerkunde in Berlin.[98] He then added:

> The cause and also the consequence of the stagnation of ethnography in France
> is the absence or the inadequacy of institutions that might concern themselves
> with it. We have no teaching programs, no good museums, no centers of eth-
> nographic research because we are not interested in ethnography. And, con-
> versely, we do not interest ourselves in this science because there is no one
> amongst us who is particularly interested in its success. A science does not live
> only from verbal promises; it needs material and personnel. It needs perma-
> nent organizations, durable institutions that create and nurture it.[99]

Yet within the space of fifteen years Mauss and an assistant to the chair
in anthropology at the Muséum, Paul Rivet, had founded a new Institut
d'Ethnologie at the Sorbonne, with ethnographic methods at the core of its
curriculum, alongside the study of races, prehistory, and languages; that same

[95] Blanckaert, *De la race à l'évolution*, 530.
[96] Ibid., 105–6.
[97] Marcel Mauss, "L'ethnographie en France et à l'étranger I," *La Revue de Paris* 20:5 (1913): 549.
Mauss was referring here, presumably, to the Gothenburg Museum in Sweden, which will be
discussed in chapter 3. The Swiss had several ethnographic museums as a result of their long
missionary tradition. On the history of these museums, see Serge Reubi, *Gentlemen, prolétaires et
primitifs. Institutionalisation, pratiques de collection et choix muséographiques dans l'ethnographie
suisse, 1880–1950* (Bern, 2012).
[98] IMEC/Fonds Marcel Mauss/MAS 21.17/Marcel Mauss, "Rapport au ministre," n.d. [1913].
[99] Marcel Mauss, "L'ethnographie en France et à l'étranger II," *La Revue de Paris* 20:5 (1913): 820–21.

year a new series was launched for publishing monographs in all branches of ethnology; and by 1928 Rivet had embarked on a dramatic overhaul of the Musée d'Ethnographie that would catapult it to the forefront of anthropological museums internationally. In short a new "Institute"—only this time with the study of languages and civilizations fully integrated—seemed rather suddenly to materialize. With the benefit of hindsight, it is clear that the previous half century of efforts to organize a general anthropology, combined with the shock represented by the eruption of scientific racism during the Dreyfus affair, had prepared the ground for such a renewal and would help determine its direction.

CHAPTER 2

TOWARD A NEW SYNTHESIS

The Birth of Academic Ethnology

I first met Mauss (I think) in 1926. With Malinowski I went to see
him in his apartment in Paris, to be greeted by a burly man with a
black beard, hospitable, intellectually exuberant, and talking fairly
good English with an American accent. . . . His conversation mainly
with Malinowski was scholarly and stimulating, and they argued
amicably, but strongly about some anthropological matters which I
can't now recall. Mauss was obviously an enthusiast for ideas.

—RAYMOND FIRTH, quoted in James and Allen, *Marcel Mauss:
 A Centenary Tribute* (1998)

With the opening of the École d'Anthropologie in 1876, Broca had com-
pleted his anthropological institute: a set of interlinked world-class structures
comprising the Société d'Anthropologie, a laboratory, a museum, and now
a school as well, all dedicated to professionalizing his vision of general an-
thropology. By the turn of the century, however, the politicization of Broca's
disciples, and growing doubts about what even the most exacting measure-
ments could yield in terms of the racial classification of humans, were un-
dermining these achievements. At the same time, the few in France who had
tried to claim ethnography as their scientific domain remained fixated on
past civilizations and fragmented organizationally, when many museum-
and university-based anthropologists abroad were expanding their expertise
to include the study of contemporary "primitives."

These impasses nevertheless also represented opportunities for change,
and already in the 1890s new professionalizing groups interested in studying
Amerindian, African, and Oceanian societies began to emerge. One source of
innovation came from the anthropology chair at the Muséum, in the person
of a protégé of Hamy, the Americanist anthropologist Paul Rivet, who like his

predecessors there combined the study of ethnography with that of the human races, past and present. But reform also came from two new clusters of scholars: first, the Durkheimians, and more especially Durkheim's nephew, Marcel Mauss; and second, a more eclectic group of ethnographers, which included the folklorist Arnold van Gennep and a group of colonial administrators working in sub-Saharan Africa led by Maurice Delafosse. Delafosse had scientific aspirations but, unlike his counterparts in Algeria or Indochina, no local institution of higher learning to help guide his efforts at observation. By the late 1920s, these multiple forces for renewal in a context of heightened imperialist rivalries had coalesced to the point where a fieldwork-based and sociologically oriented science of man could enter the French university, a generation later than in Britain or the United States.[1] In 1925, an Institut d'Ethnologie was created at the University of Paris that enabled students for the first time to incorporate anthropology and ethnography in their undergraduate course of study, and the most ambitious of them to complete doctorates in the domain.

Yet it would be premature to argue that a sociocultural anthropology fully autonomous and separate from racial science emerged at this juncture, or that the Institut d'Ethnologie eclipsed the École d'Anthropologie. On the one hand, for Mauss and Rivet, the goal remained a general anthropology—a genuinely general anthropology this time—that is to say, a synthesis of languages, civilizations, and races. Racial science was demoted at the new Sorbonne institute, but not eliminated in a discipline that aspired to study humanity in all its aspects. To make sure that this broader orientation was clear, these scholars renamed their science of man "ethnology," because the term "anthropology" had become associated with physical anthropology alone.[2] On the other hand, instruction in the old anthropology—with its insistence that racial inheritance determined group mental traits—continued to be available at the École d'Anthropologie. Indeed by the 1920s, the latter institution showed signs of revival, hiring new faculty and attracting credentialed scholars interested in what they too, confusingly, called "ethnology," but defined very differently from Mauss and Rivet.

In order to reconstruct this complex story of renewal of France's science of humanity between the 1890s and 1920s, this chapter begins with portraits of Paul Rivet and Marcel Mauss and their partnership. Unlike other, more famous creative collaborations of the first half of the twentieth century in the human sciences—Durkheim and his school in the prewar years, or Lucien

[1] E. B. Tylor, for example, became professor of anthropology at Oxford in 1896, Franz Boas at Columbia in 1899. See chapter 1, note 2.

[2] Paul Rivet, "Ethnologie," in *La science française,* new ed. (Paris, 1933), 2:5.

Febvre and Marc Bloch in the interwar years—that of Rivet and Mauss might best be described as a marriage of convenience, in which political events and intellectual developments that neither man controlled played as important a role as the consciously chosen fusion of their individual scholarly interests.[3] The two men were trained in different fields; professionally they were attached to networks that did not normally overlap; and their personalities were different as well. Building a unified ethnology was thus a piecemeal process from the outset, in which even knowing what to call their renovated science of humanity was not self-evident. Yet Mauss and Rivet were also united by several factors that made it possible to tread separate paths and still work together. These included a common Socialist engagement, a generosity of spirit, and the fact that each was located in a research institution on the margins of the traditionally conservative French university—a location that made innovation easier.

Because, however, the École d'Anthropologie remained a fixture in Paris after the Institut d'Ethnologie was founded, we end the story of Rivet and Mauss's accomplishments with that of another doctor-anthropologist's trajectory: the Swiss-born George Montandon, who was Mauss's and Rivet's exact contemporary. An outsider who was an extreme racial determinist all his life in the mold of Vacher de Lapouge—although he hid his views much better than did the latter—Montandon would also come to occupy a respected niche in the human sciences in interwar Paris and internationally, as a professor of ethnology at the École d'Anthropologie. That he was able to do so is testimony to just how unsettled the professional status and content of the science of humanity was in France at this new moment of institution building, encounters with the other, and intellectual reflection on how to write "truthfully" about difference.

ANTHROPOLOGY REDEFINED: PAUL RIVET

As Christine Laurière has noted, Paul Rivet was a true son of the Third Republic. Born in 1876 into a lower-middle-class family of soldiers and civil servants in the small town of Wasigny in Lorraine, he studied philosophy and then won a scholarship to study medicine at the École du Service de Santé Militaire in Lyon. His loyalty to the regime was further solidified

[3] On the Durkheimians, see Philippe Besnard, "La formation de l'équipe de l'*Année Sociologique*," *Revue Française de Sociologie* 20:1 (1979): 7–31. For the Bloch-Febvre partnership, see André Burguière, *L'école des Annales. Une histoire intellectuelle* (Paris, 2006) and also their lengthy correspondence. Mauss and Rivet did not write to each other frequently.

during the course of the Dreyfus affair, although he would not join the French Socialist Party (SFIO) until after World War I.[4] Rivet graduated fourth in his class in 1897 with a thesis on the treatment of pleurisy and was appointed to a cavalry regiment in Paris. In 1901 he jumped at the chance to see something of the world by becoming shipboard doctor for a government-sponsored geodesic mission to Ecuador to remeasure the meridian arc. In addition to his medical responsibilities, he was instructed to collect a wide range of specimens for the Muséum—a task expected of any French scientific mission in the nineteenth century. To prepare himself, Rivet visited the anatomy, paleontology, entomology, mammalogy, botany, mineralogy, and anthropology laboratories at the Muséum; among other skills, he learned anthropometry, which came easily to him as a doctor.[5] And although he left Paris with no clear plan to change professions, the encounter with South America was transformative. In Ecuador, Rivet discovered a predilection for collecting not flora and fauna, but rather anthropological, archaeological, ethnographic, and linguistic materials, which led to a set of research questions that would inform his entire professional career as a scholar. Equally important, he was exposed to "the field" in a manner that was atypical for French doctor-anthropologists of his generation, most of whom practiced their science in laboratories.

When Rivet set off for America, the eclectic group of archaeologists, naturalists, and anthropologists who made up France's professional community of Americanists still had little interest in Amerindians for their own sake. Instead, certain historical questions dominated Americanism: Where had the peoples of South America come from originally? How long had they been there before the arrival of Columbus? What had been their level of civilization? Were similar material objects found among different cultures the result of independent invention or diffusion? Had cultural elements spread

[4] AMH/2 AP 1 B14/d/Paul Rivet, "Souvenirs sur Lévy-Bruhl." Rivet reports having been convinced of Dreyfus's innocence already in 1901. The SFIO was founded in 1905.

[5] Laurière, *Paul Rivet*, 14–19 and 42–44; Laura Rival, "What Sort of Anthropologist Was Paul Rivet?" in Robert Parkin and Anne de Sales, eds., *Out of the Study and into the Field: Ethnographic Theory and Practice in French Anthropology* (New York, 2010), 125–26. In addition to Laurière's well-documented biography, see her article "Paul Rivet, vie et oeuvre," *Gradhiva* 26 (1999): 109–28 for a chronology of his life. On Rivet's intellectual trajectory as a physical anthropologist, the most important recent work is Zerilli, *Il lato oscuro*. Jean Jamin explores Rivet's political and scientific career together in "Le savant et le scientifique. Paul Rivet (1876–1958)," *BMSAP* 1:3–4 (1989): 277–94. On Rivet's place in the larger history of Americanism in France, see Paul Edison, "Latinizing America: The French Scientific Study of America, 1830–1930" (PhD diss., Columbia University, 1999), esp. chap. 11. Rivet's reforms of ethnology are discussed briefly by Benoît de l'Estoile, "Africanisme et Africanism. Esquisse de comparaison franco-britannique," in Anne Piriou et Émmanuelle Sibeud, eds., *L'africanisme en questions* (Paris, 1997), 19–42; and Gérald Gaillard, "Chronique de la recherche ethnologique dans son rapport au CNRS, 1925–1980," *Cahiers pour une Histoire du CNRS* 3 (1989): 85–126.

between the Old and New Worlds before the arrival of Columbus?[6] Soon after arriving in Ecuador, Rivet found himself drawn to these debates, and since the ethnic groups there were much less well known than those of either Peru or Brazil, he decided to use his five years abroad to undertake "as complete a study as possible of the Indian race [*la race indienne*]."[7] True to his recent anthropological training, Rivet eventually measured 300 live Amerindians and collected some 350 crania and 500 other osteological remains.[8] But his growing interest in the deep past soon caused him to cast his net much wider.

Rivet was constantly on the lookout for those peoples ostensibly untouched by modern civilization, whose bodies (or so he thought) could provide clues to their migration patterns centuries earlier. His military responsibilities prevented him from visiting one of the two groups that best fit this notion of tribes unsullied by outside contacts, the Jivaro; he spent a little time with the other group, the Tsàchila (or Colorado).[9] He nevertheless recognized that archaeological and linguistic evidence provided important historical clues, and began gathering notes on local customs as well as transcribing a number of vocabularies of local dialects, collected secondhand from missionaries and traders in the area. He excavated between seventy and eighty different sites and acquired a stunning collection of ancient ceramics (800 pieces).[10] All this information would serve to convert Rivet to an expansive definition of anthropology when he returned to France in 1906 and fell under the sway of Hamy, holder of the anthropology chair and the nation's leading Americanist anthropologist.

As we saw in the context of his directorship of the Musée d'Ethnographie during the 1880s, Hamy had always insisted that the collection of cultural artifacts was part of anthropology's domain. Once elected to the chair in anthropology in 1892, Hamy had used his new position to further this claim. That same year, along with his assistant and heir apparent at the Muséum, the paleontologist-ethnographer René Verneau, and a second Muséum colleague and future star of paleoanthropology, Marcellin Boule, Hamy had founded

[6] On these questions, see, for example, the speech given by the president of the Société des Americanistes in 1913, M. Vignaud: "Discours de rentrée de M. Vignaud, séance du 4 novembre 1913," *Journal de la Société des Américanistes* 11 (1919): 1–12 (the war delayed the publication of this speech).

[7] Quoted in Laurière, *Paul Rivet*, 73.

[8] Laurière, *Paul Rivet*, 73 and 91; Edison, "Latinizing America," chap. 11.

[9] This lack of firsthand contact did not prevent Rivet from writing their ethnography upon his return, on the basis of all the existing published literature. Paul Rivet, "Les Indiens Jibaros: Étude géographique, historique et ethnographique," *L'Anthropologie* 19 (1908): 69–87 and 235–59. For an assessment of Rivet's field experiences, see Rival, "What Sort of Anthropologist," 132–38.

[10] Laurière, *Paul Rivet*, 92–98, 100.

a highly respected journal entitled *L'Anthropologie,* dedicated to publishing articles in prehistory, paleoanthropology, anthropometry, linguistics, and ethnography. It was largely due to Hamy that Rivet was able to obtain leave from the military after the geodesic mission and begin cataloging the data he had collected in Ecuador in the anthropology laboratory at the Muséum. When Hamy died in 1909, Verneau succeeded him as chair, which in turn allowed Rivet to become Verneau's assistant. The new post was modest, but it was a secure one, in an institution whose prestige in the natural sciences had grown with the recent expansion of the empire. Rivet was now launched on a path that would eventually lead him to the coveted Muséum chair itself in 1928, from which he—like Hamy and Verneau before him—would also gain control of the Musée d'Ethnographie and its resources. With his new career set, Rivet turned to the task of renewing the anthropological sciences in France. He advanced on two fronts simultaneously. First, he took stock of the ongoing crisis in physical anthropology and worked out his own innovative area of cultural expertise: he would become France's leading expert on South American native languages. Second, he threw himself into institutional renovation, hoping to reorganize the field of anthropology to include the study of the languages and civilizations of so-called primitive peoples in a way that reflected his own field experience.

Rivet's first major professional move was to take on the physical anthropologists at the École d'Anthropologie on their own turf. His recent contact with Ecuador's modern Amerindian populations had convinced him that anthropologists could not identify past or present "races" on the basis of measurement of physical features alone. In a landmark 1909–10 study that appeared in *L'Anthropologie,* he effectively burned his bridges with hard-core racial scientists in France by revealing the sterility of their debates over prognathism as a reliable marker of origin. Prognathism refers to the protrusion of the upper or lower jaw and is determined by measuring the facial angle (the slope of a line from forehead to jaw). Broca had believed that the facial angle could reveal intelligence, and therefore the evolutionary development of any given "specimen," and had associated a steeper angle with a higher level of development. Polygenist anthropologists in general thus maintained that the facial angle of certain ethnic groups indicated that they were closer to apes than to Europeans. Demonstrating his mastery of the techniques of craniometry, Rivet measured no fewer than 6,000 human and animal crania (the largest previous sample examined by a single scholar had been 1358). He then determined through the use of sophisticated statistical analysis that while it was possible to use the facial angle to distinguish humans from primates, these measurements did not permit scientists to classify races, much

less determine intelligence.[11] At best, he concluded, craniometry and anthropometry constituted one set of research tools among many for unraveling the complex movements of races in the past or their more recent mixing.[12]

Here it is interesting to compare Rivet's critique of anthropometry and craniometry to the better-known one that Franz Boas was carrying out at the very same time, although the two scholars were working independently of each other. As Boas's biographer Douglas Cole has shown, in the early 1900s the German-born anthropologist was wrestling with many of the same methodological and conceptual problems in racial science that were frustrating Rivet, and these would lead Boas in 1911 to publish a groundbreaking study of changing head forms among descendants of immigrants. Like Rivet, Boas beat the quantifiers at their own game by rigorously mastering the best statistical methods of the time; his analysis of close to 18,000 people revealed that the average measures of cranial size of immigrants were significantly different from those of members of these groups who were born in the United States. Boas had first trained in physics, then in physical and cultural anthropology in Germany, which meant that he "was a fish in statistical waters." Even as he had gravitated toward studying the languages and cultures of the Pacific Northwest, Boas had remained interested in the biological history of humankind, and kept up with the latest advances in statistical methods. He had supervised measurements of 17,000 Amerindians and "half bloods" at the 1893 World's Fair in Chicago, and he continued amassing measurements after the fair ended. Each time, he was struck by the extent of variability within groups that his data revealed. Such variation, he argued in 1894 and again in 1907, made any conclusions about innate differences among races premature. His 1911 study of immigrants went a step further by offering proof that biological features, like linguistic, material, and cultural ones, were subject to historical processes of change.[13] While Rivet's study was not as far-reaching as that of Boas, the underlying concern with exposing the methodological fallacies of racial determinists by coming up with better numbers was the same.

After publishing his critique of prognathism, Rivet, and his senior colleague René Verneau, quit the Société d'Anthropologie, thus further distancing the Muséum anthropologists from an association too tied to discredited scientific practices. Rivet next began analyzing his Ecuadorean archaeological

[11] Paul Rivet, "Recherches sur le prognathisme," *L'Anthropologie* 20 (1909): 35–49 and 175–87 and *L'Anthropologie* 21 (1910): 505–18 and 637–99. He did admit, however, that measuring for prognathism might be useful in establishing degrees of miscegenation. See Wartelle, "La Société d'anthropologie," 159; Zerilli, *Il lato oscuro*, 63–67; Laurière, *Paul Rivet*, 182–83.

[12] Sibeud, *Une science impériale?* 147–51.

[13] Cole, *Franz Boas*, 262–72; the quotation is from p. 267.

and linguistic materials, as well as regularly reviewing the scientific ethno-graphic literature appearing nationally and internationally. His linguistic turn would prove decisive for his future trajectory as an anthropologist. Rivet's mission had made him aware of the lamentable state of knowledge of South American languages. From 1910 he thus set about transcribing the languages of Ecuador, based on older missionary transcripts and what he had gleaned from the European informants whom he had cultivated on the spot. Yet his ambition quickly expanded beyond the confines of a single country. Rivet set himself the task of drawing a map of the distribution of local lan-guages on the continent before the arrival of the Spanish, and classifying these languages by families as part of a larger genealogical search for a "pure" first language (here the model was the recent successful classification of Indo-European languages) that might unlock the mystery of earlier migrations. This research was interrupted by World War I, during which Rivet served as a medical officer on the western front before being transferred to the Balkans.[14] These two objectives nevertheless continued to guide much of Rivet's schol-arly publication throughout the interwar period, alone and in collaboration with others within France and abroad. He also returned periodically to South America, although his administrative responsibilities and political commit-ments would keep him mostly in Paris, particularly after the professors at the Muséum elected him to the chair in anthropology upon Verneau's retirement in 1928, and he became involved in the struggle against fascism.

Unfortunately Rivet never managed to acquire the basic training in lin-guistics that might have led him to study various languages' internal struc-tures properly; in this sphere, ironically, he could not be more different from Boas, the master linguist. Nor did Rivet ever abandon the practice of working principally secondhand, either through questionnaires or from information gathered for him by contacts in the field. Much of the linguistic classifica-tion he came up with was therefore wrong, undertaken without sufficient method or data. Rivet was convinced that language held the ultimate key to the origin of "American man," and this conviction distorted his findings. He was always looking for similarities within South American languages, or between them and other languages, as definitive evidence of "civilizational contact"—that is, diffusion in the past. Rivet enthusiastically embraced the cultural diffusionism that was gaining currency among certain anthropolo-gists everywhere at the turn of the century, and that held that cultures spread

[14] On Rivet's wartime experiences, see Laurière, *Paul Rivet*, 311–19. As the head of a surgical am-bulance, Rivet participated in the battles of the Marne, Arras, the Somme, and Verdun. In 1917 he was made director of a hospital in Salonica and in March 1918 promoted to head of the Hygiene and Epidemiology Service for the allied armies in Serbia.

from one people to another through migration, rather than following a single evolutionary path. The *Kulturekreis* studies of the Vienna school influenced him less, however, than the ideas of Swedish ethnologist and archaeologist Erland Nordenskiöld, a fellow Americanist who became one of Rivet's closest friends. Nordenskiöld, like Rivet, was a great empiricist skeptical of schematic theories, who was forging his own way between evolutionism and diffusionism.[15] Rivet's most controversial move scientifically was to use certain linguistic affinities between the peoples of Oceania and South America to challenge the prevailing idea that Asia was the sole place of origin of early Americans. He argued instead that the continent's original southern inhabitants had also come from Australia, followed by subsequent waves of Melanesian, Indonesian, and Polynesian migration. The ethnographic and archaeological evidence (e.g., tools, pottery, metalworking, and musical instruments) as well as the much less conclusive osteological and anthropometric evidence corroborated, or so Rivet believed, this thesis.[16]

Given the virtual absence of South Americanist linguists in France before and after World War I, and the "origins" question that dominated the tiny field of Americanism, Rivet's mistakes are understandable. In the context of the dominant French paradigms, Rivet's interest in languages and his deeply empirical approach to studying the people of the continent were unusual. Some of France's most distinguished historians of the Indo-European linguistic system, the philologists Antoine Meillet and Marcel Cohen, for example, encouraged Rivet in his quest for parent languages.[17] There was a shared, if unconscious, assumption that "simple" societies had simpler language systems than Indo-Europeans—although in fairness to Rivet, he did come to appreciate while in Ecuador that the languages he was collecting were enormously complex. Rivet's Australian theory was given a thorough hearing in the United States in the 1920s; in contrast to Europe, where the British social anthropologist Bronislaw Malinowski—hardly a specialist in the subject—praised Rivet's thesis, the American establishment remained skeptical.[18] Yet when Columbia University anthropologist Franz Boas firmly rejected Rivet's

[15] Christer Lindberg, "Anthropology on the Periphery: The Early Schools of Nordic Anthropology," in Kuklick, *New History of Anthropology*, 165–69.

[16] Paul Rivet, "Les origines de l'homme américain," *L'Anthropologie* 35 (1925): 293–319; Rivet, "Les Malayo-Polynésiens en Amérique," *Société des Américanistes* 18 (1926): 141–278; see also Rivet, *Titres et travaux scientifiques de P. Rivet* (Paris, 1927). On the larger debate on the origins of American man, see Frank Spencer, "Ales Hrdlicka, M.D., 1869–1943: A Chronicle of the Life and Work of an American Physical Anthropologist" (PhD diss., University of Michigan, 1979), chap. 11.

[17] Laurière, *Paul Rivet*, 228–33; Rival, "What Sort of Anthropologist?" 141–42.

[18] In 1930, when he introduced Rivet at Oxford, Bronislaw Malinowski praised Rivet's daring hypotheses, which he summarized as follows: "Paradoxical as it sounds, Dr. Rivet's work suggests that the most ancient migrations were not on land, but on the sea. The earlier stratum represents the

conclusions (and Rivet continued nevertheless to uphold them), the two men found that they could agree on other matters; these included the need to collect American languages before it was too late, to promote international scientific cooperation in the 1920s, and to fight anti-Semitism and racism in the 1930s.[19]

In 1910 Rivet also began work on the material artifacts that he had brought back from Ecuador, since that evidence, he argued, could be used in tandem with language to help reconstruct the continent's deep history, in the absence of written documentation. The first volume of *Ethnographie ancienne de l'Équateur* appeared in 1912; a second volume, containing illustrations and bibliography, followed in 1922. Rivet meticulously described material culture in Ecuador, object by object, and sought through comparisons to establish affinities, and potential borrowings, among civilizations. He posited the idea that the supposedly inert Amazonian tribes had had a brilliant past, and that the civilizations of these lowlanders may have contributed to the achievements of the Incas. Rivet also drew up distribution maps indicating a particular form's geographical spread and evolution over time. He would return to these materials a final time in 1946, when he coauthored a related study on early metalworking techniques in Peru, after which he devoted his time exclusively to the study of languages.[20]

As this brief summary suggests, in his chosen field of Americanism Rivet was a largely self-taught and inventive scholar. Even before World War I, he would emerge as a gifted institution builder as well, joining forces with a number of more traditionally trained academics in addition to other

Dravidian, or what might be called the Dravidian Australian type. This was a time when the vast region comprising Indonesia, part of the Melanesian islands, India and Indo-China was peopled by tribes of which the present Australian aborigines are the best representatives. Then, probably through some special rapid biological and cultural evolution in some part of the region, there came into being a new culture, the Melanesians, who overran, forming the second wave, great parts of the region without penetrating however into Australia and Tasmania. Finally, there came the Polynesians and the Indonesians. One of the most attractive and daring aspects of Prof. Rivet's work consists in his explanations of how these various ethnic strata reached the Americas. The most difficult question is that of the Australians, whose only possible route seems to have been through the islands of Antarctica.... Prof. Rivet is compelled to assume the migration took place under entirely different climatic conditions. All his hypotheses and theories show a combination of knowledge and specialization in linguistics, archaeology, anatomy and geology unequalled in our own times." AMH/2 AP 1 C/Lettres à Paul Rivet/Bronislaw Malinowski à Paul Rivet, 17 March 1930.

[19] Rivet published a book-length defense of his theory in 1943. See also AMH/2 AP 1 C/Paul Rivet à Franz Boas, 13 Feb. 1925. Boas and Rivet first corresponded after World War I as fellow Americanists. In their copious correspondence between 1919 and 1941, Rivet discussed his research findings only once. The bulk of the letters are taken up with professional and political developments that consumed them both.

[20] Paul Rivet and René Verneau, *Ethnographie ancienne de l'Équateur,* vol. 1 (Paris, 1912); Rivet and Verneau, *Ethnographie ancienne de l'Équateur,* vol. 2 (Paris, 1922); Paul Rivet and Henri Arsandaux, *La métallurgie en Amérique précolombienne* (Paris, 1946).

mavericks like himself. Together they sought not only the further devel-
opment of Americanist studies in France—Rivet would serve as secretary-
general of the Société des Américanistes from 1922 to 1958—but also a
refounding of French anthropology. The time was propitious for such re-
newal, given the recent paroxysms of anti-Semitism that had so egregiously
claimed a scientific basis in anthropology. In addition, Rivet had a particu-
lar agenda to push. As he explained to his fellow Americanists as early as
1913, he had seen through his own eyes that only by systematically compar-
ing osteological, archaeological, ethnographic, and linguistic facts could
any anthropological problem, including that of the origins of American
man, one day be solved.[21] He then insisted that the time had come to stop
speculating extravagantly on the basis of little evidence about possible con-
nections among "Old World" and "New World" civilizations in the Ameri-
cas.[22] What was needed for every anthropological problem was laborious
and multilevel research that would establish the facts in the first place. In
Rivet's words,

> We mustn't neglect any part of this comparison. . . . Any connection that de-
> pends on only a few minor details will have no demonstrative value. . . . A
> language cannot be defined only by its phonetics, its grammar and its vocabu-
> lary, an ethnic group only by the whole of its morphological characteristics, a
> civilization only by the entirety of its expressions. Only the Americanist who
> has the courage to consider a problem, however small it may be, in all its com-
> plexity . . . can hope to reach a sure and definite conclusion, and it is with this
> kind of work that our science will progress.[23]

Rivet would be a central figure in creating the structures in France for
making comparative and collaborative research in archaeology, linguistics,
physical anthropology, and ethnography the basis for a renovated science of
humanity in the 1920s. As an assistant at the Muséum, however, he was not
in a position to lead such a movement alone. His repudiation of prognathism
as a meaningful index of intelligence, his interest in the languages of South
America, and his extraordinary energy and drive nevertheless soon led him to
other scholars (and vice versa) invested in the renewal of anthropology. Rivet's
most important new contact was the Durkheimian Marcel Mauss.

[21] Vignaud, "Discours," 18–20. Paul Rivet's comments are appended at the end of Vignaud's speech.
[22] Vignaud, "Discours," 19.
[23] Ibid., 19–20.

Paul Rivet (*center*) in Guatemala, 1930, codirector of the Institut d'Ethnologie, professor of anthropology at the Muséum National d'Histoire Naturelle, and director of the Musée d'Ethnographie du Trocadéro (later Musée de l'Homme). AMH/PH/PP0098662. Photo courtesy of the Musée du Quai Branly/Scala/Art Resource, NY.

A Historical Sociology of the "Primitive": Marcel Mauss

In the rarified intellectual world of the Left Bank, Rivet and Mauss might appear an unlikely couple. Rivet, the military doctor-turned-anthropologist who had spent five years in South America, belonged to a different world than Mauss, the to-the-academy-born nephew of Émile Durkheim with no experience of fieldwork; in his whole life, Mauss ventured to the "field" only once, when he spent a few weeks in Morocco in the early 1930s. This said, as an assimilated, non-practicing Jew who moved beyond his small, tight-knit, and observant family in Lorraine, Mauss had plenty of what might be called "field" encounters in France to match Rivet's Ecuadorean ones. In the Third Republic, which was dominated by either the secular or Catholic world, Mauss acquired the self-detachment and diplomatic skills necessary to mix with politicians, journalists, social scientists, and countless civic groups in Paris. This freedom to move in multiple worlds would make it hard for him to see the regime's exclusion of women and colonial subjects (the same was true of Rivet). But Mauss's ability to imagine other subjectivities would also make this armchair scholar a superb teacher of ethnographic methods. In the end, the porosity of Parisian networks of learned sociability, a commitment to the democratic socialism of Jean Jaurès, and overlapping intellectual interests

meant that there was room for considerable collaboration between Mauss and Rivet. Paramount among their shared concerns was a desire to place France's older science of humanity on a more credible basis by developing its ethnographic and linguistic branches alongside its physical anthropology ones. If Rivet's journey to Ecuador predisposed him to such a project, Mauss came to it as a sociologist of primitive religion under the influence of his renowned uncle.

Born in Épinal in 1872 into a merchant and rabbinical family (his grandfather was the liberal rabbi Moïse Durkheim), the bookish Mauss chose to study philosophy and sociology under Durkheim at the University of Bordeaux, rather than attend the elite École Normale Supérieure in Paris (France's traditional breeding ground for intellectuals, from which most of the Durkheimians graduated).[24] He was thus groomed from the outset to join his uncle's new school of sociology, which was based on the premise that shared beliefs in a given society guaranteed its cohesion. Mauss passed the *agrégation* in 1895 and then began doctoral studies in Paris at the École Pratique des Hautes Études in its Vth Section dedicated to the religious sciences.[25] The particular profile of the École Pratique, especially its Vth Section, is worth lingering over for a moment, because of the important role it played in legitimating in France the academic study of what Mauss called "archaic" societies.

The Ministry of Education had created the École Pratique in 1868 as a research institution with its own faculty within the larger University of Paris. It originally had four sections: mathematics (I); physics and chemistry (II); natural sciences (III); and the historical and philological sciences (IV). The idea was to allow French scientists to catch up with their German counterparts by promoting innovative research in a way that traditional French universities—dedicated as they were almost exclusively to training future lycée professors—had always failed to do.[26] École Pratique professors taught only small graduate seminars on topics of their own choosing. Then, in 1886, the anticlerical Third Republic decided to add a fifth section, devoted to the "scientific history of religions." Republicans believed that religion should be open to positive investigation, and that Christianity should no longer stand for all

[24] Marcel Fournier, *Marcel Mauss,* chap. 1. This work is the indispensable starting point for anyone studying Mauss, although it is not an intellectual biography per se. See also Bruno Karsenti, *L'homme total. Sociologie, anthropologie et philosophie chez Marcel Mauss* (Paris, 1997).

[25] The *agrégation* is a highly competitive civil service exam in France required for teaching at the secondary and university levels. An *agrégé* is anyone who has passed this exam.

[26] The nineteenth-century university's principal responsibility was to prepare future lycée teachers for a series of qualifying exams—the *licence* and *agrégation* in the traditional disciplines. This goal was at odds with teaching students research methods, especially those outside of the classical subjects included in the secondary-school curriculum. The *licenciés* were supposed to leave the university with a *culture générale* that they would pass on to their lycée pupils.

religion in France. By 1901 the Vth Section counted fifteen chairs, eight of which were devoted to the Judeo-Christian tradition, and seven to other ones (primitive religions of Europe, Islam and religions of Arabia, religions of India, religions of Greece and Rome, religions of Egypt, religions of the Far East, and religions of uncivilized peoples).[27]

Mauss enrolled in the Vth Section at his uncle's urging, but also out of genuine interest in its course offerings. In 1886 Durkheim had identified religion as "one of the major regulating organs of society" and therefore particularly suitable for analysis from "the social perspective."[28] By 1895, he had determined that the best way to approach the study of religion sociologically was through its most elementary forms, and he assigned to Mauss, and Mauss's close friend Henri Hubert, the task of reviewing the scientific literature on the religions of peoples deemed closest to the primeval condition of society for the school's new journal, the *Année Sociologique,* launched in 1898. Durkheim also advised his nephew to pick the topic of prayer for his thesis. These assignments led Mauss to the courses of Sylvain Lévi, France's preeminent Sanskrit scholar as well as historian of Indian religions, and those of the philologist and Saussurian linguist Antoine Meillet; but he also found his way to Léon Marillier, for whom a chair in the "religions of uncivilized peoples" had been created in 1890, and whose specialty was the social development of religion from an evolutionary and psychological point of view. In a victory for the Durkheimians, who were seeking positions from which to anchor their sociology, Mauss would be appointed to replace Marillier at the École Pratique when the latter died unexpectedly in 1901. It was a perfect fit for Mauss, who would take full advantage of the intellectual freedom and kind of teaching that this particular institution afforded him throughout the remainder of his career.

Mauss's early orientation toward primitive religion would have a decisive impact on his subsequent intellectual trajectory; it introduced him to a new scientific literature—descriptive and theoretical, largely in English and German—devoted especially to the ritual practices of peoples deemed to be still in the "Stone Age" and thus useful for revealing the "origins" of human society. In point of fact, when Durkheim began investigating early religious forms in the mid-1890s, this subject had been occupying British armchair theorists for at least twenty years, ever since E. B. Tylor had published his landmark work, *Primitive Culture,* in 1871. Tylor's work had inaugurated what the Durkheimians somewhat dismissively called the "English school" of cultural evolutionist

[27] A chair in the history of religions had already been created at the Collège de France in 1880.
[28] Quoted in Fournier, *Marcel Mauss*, 37.

anthropology, whose most successful popularizer was James Frazer of *The Golden Bough* (1890) fame. In the wake of Darwin, Tylor had pioneered a search for the natural, as opposed to divine, origins of civilization, and the laws of evolution that governed civilization's ostensible unilinear progress. Premodern religious practices such as "animism" and "totemism" were believed to represent the earliest accessible strata from which the whole of humanity's subsequent mental life had evolved. Firm believers in the psychic unity of humanity, these classical evolutionists insisted that through a systematic comparison of totemistic beliefs and behaviors, it was possible to reconstruct the "missing" stages in the universal evolution of the human mind from magic to religion to science based on reason. Further evidence could be deduced by comparing the data from contemporary "savages" with other "surviving forms" in modern society, such as the absurd folkways of the countryside.[29]

Tylorian cultural anthropology initially generated little interest in France.[30] Indeed, when Mauss came to Paris, the only place to study the work of Tylor and his fellow students was at the Vth Section, where at Marillier's insistence a chair on the subject had finally been created in 1890.[31] This indifference of French academics, however, began to change with the Durkheimians' own burgeoning interest in religious sociology; the debates unleashed by the

[29] For many scholars of religion in this period—a group that included philologists, classicists, and historians as well as cultural anthropologists—the most compelling question posed by Tylor was whether "surviving" relics of so-called primitive thought processes accounted for certain discordant aspects of classical Indo-European mythology. Andrew Lang, a folklorist, was quite sure that they did. The Anglo-German philologist and comparative mythologist Max Müller was equally convinced that no recourse to "primitives" was necessary to account for these "oddities": they could be explained by a degenerationist theory of language. On these debates, see George W. Stocking, Jr., *After Tylor: British Social Anthropology, 1888–1951* (Madison, WI, 1995), chaps. 1–4; and Ivan Strenski, "The Spiritual Dimension," in Kuklick, *New History of Anthropology*, 113–28. For recent historical overviews of Durkheim's interest in totemism, see Robert Alun Jones, *The Secret of the Totem: Religion and Society from McLennan to Freud* (New York, 2005); and Frederico Rosa, *L'âge d'or du totémisme. Histoire d'un débat anthropologique (1887–1929)* (Paris, 2005).

[30] On the place of religion in nineteenth-century British cultural and social evolutionism, see Stocking, *Victorian Anthropology*, chap. 5.

[31] In the 1870s and 1880s only a few French historians of religion, among them Marillier, became interested in contemporary "primitives" largely as a result of their reading of Tylor, whose work was translated in 1872. Marillier and some of his colleagues sought to disseminate the results of the "English school" among French scientists and the larger public and helped to found a chair in the subject in the Vth Section. Marcel Mauss, "L'enseignement de l'histoire des religions des peuples non civilisés à l'École des Hautes Études. Leçon d'ouverture," *Revue de l'Histoire des Religions* 45 (1902): 36–37. On Tylor's reception in France, see Frederico Rosa, "Le mouvement anthropologique et ses représentants française (1884–1912)," *Archives Européennes de Sociologie* 37:2 (1996): 375–405. As always in the wide-open field of anthropology in this era, the terminology was confusing. French followers of Tylor did not call themselves "anthropologists" because this term had already been appropriated by the racial classifiers at the Société d'Anthropologie de Paris. As one of the fold, the French folklorist Henri Gaidoz, put it, "If this word [*anthropologie*] has been abducted and denatured by people who occupy themselves only with crania, long bones, and hair and see in these all of man, the true meaning of the word is the study of man in his entirety; and where is man more [present] than in his thought?"; quoted in Rosa, "Le mouvement anthropologique," 392.

English school could not but engage Durkheim, Mauss, and several of their colleagues in such diverse realms as archaeology, ancient religions, and philology, and they soon began a spirited exchange with their colleagues across the Channel. Yet the approaches of the two schools differed from the outset. While both the Tylorians and Durkheimians sought general laws for explaining certain "religious" institutions, such as magic, for Mauss these laws had to be socially determined ones, whereas for Tylor and his followers they were almost always psychological ones. As Mauss put it, the "psychic unity of humanity" might explain in part why a particular institution appeared to be universal—since all individuals "thought" in the same way—but it could not explain why in some societies this same institution survived, and in others it disappeared. Only the particular social organization, itself historically determined, which gave individual actions their meaning and function, could fully account for them.[32] Methodologically, Mauss and Hubert were also highly critical of Tylor and his school. The Durkheimians insisted on comparing a few well-established facts that they considered typical, and preferred studying whole communities, rather than galloping piecemeal—as they accused British anthropologists of doing—through all of history to prove a "general law" of human evolution. Yet whatever their disagreements, all participants in these debates had one trait in common: they became discriminating readers of an increasingly detailed literature on particular archaic societies in the Pacific and North America, penned principally by descriptive "ethnographers" located in the field who were caught up in the primitive religion debate, rather than collected directly by the theory-minded cultural anthropologists and sociologists themselves.

Mauss was no exception to this trend of armchair theorizing—based, however, on a rigorous assessment of the data provided by the ethnographers in question. Mauss gave a "large place" in the *Année Sociologique* to reviewing the descriptive and theoretical literature generated by the debate over primitive religion, insisting that "every social fact must above all be studied in its roughest state. . . . For the editors of the *Année*, ethnography has the greatest importance." Sociology, he and Henri Hubert explained, could "only be comparative; and, as with ethnologists, the basis of comparison will necessarily be ethnographic facts."[33] In order to establish these facts in their historical particularity before interpreting them sociologically, Mauss did his best to corroborate firsthand descriptions with "more precise and complete documents," such as earlier accounts by visitors or archaeological evidence.[34] His

[32] Mauss, "Leçon d'ouverture," 54–55.
[33] Quoted in Fournier, *Marcel Mauss,* 141.
[34] Quoted in Fournier, *Marcel Mauss,* 160.

courses at the École Pratique, with titles such as "Study of Ethnographic Texts Concerning Ritual Prohibitions in Polynesia" (1906–7) and "Analysis and Critical Study of Documents Concerning Ritual Prohibitions in New Zealand" (1909–10), were also devoted to culling the facts that would then allow him to compare religious practices across time and space.

A 1906 study written in conjunction with his student Henri Beuchat on the relations between Inuit social seasonal morphology and their religious and legal phenomena, based on the fieldnotes of others, gives an idea of Mauss's sociological and ethnographic method as it was emerging in these years. The two scholars showed how the Inuit group in question was constituted in two different ways, economically, religiously, and legally, according to whether it was summer or winter. In summer the Inuit scattered; in winter they lived close together. Environment and availability of food played a part in explaining this "double morphology," but the interaction among the social phenomena that Mauss and Beuchat had uncovered demonstrated to their satisfaction that in its particulars this pattern was socially determined. Mauss ended the essay seeking an anthropological constant, and found one: all societies—and here he cited for comparative purposes the societies of the American Northwest, as well modern industrialized ones—showed a similar seasonal variation in their collective work lives.[35] This tendency to draw parallels between social and economic practices of archaic and modern peoples, along with the belief that nothing could be understood in society except in relation to everything else, would characterize Mauss's writings after the war, when comparative sociocultural anthropology became his principal preoccupation.

Despite hundreds of reviews, singly or co-authored—or perhaps because of the enormous time he spent on the *Année Sociologique*—in addition to conducting research on suicides in Paris for Durkheim, Mauss struggled to complete his thesis on prayer; the latter was still unfinished in 1909 when he tried, and failed, to get elected to the Collège de France. According to Durkheim's excoriating letters to his nephew, Mauss lacked a work ethic and discipline in his private life, which risked sabotaging his career.[36] Spurning marriage, passionately drawn to Socialist politics and journalism in the era of Dreyfus and its aftermath, a regular visitor to the home tribe in Lorraine, and a Parisian bon vivant and *fin gourmet*, Mauss was ostensibly squandering time, money, and energy that could have been focused on the dissertation. In his monumental *The Elementary Forms of Religious Life*, published in 1912,

[35] Marcel Mauss, "Essai sur les variations saisonnières des sociétés eskimo: Étude de morphologie sociale," *AS* 9 (1906): 39–132; Mauss would return to this early interest in the Inuit in the interwar years. See Bernard Saladin d'Anglure, "Mauss et l'anthropologie des Inuit," *Sociologie et Société* 36:2 (2002): 91–131.

[36] Fournier, *Marcel Mauss*, 256–58; Liebersohn, *Return of the Gift*, 141–42.

Marcel Mauss in 1936–37, codirector of the Institut d'Ethnologie, professor of "Religions of Uncivilized Peoples" at the École Pratique des Hautes Études, and professor of sociology at the Collège de France. He is shown here with Georges Duchemin, an ethnologist at the Musée de l'Homme who joined the Institut Français de l'Afrique Noire in 1941. AMH/PH/1998–14264–125. Photo courtesy of the Musée du Quai Branly/Scala/Art Resource, NY.

Durkheim nevertheless generously acknowledged the work of his nephew. Its completion marked the end of an era, as the generation of armchair scholars who had launched the debate on the primitive origins of religion began to pass away. The very notion of a single evolution of all cultures, studied from data gathered by others, was no longer credible. Internationally, a new cohort of anthropologists trained in the natural sciences was bringing different methods and different questions to the fore, ones that Mauss would begin engaging. His deep sensitivity to the particularity of cultures as products of history, rather than psychology or biology, would emerge only heightened from the war years.

Mauss's path to studying "primitives" was, then, different from Rivet's. Mauss's point of departure was the new science of the social, whereas Rivet's was the older science of man. Yet Mauss, too, would be a key actor in the renewal of the anthropological sciences in France. It is well known that the Durkheimians cultivated early on well-established intellectual allies in such "fact-based" disciplines as geography, history, economics, and the law, whom they hoped would become junior partners in the ambitious sociological

domain they were seeking to construct in the university. Once Durkheim and Mauss turned their attention to the question of religion in premodern societies, finding properly credentialed French academics who could supply them with reliable data became important.[37] As Mauss and Durkheim surveyed the underdeveloped French field of ethnography, only one group seemed remotely worthy: the anthropologists at the Muséum who had come out on the "right side" against anthroposociology in the Dreyfus affair, were attached to an institution of higher learning with a distinguished pedigree, and were in favor of a renovated anthropology that studied civilizations and languages as well as races. Mauss and Durkheim came to believe that it was in their own best interest to encourage this "new anthropology," a path that led Mauss and Rivet not only to each other, but to other scholars as well.

A New "Ethnological" Front, 1911–1925

Although it is impossible to date exactly when Rivet and Mauss first met, by 1911 they had begun collaborating.[38] That year—thus only shortly after Rivet's article on prognathism—Muséum anthropologists with the backing of Durkheim and Mauss decided to launch a new Institut Français d'Anthropologie that would replace, or so its sponsors hoped, the old Société d'Anthropologie. The challenge to Broca's society was clear in at least two different ways. On the one hand, in a thinly veiled criticism of the Société d'Anthropologie's excessive attention to physical traits, the Institut Français d'Anthropologie emphasized that its members would seek to explore the origins and manifestations of human ethnographic as well as racial diversity along a number of different and new axes simultaneously. The point was to gather "specialists in every branch of the science of man to permit them to exchange their ideas, to enlighten one another, to synthesize their findings."[39] From such an exchange of views, a better organized discipline could emerge. On the other hand, whereas any serious amateur could join the Société d'Anthropologie, the new institute's membership list was a who's who of Rivet's most eminent colleagues in the Muséum who worked in the related fields of prehistory and paleoanthropology, but also Mauss's closest academic colleagues in the hu-

[37] AMH/2 AP 1 B14/d/Paul Rivet, "Nécrologie de Marcel Mauss." One of Mauss's students and collaborators on the AS who was interested in linguistics, Henri Beuchat, began editing vocabularies in 1907 with Rivet, which gave Mauss and Rivet another point in common.

[38] In his obituary for Mauss, Rivet states that he met Mauss upon returning from Ecuador in 1906 and got to know him principally through Mauss's student Henri Beuchat. AMH/2 AP 1 B14/d/Paul Rivet, "Nécrologie de Marcel Mauss."

[39] René Verneau, "L'Institut français d'anthropologie," *L'Anthropologie* 22 (1911): 110.

man sciences who shared his interest in archaic peoples and languages and appreciated the Durkheimians' sociological methods as well as their antiracist Dreyfusard politics.

To mark the Institut Français d'Anthropologie's broad direction, Salomon Reinach, a fellow student of primitive religions who was director of the national archaeology museum at St. Germain-en-Laye, was made president, and Henri Hubert was made treasurer.[40] Since the Institut met in the Muséum, the paleoanthropologist there, Marcellin Boule, became vice president; Louis Lapicque, a professor in experimental physiology also at the Muséum, became secretary; and Rivet was appointed archivist-librarian. Durkheim and Verneau (as holder of the anthropology chair) served on the scientific council, and Mauss and his student Henri Beuchat were founding members, as was Boule's colleague, the distinguished prehistorian-priest, l'Abbé Breuil. Another well-placed ally was Lucien Lévy-Bruhl, holder of a chair in the history of philosophy at the Sorbonne since 1908 and a Durkheimian fellow traveler; he was interested in writing a new history of the human mind that broke with prevailing philosophical notions of a universal mode of reasoning, a goal that had led him, unusually, to take an interest in the "mental functions" of "primitives."[41] He and Durkheim had overlapped at the École Normale, and Rivet knew him from Lévy-Bruhl's weekly visits to the Muséum anthropology gallery, where he consulted the works received there by the Société des Américanistes; it was through a dinner at Lévy-Bruhl's that Rivet first met the Socialist leader Jean Jaurès.[42]

Yet other Durkheimian allies at the Institut Français d'Anthropologie were the linguist Antoine Meillet (who taught at the École Nationale des

[40] Salomon Reinach, a member of one of France's most prominent Jewish families and a highly visible and prolific scholar, was a polymath. He began his career as an archaeologist; in addition to reorganizing the museum at St. Germain-en-Laye, he taught archaeology at the École du Louvre. Politicized by the racism that erupted during the Dreyfus affair, he then turned to the study of religion, embracing the view that religion was psychological in origin. He set himself the task of analyzing archaic "survivals" among the peoples of the world, and comparing contemporary primitive religions to ancient ones in a classical evolutionary framework designed to prove that religion had no place in modern rational society. Aron Rodrigue, "Totems, Taboos, and Jews: Salomon Reinach and the Politics of Scholarship in Fin-de-Siècle France," *Jewish Social Studies* 10:2 (Winter 2004): 1–19.

[41] See his 1903 *La morale et la science des moeurs* and 1910 *Les fonctions mentales dans les sociétés inférieures*. Both works posited a fundamental difference between premodern and modern mentality, rather than seeing the former as a rudimentary form of the latter. Lévy-Bruhl thus challenged long-standing notions about the fixed and universal nature of the human mind. On the controversy generated by his ideas in the 1920s among fellow philosophers and France's less institutionally secure sociologists, ethnologists, and psychologists—all vying with each other to claim the study of the mind for their particular discipline—see Christine Chimisso, "The Mind and the Faculties: The Controversy over 'Primitive Mentality' and the Struggle for Disciplinary Space at the Inter-war Sorbonne," *History of the Human Sciences* 13:3 (2000): 47–68; and Chimisso, *Writing the History of the Mind: Philosophy and Science in France, 1900–1960s* (London, 2008), chap 2.

[42] AMH/2 AP 1 B14/d/Paul Rivet, "Souvenirs sur Lucien Lévy-Bruhl."

Langues Orientales Vivantes and the Collège de France) and his student, the specialist in Semitic and Ethiopian languages, Marcel Cohen (who taught at the École Nationale des Langues Orientales Vivantes and the École Pratique). Muséum anthropologists and Durkheimian *agrégés* in philosophy were nevertheless not Rivet and Mauss's only partners in 1911. They also reached out, more hesitantly, to two other marginal figures: the folklorist Arnold van Gennep and the colonial ethnographer and African linguist Maurice Delafosse. These two men represented yet another cluster of emerging professionals at the end of the nineteenth century, who were observing premodern peoples *in situ* rather than theorizing about them from data collected by others. As the historian Émmanuelle Sibeud has shown, van Gennep and Delafosse helped to launch nothing less than an ethnographic revolution in this era of Durkheimian ascendancy, one that ultimately also made fieldwork an integral part of the modern ethnology then taking shape in France.

Van Gennep was Mauss's exact contemporary in more ways than one. He had also been a brilliant student of Léon Marillier's at the École Pratique, who because of Marillier's untimely death had completed a doctorate (from printed sources) on totemism in Madagascar under Mauss. Van Gennep had then gone on to publish *Rites of Passage* in 1909, this time based on fieldwork that he had carried out on French folklore. In 1911 he was still unemployed, since Mauss held the only extant teaching position at the university in van Gennep's domain; from 1912 to 1915, however, he held a chair in ethnography at the University of Neufchâtel. Maurice Delafosse was by training a colonial administrator in West Africa. Even before joining the colonial service, he had aspired to become a genuinely scientific observer of African societies, rather than writing one more series of "amateur" travel accounts.[43] Once in Africa, however, he began to realize how difficult it was to obtain accurate information about the peoples with whom he was living, a realization that van Gennep came to share.[44] Each in his way soon emphasized the need for all serious students of the "primitive" to learn local languages and talk to informants directly about their customs, and to recognize the difficulties of transferring their results without bias into monographs for publication—the classic concerns of modern fieldwork as it emerged in the twentieth century.

[43] In France, the tradition of colonial administrators undertaking local studies of people, flora, and fauna and sending their accounts to the metropole can be traced back to the eighteenth century. See Richard Grove, *Green Imperialism: Colonial Expansion, Tropical Island Edens, and the Origins of Environmentalism, 1600–1860* (Cambridge, 1995).

[44] Sibeud, *Une science impériale?* chap. 6; Giordana Charuty, "'Keeping Your Eyes Open': Arnold Van Gennep and the Autonomy of Folklore," in Parkin and Sales, *Out of the Study,* 25–44; and Nicole Belmont, *Arnold Van Gennep, the Creator of French Ethnography,* trans. Derek Coltman (Chicago, 1979). On Delafosse, see Émmanuelle Sibeud and Jean-Loup Amselle, eds., *Maurice Delafosse. Entre orientalisme et ethnographie, l'itinéraire d'un africaniste (1870–1926)* (Paris, 1998).

Van Gennep and Delafosse were not alone in their emerging passion for direct observation: a small number of colonial officials in sub-Saharan Africa were also undertaking in-depth descriptions of the peoples inhabiting their particular districts, and encountering similar problems regarding how to describe reliably customs different from their own.[45] Unlike what had happened in Algeria since the conquest, their superiors were not commissioning these monographs; to the contrary, administrators in French West and Equatorial Africa before World War I often suffered poor marks for "wasting" their spare time pursuing such "useless" projects.[46] In the end, intellectual curiosity appears to have motivated them, but these men also hoped to raise their social status by publishing their findings in scientific journals in Paris. Few, however, of the academic anthropologists and sociologists in France in the fin de siècle showed much interest in the peoples of sub-Saharan Africa or the methodological questions Delafosse and van Gennep were raising.

Mauss was a case in point. When he set about training his first sociology students in 1902, his instinct was to produce library theorists like himself. In addition, even as new data on African religions in French were becoming

[45] The history of late nineteenth-century French ethnographic production, whether by missionaries, travelers, explorers, or administrators, is just beginning to be written. Most of this "amateur" literature was considered unusable at the time by armchair anthropologists, because they thought it was not written with any method. For Indochina, see Salemink, *Ethnography of Vietnam's Central Highlanders;* and Jean Michaud, *"Incidental" Ethnographers: French Catholic Missions on the Tonkin-Yunnan Frontier, 1880–1930* (Leiden, 2007). For North Africa, see Trumbull, *Empire of Facts;* and Jacques Frémeaux, *Les bureaux-arabes dans l'Algérie de la conquête* (Paris, 1993). For sub-Saharan Africa, see Sibeud, *Une science impériale?*; John M. Cinnamon, "Missionary Expertise, Social Science, and the Uses of Ethnographic Knowledge in Colonial Gabon," *History in Africa* 33 (2006): 413–32; Martine Balard, *Dahomey 1930. Mission catholique et culte voudoun; L'oeuvre de Francis Aupiais (1877–1945), missionaire et ethnographe* (Perpignan, 1998); and Owen White, "The Decivilizing Mission: Auguste Dupuis-Yakouba and French Timbuktu," *French Historical Studies* 27:3 (2004): 541–68. An important innovation in African missionary ethnography internationally was the founding of the Catholic journal *Anthropos* in Vienna in 1905 by the cultural diffusionist R. P. Schmidt; several French missionaries in Africa interested in ethnography found a forum there.

[46] Sibeud, *Une science impériale?* 112; and Sibeud, "The Elusive Bureau of Colonial Ethnography in France," in Tilley and Gordon, *Ordering Africa*, 50–51, 60–62. George Trumbull argues that in Algeria in the first half of the Third Republic, administrators were encouraged to produce ethnography that served the purposes of empire. Colonial attitudes toward the "usefulness" of ethnographic studies may well have varied across the empire, especially between North and sub-Saharan Africa. But Sibeud and Trumbull are also defining "colonial ethnography" differently, making it difficult to compare their findings. For Trumbull, ethnography was a discursive practice first and foremost, in which a wide variety of colonial authors—many with no real pretensions to scienticity—generated more or less the same "facts" that helped French domination. In his words, "The colonial administration exerted selective pressure on narrative *styles*, rewarding its functionaries and scholars for producing useful texts. Ethnography proved the most effective means of presenting, communicating, and, perhaps most importantly, perpetuating conceptions of Algerian identity." Trumbull, *Empire of Facts*, 12. Sibeud studies only those administrators seeking to write ethnographies that met the emerging professional practices of ethnologists in France and internationally; in her view, these practices did not always reinforce colonial domination. A detailed assessment of the colonial underpinnings of France's new academic discipline of ethnology is provided below in chapters 5 and 6.

available, he continued to use materials from North America and Australia produced by Anglo-American and British, and occasionally German, ethnographers. There were few French-authored ethnographies reviewed in the *Année Sociologique* in the period between 1896 and 1912, and Mauss did not teach many materials collected by French ethnographers in his classes. This absence partly reflected Mauss's belief that "pristine" archaic peoples comparable to those that supposedly existed in the South Pacific and the Americas no longer existed in sub-Saharan Africa because of its long history of contact with the West.[47] But Mauss also complained repeatedly that French ethnographies were not as reliable as what firsthand observers from other countries were producing in their colonies.[48] Here he had in mind certain Anglophone and German-speaking missionaries but also, increasingly, full-time academics—such as the members of the Torres Strait expedition, led by three British scholars, A. C. Haddon, W. H. R. Rivers, and C. G. Seligman, between 1898 and 1901.[49] This expedition attracted attention at the time for its innovative use of principles

[47] There were far fewer literary and historical sources on the peoples of Africa than for the South Pacific and the Americas, against which Mauss could check the new ethnographic material being collected at the turn of the century. Mauss also worried about the impact of slavery, Islamic revolution, and global trade, and most immediately imperialism, on African societies, which he believed had covered over the archaic traces of human society there more than in Australia, for example. Wendy James, "The Treatment of African Ethnography in *L'Année Sociologique* (1–12)," *AS*, n.s., 48:1 (1998): 193–207.

[48] Mauss's two articles in *La Revue de Paris* in 1913, "L'ethnographie en France et à l'étranger I" and "L'ethnographie en France et à l'étranger II," summarized his feelings on the subject. The Durkheimians were particularly critical of the descriptions published by military officers, colonial administrators or judges in France's sub-Saharan and Asian territories, accusing them of being too preoccupied with their "real jobs" to produce professional descriptions of social facts. See the following reviews: Émile Durkheim, "Compte-rendu de Albert Cahuzac, *Essai sur les institutions et droit malgache*," *AS* 4 (1901): 342–45; Henri Hubert, "Compte-rendu de Capitaine Maire, *Étude sur la Race Man du Haut Tonkin*," *AS* 9 (1906): 208–9; Hubert, "Compte-rendu de E. Lunet de Lajonquière, *Ethnographie du Tonkin Septentrional*," *AS* 10 (1907): 241–43; Marcel Mauss, "Compte-rendu de Commandant Delhaise, *Les Warega*, Joseph Halkin, *Les Ababua*, et Fernand Gaud, *Les Mandja*," *AS* 12 (1913): 139–42. Lucette Valensi has similarly noted the failure of the prewar *AS* to pay any attention to the scholarship on Islam in North Africa that appeared in such journals as the *Revue Africaine* (1856), the *Revue Tunisienne* (1894), and *Archives Marocaines* (1904)—all published in North Africa, and whose scientific standards were high. She blames this lack of coverage—only 1.5 percent of the *AS*'s contents was devoted to such scholarship—on the premature death of the great Arabic scholar Émile Masqueray, Durkheim's own loss of interest in the topic, and the elitism of the Durkheimian network before 1914. Lucette Valensi, "Le Maghreb vu du centre. Sa place dans l'école sociologique française," in Jean-Claude Vatin et al., eds., *Connaissances du Maghreb. Sciences sociales et colonisation* (Paris, 1984), 227–44. On French sociology of Islam more generally, which became a field of study with its own structures and chair at the Collège de France as of 1902, see Edmund Burke III, "France and the Classical Sociology of Islam, 1798–1962," *Journal of North African Studies* 12:4 (December 2007): 551–61.

[49] On the Torres Strait expedition, see Anita Herle and Sandra Rouse, eds., *Cambridge and the Torres Strait: Centenary Essays on the 1898 Anthropological Expedition* (Cambridge, 1998). The other pioneering ethnography of this period was the much-acclaimed 1899 monograph *The Native Tribes of Central Australia,* by Baldwin Spencer, a biologist at the University of Melbourne, and F. J. Gillen, a colonial civil servant. Durkheim and Mauss reviewed it separately in the third volume of the *AS* (1900).

drawn from the natural sciences, in which all three men had been trained, to observe "primitives" more "objectively" than in the past. In 1902, Mauss was aware of this event, noting in his inaugural lecture at the École Pratique that the Torres Strait expedition had yielded "observations on the blacks of the island more complete and possibly more exact than any description or survey undertaken on the customs and mores of the inhabitants of a French department."[50] But he then added that, as far as he was concerned, the main problem for the future of French sociology remained not a dearth of similarly reliable field observers in his own country, but rather one of armchair experts like himself.[51]

Yet by 1911 Mauss was making overtures to van Gennep and Delafosse and taking an interest for the first time in training students in field observation. What had changed? The initial indifference of Mauss and other Durkheimians to van Gennep and Delafosse had led the latter to do what any self-respecting French scholars would do: in 1907 van Gennep founded his own journal, the *Revue des Études Ethnographiques et Sociologiques,* in collaboration with Delafosse, and in 1910 they launched their own democratically run learned society, the Institut Ethnographique International de Paris, dedicated to answering, through peer review and regular meetings, the questions of ethnographic method with which they were grappling.[52] Both of these initiatives were considered cheeky acts of intellectual insubordination—or "dissidence," to use Sibeud's term—in the subtly calibrated hierarchical world of the Left Bank where neither van Gennep or Delafosse was considered a "player." To add insult to injury, their success was immediate: at 225 in 1914, membership in Delafosse and van Gennep's society had outstripped

[50] Mauss, "Leçon d'ouverture," 48–49.

[51] Mauss did not entirely leave to others the question of how to guarantee the particular kind of data necessary for forging a new science to the exacting standards of Durkheim. In 1903–4 he had devoted several lessons to drawing up a questionnaire on folklore and one on technology to be used in Korea. At the behest of the colonial lobby group, the Comité de l'Afrique Française, he tried his hand at devising an "infallible" questionnaire that could be sent to French travelers or residents in Africa for collecting ethnographic data; and part of his course at the École Pratique in 1906–7 was devoted to establishing such ethnographic instructions, which were never completed. Sibeud, *Une science impériale?* 219. He also applied for the directorship of the Musée d'Ethnographie in 1906 when Hamy retired, and in 1912 visited London (British Museum), Berlin (Museum für Völkerkunde), and Belgium (presumably the Royal Congo Museum) to examine their "flourishing ethnographic establishments." Cited in Fournier, *Marcel Mauss,* 35; see also IMEC/Fonds Marcel Mauss/MAS 21.17; and Marcel Mauss, *Oeuvres,* vol. 3, *Cohésion sociale et divisions de la sociologie,* ed. Victor Karady (Paris, 1969), 354.

[52] Sibeud, *Une science impériale?* chap. 6. David L. Hoyt intriguingly suggests that van Gennep's discovery of ethnography was tied less to fieldwork experience (of which he had very little) and more to a general late nineteenth-century rejection of social evolutionism, and especially the latter's tendency to turn the "primitive" into fossils. "Above all the resources of ethnographic discourse ceased to endow an *archaeological* metaphor of the primitive, in favor of a *vitalist* one." David L. Hoyt, "The Reanimation of the Primitive: Fin-de-siècle Ethnographic Discourse in Western Europe," *History of Science* 39 (2001): 332.

that of the Société d'Anthropologie.[53] In 1907 Delafosse and van Gennep also proposed, less successfully, that all future ethnographers be properly trained, and that the best place to do so would be a "Bureau of Colonial Ethnography" funded by the Ministry of Colonies, which they believed had a vested interest in securing reliable information about the peoples of the empire.

In the shifting ground of early twentieth-century French human sciences, these initiatives posed an invitation and a threat to not only the university-based Durkheimians, but also laboratory-based anthropologists like Rivet who were attempting to chart anthropology's future in the new century. The invitation was for French armchair theorists to think concretely about training a cadre of ethnographers whom they could trust. The threat was that a particular branch of knowledge of direct interest to the Durkheimians—the description of elementary forms of social phenomena—might escape the supervision of accredited academics. If Delafosse and van Gennep had their way, sociologists in Paris would become dependent on informants employed by the colonial service, who would lack the intellectual autonomy of university-educated ones. In addition, under these circumstances the state would have even less incentive to create new positions in sociology in the university to which Mauss's students in particular could aspire, since colonial administrators rather than sociologists would be training all future ethnographers. Partly as a result of these fears, Mauss took the preemptive step in 1913 of proposing an "institute" for ethnographic instruction attached to the university, on the grounds that "ethnographic facts, borrowed from inferior societies, are now an integral part of the body of evidence considered by the most classical disciplines." The Ministry of Colonies rejected the initiative, which Mauss had drafted only in rough form.[54] Despite their preference for academic allies, Mauss and Durkheim also invited Delafosse and van Gennep into the new Institut Français d'Anthropologie in 1911; the latter responded positively, seeing this long overture as academic recognition of their work.

Above and beyond the particular politics of institution building, Mauss by this time had another reason for making this overture. As a deep reader of the anthropological literature in all languages, he knew that the question of fieldwork had become an increasingly important object of discussion among professionals internationally. In Britain, the results of the Torres Strait expedition had raised new concerns; how accurate, scientists immediately asked, could the data be when collected by a team of eight arriving en masse with

[53] Sibeud, "Elusive Bureau," 59.
[54] IMEC/Fonds Marcel Mauss/Marcel Mauss à M. le Ministre de l'Instruction Publique, typescript, n.d. [1913], 2 pp.; and "Projet de création d'un Bureau ou Institut d'Ethnologie," n.d. [1913], 7 pp. See also Sibeud, "Elusive Bureau."

their instruments in a village with no prior European contact? Upon his re-
turn, W. H. R. Rivers soon advocated an alternative model of fieldwork, in
which a professional investigator studied a group of 400 to 500 individuals
intensively and alone—so as not to disrupt the social life of those being ob-
served or to be distracted by any other duties—and then wrote up the results.
Seeing with one's own eyes, experiencing with one's own body, professional
anthropologists were realizing, were central parts of describing and under-
standing. Facts did not simply exist for the ethnographer to observe but were
always mediated by the ethnographer's subjective perception of them.[55] More
or less at the same time as Rivers, Franz Boas and Richard Thurnwald, two
academically trained German anthropologists, along with Rivers's most fa-
mous student, the Polish-born anthropologist Bronislaw Malinowski, were
also "feeling their way" toward these modern principles of participant ob-
servation. Given the visibility of these discussions, it would have been sur-
prising if Mauss had not taken notice of French-authored innovations in the
domain.[56]

Disrupted by World War I, the budding alliance between Mauss, Rivet, and
the "dissidents" would nevertheless yield rich dividends after 1919—despite
the horrific loss of life that touched all of them.[57] Durkheim died in 1917, and
several of Mauss's most talented students and collaborators also perished in
the war.[58] Mauss was devastated by his uncle's s death, but it also freed him
to formulate his own research questions for the first time.[59] Within a year of
the armistice, Mauss was already pointing out in a report on "the status of

[55] It is now argued that there was no single "fieldwork" revolution announced by the publication of
Malinowski's "legendary" *Argonauts of the Western Pacific* in 1922, but a gradual and much debated
transition between the end of the nineteenth century and the 1920s to more rigorous methods. For
the case of British anthropology and Malinowski's place in it, see James Urry, "*Notes and Queries on
Anthropology* and the Development of Field Methods in British Anthropology, 1870–1920," *Proceed-
ings of the Royal Anthropological Institute of Great Britain and Ireland* 1972 (1972): 45–57; and Hen-
rika Kuklick, "Personal Equations: Reflections on the History of Fieldwork, with Special Reference
to Sociocultural Anthropology," *Isis* 102:1 (March 2011): 1–33. For Germany in the early twentieth
century, see Zimmerman, *Anthropology and Antihumanism*, chap. 10. An excellent comparative
overview that includes France is Daniel Céfaï, "Présentation," in *L'enquête du terrain. Textes réunis,
présentés et commentés par Daniel Céfaï* (Paris, 2003), 15–64.
[56] Liebersohn, *Return of the Gift*, 122.
[57] Rivet and Mauss had already begun exchanging views on ethnography before the war. In 1913,
Rivet read Mauss's article "L'ethnographie en France" and immediately sent him a letter praising
him but also pointing out "a few small errors and omissions." IMEC/Fonds Marcel Mauss/MAS
11.20/Paul Rivet à Marcel Mauss, 10 Oct. 1913.
[58] Closest to Mauss were Durkheim's son André, who died of wounds in 1915, and Robert Hertz,
killed the same year. Other war dead among the Durkheimians were Maxine David, Jean Reynier,
and Antoine Bianconi.
[59] On the impact of the war on Mauss, see Jane I. Guyer, "The True Gift: Thoughts on *L'Année So-
ciologique* Edition of 1923–24," *Revue du M.A.U.S.S.* 36, "Marcel Mauss vivant" (Nov. 2010) (only
available online).

the anthropological sciences" to the Institut Français d'Anthropologie that the death of almost every young scholar he had trained—including those marked already as future "maîtres"—was felt all the more acutely given that France's empire had suddenly grown. France, he continued, had to assume its "scientific responsibilities" overseas and do all in its power to develop the sciences of man that still languished at home.[60] He then began to make good on his own recommendations. When the society's meetings resumed in Paris in 1919, Mauss and Lévy-Bruhl developed a real working relationship with Delafosse (van Gennep had by then moved on to other things).[61] At the center of their discussions were questions of how best to study archaic societies, which also engaged both Rivet and a talented young ethnographer of the Chaco people in Argentina, the Swiss-born *chartiste* (and future student of Mauss and Rivet) Alfred Métraux.[62] Mauss, Rivet, and Lévy-Bruhl began attending the meetings of the "dissident" society that Delafosse and van Gennep had founded in 1910, renamed the Société Française d'Ethnographie and now run exclusively by Delafosse, and submitted their own work for debate. These were exciting years not only in Paris but in the larger scientific world, after the five-year hiatus in publications and exchanges imposed by the war, years that for some anthropologists were extraordinarily productive. Malinowski, for example, had used his immersion in the South Pacific between 1914 and 1917 to complete a pioneering economic anthropology of the traditional "kula," or trading networks, of the Trobriand Islanders. Rendered in a pathbreaking narrative style that was also a militant manifesto for the importance of solo in-depth scientific fieldwork, Malinowski's *Argonauts of the Western Pacific,* published in 1922, was an instant international success and the subject of Mauss's École Pratique seminar a year later.[63] Both Malinowski's economic concerns and his insistence that a social anthropologist learn the local languages and live as discreetly as possible among his

[60] Marcel Mauss, "L'état actuel des sciences anthropologiques en France," *L'Anthropologie* 30 (1920): 153.

[61] Van Gennep continued to forge his own path, seeking to establish a science of ethnography from which physical anthropology was completely eliminated. He did not especially want an academic post in Paris, which would have constrained his freedom. After the war, he survived as a freelance writer.

[62] Métraux's father, a doctor, had moved his family to Argentina, but then sent his son to Paris to be educated. In 1922, at the age of twenty, Métraux interrupted his studies at the École des Chartes (France's most prestigious school for the training of archivists) and the École Nationale des Langues Orientales Vivantes to undertake an eight-month fieldwork trip in the Chaco region in Argentina. In 1925 he published in Delafosse's *Revue d'Ethnographie* the first "professional" account in French of how to conduct fieldwork. For a reprint, see Alfred Métraux, "De la méthode dans les recherches ethnographiques," *Gradhiva* 5 (1988): 57–71.

[63] For the list of Mauss's seminar topics from 1920–39, see Fournier, *Marcel Mauss*, 472–74. In addition to Malinowski's *Argonauts*, other landmark studies of single societies from this time include Arthur Radcliffe-Brown's *Adaman Islanders* (1922) and Richard Thurnwald's *Banaro Society* (1916 in English, followed by a German translation five years later).

informants would influence interwar French ethnology students, because of Mauss's endorsement of these aspects of Malinowski's ethnography.[64]

From these various postwar encounters emerged, finally, a more ambitious plan in Paris for a university institute in the human sciences than the ones that Delafosse and Mauss had each on their own drawn up earlier.[65] Lévy-Bruhl, who by 1920 presided over the professors' council at the Faculté des Lettres, and Mauss, who like Lévy-Bruhl had the academic credentials necessary to sponsor such an initiative, spearheaded the effort, but Rivet and Delafosse were also involved. The idea, the organizers explained, was to re-group existing relevant courses on offer across Paris, to create new lessons in methodology, and to sponsor fieldwork, missions to collect artifacts, and scientific publications—all with an eye to establishing the discipline of ethnology in France, with a special (but not exclusive) emphasis on studying the archaic peoples of its colonies.[66] The ministers of education and colonies were persuaded this time around for a variety of pragmatic reasons, as was the University of Paris faculty who had to vote on the proposal. First, a major 1920 reform in higher education facilitated the creation of such institutes throughout French universities, in order to promote specialized research by concentrating teaching personnel and facilities in a single center.[67] The rigidity of the French educational system had long discouraged professors from teaching research methods, a situation deemed intolerable after the Great

[64] That Mauss did not like Malinowski personally and criticized his functionalist school, while still admiring his work on the kula trade, is well known; but Mauss's embrace of the British school's field-work methods has not been sufficiently emphasized. Part of Malinowski's appeal to ethnographers was the down-to-earth way in which he explained his research methods in the introduction of *Argonauts*. For example, he acknowledged the ignorance of the outsider seeking to understand tribal life and utterly failing in the first few months. Malinowski then explained that only immersion in daily life over several years would achieve the goal of grasping "the native's point of view" and realizing "[*the native's*] vision of *his* life." Scientific training before going into the field was also essential in order to identify "all the rules and regularities of tribal life" that "are nowhere *formulated.*" One had to learn how to collect concrete data and draw general inferences—a process that sounded obvious but had occurred only "since men of science" had undertaken fieldwork. Bronislaw Malinowski, *Argonauts of the Western Pacific: An Account of Native Enterprise and Adventure in the Archipelagoes of Melanesian New Guinea* (1922; New York, 1961), 25, 11, and 9–10.

[65] Sibeud, *Une science impériale?* 261–64.

[66] IMEC/Fonds Marcel Mauss/MAS 8.10/Lucien Lévy-Bruhl à Marcel Mauss, 15 June 1925, 18 June 1925, 27 June 1925, and 19 August 1925; IMEC/Fonds Marcel Mauss/MAS 4.24/Louis Finot à Marcel Mauss, 14 Oct. 1925; IMEC/Fonds Marcel Mauss/MAS 11.50/Marcel Mauss à Dr. Beardsley Ruml, Dec. 1925 (two letters); and IMEC/Fonds Marcel Mauss/MAS 17.6/Marcel Mauss à M. le Gouverneur Général de l'Indochine, 3 Nov. 1926.

[67] The 1920 decree envisioned two types of institutes: Faculté institutes, attached to one of the five major Facultés that made up every French university (Droit, Médecine, Pharmacie, Lettres, and Sciences) and university institutes, designed for disciplines in which the spheres of two different Facultés overlapped. The Institut d'Ethnologie was designated a university institute, because it regrouped into one discipline (ethnology) subdisciplines from the Faculté des Sciences and the Faculté des Lettres respectively. The two types of institutes were administered differently. Faculté institutes

War had ushered in the dominance of the technologically advanced United States. Institutes were cheaper to fund than chaired professorships (which had to be endowed either privately or by the state), since they required no new faculty lines of their own but rather regrouped existing ones.

Second, France's new League of Nations mandates in formerly German and Ottoman territories in Africa and the Middle East went into effect in 1922 and 1923; henceforth colonial governance would be subject (in theory) to international oversight. In this context, French authorities eager to demonstrate their credentials as modern, scientific colonizers would prove willing to underwrite the discipline of ethnology in the university. Third and last, the victory of the left-wing coalition known as the Cartel des Gauches in the 1924 elections brought to power a government in which the Durkheimians had strong allies—in particular Édouard Daladier as minister of colonies.[68] Without the latter's approval, the project would not have gone forward.

On 1 August 1925, France's first university institute devoted to ethnology was formally signed into existence, some twenty years after the first anthropology departments had been founded in German, English, and American universities.[69] Although modest in scale, it was a milestone for the diverse group of anthropologists, sociologists, and ethnographers who had begun to crystallize around common questions in the first quarter of the century. How exactly to set up this discipline—the range of courses to be taught, the nature of certification for coursework completed, the need for a proper museum and library, even what to call what they were doing—would nevertheless remain a topic of discussion through the late 1920s.

ETHNOGRAPHY OR ETHNOLOGY?

For the armchair theorists Mauss and Lévy-Bruhl, it seemed evident that the primary focus of the Institut d'Ethnologie would be ethnography, which they defined as the study of the languages and civilizations, past and present, of archaic

were integrated into the particular schools of which they were a part, while university institutes were more independent, with their own budget and council. The reform was part of a postwar effort to introduce more differentiation into the French university system, where the dominant disciplines in the arts and sciences remained the classical ones of philosophy, history, geography, literature, and languages (Lettres) and mathematics, physical sciences, and natural sciences (Sciences).

[68] For the role played by the Cartel des Gauches in the founding of the Institut d'Ethnologie, see Victor Karady, "French Ethnology and the Durkheimian Breakthrough," *Journal of the Anthropological Society of Oxford* 12 (1981): 165–76.

[69] Lucien Lévy-Bruhl, "L'Institut d'Ethnologie de l'Université de Paris," *Revue d'Ethnographie et des Traditions Populaires* 23–24 (1925): 233–36; Clark, *Prophets and Patrons*, 188, 200, 214, 227, 232–33; and Tai, *L'anthropologie française*, 89–97.

peoples everywhere but especially in the empire; this study was to be conducted in the field, but also in the library and the museum. Indeed, when Lévy-Bruhl first approached the minister of education about the possibility of founding an institute in November 1924, he called the project an Institute of Ethnography, not Ethnology.[70] Mauss, too, initially referred to the new center as an Institute of Ethnography in letters to potential supporters.[71] Yet a couple of months later, Lévy-Bruhl told the minister that a number of "savants"—he did not specify which ones—preferred the name "Institute of Ethnology," which was duly adopted.[72] These savants probably included Paul Rivet, whom Lévy-Bruhl asked to be one of the two secretary-generals of the institute (Mauss would be the other one, while Lévy-Bruhl, as the only university professor among the founders, would serve as president).[73] As a physical anthropologist and doctor by training, Rivet had a vested professional interest in making sure that the discipline being defined within the walls of the Sorbonne would include the natural as well as the sociocultural history of man. "Ethnology" was, in this sense, more expansive than ethnography, with its narrower socioculturalist and linguistic orientation.

When the Institut d'Ethnologie opened its doors in January 1926, Article 2 of its charter stipulated that the institute should "coordinate, organize, and develop ethnological studies," "train workers [*travailleurs*] for these studies," "publish their works," and "send missions to the colonies and exceptionally elsewhere." Article 5 specified that the subjects to be taught should include "methods of research and of ethnological description—native institutions, in particular their languages, religions, customs, techniques, anthropological characteristics, history, and archaeology." And Article 8 mandated that a *diplôme d'études supérieures* in ethnological studies be granted to students who passed the proper exams.[74] By the end of its first year of operation, Lévy-Bruhl lamented that they had not yet been able to organize "what the British called fieldwork."[75] But they had managed to launch the publication of ethnographies under a new imprint (Travaux et Mémoires de l'Institut d'Ethnologie), another important priority. In 1925 Mauss was already hoping "to publish at least six big things a year."[76]

[70] ARP/IE/26/"Projet de création à l'Université de Paris d'un Institut d'Ethnographie," Conseil de l'Université de Paris, 24 Nov. 1924; "Institut d'Ethnographie: Projet de Statut," [n.a., n.d.]; M. le Ministre de l'Instruction Publique à M. le Recteur de l'Académie de Paris, 19 Dec. 1924.
[71] See, for example, IMEC/Fonds Marcel Mauss/MAS 4.24/Marcel Mauss à M. le Résident Général de la République Française au Maroc, 30 Dec. 1925; Louis Finot à Marcel Mauss, 3 Feb. 1925. He often used the terms "ethnography" and "ethnology" interchangeably, seeing the former as a largely descriptive science and the latter as the more general and theoretical science.
[72] ARP/IE/26/Recteur de l'Académie à M. le Ministre de l'Instruction Publique, 5 Jan. 1925.
[73] AMH/2 AP 1 C/Lucien Lévy-Bruhl à Paul Rivet, 6 Dec. 1925.
[74] ARP/IE/26/Statuts/Décret portant création à l'Université de Paris d'un Institut d'Ethnologie, 1 Aug. 1925.
[75] ARP/IE/25/Procès-verbal, Séance du Comité directeur, 12 Nov. 1926.
[76] IMEC/Fonds Marcel Mauss/MAS 11.50/Marcel Mauss à Dr. Beardsley Ruml, Dec. 1925.

In addition, the Institut d'Ethnologie brought in speakers, made questionnaires available, and, most importantly for the future, organized its own core teaching program.[77] Marcel Cohen (a specialist in Ethiopian languages) would give five lessons in "descriptive linguistics," Maurice Delafosse five lessons in the linguistics and ethnography of Africa, and Jean Przyluski (an Orientalist at the École Pratique and a former student of Mauss's) the same number of lessons for Asia. The centerpiece, however, was a course taught by Mauss called "Instructions in Descriptive Ethnography," which grew from twenty-two lessons in 1925 to thirty in 1926 to fifty in 1927.[78] This course would always remain the heart of the institute's training, far exceeding in breadth and depth any other course offered, and Mauss would soon find himself immersed in a new "tribe" of students whose field experiences differed markedly from the erudition he had acquired in libraries and museums. In the give-and-take spirit that had characterized his teaching and writing before and right after the war, he would nevertheless learn from his disciples, while also teaching them how to situate their ethnographic facts in the broader contexts that he knew from his reading.

Between 1925 and 1927, two further changes at the Institut d'Ethnologie were made. First, a certificate in ethnology was created in addition to the *diplôme d'études supérieures*.[79] Students who passed the examinations leading to the certificate could apply that certificate toward their bachelor's degree—the *licence libre*—at the Faculté des Lettres; they were required to have four such certificates in fields of their own choosing, in order to complete their studies.[80] The *licencié* could then go on to a doctorate, if sufficiently motivated. The importance of the new certificate in ethnology cannot be exaggerated: it meant that Mauss and Rivet for the first time would be able to

[77] The published annual report of the first year indicated that anthropometric, linguistic, and ethnographic questionnaires were available for distribution to travelers to the colonies, as well as a set of instructions drawn up by the prehistorian l'Abbé Breuil for the safe removal and conservation of cave paintings. L. Lévy-Bruhl, "L'Institut d'ethnologie pendant l'année scolaire 1925–1926," in *Annales de l'Université de Paris* (Paris, 1927), 2:92.

[78] ARP/IE/26/Rapports Annuels; those of 1925–26, 1926–27, and 1927–28 were signed by Lévy-Bruhl.

[79] Arrêté of 19 March 1927. No explanation was provided, but this innovation was surely a response to the immediate success of the institute among undergraduates.

[80] The *licence libre* (the equivalent of a bachelor's degree) was also a postwar innovation. After 1920, students could choose between pursuing a *licence libre* or a more traditional *licence d'enseignement*. The latter prepared them for lycée teaching in history and geography, philosophy, or languages and required a sequence of four certificates set by the university in one of these disciplines. Before 1920, only one *licence* option had existed, the teaching one, and universities had limited their offerings accordingly. In a university system legendary for its resistance to innovation, specialization, and research, the creation of the *licence libre*—like the decree creating institutes—was a major innovation: it meant that interested faculty could design new courses and examinations in fields that had never before been recognized.

offer their science to those attending university (many of them women) after
World War I, rather than relying, as in the past, on the few scholars who had
found their way on their own to Mauss's more specialized courses at the École
Pratique, or to Rivet at the Muséum.[81] Ethnology's leaders could thus ensure
the discipline's further growth.

A second change was to expand the institute's core course offerings beyond
ethnography and linguistics to include instruction in archaeology, prehistory,
and physical anthropology. In 1926 Rivet began to teach five lessons (even-
tually nine) in physical anthropology, which was considered "indispensable
for all ethnographers." L'Abbé Breuil was also asked to teach five lessons in
"exotic prehistory" on the grounds that the field had developed phenomenally
in the last two years, with especially important finds in Tonkin. These new
offerings served in turn as a prelude toward developing an even more "hard"
science component to the institute, by bringing in three members of the Fac-
ulté des Sciences. Indeed, by 1927 three more courses had been added to the
roster: ten lessons in zoological and biological anthropology by Étienne Ra-
baud, ten lessons in geology and human paleontology (specializing in North
Africa) by Léonce Joleaud, and four lessons in the "psycho-physiology of hu-
mans and anthropoids" by Paul Guillaume.[82] A second ethnology certificate
was created, this time at the Faculté des Sciences. Henceforth students could
pick one of two tracks in ethnology and choose their additional coursework
accordingly, although students in both tracks would continue to have a core
set of institute courses in common: Mauss's ethnographic methods, Rivet's
lessons in anthropology, and Cohen's in linguistics.

The creation of the second certificate was the last significant change until
the Occupation. As Lévy-Bruhl noted in the fall of 1927, its creation was "less
an innovation than a return to a more rational situation." [83] It was illogical, he
continued, to attach ethnology exclusively to the Faculté des Lettres; circum-
stances unique to France, he admitted, had given ethnological studies for over
a century "an almost purely literary character." Certainly these studies were
closely allied to psychology, sociology, and history, and there was no question
of breaking these links. "But it is no less true that ethnology cannot aspire to

[81] On average 6,382 students a year attended from 1900–1913, of whom 35 percent were women; by
1924–29, however, the yearly average rose to 14,297, and ten years later was 17,853; in each case, 50
percent were women. Figures cited in Heilbron, "Les métamorphoses," 226.
[82] Another anthropology course entitled "The Physiology of the Human Races" (five lessons) was
approved in 1930, but Jacques Millot did not begin teaching it until 1932. AMH/IE/2 AM 2/A1/
Procès-verbal du Conseil d'administration, 11 July 1930; ARP/IE/25/Arrêté, 29 June 1932. Rabaud
and Guillaume knew Rivet and Mauss not only from the Institut Français d'Anthropologie, but also
from the Société de Psychologie, where all four were active.
[83] AMH/IE/2 AM 2/A1/Procès-verbal du Conseil d'administration, 15 Nov. 1927; Arrêté of 24
November 1928.

solidly established results if it is not anchored in the biological sciences and more particularly anthropology, and if it does not familiarize itself . . . with the spirit and methods of science itself." He concluded that with the creation of the second certificate, a simple glance at the Institut d'Ethnologie's course listings will make clear that "this science depends on both Facultés."

Yet there was another reason for introducing the second certificate, which would attract students more interested in human biological evolution than social development. As a detailed justification pitched to the Faculté des Sciences professors explained, the point was not simply that the scientific study of man encompassed a knowledge of biology (to determine man's place in the natural order and understand his relationship with the animal kingdom and early hominins), and of geology and paleontology (to date fossil remains and establish the correct chronology of prehistoric man's physical and social evolution). Equally important was the fact that in France (unlike abroad) these anthropological sciences still had no official place in the public university. Only the Muséum chair in anthropology existed, whose purpose was "to create and study collections rather than to systemize the knowledge acquired and to direct research." Meanwhile, the teaching of physical anthropology had been "abandoned to private initiative, devoid of personnel and means"— a clear reference to the École d'Anthropologie. What was needed was for the Faculté des Sciences to "make its own a discipline which logically belonged to it," thereby endowing "that important branch of knowledge with all the impetus that comes from research that is carefully conducted and from regular teaching." As with the Faculté des Lettres, adopting the certificate would cost the Faculté des Sciences nothing, since students would attend existing courses and the new lessons offered by the institute.[84]

The creation of the second certificate had one final consequence. The Faculté des Sciences required all students to carry out *travaux pratiques*, or practical training. *Travaux pratiques* in geology and anthropology were thus added to the science track, which included instruction in anthropometry and racial diagnostics, reconnaissance and description of ethnographic objects (including prehistoric tools), comparative osteology, and the use of tape recorders.[85] Professors Rabaud and Joleaud also began taking groups of faculty and students to local prehistoric sites, and students visited the archaeological museum at St. Germain-en-Laye as well as the Musée d'Ethnographie. In 1931, Mauss and Rivet then decided—in the spirit of learning from the example of "science"—to institute a comparable set of *travaux pratiques* in ethnography

[84] AMH/IE/2 AM 2/B3/Certificats, typescript justifying creation of a certificate at the Faculté des Sciences, [n.a., n.d.].
[85] AMH/IE/2 AM 2/A1/Procès-verbal du Conseil d'administration, 7 July 1927.

that would be obligatory for all students preparing the Faculté des Lettres cer- tificate. Complaining that "humanities" students had a theoretical rather than practical notion of their subject of study, the institute's founders concluded that it would be more useful "to make more demands upon their intelligence than their memory." A practical exercise—for example the identification of a particular artifact—would henceforth be added to the final exam series.[86]

By 1931, however, this practical training was already a fait accompli thanks to a second institutional victory a few years earlier. Upon Verneau's death in 1928, Rivet became the holder of the chair in anthropology at the Muséum and was simultaneously appointed director of the Musée d'Ethnographie. The Institut d'Ethnologie faculty suddenly had a "hands-on" laboratory for teaching their science, and Mauss and Lévy-Bruhl joined Rivet on the Musée d'Ethnographie's new governing council. Indeed, these new ethnologists potentially had some- thing more: Rivet with characteristic determination saw the possibilities for re- furbishing the museum with the help of his students—and whoever else wanted to chip in. Such renovation, if done right, would not only train experts, spon- sor research, and provide employment for future ethnologists; it would also win over a much broader public, since no part of ethnology was ever taught to schoolchildren in France. A broader audience in turn would help ethnology to grow, and even—Rivet idealistically hoped—foster peace among all peoples.

In the Shadows of the New *Ethnologie:* The Career of George Montandon

In 1933, Paul Rivet in his capacity as secretary-general of the new Institut d'Ethnologie wrote the minister of education to stop subsidizing the École d'Anthropologie, a school that Rivet claimed was "finished" since the cre- ation of the Institut d'Ethnologie. He was equally dismissive of the Société d'Ethnographie (formerly the Société d'Ethnographie Orientale et Améric- aine), which had been resurrected before the war and which Rivet described as "a moribund and lusterless society, in which ethnology is still treated the old-fashioned way."[87] Yet if Rivet bothered to dismiss these institutions, it seems fair to surmise that neither was quite as insignificant as he chose to make out. We thus end our story of the institutionalization of a new ethnol- ogy in the late 1920s with a reminder that—regardless of what Rivet may have

[86] AMH/IE/2 AM 2/A1/Procès-verbal du Conseil d'administration, 7 Dec. 1931.
[87] AMH, 2 AM 1 A5/a/Paul Rivet à M. de Monzie, Ministre de l'Éducation Nationale, 21 Jan. 1933, no. 82; AMH/2 AM 1 A12/c/Paul Rivet à M. Deschamps, Gouverneur de la Côte française des So- malis, 18 April 1939, no. 657.

wanted—there still were many paths into, and many competing visions of, the science of man that remained academically legitimate in France between the 1890s and the 1920s. Here the deeply troubling case of the racist George Montandon can serve as a counterexample to Mauss and Rivet, in whose shadow Montandon forged his own career. A cosmopolitan who trained in several countries, including France, Montandon would acquire sufficient credentials to become a professor of ethnology at the École d'Anthropologie in 1932.

Born in 1879 in Cortaillod, Switzerland, Montandon first chose a career in medicine.[88] After practicing a few years, however, he discovered his true passions: exploration, *les belles lettres*, descriptive ethnography, and racial science. Montandon traveled to Hamburg and London to prepare for his new vocation, where he was exposed to the German diffusionist or *Kulturkreis* school (from which Rivet had kept his distance); then in 1909 he set off to explore one of the more remote parts of Ethiopia. Upon his return in 1911, he gave guest lectures at prestigious geographical societies across Europe and published his first travelogue, *Au pays Ghimirra. Récit de mon voyage à travers le massif éthiopien (1909–1911)* (1913). During World War I he volunteered as a surgeon from 1914 to 1916, but in 1917 he was back to writing. And although the paper trail here is thin, the few articles that Montandon wrote in this period suggest that he already harbored not only extreme anti-Semitic tendencies, but also fantasies about the existence of a pure master race inspired by his reading of Gobineau.

Montandon's flirtation with Gobineau in 1917 came in the form of two reviews he wrote of a strange work by Camille Spiess entitled *Impérialismes. La*

[88] No biography of George Montandon exists, nor is there a complete bibliography of his journalistic and scientific works. Many accounts mention different aspects of Montandon's career, but almost all focus on his final years as a public anti-Semite, then a collaborator. In reconstructing Montandon's life, I have found the following most helpful: Joseph Billig, *L'Institut d'étude des questions juives, officine française des autorités nazies en France. Inventaire commenté de la collection de documents provenant des archives de l'Insitut conservés au C.D.J.C* (Paris, 1974), 186–204; "Interview de Henri Victor Vallois (le 15 février 1981)," *BMSAP* 8:1–2 (1996): 81–103; Marc Knobel, "L'ethnologue à la dérive. George Montandon et l'ethnoracisme," *Ethnologie Française* 18:2 (1988): 107–13; Knobel, "George Montandon et l'ethnoracisme" in Taguieff, *L'antisémitisme de plume*, 277–93; Carole Reynaud-Paligot "Naissance de l'antisémitisme scientifique en France," *Archives Juives* 43:1 (1er sem. 2010): 66–76; Introduction to *Georges Montandon et l'ethnie française*, n.a. (Paris, 1993), 5–11(this volume is a reprint of the entire run of the journal *L'Ethnie Française*, which Montandon published during World War II; its reissue in 1993 with an unsigned introduction suggests that the editors were sympathetic to Montandon's racist views and wished to make them available again); Sébastien Jarnot, "Une relation récurrente. Science et racisme. L'exemple de l'ethnie française," *Les Cahiers du Cériem* 5 (May 2000): 17–34; "Famille Montandon," http://www.genealogiesuisse.com/montandon.htm. A short biography of Montandon, dated July 1942 and presumably compiled by the Vichy authorities, also exists in ANF/F17/13341. Montandon's association with literary anti-Semites, and particularly Céline, in the late 1930s has also received attention. See E. Mazet, "Céline et Montandon, http://louisferdinandceline.free.fr/indexthe/antisem/montandon.htm; and Jean-Paul Louis, *Lettres à Albert Paraz, 1947-1957*, 2nd ed. (Paris, 2009), 213–15.

conception gobinienne de la race. Sa valeur au point de vue bio-psychologique.[89] Spiess was an iconoclastic Swiss anarchist of the Right, who believed the future of humanity lay in the development of androgyny and the elimination of impure races.[90] In *Impérialismes*, Spiess wrote as a "French patriot" purporting to show that contemporary German democratic culture, far from the product of Gobineau's superior Aryan race, represented instead a debased "Judaized" one.[91] While Spiess accepted that there were no pure races from a physical anthropological point of view, he nevertheless maintained that they did exist from a "psychosexual" one. A group that managed to sublimate the sexual instinct and attain a certain Platonic spiritual androgyny was, in his eyes, a "pure race."

Montandon, who shared Spiess's French nationalist sentiments, particularly liked two aspects of the latter's work: first, his recognition that from a somatic point of view the Aryans that Gobineau had admired as "the master race" could not be Germans, since, according to the latest race classifications, long-headed blonds were concentrated in Scandinavia alone; and second, Spiess's "Nietzschean" reading of Gobineau. According to Montandon, Nietzsche had transferred Gobineau's "racial point of view into the domain of spirituality, by his creation of the super-man whom he opposed to men." Spiess had added to these two criteria—race and spirit—for classifying humanity, a third: "le sexe." From this heady brew, Montandon concluded that a race of Aryan supermen, whose purity and superiority were defined as much spiritually (i.e., culturally) as by blood (Montandon never showed any interest in the sexual part of Spiess's philosophy), existed, and were born to rule. With the benefit of hindsight, it is tempting to see Montandon's subsequent ethnological work on race and culture as an attempt to recast in acceptable scientific terms this mixture of fin-de-siècle philosophy and Gobineau's racism.[92]

[89] Camille Speiss, *Impérialismes. La conception gobinienne de la race. Sa valeur au point de vue bio-psychologique* (Paris, 1917). One of Montandon's reviews was reprinted in Joseph Rivière, ed., *Camille Spiess. Sa vie, son caractère et sa pensée* (Paris, 1919), 113–30. For the other, see George Montandon, "Camille Spiess et ses commentaires sur les théories raciales de Gobineau," in *La Revue Contemporaine* 11:25 (September 1917): 589–93. On Spiess, see Florence Tamagne, *A History of Homosexuality in Europe* (New York, 2006), 2:256–58.

[90] Montandon, "Camille Spiess," 589–93.

[91] Speiss, *Impérialismes*.

[92] Suggestive here is the fact that, writing under the influence of the fin-de-siècle Austrian cultural philosopher and esotericist Rudolf Steiner, Spiess adopted early on the name of "Anthroposophie" for his psychosexual "science." In a 1914 article published in Geneva, Montandon proposed replacing "anthropology" with "anthroposophy," noting that even if the term was used by a "religious sect," it best described the union between anthropology and ethnology that should characterize the science of man. See George Montandon, "Des tendances actuelles de l'ethnologie à propos des armes de l'Afrique," in *Archives Suisses d'Anthropologie* (May 1914): 105; and Camille Spiess, *Mon autopsie. Éjaculations autobiographiques* (Nice, 1938), 145. The particular copy that I used, from the Bayerischen Staatsbibliotek München, was sent by Spiess to Alfred Rosenberg with a dedication stating that the book represents a "lived solution to the Jewish problem."

In 1919, however, Montandon's professional career as a scientific racist still lay in the distant future. That year he contracted with the Red Cross to negotiate the release and repatriation of POWs from the Austro-Hungarian Empire who were being held in Siberia, and set off across central Asia on the trans-Siberian railroad in pursuit of more ethnographic adventure. This trip helped form a lifelong fascination with the Ainu, whom he encountered on Hokkaido Island, as well as the Bouriats around Lake Baikal, and provided fodder for his second travelogue, *Deux ans chez Koltchak et les Bolsheviks pour la Croix-Rouge de Genève (1919–1921)* (1923). While in Siberia, he also married Maria Zviaghina, with whom he would have two daughters and a son and who would win him over to communism. According to the recollections of French anthropologist Henri Victor Vallois, who knew him personally, Montandon met his future wife while he was serving on a train for the Red Cross and she was a nurse on board a train for the Red Army. He apparently allowed her to transfer his own wounded, who were largely White Russians, to her Red Army train; the episode would come back to haunt Montandon after he returned to Switzerland in 1921.[93]

At this point, the trail becomes even murkier. Montandon initially resumed his international journalistic connections, putting his ethnographic knowledge, for example, at the service of abolitionists fighting slavery in Ethiopia; this was a popular cause after the founding of the League of Nations, and Montandon presumably wished to show off his scientific expertise and his new Bolshevik credentials. He also became a member of the Lausanne Communist Party, subsidized by the Soviet secret service, and wrote several flattering articles on Lenin, perhaps seeing in him Spiess's charismatic "superman" who was destined to rid Europe of its impurities.[94] At the same time he resumed his medical practice and began publishing more scholarly ethnographic articles, in anticipation of switching to an academic career. When he applied for Arnold van Gennep's former chair in ethnography at the University of Neufchâtel, however, he was turned down because of his Communist connections.[95] An embittered Montandon then decided to explore alternative scientific career options in France, and at the same time to abandon politics.

Two "affairs" involving Montandon between 1923 and 1925 helped to push him in this direction. In 1923, he became embroiled in a nasty libel suit with the editor of the *Gazette de Lausanne*, Charles Brunier, which

[93] "Interview de Henri Victor Vallois," 99.
[94] These articles appeared in the French journal *Clarté*. Montandon stayed in touch with *La Lutte des Classes* (the successor of *Clarté*) until 1928.
[95] George Montandon, *L'ologenèse humaine (Ologénisme)* (Paris, 1928), XI.

Montandon lost two years later. Outraged when Brunier's newspaper had failed to review his book on Siberia, Montandon published a series of scurrilous pamphlets insulting Brunier, which led Brunier to sue Montandon. Then, while this libel suit was playing out, Montandon stridently and repeatedly accused a popular Polish explorer/travel writer, Ferdinand Ossendowski, of making up parts of an account of crossing central Asia that he had recently published—an accusation that Ossendowski denied, even though it happened that this time Montandon was right. In the "Ossendowski controversy," as it came to be known, Montandon aggressively assumed the role of the "scientist," who, having traveled the same route as Ossendowski, knew the "hard facts"; Ossendowski in contrast was cast as an esoteric adventurer who had invented his mystical account of Tibet. This war of words eventually led to a public confrontation between the two men in Paris, to decide who was telling the "truth." Politics, in fact, underlay the whole event: Ossendowski was a liberal Socialist who supported the same White warlord Koltchak operating out of Siberia whom Montandon had condemned in his pro-Bolshevik Red Cross account. The French periodical *Les Nouvelles Littéraires* organized the final showdown in 1924, and the cream of the young and old literary establishment on the Left and Right—including Georges Duhamel, Louis Aragon, and René Crevel—as well as Montandon's Swiss friend Spiess, attended. Montandon was officially vindicated, and the Communist newspapers *L'Humanité* and *Clarté* supported him by covering the event in their pages.[96] He thus emerged from the affair with a reputation in Paris as a solid empiricist, and a known quantity to French Communists. Beginning anew in France as an anthropologist now seemed possible; when his Brunier libel resulted in a prison sentence, Montandon decided in 1926 to flee Switzerland for good and relocate his family in Paris. Eager to make it professionally in his new *patrie,* however, Montandon now renounced his former communism. Politics had, after all, brought him nothing but grief in Switzerland; he would henceforth propel his career forward on the basis of science alone.

In Paris, Montandon began studying physical anthropology and ethnography in earnest and published two enormous scientific volumes in relatively rapid succession: first one on evolutionary race formation, *L'ologenèse humaine* (1928); then a parallel one on the evolution of material culture, *L'ologènese culturelle* (1934). He also volunteered at the Muséum anthropology laboratory, where he met Rivet, who by then was already in line to succeed to the chair in

[96] See "The Ossendowski Controversy," *Geographical Journal* 65:3 (March 1925): 251–54; *L'Humanité* 12 April, 9 Aug., 15 Sept., and 26 Nov. 1924.

anthropology. A vicious professional rivalry reportedly ensued between the two, which seems plausible, since Rivet, although only three years Montandon's senior, held the most prestigious professional post in French anthropology available at the time. Until 1933, Montandon and Rivet nevertheless attended the same meetings of the Institut Français d'Anthropologie, the learned society that Rivet and Mauss had founded in 1911 to promote ethnology as a synthetic science.[97] In 1931, the politically conservative deputy and ethnographer of France Louis Marin hired Montandon as an assistant to teach ethnography and bioanthropology at the École d'Anthropologie; Marin had become head of the school in 1922 and overseen the hiring of six new professors as the last of the Broca-trained faculty died. In 1932 Montandon was promoted to the rank of adjunct professor (*professeur hors cadre*) in the chair in ethnology, dedicated to the study of the biological and cultural traits of humans.[98] Montandon could not, however, become a full professor (*professeur titularisé*) until naturalized. In 1932 he thus applied for French citizenship; it was finally granted in 1936, when Marin convinced the authorities that Montandon had left behind his pro-Soviet activities since coming to France.[99] In another sign of tensions between Montandon and Rivet—if not outright paranoia on Montandon's side—the latter later accused Rivet of doing everything in his power first to hold up his citizenship, and then of having expedited it through his political connections with the Popular Front, which came to power in 1936, in order to hold Montandon in his debt.[100] Once he was naturalized, Montandon's position was made permanent at the École d'Anthropologie, and he was also made head of the Broca Museum, which housed mostly osteological collections. After 1936 he developed an ever-greater expertise in the racial "ethnology" of

[97] That a rift between Montandon, and Rivet and Mauss, opened up in 1933 is suggested by Montandon's absence from the Institut Français d'Anthropologie after May of that year. Montandon's name also disappeared then from the masthead of the journal *L'Anthropologie,* the organ of the anthropologists and paleontologists clustered at the Muséum. Earlier he had been listed as a *collaborateur.* Whether Montandon could no longer tolerate working with anthropologists more professionally successful than himself, who were insiders in the academic world in ways he was not, or whether he was made unwelcome in the Muséum networks because of his ideas and overbearing personality, is unclear.

[98] Broca had founded the chair in ethnology in 1876 for the study of the races. Its holder from 1890 to 1930, G. Hervé, had tended to look for the biological origins of cultural traits of various human groups (prehistoric and contemporary), a tradition that Montandon would continue.

[99] After moving to Paris in 1926, Montandon came under the surveillance of the French police, the Sûreté Générale, who assumed he was a member of the Communist cell in Lausanne. By 1934 they had found nothing to report. Reynaud-Paligot, *Races*, 51 nn. 3, 5.

[100] Weil, *How to Be French*, 116; Gérard Mauger, "L'affaire Montandon," *Ethnie Française* 3 (May–June 1941): 2. A reference to an "affaire Montandon" at the Musée d'Ethnographie in 1933 attests to the fraught relationship between Montandon and Rivet. AMH/2 AM 1 D14/Rapport, 14 Nov. 1933.

France, while focusing more openly on Jews as culturally and racially alien, as we shall see in chapter 4.[101]

By the late 1920s, the anthropological sciences—in such disarray at the turn of the century—had entered the Third Republic's scientific institution par excellence, the university, under the banner of ethnology. And yet it would be a mistake to see ethnology at this moment as a discipline disentangled from the older traditions and structuring concepts of French museum-based ethnography or nineteenth-century physical anthropology, or the Institut d'Ethnologie faculty as having the professional field to themselves. As the new Institut d'Ethnologie's curriculum revealed, Mauss and Rivet continued to sanction tried-and-true indirect observation methods (questionnaires, collections of artifacts and bones) inherited from their predecessors, alongside the more novel task of preparing students to study social structures *in situ* in imitation of their foreign colleagues.

This mixture of old and new was made clear in a 1931 session of a recently created interdisciplinary institute in Paris, the Centre International de Synthèse—a highly visible intellectual hub for all sorts of reform-minded academics in the 1920s and 1930s. The brainchild of the historian Henri Berr, who called his center "a Foundation for Science," its goal was the creation of a holistic science of society that would bring together historians and sociologists. At one of the center's seminars, Rivet and Mauss were asked to respond to a paper given by the sociologist Paul Deschamps entitled "Ethnology and Ethnography."[102] The term "ethnology" in France, Mauss explained, was applied "exclusively to the knowledge of peoples of inferior civilization and to the totality [*ensemble*] of the phenomena that they present, from biological characteristics to sociological and linguistic ones." As

[101] On his career at the École d'Anthropologie, see AMH/MS 15/3/Procès-verbaux/"Rapport du 21 juin 1933," and "Rapport du 10 juin 1936." Already in 1935 Montandon was in regular touch with such prominent German anthropologists as F. K. Gunther, Egon von Eickstedt, Erwin Baur, Eugen Fischer, and Fritz Lenz. See Knobel, "George Montandon et l'ethnoracisme," 282 n. 6; and Billig, *L'Institut d'étude des questions juives*, 196.

[102] Giuliana Gemelli describes Berr's center, founded in 1925, as an "interscience with flexible disciplinary boundaries." Berr was yet another insider/outsider in the Parisian intellectual establishment, who without ever holding a university post built a small empire to advance his ideas and disseminate them widely, initially in response to the Durkheimian attack at the end of the nineteenth century on the lack of method among historians. Berr launched the successful journal *Revue de Synthèse Historique* in 1900 and his multivolume and multiauthored *Évolution de l'humanité. Synthèse collective* in 1920. He attracted a number of younger disciples, most notably Lucien Febvre and Marc Bloch, and several collaborators of his own generation, including Mauss and Lévy-Bruhl. Giuliana Gemelli, "Communauté intellectuelle et stratégies institutionelles. Henri Berr et la fondation du Centre International de Synthèse," *Revue de Synthèse* 108: 2 (April–June 1987): 228.

such, he added, it consisted especially of observation and descriptive methods. But, he continued, it did not proscribe the use of comparison when it was a question of classifying people according to families of peoples, that is to say, when it organized them "according to 1) common somatological features, to identify a common stem; 2) common linguistic roots that prove either a common origin or long contact; or 3) common sociological traits, artistic or institutional ones, which allow one to suppose common civilizations, common origins of these civilizations, or intimate contact between these civilizations." Mauss then concluded that ethnology was as much a part of sociology as it was of "anthropology." Rivet's response (in the same forum) was only to quibble over the last part of Mauss's statement, by pointing out that in the current usage of the term, "anthropology" (understood to designate "physical anthropology") was itself a branch of ethnology (and not the other way around).[103] Three years later, when asked to define ethnology for a scientific encyclopedia, Rivet echoed Mauss again, when he replied that it was "the synthesis of the sciences dedicated to the study of races, of civilizations, of societies and of languages," as, he reminded his audience, in the time of Broca.[104]

The reference to Broca notwithstanding, Mauss's and Rivet's definitions were on balance more of their times than backward-looking. Rivet's use of the term *synthèse*, and Mauss's reference to the need to grasp social phenomena in their "totality" here, were especially revealing. As the success of Berr's center in the interwar years suggests, the search for a new kind of "synthesis" was part of a modernizing vocabulary that was sweeping all the human sciences in France between 1900 and 1930. Not just the upstart Durkheimians and their fellow travelers, but innovating scholars from fields as established as history and philosophy, were searching for a rigorous, self-conscious, and shared scientific method for grasping reality—one that would avoid the excessive compartmentalization of their fields, as well as move beyond an older synthetic tradition of erudition for its own sake, which had long been the norm in the French university, with its greater emphasis on pedagogy than research. What was needed was a marriage of empiricism and theory—that is to say, a new method for moving from the endless accumulation of facts to explication, from partial views to an apprehension of reality in its totality; this attempt at "total" synthesis of knowledge would remain a work in progress,

[103] Marcel Mauss, "Remarques," and Paul Rivet, "Compte-rendu de la séance. Intervention du Dr. Rivet," both in *Revue de Synthèse Historique* 1 (March–Sept. 1931): 202–3.
[104] Rivet, "Ethnologie," 2:5.

but it would also make science more useful and accessible to a broader public at a time when science was assuming an ever-greater importance in the lives of citizens.[105] As the quotations above suggest, Rivet and Mauss, too, espoused this modern synthetic goal for a new science of humanity that was devoted to more than measuring skulls and classifying races—a goal deemed all the more necessary in the wake of a world torn asunder by the Great War and the rise of extreme ideologies on the Right and Left. Rivet would try to bring this vision to fruition in the ethnographic museum that he had inherited with his chair in anthropology, and that he wished to transform into a museum not only *about* humanity but *for* humanity. Mauss would contribute to the same project by training a new generation of gifted graduate students to work and think cooperatively and synthetically in their pursuit of the human in every archaic society. Both men believed that in the face of their reformed science, the dehumanizing claims of a scientist like Montandon would, if not disappear, wither into insignificance.

[105] Henri Berr may have developed his own theory of historical synthesis in his essay *La synthèse en histoire. Essai critique et théorique* (1911), but the concept of synthesis has a much longer history in France. More research is needed to establish the particular valence of the term in the interwar years, but Berr certainly played a key role in defining its usage among social scientists from 1900 to 1930. On the close relations between Berr and Mauss, see Michel Blay, "Henri Berr et l'histoire des sciences," and Jacqueline Pluet-Despatin, "Henri Berr éditeur. Élaboration et production de 'L'évolution de l'humanité,'" in Agnès Biard, Dominique Bourel, and Éric Brian, eds., *Henri Berr et la culture du XXe siècle. Histoire, science et philosophie. Actes du colloque international, Paris, 24-26 octobre 1994* (Paris, 1997), 121–37 and 230–67; Mauss was also a participant in the first of the weeklong seminars of the center, which were held regularly from 1929 around certain key themes. Marcel Mauss, "Les civilisations. Éléments et formes," in Lucien Febvre et al., *Civilisation. Le mot et l'idée* (Paris, 1930), 81–108.

ETHNOLOGY FOR THE MASSES

The Making of the Musée de l'Homme

> Our goal is an educational museum, where visitors, whatever their
> degree of culture, will find a means to learn and to understand. . . .
> The Museum of Man, made and conceived for the people, will be
> open at times when the working man can benefit. . . . We thus hope
> to make available to all the inexhaustible treasures of a science that
> for too long has remained the privilege of an elite.
>
> —PAUL RIVET, *Vendredi*, 26 JULY 1937

When the Institut d'Ethnologie was founded, neither Mauss nor Rivet
saw it as a stand-alone initiative. If *ethnologie* was to thrive as a new science,
its founders took it for granted that their discipline would need a museum-
laboratory, complete with a library, conference and seminar rooms, and os-
teological and ethnographic collections to train students *before* they went
into the field. When it came to skulls and bones, Paris was already amply en-
dowed, thanks to the anthropology gallery at the Muséum National d'Histoire
Naturelle and the old Broca Museum. Cultural artifacts, on the other hand,
were harder to come by, because the capital's premier ethnographic collection
at the Trocadéro had fallen into considerable neglect since its founding in 1878.
As heir apparent to the Muséum chair in anthropology, however, Rivet could
hope to reverse this decline; by tradition the holder of this chair also became
the director of the Musée d'Ethnographie, although there was no official link-
age between the two positions. In 1928, this opportunity for ethnographic
renewal finally materialized when René Verneau retired from the Muséum,
thus clearing the way for Rivet's election to the chair. Even before being
elected, Rivet contacted the minister of education about formally attaching
the Trocadéro to the Muséum; he had, he told him, plans to turn the former
into a premier center for ethnological studies, by centralizing on its premises

"all the organizations currently involved in some branch of ethnology," along with their collections and libraries.[1] Making the Musée d'Ethnographie an annex of the Muséum and securing permission to hire an assistant director, Georges Henri Rivière, would be first steps in this direction.

Yet from the outset Rivet had a bolder vision still: he wished his renovated museum to appeal not only to specialists as in the past, but to a vast viewing public. Ethnology did not feature anywhere in the French educational curriculum, leaving the field wide open to such popular venues as colonial fairs, the mass media, and travel and science literature. While anyone could visit the existing ethnographic collections at the Trocadéro, in practice this institution remained the preserve of elites, as did the primitive art exhibitions that became increasingly successful in the 1920s. Meanwhile older museums across Europe were becoming, like their American and Soviet counterparts, more rationally organized and more democratic in aspiration. Despite a growing consensus that such changes were needed in France as well, few museums had modernized. Rivière, an ambitious recruit from the art world, was determined to reverse this situation, with Rivet's full support. With a miniscule budget, they together gradually transformed the Musée d'Ethnographie from a small, crowded, underfunded, and deteriorating institution housing ethnographic objects into a state-of-the-art pedagogical Museum of Man (Musée de l'Homme) worthy of the competition abroad and peerless in France.

Circumstances nevertheless forced Rivière, the principal architect of the museum's material (as opposed to scientific) overhaul, to proceed in two stages: a first renovation between 1931 and 1934, followed by a second unexpected expansion from 1936 to 1938 in conjunction with the 1937 World's Fair in Paris, which allowed Paris's ethnographic and osteological collections to finally be centralized in one location. Rather than take the museum's physical modernization and move toward the masses for granted, this chapter considers the key role played by Rivière and the larger international context in which his and Rivet's ambitions were conceived and realized. Contrary to what has often been assumed about the Musée de l'Homme, many of its most important innovations had their roots in the first period of overhaul, when Rivière had just arrived. The pages that follow will thus be devoted principally to the early 1930s, when American museums loomed large as a reference. We will conclude, however, with an overview of the second renovation, which coincided with the advent of the Left to power under the Popular Front in 1936,

[1] ANF/F[17]/13567/Paul Rivet à Directeur du Muséum National d'Histoire Naturelle [Louis Mangin], 4 Feb. 1928 (personal). See also AMH/2 AM 1 G2/a/Procès-verbal de la Commission consultative du Musée d'Ethnographie du Trocadéro, 30 June 1928.

and which briefly made Soviet museography an attractive model to emulate. The two-stage transformation from 1928 to 1938 reflected the tenacity of a group of scientists to create a modern laboratory geared to their professional needs. But Rivet and Rivière's successful remake of their museum qua museum also makes it a symbol of a different, broader interwar trend in French politics and society at large: a rejuvenation of France's ostensibly decadent institutions by borrowing from more dynamic institutions abroad, including, but not exclusively, those on the other side of the Atlantic.

The Musée d'Ethnographie's New Face in 1928: Georges Henri Rivière

We last encountered the Musée d'Ethnographie at the moment of its creation, in the late 1870s, at a time when many European and American cities were either founding new ethnographic museums or expanding older collections.[2] Yet, as Mauss among others had repeatedly lamented, within a generation the achievements of the institution had been outstripped by an international boom in ethnographic museums, all better endowed than the Trocadéro. The great cities of Germany and the United States had led the way; London had impressive collections, too, as did St. Petersburg. Even smaller countries ostensibly put France to shame: Switzerland, Sweden, Belgium, the Netherlands, and Italy. In all of these cases, anthropologists, explorers, and ethnographers had begun collections in the mid-nineteenth century to supplement the eclectic cabinets of curiosities inherited from an earlier age.[3] By the 1880s and 1890s, state and municipal authorities, civic associations, and philanthropists caught up in the imperialist rivalries and scientific controversies of the day were creating much grander museums than the Musée d'Ethnographie. In Berlin, Munich, Leipzig, Hamburg, Cologne, and Dresden, an older cosmopolitanism and commercialism combined with a new creeping colonialism to promote the collection of ethnographic artifacts. Britain's long-standing overseas imperialism and Russia's internal colonialism continued to fuel their collecting efforts; in the United States, the presence of an internal other, the

[2] See chapter 1. I do not include folklore museums (i.e., museums devoted to the artifacts of vanishing rural cultures within national borders in the wake of industrialization) in the discussion that follows, although they were being founded during the same period.
[3] William Sturtevant, "Does Anthropology Need Museums?" *Proceedings of the Biological Society* (1969): 619–49; Anita Herle, "The Life-Histories of Objects: Collections of the Cambridge Anthropological Expedition to the Torres Strait," in Herle and Rouse, *Cambridge and the Torres Strait*, 77–105; and the many essays in Stocking, *Objects and Others* and in Kuklick, *New History of Anthropology*.

American Indian, determined the kinds of collections amassed.[4] Such multi-faceted investment in either stand-alone ethnographic museums or ethnography collections in museums of natural history in the fin de siècle embodied the global ambitions, wealth, and power of their home cities and nations. For professionalizing anthropologists, it was a matter of collecting the objects of peoples who were "fated" to disappear at the hands of modernizing forces; natural curiosity and a hegemonic impulse to "know" the colonized—the better to hold them—entered into this salvage ethnography in equal measure.

Ironically, no sooner had ethnographic museums come into their own than they began to lose their appeal for scientists, particularly in the United States, where museums had always had a more popularizing vocation than their counterparts in Europe.[5] As William Sturtevant argued long ago, anthropological theories in Britain and the United States were changing so rapidly as to make ethnographic museums seem unwieldy institutions in which to work. Academic positions began to open up, making anthropologists less dependent on museums for funds.[6] One of the best-known examples of a growing university-museum methodological divide was Franz Boas's experiences at the American Museum of Natural History in New York City between 1896 and 1906, where he worked as a curator while also teaching at Columbia University. Boas rejected the evolutionary and typological schemes—in which objects were displayed linearly on the basis of outward form/function—that tended to dominate ethnographic displays in the United

[4] On ethnographic collections in Germany, see Penny, *Objects of Culture;* Rainer F. Buschmann, *Anthropology's Global Histories: The Ethnographic Frontier in German New Guinea, 1870–1935* (Honolulu, 2009); Zimmerman, *Anthropology and Antihumanism,* chap. 8; and Youssouf Diallo, "L'africanisme en Allemagne. Hier et aujourd'hui," *Cahiers d'Études Africaines* 161 (2001): 13–44. For the case of Britain, see Annie Coombes, *Reinventing Africa: Museums, Material Culture, and Popular Imagination in Late Victorian and Edwardian England* (New Haven, CT, 1994); and for the United States, see Steven Conn, *Museums and American Intellectual Life, 1876–1926* (Chicago, 1998); Curtis M. Hinsley, *The Smithsonian and the American Indian: Making Moral Anthropology in Victorian America* (Washington, DC, 1981); and Sally Gregory Kohlstedt, "Thoughts in Things: Modernity, History, and North American Museums," *Isis* 96 (2005): 586–601. These same trends were also visible in certain colonies, especially settler ones, where museums were being created, too, although French anthropologists initially never referred to developments outside of European and North American collections. See McCarthy, *Exhibiting Maori;* and Gyan Prakash, *Another Reason: Science and the Imagination of Modern India* (Princeton, NJ, 1999).
[5] Although there is no question that museum directors a century ago claimed to seek a broad audience, scholars in critical museum studies have explored the built-in limits to such aspirations, as well as the difficulty of measuring museums' impact on their public. See Tony Bennett, "Museums and 'the People,'" and Eilean Hooper-Greenhill, "Counting Visitors or Visitors Who Count?" in Robert Lumley, ed., *The Museum Time Machine: Putting Cultures on Display* (London, 1988), 63–84 and 211–30.
[6] See in addition to Sturtevant, "Does Anthropology Need Museums?," Ira Jacknis, "Franz Boas and Exhibits: On the Limitations of the Museum Method of Anthropology," in Stocking, *Objects and Others,* 75–111; and George W. Stocking, Jr., "Philanthropoids and Vanishing Cultures: Rockefeller Funding and the End of the Museum Era," ibid., 112–45.

States. His preference was to group objects from a single ethnic group holistically and contextually, in order to highlight the multiple functions and inner meanings of a given form.

In contrast, the director and the board at the American Museum of Natural History believed that the public could respond only to simple messages and objects sure to entertain.[7] The principal innovation of this pre–World War I heyday of museum expansion—the dramatic diorama—reflected this trend. In 1905, Boas thus left his museum job and turned to full-time teaching and research, although as someone interested in historical relations between Amerindian communities he never lost interest in artifacts per se. Most of his students, however, would abandon object-oriented research; museum anthropology, in their view, rested on an outmoded and degrading concept of culture, one that either confined "primitives" and their "things" to an earlier stage of human development, or conceived of civilizations as collections "of easily transportable thing-like elements."[8] British social anthropology evolved similarly; in the wake of Malinowski's turn to participant-observation and that of Alfred Radcliffe-Brown to functionalism, a new generation of field-workers shifted from the study of past migrations to that of human behavior in the present. By the 1930s, ethnographic museums became backwater institutions that a new generation of academically trained American and British anthropologists visited only occasionally.

At first glance, it is tempting to see Boas's trajectory as "normative" for a professionalizing Western anthropology writ large—that is to say, an inevitable bifurcation between, on the one hand, museums required to please the public and devoted to the collecting, describing, and cataloging of objects, and, on the other hand, the university and the field as the primary loci for creating new knowledge; indeed, this is how histories of anthropology have generally been written. Yet the decision of Rivet and Mauss to associate the Musée d'Ethnographie with the Institut d'Ethnologie, and for Rivet to oversee the museum's transformation in the 1930s, does not cleave to this model and raises questions about how closely Anglo-American and Continental European experiences paralleled each other. In point of fact, the divergences are more instructive than the similarities. European anthropological museums remained sites of valued research longer than their American counterparts, in part because academic jobs were slower to materialize on the Continent and in part because a historically oriented

[7] Jacknis, "Franz Boas," 82–83; Cole, *Franz Boas*, chap. 14.
[8] Stocking, "Philanthropoids and Vanishing Cultures," 114. The obvious exception here is Boas's student and the great "popularizer of anthropology," Margaret Mead. She started working at the American Museum of Natural History in New York in 1926 while still a doctoral student and spent her entire career there, although she later also became an adjunct professor.

anthropology remained dominant there longer.[9] This said, by the interwar years, an increasing number of European directors sought to make their elitist museums more accessible to a broad public and began scrutinizing the popularizing ethos that the Americans had pioneered. The Trocadéro fell into this category; Rivet's professed goal was, as he put it, the creation of a "grand establishment for popular education" as well as for "scientific research."[10] The individual most responsible for realizing this goal, however, was not Rivet but his second-in-command at the museum, Georges Henri Rivière, whom Rivet hired in 1928.

Rivière, a thirty-year-old bourgeois aesthete and jazz enthusiast with no scientific training, settled profession, or political principles, was an unusual choice for assistant director.[11] Well-connected in Paris's journalistic, intellectual, aristocratic, and avant-garde art circles, he had studied the art of antiquity for three years at the École du Louvre, France's training ground for future curators, before going to work for the prominent Parisian art connoisseur David David-Weill. As it turned out, under the dilettantish facade was a man of driving ambition who saw in Rivet's sudden offer an opportunity to channel his energy and creativity, as well as acquire new visibility and a steady income. Rivière came to Rivet's attention when Rivière organized the first major exhibit of "the ancient arts of America" in Paris in May 1928, at the Musée des Arts Décoratifs in the Marsan wing of the Louvre, which had already hosted a series of exhibits in the 1920s on Japanese, Khmer, and Islamic art.[12] Over half of the objects in the exhibit came from the Trocadéro, and the show's runaway success brought Rivière to Rivet's attention for three different reasons. First, Rivière mobilized several acquaintances to help with the exhibit, including André Schaeffner, who had just published the first book in France on jazz, and the former surrealist writers Michel Leiris and George Bataille. This small group began meeting regularly in the modernist villa of Éric and Hélène Allatini, cousins of the composer Darius Milhaud, to discuss an awakening passion for Americanist artifacts and ethnography in general; they would continue to work together after the exhibit closed.[13] Through Rivière, Rivet

[9] German museums as well as the Musée de l'Homme offer a case in point, although in both Germany and France ethnographic museums would lose their privileged positions after World War II. See Buschmann, *Anthropology's Global Histories*.
[10] AMH/2 AM 1 G2/a/"Rapport présenté par le Dr. Rivet, Professeur d'Anthropologie, Directeur du Musée d'Ethnographie du Muséum National d'Histoire Naturelle," 23 June 1930.
[11] Rivet's initial choice was the archaeologist Georges-Henri Luquet, a *normalien agrégé* in philosophy, who by the 1920s had published extensively on prehistoric art. Laurière, *Paul Rivet*, 384.
[12] Laurière, *Paul Rivet*, 374–83. On this exhibit, see Williams, "Art and Artifact," 145–66; and the exhibit catalog, Georges Henri Rivière and Alfred Métraux, *Les arts anciens de l'Amérique, exposition organisée au Musée des Arts Décoratifs, Palais du Louvre, Pavillon de Marsan mai-juin 1928* (Paris, 1928).
[13] Jean Jamin, "André Schaeffner (1895–1980)," *Objets et Mondes* 20:3 (Autumn 1980): 132.

Georges Henri Rivière, assistant director of the Musée d'Ethnographie du Trocadéro, on the terrace of the Musée de l'Homme under construction, 1936–37 AMH/PH/1998–14263–125. Photo courtesy of the Musée du Quai Branly/Scala/Art Resource, NY.

could thus count on certain elements of the avant-garde (and their bourgeois audience) to rally to the cause of a renovated Musée d'Ethnographie; indeed Schaeffner and Leiris joined Rivière as staff members at the museum almost immediately.

Second, the show was an instant success with Paris donors and made clear that private resources might also now be tapped to support Rivet's project. As an appendage of an educational institution (the Muséum National d'Histoire Naturelle) rather than a national museum, the Musée d'Ethnographie would always be starved for funds. By bringing Rivière in to copilot this renovation, Rivet would secure the future patronage of not only David-Weill but also Rivière's other collector-friends, including the fabulously wealthy Viscount de Noailles and his wife, Marie-Laure. David-Weill had already provided the financing for the 1928 exhibit while the Noailles were the most visible members of a roster of wealthy Parisians caught up in the postwar rage for primitive and exotic art. Last but not least, when Rivière had conceived the idea to showcase this art, he had also sought out an ethnographic expert in the field, Alfred Métraux, to help select the objects and cowrite the catalog. Although only in his early twenties, the Swiss-born Métraux was an experienced field and museum "new-style" ethnologist; he had studied with one of the world's leading Americanist specialists, the anthropologist Erland Nordenskiöld of Gothenburg, before becoming a student of Mauss's and Rivet's in Paris—their first, indeed, to finish a doctorate.[14] Rivière's collaboration with Métraux proved to Rivet that the former, despite his art history background, appreciated that these artifacts fell as much within the scientific domain as they did within that of the arts. In short, in Rivière, Rivet had stumbled on someone endowed with superb administrative, artistic, and "people" skills and connections who could considerably broaden and rejuvenate ethnology's audience while deferring in matters scientific to the experts.[15]

Yet the fact remains that at his hiring, in 1928, Rivière had no experience in either ethnology or organizing a museum. Although he enrolled in Mauss's Institut d'Ethnologie course on ethnographic methods, he never would find the time to attend regularly, preferring to learn on the job. No sooner had he arrived at the Musée d'Ethnographie than he began preparing a tour of American museums, the first of many research trips abroad that he would undertake over the next ten years. Rivière would remain outward-looking because—with the exception of the Musée Guimet, devoted to the archaeology and religious

[14] Alfred Métraux, *La civilisation matérielle des tribus Tupi-Guarani* (Paris, 1928).

[15] On Rivière's professional career, see Nina Gorgus, *Le magicien des vitrines. Le muséologue Georges Henri Rivière,* trans. Marie-Anne Coadou (Paris, 2003); Jean-François Leroux-Dhuys, "Georges Henri Rivière, un homme dans le siècle," in *La muséologie selon Georges Henri Rivière. Cours de muséologie, textes et témoinages* (Paris, 1989), 11–32; Isac Chiva, "Georges Henri Rivière, un demi-siècle d'ethnologie de la France," *Terrain* 5 (1985): 76–83; Martine Segalen, *Vie d'un musée* (Paris, 2005); and Christine Laurière, "Georges Henri Rivière au Trocadéro, du bric-a-brac à la sécheresse d'étiquette," *Gradhiva* 33 (2003): 57–66. Gorgus's biography, and much of what has been written on Rivière, focus on his subsequent career rather than his role in renovating the Musée d'Ethnographie. Rivière himself wrote little about his plans for the museum either at the time he was there or later, although he gave many interviews to the press that are helpful in retracing his ideas.

art of Asia—French museums in general had not changed much in the last half century.[16] Abroad, in contrast, several ethnographic museums were rethinking their organization, installation techniques, and audience. In addition, museography by the 1920s had become an international science, thanks to the League of Nations' new Office of Museums headquartered in Paris. Its monthly newsletter, *Mouseion,* began publication in 1927, featuring articles about particular renovation projects, new museum conservation theories and techniques, and events of interest to all museum professionals; the first international conferences devoted to the subject soon followed, with Rivière in attendance.[17] From the moment he arrived, in short, Rivière showed an avid interest in modernization, and most especially in museums abroad "that have left us behind."[18]

PIONEERS OF THE MODERN MUSEUM: THE UNITED STATES AND THE SOVIET UNION

Perhaps not surprisingly for an aficionado of jazz and an ambitious young curator seeking the museographic "cutting edge," Rivière's first voyage as assistant director was to the "birthplace" of what was commonly referred to in interwar Europe as the "modern museum," the United States. So eager was Rivière to see these museums that in January 1929, within months of becoming assistant director, he devoted his honeymoon to visiting them with his American wife, Nina Spalding Stevens. The backstory to this "working" wedding

[16] The Guimet's director, Joseph Hackin, was a friend and mentor to Rivière and had first recommended him to Rivet. Between 1923 and 1936, Hackin modernized the Guimet, and in the early 1930s Rivière cited Hackin's changes as a model for the Musée d'Ethnographie. "Your museum," he wrote to Hackin during the latter's temporary absence, "has kept up the momentum you gave it, and is now the most up-to-date [he used the English phrase here] museum in Paris. . . . We [at the Musée d'Ethnographie] will have a tough job catching up to you, but we are trying with all our heart." AMH/2 AM 1 A4/c/Georges Henri Rivière à Joseph Hackin, 22 Oct. 1932, no. 2272. A year later he wrote to Hackin again, stating admiringly that the Guimet was "unrecognizable." AMH/2 AM 1 A5/b/Georges Henri Rivière à Joseph Hackin, 11 April 1933, no. 747. See also Philippe Stern, "La réorganisation du Musée Guimet et les problèmes muséographiques," *Mouseion* 33–34 (1936): 101–12. Installation of electrical lighting at the Louvre was finally under way by the 1930s but proceeded very slowly and was hotly debated. See Gorgus, *Le magicien des vitrines,* 80–82.

[17] On the history of *Mouseion,* see François Poncelet, "Regards actuels sur la muséographie d'entre-deux-guerres," *CeROArt*2 (2008), http://ceroart.revues.org/565; François Maresse, "The Family Album," *Museum International* 197, 50:1 (1998): 25–30; Gorgus, *Le magicien des vitrines,* 73–79. Rivière sought immediately to bring the renovation of the Musée d'Ethnographie to the attention of the Office of Museums and asked to demonstrate "un projet d'appareil de désinfection [against insects]" and their plans for new protected glass at the upcoming congress. AMH/2 AM 1 A1/b/ Georges Henri Rivière à E. Foundoukidis, Secrétaire Général de l'Office International des Musées, 14 Aug. 1930, no. 1052.

[18] Paul Lester, Paul Rivet, and Georges Henri Rivière, "Le laboratoire d'anthropologie du Muséum," *Nouvelles Archives du Muséum d'Histoire Naturelle* 6:12 (1935): 520. Rivet and Rivière made this point regularly in the press as well. See, for example, AMH/2 AM 1 B1/d/Paul Dany articles in *L'Ami du Peuple,* 17 Nov. and 8 Dec. 1931.

trip is worth pausing over, for what it reveals about Rivière's professional ambitions at the start of his new career, and the place of American museums in the interwar European imagination.

Stevens, a widow when Rivière met her, was a pioneer in her own right at the Toledo Art Museum, which she had founded in 1901 in conjunction with her husband George Stevens and with backing from the millionaire George Libbey.[19] Nina and George Stevens had wished to expand the social role of museums by bringing the public into them more. Rivière and Stevens met in Paris in 1927 on one of Stevens's regular trips there (her husband George had died in 1926); they were soon visiting French museums and private collections together, and Stevens became part of Rivière's inner circle. Early correspondence between the two makes clear that Rivière was already assiduously cultivating Stevens during the planning stages of his great (in his words) "pre-Columbian or, the name is better, pre-American" art show. At the end of 1927, he wrote to her in English about how many things they still had to see on her next visit and recounted whom among "their friends" he had recently hosted—"all your friends of the French museums." He then asked for her help in securing if not loans from American museums, then at least photographs. He wanted to do everything possible "to make this exhibit important, by the presentation, the classification, the choice," and planned to have one of the four rooms reserved for photographs. Rivière, a regular contributor to Christian Zervos's monthly magazine devoted to modern art, Les Cahiers d'Art, also requested Stevens's opinion about a project that he was planning:

> To prepare an important issue devoted to America [underscored]: Mexican, Maya, Columbian and Peruvian old art—modern architecture (sky-scrapers and industrial buildings)—American music of jazz (the most important modern music, I think, and the first artistic message, the splendid message, the new Continent is sending to us)—organization and treasures of your museums of fine arts.

Rivière added that previous issues of Les Cahiers d'Art had taken up "Negro art," and that he had recently written an article "on wonderful Khmer cultures, not yet known, which will be soon presented at the Musée Guimet."[20]

[19] See her biography of her husband: Nina Spalding Stevens, A Man and a Dream: The Book of George W. Stevens (Hollywood, n.d. [ca.1940s]). By the interwar years, most American ethnographic and natural history museum curators saw their institutions as already in need of serious overhaul, and the most important innovations in those years occurred in programming and outreach. Here the key figure was John Cotton Dana of Newark, New Jersey. See Carol G. Duncan, A Matter of Class: John Cotton Dana, Progressive Reform, and the Newark Museum (Pittsburgh, 2010).

[20] Archives, Toledo Museum of Art, Georges Henri Rivière to Nina Spalding Stevens, 19 Dec. 1927; see also Nina Spalding Stevens to Georges Henri Rivière, 13 Feb. 1928. The promised special issue on America was never published, presumably because Rivière was then hired by the Musée d'Ethnographie.

Charm, opportunism, and high standards; delight in publicizing art "not yet known"; and enthusiasm for the "new" continent's modernity in the form of skyscrapers, music, and museums—this letter exudes all of these traits, which were to remain Rivière's distinctive trademarks as he moved from the "pre-Columbian" exhibit into ethnology's official orbit. And at least initially, Stevens was his partner in that transition (the two would divorce in 1935).[21] In February 1928, Stevens contacted several American museums to request photographs on behalf of Rivière, and by the end of March had sent on seventy-eight pictures of "the greatest objects in North, Central and South America," with more to follow—thus helping to put the imprimatur of the best American collections on Rivière's exhibit.[22] In early 1929 Stevens announced her engagement to Rivière, and the two married on January 26, 1929, in a private ceremony in Toledo.[23] They then embarked on their American museum tour. While Rivière left no detailed account of his impressions of the museums he visited with Stevens in Cleveland, Chicago, Detroit, Philadelphia, Boston, and New York, a lecture he delivered in May 1930 to the American Women's Club in Paris on the renovations underway at the Trocadéro, which was surely a result of his wife's connections, provides some clues.[24]

He flattered his audience first by calling them "happy Americans" and invoking "those magnificent buildings of white marble, where the air, the temperature and cleanliness are minutely regulated (almost as if a nurse attended every object, making sure this relic from the past had no temperature)." Citing

[21] The marriage lasted six years, a casualty perhaps of misunderstandings over Rivière's homosexuality. Although the two set up an apartment in Paris, Stevens's plan from the outset was to live six months of every year in the United States, so that she could continue to lead Toledo museum's education program, which enrolled thousands of students weekly, as well as remain in charge of all temporary exhibits. Within a year the apartment had been vacated, but Stevens still presided with Rivière at exhibit openings at the Musée d'Ethnographie into the early 1930s. Gorgus, *Le magicien des vitrines*, 27; and AMH/2 AM 1 B1/e/"Today in Society by May Birhead," *Chicago Tribune*, 3 June 1933.

[22] Archives, Toledo Museum of Art, Nina Spalding Stevens to Mr. A.L. Spitzer, 26 March 1928. See also Nina Spalding Stevens to Georges Henri Rivière, 12 March 1928; and Nina Spalding Stevens to Georges Henri Rivière, 26 March 1928; there is also extensive correspondence between Stevens and the curators she contacted, at the Carnegie Institution and the National Museum (Smithsonian) in Washington DC, the Peabody Museum, the American Museum of Natural History, the Museum at the University of Pennsylvania, the Ohio State Archaeological and Historical Society, the San Diego Museum, the Archeological Institute in Santa Fe, and the Detroit Institute of Arts.

[23] Archives, Toledo Museum of Art, press clippings from *The Blade*, 26 Jan. 1929; *The Times*, 27 Jan. 1929; and *News Bee*, 28 Jan. 1929.

[24] In a letter to Marcel Mauss on the night of his return, he noted only that the trip, designed to "serve my museum and to teach me my job," had surpassed his hopes in terms of meeting curators, creating goodwill and contacts, and acquiring documentation. He was sure that on his next trip he would obtain financial assistance as well. IMEC/Fonds Marcel Mauss/MAS 11.22/Georges Henri Rivière à Marcel Mauss, 23 Feb. 1929. Rivière would not return to the United States again until after World War II, but other Musée d'Ethnographie personnel visiting the United States continued fact-gathering for him in the early 1930s. See also AMH/2 AM 1 B1/d/"American Ideas Adopted in Trocadéro Renovation," *New York Herald*, 11 Nov. 1931.

America's great ethnographic institutions as models—the Smithsonian, the Field Museum, the American Museum of Natural History, the Heye Museum of the American Indian—he recommended patience and confidence in the future with respect to the Musée d'Ethnographie—"we will have all of that and many other things." He then noted that the Trocadéro, while rich in objects, was housed in a small and ridiculous building whose appearance would have been an embarrassment in a small American city. One of his many wishes was at some future point to be able to open the museum in the evening "so that the working people of Paris will come after the day's work. Is not one of my best American souvenirs this lighted library that I could still see shining across my hotel at ten o'clock at night?" Rivière again turned to American innovation when he discussed museum layout. Following the American model, the Trocadéro needed to add storerooms; the best ethnographic museums now divided their collections, exposing their choicest objects to the public while reserving the rest for specialists. In terms of cataloging, Rivière pointed out that he had studied the systems in each museum that he visited. At the end of his overview, Rivière paid one last homage to the women listening to him: "As good Americans [I and Rivet] have also had to attend to advertising"—so they had launched a new museum bulletin to document their collections.[25]

While clearly pitched to a group he wished to win over—during the course of the lecture Rivière invited all to become members of the Association of Friends of the Musée d'Ethnographie for 30 francs annually, thus joining eminent personalities from the art world, socialites, and art collectors—Rivière's positive endorsement of American museum techniques was nevertheless typical of interwar European commentary. All but the most conservative museum curators tended to agree that the modern museum had been "born in the United States."[26] There, as the secretary of the National Bureau of Museums in Belgium Jean Lameere put it, "our friends across the Atlantic have the good fortune of being able to build from scratch, inspired by new principles"—unlike in Europe, where museums were the preserve of specialists and remained the prisoners of much older collections assembled haphazardly, poorly housed, and inattentive to such concerns as visitor fatigue and sensory overload.[27] Europeans, he

[25] AMH/2 AM 1 B1/a/"Conférence de Georges Henri Rivière," 9 May 1930, addressed to the American Women's Club.

[26] Jean Lameere, "La conception et l'organisation modernes des Musées d'Art et d'Histoire," *Mouseion* 12:3 (1930): 240.

[27] Jean Capart, "Le rôle social des Musées," *Mouseion* 12:3 (1930): 221. This and the article by Lameere (see above) made up this entire issue of *Mouseion*, devoted to "La conception moderne du Musée," *Mouseion* 12:3 (1930): 217–311. On the "modern museum" more generally, see also Augustin Perret, "Le musée moderne," Ludwig Pallat, "Le musée et l'école," and the rubric "Muséographie générale," in *Mouseion* 9:9 (1929): 225–35, 236–43, and 283–98; Richard Bach, "Le musée moderne," *Mouseion* 10:1 (1930): 14–19; Fritz Schumacher, "La construction moderne des musées," *Mouseion* 11:2 (1930): 111–16; and Louis Hautecoeur, "Architecture et organisation des musées," *Mouseion* 23–24:3–4 (1933): 5–29.

argued, had a great deal to learn from American innovations. In the United States, public elementary schools and museums had long been collaborating, thereby inculcating early on among its future citizens the museum-going habit. Almost always state-run, museums in Europe would never be as wealthy as their private American counterparts, but they could at least organize themselves in any given country to avoid duplicating collections. In Europe, the public for the most part boycotted museums because of their overflowing and disordered galleries. Here again, it made sense to follow the Americans, especially in their concept of the "double" museum—one part devoted to significant works appropriately labeled for the public, the other devoted to "interesting but secondary objects," also carefully classified but placed in ancillary workrooms reserved for specialists.[28] Lameere applauded as well the American technique of constantly changing temporary exhibits to offset the permanent ones, the use of cinema, museum tours and talks, the notion of "museum memberships and societies, and the creation of a separate educational service within museums to manage their relations with the public."[29]

Lameere's report suggests that he was most impressed by the modern American museum's sense of mission and responsiveness to public opinion. By 1930, however, these were not the only popularizing museums on offer; closer to France, the Soviet Union had by then embarked on a dramatic policy of ethnographic museum expansion. These new developments were initially not much discussed in the pages of *Mouseion*, and Rivière would not travel to the Soviet Union until 1936. Yet as early as December 1931 he was invoking the Bolshevik example as yet further proof that the Trocadéro was disgracefully behind the times. "Our dearest desire is to instruct and to interest the workers," Rivière wrote to the editor of the Communist daily *L'Humanité*, "and if you were to inform yourself about current Soviet policy regarding ethnographic museums, you would be edified. Their number has considerably increased in the last few years, and several could serve us as a model."[30] Rivière had already referred to the Soviets earlier that month, in a note that he had written identifying four roles for an ethnographic museum: a scientific role, an educational role, an artistic one, and a national one. As far as the "national" function was concerned, ethnographic museums were incomparable instruments of cultural propaganda, as proven by the many such institutions "created by the Soviet Union in all the governments of the former Russian empire."[31] In January 1932, Rivière announced that he hoped to visit these museums, and a year later he flagged for his staff a talk being given at the

[28] Lameere, "La conception," 278, 279.
[29] Ibid., 285, 297.
[30] AMH/2 AM 1 A3/a/Georges Henri Rivière à *L'Humanité*, 24 Dec. 1931, no. 2330.
[31] AMH/2 AM 1A 3/a/Georges Henri Rivière "Note complémentaire," 14 Dec. 1931; other references to the need to emulate the Soviets include AMH/2 AM 1 G2/c/Draft of a report "sur la nécessité de

Guimet by M. Kazakevitch of the Russian Museum in Leningrad, on "ethno-graphic museography."[32]

Rivière was remarkably well informed. Since the end of the civil war in Russia, the Bolsheviks had taken a new interest in anthropology in general, and ethnography in particular, for ideological reasons. As Francine Hirsch has shown, they developed a plan to sovietize their entire citizenry by creating—paradoxical as it sounds—national identities for the non-Russian eth-nicities who peopled the regime's new republics and districts. Officially anti-imperialist, the Soviets had to reconcile this aspect of their ideology with their desire to control the resources and the peoples of the former Russian empire. They did so by adopting a policy of "state-sponsored evolutionism" vis-à-vis the latter, predicated on their reading of the Marxist timeline of historical development. "Feudal-era" tribes and clans had to be first transformed into economically advanced "nationalities" before becoming Socialist-era nations "which at some future point would merge into communism."[33] Woefully igno-rant, however, about these "backwards" peoples, the Bolsheviks had turned to a legion of former imperial ethnographers and economists for information. Central to the effort to create such nationalities was the Ethnographic Depart-ment of the Russian Museum, founded in 1902 in St. Petersburg as the first showcase of the lands and peoples of the Russian empire, but which did not open to the public until 1923. Its personnel focused on working out Marxist exhibits and guided tours that would educate the masses about the peoples of the new republics and their progress toward socialism. The most important innovation of the 1920s was the "ethnographic evening of solidarity" to which each week a hundred or so workers were invited to enjoy "museum tours, mov-ies, performances, and discussions."[34] Just as the future Musée de l'Homme

doter le Musée d'Ethnographie du Trocadéro du personnel indispensable à son fonctionnement" [n.a. and n.d. (1930)], which stated that "the Soviet Union has, finally, considerably endowed its ethnographic museums;" and AMH/2 AM 1 A5/d/Paul Rivet à Anatole de Monzie, 4 Aug. 1933, no. 1453: "We have been outdistanced by Great Britain, Germany, Belgium, Holland, Italy, the United States, and the Soviet Union."

[32] AMH/2 AM 1 G2/e/"Plan de travail pour l'exercise 1931 et les prochaines années," 14 Jan. 1932.

[33] Francine Hirsch, *Empire of Nations: Ethnographic Knowledge and the Making of the Soviet Union* (Ithaca, NY, 2005), 6.

[34] Ibid., 202. Soviet museographers in the 1920s struggled to free themselves from the long ethno-graphic tradition of presenting "other" cultures as essentially premodern and static but found little material evidence of a Socialist-led national consciousness. The curators tried to compensate by adding photographs, for example of tractors, to the pre-1917 displays. Only in the late 1920s, in the wake of Stalinization, did ethnographers work out a template for a new series of exhibits. Specific artifacts ostensibly illustrated stages on the Marxist historical timeline, from primitive communism to feudalism to capitalism and finally to socialism. But against the backdrop of the bitter "class war" being waged in the Ukraine, an ominous new twist was added: instead of glossing over the revolu-tion's setbacks, the exhibit documented how certain "survivals" from an earlier stage of historical development were impeding the revolution—priests, imams, kulaks. Once they were "defeated," progress toward socialism would resume, indeed accelerate.

would bill itself as providing visitors a tour of the world in eighty minutes, the Russian Museum claimed that it was possible for ordinary people—who could not possibly travel the breadth of the Soviet Union—to visit all its peoples and lands in the course of one guided visit.[35]

When considered in the context of museological developments internationally, the efforts of conscientious scientists to create exhibits that would represent Soviet peoples "as nationalist in form and socialist in content" seem quite extraordinary. Americans may have inaugurated many of the techniques that the Soviets adopted to get their message across to a large viewing public—especially the didactic display complete with dioramas and graphic explanations, supported by guided tours. But the Soviets were more ambitious in terms of the content (the Marxist dialectic) that they thought could be communicated through these media, and more determined to involve their targeted audience of workers and peasants in the exhibits. Viewers were asked to write down what they had learned, as party members sought to engage their interest but also measure whether the desired change in consciousness was occurring.[36] For someone like Rivet—a Socialist with no tolerance for Stalinism but who was committed to workers' education—the investment of the Soviets in bringing ethnography to the formerly disenfranchised might well have been considered a logical extension of and an exciting improvement on the American concepts of outreach. Rivet continued to have contact with at least one senior ethnologist in the Soviet Union, Vladimir Bogoraz, who visited the Musée d'Ethnographie in 1932.[37]

ALTERNATIVE EUROPEAN MODELS

American and Soviet museums did not exhaust the possibilities of what a renovated Musée d'Ethnographie might look like. In October 1929, Rivet sent Rivière to Gothenburg in Sweden, where Rivet's colleague and mentor in the field of South American archaeology and ethnography, Erland Nordenskiöld, had recently transformed that city's museum.[38] Rivet had visited Gothenburg in 1924 and discovered then the depth of its Americanist collections and their

[35] Hirsch, *Empire of Nations,* 189. For the Musée de l'Homme publicity, see, for example, AMH/2 AM 1 B2/d/Armand Lanoux, "Le tour du monde en 80 minutes," *L'Émancipation Nationale,* 27 Jan. 1939; other press articles used this title, too.

[36] Hirsch, *Empire of Nations,* 198, 211–15.

[37] AMH/2 AM 1 G2/e/"Rapport sur l'activité du musée," 14 Jan. 1932.

[38] According to Métraux, Mauss in his course on ethnographic methods "states very often that the Museum of Gothenburg is the most beautiful he has ever seen and that every ethnographer should go there if they wish to learn how to assemble good collections [*de belles collections*]." Archives/ Världskulturmuseet/Alfred Métraux à Erland Nordenskiöld, 5 Feb. 1928.

scholarly presentation, and more specifically Nordenskiöld's use of cartography. Nordenskiöld had long focused on historical questions of migration, diffusion, and the role of geography in shaping early American cultures, for which material objects constituted the critical evidence. After leading several expeditions to South America, in 1913 he was appointed curator to the ethnography department of the Gothenburg museum and professor at the university; at the time, the museum contained little more than a local natural history and folklore collection. Nordenskiöld began a systematic program of trading and purchasing South American artifacts and within ten years had created a highly specialized and internationally important collection.[39] Rivière did not miss the point of Rivet's sending him to Sweden; he wrote to his boss that the museum was a "wonder of patience and science," unlike any he had seen so far, and that he was bringing back a great deal of documentation on the installations, including a technical demonstration on pottery (with original fragments, commentary, and distribution maps). Nordenskiöld, he added, proved that ingenuity and a modest budget could achieve more than "the luxury" often deployed by richer institutions. "This is an excellent lesson."[40]

Nordenskiöld's transformation of the Gothenburg museum is a reminder of how vibrant the interwar years in Europe could be for smaller anthropological institutions with clear-cut scientific agendas. Yet these same years witnessed another trend in a different direction: the first attempts by some museums to privilege ethnographic objects as art rather than artifacts.[41] Here the great German ethnographic collections, which Rivière visited more than any other, provide a case in point. In Germany, curators, scholars, and artists

[39] Christer Lindberg, "Anthropology on the Periphery: The Early Schools of Nordic Anthropology," in Kuklick, *New History of Anthropology*, 165–67; Henri Wassen, "Le musée ethnographique de Göteborg," *Revista del Instituto de Etnologia de la Universidad de Tucuman* 2:2 (1932): 237–62.

[40] AMH/2 AP 1 C/Georges Henri Rivière à Paul Rivet, 3 Nov. 1929; on Gothenburg's displays, see AMH/2 AM 1 G2/b/"Rapport sur la réorganisation du musée," 1 Sept. 1931.

[41] It is worth noting that the Nazi regime had no particular interest in Germany's ethnographic (as opposed to folklore) museums, undoubtedly because they confirmed the ostensible inferiority of the "races" that had produced the collections—and by extension the superiority of "Aryans." In addition, these museums served Hitler's colonial ambitions, especially since some of the most impressive collections—for example, those from Cameroon—were from the previously German territories in Africa and the South Pacific, which the Treaty of Versailles had "wrongfully" confiscated. Neither were their newly streamlined and spare installations problematic, since the Nazis astutely adapted modern aesthetics to their own reactionary and savage ends. For the fate of German ethnographic museums and their personnel under the Nazis, see Buschmann, *Anthropology's Global Histories*, chap. 7; Diallo, "L'africanisme en Allemagne," 20–23; and H. Fischer, *Völkerkunde im Nationalsozialismus. Aspekte der Anpassung, Affinität und Behauptung einer wissenschaftlichen Disziplin* (Berlin, 1990); Pierre Centlivres, "Julius Lips et la riposte du sauvage," *Terrain* 28 (1997): 73–86; Julius Lips, *The Savage Hits Back* (New Haven, CT, 1937); Herbert Tischner, "Les collections océaniennes d'ethnographie en Allemagne après la guerre," *Journal de la Société des Océanistes* 3 (1947): 35–41.

had long been engaged in discussions about the purpose, proper role, and display strategies of their existing ethnographic collections. Both the immense Berlin Museum für Völkerkunde, which had opened its doors in 1886 under Adolf Bastian's direction, and the Munich ethnographic museum, second only to Berlin and especially rich in Asian artifacts, were considered to be in a state of crisis by 1900 because of object overflow, lack of reserves, and outdated display modes designed for scientists alone.[42] Each would be moved to expanded quarters in the mid-1920s—a point Rivet and Rivière jealously referred to—and reordered according to modern principles, yet in two different ways.[43] In Berlin, overstuffed cases yielded to "rational order" less fatiguing to the lay viewer, including families; but the primary criterion for selecting objects for display to the general public was their scientific interest.[44] In Munich, in contrast, the arrival of the linguist Lucian Scherman led to an emphasis on aesthetic considerations.

Scherman was one of the first of a new generation of museum-based ethnologists to view some artifacts as works of art (as defined by European standards), in the wake of Expressionists' "discovery" in Germany of African and Oceanic art at the turn of the twentieth century.[45] He insisted that true appreciation required knowledge of the milieu in which art—any art— was produced.[46] As part of his initial overhaul, he invited artists in to paint the walls a variety of colors, introduced mirrors, replaced flat display tables

[42] For the Berlin museum, see Penny, *Objects of Culture,* 147. The goal for Bastian had been to form exhaustive collections of material culture from the entire world—in Penny's words, "rows of Bantu spears, a 'complete' collection of Benin bronzes, or an entire 'set' of 'prehistoric' pottery from a particular German region"—all of which *had* to be placed on display simultaneously in order to allow the specialist to compare similar human material development across time, cultures, and space. Bastian's was a humanist worldview that bucked the hierarchical and evolutionary displays of many of his contemporaries, but from a curatorial point of view, it soon posed a logistical nightmare. Younger curators began to recommend choosing "'representative' artifacts that allowed easy comparison, a few 'life groupings,' plenty of empty space, and a clear message or narrative"—that is to say, the concept of the double museum, with a visible part for museumgoers and another part reserved for specialists, which was already well developed in the United States.

[43] AMH/2 AM 1 G 2/c/Draft of a report "sur la nécessité de doter le Musée d'Ethnographie du Trocadéro du personnel indispensable à son fonctionnement": "In the Germanic countries, which boast over a dozen [ethnographic] establishments, Berlin, Leipzig, and Munich have magnificently renovated their Völkerkunde."

[44] In fact the collections were doubly divided, on the one hand between public galleries and reserves, and on the other between purely aesthetic objects (all of which were Asian)—which now joined a museum of Asian art—and objects whose primary interest was as cultural artifacts. Anne-Solène Rolland, "Art ou ethnologie? Questions de présentation dans les *Museen für Völkerkunde* en Allemagne après 1900," in *Histoire de l'art et anthropologie*, Paris, coédition INHA/Musée du quai Branly ("Les Actes") (2009), http://actesbranly.revues.org/155.

[45] Annie Coombes has analyzed the ways in which the British looting of the Benin bronzes sparked not only a scramble among European museums to acquire one or more of them, but also a new valuing of an African art form. Coombes, *Reinventing Africa,* chaps. 1–3.

[46] Martin Heydrich, "La réorganisation du musée ethnographique de Munich," *Mouseion* 11:2 (1930): 129.

with vertical glass cases, and allowed the best ethnographic pieces to become freestanding. The truly radical transformation, however, occurred after 1923, the year in which Scherman lobbied successfully for a transfer of his collections to the much vaster quarters of the old National Museum, where he redesigned the installations from the bottom up at very little cost. According to museum reviewer Martin Heydrich, "Each room, and sometimes each group of rooms, was organized as an artistic unit, to better highlight its contents." Everyday objects were grouped synoptically in cases, while works of art were set apart, with enough space to produce the maximum effect; instead of small displays of particular ethnographic groups, vast educational ensembles were mounted. To avoid monotony and fatigue, geographic installations were interrupted by comparative groupings, for example cloths, ceramics, and musical instruments. And, Heydrich continued: "If specialists might be unpleasantly jarred by the lack of unity in this or that display, the advantages of this organization are evident for the public. . . . The Munich Museum is at the head of all the ethnographic museums in Europe."[47] Rivière, with his predilection for the new, quickly developed a cordial professional relationship with Scherman; the two curators wrote regularly to each other about the Musée d'Ethnographie's progress from August 1930 until Scherman's "resignation" (he was Jewish) from the Munich museum in October 1933. In his final letter, Rivière expressed the wish that when he came to Munich that winter, "it is with you as my guide that I will visit the Museum that you have, I know well, so magnificently renovated."[48]

In his exploratory travels, Rivière targeted one other possible model from which to draw inspiration: certain colonial museums, especially the Congo Museum outside of Brussels (today called the Royal Museum for Central Africa), founded in 1898, and the Colonial Institute of Amsterdam (today called the Royal Tropical Museum), just opened in 1926. He traveled to both in the fall of 1931, after having earlier visited some of the main colonial collections of the British Empire: the Pitt Rivers Museum at Oxford, Cambridge's Ethnographic Museum, and the British Museum.[49] None of these British

[47] Ibid., 130–31, 136.

[48] AMH/2 AM 1 K/68/b/Georges Henri Rivière à Lucien Scherman, 5 Oct. 1933.

[49] Rivière and Rivet considered the British Museum to be as colonial as the newer Dutch and Belgian museums. For example, a museum report from late 1930 pointed out that "the British Empire was planning to fill a great lacuna by expanding ethnography at the British Museum, thus helping it to catch up with the establishments at Oxford, Cambridge, Ottawa, Wellington, Sydney, Melbourne, Victoria." No such expansion in fact materialized. AMH/2 AM 1 G 2/c/Draft of a report "sur la nécessité de doter le Musée d'Ethnographie du Trocadéro du personnel indispensable à son fonctionnement." Yet another report pointed out that the renovated Musée d'Ethnographie would do for French Indochina what London had done for India. AMH/2 AM 1 G2/b/"Rapport sur la réorganisation générale du musée," 1 Sept. 1931. The "colonial" ambitions of the Musée d'Ethnographie/Musée de l'Homme are analyzed in more detail in chapter 5.

institutions were being remodeled, and there is no trace of Rivière's impression of them. The museum at Tervuren, in contrast, had caught his interest early, to the point that he had invited its chief ethnographer, Dr. J. Maes, to give one of the first lectures sponsored by the MET, on the "Belgian Congo and its Museum."[50] When he set off to visit Belgium and the Netherlands, however, he did so not only in his capacity as assistant director of the Trocadéro. At the time, he was also serving as interim director of France's new Musée Permanent des Colonies, which had been created in conjunction with the Colonial Exposition of 1931 in the Parc de Vincennes, and whose mandate included "the history of French colonization, the social and economic development of the colonies, the diffusion of the colonial idea in France and liaison with colonial associations [*milieux*] abroad."[51] The new director of the colonial museum, Gaston Palewski—a friend of Rivière's from his École du Louvre days—was away on mission in French Indochina, and Rivière had agreed temporarily to take his place.

Rivière's interim directorship as director at Vincennes was not a coincidence. When the first appointments to the Musée des Colonies were being made, Rivière worked hard, by his own admission, to make sure they went to "friends of the Musée d'Ethnographie"—so as to avoid "dangerous problems" later on.[52] He feared that, in the wrong hands, the new museum might become a competitor to his own, just then beginning its reorganization; after all, in Belgium and the Netherlands the premier ethnographic collections were housed in specifically designated colonial museums. The Musée des Colonies was, moreover, a plum: its proposed personnel budget was close to 500,000 francs, compared to the Musée d'Ethnographie's budget of 140,000 francs (in 1930).[53] This disparity was a great source of frustration for Rivet, who complained about the state "richly endowing the Musée permanent des Colonies Françaises, which will be the economic and historical museum of the French colonies, while neglecting the Troca, which is its indispensable scientific complement."[54] Given Rivet's colonial ambitions, it made perfect sense to Rivière to see what other imperial powers were doing with their ethnographic collections, but at the same time to make sure that the new Musée des Colonies understood that the "scientific" display of the peoples of the

[50] AMH/2 AM 1 A2/d/George Henri Rivière à Dr. Maes, 18 Dec. 1930, no. 1840.

[51] AMH/2 AM 1 K69/c/"Exposé des motifs" for the creation of the museum, [n.a., n.d.].

[52] AMH/2 AM 1 A2/c/Georges Henri Rivière à Michel Leiris, 21 Aug. 1931, no. 1435. See also on the same subject, AMH/2 AM 1 A2/d/Georges Henri Rivière à Marcel Griaule, 4 Sept. 1931, no. 1539.

[53] AMH/2 AM 1 K69/c/Gaston Palewski à Georges Henri Rivière, 25 May 1932; AMH/2 AM 1 G2/d/Budget, 11 April 1930.

[54] AMH/2 AM 1 G2/d/Draft of a report "sur la nécessité de doter le Musée d'Ethnographie du Trocadéro du personnel indispensable à son fonctionnement."

empire would be the Musée d'Ethnographie's exclusive preserve—a goal best achieved by working closely with the new director.[55]

Rivière returned from his trip bowled over by the resources devoted to research at the Congo Museum at Tervuren and the Colonial Institute in Amsterdam. King Leopold II had created the Congo Museum to help legitimate his scandalous regime there, a past to which Rivière made no reference. The museum had sections devoted to the ethnography, natural and mineral resources, and colonial history of Belgium's only overseas possession. At 8000 square meters, the building was already reportedly too small. And although a Center of Ethnographic Documentation (which Dr. J. Maes ran) complete with its own scientific committee and devoted to studying the different peoples of the colony had opened in 1929, there were plans for a further expansion.[56] With a budget of 1 million francs, Tervuren was "peerless" in terms of the "seriousness and abundance" of its ethnographic documents, reserves, and publications. The economic section had, in contrast, barely been outlined.[57] In Amsterdam a tripartite organization also existed, with one third of the Colonial Institute devoted to economic development and commerce, one third ethnography and anthropology, and one third tropical hygiene. Its patrons had already raised 45 million francs, and its operating budget was 4 million. Here Rivière was dazzled by the library with seven floors of stacks, a separate schoolchildren's lending library, a 650-person cinema with three screens, electrical lighting throughout the museum including inside the display cases, illuminated wall panels, a lounge with pivoting chairs, and by the complete order and cleanliness reigning everywhere. The cleaning ladies were

[55] Palewski accepted the proposed division of labor between the Musée d'Ethnographie and the Musée des Colonies: the latter, he wrote to Rivière, would not try to compete with the former, "en pleine renaissance," which had convincingly shown that it would undertake "the study and presentation of ethnography in the French colonies." The new museum would limit itself "to following the native since his contact with French civilization," the history of the French empire, and colonial propaganda. AMH/2 AM 1 K69/c/Gaston Palewski, "Rapport sur l'organisation du Musée des Colonies et plan d'organisation du Musée des Colonies," 17 Jan. 1933.

[56] This new center inherited a series of monographs and bibliographies on the Congo from its predecessor, the Belgian International Bureau of Ethnography, founded in 1905. Pierre-Philippe Fraiture, *La mesure de l'autre. Afrique subsaharienne et roman ethnographique de Belgique et de France (1918–1940)* (Paris, 2007), 45–70; Sophie Decock, "Le Centre de documentation en sciences humaines entre passé et futur," in *Africa-Museum Tervuren, 1898–1998* (Tervuren, 1998), 115–19. On the history of the collections, see Sarah van Beurden, "Authentically African: African Arts and Postcolonial Cultural Politics in Transnational Perspective (Congo [DRC,] Belgium and the USA, 1955–1980)" (PhD diss., University of Pennsylvania, 2009), 25–103 ; Debora L. Silverman, "Art Nouveau, Art of Darkness: African Lineages of Belgian Modernism, Part I," *West 86th: A Journal of Decorative Arts, Design History, and Material Culture* 18:2 (Fall-Winter 2011): 139–81; and Silverman, "Art Nouveau, Art of Darkness: African Lineages of Belgian Modernism, Part II," *West 86th: A Journal of Decorative Arts, Design History, and Material Culture* 19:2 (Fall-Winter 2012): 175–95.

[57] AMH/2 AM 1 K69/c/"Rapport provisoire a.s. d'une visite d'études à Amsterdam et Bruxelles, pour la réorganisation du Musée des Colonies," 23 Oct. 1931.

Colonial Institute, model of a sugar refinery in Dutch Indonesia, 1930. Built in 1926 and richly endowed, the Institute offered one model of what a state-of-the art colonial museum might look like in interwar Europe. Photo courtesy of the Tropenmuseum, Amsterdam. Coll. nr. 60059428.

not, he added, civil servants (*fonctionnaires*) as they were in Paris, and could be let go when their work was unsatisfactory—a situation of which he obviously approved.

Rivière's report on these foreign colonial museums made clear that he believed that the Vincennes museum—as one starting from scratch with state funds—had an opportunity to match them. But he was surely speaking for his "own" colonial museum when he noted that "a museum of the colonies can be an excellent instrument of popular education, if it is properly directed," and that it must also "be a great center of scientific study and research." And he added: "We must keep up. It is humiliating not to be their equal. A modern museum must be a living museum, not a retirement community for the decrepit and the lazy."[58] Indeed, in 1932 Rivière wrote to a critic that the ethnographic section of Tervuren was one of "our models."[59] By then, Rivière had not given up his traveling. But he had seen enough to have begun adapting elements of current museography to the Trocadéro, within the constraints of

[58] Ibid.
[59] AMH/2 AM 1 A4/d/Georges Henri Rivière à Gaston Monnerville, 22 Dec. 1932, no. 2703.

the possible. Some of these were set by Rivet's own vision of what an ethnographic museum should include; others by a lack of funds. However, by the early 1930s, Rivière was well on his way to putting his own distinctive stamp on the Musée d'Ethnographie, transforming it from a marginal institution, housed in a "ridiculous" building, into an aesthetic, scientific, popularizing, and modern one.

First Steps: 1928–1931

When Rivet lobbied to transfer the ethnographic collections to his chair in anthropology at the Muséum, he aimed to create a world-class scientific and educational center for France that he would direct, and that would be "a conservatory of material civilization considered in its totality: hunting, fishing, habitation, clothing, decoration, ceremonial attributes, ritual, magical and legal objects, games, the arts etc. . . . of contemporary primitives." In keeping with his interest in the migrations of early humanity and his belief that "the primitives of yesterday and today" had much in common, he wished to add new sections in prehistory. The museum would thus be able to "measure human technical progress, reveal migration patterns, suggest the milieu of prehistoric man, and retrace the stages of the social and religious evolution of humanity."[60] On the practical side, it was necessary to save, identify, and catalog as many as possible of the Trocadéro's 150,000 objects before any more rotted; inventory and expand the existing library; increase the museum's holdings to include (among others) new collections from the empire, particularly Indochina (it was scandalous, he noted, that the existing museum had no Asian gallery); create vast reserves, which he proposed to do in part by moving the Musée d'Ethnographie's French folklore collections to the provinces or to their own museum; remake and standardize the locks and install new lighting; and obtain further space overall, first by dividing vertically one of the Trocadéro's existing high, vaulted galleries, which would require adding a floor and stairway; and second, by enclosing (with glass, to allow maximum light) the colonnaded circular exterior walkway of the existing palace.[61]

Yet while Rivet had an overall vision for what the Musée d'Ethnographie should become, he knew from the outset that money would be a problem: in 1928 the personnel budget was 69,000 francs, which provided for a director's

[60] AMH/2 AM 1 G2/b/"Rapport sur la réorganisation générale du musée," 1 Sept. 1931.
[61] ANH/2 AM 1 G2/c/Paul Rivet, "Rapport sommaire sur l'activité du Musée d'Ethnographie du Trocadéro depuis son rattachement au Muséum National d'Histoire Naturelle," 29 June 1929.

salary and pay for five guards, and the operating budget for material costs was 20,000 francs. Rivet managed to negotiate an additional 48,200 francs for personnel, and his material budget was raised to 100,000 francs annually in 1930. To help cover the costs of refurbishing, he reported to the museum's consultative commission in June 1928 that admission would be charged except on Sundays, and that he had already secured a promise for an annual 150,000-franc colonial subvention.[62] But even this latter contribution could not begin to cover the costs of the anticipated structural renovations or the personnel required to modernize, much less grow and display the collections systematically in order to create the totalizing "history of humanity" museum of Rivet's dreams. Rivet's solution to these challenges was to sell his dream to the untested but well-connected Rivière, and to give the latter considerable freedom to realize it with the limited means at his disposal.

Once on the job, Rivière, began immediately applying what he was learning on his travels, as well as mobilizing his networks among the influential, especially the art world.[63] A day after returning from his United States museum tour, he noted in a letter to Mauss a need for "exposition galleries with metal cases, geographical maps, synoptic charts [*tableaux*], posters, standardized and printed labels, easily visible numbering of objects, shelves, cases, rooms." The "outmoded" panoplies and mannequins were to be eliminated. He added that he had already determined where the new offices, library, conference room, laboratories, and washrooms were to go.[64] Rivière went public with these plans a few months later, in an article clearly designed to catch the attention of the art world. It appeared in a new avant-garde periodical with which Rivière was directly associated—*Documents. Doctrines, Archéologie, Beaux-Arts, Ethnographie*—and which was bankrolled by another patron, the art dealer Georges

[62] ANF/F[17]/13567/MNHN/Paul Rivet à M. le Directeur du Muséum National d'Histoire Naturelle [Louis Mangin], 4 Feb. 1928 (personal); AMH/2 AM 1 G2/a/Procès-verbal de la Commission consultative du Musée d'Ethnographie du Trocadéro, 30 June 1928; AMH/2 AM 1 G2/d/Budget, 11 April 1930. The question of colonial subsidies will be examined in chapter 5.

[63] Rivet had always planned to turn to private funds, recommending early on that "donors" (*mécènes*) be represented on the museum's consultative commission. IMEC/Fonds Marcel Mauss/ MAS 11.20/Paul Rivet à Marcel Mauss, 14 Sept. 1927. His gamble in hiring Rivière for his rich connections was already paying off. Later that year the Viscount de Noailles joined the consultative commission of the Musée d'Ethnographie, while Rivière's other mentor, David David-Weill, and indeed Rivière himself, began funneling money into the Association of Friends of the Musée d'Ethnographie (later Musée de l'Homme). Between 1929 and 1940, David-Weill would contribute a total of 218,456 francs in addition to numerous objects. AMH/2 AM 1 K30/e/David David-Weill. Another important supporter was the Comité Argentin of Paris.

[64] IMEC/Fonds Marcel Mauss/MAS 11.22/Georges Henri Rivière à Marcel Mauss, 23 Feb. 1929. Rivet also decided to forgo his director's salary to help cover the new costs of hiring an assistant director (32,000 fr.), a technical assistant, and one additional guard.

Wildenstein.[65] In this article, Rivière noted first how far France's museum had fallen behind those of most other countries; to address this lag, the new museum would include permanent and temporary exhibition galleries, a library-conference room, workrooms, offices, and laboratories; each floor would also have a reserve. In addition, they would be "dividing the collections" between rooms destined for the public, where unique or characteristic pieces would be displayed, and the new reserves, made readily accessible to qualified scholars; installing electricity not just in the galleries, but possibly in the display cases; developing relationships with "the administration, savants, collectors, merchants in order to elicit gifts, legacies, deposits, and loans"; and "advertising by means of works and periodicals, . . . editing a trimestral bulletin, establishing scientific relationships with savants, museums, and institutes abroad."

Rivière then turned to the question of the Musée d'Ethnographie's tiny personnel budget, and a budget of only 30,000 francs for material—"still very little." Fortunately, he continued, the Viscount de Noailles had recently reinvigorated the Association of the Friends of the Musée d'Ethnographie, and this organization was provisionally covering the salaries of three new hires: a librarian (Yvonne Oddon), a technical assistant (Adrien Fedorovsky), and a secretary-archivist (Thérèse Rivière, his sister); in addition, a few volunteers were helping out.[66] Meanwhile the director had applied to the government for special funds for the installation of central heating. The article said no more

[65] Georges Henri Rivière, "Le Musée d'Ethnographie du Trocadéro," *Documents. Doctrines, Archéologie, Beaux-Arts, Ethnographie* 1 (1929): 54–58. A shorter article a year later in *Cahiers de Belgique* reiterated these themes, "De l'objet d'un musée d'ethnographie comparé à celui d'un musée des Beaux-Arts," and was reprinted two years later in *Omnibus, Almanach aus das Jahr1932* (1932): 113–17; see also Paul Rivet and George Henri Rivière, "La réorganisation du Musée d'Ethnographie du Trocadéro," *Bulletin du Muséum National d'Histoire Naturelle* 2 (1930): 478–87. *Documents*, founded by surrealist fellow travelers Georges Bataille and Pierre d'Espezel, juxtaposed articles on traditional art, modern art, and ethnography by artists and scholars in an effort to destabilize existing cultural hierarchies. Provocative and ephemeral, it would last two years and produce only fifteen issues, a victim of internal editorial dissension. Rivière may or may not have played a key role in the enterprise's inception, but he was on the editorial committee, and his close friends from the early American arts exhibit were involved in *Documents* in some capacity as well: Leiris was secretary, and Schaeffner contributed articles (as did Rivet and Nordenskiöld).

[66] As noted earlier, Leiris and Schaeffner had joined Rivière at the Musée d'Ethnographie, despite their previous roots in the arts. This intense *va et vient* between an institutionalizing ethnography and surrealism has been the subject of much scholarship, beginning with James Clifford's classic essay, "On Ethnographic Surrealism," in *The Predicament of Culture: Twentieth-Century Ethnography, Literature, and Art* (Cambridge, MA, 1988), 117–51. For responses to Clifford, see Jean Jamin, "L'ethnographie mode d'inemploi. De quelques rapports de l'ethnologie avec le malaise dans la civilisation," in Jacques Hainard and Roland Khaer, eds., *Le mal et la douleur* (Neuchâtel, 1986), 45–79; Michael Richardson, "An Encounter of Wise Men and Cyclops Women: Considerations of Debates on Surrealism and Anthropology," *Critique of Anthropology* 13:1 (1993): 55–75; and Gorgus, *Le magicien des vitrines*, 36–44. In many ways, this focus on surrealist connections has eclipsed a more complex early genealogy of the Musée d'Ethnographie in France, in which Rivière embraced a number of different influences.

on the subject of funding, but the subtext was clear: here was a modernizing ethnological museum whose renovation already had the support of one of Paris's most visible patrons of modern art. Rivière went on to explain this apparent conversion of Noailles from art appreciation to that of science: the rage for primitive art, he noted, had so decontextualized the material culture of archaic peoples that it was time for experts such as Rivet to step in and install these artifacts properly—a move that would obviously enhance the value of the objects and the connoisseurship required to curate them. These experts were at the same time committed to creating an ethnographic museum that would please multiple audiences: in Rivière's words, one "useful to science and country, loved by the artist, and appealing to the public."[67]

From 1929 until the mid-1930s, Rivière hewed to the renovation plans announced to Mauss and in *Documents*. He believed that the best way to attract a diverse viewing public was to make the Musée d'Ethnographie as modern as possible in both its "invisible" work spaces and "visible" galleries; given the building he had to work with—the dark, damp, and cold neo-Mauresque Trocadéro Palace—his first goal was to create more light as well as expanded gallery and reserve space. Rivière and Rivet were soon mobilizing their respective political and social networks to lobby for public funds for the construction of an extra floor and staircase, the glass enclosure of the building's semicircular terrace, the installation of central heating and electric lighting, and the purchase of glass and metal airtight display cases to replace the old warped wooden ones. In each instance funds were voted, although the onset of the Depression delayed the purchase of the cases—to the tune of 5,750,000 francs—until 1932; but in 1931 the enclosure was done, and work on the new floor and staircase under way.[68] At that point Rivière and Rivet had hoped to open the first major gallery installed according to "the new methods."[69] Yet without new display cases the staff could not make that deadline.

Despite this setback, the directors could point to other accomplishments that year. A small army of volunteers made up of socialites and students recruited from the Institut d'Ethnologie had begun the time-consuming material

[67] Rivière, "Le Musée d'Ethnographie du Trocadéro," 54–58.
[68] AMH/2 AM 1 A3/b/"Plan de travail pour l'exercise 1931 et les prochaines années," [n.a., n.d. (Jan. 1932)]. In 1933, Rivet calculated that 7,656,803.58 francs had been spent in renovations over the previous five years. ANH/2 AM 1 G3/c/Paul Rivet à Albert Monzie, Ministre de l'Enseignement National, 8 Nov. 1933.
[69] The gallery in question was the American one, given priority because a substantial collection already existed. ANH/2 AM 1 G2/c/Paul Rivet, "Rapport sommaire sur l'activité du Musée d'Ethnographie du Trocadéro depuis son rattachement au Muséum National d'Histoire Naturelle," 29 June 1929. See also ANH/2 AM 1 G2/a/Paul Rivet, "Rapport présenté par le Dr. Rivet, Professeur d'Anthropologie du Musée d'Ethnographie du Muséum National d'Histoire Naturelle," 23 June 1930. One estimate valued the American collection at 20,000,000 francs. AMH/2 AM 1 B1/d/"American Ideas Adopted in Trocadéro Renovation," *New York Herald*, 11 Nov. 1931.

restoration and cataloging of the museum's collections, while new artifacts began to be acquired through gifts, exchanges, and Institut d'Ethnologie-sponsored expeditions to the field. Rivière had by then imposed a meticulous system of inventorying objects, modeled on that used in Gothenburg and several United States museums.[70] The Trocadéro printed and issued a set of free "summary instructions" prepared by Michel Leiris to anyone collecting for the museum, to guarantee that the provenance of every object was record-ed consistently. The traveler in question was to give the exact site and date of "harvest," the name (or names) in the local languages, and the function. Only pieces properly documented would be accepted. These pieces, moreover, should not be exceptional or beautiful ones; what was needed were the most typical and practical objects of a given ethnic group—their tools, weapons, utensils, and clothes but also their musical instruments, games, and sacred masks—that the daily lives of ordinary peoples might be adequately repre-sented.[71] A biannual bulletin devoted to ethnological articles on objects in the collections began to be published in 1931 as well, funded in part by George Wildenstein, the Friends of the Musée d'Ethnographie, and Rivière himself.

Equally impressive, Rivière managed to keep the Musée d'Ethnographie's rejuvenation efforts constantly in the news even as the permanent galleries remained closed, as a result of a press campaign that targeted a vast range of specialized and general-interest periodicals of all political persuasions. Jour-nalists were invited to preview the new museography and encouraged to dis-seminate the news of—until now—France's relative museum backwardness. Reporters in return responded positively to Rivière's overtures, a reaction that suggests that the concept of an American-style museum rationally organized for a broad public by a young iconoclast was a noteworthy novelty.[72] In 1929

[70] AMH/2 AM 1 G2/c/"Ordre de service no. 6, 29 June 1929, reviewed 7 July 1930." Also printed in "Les méthodes d'inventaire du Musée ethnographique de Paris," *Mouseion* 21–22:1–2 (1933): 238–45.
[71] Michel Leiris, "Instructions sommaires pour les collecteurs d'objets ethnographiques," May 1931 (Musée d'Ethnographie), 8–10.
[72] See AMH/2 AM1 B1 to 2 AM1 B11 for the press clippings on all aspects of the museum's activity between 1929 and 1949. There was the colonial press (*La Dépêche Coloniale, Annales Coloniales, Presse Coloniale, L'Orient* [Beirut], *Revue de l'Empire Français, L'Avenir du Tonkin, L'Écho d'Oran, L'Afrique du Nord Illustré*); literary journals (*Nouvelles Littéraires, Mercure de France, L'Europe Nouvelle, Avant Garde, Vingtième Siècle*), scholarly journals (*Revue Internationale de Sociolo-gie*), museography newsletters (*Bulletin des Musées de France, Museum News*), and art magazines (*Beaux Arts, Cahiers d'Art, Arts et Industries, L'Art Vivant*); newspapers and periodicals on the Left (*L'Humanité, Midi Socialiste, Coemedia, Le Coopérateur de France, Le Lien Fraternel, Le Peuple, L'Oeuvre, L'Homme Libre, Le Rempart, Marianne, Progrès du Nord, Politique, L'Écho Républicain de Neuilly, Lumière, L'Est Républicain, La Liberté*) and newspapers spanning the center to Far Right (*L'Ami du Peuple, Le Matin, L'Intransigeant, Le Temps, Le Journal, L'Avenir, Candide, Gringoire*); generalist, information newspapers (*Paris Soir, Télégramme, Paris Midi, Le Jour, L'Écho de Paris, Le Petit Parisien*) and illustrated magazines (*Le Mois, L'Illustration, Le Monde Illustré*); and finally, more fitfully, the American press (*New York Herald, New York Times, Chicago Tribune*), other for-eign press, and the provincial press.

the big daily *Le Matin* announced the Musée d'Ethnographie's plans for "new lights, heating and display cases."[73] In October 1930, Jean Archambaud of *Paris Soir*—another big daily—noted the ongoing transformation of the dusty Trocadéro into a "beautiful modern museum," which meant that the collections would be divided between a "didactic" section and one for "specialists." A map would be included in each cabinet, so visitors could see the region occupied by the tribe whose objects were on display. Objects would be classified by category. A sorcerer's mask might serve as a point of departure for a whole series of documents regarding the ceremony for which it was destined, and serial numbers would correspond to those in other sections. "The museum will be well lit and alive. . . . Each room will later have small automatic *cinématographes:* for a small sum one can watch films about the nations represented in the gallery."[74] The reporter Paul Dany from the right-wing *L'Ami du Peuple* met Rivière upon the latter's return from his 1931 trip to Belgium and the Netherlands. He noted that Rivet's assistant hardly conformed to the typical image of a curator as someone "nearsighted and knock-kneed." Rather,

> He is a young, elegant, and athletic-looking man, who received us in an office . . . where the telephone, central heating, and metal chairs create a business atmosphere. In a clear voice, where one is astonished for no good reason not to detect an Anglo-Saxon accent, M. Rivière professes his faith.

In a follow-up article, Dany again presented Rivière as an apostle of modernity who was attacking "the somnolence of French ethnography since 1878." He also approvingly quoted Rivière on the subject of making France competitive internationally: "We had to make a serious appeal to the experience of foreigners to recover the time lost. It is from our notes that all the new ideas in France emerged."[75] Previewing the museum in 1932, Joseph Billiet echoed

[73] AMH/2 AM 1 B1/d/Paul Croize, "Le Musée d'Ethnographie du Trocadéro qui demeura si longtemps méconnu va être réorganisé," *Le Matin*, Jan. 1929.

[74] AMH/2 AM 1 B1/d/Jean Archambaud, "Le Trocadéro poudreux devient sans doute un beau musée moderne: La civilisation et l'art primitif vont être présentés au public sous des aspects aimables," *Paris Soir*, 26 Oct. 1930. A few months later, Archambaud would meet (and later marry) the Native American dancer Molly Spotted Elk, who traveled to France as part of the United States contingent at the 1931 Colonial Exposition in Paris. Bunny McBride, *Molly Spotted Elk: A Penobscot in Paris* (Norman, OK, 1997).

[75] AMH/2 AM 1 B1/d/Paul Dany, "Grace aux crédits de l'outillage national le Musée d'Ethnographie du Trocadéro va être transformé et modernisé," and "Nous verrons des merveilles au Musée d'Ethnographie du Trocadéro," in *L'Ami du Peuple*, 17 Nov. 1931 and 2 Dec. 1931; see also the third article in this series, "Notre Musée d'Ethnographie se réveille de son long sommeil," 8 Dec. 1931. For a sampling of articles focusing on the need to catch up with other museums internationally from the left-wing press, see Claude Martial "Renaissance merveilleuse du Musée d'Ethnographie du Trocadéro," and "Tour du monde et revue des siècles," in *L'Oeuvre*, 26 and 27 Dec. 1932. The

these themes in the centrist *L'Avenir*, but he especially praised what he saw as the museum's new didacticism. "The basis of all learning is sensorial. . . . The reorganized Musée d'Ethnographie has understood this." Each viewing case had double lighting, and photographs, maps, drawings, and explanatory panels were affixed to the walls, which was a method of presentation that already existed in most of the great ethnological centers of the world. He concluded:

> Confronted with these vast clear rooms, these objects purely presented, this vast documentation that immediately made sense, one begins to think that the teaching of living subjects—history, geography, . . . the linguistic sciences, and the formation of critical thinking . . . —should be organized in the same manner.[76]

And Rivière could point to another achievement in his first years: the inauguration of a new research library in the summer of 1931, it too a marvel of rationality. Rivet had always considered the creation of a "modern center of bibliographic documentation" essential for his renovated museum-laboratory, because no ethnological library existed in Paris yet—the Institut d'Ethnologie, for example, had no room for one.[77] Rivière came to share this view, investing much of his own small fortune to create one and ranking it above "less urgent" new departments in the museum that he was determined to see through, such as "photographic documentation."[78] Equal credit nevertheless belongs to the remarkable young librarian he brought on board at the outset, Yvonne Oddon. Thanks to her, the library, like so much else in Rivière's rejuvenated Musée d'Ethnographie, was inspired in large part by methods pioneered in the United States.

American press, more chauvinistically, made many of the same comments. For example, one reporter wrote that the Musée d'Ethnographie would be the "only museum in France with American methods," i.e., exhibit cases lighted electrically with automatic shutoffs and a selection of material, so "fewer and better pieces in more artistic and spacious settings." 2 AM 1 B1/d/"American Ideas Adopted in Trocadéro Renovation," *New York Herald*, 11 Nov. 1931. See also in the same file "Trocadéro Museum Is Now Being Renovated," *New York Herald*, 23 Oct. 1930, and "Cleaning Up the Paris Trocadéro," *New York Times*, 4 Jan. 1931.

[76] AMH/2 AM 1 B4/a/Joseph Billiet, "Le Musée d'Ethnographie du Trocadéro," *L'Avenir*, 16 July 1932. See also AMH/2 AM 1 B1/d/Jean Malo, "Décadence et grandeur du Musée d'Ethnographie du Trocadéro," *L'Homme Libre*, 25 Jan. 1932; René Chavance, "Le Musée d'Ethnographie sera métamorphosé," *La Liberté*, 28 Feb. 1932; André de Wissant, "Le Musée d'Ethnographie va renaître," *Télégramme*, 23 March 1932.

[77] AMH/2 AM 1 A2/b/Paul Rivet à Louis Mangin, Directeur du Muséum National d'Histoire Naturelle, 19 June 1931.

[78] AMH/2 AM 1 A1/e/Georges Henri Rivière à Ernest Gutzwiller, 27 Jan. 1931, no. 132. By 1932 Rivière had spent 245,347.55 francs of his own money on the Musée d'Ethnographie. AMH/2 AM 1 A4/b/Georges Henri Rivière à M. d'Harcourt, 14 Sept. 1932, no. 1992.

Rivière, or so the story goes, hired Oddon on the spot when he met her for an interview in a taxicab on the rue de Rivoli. She had at the time two important credentials that impressed him. First, she was a 1924 graduate of a short-lived (1923–29) American library school in Paris, which was the first in France to offer a certificate in library science.[79] It taught the creation of author/title card catalogs, the use of decimal classification, as well as the introduction of reference services and programs for adults and children. Second, Oddon had spent two years in Ann Arbor on an exchange program researching the University of Michigan's library, and she had just published the results in 1928.[80] Oddon's unusual skills were at risk of going to waste when she fortuitously crossed paths with some of Rivière's art-world connections. No sooner had Rivière moved to the Musée d'Ethnographie, then David-Weill told him to hire a librarian at his expense, while his brother Pierre David-Weill generously endowed the library with a purchasing fund. David David-Weill's secretary, Marcelle Minet, knew Oddon and encouraged Rivière to hire her.[81]

Oddon started at the Musée d'Ethnographie in January 1929 and soon put her distinctive stamp on the library, one that would transform it into an "indispensable complement" to the collections by aligning it with the best practices internationally—in other words, American practices.[82] For example, she insisted on adopting the Library of Congress classification rather than the Dewey Decimal System, because the former better accommodated new categories of knowledge like ethnography. This classification was only beginning to be known in Europe.[83] Oddon also modeled the library's layout on the University of Michigan's, creating a reading room with current issues and bound volumes of the main scientific journals accessible to scholars, instead of placing them in closed stacks—another Parisian novelty. She and a

[79] Françoise Weil, "Yvonne Oddon (1902–1982)," *Revue du Musée de l'Homme-Muséum National d'Histoire Naturelle* 22 (Spring 1982): 4. On the history of the École Américaine des Bibliothécaires, see Mary Niles Maack, "Americans in France: Cross-Cultural Exchange and the Diffusion of Innovations," *Journal of Library History* 21 (Spring 1986). A lack of resources combined with opposition from those who wished to preserve libraries as elite sanctuaries forced the school's closure. Daniel Renoult, "Formation professionnelle des bibliothécaires," *Bulletins des Bibliothèques de France* 5 (2009): 63–66, http://bbf.enssib.fr.

[80] Yvonne Oddon, "Une bibliothèque universitaire aux États-Unis. La bibliothèque de l'Université de Michigan," *Revue des Bibliothèques* 36 (1928): 129–55.

[81] Weil, "Yvonne Oddon," 4.

[82] AMH, 2 AM 1 A2/d/Paul Rivet and Georges Henri Rivière à M. le Haut Commissaire [High Commissioner for India], 8 Sept. 1931, no. 1572.

[83] AMH/2 AM 1 A1/b/Yvonne Oddon à Mr. Bishop, University of Michigan Library, 28 Aug. 1930. A Carnegie Endowment initiative led by a trio of American librarians, including the head of the University of Michigan's libraries, Dr. William Warner Bishop, was currently working with the Vatican to recatalog its collection using the Library of Congress classification.

staff of volunteers who had also graduated from the American library school contacted museum and academic libraries across the world to exchange their publications with the projected Trocadéro *Bulletin*. At the library's inauguration on 31 July 1931, an internal report noted that they had installed the library "in the most modern and practical way"; a vast extension was announced, even though they had already spent 200,000 francs, much of it privately raised.[84] Three years later, Oddon could report that 6,000–10,000 books had been classified and cataloged that year, and that there was a regular exchange of publications between the Musée d'Ethnographie and ninety French and foreign institutions.[85]

"Un musée . . . attrayant pour le public": 1932–1935

Oddon's library and the many descriptions by journalists of modern installations offered a tantalizing foretaste of the renovation of the rest of the museum. The overhaul of the permanent galleries nevertheless proved much more time consuming than that of the book collections. In 1931 Rivière had yet to create the reserves that were required for the double museum principle to be implemented, and without which the public remained "deprived of the first rational exhibits so frequently announced."[86] A year later, Rivet was complaining that the planned reserves were already too small, given that 10,000 new objects were arriving every year.[87] Despite these setbacks, in 1932 the first public permanent galleries reopened: in July, sections of the American Hall, and in December, a European Ethnography Hall and a Hall of Treasures (Salle du Trésor) (also a *phonotèque* and *phototèque*). The African, Asian Prehistory, and Black African halls followed in 1933, and the Asian and Oceanian halls opened in January 1934. By the end of 1934, the White African (i.e., North African), American Prehistory, Arctic, and Madagascar galleries (the last in fact a subsection of the African Hall) had also opened; and the American Hall (in particular its archaeological sections) was finally completed in March 1935.[88] By 1934, scientific departments had been created as well, headed by doctoral students who typically survived on small subsidies cobbled from research fellowships, the Association of Friends of the Musée d'Ethnographie,

[84] AMH/2 AM 1 G2/a/Commission Consultative, 22 June 1931.

[85] AMH/2 AM 1 A6/c/Yvonne Oddon, "Note sur le fonctionnement de la bibliothèque," 23 Feb. 1934.

[86] AMH/2 AM 1 G2/b/"Rapport sur la réorganisation générale du Musée," 1 Sept. 1931.

[87] AMH/2 AM 1 A4/c/Paul Rivet à M. le Sous-Secrétaire des Beaux-Arts, 20 Oct. 1932, no. 2249.

[88] On these openings, see AMH/2 AM 1 A4/a/Georges Henri Rivière à Michel Leiris and Marcel Griaule, 22 July 1932, no. 1600; and press clippings in AMH/2 AM 1 B4, B5, and B6.

or temporary contracts. The publications of departmental members began to be reported annually to their parent institution, the Muséum, another sign that the research mission of the museum was taking off.[89]

As even a cursory glance at this list of galleries and departments indicates, there was little question of deviating from the principle of organizing artifacts geographically and then by ethnic group or civilization; objects and tools of everyday life, moreover, took pride of place. Only one gallery, the Hall of Treasures, broke from this model. Its presence is a reminder, as Christine Laurière and others have noted, that Rivière understood by 1932 the way in which the growing market for primitive art could be used to the mutual advantage of the Musée d'Ethnographie and dealers. In 1929, Rivière had criticized the current fashion for "art nègre" because connoisseurs were ignoring the functional and symbolic dimensions of the pieces they were buying. Far from taking umbrage at Rivière's criticisms, collectors and dealers welcomed the value and prestige added to their art when examples of the latter appeared in a renovated science museum. Rivière in return came to accept that the Musée d'Ethnographie would be mostly scientific and pedagogical in its permanent galleries, although it would periodically mount temporary exhibits of a spectacular and aesthetic nature, since such exhibits would draw in a more diverse and affluent public.[90]

The creation of the Hall of Treasures reflected this appreciation. Its sole purpose was to display objects, in Rivière's own words, "remarkable from an artistic point of view," "gathered purely for the pleasure of the eye." As such, this "small kingdom" enjoyed the rights of "extra-territoriality," "free of all [the] scientific and classificatory apparatus" that obtained elsewhere in the museum. Rivière brought in a leading sculptor of the day, Jacques Lipchitz, to install black marble pedestals against a red background, subdued lighting, and glass cases recessed into the walls. Most of the "treasures" came from the prized older collection of American and Oceanic objects. The objects displayed were chosen for their beauty, rarity, and value on the current art market: "a Hawaiian feathered helmet"; "a Tiki god statue from the Marquise Islands"; "a golden pendant from Colombia"; "a crystal skull from Mexico";

[89] AMH/2 AM 1 G3/b/Rapports d'activité des différents départements, 1934; AMH/2 AM 1 A7/b/Ordres de service nos. 4, 5, 6, 7, and 8, 26 July 1933.

[90] Laurière, *Paul Rivet*, 406–8; Maureen Murphy, *De l'imaginaire au musée. Les arts d'Afrique à Paris et à New York (1931–2006)* (Paris, 2009), 17–41. On primitivism in Paris in the 1930s, see Robert Goldwater's 1938 classic, *Primitivism in Modern Art*; Sherman, *French Primitivism*, chap. 1; and John Warne Monroe, "Surface Tensions: Empire, Parisian Modernism, and 'Authenticity' in African Sculpture, 1917–1939," *American Historical Review* 117:2 (April 2012): 445–75. For an incisive analysis of how scientific ethnography at the Musée de l'Homme "replicated . . . the modern capitalist economy to which it pretended to be an alternative," see James D. Herbert, *Paris 1937: Worlds on Exposition* (Ithaca, NY, 1998), 43–67; quotation on p. 66.

Hall of Treasures, Musée d'Ethnographie du Trocadéro, 1934. AMH/PH/1998–6686. Photo courtesy of the Musée du Quai Branly/Scala/Art Resource, NY.

"an Aztec feathered serpent"; "two masks from pre-Columbian Mexico"; "a Mexican pyrite mirror"; "a great cloth from ancient Peru"; "an obsidian block carved with a sign from the Aztec calendar." A few African "treasures" were included as well: a sixteenth-century Bénin bronze, an ivory from the Belgian Congo, and a gold mask from the Ivory Coast.[91] In 1932, a year after the Hall of Treasures opened, Rivière also explained to his staff that the empty large glass case to the right of the African gallery's entrance would exceptionally be assigned to "art nègre." This policy was already in place in the museums of Berlin, Frankfurt, and Munich, and would preempt any complaints from the press or public.[92] These embedded spaces of pure aestheticism would not make it into the museum's second renovation.

[91] AMH/2 AM 1 A4/a/Georges Henri Rivière, "L'exposition de Bénin et les transformations du Musée d'Ethnographie du Trocadéro," *Les Nouvelles Littéraires*, 6 July 1932. Rivière had bought the Bénin bronze in London a year earlier, with funds from the Friends of the Musée d'Ethnographie. AMH/2 AM 1 A2/c/Georges Henri Rivière à Marcel Griaule, 30 July 1931, no. 1230; and AMH/2 AM 1 A2/c/Georges Henri Rivière à M. Piétri, Ministre du Budget, 12 Aug. 1931, no. 1372. Rivière did not explain what criteria he used for selecting which pieces to include in this gallery.
[92] AMH/2 AM 1 A5/d/Ordre de service, 23 Aug. 1933.

Along with separating out "masterpieces" for special display, between 1932 and 1935 Rivière honed a more general set of museographic principles that also bore traces of his travels. Since Rivière left so few accounts of these principles, we can best glimpse them through the writings of yet another close collaborator: Anatole Lewitsky, an émigré Russian who arrived at the Musée d'Ethnographie in 1931 to help with storage and installation. Lewitsky would become a serious student of museography in his own right, while also researching Siberian shamanism with Mauss.[93] He was particularly conversant with the new Soviet practices that interested Rivet and Rivière throughout the 1930s. In his notes, for example, Lewitsky observed that the Soviets had rejected the colors that Scherman had adopted in Munich as too intense, preferring neutral backgrounds and a "sober" and "aesthetic" presentation. Texts should never be too long, sentences should be "short and expressive." He also stressed the Soviet political use of "exhibits" as part of the "shock" campaigns in the countryside, and the ways in which the museum had been deliberately "associated with the constructive (and destructive, i.e., religious) policies of the regime."[94]

Even more revealing were notes and a report on museographic methods that Lewitsky compiled in 1935, illuminating the kinds of decisions he and Rivière had made in modernizing. Ethnographic objects, Lewitsky wrote, were by definition hard to work with; they came in every size and shape, yet display cases came in one basic shape. Museums, however necessary for the advance of science, rendered living objects dead, by ripping them from their milieu and immobilizing them. The use of alternative materials to resuscitate them—maps, photographs, texts—introduced a different problem: the viewer's eye had to travel constantly between and among object, text, and context. Classifying these objects was equally problematic, since a single object could easily fall into multiple categories: a wooden ritual drum belonged simultaneously to music, religion, woodworking, and art. Adherence to a few elementary principles nevertheless could help overcome these challenges. Individual objects should be seen effortlessly, with the largest objects in back; objects in general should be displayed horizontally or vertically (rather than at an angle, which could fatigue the eye); smaller objects could be hung ("Paul Rivet and Georges Henri Rivière have used this method a lot since coming to the museum"). The staff should continue to avoid wax models (too

[93] See Lewitsky's instructions for cataloging the African objects, drawn up right after his arrival, 6 Feb. 1931, in AMH/2 AP B11/c/.
[94] AMH/2 AP 5 4.1/Activité au Musée de l'Homme. These ideas appeared in notes (undated) that Lewitsky took on Soviet museography based on his reading of L. Rosenthal, *Le musée soviétique* (after 1932) and Sololiev (after 1936).

jarringly artificial).[95] Many of the techniques outlined by Lewitsky were first tried out at the Musée d'Ethnographie, only to be further honed at the Musée de l'Homme.

With the opening of the completed galleries in the American Hall in 1935, Rivet and Rivière believed that after "seven years of abnegation," their work was done. Rivière had dedicated every waking hour to the renovation, to the point of becoming positively monastic in his habits. Rivet had given up his own research, to fight for "a science I must serve and defend, and [in the interests] of the young generation of ethnologists whom I have helped to train, and made to share my passions and hopes."[96] Throughout the renovations of the permanent galleries, they had never closed the museum, organizing a steady stream of temporary exhibits. Receipts had climbed annually between 1929 (18,519 fr.) and the first seven months of 1935 (99.764 fr.), with an exceptional intake in 1934 (145.410 fr.) when an enormous exhibit on the Sahara had beaten all records.[97] In keeping with Rivet's educational vocation, thousands of schoolchildren and other groups had been admitted free or with reduced rates, and he hoped eventually to be able to open the museum in the evening. Since 1930 department heads, including Rivet, had been giving guided tours to groups. Modern technology and outreach were combined to a different effect in March 1935, when Rivière accepted a proposal by the secretary-general of the state-run radio for his staff to broadcast short lectures, "in a spirit of even greater vulgarization."[98]

Yet just at the moment that Rivet and Rivière hoped to turn to other projects, the city of Paris put the Musée d'Ethnographie's staff on notice that the Trocadéro Palace was to be partially gutted and rebuilt on a much grander scale for the 1937 Exposition Universelle des Arts et Techniques. The fair's commissioners wished to construct a commanding esplanade overlooking the Champ de Mars and the Eiffel Tower, which would require demolishing the central portions of the existing building, where the refurbished American Hall was housed. The flanking wings and towers of the Trocadéro, meanwhile, would be preserved, extended, and sheathed in new Art Deco facades.

[95] AMH/2 AM 1 G3/d/Anatole Lewitsky, "Quelques considérations sur l'exposition des objets ethnographiques," 1935.
[96] AMH/2 AM 1 G3/c/Paul Rivet au Ministère de l'Instruction Publique, 1 March 1930 (never sent).
[97] AMH/2 AM 1 A8/d/Statistique des entrées du Musée d'Ethnographie, 8 Aug. 1935, no. 1686.
[98] AMH/2 AM 1 A6/b/"Avis aux visiteurs," 1934; AMH/2 AM 1 A8/b/Georges Henri Rivière à M. Brémond, Secrétaire Général des Émissions de la Radiodiffusion, 25 March 1935, no. 7. The programs on the Poste Radiophonique de Paris PTT began on 7 May 1935, under the title "Voyages et explorations," and the speakers were told not to "demonstrate useless modesty" in introducing themselves. AMH/2 AM 1 J1/a/Ordre de service no. 14, 19 April 1935. For the full list of broadcasts between 1935 and 1939, see AMH/2 AM 1 C8/a-e.

If Rivet agreed to move, he would be given a much larger and more modern building, along with funds for the reinstallation.

Despite the dreary prospect of seeing half of the recent structural improvements razed and packing up the museum's entire contents, the offer proved too good to pass up. There would be room in the Palais de Chaillot, as it was now to be called, for the transfer of Rivet's anthropology laboratory, library, and osteological collections (still housed at the Muséum) as well as the Institut d'Ethnologie, not to mention the creation of much vaster storage areas; an expansion of exhibition space from 2000 to 4000–5000 square meters; a workroom for each department; a seminar room; a bigger disinfection laboratory (against the parasites that attacked the artifacts) and larger library, *photothèque*, and *phonotèque*; a studio for recording; a *cinémathèque/* auditorium; a bookstore; and a café-bar.[99] Rivet would finally be able to realize his vision of a grand center for the complete study of humanity, one that combined physical remains and cultural objects under one roof—although not without tremendous opposition from some of his colleagues at the Muséum who believed that their human fossil collection should stay in the same institution as animal ones, for the purposes of comparative anatomy.[100] No sooner had Rivet given the go-ahead than he changed the name of his chair from "anthropology" to "ethnology of contemporary and fossil humans" and rebaptized the Musée d'Ethnographie the Musée de l'Homme.[101]

The opportunity to reinstall the old Trocadéro's displays and library so soon had another advantage. The past seven years had been something of an experiment in applying the latest museum principles. Here, then, was a chance to consolidate the lessons learned. As Rivière put it in a request to travel abroad again in May 1937—to Holland, northern Germany, and Scandinavia—the new space of the Musée de l'Homme meant that its staff could use the most modern museographic resources, and he wished to study other models "closely and critically . . . before putting on the final touches."[102] Rivière also had more experienced ethnologists this time around, who were willing to devote their time and energy to a second renovation—Schaeffner, Leiris, Oddon, Lewitsky, Thérèse Rivière (hired as secretary but becoming an ethnographer in her own right)—and several new recruits as well. The latter included an American volunteer and student of the paleontologist l'Abbé Breuil,

[99] AMH/2 AM 1 A11/b/Jacques Soustelle à Henri Labouret, 11 May 1938, no. 705. The total surface would be 8000 square meters, of which half would be devoted to exhibit halls.

[100] Two different scientific concepts of anthropology were at stake here: one that focused on the natural history of man, and one that took as its point of departure the total history of man. For details on the dispute, see Laurière, *Paul Rivet*, 367–70.

[101] This name was proposed by André Schaeffner as early as 1933. Laurière, *Paul Rivet*, 420–21.

[102] AMH/2 AM 1 A10/b/Georges Henri Rivière à M. le Ministre de l'Éducation Nationale, 24 May 1937, no. 727.

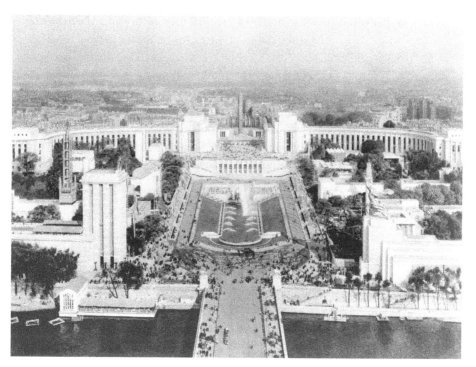

Palais de Chaillot, viewed during the Exposition Internationale, Paris, 1937. Edmond Labbé, *Rapport general. Exposition internationale des arts et techniques de la vie moderne* (Paris, 1938–40), vol. 2, pl. 69. Photo courtesy of the Getty Research Institute, Los Angeles (87-B9569).

Harper Kelley, who almost single-handedly installed the prehistory sections, partly at his own expense; the Americanists Jacques Soustelle and his wife, Georgette, as well as a refugee from Hitler's Germany trained at the Berlin Museum, Henri Lehman; Marcelle Bouteiller of the Asian Department; the Africanists Denise Paulme (who soon married the museum's musicologist, André Schaeffner) and Deborah Lifszyc, a Polish-Jewish émigré; and Jacques Faublée, who had no field experience yet and was assigned to the new Madagascar section (he would later travel there).[103]

In 1933, André Leroi-Gourhan and Paul-Émile Victor had begun to build the new Arctic Department and to plan one for the peoples of the Soviet empire. Victor was an aspiring ethnographer of the Inuit, planning to do fieldwork in Greenland; Leroi-Gourhan had a background in physical anthropology and a passion for material culture and Siberia in equal measure and was already a serious

[103] Madagascar had a dedicated section not only because it was a colony from which objects had been sent. The origins of its ethnically and culturally diverse but linguistically unified people had also long been a subject of debate among anthropologists. See Eric T. Jennings, "Writing Madagascar back into the Madagascar Plan," *Holocaust and Genocide Studies* 21:2 (Fall 2007): 191–202.

museographer with a sociologizing bent. His first display (1934) had been one of the most innovative in the entire museum: a triptych on the life cycle of the Inuit in its familial, gendered, social, and technical dimensions. One display case was devoted to "man," a second to "woman" and "child," and a third to "objects."[104] The Departments of White Africa, Oceania, and even Asia, in contrast, were still struggling to find staff. Graduate students were not yet choosing to study the peoples of these regions, presumably because North Africa was too close (and thus too familiar), Oceania was too far (and thus too expensive to reach), and Asia was both too far and deemed not "primitive" enough. With the additional pressure of the real "deadline" of the 1937 World's Fair, the Musée d'Ethnographie's second transformation would proceed more quickly than the first.

A MUSEUM FOR ALL? 1936–1938

The Musée de l'Homme would of course bear a close family resemblance to the renovated Musée d'Ethnographie that it replaced. But it would also be a different museum in a number of ways. First and most obviously, by adding skeletal remains it was to become a museum of humanity in its physical as well as cultural dimensions—a theme we will take up more closely in the next chapter. Second, even among the reinstalled ethnographic displays, certain changes in organization were made that reflected a change in personnel. By 1936, Rivière was as engaged in a new project—the creation of a French folklore museum—as he was with the Musée de l'Homme move. In early 1937 he would yield his position as head of ethnography to the Institut d'Ethnologie-trained Jacques Soustelle, who was determined that sociology should now "be featured in the galleries."[105] In this spirit, Rivière's "treasures" were apparently reintegrated into the permanent ethnographic galleries, according to provenance, and the Hall of Treasures disappeared.[106] Rivet did, however,

[104] AMH/2 AM 1 K59/d/André Leroi-Gourhan à Georges Henri Rivière, 13 Sept. 1934. See also Philippe Soulier, "André Leroi-Gourhan, de la muséographie à l'ethnologie," in Jacqueline Christophe, Denis Michel, and Régis Meyran, eds., *Du folklore à l'ethnologie* (Paris, 2009), 206–8. Until more research is done, it is impossible to know how family life and gender roles were represented in other displays.
[105] AMH/2 AM 1 D14/"Rapport," 1 April 1937.
[106] The British heiress and activist Nancy Cunard claimed in 1946 that the Hall of Treasures was going to be recreated, although to my knowledge it never was. At the beginning of World War II, she wrote, the most precious things "were evacuated to safety and other exhibits of importance marked for removal if this became urgent.... When all is in place again the best and rarest exhibits will be shown more or less in the same setting as that of 'la Salle du Trésor'." Nancy Cunard, "The Musée de l'Homme," *Burlington Magazine for Connoisseurs* 88:516 (March 1946), 66. The memory of the hall lives on. The art historian J.-L. Paudrat invoked it in his article "Les classiques de la sculpture africaine au Louvre," in Jacques Kerchache and Vincent Bouloré, eds., *Sculptures. Afrique, Asie, Océanie, Amérique* (Paris, 2000), 48–49.

allow a "display of the month" (this system existed, he claimed, at the Victoria and Albert Museum in London) in the Musée de l'Homme's lobby for recent acquisitions or special thematic displays.[107] Meanwhile, two new comparative galleries were planned, one devoted to arts and techniques, another to music and dance. The opening of both was delayed until after the Second World War, but their conceptualization began in early 1937.

A third significant difference between the two "renovations" was the changed political context in which the second occurred, nationally and internationally. Early in 1936, Radicals, Socialists, and Communists in France put aside their traditional differences to form a Popular Front that promised to defend republican liberties from the growing threat of fascism at home and democratize French society. Unprecedented numbers of ordinary men and women mobilized in support, and the all-male electorate voted the Popular Front into office in May 1936 by a slim margin. The Socialist leader, Léon Blum, became France's first Jewish prime minister, at a time when Hitler's anti-Semitism threatened to engulf the Continent. As a Socialist municipal councilor, Rivet had played a key role in forming the Popular Front, and Soustelle—a fervent Marxist internationalist at the time—was determined to help the people breach the walls of elitist cultural institutions. In the wake of the Left's victory, Rivière, Rivet, and Soustelle formulated a new goal for the Musée de l'Homme: it was to be not only a modern ethnological center, but a self-consciously popular one.

A few months earlier, Rivet had announced that an institution destined for the people needed a simple and clear name: henceforth the Musée d'Ethnographie was to be known as the Musée de l'Homme.[108] The new museum, he further explained in early 1937, "is founded on an entirely new concept, because it resolutely addresses the laboring and school-age masses"; following the lead of the great Soviet and Scandinavian museums, specially trained "collaborators" would conduct groups to "associate the people with the results of the scientific activity of the Ethnology Laboratory."[109] The survival of peace in the world, Rivet implied, required nothing less: "We have worked for the people, for the education of the people with all our heart. We hope they will respond to our fraternal appeal, that they will understand its full importance.[110] Soustelle echoed these sentiments: "The museum of

[107] AMH/2 AM 1 G3/d/"Rapport annexe aux plans des nouvelles installations du Palais du Trocadéro," 27 Jan. 1936; "Le Musée de l'Homme," 31 March 1936, second version; AMH/2 AM 1 A9/b/ Aide-mémoire, 27 April, 1936, no. 563.

[108] AMH/2 AM 1 G3/d/"Rapport annexe aux plans des nouvelles installations du Palais du Trocadéro," 27 Jan. 1936; "Le Musée de l'Homme," 31 March 1936, first version.

[109] AMH/2 AM 1 A10/a/Paul Rivet à Louis Germain [Directeur du Muséum National d'Histoire Naturelle], 22 Jan. 1937, no. 146.

[110] AMH/2 AM 1 B2/a/Paul Rivet, "Musée des races et des civilisations," Monde Libre 1, May 1938.

tomorrow can be the museum of the people . . . through the union of the [museum] technicians and the museum-goers."[111] Other museum staff, including Michel Leiris, were no less eloquent:

> To make of the Musée de l'Homme an instrument of popular culture as well as a center for specialists, that is the goal that the director and the personnel have assigned to themselves. . . . It is certain that in our times one of the most urgent tasks is an extensive diffusion of the anthropological sciences, [the] concrete foundation of a new humanism whose advent no independent spirit can cease to hope for.[112]

These were not only ideals; they lay behind a final important change, which affected the layout of the ethnographic sections and reflected Rivet's greater emphasis on pedagogy in the late 1930s. As in the past, each "civilizational area" (America, Oceania, Asia, Arctic, the Soviet Union, Europe, Black and White Africa) would have its own gallery and research department—although the younger staff was beginning to replace this geographical division with "an ethnological classification."[113] But the most visible innovation, on which everyone agreed, was a new division of each of the permanent exhibit halls into two viewing circuits. Rivet ordered this change because "the decidedly popular character of the future museum requires that all objects be displayed in a manner that highlights their human significance." On one side, under the windows and occupying one quarter of each lengthwise gallery, was to be a set of synthetic displays with general themes that summarized the sociocultural traits of major ethnic groups; these were for the visitor in a rush, but more specifically for schoolchildren and workers. Directly opposite these synoptic displays, a series of "annex" displays were to be installed with objects organized analytically by "techniques, functions, or representations" for the better-informed and initiated visitor.[114] Here, the clothing, agricultural tools, pottery, or weaving of a particular society might be displayed, since in "primitive" societies artistic and technical activities were ostensibly less differentiated than in "advanced" ones. These analytic exhibits were to make up the other three quarters of the gallery and would allow the viewer to move from the general to the specific. A bibliography would be included

[111] Jacques Soustelle, "Musées vivants, pour une culture populaire," *Vendredi*, 26 Aug. 1936.

[112] AMH/2 AM 1B1bis/d/Michel Leiris, "L'Exposition. L'Encyclopédie à la portée de tous," *Avant-Garde*, 14 Aug. 1937.

[113] AMH/2 AM 1 G3/d/"Rapport annexe aux plans des nouvelles installations du Palais du Trocadéro," 27 Jan. 1936; AMH/2 AM 1 A9/b/Jacques Faublée à Charles Le Coeur, 18 April 1936, no. 522.

[114] AMH/2 AM 1 G3/d/"Le Musée de l'Homme," 31 March 1936, second version.

in these annexes, to encourage visitors to go up to the fourth floor and consult the appropriate works in the much expanded library, which was open to all. Finally, an introductory and concluding panel should bookend each of these galleries. In the latter, "the ethnographic objects and documents will be brought together methodically, and not by ethnic group," in order to suggest possible connections with other parts of the world.[115]

Yet if the inspiration for this particular style of presentation can be traced to a combination of domestic political events and new pedagogical aspirations, it also bore the imprint—one last time—of Rivière's travels. In late July and August 1936, Rivière undertook a new museum tour of eastern Europe and the Soviet Union to see for himself "the dispositions taken there" to bring people into museums. The trip was justified as preparation for his future role as director of France's new folklore museum, aptly named the Musée des Arts et Traditions Populaires, but at the time Rivière was still involved in the Musée de l'Homme transition.[116] Rivière was deeply impressed by the "special organizations within the museums, collaboration with the unions and the Kolkhozes, exhibits in factories, in parks, in cultural centers, museums [pitched toward] youth, collective excursions to museums."[117] As he rapturously wrote Rivet from Leningrad, the museums there were "human, profound, fertile . . . what a joy to find here . . . the kind of museum of which I had been dreaming and laboriously trying to work out a theory these past few months." Upon his return, Soustelle, Lewitsky, and Rivière discussed the latter's findings at length and realized that the guiding principles of Soviet museums squared with the plans that they were already making to create a living museum, "whose parallel synthetic and analytic exhibits would reproduce [like the Soviets' Marxist timeline—although this comparison was not stated] the history of evolution up until the present."[118] For Rivet as well, the Soviets became an increasingly obligatory reference. Where once he had invoked the German museums to try to shame the authorities into giving him more money, Rivet now pointed to the Leningrad Academy of Sciences' Institute of Anthropology and Ethnography, established in 1878. With the same program as the Musée de l'Homme, he wrote, the Soviet institute had 105 full-time paid personnel and 30 temporary scientific workers, to Paris's 17.[119]

Rich in ideas for reform, but heir to an intractable depression, the Popular Front did not subsidize Rivet's museum any more generously than had

[115] AMH/2 AM 1 G3/d/"La réconstruction du Troca et le Musée de l'Homme," 29 Dec. 1936.
[116] On the overlap between Rivière's work there and the Musée de l'Homme, see Sherman, *French Primitivism*, chap. 2.
[117] AMH/2 AM 1 A9/e/Georges Henri Rivière à Albert Henraux, 18 Dec. 1936, no. 1629.
[118] AMH/2 AM 1 A9/c/Anatole Lewitsky à Jacques Soustelle, 12 Sept. 1936, no. 1042.
[119] AMH/2 AM 1 A9/d/Note pour le Directeur de l'Enseignement, 26 Nov. 1936, no. 1392.

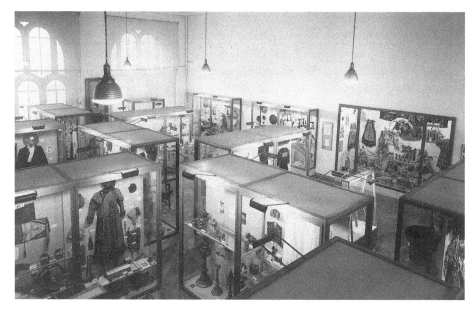

Asian Hall, Musée d'Ethnographie du Trocadéro, January 1934. This photograph conveys how cramped the museum was, even after its first renovation was completed in 1934. AMH/PH/1998–19144. Photo courtesy of the Musée du Quai Branly/Scala/Art Resource, NY.

preceding governments. Meanwhile, the fate of the Musée de l'Homme renovation seemed to follow that of Blum's increasingly fractured and crumbling political coalition. As labor grew disillusioned with Blum, the construction crews at the Palais de Chaillot went on strike. Rivet had to accept that the museum would not open with the World's Fair in 1937 as announced, but in 1938. The delay bought the staff more time to transfer the osteological collections to the Musée de l'Homme, contact specialists for documentation (photographs, maps, nomenclature) and objects, and work out consistent spelling for the names of particular ethnic groups or languages.[120] Creating the double circuit was a challenge, given the vagueness of the assignment, the patchwork nature of the museum's collections, and the difficulty of translating ethnological theory into museographic practice. As Henri Lehman, then working on the American Hall, wrote to Soustelle in November 1936, "I'm not at all satisfied with where we are. Our general themes are insufficiently brought out; they are entangled in comparisons and sometimes too far removed from the annex themes." The results were so confusing, he concluded, that it seemed

[120] AMH/2 AM 1 A10/d/"Rapport mensuel du jeudi," 2 Sept. 1937. See also the 1937 "rapports hebdomadaires" in AMH/2 AM 1 D14.

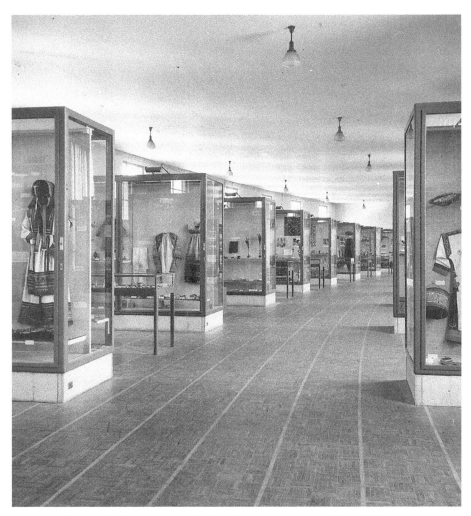

Asian Hall, Musée de l'Homme, 1939. Thanks to the new space acquired through the trans-formation of the old Trocadéro into the Palais de Chaillot, the viewing circuit of the galleries changed from the 1934 renovation to the 1938 one. After 1938, synoptic displays were grouped on one wall of the hall; more detailed analytical displays were grouped opposite them. AMH/PH/1998–14262-125. Photo courtesy of the Musée du Quai Branly/Scala/Art Resource, NY.

next to impossible to work out distinct circuits adapted to different groups' needs.[121]

The delay in the opening of the Musée de l'Homme also allowed the ethnographers to acclimate to Soustelle, who believed that the personnel, whether paid or volunteer, should equally divide administrative, research,

[121] AMH/2 AM 1 A9/d/Henri Lehmann à Jacques Soustelle, 19 Nov. 1936, no. 1341.

Jacques Soustelle, assistant director of the Musée de l'Homme, addressing striking workers during the construction of the Palais de Chaillot, 1936–37. AMH/PH/1998–14400–26. Photo courtesy of the Musée du Quai Branly/Scala/Art Resource, NY.

curatorial, and outreach tasks—tasks that were expanding given the museum's new popularizing agenda.[122] Soustelle paid attention as well to completing the scientific organization of the Musée de l'Homme. He created a new department of comparative technology, with responsibility for the anticipated Arts and Techniques Hall; in early 1939 he would place Lewitsky in charge.[123] He added a new Department of Drawings and Iconography as well, for all those "representations and reproductions that are not be cataloged as 'objects'"; the term "object," the staff collectively decided, was to apply only to "representations and reproductions made by natives themselves, for their own use, on their own initiative."[124] Thérèse Rivière was "promoted" to head of the Department of North Africa. She had recently returned from eighteen months of joint fieldwork with Germaine Tillion among the Ath Abderrahman tribe in the remote Aurès Mountains of Algeria, where Rivière had studied patterns of transhumance and material culture. Georgette Soustelle ran

[122] AMH/2 AM 1 B11/d/"Le laboratoire d'ethnologie. Son organisation," *Bulletin Mensuel d'Informations* (Musée de l'Homme) 1:4 (July–August 1939).
[123] AMH/2 AP 5 1.6/Anatole Lewitsky à Maurice Leenhardt, 22 June, 1939.
[124] AMH/ 2 AM 1 D14/a/Rapport mensuel, 2 Sept. 1937.

the American department alone, now that her husband was assistant director; and Charles van den Broek D'Obernon was convinced to set up the Oceanic department. Independently wealthy, he and his crew had sailed his yacht *La Korrigane* around the world from 1934 to 1936 and "harvested" objects in France's South Pacific islands for the museum. With this gallery filling out, Rivet and Soustelle felt they could open, and on 21 June 1938, the Musée de l'Homme was inaugurated.

In the summer of 1938, the Carnegie Corporation and the American Association of Museums sent Betty Holmes of the Colorado Museum of Natural History on a tour of European anthropology museums. Allowed to preview the Trocadéro, she concluded her published report as follows: "There is nothing completely new or without precedent in this new Trocadéro. . . . What makes it worthy of description is that we have here, on a scale never previously attempted, the best of modern educational method and the best of museum showmanship synthesized into a consistent whole."[125] A few months later, the *New York Herald* also called the Musée de l'Homme "one of the most complete and best arranged ethnological centers in the world, which is catching on like wildfire. Authorities announce that from now on it will be open three evenings a week."[126] And *Time* magazine reported that the "best idea" of the new museum was to have arranged "the showcases like text and footnotes in a book, one line of cases along left walls giving a bird's eye impression of each period of each civilization, while other cases standing out from the distant right wall contain complete museum collections." From the American perspective, the most noteworthy aspect of the Musée d'Ethnographie's second face-lift was clearly its modern attempts at outreach. A large segment of the French press agreed. *Candide* applauded the first café-bar in a Paris museum. For *Le Journal*, the Musée de l'Homme was above all a triumph of "rational organization and technicity," which broke happily with French "antimodern" tendencies. Armand Lanoux, in the Far Right *L'Émancipation Nationale* complimented Rivet on having transformed the ethnographic museum from "a dead to a living thing," now "the most youthful museum of Paris."[127]

[125] Betty Holmes, "Display Technics in Three European Museums of Anthropology," *Newsletter* no. 6 (Nov. 1938), Clearing House for Southwestern Museums, 20.

[126] AMH/2 AM 1 B2/b/*New York Herald Tribune*, 4 July 1938; AMH/2 AM 1 B2/d/*Time*, 30 Jan. 1939.

[127] AMH/2 AM 1 B2/b/Jacques Perret, "Le Musée de l'Homme au Palais de Chaillot," *Le Journal*, 19 June 1938; Jean Bouchon, *Candide*, 19 Nov. 1938; and Armand Lanoux, "Le tour du monde en 80 minutes, ou à la recherche du plus haut totem d'Europe," *L'Émancipation Nationale*, 27 Jan. 1939.

With reviews like that, Rivet, Rivière, and Soustelle had arguably reached one of the goals that Rivière had professed early on: to have all that American museums had, and more. Indeed had they not surpassed the latter when it came to popularization, by borrowing a card from the Soviets? In a 1937 article Rivière insisted that to reach the people, you needed galleries that synthesized information through photographs and large explanatory placards, and objects that had been "ultra selectionnés." The ideal museum, in short, was one that could be visited *without* a guide, as currently obtained in the Soviet Union.[128] By 1938, modernity at the Musée de l'Homme meant not just spare and electrified installations and an American-style bar, but synthesizing information to maximize communication.

But synthesizing and communicating what, and to what larger end? This chapter has dwelt on the modernizing form and projected audience of first the Musée d'Ethnographie, and then the Musée de l'Homme, because an embrace of the new and the didactic was unusual in Paris museums at the time; in this sense Rivière's handiwork exemplified how cultural innovation in France of the late Third Republic could sometimes occur more easily in marginal institutions than in mainstream ones. For Rivet, however, the creation of a "Grand Central" of the science of man, accessible to all, was tied by 1938 to another agenda: combating a resurgence of scientific racism, especially in Germany but in France as well. How effectively the Musée de l'Homme—especially with its addition of crania and skeletal remains—would challenge commonsensical and scientific notions of race difference and race hierarchy in an imperialist but also Fascist age is the subject of the next chapter.

[128] Georges Henri Rivière, "Les musées de folklore à l'étranger et le futur Musée des Arts et Traditions Populaires," *Revue de Folklore Français et de Folklore Colonial* (May-June 1936), 68.

CHAPTER 4

SKULLS ON DISPLAY

Antiracism, Racism, and Racial Science

Our primary objective is essentially to collect and popularize documentation on primitive populations. . . . By showing the richness and diversity of their practices and beliefs, we seek to illustrate the history of human endeavors and help to dispel prejudices against the supposedly inferior races.

—GEORGES HENRI RIVIÈRE À GASTON MONNERVILLE,
 22 December 1932

In 1938, Rivet's Musée de l'Homme opened its doors in Paris. After ten years of overhaul, it could proudly boast that it was the most modern of the world's institutions devoted to the display of humankind's cultural and racial diversity. Its guiding premise was that the entire natural history of man from the earliest hominins to modern "primitives" could and should be known, ordered, and presented to an audience made up of specialists and the masses. Yet Rivet had another ambition for his new institution. In Depression-era France, and in Europe more generally, racism reared its ugly head in ways not seen since the Dreyfus affair—among the larger public, on the political extremes, and among experts of all sorts, including some anthropologists. In the face of this resurgence, Rivet wished the museum's latest installations to carve out a progressive position on the race question that would challenge the scientific racism of the era. Did he succeed?

This question is not easy to answer. On the one hand, as we have seen, the first decades of the twentieth century had witnessed growing questioning among French sociologists and certain anthropologists of the validity of racial classifications as a meaningful way to study human variation. The renovated Musée d'Ethnographie and the Institut d'Ethnologie had been partially inspired by this move toward the study of civilizations and languages

independently of race, and the lion's portion of the museum was dedicated to the display of artifacts. On the other hand, when the Musée de l'Homme opened, race was directly represented in its displays. The museum included a physical anthropology hall, highlighting the prehistory and evolution of man through the ages as well as the major racial subdivisions of humankind. More surprisingly, the ethnographic galleries each included crania, suggesting, it would seem, a link between biology and level of social development.

Given the humanistic outlook that informed so much of Rivet's ethnography, how are we to account for these seemingly anomalous skulls on display in the galleries otherwise devoted to the social and cultural lives of individual peoples? This chapter seeks to answer this question by exploring Rivet's views on race, then contextualizing them with reference to what other anthropologists and biologists of the era were writing. In the interwar years, the nineteenth-century project of race classification and the belief that race correlated in some way with capacity received a new lease on life internationally, thanks to the recovery of Mendel's laws in 1900 and the birth of modern genetics, the development of biometrics, and the discovery of human blood groups and their distribution. These developments meant that in the 1920s and 1930s, the biology of human differentiation remained unsettled. If most anthropologists and biologists rejected older notions of racial purity and racial stability, they had yet to show how heredity interacted with the environment to produce the physical distinctions vital to racial classification. In the face of these uncertainties, even the most antiracist interwar ethnologists continued to accept race as an essential biological component of human identity while also analyzing societies in cultural and historical terms—the product of human volition and intermixing, not of some pure essence. Rivet very much fell into this category.[1]

Other academic ethnologists, however, used this same uncertainty to put forward new racist theories that argued *for* the permanent inferiority of certain human groups and the potential purity of others. The most infamous new anthropological school of heredetarian racist science to emerge in Europe after World War I developed across the Rhine under the name *Rassenkunde*. It sought to bring physical anthropology and ethnography into a single holistic discipline in which race and culture always correlated.[2] France's community of human scientists in the 1920s and 1930s nevertheless had its own version of this trend, whose most visible and disturbing representative was George Montandon. While Rivet wished the Musée de l'Homme to counter the theses of these

[1] Following Barkan, *Retreat of Scientific Racism,* I use the terms "racist" and "antiracist" in this chapter to designate scientists who sought to publicize the findings of science, in an effort to argue one or another point of view in the politically charged 1930s.

[2] For a succinct overview of this shift, see Evans, *Anthropology at War,* chap. 6. *Rassenkunde* represented a "new" racial science that held that race and culture were necessarily linked genetically.

extreme scientific racists—whether homegrown or foreign—it is unclear what message museumgoers would have taken away with them; there was, after all, only so much antiracist work that Rivet's installations could do in an age of flourishing scientific theories of racial essentialism, as long as he continued to believe in—and place on display—racial typologies and crania in the midst of artifacts.[3]

Before turning to an analysis of Rivet's galleries and the larger world of interwar racial science, a few additional words are in order about museum installations as particular kinds of archives for recovering the ideas of the past. There is never a direct fit between ideology, science, and museum display, even in the best of circumstances. Although modernizing in form and audience, for its content the Musée de l'Homme drew in part on vestigial collections, such as the skulls and skeletons formerly housed in the anthropology laboratory at the Muséum. Inevitably, the categories of knowledge and visual practices of these earlier collections influenced their later display.[4] Founded as a study of difference, anthropology first became "scientific" by rendering visible, through disciplined measurement and categorization of crania, the immutable and unequal racial essences that ostensibly underpinned human diversity. More often than not, curators had supplemented these collections with photographs or busts of representative individuals, presented as specific instantiations of generalized racial archetypes whose difference could be read in their very bones. This tendency to embody race difference in a *particular* selection of measurable features had been, as we have seen, especially strong among nineteenth-century French anthropologists. After a century of naturalization in authoritative collections, race typology had become part of a modern way of seeing (racial) difference, and proof of its existence. Along with the uncertain results of modern biometric and genetic research, this highly developed "visual regime" made it difficult for antiracist ethnologists to challenge the biological reality of race in the interwar years.[5]

It marked a departure from the liberal nineteenth-century German tradition of studying physical traits independently of psychological and cultural ones, which had allowed physical anthropology and ethnography to develop as separate disciplines. *Rassenkunde* practitioners believed that a new understanding of heredity would allow them to prove the link between the "Volk" and race in a way that had eluded previous generations of race classifiers; these new scientists focused their energies, in the wake of the Treaty of Versailles, on the racial mapping of Central Europe. On *Rassenkunde* exhibits in the 1920s see Evans, "Race Made Visible: The Transformation of Museum Exhibits in Early Twentieth-Century German Anthropology," *German Studies Review* 31:1 (2008): 87–108.

[3] For an analysis of similar mixing of the categories of race and culture among American anthropologists, see Tracy Lang Teslow, "Reifying Race: Science and Art in *Races of Mankind* at the Field Museum of Natural History," in Sharon Macdonald, ed., *The Politics of Display: Museums, Science, Culture* (London, 1998), 53–76; Teslow, *Anthropology and the Science of Race*.

[4] For an in-depth exploration of how a later French museum remained a prisoner of its past collections, see Sherman, *French Primitivism*, chap. 2.

[5] I borrow the term "visual regime" from Nélia Dias, "The Visibility of Difference: Nineteenth-Century French Anthropological Collections," in Macdonald, *Politics of Display*, 49. See also, for comparative purposes, Zimmerman, *Anthropology and Antihumanism*, chap. 3.

From a museographical point of view, it is also unclear how contemporaries might have represented more complicated ideas about race when scientists themselves disagreed about how to explain human variation. The Musée de l'Homme's pedagogical vocation militated even further against a nuanced presentation of what race was, since the curators had to simplify the content of any text affixed to their objects. The objective of all museums in this era was not to demonstrate that scientific truth might be debated among scholars, but to offer a reassuring vision of science as agreed-on-truth.[6] In the late 1930s, the biological reality of race was still "true" enough to warrant its public display in an institution devoted to the science of humanity in all its aspects. With these caveats in mind, let us first visit the museum, then proceed to competing scientific notions of race in the interwar years.

A Guided Tour

Reconstructing the Musée de l'Homme's exhibits is challenging, since the photo archives from the era are incomplete. Rivet refused to publish a catalog at the museum's opening, on the grounds that exhibits even in the permanent galleries should constantly change "to excite [the public's] curiosity."[7] A further difficulty is posed by Rivet's belief that "politics" and "science" could and should be kept separate. Rivet most directly condemned Hitler's regime by becoming one of the founding members of the group Races et Racisme—an association of public intellectuals organized in 1937 whose monthly newsletter by the same name was designed to alert the public to the atrocities occurring in Germany, and to publicize efforts being made around the world to fight Nazi racism. In the museum, however, the facts were supposed to speak for themselves.

Despite the gaps in the archival record, it is possible to piece together partially the original displays of the Musée de l'Homme from press reports, extant photographs, notes from the weekly meetings held by the museum staff, and later descriptions.[8] The museum-laboratory occupied one of the two central towers of the Palais de Chaillot and the two upper floors and basement of the west wing. The permanent display halls were found principally on the first and second floors of the west wing, and most of the gallery space was devoted to

[6] On this point, see Teslow, *Anthropology and the Science of Race,* introduction.

[7] Paul Rivet, "The Organization of an Ethnological Museum," *Museum* 1:1–2 (January-December 1948): 112.

[8] For example, Philippe Thomas and Jean Oster, *Le Musée de l'Homme* (Rennes, 1982) is helpful for reconstructing the displays.

the ethnographic halls organized by "civilizational" area, where the "material and moral life" of the major ethnic groups was represented.[9] The goal here, as Rivet put it retrospectively in 1956, was to relativize "white" achievements by showing that technical accomplishment was the shared heritage of all humanity: "To demonstrate that our civilization, of which we are rightfully proud, is in part the result of contributions that we owe to the entire world, and that therefore the genius of invention is not the privilege of the White [Man]."[10]

The "official" itinerary began at the doorway, where a gigantic totem pole from British Columbia greeted visitors as they entered the foyer. There they met a magnificent sculpted head or moai (a human figure carved from tuff) from Easter Island, and the display case of the month along with a huge globe (*mappemonde*).[11] Panels indicating the layout of the museum's rooms next oriented the visitor toward the Anthropology, Paleontology-Prehistory, and African Prehistory halls (1000 sq. meters). The visit continued with "contemporary man in the five parts of the world": first, the Black African Hall (500 sq. meters) and its adjoining Madagascar section (50 sq. meters), then the White African and Levant Hall (350 sq. meters), and finally the European displays (410 sq. meters), all on the first floor. On the second floor one began in the Arctic Hall (140 sq. meters), proceeded to the Asian Hall (650 sq. meters), then on to Oceanian Hall (440 sq. meters), and finally ended the visit with the Americas (1100 sq. meters).[12] A comparative gallery devoted to arts and techniques organized thematically rather than by ethnic group was planned, but not yet open, as a kind of conclusion to the entire ethnographic section of the museum.

All of the anthropology and prehistory galleries were designed to instruct viewers on the evolution of humanity and classification of the races. At the entrance to these galleries, several huge maps of the world lined a wall, one each showing the world's topography, races, peoples, political divisions, and languages.[13] For those who cared to think about it, the maps made clear that the boundaries between these different categories did not coincide. In the anthropology section, an important theme was illustrating the physical characters that anthropologists used to delimit the various human types, including hair form and hair color, pigmentation, eye color and eye form, head form, nasal form, jaw form and lips, the form of breasts and buttocks, and stature.

[9] Leiris, "L'Exposition."

[10] Paul Rivet, "Réponse à Jean Cassou," *France Observateur*, 26 July 1956.

[11] The traveler-writer Pierre Loti had given this moai to the Muséum in 1872.

[12] AMH/2 AM 1 B2/d/Michel Maubourg, "Le tour de l'humanité," *L'Écho d'Oran*, 6 Jan. 1939.

[13] AMH/PH/1998–14434–26, 1998–14435–26, and 1998–14490–26. Much of the following description is taken from the photographs in the Musée de l'Homme's *photothèque*, now housed in the Musée du Quai Branly. Many of the original photographs have been digitized and given a new classification that begins with 1934 or 1998. All other photos are cited by their original classification.

Some displays showed the differences between head forms in the skeleton structure of the various races, complete with skulls and photographs of living men and women belonging to each race. Another had examples and photographs of typical jaw bones and teeth. Rather than simply invoking the cephalic index, the latter was explained with the help of diagrams and skulls as well as a display of the anthropologist's "tool kit" for taking measurements. One case highlighted skulls differentiated by sex. The distribution of blood groups throughout the world was diagrammed on a large map, reflecting an important new development in the science of race classification.[14]

The anthropology gallery also featured the original plaster cast of Sara Baartman (b. late 1770s–1815), alongside her skeleton, to illustrate the "racial" trait steatopygia.[15] Photographs of bare-breasted European women side by side images of naked "primitive" women were included in a case devoted to different breast types (part of a larger display devoted to prognathism, the eye, and hair types). Other displays included the stages in the development of the human embryo from eight to twenty-two weeks (a series of embryos in formaldehyde), the growth of the human skeleton from age three and a half to five, and skeletons deformed by various abnormalities and pathologies. Yet more cases exhibited "trophy heads and funerary rites." Last but not least, a section of the Anthropology Hall was devoted to each of the three major "races" of the world (Black, Yellow, and White) and their subdivisions. These display cases included some cranial. Photographs of living racial types (male and female), maps indicating where the races in question could be found, and a brief descriptive notice naming the types who belonged to each race completed this section.[16] If one followed the installations in numerical order, "les Noirs" came first, followed by the intermediate group "les Jaunes." "Les

[14] AMH/PH/1998–14411–26 through 14414–26; 1998–14398–26; 1998–14421–26; C 40–1645–54; C 48–2654–493; C 40–1640–54; C 48–2160–493; C 40–1383–54; C 40–1384–54; C 40–1643–54; C 48–2155–493; C 48–2159–493. In France, the great popularizer of classifying types according to blood groups in the interwar years was René Martial. For an extended discussion of Martial's ideas and impact, see Schneider, *Quality and Quantity*, 231–55; and Pierre-André Taguieff, "Catégoriser les inassimilables: Immigrés, métis, juifs. La sélection ethnoraciale selon le Docteur Martial," in Gilles Ferréol, ed., *Intégration, lien social et citoyenneté* (Paris, 1998), 101–34.

[15] For the tragic history of how Baartman's remains came to be in Paris and the continuing struggle over their meaning, see F.-X. Fauvelle, "Le Hottentot, ou l'homme-limite. Généalogie de la représentation des Khoisan en Occident, XVe-XIXe siècle" (Thèse de doctorat, Université de Paris I, 1999); Clifton Crais and Pamela Scully, *Sara Baartman and the Hottentot Venus: A Ghost Story and a Biography* (Princeton, NJ, 2010); and Barbara Sorgoni, "'Defending the Race': The Italian Reinvention of the Hottentot Venus during Fascism," *Journal of Modern Italian Studies* 8:3 (2003): 411–24.

[16] AMH/PH/C 48–2157–493; C 56–1109–682bis; C 48–3158–493; C 48–2156–493; C 40–1361–54; C 41–469–54; C 47–654–540; C 56–1123–682bis; C 39–2244–54; C 39–2345–54; C 40–1644–54; C 46–1356–493; C 40–1638–54; C 40–1639–54; C 40–1641–54; C 40–1642–54; C 40–1646–54; C 40–1647–54; C 40–1648–54.

Blancs" came at the end of this parade of humankind, implicitly occupying the most advanced position on a linear evolutionary scale, although there were no descriptive tags proclaiming the superior achievements of the Nordic, Alpine, and Mediterranean races.

The Anthropology Hall was not only about racial differences; the single human embryo on display was a tacit admission that humanity was one. But racial classification featured prominently as a theme in the skeletons and skulls that the museum's staff chose to display there. In the Paleontology and then two Prehistory halls, in contrast, the point was to demonstrate the physical, technical, and cultural evolution of humans; the first prehistory gallery documented remains found in France, the second Africa. Skeletons of anthropoid apes figured alongside those of humans to facilitate comparisons and help "situate . . . our species in the animal kingdom."[17] Another contained Cro-Magnon fossil remains, for a purpose of this part of the museum was to show all the human races, living and extinct.[18] Maps illustrated sites for such remains. Casts of ancient skull types were associated with certain implement types, and various series of stone-, bronze-, and ironwork were displayed. Both of the prehistory sections ended with cave art (from French, Saharan, and South African locations). The African prehistory gallery led next into the Black and White African halls; small sections on the prehistory of Asia and the Americas were included at the beginning of each of the ethnographic halls devoted to those continents.

If we now follow the trail of crania through the rest of the museum, the first thing to note is that, in the vast ethnographic galleries, their presence was much more discreet. The guiding principle was to highlight the different ethnic groups peopling each geographical area, along with representative objects from everyday life. Although information here is again incomplete, the kinds of artifacts chosen varied considerably from one geographical area to another, depending on what was available in the collections that Rivet had inherited or been able to acquire. Most of the objects featured in the large analytic display cases (the "footnotes") were devoted to a particular aspect of social, material, or spiritual life.[19] From African prehistory one entered the vast Sub-Saharan Africa Hall, whose collections were among the most impressive because of France's many colonies in West and Equatorial Africa. Presented mostly in

[17] M. V. Fleury (Eugène Schreider), "Le Musée de l'Homme," *Races et Racisme* 16–17–18 (Dec. 1939): 2.
[18] AMH/2 AM 1 B2/d/ R.F.S., "A Museum of Man," *Manchester Guardian*, 14 April 1939; AMH/PH/1998–14412–26 and 1998–14417–26.
[19] Roger Falck, "Technique de présentations des vitrines au Musée de l'Homme," *Museum International* 1:1–2 (Jan./Dec. 1948): 70.

a "timeless" present, there were nevertheless some references to a historical past; the gallery, for example, included statues and the throne of the nine-teenth-century Dahomey kings Glélé and Béhanzin, as well as polychrome plaques from the royal palace, which the French had seized when they had conquered the monarchy in 1894.[20] Ethnic groups from the colonies predom-inated; the exceptions were a few displays on Central Africa (Kasai grass-velvets from the Congo), East Africa (Masai ivory bracelets) and South Africa. A section on Madagascar preceded a display of Ethiopian frescoes taken dur-ing the Mission Dakar-Djibouti (1931–33) by the ethnologist Marcel Griaule from an early Christian church in Gondar—a display that attached this part of Africa culturally to the West.[21] In the White Africa and Levant Hall, the curators highlighted the importance of Islam while dividing the gallery into sections on nomads, oasis dwellers, and mountain peoples; urban life was also represented by one case. The scant European collections contained mostly southern, central, and eastern European folklore represented through reli-gious icons, musical instruments, woodwork, pottery, and especially clothing.

The "official" tour continued on the second floor with the Arctic Hall, which featured eighteenth- and nineteenth-century ivory carvings and tools from the Inuit of Alaska and Canada. André Leroi-Gourhan's demonstration of the life cycle of contemporary Inuit from the Angmassalik region of Green-land was the centerpiece, supplemented by the new collections that Institut d'Ethnologie students Robert Gessain and Paul-Émile Victor had brought back to Paris from their fieldwork in the mid-1930s. The Asian collections were uneven. First came Stone and Bronze Age artifacts, followed by Sibe-rian and Ainu displays, sections on Tibet, Afghanistan, and India, then single cases of Chinese theater costumes and Japanese armor. The most extensive ethnographic artifacts were from the Vietnamese highland minorities, which reflected a 1935 decision by Rivet to concentrate collecting in Indochina as opposed to "China and India, whose transformation is relatively slow."[22] By comparison, the Oceanian and American halls were, like the African galler-ies, among the museum's most eye-catching and richest. In the Oceanian gal-leries, old and newer dramatic masks and sculptures from New Guinea, the Solomon Islands, the New Hebrides, New Caledonia, the Marquesas Islands, Easter Island, and Hawaii dominated, making spiritual life and aesthetics the

[20] On the history of the Dahomey collections, see Marlène-Micheline Biton, *L'art des bas reliefs d'Abomey* (Paris, 2000); and Biton, *Arts, politiques et pouvoirs. Les productions artistiques du Da-homey. Fonctions et devenirs* (Paris, 2010), chaps. 1–3.
[21] AMH/PH/1934–4131; 1934–4133; 1998–19152; and 1998–14472–26. The colonial origins of these collections are discussed in chapter 5.
[22] AMH/2 AM 1 A8/a/Paul Rivet et Georges Henri Rivière à M. le Directeur, Maison Franco-Japonaise, 21 Jan. 1935, no. 172.

focus, although the tools of everyday life were also well represented. Alfred Métraux, on mission for the museum to Easter Island in the mid-1930s, had brought back more than 200 objects, including a second monolithic moai. A 1938 description of the Musée de l'Homme prepared by Soustelle for *Les Informations Parisiennes* called particular attention to the visual appeal of the Oceanian Hall; at the Musée de l'Homme, this press release stated, one would find "Peoples and Races. Disappeared Civilizations. The Arts of Oceania."[23]

The "disappeared civilizations" referred to by Soustelle were, of course, those of Mesoamerica and South America. The American galleries were also divided geographically. First came Terra del Fuego, Patagonia (represented by painted skin-capes), and Amazonia; here could be seen the oldest ethnographic artifact in France, the feather coat of the Tupinamba brought back from Brazil in the sixteenth century. Collections from the Andes, the Antilles, Mexico, and North America followed: ancient Peruvian textiles; Mochicha, Chimu, and Nazca earthen vessels; Incan metal-work and pottery; Jivaro shrunken heads; two large funerary urns (Colombia); and pre-Aztec and Aztec sculptures and jadework. The dominant narrative mode was thus historical and archaeological—the rise and fall of empires with photographs and explanations of key sites—although contemporary Amerindians were also represented, albeit thinly, in the gallery's other sections.

And where did skulls fit in any of these exhibits of the world's peoples, cultures, and civilizations? In keeping with the double-circuit principle, all the ethnographic galleries contained not only the large and detailed analytic cases on one side, but smaller synthetic cases—for specific regions or races, with accompanying wall panel—on the other side. The panel usually included the geographic region, the local race(s) or ethnic group(s), several maps and photographs, and a typed text with the rubrics "geographic description, political divisions, material life, populations." Within the case were grouped "anthropology, typical objects, photographic documentation, and small typed texts describing *l'homme,* social life, and religion."[24] These synthetic cases almost always had one shelf with crania; the other shelves illustrated a typical "technique" from the area or group in question. For example, in the American Hall there was a case on "Middle America" (Amérique Moyenne) with a shelf with three crania, underneath which was another shelf devoted to "maize and manioc"; on the other side of the same case, ceramics were displayed.[25] Many of the permanent galleries also had a separate case devoted to the races of the

[23] AMH/2 AM 1 A11/d/Jacques Soustelle à M. Sourdis, *Informations Parisiennes*, 12 Oct. 1938, no. 1567.
[24] Falck, "Technique," 70.
[25] AMH/PH/B 43–15–427.

larger region, often but not always with skulls. At the entry of the American Hall, a case devoted to the "races d'Amérique" explained through panels that modern science had concluded that these peoples had originally migrated from somewhere else. Thus "America was not a cradle of humanity."[26]

The Asian Hall had at its entrance a case devoted to "les races d'Asie" that contained only crania.[27] In the Russian section, the synthetic displays on the Turks, Mongols, and Finno-Ugrians included skulls.[28] There were individual exhibits of Iranian and Chinese crania in another section of the gallery. A whole section of the Asian Hall was devoted to French Indochina. Here, too, skulls figured in the introductory synthetic case, and in the exhibits on Cambodians, Thais, "Annamites," and the "hill tribes"; there were also displays devoted to their traditions, crafts, clothing, and way of life. Some ethnic groups were described with no accompanying crania. In the North and Sub-Saharan Africa halls, skulls were displayed as well. Sections on nomadic life in North Africa and the Levant featured skulls, alongside weapons and camel saddles, or descriptions of agriculture and commerce. The Sub-Saharan Africa Hall had the most crania, but also the most synthetic display cases. Several included skulls, among them those labeled "Negroes [Nègres], East Guinea," "Negroes, Southern Africa," "Negroes, French Soudan," "Negroes, Senegal," "Negroes, North Central Africa," "Negroes, South Central Africa," as well as "Northern and Southern Ethiopians," "Haoussa," and "Hottentot Negrilloes [Négrilles]."[29]

The juxtaposition of crania and man-made objects was not new in museums in France or elsewhere. The Musée d'Ethnographie had included human remains when it opened its ethnographic collections in 1878 under the direction of Hamy. As Nélia Dias has argued, for Hamy, the physical and the cultural were always conjoined, and for each stage of a people's evolution, bones could be matched to man-made objects. In such a system, the skull of the producer of an artifact "naturally" belonged next to the artifact itself, and all of humanity shared the same basic needs and evolutionary trajectory.[30] Rivet's training was in the tradition of Hamy, and this continuity accounts in part for the layout and content of the Musée de l'Homme's installations. Indeed it is tempting to argue that when the opportunity finally presented

[26] AMH/PH/C 53–1161–493; see also the following photographs of wall panels in the American Hall: C53–1429–493; C 40–1671–54; C 40–1675–54; C 40–1676–64.

[27] AMH/PH/C 47–2016–493.

[28] AMH/PH/C 47–1961–493.

[29] AMH/PH/B 42–3189–427; C 48–1620–493; C 48–1628–493; C 53–3681–493; C 56–1092–682bis; C 48–1623–493; C 64–10657–493. I have found no photographic evidence of the presence or absence of skulls in the displays in the Oceanic section.

[30] Dias, Le Musée d'ethnographie, 153–55.

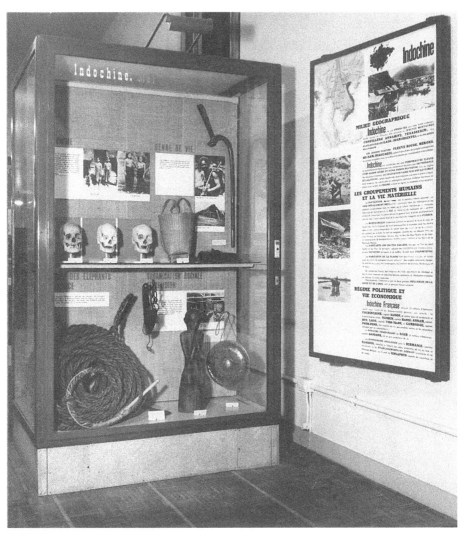

Introductory display with skulls, Indochina section, Musée de l'Homme, 1939. Next to this case is a wall panel on Indochina devoted to "Generalities," with the following subheadings: "geographic milieu," "human groups and material life," and "political regime and economic life." AMH/PH/1998–14407–26. Photo courtesy of the Musée du Quai Branly/Scala/Art Resource, NY.

itself to bring the ethnographic and physical together under one roof, Rivet remained as much a prisoner of past ways of thinking about the classification of humanity as he did of the Musée de l'Homme's inherited osteological collections. Yet this would be inaccurate, both because Rivet had imbibed a Durkheimian view of culture as social rather than biological in origin, and because his writings make clear that he had a firm grasp of how tentative

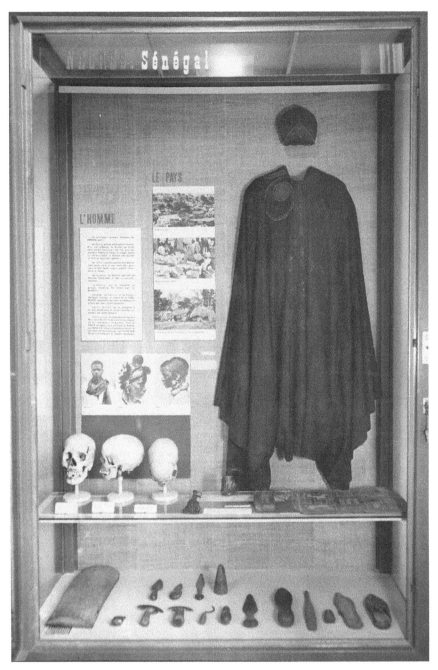

Introductory display with skulls, Senegal section, Musée de l'Homme, 1942. AMH/PH/
PP0093480. Photo courtesy of the Musée du Quai Branly/Scala/Art Resource, NY.

certain former scientific truths about race had become since the late nineteenth century.

PAUL RIVET'S RACIAL SCIENCE IN 1930

One pathway into the scientific thinking that informed the display of skulls in both sections of the Musée de l'Homme is Rivet's own rare published statements on the question of race, supplemented by those of his staff. Rivet's most comprehensive statement on the place of race in the overall discipline of ethnology can be found in a lengthy 1930 scientific article entitled "Les données de l'anthropologie." The article was divided into two parts: Part I, on "dialectic and methods," and Part II on "the facts" of the science of man.[31] Part I established that anthropology as a synthetic discipline encompassed much more than anthropometry, whose nineteenth-century methodology was universally recognized as faulty. Anthropology was in fact made up of three core disciplines: an "updated" physical anthropology that sought to classify human groups using statistical analysis, blood-typing, and genetics; linguistics; and ethnography broadly defined (to include prehistory, sociology, and archaeology). Rivet then explored the relationship among these three branches, before examining each branch in turn. Having succinctly defined anthropology and its "methods," he devoted Part II of the article to the "facts." Here he declared the "facts" of civilization were too vast, too complex, and too uncertain to be summarized without grossly simplifying. Thus he would limit himself to a discussion of the findings of prehistorians on the earliest races of man (Neanderthal, Cro-Magnon, and so on), as well as what was known about the modern races and language groups of the world.

Rivet's article makes clear that his interest in race was for the most part historical; he sought to explain how the modern races differed from humans' ancestors, and how the prehistoric or fossil races had first come into contact with each other as they spread across the globe. This last preoccupation was understandable, given the prominence of French paleontologists internationally, many of whom were his colleagues at the Muséum. But it also reflected

[31] Paul Rivet, "Les données de l'anthropologie," in George Dumas, ed., *Nouveau traité de psychologie* (Paris, 1930), 1:55–101; see also Rivet, "L'étude des civilisations matérielles. Ethnographie, archéologie, histoire," *Documents* 3 (1929): 130–34; Rivet, "Ethnologie," in *La science française* (Paris, 1934), 2:5–12; Rivet, "Ce qu'est l'ethnologie," in *Encyclopédie française,* ed. Lucien Febvre, vol. 7, *L'Espèce humaine* (Paris, 1936), 7.06-1–7.08-16; Rivet, "L'ethnologie en France," *Bulletin du Muséum National d'Histoire Naturelle* 12:1 (Jan. 1940): 38–52; Rivet and Rivière, "La réorganisation du Musée d'Ethnographie"; and Lester et al., "Le laboratoire," 507–31. These articles repeated the same information, as Rivet sought to publicize his reforms.

his own expertise as an Americanist and as a "moderate" diffusionist, who had long sought to identify the past migrations that peopled the American continents (see chapter 2). Rivet explained that he had reached his controversial conclusion that the original South Americans had traveled by canoe from Melanesia first by comparing skull forms—to no avail—and then by studying language patterns. His position on the value of studying racial characteristics was that of the three kinds of facts (racial, linguistic, and archaeological) with which anthropologists *always* had to work, anatomical characteristics were the *least* reliable.

Two peoples who came into contact almost invariably produced a new mixed people "having characters borrowed from the two peoples who had fused." Given that the original two peoples were already themselves mixed or "métis," it then became "almost impossible to find in this mix the dominant physical type of each."[32] Languages, on the other hand, rarely fused at moments of contact between two distinct peoples; one language persisted "in its internal structure [*structure intime*], in its grammar," even if its vocabulary changed. Language was thus a key marker for understanding community of origin. Ethnographic evidence—what Rivet referred to as "civilization: objects, customs, conceptions"—fell somewhere in the middle.[33] Two civilizations often mixed to produce an entirely new type, again making it difficult to sort out which elements originated with each of the two "parent" civilizations. Yet a people conquered by another rarely adopted a new language without also adopting the civilization expressed through that language. At the end of the day, this meant that the three kinds of evidence were always "congruent" (*solidaires*) rather than "independent of each other."[34]

Rivet's insistence that physical characteristics—despite their unreliability—be taken into account when defining a people provides another revealing clue to his attitude toward race. He fully accepted that one task of anthropology was "the diagnostic of different human races and their distribution among the diverse groups of populations; it corresponds to both *la systématique* and to human biogeography." But he also recognized that anthropologists had erred in the past by relying too heavily on certain measurements—typically the cephalic index (percentage of breadth to length in any skull)—to try to identify the different physical types among human populations, and by assuming types to be fixed. Such measurements often produced averages that placed morphologically different populations close together (Great Russians

[32] Rivet, "Les données de l'anthropologie," 58.
[33] Ibid., 57–58.
[34] Ibid., 60.

and Salamander Islanders, for example, had the same cephalic index), rendering the classification meaningless.[35] Rivet argued that anthropologists needed to work comparatively on entire series of individuals within two given populations, in order to decide whether they were dealing with a relatively pure or a mixed group. The former was, he acknowledged, extremely rare. It could only be found among peoples who had lived in complete geographic isolation for centuries, if not millennia. Well-characterized human types had existed only in the mists of prehistory. Indeed, once "all the fossil races are known, it will be relatively easy to trace their descendants in the protohistoric races and in this way reach the modern races." Meanwhile, biologists working on unraveling the rules of heredity would surely soon facilitate "the study of mixed populations who constitute the great majority of living humanity." In addition, the "study of serological reactions in the different races" should in the near future provide "a remarkable tool of ethnic diagnosis."[36]

Rivet, then, was not intellectually opposed to the project of racial typology, while accepting that racial mixture was part of what had advanced human civilization historically, since all modern peoples were mixed. But as the above statements suggest, he had increasing doubts about the viability of older methods for determining racial (or ethnic—he tended to use the terms interchangeably) identity, preferring newer tools for sorting out accurately the world's current populations. Rivet did not suggest that skin color, or any other morphological or anatomical feature, had any necessary connection to culture. Anthropologists, he insisted, should also always study civilizations comparatively. Only a civilization studied in tandem with the civilizations that surrounded it would reveal "relations, affiliations, and . . . the paths by which cultural elements were diffused."[37] Last but not least, however congruent the three kinds of diagnostic evidence at the disposal of anthropologists were, Rivet concluded that language remained the single most reliable kind of evidence for understanding the past. According to Laura Rival, this conviction can be traced back to Rivet's five years in Ecuador, where he had been struck by the fact that several centuries of biological intermingling between Spanish and Indians had not diminished the cultural or linguistic diversity of the local peoples, which proved that human biology and languages did not change at the same rate or in the same direction.[38]

[35] Ibid., 61–62.

[36] Ibid., 65–66.

[37] Ibid., 66–67.

[38] Rival, "What Sort of Anthropologist?" 141–42. Rival argues that Rivet pioneered a theory of *métissage* that resonated deeply with Latin American Creole intellectuals, especially after World War II.

Given Rivet's early skepticism about what thoroughly mixed modern bodies, as opposed to "fossil" bones, could actually tell anthropologists about origins, and his greater interest in the diffusion of languages and cultures, it might seem surprising that he did not dispense with racial diagnostics on contemporary peoples altogether. Yet no physical anthropologist in pre–World War II Europe or America—regardless of his or her politics—was ready to do so; racial classification was simply too entrenched institutionally, and not only in France. In addition, anthropologists were continuing to develop new approaches to understanding race borrowed from allied disciplines, which appeared to prove the continued viability of racial science. For example, biologists' discovery of the ABO blood system in 1900, and then in 1910 that blood groups were inherited according to Mendelian laws of heredity, seemed to promise a more reliable basis for defining race. In the end, blood-typing would run into the same problems as the old anthropometric classifications— that is to say, "peoples with very different historical backgrounds and physical features had precisely the same distribution of blood groups in their populations."[39] Yet because serological studies took off in France only in the 1930s, such problems were not evident before World War II.

Alongside blood-group typing, statistical tools pioneered by the British biometricians Francis Galton and Karl Pearson in the early twentieth century also appeared to offer more refined quantitative methods than those used in the past for sorting human beings into bounded racial categories. Rather than settling for simple averages, biometricians analyzed biological measurements statistically to yield averages, distributions, indices, and frequencies among series. Their work was predicated on the idea that race was a statistical notion that could not be credibly instantiated in a single individual but still existed as a biological reality. In the right hands—Boas's 1911 study proving the plasticity and instability of the quintessential "racial" marker, the skull, comes to mind—biometrics encouraged anthropologists to explore more carefully the role of environment in shaping human biological difference, with no prior assumption that race determined capacity.[40] Yet even Boas continued to think of lines of heredity in a broadly typological manner, one that anticipated but did not yet share a postwar conception of difference informed by population genetics.[41] Biometric methods had some influence in France in the 1930s, much more so than another even newer technique of racial science based on quantitative methods: the field of race psychology that began to develop in the

[39] Schneider, *Quality and Quantity,* 227.
[40] Teslow, *Anthropology and the Science of Race,* introduction and chap. 1. See also Barkan, *Retreat of Scientific Racism,* chap. 3.
[41] Teslow, *Anthropology and the Science of Race,* chap. 1.

United States after World War I, using intelligence testing to try to prove that race determined mental capacity.[42]

If Rivet was optimistic in 1930 about the power of new racial diagnostic tools to sort races once and for all, had his position changed later in the decade, given the paroxysms of racist hatred unleashed by the combined pressures of the Depression, Hitler's policies, and the rise and collapse of the Popular Front? Not much, even though across the Rhine scientists with distinguished academic careers under Weimar were at the forefront of using such tools to support Nazi political ends.[43] In the late 1930s, Rivet developed his earlier ideas in two further statements, whose only real difference with his earlier one was that they were directed to a broader audience. The first was a short newspaper article entitled "Two Words from a Friend of Youth: Professor Paul Rivet on the 'Problem of 'Races,'" which appeared in the popular leftist weekly *L'Oeuvre* on 13 September 1938. Rivet's opening salvo was unequivocal on the question of pure races: "We are all mongrels [*chiens de rue*], and contemporary humanity is nothing but the product of an enormous mixing that began in the Quartenary period." However, when the interviewer asked him about whether new blood-typing research did not substantiate *les thèses racistes*—a question that revealed how quickly this new scientific method had been misappropriated over the course of the decade for anti-Semitic ends—Rivet did not condemn the tool that he had endorsed in 1930. Instead he toned down his enthusiasm, asserting that while it was still too early to draw ethnological conclusions from serological studies, "they might prove useful in determining racial ancestry."[44]

Rivet's second "race" statement from the late 1930s conformed even more to this pattern. It was part of a set of articles devoted to the science of races at the Musée de l'Homme that was featured up front in the December 1939 issue of the antiracist journal *Races et Racisme*—its final edition, as it turned out. Scientists had not been the primary contributors to the journal so far, but

[42] On the American school of "race" psychology, see Graham Richards, *"Race," Racism, and Psychology: Towards a Reflexive History* (London, 1997), chap. 4. This school was contested by antiracist psychologists from the outset. For the use of American methods of race psychology by a small number of anthropologists in interwar Germany, see Egbert Klauptke, "German 'Race Psychology' and Its Implementation in Central Europe: Egon von Eickstedt and Rudolf Hippius," in Marus Turda and Paul Weindling, eds., *Blood And Homeland: Eugenics and Racial Nationalism in Central and Southeast Europe, 1900–1940* (Budapest, 2007), 27–28.

[43] Rivet was hardly alone. Antiracist Soviet anthropologists and ethnographers in the 1930s shared the same conviction that racial classifications, like linguistic ones, were an important tool for determining the history of a people, whose use carried no necessary prejudice. Hirsch, *Empire of Nations*, chap. 6.

[44] Paul Rivet, "Deux mots d'un ami de la jeunesse, le professeur Paul Rivet sur le problème des 'races,'" *L'Oeuvre,* 13 Sept. 1938, 6. See also Schneider, *Quality and Quantity*, 244.

the essays included in the 1939 issue were exceptionally authored by Institut d'Ethnologie/Musée de l'Homme ethnologists. As one of the founders in 1937 of *Races et Racisme*, Rivet was surely the inspiration behind the issue, and he wrote the first article on race in the series, "L'origine des races humaines."[45] Articles on the races of each continent followed, written by the Musée de l'Homme's young department heads. A biometrics enthusiast, Eugène Schreider, wrote the closing essay of the series, entitled "How One Studies Human Races." A closer look at this issue further illuminates the contours of Rivet's antiracist racial science on the eve of World War II.

As the title of Rivet's article in the series indicates, his perspective on race in 1939 as in 1930 was that of "deep history" or geological time—the only time when pure races existed. In "L'origine" he again patiently explained that the upper Pleistocene (125,000–10,000 years ago) had witnessed both the appearance of polished stone tools and cave paintings, and the original racial diversification of humanity: "We find in the upper Pleistocene in Asia and in Europe the representatives of the three great subdivisions of our species, . . . a white type, a black type, and a yellow type."[46] Having established this crucial fact, Rivet went on to develop in greater detail his other favorite corollary: that in the Western world, the *métissages* necessarily dated back at least to this distant past, because humanity's original "racial purity had rapidly vanished" while individual variations became more accentuated. Rivet's concluding words were that it was easier to classify a Neanderthal cranium than a modern one.

The subsequent articles by Rivet's and Mauss's students made this last point even more emphatically: while sketching out typologies of the major races on each continent, each author also underscored that since prehistoric times "mixtures continued to become more pronounced."[47] This did not mean that there were not areas of physical homogeneity, where peoples had been spared constant invasion; but by and large all peoples were the result of complex mixings, whose longer history remained unclear. Boris Vildé, a specialist in northern Europe and author of the article on the races of Europe, insisted there was an Aryan language but no Aryan race. The great ethnic groups—Germans, Celts, Latins, Slavs—formed defined linguistic and cultural units. However far back in history one went, one would never discover racial homogeneity within these groups.[48] The remaining articles struck the same note.

[45] Rivet's article appeared in *Races et Racisme* 16–17–18 (Dec. 1939): 5–8. Its directors' committee included G. Lefebvre, E. Vermeil, C. Bouglé, L. Le Fur, J. de Pange, and P. Rivet.

[46] Rivet, "L'origine des races," 8.

[47] Boris Vildé, "Les races de l'Europe," *Races et Racisme* 16–17–18 (Dec. 1939): 8.

[48] Ibid., 8–10.

Marcelle Bouteiller, curator of the Asian collections, noted "the complexity of the facts, due to *métissages* and migrations."[49] According to Michel Leiris, Africa also afforded endless "examples of those constant movements of people that provide the template of the human history of the continents."[50] In Oceania, according to Charles van den Broek d'Obrenan, "*métissage*, due to the different successive migrations, does not allow for as sure a [racial] diagnostic as for the other [i.e., cultural] manifestations of Oceanic life."[51] Jacques Soustelle noted that the Americanist in the New World confronted peoples and tribes, not races, because the Americas had been the theater of migrations, wars, and other such complicated contacts.[52] As assistant director of the Musée de l'Homme, he, too, elaborated on these ideas in an interview in *L'Oeuvre*, a couple months after Rivet:

> We ethnologists, we know that there is no race that has not contributed to the common patrimony of civilization often through major innovations. . . . Racism then depends on a first confusion between the idea of race and that of culture. We should denounce a second confusion, that between race and language. The map of the world's racial boundaries does not coincide with that of its linguistic boundaries. . . . That the opposite is taught in Germany can only be explained by the fact that German intellectuals have either left their country or been forced into line. A third confusion exists, the worst of the three, between the notion of race and that of a people. It is an abuse of language to make demands in the name of a race, when one means to speak in the name of a linguistic group, for example. But even the term race is just a convenient expression, constantly subject to revision, that does not involve any internal unity or, even less, any spiritual unity.[53]

Having thus relegated the concept of pure races to the early mists of time and reiterated the tentativeness of any race typology, the series ended with Schreider's article on how anthropologists actually studied races—since "it was the public's ignorance of [anthropologists'] methods and techniques that accounted in part for the thoughtlessness with which questions of race are treated today."[54] Even though relatively jargon-free, this article was the most

[49] Marcelle Bouteiller, "Les races de l'Asie," *Races et Racisme* 16–17–18 (Dec. 1939): 13.

[50] Michel Leiris, "Les races de l'Afrique," *Races et Racisme* 16–17–18 (Dec. 1939): 15.

[51] Charles van den Broek d'Obrenan, "Les races de l'Océanie," *Races et Racisme* 16–17–18 (Dec. 1939): 18.

[52] Jacques Soustelle, "Les races indigènes de l'Amérique," *Races et Racisme* 16–17–18 (Dec. 1939): 15–17.

[53] AMH/2 AM 1 B11/a/Georges Schneeberger, "Un quart d'heure avec un jeune: Jacques Soustelle," *L'Oeuvre*, 20 Nov. 1938.

[54] Fleury, "Le Musée de l'Homme," 2.

technical, because it tried to summarize in a layperson's language a biometric approach to race classification. The inclusion of Schreider's final essay illustrates once again how even politically antiracist anthropologists were not ready to relinquish the biological category of race in the face of more promising tools for racial diagnostics—in this instance not blood-typing, but a biometric one that went under the name of a new popular theory internationally, biotypology.

Biotypology in the 1930s was an emerging interdisciplinary field at the intersection of physiology, psychology, and anthropology that developed in the wake of the spread of Mendelism, and whose project was the identification and classification of specific biotypes, considered to be the product of heredity and environment.[55] Instead of using traditional morphological features, biotypological classifications were based on the measurement of physiological (basal metabolism, blood pressure, visual acuity, pulse, muscle strength, body size, etc.) as well as mental and behavioral characteristics. Equally important, biotypologists used this data to create norms and averages. In a confusing manner that was typical of the era, they deliberately approached the category of race as a statistical fiction while still maintaining several aspects of racial theory. Biometric studies could be, and were, used on any group; for example, children in France were targeted, to reveal correlations between their biotypological profiles, family income, and performance at school. Such studies were supposed to clarify the respective weight of heredity and environment, and to allow specific biotypes to be matched to particular social tasks. Not surprisingly, some anthropologists in France and abroad carried out biotypological studies on groups that were commonly thought of as races, in the hope of properly sorting out their racial mixtures—an approach that once again left the biological reality of race unquestioned. As Alexandra Mirna Stern has put it with reference to biotypological research in Mexico in the late 1930s (with which many French specialists were associated), "by elaborating and utilizing the seemingly more neutral statistical language of averages, deviations and quintiles [biotypologists] re-signified overt racial typologies," even as they claimed to be eschewing old race taxonomies.[56]

Schreider's article on biotypological methods is a case in point. A militant antiracist, he began his essay by describing how anthropologists had historically gone about classifying the human races, and the challenges they

[55] William H. Schneider, "Henri Laugier, the Science of Work, and the Working of Science in France, 1920–1940," in *Cahiers pour l'Histoire du CNRS, 1939–1989* 5 (1989): 7–34.
[56] Alexandra Minna Stern, "From Mestizophilia to Biotypology: Racialization and Science in Mexico, 1920–1960," in Nancy P. Appelbaum, Anne S. Macpherson, and Karin Alejandra Rosemblatt, eds., *Race and Nation in Modern Latin America* (Chapel Hill, NC, 2003), 188.

had faced. The problem, as he succinctly put it, was that while racial differences were most pronounced morphologically (skin color, hair types, etc.), they became attenuated in the domain of physiology, and became extremely problematic when dealing with mental facts.[57] He continued that, nevertheless, enough measurements and descriptions had been taken of peoples in Europe to begin to draw tentative ethnological distribution maps. But the real and arduous work of proper racial analysis lay ahead. Anthropologists should begin from the premise that every population was mixed, and that what met the eye were rarely reliable indicators of racial inheritance. They then needed to complicate their methods, "by according an enlarged place to probing mathematical elaboration." The goal was not to establish a list of distinctive particularities, but to draw up for each branch of the human family as complete a biological inventory as possible, by exploring anatomical and sensorial characters simultaneously. Every science was moving toward embracing mathematical methods, and anthropology was no exception. "As soon as we operate on several orders of biological phenomena, studying their reciprocal influences, tracking back through factorial analysis as much as possible to their common cause, establishing their relationship to the environment [*l'ambiance*] . . . we will be responding to pressing scientific needs." Ever more numbers, in short, held the key to race's elusive reality.[58]

Rivet's Musée de l'Homme in Context: Other Scientific Antiracisms in the 1930s

Taken together, all of the articles in the series "La science des races au Musée de l'Homme" warned—much as Rivet's 1930 article had—against the "deceptive" nature of race. Race, they argued, was not what it seemed superficially or what less responsible voices—Aryan supremacists and other distorters of science—were claiming it to be. The authors nevertheless held out the hope that scientists would someday further elucidate race's biological nature, thanks to such new statistical methods as those employed by biotypologists or further advances in modern genetics. Was this understanding of race typical of what other antiracist scientists inside France and beyond its borders had to say on the subject during these same years? A brief survey of scientific opinion suggests that there was one discursive move that certain antiracist biologists in particular made that Rivet did not: self-consciously dropping

[57] M. V. Fleury (Eugène Schreider), "Comment on étudie les races humaines. Anthropologie et biotypologie," *Races et Racisme* 16–17–18 (Dec. 1939): 21.
[58] Ibid., 23–24.

the term "race" altogether when describing different human groups and substituting a less politicized alternative. This move was arguably more radical than Rivet's stance, but it also reflected the fact that the discipline of biology internationally had never focused on the race question as exclusively as had that of anthropology (and especially its French school).

In the Anglo-American world, the most important scientific book seeking to educate the public on the misuse of the race concept was *We Europeans*, coauthored in 1935 by the biologist Julian Huxley and one of Great Britain's most senior and illustrious physical anthropologists, A. C. Haddon.[59] In 1924 Haddon published what had become one of the standard race classifications of the era, *The Races of Man*.[60] Faced with the rise of Nazi race propaganda and policy, in *We Europeans* the two authors deliberately sought to demystify for the public the latest scientific findings on the biology of race as it applied to Europe. The book was divided into two parts. The first part argued that race was hardly definable in genetic terms, except as an abstract concept. The "racial concept," Huxley wrote, was "almost devoid of biological meaning as applied to human aggregates" because of the constant crossing and recombining of populations since the first appearance of Homo sapiens.[61] Huxley nevertheless believed that genetic research would eventually produce "frequency maps for all the important genes which distinguish human groups."[62] Until then, anthropologists should continue to do what they had always done: try to come up with a descriptive picture of the visible characteristics of different types.

Huxley did, however, introduce one new element to his conclusions. He insisted that the entirely misleading term "race" be dropped in any mapping of Europeans and be replaced with the term "mixed ethnic group," and that the ideal "ethnic" types chosen to represent these groups be acknowledged as just that—hypothetical ideals that never existed in pure form in the past. In his words, "An ethnic type is a subjective judgment of the normal or ideal characteristics of a component of an existing population."[63] All modern peoples were of mixed ancestry and "can never be genetically purified into their original components or purged of the variability which they owe to past

[59] Julian S. Huxley and A. C. Haddon with a contribution by A. M. Carr-Saunders, *We Europeans: A Survey of Racial Problems* (London, 1935). For a more extensive survey of British and American antiracist scientists' views, see Barkan, *Retreat of Scientific Racism*; and Nancy Stepan, *The Idea of Race in Science: Great Britain, 1800–1960* (London, 1982).
[60] A. C. Haddon, *The Races of Man* (Cambridge, 1924).
[61] Huxley et al., *We Europeans*, 144.
[62] Ibid., 127–28.
[63] Ibid., 141. The more radical move here was for a scientist to abandon the term "race"; biologists and anthropologists had long known that all "types" identified in their classifications were hypothetical ones.

crossing."[64] These conclusions then paved the way for Haddon, in the second part of the book, to present a fairly traditional view of the major subdivisions of Europe, based on morphology. But Haddon also invoked the arbitrary nature of all classificatory systems, reminding his readers that in the face of continuing scientific ignorance "any biological arrangement of the types of European man is still largely a subjective process, and is at best classificatory in a descriptive sense only."[65] As Elazar Barkan has pointed out, the most important aspect of *We Europeans* was the attention its authors paid to discrediting fallacious arguments about race. The book made no new claims about what race actually was.[66]

If we return now to France, one of the most progressive positions staked out on the question of race seems to have been an article published in 1938 in *La Jeune-République* by a biologist at the University of Poitiers, Étienne Patte, and entitled "Le problème de la race: Le cas de l'Europe passé et présent." Patte also wrote for a broad audience and tried to summarize in lay language how modern genetics had dramatically altered past notions of what constituted a race. For him the genetic variety of the human species meant that "the definition of a race does not differ from that of an individual. We must thus define a race as all those individuals possessing the same genetic makeup. . . . Given the colossal number of different genetic formulae we can say that there are as many races as there are individuals."[67] To those who objected, on the grounds that the black race and the yellow race were obviously different from each other, he replied that all existing racial taxonomies were based on an arbitrary selection of characteristics that appeared to be hereditary, were easy to observe, and seemed to be tied more or less to specific geographical regions.[68] Patte thus agreed with Haddon and others who maintained that race exists only in our minds. Having determined that "in a rigorous sense there is thus neither race nor pure race," Patte nevertheless (like Haddon) proceeded in the remaining section of his article to sketch out a traditional typology of the peoples of Europe.[69] The principal difference was that where Haddon and

[64] Huxley et al., *We Europeans,* 143.

[65] Ibid., 166.

[66] Barkan, *Retreat of Scientific Racism,* 167.

[67] Étienne Patte, "Le problème de la race. Le cas de l'Europe passé et présent," *Cahiers de la Démocratie* 52 (Nov.–Dec. 1938): 16.

[68] Ibid., 17.

[69] Ibid., 22. The authoritative typology for many anthropologists before Haddon was Joseph Deniker's massive *The Races of Man: An Outline of Anthropology and Ethnography* (London, 1900), which was immediately translated into English. Deniker (1852–1918), a naturalist and anthropologist, worked as a librarian at the Muséum. Already in 1900, thus at the height of the Dreyfus affair, Deniker had rehearsed many of the arguments that resurfaced among antiracists in the 1930s about the differences between "races" and "ethnic groups" and the dangers of confusing the two. Deniker's classification continued to be revised by anthropologists internationally and in France, as new research challenged his results.

Huxley had preferred to substitute the term "mixed ethnic group" for "race"
Patte continued to use the term "race" in its "approximate" or "larger"—that
is, arbitrary—sense. He also accepted the use of the word "type" to designate
groups in which "several individuals who are different genetically possess a
very small number of traits in common, which would suggest that they are
related, when in fact any such kinship [*liens de parenté*] is extremely weak."[70]
But Patte's final summation was unequivocal about the artificiality of race:

> We have encountered in the course of this short exposé neither a Latin race
> nor . . . an Aryan race. These names refer only to languages, peoples, nations,
> or civilizations.
> We have not even encountered, in the true sense of the word, a single race,
> since it is only by abusing and simplifying our language that we have identified
> races in Europe.[71]

Also at the forefront of the antiracist struggle in France was Henry Neu-
ville, a zoologist and biologist at the Muséum. Neuville had shown a consistent
interest in the race question throughout the 1930s and was another close as-
sociate of Rivet's. When Lucien Febvre approached Paul Rivet in 1934 to edit
the volume in the new *Encyclopédie française* devoted to the "human species,"
Rivet in turn asked Neuville to write the section on human diversity. Neuville
provocatively titled his section "Peuples ou races?" Although Neuville also
concluded that race could not be defined except on the level of the individual,
he initially argued that the word be retained. Darwin, Neuville insisted, had
suggested that given the difficulty of defining human races, the term "subspe-
cies" was preferable to that of "race." But Darwin himself had conceded that
its long established use would lead people to continue to employ the latter
term. Neuville concurred: "It seems that there can no longer be any question
of removing the word race from the anthropological lexicon. . . . It would be
vain to contest its right of citizenship acquired so long ago."[72] In an article
that appeared in the widely read literary journal the *Revue de Paris* in Octo-
ber 1938, entitled "La race est elle une réalité?" Neuville nevertheless nuanced
these findings, particularly in light of a failed attempt in 1935 by a commission
of the British Royal Anthropological Institute to come up with a definition of
"race" that would satisfy both biologists and anthropologists. This time, he
concluded that what "we see" are temporary "types: national, local or provin-
cial . . . family types (like those of the Habsburgs or the Bourbons, the latter

[70] Patte, "Le problème de la race," 25–26.
[71] Ibid., 52.
[72] Henri Neuville, *L'espèce, la race et le métissage en anthropologie* (Paris, 1933), 35.

sometimes taken for Jews!) or frankly artificial types (social or professional)." To drive his point even further, he noted that studies of human physiology had yielded no "formal racial distinctions," except those long ago noted by Buffon in jest—between "a masculine race and a feminine race." Sexual differences, in short, had a much greater claim to the label "race" than the unstable morphological differences usually designated by that name.[73]

As noted above, it is not so surprising that biologists—for whom "race" had never constituted the privileged object of study that it had for physical anthropologists—should be the first to suggest giving up the term altogether. And even scientists as antiracist as Huxley, who rejected outright the possibility of grouping Europeans into entities called "races"—because of Nazi ideologues' abuse of the term—continued to accept a descriptive classification of different populations based on the same selection of physical characteristics that had been used in the past: hair type and hair color, skin color, eye color and eye form, stature, head form, and nasal form. The one invisible genetic descriptor added by Haddon, and by many other anthropologists (including Rivet) in the interwar years, was blood type.

Where, then, did Rivet fall on this spectrum? There is no evidence that he personally kept up with new research abroad in genetics throughout the 1930s, although he followed developments first in blood-typing and then in biometrics when they made their way to France. French academic biologists had rejected research in the field of human genetics in the interwar years.[74] British and Germans instead dominated the field, albeit with different outcomes for institutional anthropology in each of the two countries.[75] *We Europeans* was not translated into French until 1947, and despite Rivet's and Patte's shared commitment to combat racism, Patte did not move in the same political or scientific networks as Rivet. It is telling, in this context, that Paul Lester, Rivet's second assistant director (responsible for the anthropology department, while Soustelle remained assistant director of the ethnographic departments), also coauthored an ostensibly up-to-date book on racial classification, *Les races humaines,* in 1936. In it he managed to include in the same

[73] Henri Neuville, "La race est–elle une réalité?" *La Revue de Paris* 44: 20 (1937): 870. Durkheim had made a similar point about sexual difference in his comparison of "primitive" and "civilized" marriage in *The Division of Labor in Society.* See Jean Elisabeth Pedersen, "Sexual Politics in Comte and Durkheim: Feminism, History, and the Social Scientific Canon," *SIGNS: A Journal of Women in Culture and Society* 27:1 (Fall 2001): 229–63.

[74] Richard M. Burian, Jean Gayon, and Doris Zallen, "The Singular Fate of Genetics in the History of French Biology, 1900–1940," *Journal of the History of Biology* 21:3 (Autumn 1988): 357–402.

[75] For the impact of genetics on the study of race in Britain, see Larry T. Reynolds and Leonard Lieberman, eds., *Race and Other Misadventures: Essays in Honor of Ashley Montagu in His Ninetieth Year* (Dix Hills, NY, 1996); Barkan, *Retreat of Scientific Racism,* part 2; and Stepan, *Idea of Race,* chap. 5.

breath what had become majority scientific opinion in France—that "[races] are never pure. . . . They are constantly changing, and . . . none is really superior to another"—and to undercut this statement by adding that "the human races are different, each having for a time physical and moral characteristics, a marked personality. . . . Among the hereditary combinations that contribute to their formation, it is clear that some are more favorable than others. Certain races are not particularly talented for the plastic arts, others for music."[76] Lester nevertheless tempered these essentialist statements by asserting that the study of anthropology and ethnography led to ways of thinking that challenged imperialism and warmongering.

This muddled statement makes clear how easy it was to slip into stereotypical views of racial difference, in an era when anthropologists as sensitive to racism as Rivet and Schreider tended to continue to racialize bodies while also representing them linguistically and culturally. Lester was not of the same intellectual caliber as Schreider or Rivet, but he shared enough of Rivet's basic assumptions about race to remain in charge of the anthropology department at the Musée de l'Homme. Clearly the preferred approach among self-consciously antiracist French anthropologists committed to educating a general public about human variation was to keep the term and the classic division of the races on display, even as they insisted on the "arbitrariness" of such typologies in light of ongoing research. This position, ironically, made it that much harder to refute the slippery racist theses of another establishment scientist in the interwar years whom we have already encountered, the École d'Anthropologie anthropologist George Montandon. Although Rivet and Montandon were worlds apart politically throughout the 1930s, Montandon's science engaged enough similar questions to that of Rivet, and with such apparent erudition, to make it difficult for Rivet and other antiracists to criticize Montandon's scholarship directly. Because Montandon had attempted to popularize many of his racist ideas before Rivet presented his alternative views in 1938 at the Musée de l'Homme, and because Rivet was at least in implicit dialogue with him, we now turn to Montandon's scientific racism.

George Montandon's Racist Ethnology

In 1939, Paul Lester compiled an international bibliography in all branches of ethnology for the journal of the Société des Africanistes—a learned society founded in 1930 with help from Rivet to showcase the new ethnography being

[76] Paul Lester and Jacques Millot, *Les races humaines* (Paris, 1936), 208–9.

done by Institut d'Ethnologie students in France's colonies during the Mission Dakar-Djibouti, as well as the research of physical anthropologists, prehistorians, and linguistics.[77] Under the rubric of *anthropologie*, this bibliography included articles not only by antiracists, but also by anthropologists for whom biological determinism—and anti-Semitism—were givens. One entry in 1939 stands out: George Montandon's article "L'état actuel de l'ethnologie raciale," published in *Scientia,* an international journal based in Bologna.[78] On the very first page of this essay, Montandon—the holder of the chair in ethnology at the École d'Anthropologie—noted that the "importance of racial facts was proven by the efforts, international and Jewish in particular, to suppress the findings of raciology [i.e., racial science]." Montandon then went on to claim:

A certain great [Paris] museum pertaining to Man is stuffed full of cultural artifacts—of which a large number are wrongly labeled—in order to better extinguish racial facts, to silence, hide, and disperse cranial series—that is to say, [to silence] the demonstration of certain great racial circumstances. Jewish influence, in short, boycotts anything that exposes racial fact.

He concluded that "he who examines the contingencies without bias does not have any reason to maintain silence on any part of them."[79]

The inclusion of an article that began on such an openly anti-Semitic tone in the Société des Africanistes' bibliography speaks volumes about what passed as scientific discourse in the late 1930s. But Montandon's article is of interest for another reason as well: his direct allusion to the Musée de l'Homme and his criticism that it was "hiding" racial facts by dispersing "cranial series" and overwhelming them with cultural objects. Montandon disagreed with Rivet's view that the proper place for crania was the Anthropology Hall and the ethnographic galleries, where they were part of a synthetic introduction to each ethnic group that included a "typical" morphological profile as well as distinctive objects. Montandon presumably wanted a much bigger and hierarchically organized race gallery, as well as "cultural galleries" that underscored essential differences among civilizations; indeed this was the drift of the ethnology that he had been writing for years. Despite its racism,

[77] On the founding of this society, see Émmanuelle Sibeud, "L'Afrique d'une société savante. Les Africanistes et leur mémoire," in Piriou and Sibeud, *L'africanisme en questions,*71–88.
[78] Paul Lester, "Bibliographie africaniste," *Journal de la Société des Africanistes* 9:2 (1939): 229. In addition to Montandon's article, Lester listed works by Boas, Patte, and Georges Lakhovsky (from the antiracist camp) and by Ruggles Gate, Charles Davenport, and Egon von Eickstedt (from the racist camp).
[79] George Montandon, "L'état actuel de l'ethnologie raciale," *Scientia* 65 (1939): 32–33.

his ethnology was accepted as falling, as much as Rivet's, within the pale of legitimate science.[80] Indeed, as late as 1981, one of France's most professionally entrenched physical anthropologists, Henri Victor Vallois, vouched for the absolute professional respectability of Montandon in the interwar era.[81] The latter's works even found their way onto the shelves of the library of the Musée de l'Homme.[82] In the crisis-ridden 1930s, moreover, Montandon was able to disseminate his science to a broader public through a series of books he wrote for the prominent French publisher Gustave Payot, in its "Bibliothèque Scientifique" collection—he was Payot's nephew. Montandon's relative success offers an object lesson in how an overtly racist racial science, earlier discredited during the Dreyfus affair, could under a new, more subtle guise once again become part of "good science" in France of the late Third Republic, when the nation was again polarized politically.

As suggested in chapter 2, George Montandon was an extremely ambitious and opportunistic ethnologist at the École d'Anthropologie who was most likely a racist long before 1938—the year in which he chose, for the first time since his arrival in France thirteen years earlier, to reenter politics as a public anti-Semite. Up until that point, Montandon had avoided any ideological entanglements, working hard instead to establish visibility as a serious ethnologist alone; in the early 1930s, Montandon donated Ainu artifacts to Rivet's renovating Musée d'Ethnographie and also appeared on the museum's guest list of "scientific personalities."[83] As an outsider new to France and the

[80] Montandon's stature is also confirmed in the article on "ethnology" that appeared in the report on the social sciences in France prepared by the Groupe d'Études des Sciences Sociales. The elderly Durkheimian Celestin Bouglé, himself an ardent antiracist during the Dreyfus affair, had formed the group to revitalize the social sciences after World War I. A young agrégé in philosophy, Raymond Polin, authored the essay on ethnology, which provides a rare account of the field from someone sympathetic to Mauss and Rivet, but outside their circle. Polin noted that a definition of modern French ethnology could begin with Boas's definition: it was the study of man "as a social being." Polin nevertheless named Montandon and the École d'Anthropologie alongside Rivet, the Institut d'Ethnologie, and the Musée de l'Homme as colleagues in the same disciplinary field. Raymond Polin, "L'ethnologie," in Raymond Aron et al., Les sciences sociales en France. Enseignement et recherche (Paris, 1937), 78–99.

[81] Vallois was France's second most powerful physical anthropologist after Rivet on the eve of World War II. A professor of anatomy and zoology, he was a race typologist who knew how to avoid extremes while cultivating the right contacts in Paris. In 1930 he was named coeditor of the most important journal in the field, L'Anthropologie, which the paleontologists Verneau and Boule with Hamy had founded in 1892 to rescue French anthropology from the crisis precipitated by Broca's early death. Vallois became president of the Société d'Anthropologie in 1932 and moved to Paris in 1937, when he became director of the Laboratoire d'Anthropologie at the École Pratique; he would continue to advance professionally under and after Vichy.

[82] AMH/2 AM 1 A11/d/Jacques Soustelle à M. Perrin [Éditions Payot], 11 Aug. 1938, no. 1284.

[83] AMH/2 AM 1 G3/b/Rapport d'activité par département, Asie; AMH/2 AM 1 A2/a/Georges Henri Rivière à M. le Rédacteur de L'Intransigeant, 24 March 1931, no. 474; AMH/2 AM 1 K67/c/ Georges Henri Rivière à George Montandon, 16 Feb. 1934; and Anatole Lewitsky à George Montandon, 28 March 1934, no. 603.

Left Bank—he had arrived only in 1925—however, Montandon achieved scientific respectability mostly through a series of erudite publications. These caught the eye of Louis Marin, the head of the École d'Anthropologie since 1923, who hired Montandon in 1931 and then played a critical role in securing his citizenship.

Before turning to Montandon's publications, it is worth considering what the profile of the École d'Anthropologie had become in the interwar years under Marin's direction. Marin was a nationalist ethnographer of France, as well as an influential deputy on the Right in the parliament who was closely connected to some of the most powerful, richest, and most conservative industrialists in France.[84] He was also president of the Société d'Ethnographie, whose fortunes he helped to revive in the 1920s, along with those of the École d'Anthropologie. From 1924–25 to 1925–26 enrollment at the École d'Anthropologie fell from 3,146 to 2,689, but by 1927–28 it had increased to 4,898, and there were no further complaints in the 1930s of a lack of students.[85] As we saw in chapter 2, Marin successfully recruited six new professors—of whom Montandon was one—as the last generation of Broca's students died between 1927 and 1931. Last but not least, he founded a chair in heredity at the very moment that the new genetic conception of race that linked physical, cultural, and psychological traits was emerging internationally, especially in Germany.[86]

Under Marin's direction, then, the École d'Anthropologie became an important locus again in Paris and even beyond for those most interested in debating the problems of how to classify the human races; several École d'Anthropologie members were also prominent members of France's eugenics society, which grew more receptive after World War I to such negative measures as birth control, sterilization, and immigration restriction to improve the quality and quantity of the French population. Yet, it would be wrong to conclude that because of this interest in racial science, the faculty as a whole exhibited a greater racist and anti-Semitic orientation than many other scientific circles in France, at a time when interest in race was on the rise generally among professional and intellectual elites. For example, a leading antiracist biologist, Nicholas Kossovitch, found a job there at the same time Montandon

[84] Information about the history of the École d'Anthropologie under Marin is available on its website but should be approached with caution: http://www.ecoledanthropologie.info. On the career of Marin, see Lebovics, *True France*, chap. 1.

[85] AMH/MS 15/3/Procès-verbaux/"Rapport du Sous-Directeur pour 1924–1925," "Rapport du Sous-Directeur pour 1925–1926," and "Rapport du Sous-Directeur pour 1927–1928."

[86] The first professor of heredity, Henri Briand, however, was a doctor and eugenicist, not a geneticist; he would prove sympathetic to Nazi racial hygiene during the Occupation. Schneider, *Quality and Quantity*, 257.

did, yet Kossovitch (unlike Montandon) was one of those who argued most forcefully that Jews had no distinctive racial traits.[87] Even some of Rivet's and Mauss's own students occasionally taught at the École d'Anthropologie, perhaps because of a lack of other options.[88]

For a school long associated with the study of human biology and its impact on human development and capacity, but directed in the 1930s by a deeply conservative ethnographer of France, Montandon's work must have seemed a particularly good fit. In 1928 Montandon published a treatise in physical anthropology, *L'ologenèse humaine,* and in 1934 he followed it up with one in cultural anthropology, *L'ologenèse culturelle.* Together they contained the core scientific concepts that he would eventually publish in more popular forms. Neither work, however, engaged with the newest techniques or concepts in international racial science. Both were influenced instead by the maverick theory of the Italian zoologist Dr. Daniele Rosa, called hologenesis, which was unknown outside Europe and little known within, or at least not among ethnologists. Montandon's books nevertheless were accepted as erudite scientific works by his peers, although a close reading reveals that his ideas had not much advanced beyond his youthful flirtation with Gobineau's racism, and more particularly the latter's reveries regarding the possibility of a master race in which superior spirituality and biology mystically merged. Montandon's interwar ethnological work on race and culture can be seen as an attempt to recast in acceptable scientific terms this perverted ideal, which required for its fulfillment the elimination of the "impure" Jew.

The theory of hologenesis held that all species evolved as a result of internal causes, because they were each endowed with an "ideoplasm" or substratum responsible for heredity, in a pattern of constant spontaneous dichotomy. Life began as a single species present throughout the world, from which all new species developed. At a critical maturation point, species split into two different kinds of offspring that eventually (over several centuries) replaced the original mother-species. Two more points were crucial to the theory. First, "at every splitting, the range of possible variability of any single character was progressively restricted until the species [could not] vary anymore."[89] At

[87] Schneider, *Quality and Quantity,* 225 and 246; Kossovitch was a pioneering investigator of blood-typing in France, a new way of identifying the human races that was developed in the 1930s.
[88] Marin was able to get a "special subsidy" of 20,000 fr. from the Ministry of Foreign Affairs in 1937; the Paris city council reinstated the subsidy that it had withdrawn in early 1939 later that same year. AMH/MS 15/3/Procès-verbaux/"Rapport du 15 décembre 1937," "Rapport du 20 juin 1939," and "Rapport du 19 décembre 1939." Maurice Leenhardt, who was close to Mauss, requested "conferences" there in 1935 and was granted ten, presumably to help make ends meet. "Rapport du 5 juin 1935."
[89] Michele Luzzato, Claudio Palestrini, and Pietro Passerin d'Entrèves, "Hologenesis: The Last and Lost Theory of Evolutionary Change," *Italian Journal of Zoology* 67:1 (2000): 131.

that point, species survived without variation—they became living fossils—or they died out. Second, the splitting of species was asymmetrical: at every splitting, one of the two branches, the so-called late branch (*rameau tardif*), produced more "daughter species" with wider variability; the other, the so-called precocious branch (*rameau précoce*), gave rise to a lesser number of daughter species with more primitive characteristics.

Although Rosa never meant his ideas to be applied to human biological or sociocultural evolution, he approved of the way in which Montandon made use of his theory.[90] Montandon became convinced that hologenesis explained best, among competing neo-Darwinian theories, the origin and—to him obvious—uneven evolution and endowment of human races and cultural complexes. Basing his ideas on the incomplete fossil record, which created a climate in which even the wildest of conjectures flourished, Montandon first developed in *L'ologenèse humaine* a view of racial evolution that radically departed from how most physical anthropologists understood the origins of the human races. The conventional wisdom in the interwar years was that there was a single cradle of humanity, whose location was still in debate; the races were assumed to have differentiated in prehistorical times from single populations in isolated geographical sites, and then to have migrated to other locales where they mixed with other races. This is why, for someone like Rivet and his students, the history of the human races was one of both continuous migration and *métissage,* making the racial composition of contemporary populations almost impossible to sort out—and race irrelevant to a people's particular social, linguistic, and cultural achievements. In this scheme of things, races began "pure" at the dawn of time, but over the long course of human evolution had become exuberantly hybrid; civilizations were similarly hybrid, the fruit of endless mixing and borrowing.

For Montandon, however, the scenario was reversed: the fossil record of early Homo sapiens did not bear out the single-center-of-origin-followed-by-differentiation thesis. If this theory were correct, he argued, there should have been a concentration of like fossils at the point where each race originated. Instead, Montandon hypothesized that at first an undifferentiated human ancestor occupied the entire globe, and then gradually and continuously split dichotomously into the various races and subraces. Each split produced a late branch and a precocious branch, and while the races of the late branches advanced steadily, the races of the precocious branches faced arrested development. Also according to the rules of hologenesis, these new races over time

[90] Daniele Rosa, *L'ologenèse. Nouvelle théorie de l'évolution et de la distribution géographique des êtres vivants* (Paris, 1931), XI.

became geographically more concentrated as well as more accentuated. As Montandon liked to put it, "Pure races did not exist in prehistory. . . . The pure race represents not a past, but a becoming [*un devenir*]." And he gave as one of his myriad examples the case of the "Negro." Even though the latter began "more primitive and more simian than the other races," he only gradually acquired such specific traits as black skin, reduced pilosity, frizzy hair, and thickening and eversion of the lips. "The Negro becomes, except in the case of *métissage* . . . ever more Negro." As this passage suggests, Montandon recognized that modern communications had interrupted the process of ever-greater racial distillation by promoting a mixing of peoples: "As a general thesis, we must believe there is a tendency toward the formation of pure races, but that this tendency is simultaneously eroded by miscegenation, just as the mountains that rise up are at the same time leveled by the elements."[91] Counterintuitively, the *métissage* to which Montandon was referring here was cultural, not racial—although he only spelled this point out in his footnotes. Different bloods, he argued, did not "mix": there was replacement of one by another, not transformation. The process of race distillation became compromised instead when peoples borrowed languages and customs of another. To quote: "Using the words Semitization, Negritized, Mongolized makes no sense somatically. . . . However, Europeans could deck themselves in the dress of the Mongolics [*sic*] and adapt their language; ethnographically, linguistically, historically, we could thus speak of a Semitized people, in a Gallicized country."[92] Having laid out these dense theories in close to 200 pages in part 1, in part 2 of *L'ologenèse humaine* Montandon provided a classification and detailed description of the nine "great races" and the twenty "races" into which humanity had divided through spontaneous dichotomy. In Montandon's scheme, the oldest and most primitive great race was the Pygmoid, the latest and most developed the Europeanoid.

In his second, even more massive (778 pages to 448 pages) work, *L'ologenèse culturelle*, Montandon applied the same zoological principles of hologenetic theory that he had used to explain human racial variation and to rank the races to civilizational development, from preliterate peoples down to the modern. The book began by identifying and describing twelve "cultural cycles" or civilizations that Montandon claimed had emerged dichotomously from a primeval cultural soup, each of which had spread as various groups migrated, and then become concentrated in a specific location. All the

[91] These quotes are from Montandon's more popular version of *L'ologenèse humaine*, which was published by Payot in 1933 as *La race, les races. Mise au point d'ethnologie somatique*. See 112, 114, 113.

[92] Montandon, *L'ologenèse humaine*, 130 n. 3.

cultures, past and present, of the world belonged to one of these cycles, whose defining customs were always sui generis, a product of their ideoplasm—not a stage in universal human development or the product of cultural borrowings:

> It would be an error ... to believe that the customs of primitives and savages are a threshold which we once attained and from which we then moved on. Their ways are often different and diverging from those followed by the Occidental civilizations. The indigenous procedures of fabrication, construction, ... etc. are sui generis. When the lineage ... becomes extinct, the procedures they used are definitively lost.[93]

Montandon also divided these "cycles" between a late branch and a precocious one, because "a cultural cycle is, in cultural ethnology, what a race is in somatic ethnology." Those considered latecomers advanced, like late races, slowly but surely to modern civilization, while the early ones "lost themselves in blind alleys."[94] The twelfth cycle, needless to say, was the late arriving "Europeanoid" and represented the highest form of civilization known, whose superiority was proven by its ability to incorporate and surpass the technological achievements of earlier, stymied civilizations, such as the Chinese.[95] In short, civilizations, like races, were not born "pure" but became so over the long sweep of time. After having once again laid out his theory in the first half of the book, in part 2 Montandon exhaustively surveyed ethnographic traits worldwide, such as metalworking and hunting. L'ologenèse culturelle reflected in addition to Rosa's influence that of the Viennese diffusionist school of cultural circles or Kulturkreis, which few French ethnologists fully endorsed.

Both works, then, were in large part descriptive volumes; the hologenetic theory and subjective ranking of races and cultures were presented up front, and what followed were synthetic and seemingly value-neutral compendia of anthropological and ethnographic data, scrupulously culled from the existing scientific literature internationally. Although Montandon's theory was met with skepticism by scientists who reviewed the two books, the classifications found in the second parts of each work, and their extensive bibliographies, were uniformly praised.[96] The descriptive section of L'ologenèse culturelle was in fact the first such general ethnography in French, and Mauss and Soustelle would

[93] Montandon, L'ologenèse culturelle, 215.
[94] Lowie, History, 186. See also Montandon, L'ologenèse culturelle, 177–78.
[95] Montandon, L'ologenèse culturelle, 156, 208–9.
[96] For L'ologenèse humaine, see A.C. Haddon, Review 104, Man 29 (Aug. 1929): 144–46; for L'ologenèse culturelle, see in particular Arnold van Gennep, "Ethnographie," Mercure de France, 15 Sept. 1935, 604–8; H. J. Fleure, Review 110, Man 36 (May 1936): 87; Wilson D. Wallis, American Anthropologist, n.s., 37:3, pt. 1 (July-Sept. 1935): 521.

recommend it to students (presumably because it contained a lot of detailed drawings of tools and other artifacts), with the proviso that it rested on a "very debatable general theory." The work also caught the attention of the general press at a time when the question of the origins of civilizations was as debated a topic as that of the races.[97] *L'ologenèse humaine,* in contrast, did not sell at first, in Montandon's view because of its theoretical apparatus, size, and expense. In the early 1930s, he thus decided to publish a compact version of it with Payot entitled *La race, les races* (1933), pitched this time to a broad audience. In it he reduced his "novel" theory on the origin of the races to a couple of pages, and then set out an even more up-to-date race classification, compared to the one he had published five years earlier. Since he was a reasonably good writer and, as Montandon correctly gambled, since there was also a growing demand for authoritative works on race, the book quickly won the praise of the literary establishment. Writing in 1934 in the *Mercure de France,* the ethnographer Arnold van Gennep praised the author for his "systematic elimination of those confusions between people, language, and race . . . that we see . . . being resuscitated to Hitler's great benefit."[98] In 1939, Soustelle recommended *La race, les races* and the antiracist journal *Races et Racisme* to an editor at the *Nouvelle Revue Française* requesting bibliography on "the races."[99] Compared to the pseudo-scientific racists who were now championing such notions as the ancient purity of the Aryan race, Montandon appeared to be sticking to "the facts."

And yet, he was doing anything but that. If Montandon's acknowledgment that there were no pure races seemed to place him in the mainstream of what all "good" race scientists knew in the interwar years, and if his diffusionism was entirely within the pale of what certain cultural anthropologists were arguing about in this period, his underlying biologistic concept of culture cycles swam against not only the Durkheimian current, but the facts themselves. So-called primitive races and cultures were disappearing not, of course, because of innate inferiority, but because of Western imperialism—which Montandon simply ignored. If the Incas had perished, he wrote, it was not because of the Spanish conquest, but because of their own inherent decadence as an early

[97] Marcel Mauss, *Manuel d'ethnographie*; AMH/2 AM 1 A13/a/Jacques Soustelle à Robert Delavignette, 18 July 1939, no. 1248. See René Sudre's review in the mainstream newspaper *Le Journal des Débats,* 22 Nov. 1934, in which he stated that Montandon was attempting to bring to the study of civilizations "the same reform that anthropologists did when they separated the idea of race from that of the ethnic group."

[98] Arnold van Gennep, review of *La race, les races,* in "Anthropologie," *Mercure de France,* 1 June 1934, 370. Other reviews of *La race, les races* in the same vein are Henri Victor Vallois, *L'Anthropologie* 44 (1934): 381–82; H. J. Fleure, Review 13, *Man* 35 (Jan. 1935): 14–15.

[99] AMH/2 AM 1 A12/d/Jacques Soustelle à Brice Parrain, 9 May 1939, no. 813. Soustelle also recommended Paul Lester and Jacques Millot, *Les races humaines,* and the article by Henri Neuville, "Peuples ou races?" in vol. 7, *L'Espèce humaine,* of the *Encyclopédie française.*

developing culture.[100] Nevertheless, because Montandon was extremely good at embedding his most extreme ideas in his footnotes, because he insisted that hologenesis was merely a theory—just as the sociologists had their theory—because his descriptive surveys were carefully done, and finally because even many antiracist authors accepted that some cultures were more advanced than others, his essentializing views went largely uncriticized.[101] This was all the more true given that there was an entire school of conservative ethnographers in interwar France—beginning with Louis Marin—who were more than ready to believe that "the processes of social evolution, of civilization and of nation formation were . . . primarily processes of distillation, concentration and purification," and would welcome any scientific work that bolstered this form of irredentism.[102] Perhaps for this reason, Montandon's next step was to apply his ideas to the French nation that he was then trying to join.

From Science to Ethnoracism

Having established by 1934 his ethnological credentials and his ability to sell books, Montandon within a year brought out a new title with Payot, *L'ethnie française*. *L'ethnie française* began with three provocative sentences: "To speak of a French race is not to know what a race is. There is no French race. There is a French *ethnie*, whose constitution is made up of elements of several races."[103] With this opening salvo, Montandon pitched his work less at his fellow anthropologists (for whom the idea that there was no French race was hardly new) than, once again, at a broader public whose growing xenophobic mood—fueled by the Depression and fears of immigration as well as by the rise of the Nazis in Germany—he had correctly gauged. He probably derived his distinction between race and *ethnie* from the most widely read racial theorist in interwar Germany, Hans F. K. Gunther, who had treated races and peoples separately in the 1920s.[104] Immigration specialists like

[100] Montandon, *L'ologenèse culturelle*, 118.

[101] For Montandon's "buried" criticism of Durkheim, see *L'ologenèse culturelle*, 37 n. 1.

[102] Nathan Schlanger, "Introduction" in *Marcel Mauss. Techniques, Technology, and Civilization*, ed. Schlanger (New York, 2006), 25.

[103] George Montandon, *L'ethnie française* (Paris, 1935), 9, also 26–27. Although *ethnie* can be translated as "ethnic group," Montandon's definition does not match current use of the term. I have thus chosen to use his original French term in this and the following chapters.

[104] On the early career and ideas of Gunther, who became a senior Nazi scientific racist, see Klauptke, "German 'Race Psychology,'" 24–25. Montandon was later in touch with Gunther, who professed to admire his work. Karen H. Adler, *Jews and Gender in Liberation France* (Cambridge, 2003), 131–32. Noiriel traces the appearance of the term *ethnie* to the 1903 *Tableau de la géographie* of Paul Vidal de la Blache. Noiriel, *Les origines*, 243.

René Martial were also using the term *ethnie* in the early 1930s, but, as with the more widely used term "race," its meaning was unstable.[105] After a brief exposé of the hologenetic theory of racial diversification, Montandon went on to explain how the taxonomic category of *ethnie* compared to that of "race." Race was determined purely by somatic features. An *ethnie*, however, was a natural human group "as defined by its members" that took into account all of their human characteristics, somatic, linguistic, and cultural. *Ethnies* did not necessarily coincide with a single race, language, or culture, but they might; for example, the French *ethnie* contained multiple races, but only a single language (meaning Belgians, Swiss, and Québécois were part of the *ethnie*). In the United States, in contrast, language did not define the *ethnie*; rather, race did: "Negroes" and "Anglo-Saxons" might share the same language, but no one would make the mistake of claiming blacks and whites shared the same *ethnie*.[106]

In the context of 1930s racism, Montandon's concept of *ethnie* was once again initially seen, in the words of the liberal anthropologist H. J. Fleure, who reviewed the book for the British journal *Man*, as welcome relief "from current talk about Latin and Germanic races and the like."[107] Yet even as Montandon insisted that there was no French race, the bulk of the book was a classical exercise in racial typology, with a deep strand of biological anti-Semitism mixed in. First, Montandon outlined with scientific precision the four different subtypes of the great "Europeanoid" race that he thought made up the French *ethnie*: Nordic, Alpine, Mediterranean, and Dinaric. Then he turned to foreign races, what he called *les composantes allogènes*, which included Jews, Negroes, and Mongoloids. France had repeatedly assimilated individuals with Negroid or Mongoloid traits. Jews were different: while apparently being assimilated, they remained a socially cohesive *ethnie* of their own.[108] Here Montandon picked up a thread he had introduced in *La race, les races* two years earlier: the "perennial" question of the Jewish race—was it one, or was it not? In 1933, Montandon had already stated that Jews did not form a race, but rather an *ethnie*, "a social reason." Somatically speaking, they were absorbed into the major races of wherever they settled, while sometimes retaining recognizably Jewish secondary traits.[109] In 1935, Montandon went a step further to conclude that as an *ethnie* of their own Jews posed a problem for France, for which there was one social solution: the creation

[105] Adler, *Jews and Gender*, 123–25.
[106] Montandon, *L'ethnie française*, 27.
[107] H. J. Fleure, Review 109, *Man* 36 (May 1936): 86.
[108] Montandon, *L'ethnie française*, 137–55, and esp. 142.
[109] Montandon, *La race, les races*, 262.

of an independent state of Palestine, to which those "Israélites" wishing to maintain their Jewishness could emigrate. All others would no longer have a reason not to assimilate.[110]

On its own terms, as other scholars have pointed out, *L'ethnie française* was not overtly anti-Semitic. In the end the book was little more than a fairly standard description of the different racial types that made up France; Montandon stated outright that the French culture and French language that defined members of the French *ethnie* existed independently of physical type. And yet it is a mistake to take each of Montandon's works "on its own terms," because each publication was only one piece of a larger whole, and this whole was a consistent working out of the same racist racial theories. In fact, Montandon had published on the Jewish question even before his "first" reference to Jews as an *ethnie* in his 1933 work, *La race, les races*. Writing under the pseudonym P. Montardit when he first came to Paris in 1926, Montandon had published a short article in the Communist daily *L'Humanité* before giving up politics, entitled "L'origine des juifs."[111] Once again scholars of Montandon, viewing this piece in isolation, have not known what to make of it and have tended to dismiss it as irrelevant: in it Montandon states that Jews do not constitute a pure race, and he cites an English authority, himself Jewish, on the subject. One can only assume that *L'Humanité* published the piece, which appeared in a science section along with an article on glaciers and another on "the sexual question," because Montandon's rejection of a pure Jewish race supported the Bolshevik notion that class not biology was the motor of history. But while Montandon began his piece with the claim that there was no pure race, he then promptly noted that Jews could be divided among three racial types: Semitic, a type characterized by a long head and heavy nose, mouth, chin, and forehead; Hittite, a round-headed type in which all traits are mushy and rounded—the typical Jew; and finally, Philistine, a type that was essentially European, with small and finely chiseled features, including a straight nose, a refined mouth, and a square forehead. Montandon's race hierarchy is distinctly recognizable already, as is his particular interest in Jews and his conviction that they bear distinctive physical characteristics that the discerning scientist could diagnose.

Between 1926 and 1935, Montandon's views on Jews evolved only slightly: while not a pure race, they were now described as having their own *ethnie*, despite their "assimilation" into French culture. Montandon had simply found a new "scientific" way of essentializing their difference: Jews alone constituted

[110] Montandon, *L'ethnie française*, 144–45.
[111] Montandon, "L'origine des juifs," *L'Humanité*, 15 Dec. 1926.

an impurity within the larger nation that should be removed. All of Montan-
don's scientific ethnology was distilled here: there were no pure races, but
there were natural groups defined biologically and socioculturally whose des-
tiny was to evolve into ever more distilled forms among their own. In the end,
Montandon's description of the French *ethnie* was a deeply racialized and rac-
ist portrait of France, which comforted growing anti-Semitism by dressing
up old prejudices in such complex technical language that "nonspecialists"
would easily be overwhelmed.[112] In France a part of the scientific reception to
the 1935 work *L'ethnie française* was again slightly cool, but only on technical
grounds (his racial measurements were considered outdated); as the anthro-
pologist Daniel Fabre has noted, no "savant de renom" at the time made the
effort to contest Montandon's theses.[113] Was this because, confronted with an
anti-Semitism that had deep roots in France, now thoroughly disguised in
their own scientific discourse, antiracist ethnologists in France were simply
disarmed? The Academy of Moral and Political Sciences, meanwhile, award-
ed the book one of its nine Audiffred prizes in 1936, praising Montandon for
talking about "race with much wisdom."[114] The head of the committee, Ernest
Seillère, was a leading French expert on romantic literature in general and
Gobineau in particular at a time when the latter had again become de rigueur
reading for many intellectuals, although not for the same reasons or because
they necessarily agreed with his conclusions.[115]

Between 1936 and 1938, Montandon continued working out—more and
more openly—his anti-Semitic theories in various scientific publications.
The Nazis' recent racist legislation was clearly giving him hope. For example,

[112] At Payot, Montandon oversaw the translation of several scientific works on race in the 1930s, for
which he wrote prefaces.

[113] Daniel Fabre, "L'ethnologie française à la croisée des engagements (1940–1945)," in Jean-Yves
Boursier, ed., *Résistants et résistance* (Paris, 1997), 354. Henri Victor Vallois in *L'Anthropologie* ques-
tioned Montandon's data, but P. Royer's review in the journal of the École d'Anthropologie was only
positive; *L'Anthropologie* 46 (1936): 442–44; *Revue Anthropologique* 46 (1936): 102–3.

[114] E. Seillère (rapporteur), Séance du 20 juin 1936, *Revue des Travaux de l'Académie des Sciences
Morales et Politiques et Comptes Rendus de ses Séances* (1936): 599–601.

[115] Seillère admired Gobineau's stylistic talents but also accepted his racial view of history. W.J.
Roberts, "The Racial Interpretation of History and Politics," *International Journal of Ethics* 18:4 (July
1908): 475–92; and Francis A. Christie, "*Morales et religions nouvelles en Allemagne. Le Néoroman-
tisme au delà du Rhin* by Ernest Seillère," *American Historical Review* 33:2 (Jan. 1928): 399–401. One
sign of Gobineau's growing visibility among French writers and poets in the 1930s was a conference
held at the Sorbonne on the fiftieth anniversary of his death in 1932, whose proceedings became a
special issue of the *Nouvelle Revue Française* (1934). Despite his philo-Semitism, Gobineau began
in the 1920s to be read by German race theorists, whose *Rassenkunde* drew inspiration from him;
some antiracists—such as van Gennep—read Gobineau to refute him, while others like Senghor and
Césaire were attracted to his notions of impure civilizations. See Gaulmier, "Dossier Gobineau,"
87; Fabre, "L'ethnologie française," 345; Wilder, *Imperial Nation-State*, 356. Under Vichy, theorists
of the New European Man drew on Gobineau for their model of an elite of blood for the future.
Bernard Bruneteau, "*L'Europe nouvelle" de Hitler. Une illusion des intellectuels de la France de Vichy*
(Paris, 2003), 135.

Montandon made one more foray in 1936 into the subject of race hygiene for France, in an essay entitled "Revue d'ethnologie" that appeared in the journal *La Revue Générale des Sciences Pures et Appliquées*. In it he proclaimed his admiration for Germany's new racial policies and the Nazi government's appreciation of the valuable role "raciologues" had to play in their elaboration. Berlin, he lamented, had 800 students enrolled in courses devoted to studying heredity, while the École d'Anthropologie was lucky to get a few dozen auditors. If raciological studies were thriving in Germany, he continued, it was because "race . . . was the foundation of politics [*une politique*]." He then reviewed the most recent studies carried out on discrete populations (statistical, blood-typing) as well as developments in racial psychology, before turning to "teaching and legislation." In all countries that wished to increase "qualitatively and quantitatively the racial elements of their *ethnie*," ethnological studies were being supported. He went on to note that the French weekly, *Les Nouvelles Littéraires*, had recently opened an investigation on the race question and the policies that should be taken "to improve [*relever*] the French ethnicity." Montandon concluded by "enlarging upon and reiterating" three eugenic proposals he claimed to have already made, based on the premise that simply maintaining the current population in France required each family to have three children instead of two. These proposals were that votes should be allocated according to the number of children, the cost of educating children should be borne not by the state but by those who had no children, and women should be both given more rights and banned from the workforce (except for certain menial jobs) as long as they did not have three children.[116] These proposals fell within the pale of what many French racial hygienists at the time were arguing, including the well-known experts on immigration, Dr. René Martial and the geographer Georges Mauco. Montandon did not build strong links to the eugenics community, whose conclusions based on the heredity of blood types he sometimes criticized, although he and Mauco later collaborated with each other (and the Germans) during the war.[117] He seems to have preferred his connections with Italian racists.[118]

[116] George Montandon, "Revue d'ethnologie," *La Revue Générale des Sciences Pures et Appliquées* 47 (1936): 448, 449.

[117] As William Schneider has shown, René Martial used serological studies to argue for the "selection" of immigrants in France based on "racial" compatability. Montandon used his hologenetic theory to argue that blood type alone could not determine who belonged to the French *ethnie*. Schneider, *Quality and Quantity*, 255, and chap. 8 passim. In 1932 Mauco had published *Les étrangers en France. Leur rôle dans l'activité économique* (Paris, 1932), and in 1934 Martial published *La race française* (Paris, 1934). On Montandon's later influence on Mauco, see Adler, *Jews and Gender*, 126–31. On race and immigration, see also Elisa Comiscoli, *Reproducing the French Race: Immigration, Intimacy, and Embodiment in the Early Twentieth Century* (Durham, NC, 2009); and Clifford Rosenberg, "Albert Sarraut and Republican Racial Thought," *French Politics, Culture, and Society* 20:3 (2002): 97–114.

[118] Montandon, for example, contributed many articles in ethnography to the *Enciclopedia italiana* between 1928 and 1936.

On yet other "ethnological" fronts, Montandon in the late 1930s busied himself with restoring order to the osteological collections in the Broca Museum, to which he had been appointed director in 1936—which would also explain his concern with how crania were displayed in the Musée de l'Homme.[119] In 1937, he helped to found a Société des Océanistes in imitation of the older Société des Americanistes (of which Rivet was president) and the Société des Africanistes created by Rivet in 1930, claiming the "civilizational area" of the South Pacific as part of his scientific domain before his rival Rivet beat him to it. In the complex world of French politics (scientific and otherwise), launching this new learned society appears to have been a way for Montandon to win influential patrons, but even here he remained a marginal figure.[120] Rivet and Soustelle retaliated by creating a society of their own, the Centre d'Études Océaniennes, at the Musée de l'Homme in early 1938, which suggests that Rivet was indeed watching his "colleague's" actions.[121]

Then, after years of staying out of politics, in May 1938 Montandon suddenly became a public anti-Semite, on the basis of the dictates of the "science" that he had been developing for so long.[122] In particular, he began lecturing on such subjects as "the problem of the races in France" to openly racist and nationalist audiences in Brussels and in Paris—including at the Sorbonne—and calling for the expulsion of all French Jews to Palestine on the grounds of ethnic incompatibility.[123] Several factors explain his change in behavior at

[119] Henri Victor Vallois, "Rapport moral pour l'année 1938," Compte-rendu des Actes de la Société, *BMSAP* 9:4–6 (1938): 113.

[120] The Société des Océanistes was associated with the traditional Right in France. Comte Henri Begouën was a founding member, and Louis Marin was its president. Begouën was one of the discoverers of the Lascaux cave drawings, but he was not a trained scientist. The society was more interested in ethnography than in racial science. In 1939, Begouën's friends published a volume of essays entitled *Mélanges de préhistoire et d'anthropologie offerts par ses collègues, amis et disciples au Professeur Comte H. Begouën* (Toulouse, 1939). Montandon was not listed among the organizers of this celebration or subscribers to the volume, but he did contribute an article—a confirmation that he did not quite "fit" in this world of conservative amateurs, any more than he "fit" in Rivet's and Mauss's network of allies and patrons.

[121] AMH/2 AM 1 A11/a/Jacques Soustelle à M. Surleau, 19 Feb. 1938, no. 288. The organizers were Maurice Leenhardt, Patrick ("Père") O'Reilly, and Paul Rivet, and the society was "to increase [France's] scientific prestige in one of our [colonial] domains."

[122] With his citizenship secured in 1936, Montandon may have begun to frequent anti-Semitic political circles. The short biography of Montandon in the Vichy archives indicates that toward 1933 he was involved with the royalist Action Française and gave public lectures on "ethnic questions," and that by 1936 he had met the anti-Semite Darquier de Pellepoix. ANF/F¹⁷/13341.

[123] George Montandon, "Le problème des races. L'ethnie juive devant la science," speech of 3 May 1938 in Brussels, Centre d'Examen des Tendances Nouvelles, published in the first issue of its *Cahiers*, Sept. 1938; "Développement actuel de l'ethnologie raciale," speech of 5 Nov. 1938, Sorbonne, published in *Scientia*, Jan. 1939; "La solution ethno-raciale du problème juif," speech of 15 Dec. 1938, Club du Faubourg, published in *Contre-Révolution*, April 1939: "Le problème des races," speech of 24 March 1939, published in *La France Enchaînée*, April 1939; "L'ethnie juive et le type racial juif," speech in April 1939, published in the *Revue Internationale des Sociétés Secrètes*, June

this junction. In July 1938 a Fascist "Manifesto of Racist Scientists" was published for the first time in Italy, arguing for a biological rather than political solution to the "Jewish" problem; Montandon's contacts with Italian scientific racists were long-standing. In addition, Montandon was fascinated but also frustrated with Hitler's racial policies: he believed at first that the annexation of Czechoslovakia was a mistake on "ethnic" grounds.[124] In France itself, anti-Semitism was escalating rapidly, as the nation reeled from one war scare to the next. Finally, the consolidation of Montandon's own naturalization had made it safe for him to return to politics. It was almost as if Montandon by 1938 could no longer contain himself; Germany, he explained, had already faced the scientific facts and made racism—"really ethnoracism"—the official policy of the state; his "Italian friends" had now adopted the same *politique*. France "could do the same."[125] To this end he sought to win like-minded allies, starting with those who would be, or so he hoped, most receptive to his overtures: France's right-wing anti-Semites, none of whom were as well versed in biology or anthropology as him.

Taken together, Montandon's published works of ethnology in France between 1925 and 1938 bear all the trademarks of his early literary dabbling in notions of a master race and suggest that he believed that he had discovered in science the secret to the mysteries of differential human development and endowment. It is hard to escape the conclusion that his anti-Semitism was probably already formed in 1919 and was there in its scientizing guise from 1926 onward, waiting for an opportunity to express itself politically. Montandon had failed earlier in his life to combine political action, journalism, and science; disgraced in Switzerland in the early 1920s, he had then moved to France and bent his considerable ambition, energy, and synthetic abilities to ethnology alone, but it was an ethnology tainted at all times by the racist concepts that he had absorbed before and during World War I and a desire to put them into action. Montandon's late-blooming vitriol would be briefly silenced

1939. The Sorbonne talk was addressed to the members of the Société d'Ethnographie. According to *Action Française*, Montandon had discussed the recent Italian laws, which "evinced much interest." "The notorious anti-Semites Louis-Ferdinand Céline and G. Poisson were in attendance as well as numerous professors from the University." *Action Française*, 6 Nov. 1938. For Montandon's characterization of his talk, see CDJC/XCV-33/George Montandon à Robert Petit, 30 Oct. 1938.

[124] CDJC/XCV-89/George Montandon à R. Gontier; and XCV-80 to XCV-98, correspondence between Montandon and Fleishchauer, as cited in Billig, *L'Institut d'étude des questions juives*, 195 and 198–99. Montandon would later cease such criticisms, because, as Billig points out, he understood that Hitler was going to eliminate anyone who threatened the purity of the German people. Billig, *L'Institut d'étude des questions juives*, 204.

[125] CDJC/XCV-54/George Montandon à Jean Pierre Maxence, 1939. Montandon made a point of correcting German and Italian racists: they mistakenly used "racism" when the proper term was "ethnism," as Montandon had shown in his work on races, *ethnies*, and nations.

in France by the 21 April 1939 Marchandeau law banning hate speech; in its wake, he nevertheless chose to publish his worst diatribe yet, in Italy: an article entitled "L'etnia puttana" in a new racist journal called *La Difesa della Razza*. This time he wrote: "Let us admit for a moment that there is an intention in Germany to destroy its Jews. Whether this is good or bad, useless, advisable, or inadvisable is irrelevant. The only thing we need to consider, biologically speaking, is whether it is possible. Theoretically it is surely possible. But practically, only the laboratory will tell." Montandon went on to cite "the massacre of the Greeks by the Turks at Smyrna" as one of many examples of such a laboratory experiment.[126] A year later, Montandon welcomed the German victory over France for finally opening the way, or so he thought, to a French "ethnoracist" politics informed, as in Germany and Italy, by "science."

Was the Musée de l'Homme "an arsenal," as Eugène Schreider put it in the special 1939 issue of *Races et Racisme*, "where any thoughtful visitor will find impeccable weapons, impartial arguments, and limpid proofs that will allow him to counter, with the serenity that only . . . an impassive science can reveal, . . . the hateful attacks of the enemies of humanity"—among which not only Montandon's anti-Semitic attacks must be counted, but also his earlier treatises on the supposed difference between *ethnie* and race?[127] Schreider was surely asking too much of science; in fact, it was in part because Rivet and Schreider could not imagine questioning the natural reality of "race," even as they emphasized the inevitability and value of racial mixing, that they found it so difficult to silence the scientific racists in their midst. This said, Montandon's 1939 anti-Semitic rant about the "suppression" of racial facts at the new Musée de l'Homme must be read as proof that the new museum's antiracist racial science was understood as just that, at least by Rivet's and Mauss's rival throughout the 1930s.

Can we know how others reacted to the Musée de l'Homme's attempt to put the findings regarding race "impassively" on display? While determining reception is always tricky, press clippings that were preserved from the opening reveal that only a few journalists related what they saw there to the Fascist threat and the racist claims that underpinned it. In *L'Humanité*, Claude Martial noted that all "savages" were represented in the museum except

[126] Montandon, "L'etnia puttana," *La Difesa della Razza*, 5 Nov. 1939, 18–22, cited in Jacques Biélinky, "La science au service de la haine," *La Terre Retrouvée*, 21 Jan. 1939. On the history of this Italian publication, see Sandro Servi, "Building a Racial State: Images of the Jew in the Illustrated Fascist Magazine *La Difesa della Razza*, 1938–1943," in Joshua D. Zimmerman, ed., *Jews in Italy under Fascist and Nazi Rule, 1922–1945* (Cambridge, 2005), 114–57.
[127] Fleury, "Le Musée de l'Homme," 5.

the savage men of the present. A formula should be found to explain the forms of neo-paganism that are an exaggerated racial cult. One would have to group with the worst fetishizers those obtuse idolaters who prostrate themselves before the fetish of the fasces or the swastika, [and] who had the idea to irrigate steel, in order to harvest bayonets.[128]

The Catholic writer for *Pratique Automobile* remarked:

> Once again France reveals herself a champion of humanity, by showing by her research that the deification of Race, a theory which His Holiness the Pope has just condemned, and which replaces charity with egotism, is as absurd as it is iniquitous, and that it is ridiculously pretentious for one race to arrogate the right of looking down on others, and to think that it is the emanation of a so-called divinity created for that sole purpose.[129]

And an article in the big daily *Le Matin* left little doubt as to its views, given its title: "From the Nose of Cro-Magnon Woman to That of Cleopatra: How One Can Draw a Lesson of Humility regarding the Racists of the Third Reich from the Nasal Index." Its author noted that given how ethnologists' measurements had divided all peoples throughout the ages into three types of noses, it was worth concluding "that the great apes are, after all . . . generally leptorrhinians, and that the difference, in this regard, between the pure Aryan from the borders of the Spree [River] and the solitary gorilla of the equatorial jungles is slight."[130] Most of the commentary focused instead on the dazzling profusion of exotic objects, or the modern installations, and made only passing reference to the physical anthropological and prehistory galleries and none at all to the skulls in the rest of the museum.

Perhaps this overwhelming focus in the press on the ethnographic displays meant quite simply that race went unremarked, and hence did not matter to many viewers. Such a verdict could be read as a triumph for Rivet's strategy of dissipating race prejudice through overwhelming evidence of all of humanity's diverse material achievements. Yet a second, more ominous reading of the potential impact on viewers of the dispersed crania on display also seems possible. Recent work on racialized immigration policy in France has

[128] AMH/2 AM 1B2/a/Claude Martial, "Passage douté. Musée de l'Homme," *L'Humanité*, 20 June 1938.

[129] AMH/2 AM 1B2/b/*Pratique Automobile*, 1 Sept. 1938.

[130] AMH/2 AM 1B2/d/"Du nez de la femme de Cro-Magnon au nez de Cléopâtre. Et comment on peut tirer d'une étude sur l'appendice nasal une leçon d'humilité à l'usage des racistes du Troisième Reich," *Le Matin*, 26 Dec. 1939.

stressed continuities between the late Third Republic and Vichy, and between Pétain's regime and postwar governments.[131] As the repopulating of France emerged as a key discourse in the post-1945 Liberation period, experts from a range of fields—medicine, demography, physical anthropology—firmly rejected any notion that a pure French race (or any pure races) existed, yet still ranked according to racial type those groups who could be most successfully assimilated. In these rankings biological and cultural differences were conflated, and standard prewar and Vichy racial typologies (Nordic, Alpine, and Mediterranean)—used in different ways by Rivet and Montandon—were transparently transposed onto national ones (Belgian, Swiss, Italian). Nordics came out as the most desirable type of immigrant, Arabs as the least.[132]

Given these developments, it is unclear whether the "purely descriptive" and "arbitrary" race typologies showcased in the Anthropology Hall of the new Musée de l'Homme were understood as such before the war by the non-professional audience they were targeting. The very notion that races were constantly mixing and changing was by definition one resistant to the kind of static display techniques still used in even the most modern interwar museum. Instead, these typologies may have gained a wider lease on life throughout certain parts of French society and the state in these same years, or been read implicitly as further evidence that race differences were biologically real and thus significant, at least in part as a result of the imprimatur of a state-of-the art museum of science. This more pessimistic reading of the impact of the Musée de l'Homme's displays on the wider public seems the more accurate one, given that the museum's staff also fully supported France's imperialist cause.

[131] In addition to Adler, *Jews and Gender,* see Noiriel, *Les origines*; Patrick Weil, "Racisme et discrimination dans la politique française de l'immigration, 1938–1995," *Vingtième Siècle. Revue d'Histoire* 47 (July-Sept. 1995): 77–102; and Julie Fette, *Exclusions: Practicing Prejudice in French Law and Medicine, 1920–1945* (Ithaca, NY, 2012).
[132] Adler, *Jews and Gender,* 85.

CHAPTER 5

ETHNOLOGY

A Colonial Form of Knowledge?

An ethnographic museum is a place to see how other people live in society. . . . [It] can contribute to the public's education regarding global development [*l'évolution mondiale*]. Young people, by learning in an agreeable manner about the varied and colorful mores of nations of different cultures will want to go visit them. . . . Colonial vocations can thus be born and develop for the greater good of these young people and for that of France.

—MICHEL PETITJEAN, *Lien fraternel*, 1930

Was the professionalizing field of ethnology a colonial science? Historians have long taken for granted that the modern age of empire developed "colonial" forms of knowledge, including "colonial science," which aided and abetted imperialism.[1] Yet there has been little consensus on what the concept "colonial science" actually designates, particularly with respect to the discipline of anthropology. For many specialists the term implicitly refers to any scientific knowledge produced in the colonies, usually by professionals trained in the metropole. Other historians eager to "provincialize Europe" have highlighted the role that colonial administrators played in creating new forms of scientific knowledge, which then returned to Europe. Still other scholars have explored how subaltern subjects adopted aspects of "colonial" knowledge, either to bend science to their own ends, or to co-produce new knowledge with, rather than against, Europeans. Meanwhile postcolonial critics have argued more broadly that the same violent processes that produced colonial power

[1] See such classic formulations as Michèle Duchet, *Anthropologie et histoire au siècle des Lumières*, rev. ed. (Paris, 1995); Cohn, *Colonialism and Its Forms of Knowledge*.

also produced scientific knowledge.[2] This very lack of agreement on what, if anything, is specific to colonial science has caused Helen Tilley recently to jettison the term altogether when discussing the "problem" of scientific knowledge created in territories defined by empire. For Tilley, a specialist on the British in Africa, all science by definition circulates in ways that its producers cannot control, even when this research is sponsored by governments seeking solutions to problems of colonial governance. From this perspective, defining any science as specifically "colonial" obscures more than it illuminates.[3]

Pierre Singaravélou has further complicated this debate with respect to France and its empire by pointing out that under the Third Republic specialists established a new field of study called "the colonial sciences" at the same time that the human sciences were professionalizing. Even though this field failed to survive World War II, Singaravélou argues that it played a central role in the modern empire. Between 1880 and 1940 a constellation of academics, imperial officials, and lobbyists built a network of postsecondary teaching positions in colonial domains, including several university chairs.[4] They founded such sciences as "colonial geography and history," "colonial economy

[2] As noted in the introduction, the literature on empire and science is enormous. On the "colonial" practices of individual groups of French ethnologists, I have profited particularly from reading the following: Sibeud, *Une science impériale?*; Sibeud, "Un ethnographe face à la colonisation: Arnold Van Gennep en Algérie (1911-1912)," *Revue d'Histoire des Sciences Humaines* 10 (2004): 79-104; Trumbull, *Empire of Facts*; de l'Estoile, *Le goût des autres*; Singaravélou, *Professer l'empire*; Singaravélou, ed., *L'empire des géographes. Géographie, exploration, et colonisation* (Paris, 2008); Tai, *L'anthropologie française*; Marie-Albane de Suremain, "L'Afrique en revues. Le discours africaniste français, des sciences coloniales aux sciences sociales (anthropologie, ethnologie, géographie humaine, sociologie)" (Thèse de doctorat, Université de Paris VII, 2001); Jean-Hervé Jézéquel, "Voices of Their Own? African Participation in the Production of Knowledge in French West Africa," in Tilley and Gordon, *Ordering Africa*, 145-73; Pierre Singaravélou, *L'École Française d'Extrême-Orient, ou l'institution des marges (1898-1956). Essai d'histoire sociale et politique de la science coloniale* (Paris, 1999); Oscar Salemink, "*Moïs* and *Maquis:* The Invention and Appropriation of Vietnam's Montagnards from Sabatier to the CIA," in George W. Stocking, Jr., *Colonial Situations: Essays on the Contextualization of Ethnographic Knowledge* (Madison, WI, 1993), 243-84; Susan Bayly, "French Anthropology and the Durkheimians in Colonial Indochina," *Modern Asia Studies* 34:3 (2000): 581-622; Dartigues, "La production conjointe de connaissances en sociologie historique. Quelles approches? Quelles sources? Le cas de la production orientaliste sur le Vietnam (1860-1940)," *Genèses* 43 (June 2003): 53-70; Spencer D. Segalla, *The Moroccan Soul: French Education, Colonial Ethnology, and Muslim Resistance, 1912-1956* (Lincoln, NE, 2009). For ethnography by missionaries, see chapter 2, note 45.

[3] Tilley, *Africa as a Living Laboratory*, 10-11.

[4] These positions were not only at the school for training administrators (L'École Coloniale), but also in public universities and private schools in Paris (the Sorbonne, the Collège de France, and the Institut des Sciences Politiques, among others) and in provincial cities with colonial interests (Lyon, Marseilles, Le Havre, Bordeaux). The university chairs included colonial geography (1893) and the colonial geography of North Africa (1905) at the Faculté des Lettres (Sorbonne), and Muslim law (1895), colonial legislation (1898), and political economy and colonial legislation (1909) at the Faculté de Droit (Sorbonne); chairs in the sociology and sociography of Islam (1902) and colonial history (1921) were also created at the Collège de France. The Ministry of Colonies, various Governments General, and municipal councils underwrote these chairs. Singaravélou, *Professer l'empire*, 72, 79-80.

and law," "comparative colonization," and "native psychology," which sought
to produce practical knowledge of use to administrators, merchants, and in-
dustrialists. Social scientists from other disciplines—economists or law pro-
fessors, for example—with no direct colonial expertise would occasionally
teach courses in these fields; but such figures remained on the margins of the
core cluster of colonial experts.[5] Significantly for our purposes, Singaravélou
places Mauss, Rivet, and the new Institut d'Ethnologie ethnologists in this
"marginal" category, and the failure of any teaching field in "colonial ethnol-
ogy" to emerge under the Third Republic corroborates this assessment.[6]

This chapter seeks to contribute to the ongoing debate on anthropology
as a "colonial science" by analyzing the web of relations that bound French
ethnologists to the empire during the 1920s and 1930s. There is no question
that Mauss and Rivet, and other scientists who supported their work at the
Institut d'Ethnologie and Musée d'Ethnographie/Musée de l'Homme, openly
promoted the cause of the French empire and encouraged collecting mis-
sions and fieldwork in the colonies at a time when imperial rhetoric reached
its apex. Yet they did so from a complex mix of motives, both ideological
and pragmatic. In interwar France, a more established community of physi-
cal anthropologists committed to some form of biological determinism was
making it difficult for ethnologists to institutionalize their new sociocultural
science. Mauss, Rivet, and Lévy-Bruhl thus appealed to empire as a means to
sell their more "modern" expertise to a larger public, by claiming that the sci-
entific study of the cultures and peoples in France's colonies was indispens-
able to "civilizing" them. The empire in return should help fund their efforts,
although at no point did Rivet and Mauss wish to see their students' research
agenda determined by the needs of the colonial administration. This ambigu-
ous positioning of these 1930s ethnologists—trained in a humanist and anti-
racist tradition, yet dependent in many ways on a racist practice of imperial
governance to advance professionally—produced knowledge that was itself
unstable with regard to empire. On the one hand, the members of the inter-
war generation who conducted fieldwork overseas failed to condemn French
colonial rule. On the other hand, these same students began to undermine

[5] Singaravélou, *Professer l'empire*, 13–32.
[6] The core teaching cluster included a group of former colonial administrators in Africa: Mau-
rice Delafosse, Robert Delavignette, and Henri Labouret; the geographer Marcel Dubois; the legal
expert Arthur Girault; the sociologist René Maunier; the historians Alfred Martineau and Ernest
Chassigneux; the North African expert Augustin Bernard; the economist Joseph Chailley-Bert; the
publicist and social scientist Paul Bourdarie; and the energetic head of the École Coloniale in the
late 1920s and early 1930s, Georges Hardy (a geographer by training). Singaravélou makes clear that
this cluster actively supported the efforts of Mauss and Rivet to make ethnology a university-based
discipline. Singaravélou, *Professer l'empire*, 41, 72, 134.

imperial certainties from within, when they began recording and analyzing colonialism's brutal transformation of local economies and social ties.

A Declining Rival? The École d'Anthropologie in the 1920s and 1930s

In September 1937 a congress on scientific research in the overseas territories was held in Paris, under the auspices of two Popular Front ministers, Marius Moutet and Jean Perrin. Paul Rivet, now a Socialist municipal councilor as well as director of the recently reopened Musée de l'Homme, presided over the section devoted to ethnology. The conference had two aims: a *mise au point* of the research undertaken to date in the "domain of the physical and natural sciences" in the different parts of the empire, and the identification of future research initiatives and organization.[7] It boasted a research-oriented agenda, insisting that applied sciences such as medicine, agronomy, and the cultural evolution of colonial peoples fell outside the purview of the congress. Rivet invited scholars from research institutions located in the colonies, such as the prestigious École Française d'Extrême-Orient and the recently established Institut Français de l'Afrique Noire in Dakar, to attend. His goal was to further consolidate the new discipline of *ethnologie* far from the metropolitan center by having his students "colonize" local research centers on the imperial margins. Institut d'Ethnologie graduates should take charge of these centers, by wresting them from amateur savants. Such scientific imperialism emanating from Paris, however, was just the latest move in Rivet's and Mauss's ongoing embrace of the empire in order to make the study of civilizations and language, rather than human physiology and race, the leading vector of the anthropological sciences in France. Locked out of university jobs, Rivet's students needed an alternative institutional site from which not only to work, but also to professionalize and thus grow their discipline, and the colonies appeared ripe for the picking.

This effort to found a new discipline from outside, rather than from within, the proverbial hexagon in the 1920s and 1930s can be traced to the continuing visibility of the school Broca had founded, the École d'Anthropologie, and to the fact that this "old" anthropology, ironically, had never aspired to be a colonial science. Broca and many of his followers had periodically

[7] *Congrès de la recherche scientifique dans les territoires d'outre-mer* (Paris, 1938), 9. For Perrin's vision of colonial research, see Christophe Bonneuil and Patrick Petitjean, "Recherche scientifique et politique coloniale. Les chemins de la création de l'ORSTOM, 1936–1945," in Patrick Petitjean, ed., *Les sciences coloniales. Figures et institutions* (Paris, 1996), 131–61, esp. 120–24.

taken an interest in the empire's racial makeup, and some naval doctors serving in colonial theaters had sent osteological remains to the metropole and published their findings.[8] But neither Broca nor succeeding generations of scientists had tied the development of *anthropologie* to France's expanding colonial domain, to whose populations (unlike those in Europe) they had no direct access.[9] Nor had colonial officialdom shown much interest in racial science.[10] Broca and his intellectual progeny had hitched their fortunes instead to those of the medical profession, a prestigious and expanding sector in the fin de siècle. Although the École d'Anthropologie could not grant degrees, it had always enjoyed a certain academic legitimacy from its close association with the Paris Faculté de Médecine (where its classrooms and Broca's laboratory were located). Professionally speaking, doctors practiced medicine and physical anthropology simultaneously or found jobs in medical schools that allowed them to teach this science. In short, *anthropologie* had not needed the empire to become established in the first place, and this situation does not appear to have changed significantly in the interwar years.

As innovators in a domain that physical anthropologists had long had to themselves, Mauss and Rivet found themselves in a very different position. In the 1920s, they were the newcomers, who were determined not only to lead the science of humanity into the university, but to do so in a way that demoted its physical anthropology branch. Given this agenda, the Institut d'Ethnologie leadership faced a similar dilemma to that of Broca half a century earlier: how to get its revisionist science off the ground, and

[8] For example, in 1860 Dr. Boudin of the Société d'Anthropologie initiated the sending of Arab and Kabyle skulls from Algeria, and in 1878 Dr. Navarre of the French navy sent the recently severed head of the Kanak rebel chief Atai to Broca. Lorcin, *Imperial Identities*, 154–55; Clifford, *Person and Myth*, 124. See also Ricardo Roque, *Headhunting and Colonialism: Anthropology and the Circulation of Human Skulls in the Portuguese Empire, 1870–1930* (London, 2009), esp. chap. 4.

[9] Émmanuelle Sibeud argues that even if they had wanted to measure the bodies of the colonized, administrators did not have the time or the kind of control over their subjects required for such time-consuming and intrusive examinations. Only when medical services developed in the 1930s did racial science begin to make inroads in certain colonies. Sibeud, "A Useless Colonial Science? Practicing Anthropology in the French Colonial Empire, circa 1880–1960," *Current Anthropology* 53: S5, The Biological Anthropology of Living Human Populations: World Histories, National Styles, and International Networks (April 2012): S83–S93; see also Michael A. Osborne and Richard S. Fogarty, "Eugenics in France and the Colonies," in A. Bashford and P. Levine, eds., *Oxford Handbook of the History of Eugenics* (Oxford, 2010), 332–46.

[10] One important exception was the question of racial mixing (*métissage*). In 1907 the Société d'Anthropologie launched an inquiry into *métissage* throughout the French empire. As Émmanuelle Saada and Owen White have shown, local colonial concerns over how to categorize *métis* led to new legislation on their status across the empire in the 1920s. The findings of physical anthropologists entered into these discussions but did not drive them. See White, *Children of the French Empire*, chaps. 4 and 5; and Saada, *Les enfants de la colonie*. For examples of how metropolitan scientists wished to import their categories of race into the empire, see Staum, *Nature and Nurture*, 77–81; Lorcin, *Imperial Identities*, chap. 2; Osborne, *Nature*, 89–97; and Reynaud-Paligot, *La République raciale*, 66–67, 69–72, 74–75.

then to sustain its growth. Unlike *anthropologie*, however, *ethnologie* did not "naturally" fit with any existing professional training, with the possible exception of that of colonial administrators. Indeed, a critical link had been forged early on with this group, when Delafosse and van Gennep had helped convince Mauss and Rivet of the importance of "seeing" and collecting ethnographic data *in situ*. From this early encounter, Mauss and Rivet had come to understand that the empire could provide the kind of legitimacy, easily accessible "primitives," and funds necessary to promote their version of the discipline, and they had turned to the colonies first to establish the Institut d'Ethnologie, and then to secure funds for renovating the Musée d'Ethnographie. In return, they bound ethnology to the empire in a myriad of ways that benefited themselves, their students, and their science—and the colonial lobby.

The origins of this symbiotic relationship between ethnology and empire can best be seen by returning briefly to the establishment of the Institut d'Ethnologie and then the attachment of the Musée d'Ethnographie to Rivet's chair in anthropology in the late 1920s. Just how effective it could be in the postwar era to claim that France needed a scientific understanding of the peoples it was colonizing became clear when the full professors of the Faculté des Lettres proved willing in 1924 to create the Institut d'Ethnologie, as long as it cost the Sorbonne nothing.[11] At this point Lévy-Bruhl, who was leading the campaign at the Faculté, had turned to the minister of colonies Édouard Daladier for help, recognizing that enlightened imperial development was now part of every government's official priorities.[12] Underwriting the costs of ethnology, Lévy-Bruhl argued, could rationalize French overseas practices, by making available to administrators valuable knowledge about the peoples they were ruling. Daladier had agreed and granted the Institut d'Ethnologie a 150,000–franc colonial subsidy, which would be its main source of revenue; but he insisted in return that the Institut d'Ethnologie be genuinely "colonial" in its makeup. It was thus decided that students at the training school for colonial administrators, the École Coloniale, would be encouraged to take Institut d'Ethnologie courses, and that qualified colonial administrators would be

[11] ARP/IE/26/"Projet de création à l'Université de Paris d'un Institut d'Ethnographie," Conseil de l'Université de Paris, séance du 24 novembre, 1924; "Institut d'Ethnologie, Projet de Statut" (n.d. [1924]).

[12] On the importance attached to legitimating the empire scientifically in the interwar years, see Benoît de l'Estoile, "Science de l'homme et 'domination rationnelle.' Savoir ethnologique et politique indigène en Afrique coloniale française," *Revue de Synthèse* 4:3–4 (July–Dec. 2000): 291–323; Véronique Dimier, *Le gouvernement des colonies. Regards croisés franco-britanniques* (Brussels, 2004); and Dimier, "Le commandement de cercle: Un 'expert' en administration de cercle, un 'spécialiste' de l'indigène?" *Revue d'Histoire des Sciences Humaines* 10 (2004): 39–58.

allowed to teach at the institute.[13] Representatives from the colonies and metropolitan academics were to sit on the Institut d'Ethnologie's oversight committees, although their power was not quite equal. Colonial delegates were given representation on the administrative rather than the executive council. The former had twenty-eight members, of whom ten were designated by the colonial governments or the minister of colonies; the latter had five members, all of them professional scientists attached to metropolitan institutions.[14] In keeping with this bipartite structure—half academic, half colonial—Lévy-Bruhl's justifying rhetoric that accompanied the Institut d'Ethnologie's inauguration invoked both the universal scope of the Institut d'Ethnologie's study of cultures from around the world, and the particular help it could furnish colonial administrators who chose to consult with its personnel.[15]

Rivet's second major institutional initiative in the postwar decade—the linking of the Musée d'Ethnographie to the Muséum chair in anthropology—also benefited from an appeal to the new visibility of the empire. With his election to the chair finally in view in 1928, Rivet had sought to enroll Paris's major ethnographic collection in the ranks of the new ethnology, not least because the Musée d'Ethnographie would provide him with an important institutional presence in Paris from which to assert the Institut d'Ethnologie's epistemological claims. Such a linkage would, however, change the nature of the chair, which under Rivet's predecessor, René Verneau (1908–28), had hewed more closely to the research concerns of the École d'Anthropologie. Verneau had had a simplistic evolutionist understanding of the human past, seeing in cranial series the best evidence of cultural attainments; it was under his watch that the Musée d'Ethnographie had deteriorated. Because the chair

[13] ARP/IE/26/"Institut d'Ethnologie, Modifications au projet de règlement," Conseil de l'Université de Paris, séance du 27 avril, 1925; C. Gallois, "Rapport sur le projet de règlement de l'Institut d'Ethnologie," 18 May 1925; and Décret portant création à l'Université de Paris d'un Institut d'Ethnologie, 1 Aug. 1925.

[14] The Conseil d'administration included the rector (président), the deans of the main four Facultés (Lettres, Sciences, Droit, and Médecine), and one member each designated by the École Pratique (Vth section), the Collège de France, the École des Langues Orientales Vivantes, the Muséum, the École Coloniale, the École Française d'Extrême-Orient, the minister of education, and the minister of colonies. The governors-general of Indochina, French West Africa, French Equatorial Africa, Madagascar, and Algeria, and the residents-general of Morocco and Tunisia, each designated a member as well.

[15] Lucien Lévy-Bruhl, "L'Institut d'Ethnologie de l'Université de Paris," *Revue d'Ethnographie et des Traditions Populaires* 23–24 (1925): 233–36. Lévy-Bruhl appears to have been less involved with supervising dissertations in ethnology than Mauss, although many *doctorants* took his courses. He also had a following among certain high-ranking colonial officials. For example, in 1935 Jules Brévié, governor-general of French West Africa, and Georges Hardy, director of the École Coloniale, thank Lévy-Bruhl for his *La mythologie primitive*, which Hardy claims he will read "line for line" as he has the philosopher's previous books. IMEC/Fonds Lévy-Bruhl, Jules Brévié à Lucien Lévy-Bruhl, 15 March 1935; Georges Hardy à Lucien Lévy-Bruhl, 24 Feb. 1935.

at the Muséum was the only publicly funded one in what was still known in France as *anthropologie*, those with a vested interest in keeping the discipline as Broca had originally defined it mobilized against Rivet's proposed change. In the case of this campaign, too, Rivet astutely leveraged the empire to the distinct advantage of ethnology's professionalization.

Opposition to the attempt to attach the Musée d'Ethnographie to the Muséum in the 1920s came principally from certain members of the École d'Anthropologie, one of whom—Raoul Anthony—was also a colleague of Rivet's at the Muséum and only five years his senior. The dispute was all the more rancorous because the two men had once been friends. Anthony held the chair in paleontology at the Muséum and the chair in physiological anthropology at the École d'Anthropologie; he continued to believe, as he put it in 1927, that "social laws come back to biological laws." For him, unlike Rivet, of the three kinds of diagnostic evidence most critical to identifying a people—linguistic, ethnographic, and osteological—language was the *least* trustworthy, while bones could not lie: "The last word . . . must rest with anatomo-physiology."[16] This dispute had become even nastier once the Institut d'Ethnologie added a science track (physical anthropology and prehistory) to its certificate offerings, thereby challenging the École d'Anthropologie's monopoly on the teaching of those subjects in Paris. For example, in late 1928 Rivet was incensed to discover that Anthony had published an article that listed France's major educational institutions devoted to anthropology, and omitted any mention of the Institut d'Ethnologie—and he demanded a public correction.[17] Anthony obviously felt that the study of humanity should have entered the university as "anthropology," not "ethnology," as it had "properly done" recently in Belgium. He thus voted against Rivet when he was elected to the anthropology chair, and again when the issue of attaching the Musée d'Ethnographie to the anthropology chair came up at the Muséum. Anthony here had the backing of the École d'Anthropologie director, Louis Marin,

[16] Raoul Anthony, "L'anthropologie. Sa définition, son programme, ce que doit être son enseignement," *BMSAP* 8:4 (1927): 232–33. Raoul Anthony had already put forth these views in meetings of the assembly of professors of the Muséum in 1923. See ANF/F^{17}/13560/MNHN/Procès-verbal, 21 June 1923 and ANF/AJ15/737/MNHN/Rapport by Raoul Anthony, 21 June 1923. Anthony made the same argument in the 1928 meetings of the professors of the École d'Anthropologie. AMH/MS 15/3/ Procès-verbaux/"Rapport du 3 janvier 1928." Mauss shared Rivet's views of Anthony, as he made clear in a letter to Marin complaining about the latter. IMEC/Fonds Marcel Mauss/MAS 20/Marcel Mauss à Louis Marin, 10 Jan. 1928.

[17] ANF/F^{17}/13560/MNHN/Procès-verbal, 19 Jan. 1929. The article in question was Anthony, "L'anthropologie. Sa définition." Marcellin Boule, the professor of prehistory at the Muséum, shared Anthony's views about not attaching the Musée d'Ethnographie to their institution. He slyly noted at this meeting that Anthony's oversight must have been "un oubli" analogous to Lévy-Bruhl's failure to mention Anthony's chair of paleontology in his inauguration of the Institut d'Ethnologie.

although Marin's motives for opposing Rivet were slightly different. Marin later wrote to the minister of education that it would be heresy to connect the Musée d'Ethnographie to the Muséum chair in anthropology: anthropology was a "somatic science" whose integrity had to be preserved.[18] Marin, as an ethnographer most interested in pure national essences, presumably wanted to capture the Musée d'Ethnographie for himself or one of his followers rather than for a friend of the Durkheimians.

Marin and Anthony nevertheless failed to anticipate that a powerful new argument had emerged in favor of connecting the Musée d'Ethnographie to the chair in anthropology. As the delegate of the minister of education put it, if the Muséum chair's field were to be redefined as "anthropology in the broad sense," its holder would "make the effort to extend his action to include every aspect of the human races, and work in concert with the recently founded Institut d'Ethnologie of the Sorbonne, from which we expect a great deal for the development of our colonies." And he continued: "I see only advantages to the Muséum chair widening its field of action, taking inspiration from modern scientific tendencies, and studying current problems."[19] In the interwar era, claiming that one's science could benefit the empire, that to be modern was to study contemporary problems ethnographically, and that to govern well overseas was to appeal to modern science proved to be to ethnology's advantage. Rivet and Mauss had repeatedly made this argument in the 1920s and would continue to do so in the Depression-wracked 1930s, sincerely and with no sense that a colonial mandate for ethnology would constrain their or their students' objectivity.[20]

The École d'Anthropologie of course could have tried to do the same, and another of its faculty made at least one bid in that direction. In 1929

[18] ANF/F¹⁷/13567/MNHN/M. le Ministre des Pensions [Louis Marin] à M. le Ministre de l'Instruction Publique, 6 May 1928. Marin, in his capacity as member of the parliamentary budget commission, subsequently supported Rivet's efforts to renovate the Musée d'Ethnographie. See Rivet's letters to Marin in ANF/317/AP 138/Papiers Louis Marin/Société d'ethnographie. Marin's correspondence with Rivet in the early 1930s indicates limited but cordial contact. After 1933—that is, at the same moment Montandon and Rivet appear to break off contact—the letters cease. In 1945 Marin and Rivet, although on different ends of the ideological spectrum, resumed contact because they had both participated in the Resistance. For the views of other members of the École d'Anthropologie, see AMH/MS 15/3/Procès-verbaux/"Rapport du 3 janvier 1928" and "Rapport du 11 juin 1928"; ANF/F¹⁷/13567/MNHN/"Note," M. le Directeur de l'Enseignement Supérieur [Cavalier] à M. le Ministre de l'Instruction Publique, 27 Feb. 1928.

[19] ANF/F¹⁷/13567/MNHN/"Note," M. le Directeur de l'Enseignement Supérieur [Cavalier] à M. le Ministre de l'Instruction Publique, 27 Feb. 1928.

[20] From the moment Rivet started lobbying for the transfer the Musée d'Ethnographie to his chair, he proposed colonial subventions on the grounds that the value of "a modernized and reorganized museum" for the training of functionaries and propaganda purposes was self-evident. ANF/F¹⁷/13567/MNHN/Paul Rivet à M. le Directeur du Muséum [Louis Mangin], 4 Feb. 1928 (personal); AMH/2 AM 1 D 1/a/"Note explicative," Paul Rivet à M. le Directeur du Muséum [Louis Mangin], 2 Dec. 1929.

Marin, perhaps because of his friendship with one of France's most illustrious colonial "heroes," Marshal Lyautey, was put in charge of overseeing the creation of a "synthetic" introductory exhibit on colonial races and ethnography for the Colonial Exposition of 1931.[21] Lyautey was the general commissioner of the Exposition, and the anthropological exhibit in question was to be housed in a new building destined to become the future Musée des Colonies. As Benoît de l'Estoile has shown, colonial officials in the end abandoned the notion of a synthetic ethnographic display as too difficult to achieve; each pavilion—there was one per colony—instead mounted its own display as it chose. But these same officials approved a synthetic exhibit of the races of the empire, put together by Marin's associate, the sixty-eight-year-old anthropologist Georges Papillault, who taught sociology at the École d'Anthropologie—very incompetently, as Mauss had already noted in 1927.[22] Mauss's assessment seems mild: Papillault assembled a series of skeletons and accompanying panels that explained which races could assimilate French civilization, and which were biologically incapable of doing so unless they mixed with the French race. Despite the fact that the most respected anthropology journal, *L'Anthropologie*, ignored the exhibit in its review of the Colonial Exposition (a sign that it, too, considered Papillault's science problematic), Papillault's race gallery remained in place.[23] When the Exposition closed, Papillault applied to become director of the new Musée des Colonies designed to perpetuate the Exposition's work, noting that knowledge of "the anthropology of natives" was critical to a productive collaboration between them and the French. "What," he wrote, "are the physical, intellectual, and moral aptitudes of the diverse races, so different among themselves, who people our colonial empire? All our efforts will depend on the scientific answer we provide to these questions." And he concluded that the Musée des Colonies would be the ideal place to collect this documentation.[24]

In the end the directorship went to Gaston Palewski, a protégé of Lyautey and, more critically, a friend of Rivière.[25] It is clear from this whole incident that Marin had not tried very hard to turn an awakening interest on the part of colonial officialdom in the peoples of empire to the advantage of his

[21] On Lyautey's hero status in France, see Edward Berenson, *Heroes of Empire: Five Charismatic Men and the Conquest of Africa* (Berkeley, 2012).

[22] IMEC/Fonds Marcel Mauss/Marcel Mauss, 28 Jan. 1927 [recipient unknown]. This letter regarding the Anthropology Laboratory at the École Pratique is not cataloged.

[23] Benoît de l'Estoile," 'Des races non pas inférieures mais différentes'. De l'Exposition Coloniale au Musée de l'Homme," in Blanckaert, *Les politiques*, 424–26.

[24] AMAAO/15/Georges Papillault à M. le Commissaire de l'Exposition, 10 Jan. 1932.

[25] See chapter 3 for an account of the creation of the Musée des Colonies.

school.[26] And to the extent that the École d'Anthropologie had tried to sell physical anthropology as useful to colonial governance, it, too, had failed— although Papillault's crude racial classifications, as de l'Estoile reminds us, had presumably been seen by the record number of visitors (over 33 million paid entries) that the Exposition attracted.[27] In contrast to this failure, Rivet, Mauss, and Rivière would find a multitude of ways to incorporate the Exposition into their efforts to build up ethnology as a science; by the summer of 1931, however, these three men were already seasoned experts in the art of linking their new science to the empire.

ETHNOLOGY'S COLONIAL "LAUNCH": THE PREHISTORY OF THE MISSION DAKAR-DJIBOUTI

Having "sold" their version of a science of humanity to the Sorbonne professors and government officials in 1925 and 1928, Mauss, Rivet, and Rivière began cultivating lucrative overseas ties even before the Colonial Exposition offered them new opportunities to do so. Rivet in 1929 had little trouble securing the same colonial subsidy for the renovation of his ethnological museum-laboratory, the Musée d'Ethnographie, as had been granted the Institut d'Ethnologie in 1925. This subsidy represented the single largest source of revenue in the Musée d'Ethnographie's 1929 material budget (319,000 fr.) and almost 30 percent of its total operating budget (material and personnel) in 1930 (522,000 fr.); the only other contribution that came close to this subsidy was 100,000 francs from the Friends of the Musée d'Ethnographie.[28] In return for this generosity, Rivet claimed to have kept the empire's interests front and center at his museum. As he explained to the minister of colonies a few years later, when the subsidy had been reduced, "[The subsidy] has only partially covered the important services rendered to the French colonial cause by the Musée d'Ethnographie."[29] A "justifying" note in January 1931 explained that one half of that year's 150,000-franc

[26] On this point, see also AMH/MS 15/3/Procès-verbaux/"Rapport du 15 décembre 1937," "Rapport du 20 juin 1939," and "Rapport du 19 décembre 1939." These minutes indicate that even as funds from the government and the Paris city council were cut back in the late 1930s, the professors did not discuss trying to get a colonial subsidy.

[27] De l'Estoile, "'Des races non pas inférieures,'" 403; on attendance at the Exposition, see Dana Hale, *Races on Display. French Representations of Colonized Peoples during the Third Republic* (Bloomington, IN, 2008), 167.

[28] AMH/2 AM 1 G2/a/Commission consultative du Musée d'Ethnographie du Trocadéro, 29 June 1929, "Rapport sommaire sur l'activité du Musée d'Ethnographie depuis son rattachement au Muséum"; AMH/2 AM 1 G2/d/"Ressources financières du Musée," 11 April 1930.

[29] AMH/2 AM 1 A6/c/ Paul Rivet à M. le Ministre des Colonies, 20 Feb. 1934, no. 306

allocation had been used for running the museum and the other half for equipment, including the refurbishing of the library (20,000 fr.); the latter's 15,000 volumes included many on the empire, making the library "a unique center of documentation on the colonies." Of the total, 30,000 francs had gone to creating the museum's laboratory, and 12,000 francs provided stipends for two colonial personnel to catalog objects that they had donated; upon returning to the colonies, these personnel would initiate others into "their methods." In addition, 35,000 francs had been spent on temporary exhibits with a colonial theme (5,000 fr. on Annam folklore; 30,000 fr. on New Caledonia), while scientific *enquêtes*, such as one on "fire techniques" organized in conjunction with the Congo Museum in Tervuren, had cost another 10,000 francs. A sum of 6,500 francs was allocated to republish the Musée d'Ethnographie's instructions for collecting. For the first time ever, the museum had underwritten a scientific mission to the empire when it contributed 30,000 francs to the Mission Dakar-Djibouti (whose total budget was 1.3 million fr.), and it expected to need 50,000 francs to continue to subsidize missions in 1932. Rivet concluded that given the onset of the Depression, he had no choice but to accept the 20,000-franc reduction from the colonies for the following year. But his museum still desperately needed the colonial subvention: heating costs alone absorbed 80,000 of the 100,000 francs that it received directly from the state for operating costs.[30] Despite this plea, in 1932 this subsidy was reduced to 80,000 francs, in 1934 to 50,000, and in 1938 to 48,000, while the anticipated total expenses remained 740,880 francs.[31]

Yet even as this subsidy diminished, ethnology's imbrication in the empire continued to grow in other ways. Shortly after his arrival at the Musée d'Ethnographie, Rivière made clear that an important colonial priority would be acquiring artifacts from the empire. As Rivière explained in a letter to the Rockefeller Foundation requesting funds in 1930, "And can we not foresee an immense and imminent extension of our ethnographic collections, if, as we hope, we succeed in assembling in our colonies the [kind of] collections that

[30] AMH/2 AM 1 G2/d/"Note justificative," 6 Jan. 1931 [pour la subvention de 150,000 fr. des Colonies]. In these early years, museum personnel salaries (a total of 49,000 fr.) were paid by the Association of the Friends of the Musée de l'Ethnographie, because expenses routinely exceeded receipts. Between 1929 and 1935 the Friends contributed over half a million francs to the museum. AMH/2 AM 1 A12/a/Jacques Soustelle à M. Cogniot [Rapporteur du Budget de l'Éducation Nationale], 23 Nov. 1938, no. 2044. According to Soustelle's 1938 report, an additional 542,000 fr. would come from the Ministry of Education, and 150,000 fr. from entry fees into the museum.

[31] AMH/2 AM 1 G2/e/"Note relative à la subvention de 150,000 fr.," 24 June 1932; "Rapport à M. le Directeur du Muséum National d'Histoire Naturelle sur la necessité d'augmentation des crédits dévolus au Musée d'Ethnographie du Trocadéro," n.d. [1932]; AMH/2 AM 1 G3/a/"Note relative à l'activité du Musée d'Ethnographie dans le domaine colonial français," 31 Jan. 1934.

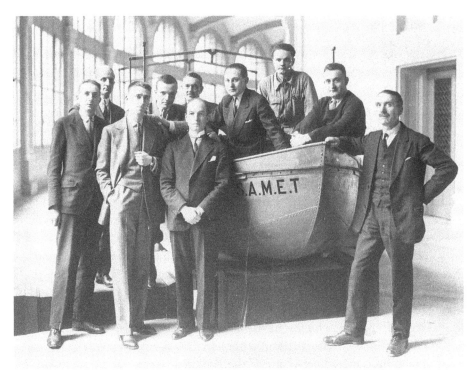

Members of Marcel Griaule's Mission Dakar-Djibouti, with the collapsible boat paid for by the Friends of the Musée d'Ethnographie du Trocadéro (SAMET), May 1931. *Left to right:* A. Schaeffner, unknown, G. H. Rivière, Baron Oumtomsky, M. Leiris, E. Lutten, J. Moufle, G. L. Roux, and M. Larget. AMH/PH/1998–20939. Photo courtesy of the Musée du Quai Branly/Scala/Art Resource, NY.

the scientific world expects of us?"[32] Fortunately, acquiring collections that educated the public about the breadth and depth of France's empire was also in the best professional interests of France's new ethnologists. Part of Rivet's bid to reorganize and consolidate ethnology in France was to document the provenance of each artifact. To do so, however, would require starting collections practically from scratch; yet with no acquisition budget, the museum had little choice but to continue to rely on donations from private individuals, as well as to organize its own collecting "missions." To quote Rivet,

> Buying ethnographic objects on the art market is a solution as expensive as it is unscientific. . . . How much more preferable, as long as there is still time, to proceed with a direct harvest on the ground, either by individuals on mission or by those on the spot who are familiar with our ethnographic methods.

[32] AMH/2 AM 1 A1/a/Georges Henri Rivière à Selskar M. Gunn, 11 July 1930, no. 875.

Only in this way will the provenances be reasonably sure and the pieces be documented in a manner that increases their worth ten times. This is why, unlike art museums, which have significant acquisition funds, ethnographic museums require above all sufficient resources to send scientific missions.[33]

And missions to the colonies could provide the richest harvests of all, because conditions for "scientific" collecting were easiest where the French flag flew. No single expedition illustrated this fact better than the first one the Institut d'Ethnologie/Musée d'Ethnographie helped to organize: the Mission Dakar-Djibouti, which traversed France's African colonies from west to east between June 1931 and March 1933. Its goals were to endow the Musée d'Ethnographie with the collections it lacked from that region, and to call attention to the colonial nature of the rejuvenated museum's holdings.

The origins of the Mission Dakar-Djibouti can be traced back to late August 1929. That month a thirty-one-year-old student of Mauss, Marcel Griaule, and Griaule's friend Eric Larget, a mechanic and a naturalist, arrived home after a year of ethnographic prospecting in Ethiopia, for which they had cobbled together a budget of 40,000 francs from various scientific funds. Griaule's interest in Ethiopia and ethnology was partly accidental. He had originally been intending to attend the École Polytechnique (France's premier engineering school for the training of high-level civil servants) when World War I interrupted his studies. After serving with distinction as a pilot, he remained in the air force until 1924 when a decisive encounter with a school friend led him to enroll at the École des Langues Orientales Vivantes and the École Pratique to study the ancient languages of Amharic and Ge'ez. He also began the Institut d'Ethnologie diploma, which he never finished, although he would complete a doctorate in the domain. Griaule's first trip to Ethiopia in 1928 had been born of his newfound passion for the country, a passion driven as much by a search for adventure as by science.[34]

In May 1930 Griaule approached the directors of the Institut d'Ethnologie with a project for a second expedition to Ethiopia. But he now proposed something much more grandiose: a four-man eighteen-month mission from Dakar to Djibouti, making stops at Kayes, Bamako, Tombouctou, Ansongo, Niamey, Zinder, Lake Chad, Fort Archambault, Bangui, Redjaf, Pays des

[33] AMH/ 2 AM 1 A3/a/ Paul Rivet, "L'activité du Musée d'Ethnographie au cours de l'exercise 1931," Dec. 1931; AMH/2 AM 1 A3/b/"Rapport sur la Mission Dakar-Djibouti," 8 Jan. 1932.

[34] On Griaule's career, see Éric Jolly, "Marcel Griaule, ethnologue. La construction d'une discipline (1925–1926)," *Journal des Africanistes* 71:1 (2001): 149–90; and Jolly, "Des jeux aux mythes. Le parcours ethnographique de Marcel Griaule," *Gradhiva* 9 (2009): 165–87; for highly hagiographic biographies, see Isabelle Fiemeyer, *Marcel Griaule, Citoyen Dogon* (Paris, 2004) and Jean-Paul Lebeuf, "Marcel Griaule," *La Revue de Paris* (1956): 131–36.

Rivières, Khartoum, Roseires, Lake Tana, and Addis Ababa.[35] For personnel he listed, in addition to Larget, Michel Leiris, a student at the Institut d'Ethnologie and Musée d'Ethnographie staff member, as secretary-archivist, and Claude Pingault, director of an unnamed company that manufactured photographic equipment, as "film operator." Griaule identified two objectives: first, an "extensive" twelve-month *enquête* in colonial territory (nine French colonies plus parts of the Belgian Congo and the Anglo-Egyptian Sudan would be traversed), to gather "important collections" for the Trocadéro as well as field notes for a thesis in ethnology, and to initiate contact with administrative and military organizations, with a view to future collaboration; and second, an "intensive" six-month *enquête* with similar goals to the extensive one, in the regions of Bahr al-Ghazal, Sobat, and Lake Tana in Ethiopia.

In order to maximize efficiency and minimize costs, Griaule had designed a boat for certain segments of the trip, which could easily be disassembled; all the mission's scientific equipment (recorders, materials for developing film and conserving collections) would be installed on it, making the equipment constantly available and thus minimizing loss of valuable work time. As to the proposed itinerary, he noted that in the case of the French colonies, the ever-greater contact between Europeans and local peoples, along with the advances of tourism—which certainly "had to be encouraged"—were nevertheless the "enemies of ethnographic facts." Soon there would be nothing left to collect. In the case of independent Ethiopia, radical transformations were occurring for internal reasons in a country that had been up until then "closed to European civilization." Referring to the advent of Haile Selassie to the Ethiopian throne just a few months earlier, Griaule warned that the country was about to be opened to European companies: "Already the king has drawn up an accord with the Americans for the use of Lake Tana. This whole region will be transformed within five years . . . and then it will be too late to obtain useful information regarding unknown civilizations."

The crux of Griaule's justification for the mission, however, was that the Musée d'Ethnographie had no properly identified African collection to speak of, when, as France's most eminent ethnographic museum, it should have an unequaled one—to continue the work of the soon-to-open Colonial Exposition at the Parc de Vincennes, on the outskirts of Paris. The collections formed by specialists, he added, would surely exceed in value the costs of the mission. The moral results of the expedition would be even more valuable: the establishment of relations between the French colonies and

[35] ANF/AJ[15]/740/"Projet de mission ethnographique et linguistique Dakar-Djibouti," Paris, 21 May 1930, Marcel Griaule, Assistant au Laboratoire d'Ethnologie, à Mssr. Les Secrétaires Généraux de l'Institut d'Ethnologie, 5 pp. The itinerary would later change slightly.

the Institut d'Ethnologie and Musée d'Ethnographie; directives for "willing [*de bonne volonté*] administrators" to instruct them in how to make "usable observations" and collect "rationally"; and last but not least, encouragement of an interest in ethnology among young French students by giving them an example of the Institut d'Ethnologie's training. Griaule concluded by asking the Institut d'Ethnologie professors to recommend him to the minister of colonies and officials in individual French territories, as well as to the ministry of foreign affairs and international scientific organizations that could facilitate his task, and to help him in soliciting aid from companies in the form of discounts and subventions. A year later, Griaule had raised over a million francs from public and private sources, extended his proposed mission to two years with a total of ten participants, and become the toast of Paris.[36]

How to account for both Griaule's conversion from his Ethiopian vocation to such a vast colonial enterprise, and his extraordinary success in marketing his mission, soon baptized the Mission Dakar-Djibouti? A close examination of the evolution of the project suggests that two personal factors played a critical role: first, Griaule's ability to learn from his previous African experience about the advantages of working and collecting inside the empire, and second, his appointment to the Musée d'Ethnographie's staff shortly after Rivière's arrival there, and the instant friendship that developed between these two equally driven and talented men.[37] Griaule's 1928–29 mission to Ethiopia, where France had a significant financial stake and imperialist ambitions, had represented the first African fieldwork by an Institut d'Ethnologie student—albeit not fieldwork premised on the kind of in-depth immersion and participant observation that was becoming normative among the students of Malinowski in Britain; Griaule's notion of fieldwork was to gather information and artifacts in short stays, working through interpreters and adopting an inquisitorial method of questioning rather than learning the

[36] For a superbly annotated version of the most famous account of the mission, Michel Leiris's 1934 *L'Afrique fantôme*, see Jean Jamin, *Leiris. Miroir de l'Afrique* (Paris, 1996); and also Michèle Richman, "Leiris' *L'âge d'homme*: Politics and the Sacred in Everyday Ethnography," *Yale French Studies* 81 (1992): 91–110; Jamin, "Objets trouvés des paradis perdus. À propos de la Mission Dakar-Djibouti," in Jacques Hainard and Roland Khaer, eds., *Collections Passion* (Neuchâtel, 1982), 69–100; Jamin, "La Mission d'ethnographie Dakar-Djibouti 1931–1933," *Cahiers Ethnologiques* 5 (1984): 1–179; and Nicolás Sánchez Durá and Hasan G. López Sanz, eds., *La misión etnográfica y lingüística Dakar-Djibouti y el fantasma de África* (Valencia, 2009). For Griaule's own account, see *Minotaure* 2 (1933): 1–89.
[37] See Georges Henri Rivière, "Témoinage," in Solange de Ganay, Annie Lebeuf, Jean-Paul Lebeuf, and Dominique Zahan, eds., *Ethnologiques. Hommages à Marcel Griaule* (Paris, 1987), 131–32; the correspondence between the two men also testifies to the close friendship that developed early on.

local language.[38] For this earlier mission, Griaule had targeted the remote mountainous areas northeast and south of Gojam, which was considered "unexplored" and "dangerous" territory, given the great difficulty of access and provisioning and the independent character of its peoples; he had also spent five months as a guest of the provincial ruler Ras Hailou in Begemder (Gondar) to study early Christian material culture in Ethiopia.[39] In the course of this mission, Griaule and his mentors had learned firsthand how important good relations were with colonial interests—private or public—even in a part of Africa that was independent. At the time, officials in French, Italian, and British Somaliland were vying for control of Ethiopia's resources, although it was France that had won the right to build Ethiopia's only railroad to the sea from Addis Ababa to the French-owned port of Djibouti. Embarking with the slimmest of resources, Griaule had decided to contact the industrial magnate who headed this railroad, Charles Michel-Côte, and received not only 10,000 francs from him, but free rail transport as well for whatever specimens the mission collected.[40] He was also able to negotiate a half-price passage to Africa and free transportation for his equipment to and from the Red Sea with the Compagnie Havraise Peninsulaire.[41] These advantages could be even more easily replicated in a French colony.

But Griaule's project and the colonial form it ultimately took also unmistakably reflected another development in his professional itinerary, after his return from Ethiopia: a close association with Rivière and Rivet's renovation of the Musée d'Ethnographie, at a time when their eyes were focused not just on what other museums were doing, but on selling their science as a colonial one. Rivet was able to appoint Griaule as a "préparateur" in his Laboratory of Ethnology at the École Pratique, albeit without a salary. Griaule's money problems, however, were temporarily solved when he was hired in the

[38] For the continuing assessment of Marcel Griaule's methods as an Africanist, see James Clifford, "Power and Dialogue in Ethnography: Marcel Griaule's Initiation," in Clifford, *Predicament of Culture*, 55–91; Gaetano Ciarcia, *De la mémoire ethnographique. L'exotisme au pays des Dogons* (Paris, 2004); Anne Doquet, *Les masques dogons. Ethnologie savante et ethnologie autochtone* (Paris, 1999); W. van Beek, "Dogon Restudied: A Field Evaluation of the Work of Marcel Griaule," *Current Anthropology* 32:2 (1991): 139–67; Van Beek, "Enter the Bush: A Dogon Mask Festival," in Susan Vogel, ed., *Africa Explorers: 20th-Century African Art* (New York, 1991), 56–73; W. van Beek and J. Jansen, "La mission Griaule à Kangaba (Mali)," *Cahiers d'Études Africaines* 158 (2000): 363–76; Andrew Apter, "Griaule's Legacy," *Cahiers d'Études Africaines* 177 (2005): 95–130; and Éric Jolly, "Écriture image et dessins parlants. Les pratiques graphiques de Marcel Griaule," *L'Homme* 200 (2011): 43–82; on Griaule's field methods, see Paul Henley, *The Adventure of the Real: Jean Rouch and the Craft of Ethnographic Cinema* (Chicago, 2011).
[39] IMEC/Fonds Marcel Mauss/MAS 19/Marcel Mauss, "Note concernant une mission de M. Griaule à M. Albert Kahn," n.d. [1928].
[40] IMEC/Fonds Marcel Mauss/MAS 5.45/Marcel Griaule à Marcel Mauss, 30 June 1928.
[41] IMEC/Fonds Marcel Mauss/MAS 5.45/Marcel Griaule à Marcel Mauss, 5 Aug. 1928.

summer of 1929 as a writer for the new avant-garde publication *Documents*, and then released to work at the museum from nine to noon.[42] Griaule and Rivière soon were hatching a much grander return trip to Ethiopia, one that would begin in West Africa and include collecting for the museum. Rivet and Mauss were won over, because the expanded expedition promised to give further tangible form to their claim that ethnology was a science dedicated to the work of empire—and more particularly to the "neglected" ethnography of its sub-Saharan colonies. Indeed, it gave Rivet the excuse he had been looking for to launch and widely publicize in June 1930 the first learned society (in Paris) dedicated exclusively to publishing articles on that part of the empire, the Société des Africanistes, with Griaule as its secretary-general.[43]

Mauss, Rivet, Griaule, and Rivière now began looking everywhere for money for the mission, turning to deputies, scientific institutions, and private philanthropy—including industrialists for soaps and perfumes that Griaule planned to distribute en route in exchange for artifacts.[44] In all of these appeals, they again emphasized the contribution that the young science of *ethnologie* was making to French imperial grandeur and renewal. To cite just one example, Rivière sent a copy of the mission's prospectus to Paramount films: would they be interested, he asked, in sending a crew along who could benefit from the expedition's scientific preparation, official status (support from the colonial administration and the army), and prestige as a national enterprise, to make "for the first time admirable documentaries with sound not only on the geographic milieu, the natives, and their customs but also on the fauna . . . which they would fully own?" In exchange Paramount would, at its own expense, make "purely scientific" films under Griaule's direction, whose rights would go to the Muséum and the Institut d'Ethnologie. Waxing eloquent, Rivière closed by pointing out how the "young French [members of the mission] would be very impressed to be collaborating with the firm that had contributed so decisively to the success of the Byrd expedition [1928–30],

[42] AMH/2 AM 1 G2/a/Commission consultative du Musée d'Ethnographie du Trocadéro, 29 June 1929. The *Documents* salary meant that Griaule was quickly absorbed into the museum's projects and Rivière's *beau monde* and avant-garde networks; it helped that he was a gifted writer who won the 1934 literary prize, the Prix Gringoire, for his account of his first "Abyssinian" journey, provocatively called *Les flambeurs d'hommes* (*The Burners of Men*). By the end of 1930, however, *Documents* had collapsed, and Griaule's best financial prospects lay in getting funded for another mission. On the tensions between Griaule's scientific and literary aspirations, see Vincent Debaene, "Les 'chroniques éthiopiennes' de Marcel Griaule. L'ethnologie, la littérature et le document en 1934," *Gradhiva* 6 (2007): 87–103.
[43] In July 1930, the Musée d'Ethnographie printed an announcement that listed the Mission Dakar-Djibouti and the founding of the Société des Africanistes as linked initiatives and distributed it widely among its scientific, colonial, and art-world contacts; more announcements were sent out in October 1930. AMH/2 AM 1 A1/a and c.
[44] AMH/2 AM 1 A1/d/Georges Henri Rivière à M. Droz, 3 Nov. 1930, no. 1562; and Georges Henri Rivière à Raymond Gouin, 24 Nov. 1930, no. 1660.

just when colonial questions were entering massively into the news [*l'actualité nationale*]." In the end it turned out that the person Rivière had written, André Daven, had no power to negotiate such a deal.[45]

Disappointed by Paramount, the media-savvy Rivière had more luck mobilizing his many friends in the journalistic world. Beginning in 1930 a wide gamut of periodicals gratifyingly emphasized the empire's need for such scientific enterprises, and for more patriotic scientists like Griaule to lead them. Gaston Poulain, writing for the daily *Coemedia* in March 1930, worried that Griaule, once back from his mission, would be "reduced to begging if he does not find a position at the Musée d'Ethnographie as an Africanist, which is not a luxury when you consider the immensity of our African empire." He added that other imperial powers were "pillaging our [African] colonies," creating "the risk of [France's] soon not being able to find anything there. . . . We're already behind."[46] In October 1930 Jean Pédron from the right-leaning daily *Le Journal* also sounded the theme of France's national renewal through such youthful visionaries, in which the empire was the implicit backdrop. Griaule, too [i.e., like Rivière], he wrote, "is a young man, but has great scientific references. . . . He gave me his proposal for the mission. . . . When I raised my head Rivière and Marcel Griaule, side by side, were bent over their maps, following together the future trip, imbued by the same sentiment of passionate research which erased all the difficulties, all the exertions to be vanquished."[47] More neutrally, in March 1931 *L'Art Vivant* noted that France had an "immense colonial empire about which we are completely ignorant. . . . That is, so to speak, the current French mentality, which we must try to interest in ethnography."[48] In a different register, the left-leaning *Le Peuple* encouraged

[45] AMH/2 AM 1 A1/b/Georges Henri Rivière à André Daven, Directeur de la production Paramount, 22 Sept. 1930, no. 1216; and AMH/2 AM 1 A1/d/Georges Henri Rivière à André Daven, Directeur de la production Paramount, 18 Nov. 1930. Griaule had already hoped to film during his first Ethiopian mission and learned the hard way the difficulties involved. Transporting 50,000 m of film on mules would add, he wrote Mauss, another 36,000 fr. to his budget. As Mauss put it in a letter to the philanthropist Albert Kahn, sponsor of the 1930s' Archives of the Planet photographic project, France's public establishments funded only "old style expeditions," and Griaule's "modern methods" would require additional funds. IMEC/Fonds Marcel Mauss/MAS 19/Marcel Mauss, "Note concernant une mission de M. Griaule à Albert Kahn," n.d. [1928]. Griaule had also written Mauss at the time that he was in negotiation with several *maisons de cinéma*, only to report a month later that "cinemagraphic preparation is a lot less simple than I imagined" and that all "deals" were off. *Lumière* had nevertheless given him 50 percent off its [photographic] products and the Banque d'Indochine "was surely going to give something." IMEC/Fonds Marcel Mauss/MAS 19/Marcel Griaule à Marcel Mauss, 10 July and 5 Aug. 1928.
[46] AMH/2 AM 1 B1/d/Gaston Poulain, "Notre Musée d'Ethnographie du Trocadéro peut éviter le pillage de notre art colonial," *Coemedia,* 26 March 1930.
[47] AMH/2 AM 1 B1/d/Jean Pédron, "Le Musée du Trocadéro en réorganisation s'enrichira des collections que doit rapporter la mission Griaule de son voyage en Afrique," *Le Journal,* 21 Oct. 1930.
[48] AMH, 2 AM 1 B1/d/Jean Gabriel Lemoine, "La réorganisation du Musée d'Ethnographie du Trocadéro," *Art Vivant,* 1 March 1931.

its readers to go see the temporary exhibit at the Trocadéro devoted to advertising the mission before its departure. What impressed its journalist was that the modern equipment—cinematography, sound recordings—would ensure a positive and serious study of "primitives," and thus help fight the prejudices that still existed about them. The well-informed reporter did not neglect to point out that this new-style mission reflected the influence of such pioneering savants, anthropologists, sociologists, and ethnographers as James Frazer, Émile Durkheim, Lucien Lévy-Bruhl, Marcel Mauss, Maurice Delafosse, and Paul Rivet.[49] Last but not least, Rivière could consistently count on the support of the colonial press, whose members he had included on the Musée d'Ethnographie mailing lists from the moment he had been hired. "The Musée d'Ethnographie is organized to initiate [visitors] into [all] things colonial" declared the *Dépêche Coloniale* in 1931.[50] A few months later, in an article entitled "A Great Center of Colonial Studies, the Musée d'Ethnographie," its reporter, Henri-Paul Eydoux, wrote: "Just as the American Museum of Natural History in New York possesses the most important collections on Indian civilizations, we wish the Musée d'Ethnographie to be the museum of the peoples and civilizations of our empire."[51]

The yearlong efforts of Mauss, Rivet, Griaule, and Rivière to combine support for ethnology with support for the empire would pay off spectacularly in the spring of 1931, not least because by that time preparations for the Colonial Exposition were also in full swing. In March, 1931 the parliament voted a subsidy of 700,000 francs (renewed in 1932) to fund the Mission Dakar-Djibouti, on the specific grounds that "at the moment when the Colonial Exposition at Vincennes is highlighting our colonial economic methods . . . it is highly opportune to prove to the scientific world and foreign powers the interest that the government [*pouvoirs publics*] is taking in the study of the civilizations of our overseas possessions."[52] Critical support in shepherding the vote through came from Rivière's friend Gaston Palewski, then serving

[49] AMH/2 AM 1 B1/d/Adolphe Hodée, "En marge de l'Exposition Coloniale, le Musée d'Ethnographie," *Le Peuple*, 9 May 1931.

[50] AMH/2 AM 1 B1/d/Henri-Paul Eydoux, "Un grand centre d'études coloniales, le Musée d'Ethnographie du Trocadéro," *La Dépêche Coloniale*, 11 March 1932; see also Georges Hardy, "La politique d'expansion au Trocadéro, le Musée d'Ethnographie est organisé pour initier aux choses coloniales," *La Dépêche Coloniale*, 5 June 1931.

[51] AMH, 2 AM 1 B1/e/Eydoux, "Un grand centre d'études coloniales."

[52] AMH/2 AM 1 M2/b/Documents/no. 4841, Chambre des Députés, 1931, Projet de Loi autorisant le Ministre de l'Instruction Publique et des Beaux-Arts à participer aux frais d'organisation de la Mission Dakar-Djibouti, et portant ouverture sur l'exercise 1930–1931 des crédits afferant à cette participation. Présenté au nom de G. Doumergue par M. Roustan (Ministre de l'Instruction Publique et des Beaux-Arts), par M. Piétri (Ministre du Budget) et par M. Flandin (Ministre des Finances).

as head of minister of colonies Paul Reynaud's cabinet.[53] Griaule also secured another 300,000 francs ($4,800) from the Rockefeller Foundation (renewed in 1932).[54] A gala fund-raiser that Rivière organized with boxing world's champion Al Brown in April 1931, which "married Sport and Science" and advertised the Musée d'Ethnographie and the mission to Paris's well-heeled, garnered an additional 100,000 francs.[55] And in December 1931 a final episode in the campaign was played out: after more intense lobbying by Rivet and Rivière—aided by, among others, art dealers and colonial interests—the Chamber of Deputies would allocate 5 million francs from the National Public Works budget for buying new display cases for the Trocadéro, in anticipation of the African "booty" soon to come.[56]

In the annals of ethnology, the Mission Dakar-Djibouti is often remembered for its unsavory and unscientific aspects. As Jean Jamin has persuasively argued, Rivière's and Griaule's successful publicity bore more than a passing resemblance to an earlier 1920s venture: André Citroën's self-financed and self-promotional motorized expedition from Algeria to Madagascar in 1924–25, popularly known as the Croisière Noire and immortalized by a film of the same name that traded in the worst stereotypes about "savages." Citroën had organized the Croisière to show that the transportation of the future, even in Africa, lay in (his) cars, and to encourage tourism in France's African colonies. He, too, had relentlessly advertised his venture, securing it with help from colonial commercial interests and officials as well as diplomats.[57] And there were more similarities once the mission arrived in Africa. Griaule and

[53] AMH/2 AM 1 E1/e/Georges Henri Rivière à Gaston Palewski, 3 April 1931, no. 538. "My dear friend, I must write to express my affectionate appreciation for all the effort crowned with success that you made on behalf of our dear Mission Dakar-Djibouti." A month later he supported Palewski's appointment to head the new Musée des Colonies. AMH/2 AM 1 E1/e/Georges Henri Rivière à M. le Directeur des Musées Nationaux et l'École du Louvre, 21 May 1931.

[54] AMH/2 AM 1 A1/b/Georges Henri Rivière à Marcel Mauss, 2 Sept. 1930, no. 1128; IMEC/ Fonds Marcel Mauss/MAS 5.46/Marcel Griaule à Marcel Mauss, 18 April 1931; AMH/2 AM 1 A3/c/ Georges Henri Rivière à M. le Directeur [Rockefeller Foundation], 7 April 1932, no. 661. See also the correspondence of Marcel Mauss and Marcel Griaule in Marcel Mauss's archives, as well as that of Griaule with Paul Rivet and Georges Henri Rivière, AMH/2 AM 1 A1, A2, and A3 and AMH/2 AM 1 K.

[55] AMH/2 AM1 M2/b/"Allocation de Georges Henri Rivière offerte à la presse le vendredi 10 April 1931"; see also Marcel Griaule's speech at the boxing match, 15 April 1931, in the same file.

[56] AMH/2 AM 1 A3/a/Paul Rivet à M. le Sénateur (sent to all senators), 5 Dec. 1931, no. 2210 bis; and AMH/2 AP 1 D/Paul Rivet à Georges Henri Rivière, 22 Dec. 1931. The prominent African and Oceanic art dealer Paul Guillaume introduced Rivière to Albert Sarraut, the former minister of colonies and a deputy, who played a critical role in securing these public funds. Laurière, Paul Rivet, 407.

[57] Jamin, introduction to Leiris, 26. On the Croisière Noire, see Alison Murray, "Le tourisme Citroën au Sahara (1924–1925)," Vingtième Siècle. Revue d'Histoire 68 (Oct.–Dec. 2000): 95–107; and Alison Murray Levine, "Film and Colonial Memory: La Croisière Noire," in Alec Hargreaves, ed., Memory, Empire, and Postcolonialism: Legacies of French Colonialism (New York, 2005), 81–97; and Peter Bloom, French Colonial Documentary: Mythologies of Humanitarianism (Minneapolis, 2008), chap. 3.

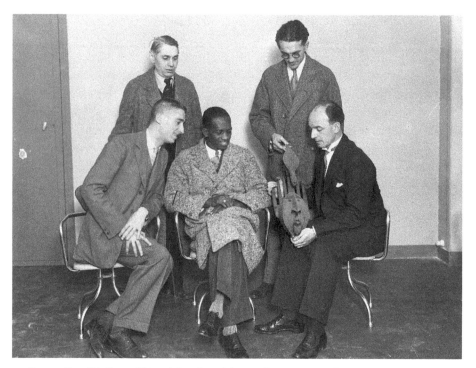

Georges Henri Rivière and Marcel Griaule with boxer Al Brown, 15 April 1931. *Seated from left to right:* Georges Henri Rivière, Al Brown, and Marcel Griaule with a Bambara mask. Marcel Griaule organized a boxing match between world champion Al Brown and a certain Simendé to raise funds for his Mission Dakar-Djibouti. Al Brown pledged the proceeds of the fight to the cause of gathering knowledge about Africa. AMH/PH/1998–19234. Photo courtesy of the Musée du Quai Branly/Scala/Art Resource, NY.

his team would collect some 3,700 objects, by means that at best were insensitive, and at worst unethical. One of the most egregious recorded depredations was the removal of fifteenth-century murals at St. Antonios Church in Gondar, Ethiopia, on the grounds that they would be lost to science if left in place; copies by the mission's artist replaced them.

For Jamin, Griaule's brutish rush to collect at any price was driven in part by the expedition organizers' desire to make the "headlines" in the same way Citroën had, except for different reasons: only by capturing the public's and the government's attention could ethnology, still a "young science in formation," hope to flourish. Without excusing the methods of the Mission Dakar-Djibouti, Jamin concludes that it was in the end a one-of-a kind expedition that did in fact reveal (in contrast to the crude exoticism of the Croisière Noire) the rich cultural variety of what were "more than ever the colonies."[58]

[58] Jamin, introduction to *Leiris,* 26.

Yet it is debatable just how unique the mission was in the annals of 1930s ethnology, or the extent to which it marked the end of a certain kind of parasitic ethnography. If no future mission sponsored by the Musée d'Ethnographie/Institut d'Ethnologie operated in quite the same commercial manner or benefited from such generous state funds, the Mission Dakar-Djibouti nevertheless bound ethnologists ever more closely to the empire's resources by initiating a set of practices that all their subsequent research and collecting missions to the colonies in the 1930s would emulate. As Mauss had pointed out in his letter of recommendation to the Rockefeller Foundation, Griaule's team would be helped "freely by the various French colonies, which will be in charge of their local expenses, transport, and buying of collections."[59] While in Africa, Griaule regularly sent a list to Rivière of those administrators who had been most helpful, and who should be sent a letter of thanks, to ensure that they would be helpful again to scientists.[60] Both men were assuming that henceforth professional ethnologists should privilege the empire precisely because they would benefit from colonial protection, discounted travel, and the right to send whatever they wished back home. They were rarely disappointed; only a year later the Africanist ethnographer and former colonial administrator Henri Labouret went first to the Ivory Coast and then to Cameroon on mission for the Institut d'Ethnologie and Musée d'Ethnographie; he returned from the second trip in 1934 with thirty-five crates—that is to say, almost as many as Griaule's team. In this case, moreover, the museum had targeted French Cameroon specifically, in order to allow the Musée d'Ethnographie to gain parity with the great colonial collections amassed there by Germany before World War I—a reminder of the ways that nationalist rivalries, too, inevitably insinuated themselves into a science that sought to live off the empire.[61]

Ethnology in the Shadow of the 1931 Colonial Exposition

If the Mission Dakar-Djibouti offered a first imperial venue for launching France's newest human science, ethnology's fate soon became entwined with another venue closer to home, in the summer of 1931: the Colonial Exposition,

[59] IMEC/Fonds Marcel Mauss/MAS 21.29/Marcel Mauss à M. le Directeur [Rockefeller Foundation], 29 Sept. 1930.
[60] Even before his return Griaule sent Rivière the names of individual officials to thank, whom they could count on in the future. See, for example, AMH/2AM 1 A3/c/Georges Henri Rivière à M. Colombani, Administrateur des colonies, 21 April 1932, no. 765; also AMH/2 AM 1 M2/b.
[61] AMH/2 AM 1 A7/c/Paul Rivet et Georges Henri Rivière à M. le Directeur du Chemin de fer, 23 Oct. 1934, no. 1756.

under whose sign the funds for Griaule's mission had been released.[62] With the latter's fate secure, Rivet and Rivière immediately turned their attention and their new colonial expertise to the Exposition, whose opening in May 1931 would also influence the evolution of their science in a number of ways. On the one hand, each of the major overseas territories provided the Exposition with an ethnographic display: here was a model Rivière could emulate and improve on in the Musée d'Ethnographie's halls, and a source of artifacts in their backyard, so to speak. On the other hand, for an anthropologist like Rivet, eager to develop ethnology's colonial ties but with no direct experience of the empire, the Exposition offered the perfect opportunity to establish contact with high-level colonial personnel and convince them to invest in his new science. Finally, the popularity of the Exposition suggested colonial themes that the Musée d'Ethnographie could draw on in the future to lure larger audiences into its renovated galleries—an ongoing concern once the Depression set in.

Rivière was alert from the outset to the possibility of acquiring the artifacts of the Exposition for the Trocadéro, although here he had to act quickly. There was an initial understanding by the Exposition's organizers that the bulk of its ethnographic objects would go to the new Musée des Colonies, scheduled to open in one of the Exposition's buildings, the Palais des Colonies. Rivière nevertheless turned this situation on its head by arguing that his institution was already France's "scientific" colonial museum and therefore that the Exposition's artifacts should go to it; the Musée des Colonies, in contrast, should focus on colonial history and economic development so that the two museums did not compete with each other. Rivière's success was due, as usual, to a combination of hard work and the right contacts. As we have already seen, he made sure that his crony Gaston Palewski won the directorship to the museum, and that Rivière served as his replacement in the critical first months of its existence.[63] Meanwhile he and Rivet contacted authorities

[62] Benoît de l'Estoile was one of the first to point to the importance of this exposition for ethnology, in his essay " 'Des races non pas inférieures'. " He argued that just as Rivet thought of the Musée de l'Homme as "colonial," the Exposition organizers aspired to make their fair "scientific"—hence the many affinities between the two venues. For other aspects of the Exposition, see Charles-Robert Ageron, "Exposition coloniale de 1931. Mythe républicain ou mythe impérial?" in Pierre Nora, ed., Les lieux de mémoire, vol. 1, La République (Paris, 1984), 567–91; Catherine Hodeir and Michel Pierre, L'exposition coloniale (Paris, 1991); Lebovics, True France, chap. 3; Patricia Morton, Hybrid Modernities: Architecture and Representation at the 1931 Colonial Exposition, Paris (Cambridge, MA, 2000); Hale, Races on Display, chap. 8; and Bloom, French Colonial Documentary, chap. 5.

[63] During the exhibit itself, Rivière lunched with Palewski's patron Lyautey and noted that "the general had discovered our activity and questioned me; he will come visit the museum." AMH/2 AM 1 A2/d/Georges Henri Rivière à Marcel Griaule, 31 October 1931, no. 1959.

at the French West African, French Equatorial African, Indochinese, Madagascan, Somalian, and Oceanian pavilions in the summer of 1931 requesting permission to choose the best pieces from their displays for deposit within the museum once the Exposition closed. They mostly gained satisfaction—to the tune of several thousands of objects—except from France's mandate territory of Cameroon, and for two rare "wooden taboos of four meters . . . , last specimens of *canaque* art" that the colonial government of New Caledonia wished to keep in the museum in Nouméa.[64]

Another self-interested move on Rivière's part was to organize a parallel temporary exhibit on the colonies at the Musée d'Ethnographie, which played subtly on the Colonial Exposition's ethnographic shortcomings to publicize the fact that France now had experts whose job it was not just to preserve the artifacts collected by administrators, but to convert them into the kind of prestigious scientific knowledge that only a museum-laboratory could bestow. The organizers of the Exposition had wished to make the fair as high-minded and noncommercial as possible, in keeping with the spirit of reformed colonialism of the postwar League of Nations mandate. Yet the fact that each colony had created its own ethnographic display, with no consistency among them or agreed-on norms of preservation and display, belied this claim to scienticity. As Rivière put it bluntly to one of his many contacts, "You can see ethnographic objects from Indochina [at the Exposition], but not I think presented scientifically."[65] Sympathetic members of the colonial and left-wing press broadcast the same message more subtly. Adophe Hodée, writing in *Le Peuple*, exhorted readers: "Go see the Colonial Exposition. There are obviously interesting things to see." But he added: "To complete the visit one must go to the ethnographic museum, designed uniquely for

[64] AMH/2 AM 1 A3/a/Georges Henri Rivière à Michel Leiris, 18 Dec. 1931, no. 2279 cf. bis. AMH/2 AM 1 G2/a/Commission consultative du Musée d'Ethnographie du Trocadéro, 22 June 1931, "Rapport présenté par Paul Rivet"; AMH/2 AM 1 F1/a/M. Guyon, Gouverneur Général de la Nouvelle Calédonie à M. André, Commissaire des Établissements français du Pacifique Australe à l'Exposition, 15 March 1932. See the files in AMH/2 AM 1 F1 for lists of what Rivière chose from each colony. In his annual report to the consultative commission of 22 June 1931, Rivet listed the figure of "several thousand objects" donated by the different commissariats of the Exposition. AMH/2 AM 1 G2/a/"Rapport présenté par P. Rivet, activité du 23 juin 1930 au 22 juin 1931."

[65] AMH/2 AM1 A1/e/Georges Henri Rivière à Karl Gustav Izikowitz, 15 Feb. 1931. Regarding the intense contact between the Musée d'Ethnographie and Exposition participants, see AMH/2 AM 1 A2/c/Georges Henri Rivière à Michel Leiris, 21 Aug. 1931, no. 1435. Rivière wrote Leiris, who was on the Mission Dakar-Djibouti, that he was way behind in museum affairs because the Colonial Exposition required "permanent contact" on his part. His efforts were paying off, he added, because they had already been promised the Indochinese and West Africa collections, most of which were excellent and identified.

instruction."[66] The *Dépêche Coloniale* noted that it was a shame that [the Musée d'Ethnographie's temporary colonial] exhibit was not at Vincennes.[67]

It is interesting to note that this alternative "expert" exhibit was the handiwork of eighteen-year-old Jacques Soustelle, then a newly arrived volunteer at the museum, and Marcelle Bouteiller, another neophyte ethnographer and volunteer who a year later would join the staff and be put in charge of the Asian collections. Soustelle, admitted first in his cohort to the École Normale Supérieure to study philosophy at the precocious age of sixteen, had quickly gravitated toward Rivet's Americanism. A rising "star" like Griaule, he would replace Rivière in 1936 as the Musée d'Ethnographie's assistant director, but on his initiation into ethnography in 1930, he experienced the field as a science of empire.[68] According to Bouteiller, the displays included, in addition to "a hundred celebrated vellums depicting flora and fauna from our colonies" borrowed from the Muséum, the Dahomey collections, jewels and textiles from French West Africa, and wooden drums from the Ivory Coast and Guinea; Laotian, Cambodian, and Haut Tonkin textiles, "whose methods were now lost"; the "ancient arts of Oceania" represented by sculptures on wood, ivory, and stone from the Marquesa Islands and New Caledonia; feather and pearl ornaments from Guyana, some dating back to the eighteenth century; and finally, musical instruments from all parts of the world. Some of these objects were being exhibited for the first time.[69]

Securing artifacts and mounting the colonial ethnography exhibit were not the only moves made by Musée d'Ethnographie personnel to use the Exposition to promote the museum's own distinctive niche in the overseas endeavor. Several scholarly congresses were held in conjunction with the Exposition, and Rivière encouraged the members of each to come visit the museum's colonial exhibit, new library, and ongoing renovations.[70] Here, too, was an opportunity to make specialists in such subjects as colonial agronomy, colonial

[66] AMH/2 AM 1 B1/d/Hodée, "En marge de l'Exposition Coloniale."
[67] AMH/2 AM 1 B1/d/Pierre de Saint Prix, "Le Musée d'Ethnographie du Trocadéro, M. Georges Henri Rivière qui en est le sous directeur, nous dit la grandeur et la misère de cet établissement, appelé pourtant à rendre de si grands services," *La Dépêche Coloniale,* 17 June 1931. The press, however, could also elide the differences between the museum and the Exposition; for example, the *Annales Coloniales* quoted the education minister, Mario Roustan, as asking reporters to encourage the public to visit the Trocadéro to discover "the variety and grandeur of our colonial empire," since "we won't always have a Colonial Exposition." AMH/2 AM 1 B1/d/J. Aytet, "Une interview de Mario Roustan au Musée d'Ethnographie du Trocadéro," 27 Aug. 1931.
[68] AMH/2 AM 1 G2/a/Commission consultative du Musée d'Ethnographie du Trocadéro, 22 June 1931, "Rapport présenté par Paul Rivet," expositions temporaires.
[69] AMH/2 AM 1 A2/b/Marcelle Bouteiller à Zina Gauthier, 23 June 1931.
[70] Five congresses visited the museum in all, three of which had a distinctive colonial dimension: Congrès International des Arts Décoratifs, Congrès International d'Anthropologie et d'Archéologie Préhistorique, Congrès des Recherches Scientifiques Coloniales, Congrès des Langues Coloniales, Congrès de la Société Indigène.

languages, and colonial decorative arts aware of the Institut d'Ethnologie and Musée d'Ethnographie's bid to acquire a place among them. Rivet made the most of this opportunity, by participating directly in one of the congresses, the Congrès des Recherches Scientifiques Coloniales of 1931, sponsored by the Association Colonies-Sciences. Tropical agronomists had founded this private interest group in 1925 to pressure the state to coordinate and fund scientific research related to imperial *mise en valeur*. Rivet explained that his museum was nothing less than a "genuine colonial laboratory," with which all overseas officials should be in contact.[71] His attempt to sell ethnology as one of the physical and natural sciences critical to empire would pay off: a year later the director of the Association Colonies-Sciences was insisting in the society's newsletter that every European colonial power should make an intimate knowledge of the peoples it governed the foundation of its policies, especially in the face of the Depression and the rise of new anticolonial ideologies.[72]

And Rivet took advantage of the visibility of ethnography at the Exposition in yet another way that would help consolidate ethnology. There was already a tradition of colonial research institutes in certain parts of the empire, such as Algeria, Morocco, Indochina, and Madagascar. Rivet thus wrote to the minister of colonies and certain governors-general to the effect that the overseas territories should be building ethnographic museums as well, and placing them in the hands of properly trained ethnologists. Ethnology was not, Rivet insisted, a vocation that could be improvised on the spot; it was a science that required the kind of training that only the Institut d'Ethnologie could provide. Any overseas museum had to have oversight from a scientifically recognized body in order to be properly organized. Rivet wrote first to authorities in West Africa to this effect, while the Exposition was in full swing and presumably because the Mission Dakar-Djibouti was already working there.[73] He began his efforts to stake out professional ethnology's place in the empire in earnest, however, as a result of his first trip to a French colony—Indochina—just as the Exposition was ending, in December 1931.

Rivet was invited to Hanoi originally to preside over the first international meeting of the "Préhistoirens de l'Extrême Orient"; he then decided to use this opportunity to conduct his own four-month-long Indochina collecting mission, since the Southeast Asian colonies were, like so many African ones,

[71] Paul Rivet, "Organisation des études ethnologiques," *Actes et Comptes-Rendus de l'Association Colonies-Sciences* 78 (Dec. 1931): 251–53.

[72] Maurice Martelli, "Rapport sur l'activité de l'Association Colonies-Sciences en 1931," *Actes et Comptes-Rendus de l'Association Colonies-Sciences* 82 (April 1932): 84–96.

[73] AMH/2 AM 1 A2/b/Paul Rivet à M. le Gouverneur Général de l'Afrique Occidentale Française, 30 June 1931, no. 1006.

barely represented in the Musée d'Ethnographie's collections. Two months after his arrival, Rivet wrote to Rivière that he was "drunk on ethnography in this admirable country" and needed another 10,000 francs because he had bought so much—mostly prehistoric artifacts, as it turned out; he was also sending along the names of contacts sympathetic to "our methods." His most exciting news, however, was that an archaeologist of the École Française d'Extrême-Orient, Jean-Yves Claeys, was going to be officially placed in charge of coordinating all research and collecting efforts in Indochina. Claeys, Rivet explained, was passionate about ethnography, married to an "Annamite," fluent in the language, and used cinema. He "would thus do for Indochina what Griaule is doing for French West Africa." Before leaving, Rivet also tried to convince Governor-General Pasquier to build an ethnographic and prehistory museum in Dalat, home to Vietnam's menaced highland peoples—a museum Pasquier did create on paper a year later.[74]

Having met with such success in Indochina, in April 1932 Rivet wrote next to the governor-general of New Caledonia, urging him to develop the museum that already existed in Nouméa in a scientific direction, in keeping with trends in Indochina, Morocco, West Africa, and hopefully soon, Madagascar.[75] He then sent the governor-general of Madagascar a project for creating an ethnographic and ethnological center at Antananarivo, pointing out that the governor-general of Indochina had just taken such a measure and

[74] AMH/2 AP 1 C/Paul Rivet à Georges Henri Rivière, 1 Feb. 1931. See also in same file Paul Rivet à Georges Henri Rivière, 19 Feb. and 28 Feb. 1932; and Pierre Pasquier à Paul Rivet, 31 April 1932. When Rivet arrived in Hanoi, the École Française d'Extrême-Orient was already maintaining museums in Hanoi, Hue, Tourane, Saigon, Phnom Penh, and Angkor, but these were all archaeological. See Singaravélou, L'École Française d'Extrême-Orient, 79–80; and John F. Embree, "Anthropology in Indochina since 1940," American Anthropologist, n.s., 50:4, pt. 1 (Oct.-Dec. 1948): 714–16. Upon his return, as a further sign of Rivet's "conversion" to colonial ethnology, Rivet dedicated his physical anthropology course "to our beautiful colony" and procured a Rockefeller fellowship for his student Georges Dobo (Georges Devereux) to conduct doctoral fieldwork among the Vietnamese highland minorities. AMH/2 AM 1 A3/d/Paul Rivet à Pierre Pasquier, 24 May 1932, no. 1074.

[75] There had been talk of an ethnographic museum in Rabat since 1930, when Mauss visited his former student Charles Le Coeur there to provide advice. In May 1932 Rivet and Rivière sent guidelines for setting up a museum to another former École Coloniale and Institut d'Ethnologie student of Arabic and Berber and volunteer at the Musée d'Ethnographie, Lucien Cochain. IMEC/Fonds Marcel Mauss/MAS 18/Marcel Mauss à M. le Directeur [Rockefeller Foundation], 29 Sept. 1930; IMEC/Fonds Marcel Mauss/MAS 20/Marcel Mauss à Bronislaw Malinowski, 28 Jan. 1930; AMH/2 AM 1 A3/d/Georges Henri Rivière à Lucien Cochain, 26 May 1932, no. 1100. The Mission Dakar-Djibouti was supposed to encourage the creation of a museum in Dakar; French West Africa did not yet have a "prestigious" school to which such a museum could be attached, but in August 1931 the inspector general of education there, Albert Charton, had drafted a project for one to which the new governor-general, Jules Brévié, was sympathetic; in 1932 Charton was corresponding directly with Rivet and Griaule about this project, which would lead to the creation of the Institut Français d'Afrique Noire and its museum in 1936. AMH/2 AM 1 A4/d/Paul Rivet à Albert Charton, 27 Dec. 1932, no 2717; 2 AM 1 A6/d/Marcel Griaule à Albert Charton, 18 April 1934, no. 715; Théodore Monod, "Historique de l'Institut Français d'Afrique Noire," Notes Africaines 90 (April 1961): 31–63.

that Governor-General Brévié in Dakar was considering the same.[76] In each of these instances, Rivet could argue that he had the backing of the minister of colonies; in July 1931, at the height of the Colonial Exposition, Minister of Colonies Reynaud had sent a circular to all governors requesting that administrators interested in ethnographic questions get in touch with the Institut d'Ethnologie and the Musée d'Ethnographie.[77]

There was yet another way in which the Colonial Exposition marked ethnology in its formative years. After the Exposition closed—and thus no longer posed any kind of competition for the Musée d'Ethnographie's own efforts—Rivet and Rivière authorized a major exhibit closer, ironically, to the "unscientific" spirit of Vincennes than the scientific one they aspired to. The hope seems to have been to lure into their museum the very public that had flocked to the Exposition, by promising this time not just ethnography, but the history of colonial exploration, both French and international. The exhibit in question was on the Sahara, a perpetual object of fascination.[78] Running from May to October 1934, it was the museum's longest and most successful exhibit to date, with over 66,000 visitors (92,367 fr.)—as compared to a total of some 22,000 admissions for all nine temporary exhibits put on in 1933.[79] Rivière and Rivet helped with the exhibit, but the idea did not originate with them; its principal organizer, Henri-Paul Eydoux, was an amateur archaeologist,

[76] AMH/2 AM 1 A4/a/Paul Rivet à M. le Gouverneur Général de Madagascar, 18 July 1932, no. 1554; see also follow-up letters in 2 AM 1 A4/d/Paul Rivet à M. le Gouverneur Général de Madagascar, 13 Dec. 1932, no. 2642; AMH/2 AM 1 A6/b/Paul Rivet à Raymond Decary, 7 Feb. 1934, no. 219.
[77] For a copy of the circular in question (no. 3975, 21 July 1931), see AMH/2 AM 1 E1/e/Inspecteur de l'Académie de Paris (Ministère des Colonies) à Paul Rivet, 22 Sept. 1932. In 1933, Rivet would list in a note on the museum's colonial objectives and activities that the following ethnographic correspondents, "principally colonial administrators," had been established in the colonies: J.Y. Claeys in Indochina, Dr. Rollin in Polynesia, Rey Lescure in Melanesia, Raymond Decary in Madagascar; in French West Africa and French Equatorial Africa, the collection of artifacts had not yet been centralized. AMH/2 AM 1 G3/a/"Le Musée d'Ethnographie du Trocadéro et les colonies françaises," 26 Jan. 1933.
[78] Although the exhibit has not been studied, there is a rich literature by historians on the long French obsession with the Sahara. Among recent works, see Hélène Blais, "Les enquêtes des cartographes en Algérie ou les ambiguïtés de l'usage des savoirs vernaculaires en situation coloniale," Revue d'Histoire Moderne et Contemporaine 54:4 (Oct.-Dec. 2007): 70–85; Benjamin Brower, A Desert Named Peace: The Violence of France's Empire in the Algerian Sahara, 1844–1902 (New York, 2009); and Jacques Frémeaux, Le Sahara et la France (Paris, 2010).
[79] AMH/2 AM 1 A7/d/Entrées au Musée pendant le Sahara, no. 1661, 10 Nov. 1934; AMH/2 AM 1 G3/a/Nombre d'entrées au Musée en 1933. Museum admissions totaled 99,764 fr. in the seven months after the exhibit's closing, which suggests that it had won the museum a broader audience. The Musée de la France Outremer (the new name for the Musée des Colonies, which finally opened in 1935) planned to mount its own Saharan exhibit, devoted to the missions of the explorer Henri L'Hôte, in early 1937; and in the fall of 1937 the Musée de l'Homme staff began to plan another Sahara exhibit, this time limited to "le Sahara maure," also requiring the help of the military. AMH/2 AM 1 K69/c/Ary Leblond à Paul Rivet, 16 Dec. 1935; and Paul Rivet à Ary Leblond, 24 Dec. 1934, no. 3329; AMH/2 AM 1 A10/d/Paul Rivet et Jacques Soustelle à M. le Gouverneur Général de l'Algérie, 28 Sept. 1937, no. 2142.

military administrator attached to the Southern Territories in Algeria, and journalist who covered the early renovations of the Musée d'Ethnographie for the prominent colonial newspaper, the *Dépêche Coloniale*. The Musée d'Ethnographie and the Government General of Algeria (whose Southern Territories made up the vast bulk of France's Saharan holdings) were co-sponsors, while five Ministries—Colonies, War, Air, Education, and Foreign Affairs—and the Governments General of French West Africa and French Equatorial Africa were patrons. Egyptian, German, Italian, and Spanish scientific societies also joined in, along with various missionary organizations, and veterans and the families of explorers sent memorabilia to be displayed.[80] In addition, all the Saharan territories, including those held by other powers, were represented; there were sections on prehistory, the continuing history of Saharan exploration (with an equal emphasis on spectacular new archaeological and cave art "discoveries" and recent French military victories), and finally ethnography, which was to be the most important. "Ethnography," however, was defined elastically: this section's principal element would be the Tuareg confederations, because in Eydoux's words, "The public loves them without knowing much about them."[81] But there were also sections on ancient and medieval cartography, on books written on the Sahara, and on the modern organization of the Sahara (i.e., administrative, economic, and military aspects, including a special room for the Ministry of Air to retrace the history of the Sahara's aerial exploration); natural history was also presented, along with some works of art of Saharan inspiration.[82]

Given the Musée d'Ethnographie's gloomy financial picture in the depths of the Depression, it would appear that Rivière and Rivet had jumped at the chance to increase the number of visitors through an exhibit that in its theatrical, patriotic, and propagandistic elements resembled the Colonial Exposition more than any other of the museum's temporary exhibits. Rivet may also

[80] As such, the exhibit appeared to overlap with the mission of the Musée des Colonies, although the latter had still not opened. In 1934 the Réunionais writer of Greek origin Ary Leblond (a pseudonym) replaced Palewski as director of the museum. Like his predecessor, Leblond agreed that the Musée des Colonies should differentiate itself from the Musée d'Ethnographie. Leblond highlighted the history of French colonization with an emphasis on "French-indigenous collaboration," "native arts," and contemporary life in the colonies, including economic development, all in a "pittoresque" style (dioramas featured prominently). Leblond, whose sensibilities were Maurrasian, also chose to create a "galérie des races" in the hall of honor in which a series of sculptures by "metropolitan and native artists" depicted "native types." This race gallery was possibly inspired by Malvina Hoffman's "Races of Man" bronze sculptures, commissioned by the Field Museum in Chicago in the 1920s and completed by Hoffman in her Paris studio in the early 1930s. The only "native" artist mentioned in the museum's archives from this period is the French-trained Vu Cao Dam. AMAAO/50/Ary Leblond, Rapport, 1935; and AMAAO/20/Ary Leblond à M. le Minstre des Colonies, 23 Sept. 1935.
[81] AMH/2 AM 1 C3/d/Henri-Paul Eydoux, press communiqué, n.d.
[82] AMH/2 AM 1 A6/a/Georges Henri Rivière and Paul Rivet à M. le Ministre des Colonies, Rome, 13 Dec. 1933.

have thought the tense political climate in Europe could be diffused by a gesture of international cooperation on the scientific front, which nevertheless called attention to France's imperial interests as well as accomplishments in the Sahara.[83] On the one hand, Rivière wrote to the Berlin Geographic Society, indicating that the museum wanted to dedicate part of the exhibit to German explorers.[84] On the other, Eydoux celebrated the fact that the Sahara had a "great role to play in the empire," with Morocco now linked to Tombouctou thanks to France's most recent "pacification" in the Western Sahara.[85] The scale and acquisitions' agenda of "the Sahara" also recalled that other successful Musée d'Ethnographie venture hatched on the eve of the Colonial Exposition's opening—the Mission Dakar-Djibouti. One of the Saharan exhibit's stated outcomes was to obtain objects that would stay permanently at the Musée d'Ethnographie, as well as new valuable local contacts in the French territories.[86] It was, for example, a way to reach out to the "savants at the University of Algiers" who were not yet in Rivet's and Rivière's overseas' network and presumably needed educating about scientific ethnology.[87]

It would nevertheless be misleading to conclude from the Saharan exhibit that the Musée d'Ethnographie by 1934 had abandoned more scholarly ambitions for its displays—far from it. Earlier that same year, Rivet had promoted another specifically colonial exhibit as a preview of the scientific presentations that would characterize all the permanent displays when they opened: one devoted to New Caledonia in January 1934. Prepared by the eminent former missionary and student of Mauss, Maurice Leenhardt, and his nephew Rey Lescure (the latter still in New Caledonia), who lent artifacts from their own collections, it was to be "the first truly ethnological exhibit in France" because "all the activities of the old *canaque* societies would be represented: techniques, industries, customs, beliefs, without forgetting the physical milieu." Scheduled originally for 1933, it had been pushed back because of its "important quality as well as the volume of objects sent by Lescure."[88] Yet although this exhibit opened with much less fanfare than the one on the

[83] Laval refers to this "solidarity" in a speech discussing the exhibit. AMH/2 AM 1 B6/a/"M. Pierre Laval préside le déjeuner des journaux de la France extérieure offert à M. Carde," *Le Journal*, 5 July 1934.

[84] AMH/2 AM 1 C2/a/Paul Rivet et Georges Henri Rivière à M. le Président de la Société de Géographie de Berlin, 17 Nov. 1933, no. 2120.

[85] AMH/2 AM 1 B6/a/Henri-Paul Eydoux, "La vie coloniale. L'actualité saharienne," *Le Petit Parisien*, 15 July 1934.

[86] AMH/2 AM 1 A5/c/Paul Rivet à M. le Gouverneur Général de l'Algérie, 12 June 1933, no. 1043.

[87] AMH/2 AM 1 B5/c/"L'exposition du Sahara se tiendra en janvier au Troca," *Dépêche Algérienne*, 19 Oct. 1933.

[88] AMH/2 AM 1 A2/b/Georges Henri Rivière à M. le Ministre des Beaux-Arts, 15 May 1931, no. 740; 2 AM 1 G2/a/"Rapport présenté par P. Rivet, activité du 23 juin 1930 au 22 juin 1931."

Sahara, it, too, sought to remind the public of France's empire, and of the role experts of all kinds were playing in its ostensibly humane governance. Meanwhile after the closing of both exhibits, a series of more modest temporary exhibits resumed that, like the pre-1934 ones, alternated between French colonial ethnography (New Hebrides, Cameroon) and non-French ethnography ("Tapestries of Ancient Peru," "Visions of Indonesia," "Kabinda, Portuguese Congo" "Baltic Folklore," "Easter Island"). Rivet may have liked to call his museum "colonial," but this designation in no way precluded the display of artifacts from non-French parts of the world.[89]

Trained Ethnologists for Hire—in the Empire

Having promoted ethnology as a modern science essential to colonial governance, France's new ethnologists were not satisfied only to create the state-of-the art collections and displays that "the world expected of an imperial power." For their science really to thrive, permanent salaried positions had to be created as well, yet neither the Musée d'Ethnographie nor the French university offered much possibility of the latter. Given this roadblock, Mauss and Rivet began to assume that the same overseas administrations that were subsidizing the Institut d'Ethnologie, the Musée d'Ethnographie, and field-work missions might also be persuaded to hire professionally trained ethnologists in some kind of research capacity. Mauss but particularly Rivet pursued this option from 1930 onward, alongside his museum activities and teaching; as we saw above, Rivet identified and allied himself with select colonial experts whom he thought might lobby for funds on behalf of the Institut d'Ethnologie or the Musée d'Ethnographie, and consistently advocated for the growth of either existing or new research institutions in the colonies that would employ ethnology students. It is nevertheless the proceedings of the congress devoted to colonial research that took place in Paris in 1937, evoked earlier in this chapter and in which Rivet participated, that best reveal this final aspect of ethnologists' efforts to harness the resources of the empire to their own professionalization—and more particularly the imperialist vision in its own right that underpinned this Paris-centric effort to grow and control ethnology in the colonies.

The 1937 conference was organized by the Association Colonies-Sciences, as a follow-up to the first gathering they had held during the Colonial

[89] See Paul Rivet's letter to Prime Minister Daladier at the opening of the Musée de l'Homme, in which he wrote: "We are above all a colonial museum." AMH/2 AM 1 A11/b/Paul Rivet à Édouard Daladier, 31 May 1938, no. 825.

Exposition; the association had also recommended that an independently financed research bureau should be created within the Ministry of Colonies to coordinate overseas scientific research and divide research funds. The recommendation had remained a dead letter, but with the election of the more open-handed Popular Front in 1936, the government suddenly showed a new interest in organizing and funding scientific research, including research in the colonies. The Association Colonies-Sciences thus decided to convene a new congress, which several Popular Front ministers attended.[90] One important outcome was a call for an overseas research program that married pure science with practical results but did not tie scientists in any way to local (i.e., colonial) authorities in a manner that might compromise their intellectual freedom.[91] The conference was divided into seven sections; six sections dealt exclusively with the hard sciences, while the seventh, presided over by Rivet, was dedicated to ethnology.[92] Not only the inclusion of ethnology but the particular way in which the conference was organized revealed Rivet's persistence over the previous ten years in selling "his" science as valuable to colonial interests, and in cultivating allies overseas.

In 1931, he alone had presented a report to the congress. This time he invited a combination of experts in ethnology from Paris and from learned associations and institutions overseas to present the state of research in their particular domain. Learned societies of various kinds existed throughout the empire, devoted to producing knowledge of local peoples and cultures, past and present. Some were run by amateurs, as in the case of the Académie Malgache (1902); others were already integrated into the French university system, such as the elitist École Française d'Extrême-Orient (1898).[93] Colonial administrations had founded several of these research institutions, and local revenues were used to underwrite all of them. To date, there had never been any overarching plan for their development from either the Ministry of Education or the Ministry of Colonies in Paris. A close reading of the conference's minutes reveals that an underlying goal of the congress, for Rivet anyway,

[90] *Congrès de la recherche scientifique dans les territoires d'outre-mer* (Paris, 1938).

[91] Christophe Bonneuil, *Des savants pour l'empire. La structuration des recherches scientifiques coloniales au temps de "la mise en valeur des colonies françaises," 1917–1945* (Paris, 1991), 71–73 and 78–81. On the long-standing suspicion of France's scientific community toward applied research, and the debates on this subject in the 1930s, see Harry W. Paul, *From Knowledge to Power: The Rise of the Science Empire in France, 1860–1939* (Cambridge, 2003), esp. chap. 9.

[92] The six hard science sections were (1) Géodésie, Astronomie géodésique, Photogrammétrie, Cartographie; (2) Physique du globe; (3) Géologie et Minéralogie pures et appliquées, Géographie physique, Pédologie; (4) Botanique pure et appliquée; (5) Chimie des végétaux; 6) Zoologie pure et appliquée.

[93] The École had an international reputation in Southeast Asian philology, archaeology, and religious studies, and a position there was almost an obligatory rite of passage for any scholar in these fields hoping for an academic position in France.

was to fold the ethnological sections of these institutions, where they existed, more formally into the Institut d'Ethnologie/Musée de l'Homme nexus, and to create such sections where none existed. Not all his interlocutors were happy at either prospect.

The "experts" whom Rivet called on to represent ethnology were evenly divided between a new generation of Paris-trained scholars, and several older scholars; fieldwork-based ethnology in the mid-1930s was still in transition from a practice in the hands of *érudits coloniaux* to a science dominated by metropolitan-trained professionals. Most, but not all, invitees had a deep ethnological or sociological knowledge of a part of the empire, regardless of their age or place of employment; only one was actively involved in colonial administration, although several others used to be. The most senior delegates were Maurice Leenhardt and Henri Labouret, both born in 1878. Leenhardt had lived in New Caledonia from 1902 to 1927, setting up there a Protestant mission, "Dö nèvâ," and undertaking a deep ethnography of Kanak spirituality; he had then returned to Paris, where he and his family lived on his pastor's salary while Leenhardt studied under Mauss and taught for him at the École Pratique. Mauss considered Leenhardt France's most experienced ethnographer, making him a logical choice to speak on the future of ethnology in New Caledonia at the conference. Henri Labouret was a former colonial administrator in West Africa turned ethnographer, with a strong pragmatic interest in the transformation of African societies under colonial rule; he represented the École Coloniale and the École des Langues Orientales Vivantes, where as Delafosse's heir he had been teaching since 1927. Many of his students took Institut d'Ethnologie courses. Robert Montagne (b. 1893) was a former soldier turned sociologist in Morocco (largely self-taught) who had founded the Centre des Hautes Études Musulmanes in Paris in 1936; since 1930 he had also served as director of the Institut Français de Damas, which had been established in 1922. Although he considered the Maghreb the privileged domain of "sociologists of Islam" rather than ethnologists, Montagne had nevertheless undertaken a mission for the Institut d'Ethnologie on the sedentarization of nomads in Syria in 1935. At the conference he reported on the general situation of research in Morocco, Algeria, Tunisia, and Syria.[94] Raymond Decary (b. 1891), a career colonial administrator and polyglot scholar of Madagascar, had been attached since 1933 to the cabinet of the governor-general at Antananarivo; in 1937, he became secretary-general of the new Permanent Committee for Scientific, Economic, and Statistical Studies. He had been a close collaborator of Rivet's since 1930 and had encouraged the

[94] AMH/2 AM 1 A8/c/Georges Henri Rivière à Lucien Lévy-Bruhl [Président de l'Institut d'Ethnologie], 7 June 1935, no. 1278; see the attached report.

latter to create a separate Madagascar section at the Musée d'Ethnographie in 1934; Decary represented the colony at the congress.[95]

Among the younger experts present were Théodore Monod (b. 1902), a naturalist who had trained at the Muséum in Paris, with a long record of missions across West Africa and a particular interest in prehistoric cave paintings in the Sahara. In 1936 he was appointed director of the new Institut Français de l'Afrique Noire, founded in Dakar by Governor-General Brévié. Monod raised the question of Saharan research at the conference. Also there to speak on the future of research in Africa was Marcel Griaule (b. 1898), who had been awarded his doctorate in ethnology in 1938 and had just turned down the directorship of the Institut Français de l'Afrique Noire to continue on as a *directeur adjoint* (with salary, since 1935) at the École Pratique. Indochina was represented by Paul Mus (b. 1902) and Pierre Gourou (b. 1900), almost exact contemporaries. Mus was a scholar specializing in Buddhism, who had studied sociology with Mauss and then joined the École Française d'Extrême-Orient, where Rivet had met him in 1932; in 1937 Mus was finishing his doctorate in Paris and had just been appointed to the École Pratique in Paris. Gourou was a human geographer of Southeast Asia and lycée professor, who had recently defended his thesis in sociology at the Sorbonne, a study of the peasants of the Red Delta. Finally, present also was Rivet's new assistant director at the Musée de l'Homme, the Americanist Jacques Soustelle (b. 1912), who had defended his doctorate in ethnology in 1937 and who proposed a research program for the French Antilles and Guyana.

This choice of scholars is revealing of Rivet's ambitions for the future growth of the discipline. Only five of those invited could be considered experienced researchers in ethnology per se, much less the ethnology of the empire: Griaule, Monod, Leenhardt, Labouret, and Decary, each of whom had worked in either Africa or Oceania. Soustelle had a stellar record in Mexican

[95] Several of these ethnologists await a biographer. Brief outlines of their careers can be found in Gérald Gaillard, *Dictionnaire des ethnologues et des anthropologues* (Paris, 1997). For Leenhardt, see Clifford, *Person and Myth;* for Labouret, see below, note 108, Singaravélou, *Professer l'empire,* Dimier, *Gouvernement des colonies,* and Wilder, *Imperial Nation-State;* for Montagne, see François Pouillon and Daniel Rivet, eds., *La sociologie musulmane de Robert Montagne* (Paris, 2000), Ludovic Tournès, "La Fondation Rockefeller et la construction d'une politique des sciences sociales en France (1918–1940)," *Annales. Histoire, Sciences Sociales* 6 (2008): 1396–97, and Renaud Avez, *L'Institut Français de Damas au Palais Azem (1922–1946) à travers les archives* (Damascus, 1993); for Decary, see Jean Valette, "The Organisation of Research in the Malagasy Republic," *Journal of Modern African Studies* 6:1 (May 1968): 97; for Mus, see David Chandler and Christopher Goscha, eds., *L'espace d'un regard. L'Asie de Paul Mus* (Paris, 2006) and Singaravélou, *L'École;* for Gourou, see Gavin Bowd and Daniel Clayton, "Tropicality, Orientalism, and French Colonialism in Indochina: The Work of Pierre Gourou, 1927–1982," *French Historical Studies* 28:2 (2005): 297–328 and John Kleinen, "Tropicality and Topicality: Pierre Gourou and the Genealogy of French Colonial Scholarship on Rural Vietnam," *Singapore Journal of Tropical Geography* 26:3 (2005): 339–58. Most of what has been written about Soustelle deals with his later career in Algeria. For Griaule's career, see above, note 38.

ethnology but had never conducted fieldwork in France's Caribbean colonies. In contrast, Mus and Gourou on the one hand, and Montagne on the other, came from imperial fields—Indochina and North Africa respectively; unlike Soustelle, however, none was an ethnologist by training. This discrepancy can be explained by the fact that sub-Saharan Africa and the Pacific Islands had traditionally been assumed to be home to the earth's only remaining true "primitives," while Asia, North Africa, and the Americas (to a lesser extent) had been defined as home to ancient if decadent civilizations and thus of greater interest to archaeologists and students of religion. Rivet's invitation to ethnological "fellow travelers" like Mus, Gourou, and Montagne makes clear his desire to use "their" parts of the empire, too, to help grow the new science.

The contents of the reports presented at this conference clarified how exactly Rivet thought the resources of the entire empire might be mobilized; here several points are worth noting. First, Rivet, Griaule, and Soustelle, Paris-based academics all, had a single overarching agenda. Modern ethnology, they insisted, could no longer rely on superficial inquiries; it had to be oriented toward in-depth and coordinated research. Each colony should create a main ethnographic center with a museum attached to it, staffed by personnel trained at the Institut d'Ethnologie who would then work together off a single research blueprint. In certain colonies such centers could be grafted onto existing museums or academies; where no research institution of any kind yet existed, new ethnological centers would have to be created. Once on site, this scientific personnel would conduct their own research but also oversee local efforts. In Rivet's vision of things, the arrival of "specialized researchers" did not eliminate the need for auxiliaries—*les bonnes volontés*—that is to say, enlightened amateurs such as tourists/travelers, settlers and administrators, and local informants. Specialized researchers would also centralize the results of all local research and send the documents gathered to professionals in Paris who would then check them for quality and point out any gaps.[96] Montagne and Mus suggested that these metropolitan professionals would also synthesize the material coming their way, since only they could recoup and conserve, in Mus's words, "information gathered from other work sites, other colonies, other continents."[97]

Second, when asked for their opinions about the feasibility of this grand research edifice, whose capstone was Paris, there was no consensus among the conference participants. Montagne noted that if the intention was to develop ethnological studies in centers already in place, funded by their own

[96] *Congrès de la recherche scientifique*, 480–82.
[97] Ibid., 522; see also 502–3.

budgets, "then these centers should be accorded a certain confidence, even if they did not deserve it. . . . Paris must bring something to these centers, funds and personnel . . . but without any direct intervention."[98] Mus was even less enthusiastic about the Hanoi-based École Française d'Extrême-Orient's potential response; the school, he suggested, might take an interest in ethnology but would not specialize in it and would never become an outpost of the Musée de l'Homme. At best it would serve as a relay between field-workers and Paris.[99] Decary, in contrast, was ready to concur with Paris's views: the existing Académie Malgache, founded in 1902 by Governor General Galliéni to study "Malagasy linguistics, ethnology, and sociology," had always had an ethnological vocation.[100] It could easily, in his opinion, anchor the kind of study center that Paris was proposing in order to coordinate and develop systematic research on the island's peoples, languages, and races—although he made no mention of any new positions.[101] Leenhardt dwelled on the great difference between Africa and New Caledonia; he believed that the European and mixed populations were too extensive in the latter to permit research by outsiders, as in Africa. The key was to awaken an interest in ethnography in the colonial population. Leenhardt then recommended the creation locally of "un groupement de recherche et de culture scientifique" in Nouméa and Papeete respectively, which could be federated into a single larger entity called l'Académie du Pacifique Français.[102] Montagne similarly mentioned the problem of having too many Europeans in the colony, only to draw the opposite conclusion: local Europeans were never interested in ethnographic research, unless there were some valuable art pieces involved.[103]

As these last two comments suggest, there was some discussion of another point raised by Rivet, Griaule, and Soustelle: the proper place for local *bonnes volontés* in this new professional research program. Montagne was the most prescient about what professionalization meant. The ideal future ethnologist would begin his/her studies in Paris, then spend two years on site to "take the temperature of the country" and learn the language. At that point he or she should join a research team: "no more theses written in isolation in Paris."[104] The other presenters, in contrast, continued to see a role for local auxiliaries but assumed (unlike Leenhardt) that they would remain just that.

[98] *Congrès de la recherche scientifique*, 503.
[99] Ibid., 522.
[100] On the history of the École Française d'Extrême-Orient, see Singaravélou, *L'École*; on the Académie Malgache, see Jean Valette, "L'Académie Malgache," *Journal of Modern African Studies* 5:1 (1967): 125–29.
[101] *Congrès de la recherche scientifique*, 512–20.
[102] Ibid., 527–33, and esp. 533.
[103] *Congrès de la recherche scientifique*, 503.
[104] Ibid., 499–501.

Mus recommended rewarding administrators who studied local customs, dialects, and languages, and suggested that administrators be able to prolong their home leaves in order to sit for an exam in ethnology. As for the training of ethnologists locally, it was in fact considered, if not foregrounded, by the younger scientists present. According to Griaule, the Institut Français de l'Afrique Noire would not only be a home to fellowship students from the metropole; it would also attempt to train "native investigators" (*enquêteurs indigènes*). But their works would be drawn up in the language of the group studied, which in the scientific world was also a way of excluding them.[105] Pierre Gourou opined that since "les Annamites" were often deprived of "a scientific conscience," it was necessary to create in Indochina institutions of scientific research that would train researchers who were also high-school teachers. They should have to write an essay (*mémoire*) in ethnology every three years if they desired promotion. The best professors would be called on to collaborate with institutions of higher learning. Thus would science progress thanks to the contribution of local intermediaries.[106]

A final goal of the conference was to compile a list of the monographs that remained to be completed before certain cultures disappeared in the face of colonization, hardly a new agenda in long history of anthropology. Nevertheless, three reports—those of Montagne, Labouret, and Soustelle—stressed the importance of also studying "the great problem of contact between civilizations."[107] Montagne recommended tracking the evolution of youth, even if ethnologists' studies thereby took on a political character. Labouret expressed surprise that up until now there had been few studies of the actual living conditions of the colonized—that is to say, of their quality of life, and more particularly their nutrition. Soustelle noted that "perhaps even more than the problem of [biological] *métissage,* the cultural problem that arises when a European civilization spreads [*essaime*] on another continent, presents a considerable practical and theoretical interest."[108] These were the first intimations of

[105] Ibid., 512.
[106] Ibid., 526.
[107] Ibid., 497.
[108] Ibid., 498–99, 508–9, and 537. Labouret, as a former colonial administrator teaching at the École Coloniale, was one of the most forceful advocates in France for an applied colonial science of ethnology, along the lines being developed in Britain. He taught his own course on colonial ethnology, which he published as *Ethnologie coloniale*, 3 vols. (Paris, n. d. [1932]). Labouret was also the French director of the London-based International Institute of African Languages and Cultures, founded in 1926 through the joint efforts of Lord Lugard and the missionary-statesman Joseph Oldham to bring together missionaries, administrators, and scientists interested in problems of African development. Rivet joined its executive council in 1933, while Lévy-Bruhl was on the governing board from the outset; Dietrich Westermann was the German director. The institute supported fieldwork in the belief that ethnologists could help colonial officials avoid costly cultural

a new orientation in ethnology, different from Rivet's evolutionary paradigm that equated living "primitives" with fossil races and an older Durkheimian approach predicated on deciphering a given society's larger signifying system without attention to social change.

At first glance it might seem that 1937 proved a turning point in "selling" ethnology as a necessary colonial science to public authorities in the metropole and overseas. The congress was held in September, and at the end of the month, the remnants of the Popular Front created the Committee of Overseas Scientific Research to coordinate research initiatives directly useful to colonization and to allocate public funds (from the metropole and colonies) on an empire-wide basis. Two sections out of seven were devoted to the human sciences: the sixth, which included ethnology, philology, archaeology, religion, and history, and the seventh, which included demography and the sociological, juridical, economic, and statistical sciences.[109] Each section had eleven members, of whom three were elected by various colonial scientific associations; metropolitan entities elected the others. Yet when elections occurred the next year, Jacques Soustelle, who had been designated secretary of the sixth section, complained bitterly that of six young Institut d'Ethnologie-trained candidates put forward by Rivet only one went through, Denise Paulme. There was, he claimed, a veritable cabal by those sympathetic to the old physical anthropology to prevent the "École du Troca" from gaining seats in the new organization—proven by the fact that the electors had preferred to vote in a zoologist over a Rivet student.[110] Despite Soustelle's complaints, the older generation had all become members: Mauss, Rivet, Lévy-Bruhl, Lester, and Labouret. The complaint is nevertheless revealing: for the first doctoral students in ethnology, the sense of being "blocked" in their career goals is palpable.

If, as Soustelle suggests, ethnology was still struggling to gain recognition in France as a science useful to empire in the late 1930s, its plans to grow

"misunderstandings." Few grants went to French students. In a late 1930s report to the institute on "ethnological activity in France," Labouret nevertheless noted that "the mentality in France [regarding Africa] had evolved considerably in the last few years, especially with the reorganization of the Musée d'Ethnographie as the Musée de l'Homme, and with the founding of the Institut Français de l'Afrique Noire." Yet Labouret especially praised a new study group—the Groupe de l'Afrique Noire—attached to the recently founded Centre d'Études de Politique Étrangère in Paris. Clearly, in Labouret's mind, ethnology in France under Rivet, Mauss, and Lévy-Bruhl remained too theoretical. AMH/2 AP 1 B7/Institut International pour l'étude des langues et civilisations africaines/"Rapport sur l'activité ethnologique en France," Henri Labouret, n.d. [1938 or 1939].

[109] AMH/2 AM 1 E2/b/Decree, 25 Sept. 1937, signed by Président (Albert Lebrun), Ministre de l'Éducation Nationale (Jean Zay), Ministre des Colonies (Marius Moutet), Ministre des Affaires Extérieures (Yvon Delbos), Ministre de l'Intérieur (Marx Dormoy).

[110] AMH/2 AM 1 A11/c/Jacques Soustelle à M. Roubault, 12 July 1938, no. 1094, and 23 July 1938, no. 1207. Griaule, too, was designated.

overseas met with mixed success as well. There were some victories; Leen-hardt, on mission to New Caledonia in 1938, established a Société des Études Mélanésiennes at Nouméa and "revived" the all-but-moribund Société des Études Océaniennes that had existed in Papeete since 1920. Both were to liaise with the new Centre d'Études Océaniennes that had been created in 1938 at the Musée de l'Homme.[111] In West Africa, Rivet had been closely involved since 1931 in plans initiated in Dakar to create a West African museum and research center there. In 1936, Governor-General Brévié—himself a self-styled ethnographer and avid admirer of Lévy-Bruhl—signed into existence the Institut Français d'Afrique Noire. Although Griaule refused at the last minute to accept the position of secretary-general of this new center—his career ambitions did not include being tied down by administrative demands in Dakar—his replacement, Théodore Monod, was a "friend" of the Institut d'Ethnologie/ Musée de l'Homme. Monod pushed through plans not only for the center, but also for a museum and an École Française de l'Afrique with three fellowships for visiting scholars: one each in ethnology or linguistics, the natural sciences, and geography. In 1938, the colonial administrator and Mauss student Bernard Maupoil was appointed, and in 1941 the first fellow in ethnology, Georges Duchemin, arrived.[112] In North Africa there were no institutional innovations, but some of Rivet's and Mauss's students were conducting fieldwork there, including Thérèse Rivière, Germaine Tillion, and Jacques Faublée in Algeria and Charles Le Coeur in Morocco.

Ethnology, as defined by Rivet, was less visibly successful in Indochina, despite the fact that the founder of the Dakar Institut, Jules Brévié, left Senegal in 1937 to become governor-general in Hanoi. The research infrastructure in this much older colony was fundamentally different from that of the sub-Saharan territories in the 1930s, which partly accounts for the failure of

[111] AMH/2 AM 1 E2/a/Paul Rivet à George Mandel, Ministre des Colonies, 17 Feb. 1940. By 1938, Rivet and Soustelle felt that they had enough ethnologists working on Oceania to sustain a learned society devoted to this part of the empire, and a Centre d'Études Océaniennes was established at the Musée de l'Homme. They were also spurred on by the unexpected creation of a "rival" Société des Océanistes a year earlier at the École d'Anthropologie (see chapter 4). AMH/2 AM à A11/a/Jacques Soustelle à M. le Gouverneur des Établissements Français de l'Océanie, 18 Feb. 1938, no. 275; Patrick O'Reilly, "Le Centre d'études océaniennes du Musée de l'Homme durant la guerre," *Journal de la Société des Océanistes* 1:1 (1945): 129; and Christian Coiffier and Michel Panoff, "Quelques aspects de l'histoire de la Société des Océanistes. Un entretien avec M.-C. Laroche," *Journal de la Société des Océanistes* 100–101, nos. 1–2 (1995): 41–55.

[112] As noted above, the real force behind the creation of the Institut Français de l'Afrique Noire was Albert Charton, longtime director of education in Dakar, with whom Rivet was in regular contact; in 1939 Charton became inspector general of education in the Ministry of Colonies in Paris, where he remained an active supporter. AMH/2 AP 1 B7/Albert Charton à Paul Rivet, 26 July 1936; 2 AM 1 E1/e/Albert Charton à Paul Rivet, 1 June 1939; 2 AM 1 A11/d/Jacques Soustelle à Théodore Monod, 13 Aug. 1938, no. 1299; Jacques Soustelle à Théodore Monod, 4 Oct. 1938, no. 1447.

ethnology to make many inroads before World War II, despite the early contacts Rivet had made with the archaeologist and ethnology enthusiast Jean-Yves Claeys. Hanoi not only boasted the École Française d'Extrême-Orient, home to philologists mostly uninterested in ethnography. Like Algeria, Indochina had an École de Médecine, established in 1902 and open to Vietnamese students.[113] With the arrival in 1933 of the career naval surgeon and anatomist Pierre Huard, this school became, ironically enough, a center for the practice of physical anthropology, much as was the case of medical Facultés in the metropole. Huard was a gifted teacher who soon founded the Institut Anatomique de Hanoi to promote osteological studies—his own and those he was encouraging among his Vietnamese students.[114]

This neglect of ethnology in Indochina appeared finally to be changing in 1937, when the tradition-bound École Française d'Extrême-Orient hired Paul Lévy. Lévy had obtained a certificate and diploma in ethnology, but his other *license* certificates were in the history of religion and Sanskrit, which made him acceptable to this institution.[115] As Lévy wrote to Rivet, "I'm entering the École under the revolutionary label of 'ethnographer-prehistorian.'" He went on to assure Rivet that his interest in ethnography was genuine—"I'm arriving under your banner"—and that he was capable of bridging "the traditional studies of the school with more modern ones."[116] Lévy announced that he was going to organize a gallery devoted to "ethnographie tonkinoise" in the existing archaeological museum; and not long after his arrival, he also helped to found a new learned society, the Institut Indochinois pour l'Étude de l'Homme, which Governor-General Brévié enthusiastically supported.

Yet the profile of this society proved how difficult it was to implant the kind of sociocultural and linguistic ethnology that Rivet wanted in the colony—coordinated, moreover, from the Institut d'Ethnologie and Musée de l'Homme in Paris. Lévy's cofounder of the Institut Indochinois was none other than Huard, and the new home of their society was the Institut Anatomique. As Lévy explained it to Rivet without any apparent sense of resentment, "There's a smart group of doctors here, full of zeal and talent for

[113] The École de Médecine had been founded in 1902; after World War I it became the École Supérieure de Médecine et de Pharmacie, and between 1936 and 1941 it was transformed into the Faculté Mixte de Médecine et de Pharmacie de Hanoi. Laurence Monnais-Rousselot, *Médecine et colonisation. L'aventure indochinoise, 1860–1939* (Paris, 1999).
[114] Georges Oliver and Claude Chippaux, "Pierre Huard (1901–1983)," *BMSAP* 10:2 (1983): 155–57.
[115] Thierry Solange, "Paul Lévy (1909–1998)," *Bulletin de l'École Française d'Extrême-Orient* 86 (1999): 6–9.
[116] AMH/2 AP 1 C/Paul Lévy à Paul Rivet, 3 Dec. 1936 and 10 June 1938. See also the note by Paul Lévy asking to be put "in touch in a semiofficial way with the Musée de l'Homme," in AMH/2 AM 1 K47/c/Correspondance/Hanoi.

anthropology."[117] A third of the studies published by the Institut Indochinois's members in its journal were devoted to physical anthropology (mostly in anthropometry); another third were largely descriptive ethnographies, and a final third took up questions of local cultural practices that might interest the administration—for example, the question of tattooing and criminality. Vietnamese scholars made up about one-third of the institute's membership, and several had been trained by Huard. Soon these Vietnamese physicians were publishing comparative anatomy articles in the Institut Indochinois proceedings that proved that "Annamites" were physically equal to Europeans.[118] On the eve of World War II, the battle for the new ethnology over the old *anthropologie* was far from being won, either at home or overseas.

A Science inside and outside the Empire

The Congress of 1937 can be seen as an important *état des lieux* for a professional *ethnologie* in transition. Absent academic positions, the hope was to create or expand the research institutions in the empire. By 1939, when French ethnologists were invited to present themselves through a display of posters at the World's Fair in New York, the Musée de l'Homme associate Anatole Lewitsky drew up a diagram of the institutional organization of French ethnology that reflected this colonial vocation. One part of the diagram listed important dates in the history of the discipline. This is the only list in which the École d'Anthropologie figured, relegated to the past. Across the top of the poster, Lewitsky prominently placed the four principal institutions currently devoted to the teaching of ethnology: the École Pratique, the Muséum, the Institut d'Ethnologie, and the Collège de France (to which Mauss had been elected in 1930). At the center of the poster, below the Institut d'Ethnologie but linked to it by an arrow, the Musée de l'Homme figured prominently, and under it there were no fewer than twenty-one "centers of ethnological studies" in the empire listed.[119] This poster may tell us more about how ethnologists wished to see their science than how it was actually perceived by

[117] AMH/ 2 AP 1 C/Paul Lévy à Paul Rivet, 21 Dec. 1937.
[118] The Institut Indochinois lasted from 1938 to 1943 and published six volumes of proceedings. On its organization and composition, see the introduction to *Institut Indochinois pour l'Étude de l'Homme. Compte Rendu des Séances de l'Année 1938* (1938): 7–17. For examples of racial science, see Do Xuan Hop and Pham Bieu Tam, "Étude anatomique et anthropologique de l'omoplate chez les Annamites," *Institut Indochinois pour l'Étude de l'Homme. Bulletins et Travaux pour 1942* 5:1 (1942): 41–48, and Do Xuan Hop and Pham Bieu Tam, "L'humerus chez les Annamites. (résumé)," *Institut Indochinois pour l'Étude de l'Homme. Bulletins et Travaux pour 1942* 5:2 (1942): 49–56.
[119] AMH/2 AP 4.3/Activité du Musée de l'Homme.

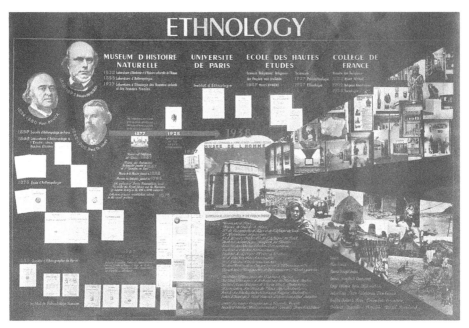

Anatole Lewitsky's poster on the organization of ethnology in France for the New York World's Fair, 1939. The Musée de l'Homme is in the center of his diagram, and the list of "ethnological study centers in the French empire" that appears directly under it includes the following: l'Université d'Alger; le Musée de Bardo à Alger; la Société de Géographie d'Alger et de l'Afrique du Nord; la Société Historique Algérienne; la Société d'Histoire Naturelle de l'Afrique du Nord; Institut Scientifique Chérifien au Maroc; l'Institut des Hautes Études Marocaines; l'Institut d'Études Sahariennes; l'Institut Français de l'Afrique Noire; la Société d'Études Soudanaises; la Société d'Études Camerounaises; la Société des Recherches Congolaises à Brazzaville; l'Académie Malgache à Tananarive, Madagascar; l'Institut Français de Damas, Syrie; l'Institut Français d'Indianisme de Karikal, Indes; l'Institut Bouddhique de Pnom Penh, Indochine; l'Association des Amis du Vieux Hué, Indochine; Section d'Ethnologie à l'École Française d'Extrême-Orient; la Société des Études Océaniennes à Papeete, Tahiti; la Société des Études Melanésiennes à Nouméa, Nouvelle Calédonie. AMH/2 AP 5 4.3/Activité du Musée de l'Homme. Photo courtesy of the Bibliothèque Centrale, Muséum National d'Histoire Naturelle.

other French social scientists in the late 1930s. It should not be read as a full indictment yet of the race concept, for ethnology still encompassed the study of cultures, languages, and races. Nevertheless, there can be no doubt about Lewitsky's attempt to occlude a particular French physical anthropology tradition in this self-definition of the discipline, or the central place he chose to assign to what has often been deemed the "margin" of modern France and its history—the colonies.

Yet for all Mauss's and Rivet's embrace of the empire in the 1930s—from the launching of the Mission Dakar-Djibouti and association with the Colonial Exposition to the cultivation of overseas outposts—they and their team remained detached from the actual work of colonizing. Although the founders

of the Institut d'Ethnologie had initially argued that the scientific knowledge produced by their colonial sponsors would make French rule overseas more humane, they did not, any more, for example, than their British counterparts, seek to place their students directly in colonial service as government anthropologists.[120] Such distancing, however, did not mean remaining indifferent to the fate of the peoples under investigation. In Rivet's words, "Ethnology may not and cannot oppose the material progress of populations."[121] He returned from Indochina ready and willing to talk about the economic problems of the Tonkin Delta.[122] When the Popular Front came to power, he argued that French officials in Algeria would have to contemplate a policy comparable to the land redistribution occurring in Mexico, if France wished to retain control over North Africa; he also served on several of the Popular Front's commissions to reform French colonial rule.[123] But Rivet insisted that the whole ethnographic project would be condemned if he and others decided to include in their presentation of other cultures "the European aspects of overseas civilizations."[124]

Mauss was even more adamant that his students not think that there was some simple translation of ethnographic knowledge into politics. Having witnessed the rise of first the Soviets, then the Nazis, he had become especially wary of the despotic potential of scientific "truth" when used alone to guide human governance. At best ethnologists could observe, in Mauss's words, "new movements in society" and produce studies "conclusive as to the present."[125] Indeed, an enthusiastic Anglophile in most things anthropological, he rejected what he saw as the overly practical orientation of the London-based International Institute for the Study of African Languages and Cultures. This institute was a major funding agency in the 1930s for fieldwork that studied problems ensuing from culture contact between Europeans and Africans. As Mauss put it in a letter to another one of his students, Charles Le Coeur, encouraging him to apply for funds, "It will consist . . . of doing . . . intensive

[120] On the colonial connections of British social anthropologists, see Tilley, *Africa as a Living Laboratory*, introduction and chap. 6: and Kuklick, *Savage Within*, chap. 5.
[121] AMH/2 AM 1 A3/d/Paul Rivet à Joseph Guyon [Gouverneur Général de la Nouvelle Calédonie], 3 June 1932, no. 1175.
[122] AMH/2 AM 1 B4/d/Paul Rivet, "Les peuples d'Indochine vus par un ethnographe," *Monde Colonial*, 1 Sept. 1932.
[123] AMH/2 AP 1 B5/d/Paul Rivet, "Nous ne pourrons conserver l'Afrique du Nord que si nous faisons une grande réforme agraire," *Œuvre*, 8 May 1937. On this aspect of Rivet's political career, see AMH/2 AP 1 B7; Laurière, *Paul Rivet*, 498.
[124] AMH/2 AM 1 A4/d/Paul Rivet à Fernand Pila [Chef du Service des oeuvres françaises à l'étranger], 17 Nov. 1932, no. 2080.
[125] Quoted in Marcel Fournier, "Introduction," in Marcel Mauss, *Écrits politiques*, ed. Marcel Fournier (Paris, 1997), 44.

ethnography, followed by what we call, in this purportedly scientific and semi-moral and missionary institute, practical conclusions." He nevertheless recommended that Le Coeur accept one of their fellowships and publish his practical conclusions separately.[126]

The desired disengagement of most Institut d'Ethnologie ethnologists from practical conclusions would in the end prove partial at best. Mauss, Rivet, and Lévy-Bruhl's particular strategy for professionalizing the discipline in the 1920s and 1930s may have kept French ethnologists mostly out of the colonial service, but it integrated these same individuals into the inegalitarian structures of colonial rule in different ways. We have already noted the colonialist practices given scientific status by the Mission Dakar-Djibouti; yet another example of such practices is provided by Dahomean ethnographer Alexandre P. Adandé. Adandé had graduated from the elite École William Ponty in Dakar in 1937, a school for training Africans as school teachers, and was immediately placed in the Secretariat of the newly created Institut Français de l'Afrique Noire. Later that year, Adandé sent the following letter from Dakar to the director of the Institut d'Ethnologie:

> For the first time, I had the good fortune to read the poster listing the different courses taught by the professors of the Institut d'Ethnologie. The question interests me enormously. . . . The aptitude that I have for the arts and my predilection for ethnography earned me my position here. It is probable that I will make my career here. . . . I had thought I would do the ethnology courses by correspondence, not as a simple auditor but finally as a student. I was disappointed to learn that the courses of the Institut d'Ethnologie are not published, and there are no other establishments in France that can satisfy my desire. . . . M. Maupoil [a colonial administrator and doctoral student of Mauss] advised me to write to you to tell you of my intentions and those of many of my compatriots and friends who are eager to take courses in ethnology.

He continued:

> The native elite would be particularly grateful if you were to institute this change. There is currently a strong desire, a real effort, developing in educated native circles to write about all that the past, as well as native life, contains in

[126] IMEC/Fonds Marcel Mauss/MAS 19/Marcel Mauss à Charles Le Coeur, 9 July 1931. Malinowski was always enthusiastic about studying the "problems" of acculturation and saw anthropologists as natural defenders of the rights of Africans against colonial administrations. See Bronislaw Manilowski, "Ethnology and the Study of Society," *Economica* 6 (Oct. 1922): 208–19; and Carlo Rossetti, "Malinowski, the Sociology of 'Modern Problems' in Africa and the 'Colonial Situation,'" *Cahiers d'Études Africaines* 100 (1985): 477–503.

terms of resources and wealth. . . . But despite every best intention on the part of researchers, they confront many difficulties and their work, although the fruit of much patient and laborious effort, is for the most part riddled with gaps. Subjects are treated without any method, hence [yielding] a profusion of useless details; [the authors] neglect or do not emphasize sufficiently the important points, the reasons for certain traditions and institutions. To the contrary, at times they launch into "guilt-ridden" criticisms of these same traditions and institutions, which, despite their primitive appearance have a profound and deep psychological reason for being, which it is interesting to discover and study. This state of things in ethnology, deplorable in my opinion, has gone on too long. It comes from, without doubt, an absence of the most elementary notion of ethnology.[127]

There is no recorded response to Adandé from Mauss, to whom the letter was referred. Mauss welcomed individual Vietnamese or Africans who came to Paris to study: Nguyen Van Huyen received his doctorate under Mauss's direction, and Paul Hazoumé of Dahomey published extensively in ethnography with Rivet's and Mauss's encouragement. But Mauss had suggested elsewhere that he thought that educated African elites like Adandé were better suited for recording the facts of cultural change than grasping their societies holistically, better suited to "ethnography" than "sociology." In correspondence with the British social anthropologist A. R. Radcliffe-Brown in 1935, Mauss discussed a recent letter he had received from the Department of Anthropology at the University of Chicago. The letter asked him for names of French anthropologists who might be interested in a seminar being organized on "racial and cultural contacts in all parts of the world." Mauss replied:

Please find below my reply to Miss Rosenfels. These studies are indeed important and urgently needed, and of great interest to the [colonial] administration. The recording of these facts is obviously an obligation for us that will allow us better to integrate present policy and [direct] the future. It is moreover a subject upon which not only the natives trained [dressés] by us can usefully work, but also those among our young ethnographers who are not quite capable of deep sociological research. Don't tell them this, but it is what I believe. Science is composed of levels, and it is the generations that follow that will be judged, to a greater extent than our own.[128]

[127] This letter was addressed to Rivet, who referred it to Mauss. IMEC/Fonds Marcel Mauss/MAS 11.21/Alexandre P. Adandé à Paul Rivet, 4 Dec. 1937.
[128] IMEC/Fonds Marcel Mauss/MAS 20/Marcel Mauss à Radcliffe-Brown, 2 Jan. 1935. In fairness to Mauss, although he himself was not interested in researching "racial and cultural contacts," he noted that several students were engaged in such studies: Claude Lévi-Strauss and his wife Dina Dreyfus, Alfred Métraux, and Charles Le Cœur, among others.

"Deep sociological research": this is what Mauss hoped for from the best of the graduate students he was training—and the topic of contemporary cultural contacts (or of "current problems," as the minister of education had put it when he attached the Musée d'Ethnographie to Rivet's chair in anthropology) did not apparently require this kind of analysis. In his quest for a sociological ethnology, Mauss carelessly endorsed a status quo in which educated "natives" would remain the junior partners of better-trained metropolitan experts.

"The Musée de l'Homme is continuing the task that the Musée d'Ethnographie set for itself: the study of the ethnology of France overseas. It constitutes a true human laboratory of our empire. France was missing a central organism to study the peoples of the empire. Now it has one."[129] In the interwar years, the founders of academic ethnology turned eagerly to the minister of colonies and administrators for support in developing their discipline's proper content, method, and laboratory. Yet for all their enthusiasm, none of them had carried out modern fieldwork in any part of the French empire. The relationship of Mauss, Lévy-Bruhl, and Rivet to the peoples living in Africa, Oceania, and Southeast Asia was thus very much a mediated one; these "founding fathers" encountered their "objects of study" mostly through the eyes of the press, published field notes, correspondence or personal acquaintance with missionaries, officials, and travelers, as well as through museum collections. By choosing, however, to send their students to the colonial field for deep immersion, Rivet and Mauss were changing the professional rules of engagement significantly. Research would now involve face-to-face encounters, and colonization's devastating effects might prove more tempting subjects of inquiry when experienced directly. This conversion was all the more likely given that these students' *maîtres* had not only bound these budding ethnologists to the empire; as we shall see next, they had also given them an intellectual framework for, if not yet questioning colonialism, at least challenging empire's categories for dividing up the world, and the assumption that local informants were perforce "junior" to them.

[129] AMH/2 AM 1 B2/d/Jean Bigorre, "Le Musée de l'Homme, laboratoire de notre empire," *France-Outremer* 12 May, 1939,

CHAPTER 6

FROM THE STUDY TO THE FIELD

Ethnologists in the Empire

If we had chosen to define the first part of this work by its . . . object, we would have called it a study and a plea for social diversity. Having noted this diversity, we demonstrated that it originates in that which is deepest in the human soul, and that the man of action can and must respect it. In our conclusion we will see the metaphysical and moral depth and the practical efficacy that this creative pluralism can reach among great colonial leaders.

—CHARLES LE COEUR, *Le rite et l'outil* (1939)

By the interwar years, thanks to the dynamic leadership of Marcel Mauss and Paul Rivet, it had become possible for students to train in ethnology in Paris. Together, the creation of the "Insti" (Institut d'Ethnologie) and the overhauling of the "Troca" (Musée d'Ethnographie/Musée de l'Homme) marked the arrival of a modern museum- and field-based science of man in Paris's university system. Yet, appearances to the contrary, this "victory" of ethnology was precarious at best, given that traditional *agrégation* disciplines still dominated in the university. Mauss and Rivet thus devoted enormous time and energy to building up their school, including soliciting funds wherever they could find them. At the Trocadéro, with Rivière's help, Rivet cast his net widely to include Parisian high society, and many of its denizens agreed to subsidize expeditions for the scientific collection of objects. For the running of the Institut d'Ethnologie and missions to the field, Mauss and Rivet secured some grants from French public funding agencies, but also from the London-based International Institute of African Languages and Cultures and the Rockefeller Foundation. Even before World War I the latter had begun underwriting the emergent social sciences in France and Germany, and especially in Great Britain, whose empiricist traditions seemed more in harmony

with American ones than the theoretical approaches that dominated on the Left Bank.[1] And critical as well to ethnology's survival, as we have just seen, was the appeal to France's empire.

At first glance, it would seem that Mauss's and Rivet's constant pursuit of funds, objects, overseas contacts, and publicity in these years, along with their other professional obligations and political commitments, took priority over determining rigorous norms for the science that they wished to promote. Indeed, it has often been argued that Mauss in particular published only fragments—and notoriously opaque ones at that—of several major works, and thus failed to leave behind a unified theory or method, much less build a distinctive ethnological school, before World War II led him to give up work altogether.[2] As Claude Lévi-Strauss put it in 1950, Mauss in his essay *The Gift* inaugurated nothing less than a "new era in the social sciences," thanks to his "discovery" of the total social fact as a symbolic system to be deciphered. But, Lévi-Strauss arrogantly continued, "that Mauss never undertook to exploit his discovery" was one of the great misfortunes of contemporary ethnology.[3] James Clifford in the 1980s described this "failure" more generously; according to Clifford, the elusive sociological notion of cultures as totalities that Mauss developed in the 1920s offered "a generation of ethnographers an astonishing repertoire of objects to study and different ways to put the world together. . . . One cannot thus talk of a 'Maussian' as one would a 'Malinowskian' or 'Boasian' ethnography." Clifford concludes that Marcel Griaule was the first ethnologist in France to develop a systematic method and tradition of ethnographic research, one based on doing fieldwork as a team.[4]

[1] Within France, funding for ethnology doctoral candidates was cobbled together from a variety of sources, including the Muséum and the Musée de l'Homme's budgets as well as the Caisse Nationale des Sciences, founded in 1930. The International Institute for African Languages and Cultures received a Rockefeller grant from 1931 to 1937, which directly funded three students, Charles Le Coeur, Thérèse Rivière, and Germaine Tillion. IAIA/8/10/Rockefeller Fellowship. Another student, Denise Paulme, also received Rockefeller funding. The Rockefeller Foundation supported social science research that might provide solutions to Europe's economic and political problems. Olivier Dumoulin, "Les sciences humaines et la préhistoire du CNRS," *Revue Française de Sociologie* 26:2 (1985): 353–74; Brigitte Mazon, "La Fondation Rockefeller et les sciences sociales en France, 1925–1940," ibid., 311–42; and Tournès, "La Fondation Rockefeller."

[2] For recent summaries of the debate on Mauss's contributions to the larger field of ethnology, see Wendy James and N. J. Allen, eds., *Marcel Mauss: A Centenary Tribute* (New York, 1998); Mike Gane, introduction to *The Nature of Sociology,* by Marcel Mauss (New York, 2005), ix-xxii; Robert Parkin and Anne de Sales, introduction to Parkin and de Sales, *Out of the Study,* 5–7.

[3] Claude Lévi-Strauss, in Marcel Mauss, *Introduction to the Work of Marcel Mauss*, trans. Felicity Baker (London, 1987), 41–42.

[4] Clifford, "Power and Dialogue," 64–65. Clifford emphasizes that Mauss endorsed the documentary and team approach to ethnography, as opposed to an experiential one, and that this approach is evident in Griaule's doctoral thesis, *Masques Dogons* (Paris, 1938). For more in-depth accounts of the "documentary" approach advocated by Mauss, which reach similar conclusions to those of Clifford, see Benoît de l'Estoile, "Une petite armée de travailleurs auxiliaires," *Les Cahiers du Centre de Recherches Historiques* 36 (2005): 1–25; and also Henley, *Adventure of the Real,* chaps. 1 and 15.

Yet if we revisit that first generation of field-workers who earned doctor-ates, most of whom were Griaule's contemporaries but who have been much less studied, a different picture emerges of Mauss's interwar accomplish-ments.[5] Several of their ethnographies reveal the lineaments of a distinctive approach, inspired by Mauss's historical and comparative understanding of social facts and the Anglo-American model of individual fieldwork that was becoming the norm internationally. These students, moreover, saw them-selves as constituting a Maussian school in the period from 1926 to 1945, a perception that deserves to be taken seriously.[6] Many were able to develop Mauss's ideas further than Mauss himself, including analyzing the devastat-ing effects of the colonial encounter. Tragically, Vichy and its aftermath would interrupt the full flowering of this school in France. A high percentage of the new ethnologists gave their lives to the Resistance, and the new universalisms spawned by the Cold War, decolonization, and the creation of the European Union—center-right in origin and thus alien to Mauss's democratic social-ism—rendered the Maussian embrace of a generous and pluralist valuing of human difference, at home and overseas, for a time politically irrelevant.[7]

For all Mauss's extraordinary impact on his Institut d'Ethnologie students, however, it is essential to note that those drawn into ethnology in the interwar years were not his progeny alone. If Mauss deserves credit for sowing many of the intellectual seeds that germinated in the interwar generation, Rivet contrib-uted decisively to this cohort's ability to stay the course through a different kind of professional mentoring. Above and beyond the example he set as an antiracist

As Clifford suggests, the collection of documents by the field ethnographer for later analysis by the theorist in the study was just one of many methods that Mauss recommended.

[5] Here my work dovetails with that of several other scholars besides Fournier, who like him have pioneered a renewed interest in Mauss. Since the late 1990s the collective known as the Mouvement Anti-Utilitariste dans les Sciences Sociales (M.A.U.S.S.) has approached Mauss's work holistically, seeing his political engagement and intellectual output as inseparable. This group has emphasized the coherence of Mauss's response to the extremism of his time and linked his politics to his under-standing of the importance of the symbolic in social relations. See, among others, Camille Tarot, *De Durkheim à Mauss. L'invention du symbolique* (Paris, 1999); and Tarot, *Sociologie et anthropologie de Marcel Mauss* (Paris, 2003); Philippe Steiner, *Durkheim and the Birth of Economic Sociology*, trans. Keith Tribe (Princeton, NJ, 2010); and Keith Hart, "Marcel Mauss: In Pursuit of the Whole; A Review Essay," *Comparative Studies in Science and History* 49:2 (2007): 1–13.

[6] See, for example, Germaine Dieterlen, "Marcel Mauss et une école d'ethnographie," *Journal des Africanistes* 60:1 (1990): 109–17 and Joseph Tubiana, "Regard dans le rétroviseur," *Journal des Afri-canistes* 69:1 (1999): 247–53. Dieterlen was trained by Griaule and Mauss. Mauss's interwar students also included many who did not complete doctorates, although almost all attended his seminar at the École Pratique. Certain French ethnologists who trained in the 1940s continued to be in-fluenced by Mauss, even if not taught by him. See Georges Condominas, "Marcel Mauss, père de l'ethnographie française," pts. I and II, *Critique* 28:297 (1972): 118–39, and 28:301 (1972): 487–504.

[7] Christian Joerges and Florian Rödl, "'Social Market Economy' as Europe's Social Model?" Badia Fiesolana, European University Institute, 2004, EUI Working Paper LAW 2004/8; Marc Joly, *Le mythe Jean Monnet* (Paris, 2007).

scientist and anti-Fascist activist, Rivet was responsible for staffing the research departments of the Musée d'Ethnographie with Institut d'Ethnologie students, thus guaranteeing them not only a temporary source of income and professional identity, but also a kind of pre- and post-"field" where they could learn to work collectively.[8] In short, the ethnographic and physical anthropology galleries of the Musée d'Ethnographie/Musée de l'Homme were only the visible part of the "ethnological" yield of these years. The Troca's "invisible" laboratory was arguably more important; it offered a space to promote and practice new ideas of tolerance, reciprocity, and cross-cultural empathy in an age of extremes.

BECOMING AN ETHNOLOGIST IN INTERWAR FRANCE

With few prospects for a university career, the choice for French students to pursue training in ethnology was a risky, even reckless one. Yet, a significant number of young people made this choice. Why? This question can be answered on two levels, one structural and one personal. On the most general level, as Johan Heilbron has argued in his study of interwar academic conditions, students born in the pre–World War I decade were collectively rebelling, some consciously and some unconsciously, against what had become a stagnant republican university establishment. Undergraduate enrollments in the Faculté des Lettres had doubled between 1920 and 1935, with no expansion of teaching positions in any field. A surplus of university graduates confronted an aging and entrenched professoriate, and this situation alone was an invitation to the young (and ambitious) to innovate, even before the Depression hit. A constellation of new intellectual trends fit this pattern, from the development of the Annales school in history to the appearance of so-called nonconformist "neo-," "anti-" or "ultra-" political movements (many launched by philosophy students) to the spurning of "classical Durkheimianism" (i.e., the version taught at the university) by younger sociologists newly interested in German and American trends in their discipline. Others sought careers that combined their commitment to research with literary aspirations.[9] The growing appeal of ethnology in the interwar period must be seen as part of this overall revolt by "the generation of 1930" against prevailing conditions in the humanities themselves.[10]

[8] Rivet was remembered as a superb teacher and mentor as well, especially among, first, the small group of French Americanists at the Institut d'Ethnologie, including Alfred Métraux and Jacques Soustelle, and then among a whole generation of anthropologists in Latin America during and after World War II, who do not figure in this study. Rival, "What Sort of Anthropologist?" 148 n. 23.

[9] For those pursuing scientific and literary careers simultaneously, see Debaene, *Adieu au voyage.*

[10] Heilbron, "Les métamorphoses," 226–37.

We can, however, be more specific about how the choice to pursue ethnology was made, thanks to the limited testimony available provided by the actors in question. Here more mundane factors intervened. When compiling their memoirs, many of these first ethnologists claimed that they had found their way to Mauss and Rivet either through *ennui* with the traditional disciplines or through the love of adventure, and then were hooked by their coursework and their teachers.[11] For example, the future Africanist Denise Paulme began studying law, chosen for practical reasons. Yet she soon discovered that the only subjects that did not bore her were Roman law and the history of law; at this point, she wrote:

> I was vaguely thinking of taking a greater interest in the institutions of primitive law and, to that end, went to enroll in the Institut d'Ethnologie to hear the "Ethnological Lessons for the Use of Colonial Administrators, Missionaries, and Explorers" that Marcel Mauss, whose very name was unfamiliar to me, gave every week. Without being prepared for it, I felt the shock of a great personality.[12]

By 1932 she had her law degree and Institut d'Ethnologie diploma and had begun thesis research with Mauss while volunteering at the Musée d'Ethnographie alongside another convert to ethnography, Germaine Tillion.[13] Tillion, who would soon travel to the Aurès Mountains of Algeria, found her way to Mauss at the École Pratique in 1928 and then the Insti/Troca in 1931, after having tried psychology, Egyptian archaeology, prehistory, and the history of the Celts—all ancillary fields to the total "history of man."[14] Paul-Émile Victor, who was fleeing a career in the family business in the Jura, insisted that he came to Paris to study the humanities with no idea where to start. Only when his uncle (Joseph Kergomard, a professor of geography at the prestigious Lycée Louis-le-Grand) gave him the *Livre de l'étudiant* (the university course guide and requirements) did Victor stumble on ethnology. Although he had never heard of it before, he "instantly" recognized

[11] AMH/IE/2 AM 2/C2/Interview with Paul Rivet, n.a., n.d. [ca. 1937], "Comment naît-on ethnologue?"

[12] Denise Paulme, "Quelques souvenirs," *Cahiers d'Études Africaines* 19 (1979): 10. See also Alice Byrne, "La quête d'une femme ethnologue au coeur de l'Afrique coloniale. Denise Paulme 1909–1998" (Mémoire de Maîtrise, Université de Provence-Centre d'Aix, 2000), http://sites.univ-provence.fr/~wclio-af/numero/6/thematique/chap1Byrne.html.

[13] AMH/2 AM 1 A 7/c/Denise Paulme curriculum vitae, n.d. [Oct. 1934]; IMEC/Fonds Marcel Mauss/MAS 11.22/Georges Henri Rivière à Marcel Mauss, 3 June 1932. See the "Rapport sur le travail fourni au Musée d'Ethnographie par les élèves de l'Institut d'Ethnologie au cours de l'année scolaire 1931–1932," attached to this letter.

[14] Jean Lacouture, *Le témoinage est un combat* (Paris, 2000), 15.

the Polynesian dreams of his youth. Soon he was "an apprentice ethnologist. Passionate. I missed none of my classes, none of the workshops at the Musée d'Ethnographie, none of Marcel Mauss's or Lucien Lévy-Bruhl's lectures at the Collège de France."[15] Victor and the physical anthropologist Robert Gessain later conducted fieldwork among the Inuit in Greenland, whose seasonal migration patterns Mauss had investigated secondhand in 1903. Victor would never finish his doctorate, preferring a career as a polar explorer and later acquiring his own island in the South Pacific, while Gessain, a student of Rivet's, would pursue a career in medical anthropology.

The Americanist Jacques Soustelle remembered that it was Célestin Bouglé, Mauss's collaborator on the *Année Sociologique* and the director of the École Normale Supérieure, who introduced him to Mauss as soon as Soustelle arrived in Paris from Lyon in 1929 to continue his studies in philosophy. Mauss had already had one recruit from the École Normale, Charles Le Coeur, a sociologist and ethnographer based in Morocco. Soustelle claimed to have been marked "indelibly" by books about discoveries that he devoured as a child growing up in a working-class family. The "dry scholasticism" and "intellectual game" of philosophy on the Left Bank thus quickly disappointed him. As a result, Soustelle turned to the study of the very peoples whom Paris's reigning gurus most disdained: "what were called 'the primitives.' "[16]

André Leroi-Gourhan, who became a leading postwar archaeological anthropologist and theorist of "the gesture," had haunted the paleontology halls of the Muséum as a child. At the age of fifteen, he encountered the works of prehistorian Marcellin Boule, and then began studying physical anthropology at the École d'Anthropologie while pursuing a library degree and scouring the flea markets for human crania.[17] But his teenage years were also marked by a second discovery: that of the Russian émigré community in Paris. This encounter led to a lifelong passion for the objects and languages of Siberia and the Far East.

Claude Lévi-Strauss was also of this generation. He, unlike his wife, never studied at either the Institut d'Ethnologie or the École Pratique; however, he would start exchanging letters with Mauss once he moved to Brazil in the mid-1930s, and as a child growing up in an artistic milieu he had always been fascinated by exotic curios. After finishing his law studies with a certificate in sociology and passing the *agrégation* in philosophy, this former Marxist

[15] Paul-Émile Victor, *La mansarde (Vents du nord, vents du sud)* (Paris, 1981), 302, 304.
[16] Jacques Soustelle, *The Four Suns: Recollections and Reflections of an Ethnologist in Mexico,* trans. E. Ross (New York, 1971), 4, 5, 6.
[17] André Leroi-Gourhan, *Les racines du monde. Entretiens avec Claude-Henri Rocquet* (Paris, 1982), 128, 123; AMH/2 AM 1 K59/d/André Leroi-Gourhan curriculum vitae, 29 Oct. 1934.

intellectual decided—or so he claimed—to embrace the new science for no better reason than the excitement it offered. As he put it,

> Toward 1930 it began to be known among young philosophers that a discipline called anthropology existed and that it aspired to obtain recognition. Jacques Soustelle was the first example of an *agrégé* in philosophy switching to anthropology. . . . I was envisaging a way of reconciling my professional education with adventure.[18]

That year he volunteered in the museum and soon contacted Mauss, explaining: "Ethnographic studies attract me deeply, and I would be very happy if I could ask you for some advice."[19] His wife Dina Dreyfus was an Institut d'Ethnologie student at the time, which also accounts for his discovery of this new discipline.[20] Biographer Alexandre Pajon offers yet another possible interpretation of Lévi-Strauss's ethnographic conversion. Noting that Lévi-Strauss remained deeply invested in the Socialist Party's internal struggles through the fall of the Popular Front and only in 1937 embarked on serious fieldwork in Brazil among the Nambikwara, Pajon suggests that it was disillusionment with both politics and Durkheimian orthodoxy that ultimately accounted for Lévi-Strauss's change of vocation.[21]

If this small sample confirms that many students later remember coming to *ethnologie* almost by chance, it also highlights a rich diversity of pathways into the discipline, from starting points as various as natural history, classical studies (philology, ancient languages and religions), archaeology, prehistory, literature, sociology, philosophy, and the law. This pattern is hardly surprising, given the breadth of specialties that ethnology as a total history of humanity was supposed to cover in its formative years. Parisian social networks,

[18] Claude Lévi-Strauss and Didier Éribon, *Conversations with Claude Lévi-Strauss*, trans. Paula Wissing (Chicago, 1991), 16. On Lévi-Strauss's family background, see Daniel Fabre's essay "D'Isaac Strauss à Claude Lévi-Strauss, le judaïsme comme culture," in Philippe Descola, ed., *Claude Lévi-Strauss, un parcours dans le siècle* (Paris, 2012), 267–93.

[19] IMEC/Fonds Marcel Mauss/MAS 8.3/Claude Lévi-Strauss à Marcel Mauss, 4 Oct. 1931. Lévi-Strauss's name appears on the list of volunteers authorized to work at the Musée d'Ethnographie on the morning of Thursday, 29 May 1930. AMH/Ordres de service/2 AM 1 J 1/b/"Note pour le concierge," 28 May 1930.

[20] IMEC/Fonds Marcel Mauss/MAS 11.22/Georges Henri Rivière à Marcel Mauss, "Rapport sur le travail fourni par les étudiants en 1932," 3 June 1932, no. 1176.

[21] Alexandre Pajon, *Lévi-Strauss politique. De la SFIO à l'UNESCO* (Paris, 2011), chaps. 3 and 4. While he met Mauss, Rivet, and Rivière in Paris in 1931 or 1932 and collected for the Musée d'Ethnographie when he went to São Paulo in 1935, Lévi-Strauss's first close personal tie with interwar French ethnology was forged in the late 1930s with his fellow Americanist and expatriate Alfred Métraux. For an early account by Métraux of his developing admiration for Lévi-Strauss, see Beinecke Library, Yale University/GM 350/Métraux-Oddon Correspondance, Alfred Métraux à Yvonne Oddon, 12 Feb. 1939.

however, were also important for recruiting new talent. Griaule took up ethnology on the advice of a chance encounter with an old school friend; Jacques Faublée, who worked on Madagascar, came to the discipline when he met Thérèse Rivière in a prehistory course at the École du Louvre.[22] As we have already seen, Georges Henri Rivière brought in a roster of eclectic ethnographers as a result of his extensive contacts among the avant-garde and art connoisseurs: Schaeffner, Leiris, and Oddon were at the Trocadéro because of him, and the same was true of his sister Thérèse. A fortuitous meeting with a classmate also pursuing a library certificate, the Polish émigré Deborah Lifszyc, led Leroi-Gourhan to enroll in the Institut d'Ethnologie and École Pratique.[23] Lifszyc was already committed to ethnology, having become an avid student of the languages and religions of ancient Ethiopia.[24]

A few recruits were also converts later in life, such as the Protestant missionary Maurice Leenhardt, who found his way to Mauss at the École Pratique after a first career spent in New Caledonia. Foreigners or foreign-born students comprised another important subgroup of those completing Institut d'Ethnologie certificates and continuing on to do graduate research: Alfred Métraux, Anatole Lewitsky, Deborah Lifszyc, and Boris Vildé (a refugee from Stalin's Russia in the 1930s) were in this sense the tip of a small iceberg.[25] Equally striking was the impressive number of women who began graduate degrees in the new science, including Élisabeth Dijour, Germaine Dieterlen, Germaine Tillion, Marcelle Bouteiller, Thérèse Rivière, Yvonne Oddon, Deborah Lifszyc, Jeanne Cuisinier, Idelette Allier, Suzanne (née Sylvain) Comhaire, and Denise Paulme; several other well-educated women became ethnologists in their own right by collaborating with their husbands, among them Georgette Soustelle, Dina Dreyfus Lévi-Strauss, Eva Métraux, Marguerite Le Coeur, and Jeanne Leenhardt.[26] Ethnology as a new discipline was easy to enter and offered career-minded women a way to validate their educations and to travel.

[22] On Griaule's "conversion," see chapter 5.

[23] Philippe Soulier, "André Leroi-Gourhan (25 août 1911–19 février 1986)," *La Revue pour l'Histoire du CNRS* 8 (2003), http://histoire-cnrs.revues.org/554.

[24] Lukian Prijac, "Déborah Lifszyc (1907–1942). Ethnologue et linguiste (de Gondär à Auschwitz)," *Aethiopica: International Journal of Ethiopian Studies* 11 (2008): 148–72.

[25] Mauss drew students from around the world, many of whom returned to their own countries. A partial list includes Ling Chusheng, China's first professional anthropologist, who received his PhD in 1929; Nguyen Van Huyen, who later joined Ho Chi Minh and became a minister of education in Vietnam while remaining a prominent ethnologist; and several Romanians, including Georges Devereux (who had a very successful career in the United States), Stefania Cristescu-Golopentia, Ernest Bernea, and Ion Ionica.

[26] Suzanne Sylvain began as a student of Mauss, then married the Belgian ethnologist Jean Comhaire, and continued her studies with Malinowski. Mauss was a supporter of these husband-and-wife or "double" missions, as he put it. IMEC/Fonds Marcel Mauss/MAS 20/Marcel Mauss à NguyenVan Huyen, n.d. [summer 1937]. For a collective portrait of several of the women ethnologists of this generation, see Marianne Lemaire, "La chambre à soi de l'ethnologue. Une écriture féminine en anthropologie dans l'entre-deux-guerres," *L'Homme* 200 (2011): 51–73.

Finally, a small fraction of Mauss's and Rivet's students discovered ethnology via the empire, from both sides of the colonial divide. Suzanne Comhaire was Haitian, and Nguyen Van Huyen was Vietnamese. Paul Mus and Paul Lévy were born in Indochina to French parents, returned to Paris and the Institut d'Ethnologie for their studies, but then went back to Hanoi for their first jobs. A second "empire" recruiting vector was through the École Coloniale, whose students were encouraged to take Institut d'Ethnologie courses; this was how Bernard Maupoil met Mauss and Rivet, which led to working at the Musée d'Ethnographie in 1931, and embarking on his doctorate—all before his first posting as an administrator in West Africa. The fact nevertheless remains that whatever path they took, all ethnologists in the 1920s and 1930s faced the reality that no new academic positions were yet being created in the field to which they were dedicating years of their lives.

Perhaps for this reason, ethnology students quickly forged their own tightly knit network, which became another defining feature of this cohort, whose material coordinates throughout their early careers remained the Insti, the École Pratique, and the Troca. Initiation into the discipline started with the Institut d'Ethnologie core courses, where they first met their teachers and each other; especially important was Mauss's instruction in ethnographic methods, which anyone interested in the subject could take.[27] Serious students would follow Mauss to his more sociological seminars on religion at the École Pratique, and after 1930 to his sociology seminars at the Collège de France. At the École Pratique, these students began work on a shorter thesis required for that institution's diploma, before moving on to a longer doctoral thesis at the University of Paris.[28] Typically, students also learned the relevant languages for their topics at the École des Langues Orientales Vivantes or elsewhere and attended more specialized seminars on the related subjects that interested them—law, archaeology, philosophy, linguistics, history of

[27] Denise Paulme helped Mauss to publish a version of his course in 1947; Marcel Mauss, *Manuel d'ethnographie*, foreword by Denise Paulme (Paris, 1947). There are also several sets of course notes taken by Mauss's students. See AMH/2 AP 2.4/c/Anatole Lewitsky, "Éléments d'ethnographie muséale, généralité, technologie, esthétique. Rédigé d'après les cours professés à l'Institut d'Ethnologie de 1928 à 1931 par M. Marcel Mauss, Prof. de Sociologie au Collège de France"; AMH/2 AP 2 A1/"Notes prises par Mlles. Y Oddon et T. Rivière au cours de M. Mauss, années 29–30. Revues par M. B. P. Feuilloley"; IMEC/Georges Devereux/ DEVD 0418/document 16/"Marcel Mauss, "Sociologie Descriptive;" and also AMH/2 AM 2 F1 through F6.

[28] The École Pratique delivered a diploma, for which a short thesis was required—equivalent to a master's thesis in the American system. Doctorates in ethnology could be delivered only by the university, usually in one of three Facultés (Lettres, Sciences, or Droit); to qualify for the doctorate, the student had to produce a major thesis (*thèse principale*) and a secondary thesis (*thèse annexe* or *complémentaire*), the latter much shorter than the former; both had to be published before the defense. Mauss's students typically did the École Pratique thesis, and then completed their doctorates at the Faculté des Lettres (Sorbonne).

The staff of the Musée d'Ethnographie du Trocadéro relaxing, 1936–37: A. Lewitsky and Y. Oddon (*bottom*), D. Lifszyc (*above, second on the right*). AMH/PH/1998–14266–125. Photo courtesy of the Musée du Quai Branly/Scala/Art Resource, NY.

religion, sociology, prehistory, physical anthropology—which were offered across Paris.

Last but not least, scientific training in ethnology in the 1930s involved one additional institution. By 1929, all ethnologists-in-training were being pulled into the orbit of Rivet's ethnographic museum, since the study and collection of material objects was one of the defining traits of the discipline in these years. At the Institut d'Ethnologie everyone studied osteological remains and material artifacts from the earliest hominins to those of living "primitives," and many were involved in collecting for the museum and mounting its displays. Not all of Rivet's and Mauss's students contributed equally to these efforts, but all spent time at the Musée d'Ethnographie/Musée de l'Homme in some capacity; they gave their labor, sent and arranged objects, or provided advice and support from afar to those of their comrades who were temporarily in the field. The Troca played an enormous role in the lives of these *apprentis ethnologues* for another reason as well: it boasted the superb research library organized by Yvonne Oddon.[29] A close friend of the many *doctorants*

[29] AMH/2 AP 2E/1/"Note biographique rédigée par Françoise Weil."

working at the museum, Oddon—along with Musée d'Ethnographie stal-warts Anatole Lewitsky, Thérèse Rivière, and Georges Henri Rivière—proved a critical force in helping this disparate group of students bond together in the common enterprise of professionalizing ethnology in the 1930s.

The letters exchanged between Mauss and Rivet and their students on the one hand, and Georges Henri Rivière, Thérèse Rivière, Yvonne Oddon, and Anatole Lewitsky and many ethnologists on the other, bear witness to a com-munity knit together by a shared vocation as well as by the experiences that they had in common: the doubts but also the exhilaration that accompanied months in the field, the material and career worries that haunted everyone, and the particular challenges of collecting and displaying objects and writ-ing theses. Already in 1931 Rivet was writing to Georges Henri Rivière to tell everyone how touched he was by their "gestures of affection" at a recent send-off at the train station: "I understood better than ever how our little eth-nographic family is dear to me."[30] In 1933, an exacting but caring Oddon wrote to Georges Henri Rivière: "As for our readers, we are beginning to receive the new Institut d'Ethnologie students, nice and shy in general, but quickly disap-pointed when they don't find science packaged as a pill here, or Mauss's course in easily digested tablets."[31] From Chicago in 1935, she worried about whether her friends "Lifszyc and Paulme are . . . still alive? And Thérèse—Tillion?"[32] The two pairs of women were in different parts of Francophone Africa con-ducting their first fieldwork.[33] André Leroi-Gourhan wrote to Anatole Lewitsky in 1938 after a year in Japan, complaining: "I'm receiving no news from the museum; have pity on my exile and tell me whom and what one sees . . . make my excuses to my friends Oddon, Allègre, Davant, Joubier, Kelley, Lei-ris, Bouteiller, and all the others, especially Lifszyc. I hate postcards."[34]

In 1936 Mauss could write admiringly, but also in a typically concerned tone about the future of the many members of his flock, to one of his stu-dents, Idelette Allier, regarding two others leaving for the field in Cameroon: "An extraordinary thing, we've even found material resources for our stu-dents, and they have no illusions regarding their limited career prospects.

[30] AMH/2 AP 1 D/Paul Rivet à Georges Henri Rivière, 22 Dec. 1931.

[31] AMH/2 AP 2 B1/Yvonne Oddon à Georges Henri Rivière, 29 Nov. 1933.

[32] AMH/2 AP 2 B1/Yvonne Oddon à Georges Henri Rivière, 28 June 1935.

[33] For more examples of correspondence among the 1930s cohort, see Denise Paulme, *Lettres de Sanga à André Schaeffner, suivi des lettres de Sanga de Deborah Lifchitz et Denise Paulme à Michel Leiris* (Paris, 1992). Paulme married Schaeffner in 1937, and she, Leiris, Schaeffner, and Lifszyc were particularly close. Alfred Métraux (based first in South America, then North America) sustained a long correspondence with Yvonne Oddon, as did André Leroi-Gourhan (in Japan 1937–38) with Anatole Lewitsky.

[34] AMH/2 AM 1 K59/d/André Leroi-Gourhan à Anatole Lewitsky, 25 Feb. 1938. Denise Allègre (a librarian) and Marie-Louise Joubier were staff members of the Trocadéro.

This is also a consolation for me."[35] A year later, Mauss wrote to Métraux, in a rare moment of optimism in the wake of the Musée de l'Homme's anticipated opening: "Here everything in ethnology . . . is coming into its own."[36] Shortly thereafter, Mauss received a letter of congratulations for his nomination as Officer of the Legion of Honor, signed by many of his students currently in residence or at the Musée de l'Homme that day—including Georges and Georgette Soustelle, Anatole Lewitsky, Michel Leiris, and exceptionally, Charles Le Coeur, who was then teaching in Rabat.[37] Mauss wrote back to Lewitsky, as "the most senior of all," to tell "your friends how touched I am by their actions and that it is one of the only things that gives me pleasure in this matter."[38] Mauss had just received a letter from a relatively new recruit, in flight from Bolshevik Russia, Boris Vildé; from his fieldwork in Petseri, Estonia, Boris thanked him for "his teaching": "Very sincerely. You know how to prepare students for the complexity of the facts to be observed."[39]

Mauss the Teacher

That Mauss in particular entranced many among the first generation of ethnologists is clear from the testimonials cited above. But to what exactly were these ethnologists responding? The death of Durkheim and the trauma of World War I transformed Mauss personally, intellectually, and politically in ways that directly benefited his second cohort of students. In the early 1920s, he entered one of the most productive eras of his life, in which he resurrected the prewar *Année Sociologique*, dedicated himself to writing and teaching ethnology, and threw himself again into Socialist politics and journalism. At the same time he remained involved in the various networks that had defined his prewar existence—whether academic, Jewish, republican, or family. Intense participation in two worlds was hardly new to members of the Durkheim clan; as assimilated and patriotic French Jews, they were also steeped in traditional Jewish culture. Yet in Mauss's case, the experience of moving seamlessly between different sociocultural backgrounds seems to have made him eager for many more such "encounters" in his own life—and after the fratricidal struggles of 1914–18, to have raised the epistemological and politically urgent question of how successful encounters occurred in the first

[35] IMEC/Fonds Marcel Mauss/MAS 18/Marcel Mauss à Idelette Allier, 25 June 1936. Mauss's exact words were "et ils ont vraiment tous un beau mépris des soucis de carrière."
[36] IMEC/Fonds Marcel Mauss/MAS 20/Marcel Mauss à Alfred Métraux, 22 June 1937.
[37] IMEC/Fonds Marcel Mauss/MAS 17.7/Laboratoire d'ethnologie à Marcel Mauss, 4 Sept. 1937.
[38] IMEC/Fonds Marcel Mauss/MAS 19/Marcel Mauss à Anatole Lewitsky, 14 Sept. 1937.
[39] IMEC/Fonds Marcel Mauss/MAS 13.41/Boris Vildé à Marcel Mauss, 31 Aug. 1937.

place. With his demanding uncle gone, Mauss abandoned the often-abstract sociological reductionism of Durkheim and began developing a more concrete approach for studying humans in society, one that led him and especially his students in ethnology to understand archaic societies on their own terms.

As recent scholarship has shown, Mauss's interwar ethnology began from the premise that the interplay of self-interest and concern for others was synonymous with the human condition, and that every society developed its own particular system of values and practices that tied the individual members to the whole, without sacrificing their freedom of action.[40] Thinking one's way into a society and economy different from one's own thus required, to quote Maurice Merleau-Ponty on Mauss, grasping the "mode of exchange which is constituted between men through institutions, the equivalences and the connections they establish"—in short, the material and symbolic forms of reciprocity that always exist between the person and the larger society of which they are a part.[41] Mauss also believed that when it came to such exchanges, archaic peoples had much to teach modern French men and women. Mauss's critique of his own society in the early 1920s was the fruit of his renewed political engagement in the aftermath of his personal wartime losses, and the development of communism in Russia and a more rationalized capitalism in France. Scandalized by the Bolsheviks' radical destruction of all social ties, but also put off by his own society's exaltation of unrestrained economic activity, he joined the burgeoning international cooperative movement, whose balance between voluntarism and self-interest, between the pursuit of the collective good and individual desire, appealed to his sense of pragmatism and his democratic ethos.[42] These commitments in turn led him partially away from the study of religion and increasingly toward economic and social anthropology.

The advent of the Institut d'Ethnologie and the chance to prepare a generation of doctoral students for fieldwork was in this sense propitious; it opened vast horizons for Mauss to test empirically his understanding of non-European societies and the sociological assumptions that underpinned it. Mauss thus embarked on a dynamic relationship with his students, in which they traveled out to the field to gather evidence in a way Mauss had never done, and he provided those who were open to his particular kind of sociological thinking with the hermeneutical tools and the broader contexts to encounter

[40] Hart, "Marcel Mauss," 3.
[41] Maurice Merleau-Ponty, *Signs,* trans. Richard C. McCleary (Evanston, IL, 1964), 115.
[42] On Mauss's interwar political commitments, see Fournier, *Marcel Mauss,* 403–61; and Mauss, *Écrits politiques.*

the full complexity and humanity of the peoples they were investigating.[43] The result was a more coherent legacy than has often been recognized. Mauss left behind two different ethnographic traditions among his students. One, which Griaule continued at least in part, was premised on the notion that there should be a division of labor between, in Benoît de l'Estoile's words, "the stage of description, of the collecting of facts, of the monograph" and "that of synthesis, of generalization, and of the discovery of laws."[44] Indeed, the Institut d'Ethnologie course in ethnography had been founded and funded in part to enable the proper collection and description of data by not only professional ethnologists but also missionaries, travelers, and administrators, before it was "too late"—precisely because Mauss and Rivet continued to believe that theorizing should happen only after all the data was in; they themselves, had been trained in this manner. Many of Mauss's students would become superb descriptive ethnographers first and foremost.

Yet as a highly original thinker coming into his own after the devastation of World War I, Mauss recognized that there was more than one way to achieve the desirable goal of "synthesis," and more than one way to imagine the division of labor in producing ethnological knowledge. Across the Channel, Malinowski's new school of social anthropology at the London School of Economics was championing the ideal of solo fieldwork, in which the student always produced her or his own functionalist analysis of a particular society.[45] In this model, the ethnographer had to learn to live with her or his subjects quietly, independently, and respectfully, in order to achieve sociological insight in the first place. Despite his lack of field experience, Mauss encouraged his best students to take this "alternative" route to synthesis—one, however, centered on analyzing not the "functions" of social institutions, but rather what Keith Hart has called the "concrete person acting in society."[46]

[43] Mauss's *Manuel d'ethnographie*, edited by Paulme, is a testimony to the exchanges between Mauss and his students. Examples from their ethnographies are cited throughout the work.

[44] De l'Estoile, "Une petite armée," 18. Yet if Griaule's methods were partly inspired by Mauss, in many others ways they were quite anti-Maussian. As noted in chapter 5, Griaule worked through interpreters and had a notoriously inquisitorial method of extracting information from his informants—all methods at odds with what Mauss's other students practiced (as we shall see below). He also lacked Mauss's historicism. See Marcel Griaule, *Méthode d'ethnographie* (Paris, 1957), published posthumously by Griaule's daughter Geneviève Calame-Griaule. For a more positive assessment of the relationship between Mauss and Griaule, see Vincent Debaene, "Étudier des 'états de conscience,' la réinvention du terrain par l'ethnologie, 1925–1939," *L'Homme* 179 (2006): 7–62; and Debaene, "Les 'Chroniques éthiopiennes' de Marcel Griaule."

[45] At least this was the case for the many students Malinowski funded with Rockefeller money through the International Institute for the Study of African Languages and Cultures. See Tilley, *Africa as a Living Laboratory,* chap. 6.

[46] Hart, "Marcel Mauss," 10. As Mauss scholars have noted, his emphasis on grasping the "whole of society" was very different from Malinowski's functionalist understanding of a culture in terms of the interrelation of its parts. To paraphrase Lévi-Strauss, where Malinowski insisted on the

Far from dispersing his intellectual energy in so many activities that he could not follow through on any one of them, Mauss in the space of ten years generously helped to mentor into print a distinctive body of French fieldwork that protested against facile assumptions of the superiority, racial and cultural, of French civilization.

To get a better sense of Mauss's ideas and their influence on his students, it makes sense first to sample the relevant works of the teacher, or *maître*, as French students then called their mentor, as well as the political contexts in which these works appeared. A lecture that Mauss delivered on the question of nationalism in 1920, in which he, who rarely discussed the question of race, exceptionally addressed the concept, can serve as a point of entry into Mauss's distinctive ethnology.[47] As a patriot and a sociologist, Mauss, like Durkheim before him, believed that the nation was the largest unit in which solidarity—or moral wholeness—was possible.[48] In addition, the French nation was the unit within which Mauss assumed modern socialism would be achieved, if only the dangers of excessive nationalism were avoided. Nations, he wrote, were particular kinds of integrated societies, characterized by a stable and permanent central government, fixed frontiers, and a relative moral, mental, and cultural unity among their citizens who consciously adhered to the state and its laws.[49] France, Britain, and Germany were the most fully realized examples, "beautiful, but still rare and fragile flowers of civilization and human progress," where "the notion of rights was most fully developed."[50] Mauss then went on to clarify that while "a modern nation believes in *its* race," "*its* language," and "*its* civilization," in fact the first and third of these were creations of the nation, not vice versa;[51] "in sum, it is because the nation creates the race that it is thought that the race creates the nation"; similarly, "because

participation of the ethnographer in indigenous life and thought, Mauss sought an empirical and subjective synthesis. Claude Lévi-Strauss, "L'anthropologie devant l'histoire," *Annales. Économies, Sociétés, Civilisations* 15:4 (1960): 627. See also Seth Leacock, "The Ethnological Theory of Marcel Mauss," *American Anthropologist* 56:1 (1954): 58–71.

[47] Mauss gave the lecture, "The Problem of Nationality," in 1920 to the Congress of Philosophy at Oxford and hoped to write a major monograph on the subject. Fournier, *Marcel Mauss*, 26–27. A fragment of this unfinished work was published as Marcel Mauss, "La nation" (1920), in *Oeuvres*, 3:626–34.

[48] According to Durkheim, a man was "morally whole" only when he was governed by his concern for "family," "country," and "humanity." Humanity, however, was "a mere abstraction, a word used to describe the sum of states, nations, and tribes," which possessed "no consciousness, individuality, or social organization of its own." As such, it would never be "a sufficient object of our moral conduct." Durkheim's ideal, then, was for each nation-state to create an internal patriotism aimed at the moral and material well-being of its own citizens. Robert Alun Jones, *The Development of Durkheim's Social Realism* (Cambridge, 1999), 93–94.

[49] Mauss, "La nation," 584.

[50] Quoted in Fournier, *Marcel Mauss*, 192.

[51] Mauss, "La nation," 595, 596, 599.

the nation creates tradition, there are those who seek to reconstitute [the nation] around 'tradition.' "[52] Like Rivet, Mauss never did relinquish the notion that pure races might have existed in the distant past. Yet he also maintained that human history was the history of race fusion determined by social factors, making race an inherently unstable biological fact, "an effect" and not "a cause" of such social behavior as nation building.[53] A nation worthy of the name could only be "the product of all its citizens freely participating in the *Idea* guiding it."[54]

Mauss's inversion of the essentialist race/nation relationship in turn raised a larger question: if citizens "invented" their racial origins and their traditions and civilizations, then what was the "real" way in which a nation came into being? To simplify, nations—like all societies—formed slowly over the ages through intersocial contacts, that is, exchanges. No society existed alone in the world, and "historically, and today more than ever, societies are formed from each other."[55] Moreover, the common elements that particular societies come to share through the circulation of peoples, objects, and ideas formed "civilizations." Societies, including nations, were "immersed in a shared pool of civilization"; what shaped these societies were "their borrowings and their refusals to borrow [from this pool of civilization]"—but either way it was partly what was outside of it that formed any given society's culture.[56] Mauss then concluded that the most important "facts of civilization" that have circulated most widely from the beginning of human time to the present were technological: "Every society that has ever existed has had a tendency to adopt those techniques whose superiority it recognized." "One cannot exaggerate, against the absurd claims to the contrary of *littérateurs* and nationalists [who read in a particular prehistoric artifact found on French soil the essence of the future nation—i.e., Montandon], the importance of technical loans, and the benefits derived from them."[57]

Mauss's attention here to tools and techniques of all kinds as rich social facts was highly innovative, and he would treat both in more depth later on. A particular interest in the ubiquitous role of exchanges in human history,

[52] Ibid., 596, 601.
[53] Marcel Mauss, "L'anthropologie des races," in *Oeuvres*, 3:391. Mauss was reviewing a book published by Harvard anthropologist Roland Dixon in 1923, *The Racial History of Man*, which was based only on craniometrical data. Mauss was critical of many of Dixon's polygenist conclusions, noting that Dixon "believed . . . in the 'primary' character of races that he had *a priori* constituted." But Mauss approved of Dixon's concept of "the fusion of races" because it recognized "the social factor in the formation of human types, not only today but always." Ibid., 391.
[54] Quoted in Fournier, *Marcel Mauss*, 410.
[55] Mauss, "La nation," 605.
[56] Ibid., 609.
[57] Ibid., 612–13.

however, comes through, too, in the challenge he raised to racialist under-standings of the European nation-state that erroneously saw nations as or-ganic units rather than as constructed entities based on choice, equal rights, and shared language and culture, as well as on encounters with other peoples, cultures, and nations. Mauss's most important interwar ethnological essay, *The Gift: The Form and Reason for Exchange in Archaic Societies* (1925), would further develop this historicizing interest in how humans encountered each other, individually within a particular society, but also collectively between societies. Focusing on a universal human institution that no social scientist had previously identified, much less tried to theorize—that of the gift and re-turn of the gift—Mauss demonstrated in particular that exchanges in archaic and earlier European societies engaged the whole person, while exchanges in modern Western societies were being reduced to an impersonal economic dimension. In one way or another, this brilliant essay would inform all his students' output.[58]

As Harry Liebersohn has demonstrated, in *The Gift* Mauss drew on the pioneering fieldwork of several of his foreign colleagues in what at the time was referred to as "primitive economics"—that of Franz Boas on the Kwakiutl of the Pacific Northwest, that of Richard Thurnwald on the Banaro of Papua New Guinea, and most decisively that of Bronislaw Malinowski on the kula trade of the Trobriand Islanders—to argue that the institution of gift giv-ing among the tribal peoples of the Pacific broadly defined involved a com-plex system of mutual obligations, in which giving always involved giving back. Primitive economics was a new branch of anthropology at the turn of the twentieth century; rather than assuming, as had an earlier generation of scholars, that archaic peoples had no economic organization to speak of be-cause each household was "self-sufficient," Boas, Thurnwald, and Malinowski revealed the existence of extremely complex economic arrangements among each of the groups they studied, in which honor, material gain, and recog-nition of social status were intertwined.[59] It was these crucial insights that led Mauss to the concept of the "gift" and "counter-gift," which he famously termed "a total social fact," that is to say, an institution that "involved all

[58] Marcel Mauss, *The Gift: The Form and Reason for Exchange in Archaic Societies,* trans. W.D. Halls, foreword by Mary Douglas (New York, 1990). For overviews of the vast corpus of writing on Mauss's *Gift,* see Liebersohn, introduction to *Return of the Gift;* and Marcel Mauss, *Essai sur le don,* foreword by Florence Weber (Paris, 2007), 7-62. On the particular way in which the politics of the early 1920s affected Mauss's essay, see Grégoire Mallard, "The Gift Revisited: Marcel Mauss on War, Debt, and the Politics of Nation," Working paper 10–004, Buffet Center for International and Comparative Studies, Working Papers, November 2010, 1–49; and Sylvain Dzimira, *Marcel Mauss, savant et politique* (Paris, 2007).

[59] For a contemporary assessment of this branch of study, see Raymond Firth, "The Study of Primi-tive Economics," *Economica* 21 (Dec. 1927): 312–35.

aspects of the society in a network of shared responsibilities."[60] Not content, however, with Pacific ethnography alone, Mauss went on to dig up similar data on classical Rome, ancient India, and early Germanic societies, to conclude that the gift and counter-gift had been practiced throughout the course of human history and were also present in his own society—despite modern Westerners' self-image as people who attached only a material value to objects exchanged, and for whom gifts were always "free," with no obligation to give back.

In Mauss's analysis, gift-giving networks in their archaic form were not premised on equality, nor did they necessarily imply friendship or loss of personal initiative; in one of Mauss's most arresting examples, the Kwakiutl potlatch, leaders vied with each other to see how many gifts they could shower on each other—a standoff that ended only when a particularly powerful chief destroyed his own clan's wealth, in a gesture of excess that no rival could match. Yet however "excessive" these encounters were, such practices had the advantage of channeling violent rivalry between individuals and groups into more peaceful forms of coexistence—an effect that Mauss chose to emphasize. Equally important for Mauss the cooperative Socialist and teacher—and here he followed Malinowski particularly closely—objects offered and returned more generously in each of the examples he looked at were never only about quantitative remuneration. Honor was also at stake, a decidedly nonutilitarian value, and a gift exchanged would also carry the spirit of its owner, making clear, for example, how the donor and the recipient who returned the gift fit into family, village, and larger society. Archaic peoples, in short, were engaged in all kinds of exchanges, both material and symbolic in nature and premised on the notion that to possess was to give; and these exchanges in turn guaranteed their solidarity.[61]

Yet while it was clear that Mauss admired the solidarity produced by such exchanges, his essay did not fetishize a lost past; the development in the modern West of the individual contract defined by the market, in which things circulated more and more independently of their owners, represented a logical progression of earlier gift-giving practices. But Mauss did suggest in his conclusion that his contemporaries would benefit from reintroducing certain lost forms of reciprocity in their own economic and social arrangements, because modern terms of commerce violated all human beings' sense of justice and concern for each other.[62] Criticizing both "over-generosity, or communism" and "the egoism of our contemporaries and the individualism of our

[60] Liebersohn, *Return of the Gift*, 2.
[61] Ibid., 136.
[62] Ibid., 156.

laws," the final pages of *The Gift* recommended more philanthropy from the rich, limits on speculative profits, a state that extended welfare to its weakest citizens even further, and a robust civil society—a return in short to greater involvement of all in the lives of their fellow humans in the spirit of the gift.[63] The future peace required nothing less:

> This is therefore what one may have found at the conclusion of this research. Societies have progressed in so far as they themselves, their subgroups, and lastly the individuals in them have succeeded in stabilizing relationships, giving, receiving, and finally giving in return. . . . This is what tomorrow in our so-called civilized world, classes and nations and individuals also, must learn. This is one of the enduring secrets of their [i.e., archaic societies'] wisdom and solidarity.[64]

The ethnology that Mauss elaborated in his essay was, in Liebersohn's words, particularly innovative for his times in several distinctive ways. Mauss's Anglo-American and German contemporaries had inaugurated modern ethnographic methods and a broader understanding of systems of exchange than had existed among nineteenth-century economic theorists, through their intensive fieldwork and analysis of a single people. But unlike Mauss, they had not included data on early modern European institutions in their writing, nor had they synthesized evidence amassed by others. In addition, where other anthropologists assumed that the emergence of the voluntary and free gift in modern Europe represented "progress" toward a more refined ethical sense, Mauss argued the opposite: the overwhelming evidence from archaic societies suggested that the full and true form of the gift involved reciprocity.[65] And Mauss was a pioneer in a third critically important way as well. In *The Gift*, he insisted that all social institutions had to be considered by ethnologists in their *living* state rather than some *static* one, because—as his own analysis implied—human institutions, even archaic ones, were also always the product of a longer history and thus subject to change.[66] In an era of hardening racism, this historicizing impulse was also a powerful tool of analysis for the ethnologist headed to France's colonies.

If Mauss's students found his notion of the gift and counter-gift inspirational, they returned regularly to another closely related Maussian concept as well—one, however, that their teacher published on only late in the 1930s

[63] Ibid., 160.
[64] Mauss, *The Gift*, 82.
[65] Liebersohn, *Return of the Gift*, 151.
[66] Mauss, *The Gift*, 80.

and in a much sketchier form: the social construction of the "person" or the "self" in all cultures. In 1938, Mauss delivered the Huxley Memorial Lecture at the Royal Anthropological Institute in London under the title "A Category of the Human Mind: The Notion of the Person; the Notion of Self," in which he argued, again comparatively and historically, that the idea of the person had taken on "a succession of forms" "in the life of men in different societies," culminating in the West's concept of the self as "sacred."[67] "The Person," with its evolutionary framework and seemingly much stronger defense of Western individualism than in *The Gift*, is open to multiple interpretations, because of its brevity and because the terms that the author used to define notions of personhood across time and space were inherently slippery.[68] When placed in the increasingly dangerous political and economic context in which Mauss was writing, his motives and the continuity of "The Person" with his 1920s work nevertheless become clearer.[69]

His goal, Mauss wrote in this essay, was to explain how "the category of the person, the idea of 'self,'" "too often considered to be innate" and even today "imprecise, delicate and fragile," was, in its Western version, a late development. "I shall show you," he began, "how recent is the word 'self' (*moi*), used philosophically, how recent 'the category of the self.'" He next established that the category of the "person" had always existed in all societies, albeit in different forms: "In no way do I maintain that there has ever been a tribe, a language, in which the term 'I' [or] 'me' . . . has never existed, or that it has not expressed something clearly represented."[70] He then discussed the concept most different from any in the modern West and typical of archaic peoples—what he called the person as "role" or "personage." Turning to North American and Australian ethnography, he concluded that individual members within a clan assumed roles through the exchange of different goods, rights, duties, titles, and kinship names, and that these roles were periodically ritually enacted through masks or dancing; no general rules applied to these "personages" as such apart from the clan. Ancient Rome, in contrast, made the "personage" into the locus of general rights in exchange for duties,

[67] Marcel Mauss, "A Category of the Human Mind: The Notion of the Person; the Notion of Self," trans. W. D. Halls, in Michael Carrithers, Steven Collins, and Steven Lukes, eds., *The Category of the Person: Anthropology, Philosophy, History* (Cambridge, 1985), 3; hereafter cited in the text and notes as "The Person."

[68] "The Person" can be usefully read alongside a lecture that Mauss gave in 1938 at the Congrès International des Sciences Anthropologiques et Ethnologiques in Copenhagen. Thanks to the efforts of Marcel Fournier, this essay has been recovered. Marcel Mauss, "Fait social et formation du caractère," *Sociologie et Sociétés* 36:2 (Autumn 2004): 135–40.

[69] See the essays in Carrithers et al., *Category of the Person*.

[70] Mauss, "The Person," 2–3.

by inventing the concept of the legal person or persona and transforming him into a citizen of a state. Last but not least, the advent of Christianity endowed this "legal person" with an inner conscience and inner life, without, however, severing the moral relationship that bound the individual to society. In the France of the Rights of Man, Mauss reminded his audience, "the normal state" was respect of self *and* "respect of others."[71] He nevertheless concluded on a more pessimistic note: "Today . . . the sacred character of the human person is questioned . . . in the countries where the principle was discovered. We have great possessions to defend. With us the idea could disappear"; this might happen in part, he implied, because history, social anthropology, and sociology all teach "how human thought 'moves on.'"[72]

As Steven Lukes aptly put it, "The Person" was a magnificent answer, but what was the question?[73] In 1938, the question at stake for Mauss was once again a political as well as an ethnological one, although as always his science and democratic concerns were mutually reinforcing. Although Mauss, unlike Rivet, had abstained from electoral politics after the 6 February 1934 riots in France, he followed with increasing despair the new international crisis that was engulfing Europe. As he wrote in a personal letter of condolence to the president of the Republic of China in the wake of the landing of Japanese troops there on 3 June 1938, "One of the saddest things for the sociologist and observer of modern societies is the sensation that even the great democracies are relatively indifferent to the unjust suffering of the rest of the world." "Among the sorrows," he continued, "that I can still experience is that Durkheim and his disciples, of whom I am one, having identified the importance of the social fact in the life of men, are witnessing, in the name of the primacy of the state, the worst crimes and the regression of societies themselves, and even in some cases their disappearance."[74] How to counter, scientifically, the Fascist and Bolshevik ideologies alike that glorified the state and defined individuals in either exclusively class or racial terms—denying entire social groups any "personhood" whatsoever—was one question motivating Mauss in 1938.

Yet Mauss was surely responding to another disheartening political development as well, this time on the "humanist" Left in France: the spiritualist current among the post-Maurrasian Catholic intelligentsia known as personalism. Personalism was one of the many nonconformist movements to emerge in the 1930s, as intellectuals on the Left and Right searched for new political and economic solutions to the social crisis precipitated by the Depression.

[71] Ibid.
[72] Ibid., 22.
[73] Steven Lukes, conclusion to Carrithers et al., *Category of the Person*, 282.
[74] IMEC/Fonds Marcel Mauss/MAS 21.38/Marcel Mauss à M. le Président, 19 July 1938.

Personalism's founders, the left-leaning Émmanuel Mounier and the more conservative Jacques Maritain—anti-Fascists both—deliberately embraced the notion of the "human person" as part of a rejection of not only Marxism but also the crude individualism they saw triumphant in the Third Republic.[75] These two ideologies, they claimed, had depleted the nation of its energy; what were needed were vital human beings, "spiritual man" in Mounier's words. Despite the semantic similarities with Mauss's "person," personalism in fact had a communitarian, elitist, and hierarchical streak that could not have been more different from Mauss's democratic humanism. As Mounier put it, "There was no true spirituality without hierarchy, and a constant purification of the inferior levels."[76] "The person could only fulfill himself in 'organic communities' where he could develop an interior life in the heart of communitarian life." Many non-Christians, he continued, were "looking for a reality all consuming enough to vanquish their avarice to the point where they forget the self."[77] Because his ideal of solidly constituted, collective persons was supposedly so difficult to find in the France of the mid-1930s—religious orders, here, were his implicit model—Mounier believed that a spiritual elite would have to set the example for the rest of society.

As these views suggest, personalism represented one more assault on republican institutions in 1930s France. Its emphasis on spirit over agency, and on hierarchy over equality, represented a slippery slope that would lead Mounier briefly to embrace Vichy's authoritarian National Revolution a few years later (he soon fell afoul of the regime). The Vichy regime in turn appropriated, and bent to racist ends that the personalists had never embraced, certain of Maritain's own slogans, such as "the primacy of the spiritual."[78] Mauss, it would seem, recognized early on the political ambiguities of personalism and responded by sketching out a "proper" understanding of the person, argued from, in his words, "that kind of museum of facts . . . which ethnography affords us."[79] Although Mauss's essay was a work in progress, a central point emerges: while acknowledging with Mounier that the dignity of

[75] John Hellman, *Émmanuel Mounier and the New Catholic Left, 1930–1950* (Toronto, 1981), 78–87; and Hellman, "The Opening to the Left in French Catholicism: The Role of the Personalists," *Journal of the History of Ideas* 34:3 (1973): 381–90. Mauss had encountered the anti-Semitism of a certain segment of the Catholic Right during the electoral campaign for the Collège de France in 1930, which gave him an additional reason to engage with the personalist movement, despite its leftist claims. Hellman, *Émmanuel Mounier,* 26.

[76] Quoted in Hellman, *Émmanuel Mounier,* 80.

[77] Hellman, *Émmanuel Mounier,* 82–83; Philip Nord, *France's New Deal: From the Thirties to the Postwar Era* (Princeton, NJ, 2010), 35–37.

[78] Samuel Moyn, "Personalism, Community, and the Origin of Human Rights," in Stefan-Ludwig Hoffmann, ed., *Human Rights in the Twentieth Century* (Cambridge, 2010), 85–106.

[79] Mauss, "The Person," 4.

the "person" was a universal value worth striving for, Mauss rejected outright the idea of a universal "spiritual man." For him, personhood was a social fact, developing throughout history in different ways as every group formed institutions for defining the role of the individual in relationship to the rest of society. Only a politics and an ethnology that acknowledged the diversity of pathways that different societies had chosen in creating "persons" could hope to respect and preserve the latter. In this sense, as Maurice Leenhardt put it, "the subject and the conclusion of Mauss's 'The Person' was the continuation of what he had written on the gift."[80]

Taken together, the interwar writings of Marcel Mauss revealed a new way to think about what all human societies shared, while also valuing their differences. Where the earlier Durkheimians had tended either to split up "primitive" social phenomena into separate abstractions that they assimilated to their own—the law, prayer—or to declare so-called primitive thought impenetrable, Mauss proceeded more instinctively and patiently, highlighting the systematic way in which every society governed, to again quote Merleau-Ponty, "the use of tools, manufactured or alimentary products, ornaments, magical formulas, chants, dances, and mythical elements." In this Maussian universe, the social was embedded in the depths of the individual without eliminating either the self or history. What is true, wrote Mauss, is not a law or a prayer, but "the average Frenchman, the Melanesian from this island or another." Ethnologists studying particular groups thus had to consider the whole together, the groups, the subgroups, and the individual acting in society, without losing sight of change over time. This view of societies as particular manifestations of a universal human need to balance self-interest with concern for others in order not merely to survive but to endow existence with meaning was another insight from which all of Mauss's students benefited.

A Maussian Ethnography

In the mid-1930s, Germaine Tillion and Thérèse Rivière were awarded fellowships from the International Institute for African Languages and Cultures to undertake fieldwork together among the Chaouïa in the remote Aurès Mountains of Algeria—a field site Rivet chose for them because France's Algerian departments "needed" ethnographers, too.[81] As was made clear in her letters

[80] Maurice Leenhardt, "Marcel Mauss (1872–1950)," *Annuaire* (1950–51): 22.
[81] IAIA/1/19/Minutes of the Meeting of Executive Council, 17 May 1934. The two women separated upon arrival, working independently, Rivière on material culture and Tillion on sociological questions. Neither finished her doctoral thesis. Tillion like many of Mauss's students completed a short thesis for the diploma of the École Pratique, "Morphologie d'une république berbère. Les

to Mauss between January 1937 (the end of her first two years in the Aurès) and October 1939 (the start of her final six months there), Tillion had become a scrupulous ethnographer:

> The interviews [*enquêtes*] take a long time to conduct, especially when you do not wish to use the method of interrogating that allows the interlocutor to say exactly what she wishes ("answer, oh spirit that is in this table"), and I came to realize that the indigenous informants generally simplified their stories for our use and that it is highly advantageous to not urge them on, to not direct them, and to let them digress at their leisure—very advantageous also to not let them translate an obscure expression but to note it in Chaouïa with its supposed translation, which is generally approximate. . . . I noticed that you learn as much from the commentaries on a story as from the story itself; so I developed the habit of going over the collected texts with another informant and of writing down the initial statement, but also appending to it a number of others that illuminate it.[82]

Her patience produced a growing trust between Tillion and her informants, to the point where she housed and fed a group of the Chaouïa who came to Paris in 1938. Upon her return to Algeria, she noted:

> All the Chaouïa whom I hosted, as well as their families, friends, and allies, received me with enthusiasm (these impoverished people do not often have the opportunity to offer their hospitality to one of us). Of course, with the extraordinary way news spreads in this country, everyone knows that I am someone honorable, that they need not fear any dirty tricks; on the contrary . . . I watch them deliver . . . honey, grapes, peaches, tomatoes, watermelon, corn cobs, all the best fruits of the south, presents. Of course I know what this potlatch means, and I act accordingly. I am even offered a contraband Italian revolver that I refused, naturally, but now you know how far their trust went.

Ah-Abder-rahman, transhumants de l'Aurès méridional" (a considerable refinement of the earlier title she had declared in 1935–36, "L'organisation sociale des Berbères de l'Aurès"), which she defended in 1939. IAIA/13/91/"Publications envisagées par Mlle. T. M. H. Rivière et Mlle. G. Tillion, Aurès, 1935–1936," 3. For a critical appraisal of Rivière's fieldwork, see Fanny Colonna's essay, "Elle a passé tant d'heures," in *Aurès, Algérie, 1935–1936, photographies de Thérèse Rivière* (Paris, 1987), 121–91; and for a more nuanced reading, Liliane Kuczynski's review of Colonna's essay in *Gradhiva* 4 (Summer 1988): 86–90. Tillion published an account of her fieldwork much later: *Il était une fois l'ethnographie* (Paris, 2000).
[82] IMEC/Fonds Marcel Mauss/MAS 12.63/Germaine Tillion à Marcel Mauss, 4 Jan. 1937.

And she concluded confidently:

> From an ethnographic point of view, there is no interview I cannot conduct. I know exactly what to ask, of whom I can ask it, and how to be persuasive.
>
> From a linguistic point of view, I can sustain a simple conversation and I know enough of the grammar to make rapid advances, but what I want is to *speak*, to do completely without an interpreter. . . . That's what I'm aiming for.[83]

Tillion would never complete her ethnography of Chaouïa kinship; she lost her five years' worth of field notes and her manuscript in progress somewhere in transit from the Fresnes prison in France, where she was incarcerated in 1942 for Resistance activity, to Ravensbrück in 1943—although some of her field reports survive. Yet her confident discussion of her ethnographic encounters and her reference to the traditions of the potlatch reflect the kind of spell Mauss cast over his interwar cohort. In addition to Tillion, four others followed their *maître* closely in the interpretations that they brought to their data, and their work suggests a larger school in the making: Denise Paulme, who worked on the social organization of the Dogon people in Mali, where colonialism had still not made many inroads; Bernard Maupoil, a colonial administrator in French West Africa interested in divinatory geomancy in coastal Dahomey, an area long subject to European influence; Charles Le Coeur, a *normalien* (like Soustelle) whose ethnology included urban Morocco and peoples of the Sahara; and Maurice Leenhardt, the older and nontraditional Protestant missionary based for years in New Caledonia, a settler colony infamous, like Algeria, for its brutal pacification in the nineteenth century.[84] While each of the ethnographies (or in Tillion's case, her notes and letters) these students produced is distinctive, all undertook their own careful fieldwork and documented their similar methods of working.[85] Each also attempted to grasp social facts by drawing on such Maussian concepts as the total system of exchanges that every society forges among its members, the

[83] IMEC/Fonds Marcel Mauss/MAS 12.63/Germaine Tillion à Marcel Mauss, 14 Oct. 1939.

[84] Consultation of Mauss's correspondence also confirmed that these five students had a close intellectual relationship with their mentor.

[85] Denise Paulme, *Organisation sociale des Dogons* (Soudan Français) (Paris, 1940); Bernard Maupoil, *La géomancie à l'ancienne côte des esclaves* (1943; Paris, 1988); Le Coeur, *Le rite et l'outil*; and Maurice Leenhardt, *Gens de la Grande Terre* (Paris, 1937). Because of space constraints, I have chosen to examine only the major monographs (all principal theses for the doctorate except in the case of Leenhardt), rather than the articles or shorter theses for the École Pratique that Mauss's ethnology students also produced, or the much shorter thèse annexe also required for the doctorate. I have limited my selection to the period from 1925 to 1945, and within those years I have chosen the ethnographies that most closely reflected Mauss's new concerns, as compared to those that preoccupied him in the pre–World War I era.

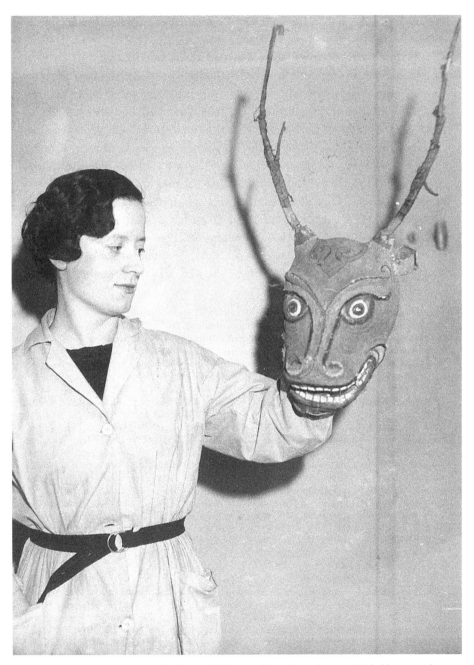

Denise Paulme volunteering at the Musée d'Ethnographie du Trocadéro in 1933, holding a mask used in religious dances in the Mekong Valley (Yunnan Province). She had been working at the museum for a year. AMH/PH/1998–20937. Photo courtesy of the Musée du Quai Branly/Scala/Art Resource, NY.

fashioning of the person through society, and the intrusion of history in all social formations, due often to outside contacts.[86]

Thanks to a Rockefeller fellowship Denise Paulme set out with Debora Lifszyc in 1935 to spend eight months among the Dogon at Sanga (Bandiagara, Mali), Paulme to study the "civil aspects of their social organization" (economic life, family organization, the role of women), and Lifszyc linguistics.[87] They overlapped for two months with the third Griaule mission to the area, but from April to October the two women were on their own. Among the most reserved and least confident of Mauss's students, Paulme would later take the time to publish posthumously her own and others' notes from Mauss's Institut d'Ethnologie course on ethnographic methods.[88] Familiar with Malinowski's corpus—Mauss had asked her in 1933 to do a book review of Malinowski's *The Sexual Life of Savages* (1929)—she began her thesis with a discussion of the challenges of fieldwork.[89] Paulme noted that although studying different Dogon institutions, she and Lifszyc cross-checked and

[86] This list of Mauss's students may be revised as we learn more about them. I have left aside Soustelle and Métraux, because their ethnographies (Jacques Soustelle, *La famille Otomi-Pame du Mexique Central* and Alfred Métraux, *La civilisation matérielle des tribus Tupi-Guarani*) showed less interest in the socioeconomic questions raised by Mauss than those included in my grouping. Métraux by his own admission did not have the sociological turn of mind that would allow him to be "entirely one of [Mauss's students]," but he hoped "to keep furnishing his mentor with documents." IMEC/ Fonds Marcel Mauss/MAS 20/Alfred Métraux à Marcel Mauss, 27 June 1927. Métraux appears to have become more "Maussian" in the 1930s. In 1932 he wrote to his close friend Oddon that he was tired of studying "material culture" and ready to turn to "sociology and *la morale*" and produce books "du genre Malinowski"; in 1934, when he was on Easter Island, he told her: "Sociologically I have made . . . an important discovery regarding the potlatch." Yale University, Beinecke Library, Yvonne Oddon Collection, Alfred Métraux à Yvonne Oddon, 7 Sept. 1932 and 12 Sept. 1934. And Soustelle, in his more popular account of his fieldwork in Mexico, also took up certain questions of social change and economic exploitation not evident in his thesis. See Soustelle, *Mexique, terre indienne* (Paris, 1936). In his 1938 thesis, *Masques Dogons*, Griaule did not draw on Mauss's sociological and historical insights, nor did his approach to fieldwork qualify him as a Maussian in the sense that I am using the term. Only additional research will clarify Mauss's impact on the "Orientalist" scholars of Southeast Asia in whose training he took part, such as Paul Mus and Paul Lévy. Susan Bayly has suggested that Mus was influenced in the 1930s not only by the larger Durkheimian school but by Mauss's concern with intersocial contacts between different societies. Bayly, "French Anthropology," 607 n. 58.

[87] Paulme, *Organisation sociale des Dogons*, 9.

[88] Paulme's adviser of record was not Mauss, but René Maunier. Maunier was a law professor specializing in what he called *sociologie coloniale*, who had taught in Algiers before moving to the Faculté de Droit (Sorbonne). Although affiliated with the Durkheimians, his sociology remained a nineteenth-century positivist and racialized one. Paulme's de facto adviser was Mauss, who helped her procure a Rockefeller fellowship and other funding, and whom she listed as her "maître" in her acknowledgments. IMEC/Fonds Marcel Mauss/MAS 19/Marcel Mauss à M. Kittredge, 13 Dec. 1934 and accompanying "Note sur une bourse Rockefeller"; Marcel Mauss, "Note," 11 June 1937; AMH/2 AP 4 2C/2c/Marcel Mauss à Membres de l'Assemblée Plénière (Caisse des Sciences), 3 July 1939. There were many theses in "colonial sociology" defended at the Faculté de Droit in the interwar years, since law studies were required for colonial administrators, but Paulme is the only Maussian to have defended her dissertation there. AMH/2 AP 4 2B/2c/Denise Paulme-Schaeffner à Marcel Mauss, 26 May 1940.

[89] IMEC/Fonds Marcel Mauss/MAS 11.79/Denise Paulme à Marcel Mauss, 3 Feb. 1933.

rechecked their facts scrupulously; Paulme eventually understood enough of the language to be able to rely less on informants. She also consulted the judicial records in the district's colonial archive to document local custom, but as her presence became accepted she could also judge for herself how "real life" departed from "the rules of ideal conduct" repeatedly described to her. She and Lifszyc never attended a village ceremony or meeting without being invited but were invited to almost every one; Paulme also named and thanked her Dogon friends and interpreters.[90]

Fellow Africanist Bernard Maupoil likewise bent over backward in his posthumously published thesis to explain how he had come to know what he "knew." A scion of France's administrative elite (his father was a prefect, his grandfather a *garde des Sceaux*), Maupoil had embarked on law studies and a colonial career at the behest of his parents, only to discover ethnology at the Institut d'Ethnologie and volunteering at the Trocadéro.[91] Posted as an administrator to Dahomey from 1934 to 1936, he used his "free time" during his years of duty there to investigate a local branch of geomancy called Fa—a method of divination based on the patterns or signs of specially marked palm nuts and other ritual objects. Fa had developed in the royal court of Dahomey in the early eighteenth century and was still practiced in the cities of Porto Novo and Abomey, albeit in a decadent form. It was believed to be an impartial force that foretold the future, whether good or evil; a hierarchy of trained and initiated diviners, or *bokonon,* learned to interpret Fa and transmitted the replies to their clients, who could then take appropriate measures to change their fates. The first part of Maupoil's thesis documented, in Mauss's words, "the religion as a whole"; the second part represented a highly original "in-depth study of the complete symbolism and mythology of the religion's 16 primary signs and 53 of its 240 secondary ones," including the charms, objects, legends, and prayers that had become associated with each sign.[92]

While Maupoil's historical and comparative research was impressive, by his own admission it paled by comparison with the feats of memory and erudition of the *bokonon* themselves. The thesis, like Paulme's, began on a note

[90] Paulme, *Organisation sociale des Dogons,* 6–8.
[91] Biographie de Bernard Maupoil, http://www.cilf.fr/f/index.php?sp=liv&livre_id=265; "Nécrologie," *Journal des Africanistes* 15 (1945): 38. Maupoil had *licences* in both *droit* (1929) and *lettres* (1931), as well as the diploma of the École Coloniale (1931), before enrolling at the Institut d'Ethnologie. He volunteered at the Musée d'Ethnographie in 1933. AMH/2 AM 1 G2/"Liste des bénévoles ayant collaborés au Musée d'Ethnographie du Trocadéro en 1933," 30 Nov. 1933.
[92] IMEC/Fonds Marcel Mauss/MAS 8.83/Marcel Mauss, "Rapport" for Bernard Maupoil's thesis, 11 July 1939. According to Marc Augé and Claude Rivière, Maupoil's ethnography remains a classic. Claude Rivière, "Postface," in Maupoil, *La géomancie,* 687–92; and Marc Augé, "Who Is the Other?" in his volume of essays, *A Sense for the Other: The Timeliness and Relevance of Anthropology,* trans. Amy Jacobs (Stanford, CA, 1998), 1–26.

of modesty. Maupoil regretted any error of interpretation, he had attempted to make his interlocutors' point of view his own, and he hoped others would identify and correct the weakest points of his own work. The ethnographer, he further cautioned, must distinguish between the "informateur en pagne" (unfamiliar with European ways of thinking) and the "informateur lettré" (educated by the French).[93] Having discovered that the latter knew nothing, Maupoil sought out only the most reputable of the former, including the ancient Gedegbe, who had been active at court at the time of the French conquest—"a sociological and historical document of the best kind," Mauss also noted, and nothing short of "sensational."[94] These aged men while responding to "useful incentives" (*utiles liberalités*), did not tell Maupoil what he wanted to hear; nor did they refuse to answer—to do so would have been too impolite—or dissimulate by affirming a counter truth; omissions were usually unintentional, digressions were always revealing; informants hesitated to reveal their most noble sentiments, out of modesty; the greatest challenge was their divergence of opinion on religious matters, and here the investigator could only "reproduce faithfully among the changing interpretations those that seemed the closest to the past and the truth."[95]

Charles Le Coeur, permanently based in Morocco since 1928, where he had completed his military service before electing to teach at the Collège Franco-Musulman of Rabat (a secondary school) and holding a research position at the Institut des Hautes Études Marocaines, offers yet another case; he was one of the most inventive of Mauss's students, whose work was as philosophical as it was sociological and ethnographic. Under the auspices as well of a Rockefeller fellowship won through Mauss's intervention, he spent 1932–33 studying with the notoriously domineering Malinowski at the London School of Economics, who noted that while he considered every Frenchman a dog, this one "seemed alert and almost intelligent."[96] Le Coeur then spent ten months with his wife, Marguerite—herself an *agrégée* in history and geography—in a remote corner of Chad among the 6,500 Téda people in the Tibesti Mountains, who along with the Daza people to the south, formed part of the larger Toubou ethnic group. In 1942–43 he returned to the same area, because "all specialists agree that one knows people well only if one has not only seen them, but reseen them after an absence, which allows the milieu of the informants to be renewed, and the ethnographer to refresh his curiosity."

[93] Maupoil, *La géomancie*, vii.
[94] IMEC/Fonds Marcel Mauss/MAS 8.83/Marcel Mauss, "Rapport" for Bernard Maupoil's thesis, 11 July 1939.
[95] Maupoil, *La géomancie*, vii-ix.
[96] IAIA/39/196/Le Coeur/Malinowski to Miss Bracket, 27 Nov. 1932. The fellowship was administered through the International Institute for African Languages and Cultures in London.

He reported using three methods concurrently: he observed the different social groups, he next questioned each group about itself, and finally he asked each group's opinion of the other group. "I even recorded at times my own reaction, thinking . . . it might reveal something of value." Le Coeur then rechecked his and his informants' first impressions for inconsistencies, adding: "The wrong idea that someone has of a social fact, or the right idea that they refuse to acknowledge, often reveals as much as the dreams and Freudian slips [*actes manqués*] that psychoanalysts study."[97]

Discussions of fieldwork practices among Mauss's students always also touched on the problems that language differences posed to the collection of field data. Le Coeur learned not only Arabic and Berber but the dialects of the Téda and Daza. Maupoil transcribed every word, phrase, proverb, and chant that he collected in the vernacular, along with his translations; working out the latter, he insisted, depended on reciprocity:

> Some words, however well translated or discovered, dissimulate not only a part of their affective content, but also a thought impossible to formulate, made up of images, memories, *schémas moteurs*, which translation sterilizes, transposes, or betrays. This opacity of language, which is reciprocal, only dissipates in an atmosphere of reciprocal sympathy whose continuity is acquired with difficulty.[98]

Paulme, like Tillion, claimed that language was the most difficult obstacle for her; there was the challenge not only of learning the local Dogon language in seven months, but also of proper translation. She was acutely aware of the pitfalls of using French kinship terms (cousins, nephews, etc.) for an entirely different social organization; there were, she noted, so many individual variations in behavior compared to the ideal types described by interpreters that it would be naive to place all one's faith in "linguistic documentation" while ignoring "the sociological nature of language." A Dogon male, she added, might refer to an aunt and a mother in the same way, but he would never be in doubt about who his mother was.[99] Maurice Leenhardt hardly needed Mauss to reflect on problems of translation; as a Protestant missionary in

[97] Charles Le Coeur, "Méthode et conclusions d'une enquête humaine au Sahara nigéro-tchadien," in *Gens du roc et du sable, les Toubous. Hommage à Charles et Marguerite Le Coeur,* ed. Catherine Baroin (Paris, 1988), 190, 191–92. See also his posthumously published field notes from his first mission to Tibesti, *Carnets de route, 1933–1934,* ed. Marguerite Le Coeur (Paris, 1969).

[98] Maupoil, *La géomancie,* viii. The concept of *schéma moteur* comes from the philosopher Henri Bergson and refers to an unconscious "habituated" system in the body that directs in advance possible action. On Maupoil's methods, see also Augé, "Who Is the Other?"

[99] Paulme, *Organisation sociale des Dogons,* 66, 69.

Paul Rivet, Maurice Leenhardt, and Lucien Lévy-Bruhl, n.d. (1930s). Leenhardt considered Lévy-Bruhl (1857–1939), the philosopher who studied "primitive mentality," his mentor along with Marcel Mauss. AMH/PH/PP0098579. Photo courtesy of the Musée du Quai Branly/Scala/Art Resource, NY.

New Caledonia between 1902 and 1921, he had struggled for years to understand Kanak concepts of the sacred in order to render Christian terms into vernacular idioms more truthfully. Mauss made sure that the Institut d'Ethnologie published Leenhardt's linguistic and other ethnographic materials upon the latter's return to Paris in the early 1920s.[100]

Careful fieldwork conducted alone or in pairs, of course, did not a Maussian make—even among the small number of those most serious about ethnology at the Institut d'Ethnologie. Paulme, Leenhardt, and Le Coeur's particular exploration of primitive economics, along the lines that Malinowski's work on the kula trade in the South Pacific had opened up and that Mauss had drawn on in *The Gift*, also marked them as Mauss's disciples. Leenhardt, in the first part of his two-volume New Caledonian ethnography, *Gens de la Grande Terre*, which was published after close to fifteen years of involvement

[100] Clifford, *Person and Myth*, 161. Maurice Leenhardt, *Notes d'ethnologie néo-calédonienne* (Paris, 1930); Leenhardt, *Documents néo-calédoniens* (Paris, 1932); and Leenhardt, *Vocabulaire et grammaire de langue houailou* (Paris, 1935).

in Mauss's seminars, devoted several sections to the symbolic dimensions of monetary exchanges that in the West were becoming more impersonal transactions. In reference to traditional Kanak notions of money, for example, Leenhardt noted that it was the "vine of the social tie" and "symbol of life." Its exchange bound clans allied through marriage, and eliminated occasions for disputes; in no way was it comparable to "our notion of money . . . with its fixed fee equivalent to an injury or a privilege." He then provided a table illustrating the three most common "modes of exchange or of unilateral giving" and their prescribed usage. In each case the exchange/gift occurred in order to restore balance among the interested parties, and as such "money" was imbued with life itself.[101]

Paulme, in contrast, emphasized that Dogon economic arrangements were similar to and different from earlier Western ones. She opened her study of the Dogon by quoting a seventeenth-century treatise on customs in rural France, because in both places one found exactly the same kind of community, whose members "through fraternity, friendship, and economic liaison" formed "a single body." But she then pointed out that Dogon economic life represented one adaptation among many possible ones to the milieu, and that while it was "not necessarily the most efficient" one, it was ingenious in meeting the many needs—subsistence and social—of its members. The Dogon were largely self-sufficient in food production, used fertilizers, and had a deep knowledge of local botany reflected in their rich vocabulary. Both liberal economists such as Karl Bucher and antiliberal ones such as Charles Gide, who had long argued that premodern peoples failed to plan ahead, were wrong in the case of the Dogon.[102] And they and Durkheim were wrong as well about an absence of any division of labor in archaic societies, beyond a sexual one.[103] According to past European observers, each household supposedly met all its own economic needs, thanks to a gendering of the tasks necessary to survival. But Paulme found no evidence that any such closed economy had ever existed. In a Dogon village, every member became the de facto expert at something on which the community depended—tailoring, making millet beer, remembering genealogies—proving that a certain level

[101] Leenhardt, *Gens de la Grande Terre*, 124–25, 126–30.

[102] Paulme, *Organisation sociale des Dogons*, 87, 131, 149.

[103] Ibid., 169. Paulme was referring to Durkheim's notion that there were two types of solidarity: mechanic and organic. "Tribal" solidarity was mechanic, based on shared beliefs and sentiments and on uniformity. Organic solidarity was based on differentiation, that is to say a "functional interdependence in the division of labour. . . . The growth of organic solidarity and the expansion of the division of labour are hence associated with increasing individualism." Anthony Giddens, *Capitalism and Social Modern Theory: An Analysis of the Writings of Marx, Durkheim, and Max Weber* (Cambridge, 1971), 77.

of individualism had been achieved, perhaps even a form of it that was superior to that of the West. As she put it, "Personal interest, understood as the desire to realize the maximum profit with the least amount of effort, is not the only force that pushes man to work. . . . Each individual is motivated . . . by the desire for the well-being, the wealth, and the prestige of the entire community."[104] Paulme concluded her five-hundred-plus-page ethnography with a plea to see the Dogon as they really were, neither prisoners of arrested traditions nor the "good savages" of Rousseau's imagination, but as individuals embedded in a socioeconomic system one of whose fundamental principles was "reciprocity."[105] Absent a modern market economy, the community could survive only through mutual support; individuals, however, happily met their social obligations because of the prestige that could accrue to them if they did their job well. Meanwhile, there was room for members to live as they liked as long as they did not break certain rules.

Charles Le Coeur's eclectic thesis, published in 1939 under the title *Le rite et l'outil. Essai sur le rationalisme social et le pluralisme des civilisations,* was a different kind of monograph from either Leenhardt's or Paulme's. Its first part combined preliminary versions of ethnographies of a small Moroccan city, Azemmour—from which many of his middle-class Muslim students came—and of the austere Téda herders in the Tibesti Mountains. The second part was not ethnographic at all. Here Le Coeur offered critical readings of several classical theorists of political economy, including Smith, Sismondi, Marx, Proudhon, and Simiand—an echo in part of his experiences as a Christian leftist involved in the neo-Socialist debates of the late 1920s and 1930s.[106] A third, concluding part mixed poetry with reflections on the Moroccan protectorate under Marshal Hubert Lyautey (resident-general, 1912–25). A member of one of the Third Republic's leading Protestant political families— his maternal grandfather was Jules Steeg, and his uncle Théodore Steeg was a former governor-general of Algeria and a former resident-general of Morocco—and a self-professed Durkheimian who also refused to apply himself single-mindedly to finishing his doctorate, Le Coeur was perhaps Mauss's favorite student. Mauss's one visit to a field site in 1930 had been to Morocco to see Le Coeur, whose unorthodox but always meticulously executed studies were not easy to classify. He shared Mauss's wide-ranging curiosity, including

[104] Paulme, *Organisation sociale des Dogons*, 194.

[105] Ibid., 559–61.

[106] Jean-Francois Sirinelli, *Génération intellectuelle. Khâgneux et normaliens dans l'entre-deux-guerres* (Paris, 1988); Le Coeur published three articles in the dissident newspaper *L'Homme Nouveau,* founded in 1934 to reform socialism in France by creating a new elite and stronger state: "Le plan de réformes du nationalisme jeune-marocain," 1 Oct. 1935; "La révolution de Lyautey," 1 Nov. 1935; and "Socialistes humanistes," 1 Oct. 1936.

his teacher's interest in material forms, and was one of the few to criticize Montandon's cultural essentialism in print.[107] When Le Coeur finally began cobbling together his doctoral thesis in 1937, Mauss wrote him worried letters that Soustelle and Griaule were finishing their theses first and risked shutting him out of the rare job that might materialize, despite, Mauss intimated, Le Coeur's greater talents. Perhaps, he continued, Le Coeur could inherit his chair at the École Pratique.[108]

Like Paulme, Le Coeur showed great interest in the different balance of economic and symbolic exchanges that obtained in archaic societies as compared to advanced industrialized societies, although his approach was more theoretical and literary. He began his thesis by criticizing the nineteenth-century rationalist tradition, especially the Marxist one, of measuring a given people's worth in terms of their level of technological achievement (or lack of it) alone. Survival required all human groups to develop certain basic "tools," but Le Coeur rejected the notion that any society was the pure reflection of its material base. "Ten years in Africa" had taught him that while *homo faber* was universal, so too was *homo vates*, man the poet, and that the two were always conjoined. In addition to "tools," every human group invented—and invented differently—specific symbols, gestures, and rites that bound the individual to the collective. In Le Coeur's words, "Nature's limits lead man to fashion tools that extend his power over things; society's limits lead him to fashion rites that make his 'self' [*leur moi*] vibrate more deeply."[109] The 6,500 Téda seminomads in the remote Tibesti Mountains confounded French administrators because they stubbornly persisted in eking out a punishing existence that left them hungry half the year, when plentiful land nearby offered them an easier life. What these administrators failed to see was that the Téda lifestyle was a creative choice freely taken, with rich rewards for its most successful members. Securing sufficient foodstuffs to survive in a harsh environment required sophisticated technical knowledge that the Téda had patiently acquired, and they traded as well with other groups beyond their mountain community. But they had also constructed an elaborate food etiquette to regulate how

[107] In 1937, Le Coeur noted that Montandon in *L'ologénèse culturelle* reduced "a complex and original fact to something vague, 'primitive' and eternal, which eludes critical assessment because on principle he defines it outside of time and civilization." Charles Le Coeur, "Les 'Mapalia' Numides et leur survivance au Sahara," reprinted in *Gens du roc*, 221.

[108] Mauss went to Morocco to give a course at the Institut des Hautes Études Marocaines, and to advise the resident-general on how to organize the protectorate's ethnographic services; he would also bring back Le Coeur's École Pratique thesis for publication. IMEC/Fonds Marcel Mauss/MAS 21.30/Marcel Mauss à M. le Président [IVe Section, École Pratique], 9 July 1931. For Mauss's career advice to Le Coeur, see IMEC/Fonds Marcel Mauss/MAS 19/Marcel Mauss à Charles Le Coeur, 8 Feb. 1937 and 1 March 1937. Le Coeur's letters to Mauss are not in Mauss's archives.

[109] Le Coeur, *Le rite et l'outil*, 15.

much food was consumed at any given moment of the year, and that bestowed honor in proportion to how generously any given member respected it. The lesson for Le Coeur was not that the Téda were prelogical (i.e., irrational) "primitives" too "culture-bound" to "progress" to "more rational" forms of economic organization. Rather they constituted a magnificent example of a human group valuing honor and cooperation over material comfort and the single-minded pursuit of self-interest. With the need for more money under colonialism, however, the Téda risked becoming the "primitives" of the colonizer's imagination: that is to say, economically and socially, elements of their civilization were turning parasitic—the opposite "evolution" posited by the "laws of progress."[110]

As Le Coeur's reference above to the Téda "self" suggests, embedded in all of Mauss's students' examination of the nature of exchanges was another investigation: that of the construction of the "person" in relation to the larger whole in each of the societies they were studying. Paulme was particularly interested in what she called "social rule and the individual" in Dogon society.[111] On the one hand, she wrote, "the need to provide an assigned place to every member of the society is so extreme that it is very difficult for an inhabitant of this region to enter into a relationship with someone not already located in the cadre of social relations." On the other hand, no individual was confused with another, and "each found a way to express his or her personality," and this was as true for women as for men. One of the most innovative parts of Paulme's work was her detailed attention to "the condition of women," in which women emerged as persons in their own right, rather than being cast in the Amazon/slave dyad that had prevailed in centuries of travel literature. While deprived in theory of a public role, the Dogon married women, she argued, enjoyed full property rights, and the concessions that husbands and wives made to each other demonstrated that sex roles were complementary rather than hierarchical.[112]

Maupoil noted how the development of Fa before the arrival of the French had represented a movement toward a more individualized personhood: "Mythology raised itself to the conception of a personal divinity, and this evolution coincided with a relaxing of social constraint." Initiation into the Fa cult constituted for its priests "a way to acquire not only dignity, a respect of self, but also a certain responsibility. . . . Above and beyond the religious content, the initiate achieves a security, a new force, the sentiment of his unity before

[110] Ibid., 43, 51. See also his radio conference on the Tibesti, AMH/2 AM 1 C8/Radio Conférences PTT, 28 May 1935.
[111] This was the title of her final chapter. Paulme, *Organisation sociale des Dogons*.
[112] Paulme, *Organisation sociale des Dogons*, 69, 558, 569, 239–61.

the changing multiplicity of circumstances."[113] Understanding the interplay of self and society in Azemmour society was likewise a part of Le Coeur's Moroccan ethnography; there "a festival was a sort of 'living tableau,' where each personage acquired meaning only relative to the whole. This solidarity made it difficult for each to avoid the gesture that custom imposed. . . . Even the apparently most individual of attitudes was caught up in this reciprocity." Yet, for Le Coeur as for Paulme, there was always room for individual invention, because a gesture never had the exact same meaning twice in the constant movement that characterized all societies. The job of the sociologist was to understand, through close observation of a single milieu, the ways in which social constraint and individual invention, in Le Coeur's phrase, "concretely adjusted to each other."[114]

In Mauss's circle, however, no one devoted himself more intensively to a study of personhood than Maurice Leenhardt, to the point where it is difficult to know which of the two men (only six years apart in age) influenced the other more. This is not the place to review the immense literature on Leenhardt, who always sought to understand the authentic world of Melanesians—to think like a Kanak—in order better to convert them to Protestantism.[115] His evangelicalism did not prevent him from producing some of the most original data ever on a Melanesian society, and in dialogue with Mauss, Leenhardt, too, came to focus on the ways in which Kanak "personhood" was experienced—albeit in a slightly different way than Paulme, Maupoil, and Le Coeur. Perhaps because Leenhardt believed that the "self" in the Western individualist sense could be achieved only through conversion, he rarely emphasized the room that existed for individual invention in traditional society in the way that Mauss's other students did. In other respects, however, Leenhardt's Kanak "person" was a Maussian one—that is, one constructed through a set of socially determined exchanges with other members of the community. According to Leenhardt, Kanak personhood always involved exchanges not only among the living, but also and simultaneously between the living and the dead. The traditional Kanak, he argued, lived in two times, real and mythic, slipping between the two "with a facility that disconcerts us, because we see two opposing worlds where the Kanaks see only one with two complementary aspects."[116] In this sociomythic landscape, as James Clifford has termed it, the

[113] Maupoil, *La géomancie*, 677, 679.
[114] Le Coeur, *Le rite et l'outil*, 13–14, 34.
[115] For an overview of the many debates Leenhardt's work has generated among anthropologists, see Jeremy Maclancy, "Will the Real Maurice Leenhardt Stand Up?" in Parkin and de Sales, *Out of the Study*, 255–72. On Leenhardt's long eclipse in France, see Jean Jamin, "De l'identité à la différence. La personne colonisée," *Journal de la Société des Océanistes* 58–59:34 (1978): 51–56.
[116] Leenhardt, *Gens de la Grande Terre*, 47.

individual grasped his existence only through relations with others, both visible and invisible—his father, his uncle, his wife, his cross-cousin, his clan, his totem, and so on. To Leenhardt's credit, although he hoped to transform this mode of being in the world, he also accepted that the archaic Kanak "personage" was a viable model of existence from whom the modern Christian might learn.[117] As he asked rhetorically in 1937, is it possible "that the person—the human being living in respiratory exchange with the atmosphere—cannot exist, cannot live, except by communal exchange?"[118]

Leenhardt, like Le Coeur, derived the distinction between "personage" and "person" from Mauss. But whereas Mauss had traced out in essentially positive terms the development over several millennia of a Western "sacred self," Leenhardt, observing the disintegration of New Caledonian society under the onslaught of colonialism, harbored growing doubts: perhaps European-style individualism was more prison than emancipation, since it cut the person off "from occasions of intense affective communion" and left him only "quasi rational modes of controlling the world."[119] As we have already seen with Le Coeur, Leenhardt was hardly alone among Mauss's students in raising questions about the changes that were occurring under their eyes in most of their field sites. Traces of the empire also erupted in each of the ethnologists' works discussed so far, in ways that echoed their teacher's exhortation to grasp societies not in some frozen state but as living entities. As rendered in the ethnographies of Le Coeur, Paulme, Maupoil, and Leenhardt, and the field reports Tillion filed for her funding agency in London, an exploitative empire was transforming once socially thick "personages" into impoverished subjects, rather than the "sacred person" of the Rights of Man.

THE COLONIAL ENCOUNTER: A FAILED EXCHANGE?

In a letter dated 19 April 1937, Mauss cautioned Bernard Maupoil, who was reworking the first draft of his thesis, against including any part of his "negative views on colonization, and especially capitalist colonization. This can only diminish the scientific value of your work." There were plenty of places outside a thesis where he could publish his opinions. Naturally, Mauss concluded, he did not in any way oppose in principle Maupoil's ideas, "but a certain discretion" was necessary.[120] Since the arrival of the Popular Front in

[117] Clifford, *Person and Myth*, 184–85.
[118] Quoted in Clifford, *Person and Myth*, 186.
[119] Quoted in Clifford, *Person and Myth*, 187.
[120] IMEC/Fonds Marcel Mauss/MAS 20/Marcel Mauss à Bernard Maupoil, 19 April 1937.

power, Maupoil had regularly shared with Mauss information that he hoped would discredit the Office du Niger—a hugely expensive irrigation scheme on the Niger River to grow cotton.[121] The Office had been created in 1932 and financed with public revenues raised locally, but five years later had little to show for the "investment," despite consistent recourse to forced labor. In 1938, in contrast, Mauss wrote to Le Coeur that he approved the latter's final thesis chapter, essentially a paean to Lyautey's protectorate policies. An earlier version of the chapter had appeared in 1935 in Marcel Déat's neo-Socialist journal, *L'Homme Nouveau*.[122] Mauss's two responses were less contradictory than it would appear, as were Maupoil and Le Coeur's respective reactions to colonialism. Mauss insisted that in their published ethnographies his students had to remain scientific; but he also allowed them to experiment in what after all was a new kind of sociological analysis and writing, especially about a "colonial situation" that was itself varied.

The responses of Paulme, Maupoil, Leenhardt, Le Coeur, and Tillion to the effects of French colonialism reflected their personalities and professional status, length of time in the empire, and the degree of colonial exploitation among the particular people they were studying, but in no case ignored recent history. Denise Paulme, the only full-time student, with just seven months of fieldwork in a recently colonized part of sub-Saharan Africa, recorded in the most neutral tones what had changed among the Dogon since the arrival of Europeans: "The spirit of solidarity and mutual aid, previously well developed, has weakened in the last thirty years, if we are to believe the information that we have gathered in areas fairly far removed from each other"; the reason, she noted, that onions were now being grown in addition to traditional foodstuffs was to procure the money needed for the annual head tax owed the French administration. The influx of cash had introduced another change: young people were more independent and less apt to submit to parental authority. A one-room school for boys with a Dogon teacher who taught a European curriculum in French had been built, although it was not serving much use. The schoolteacher, a convert to Islam who had spent years studying elsewhere, treated his students as "savages." European intervention had modified male dance societies, curtailing their political role and transforming them into pure "spectacle." Ordered by the administration now to perform for visiting dignitaries, dancers were "seeking to perfect their choreographic exploits independently of any esoteric meaning." Dancing, she concluded, had become an end in itself.[123]

[121] IMEC/Fonds Marcel Mauss/MAS 8.83/Bernard Maupoil à Marcel Mauss, n.d. [dimanche soir, 1936], 29 Oct. 1936, 3 Dec. 1936, 13 March 1938, 25 April 1938, 10 July 1938, and 23 Aug. 1938.
[122] IMEC/Fonds Marcel Mauss/MAS 19/Marcel Mauss à Charles Le Coeur, 21 June 1938.
[123] Paulme, *Organisation sociale des Dogons*, 114, 145, 484–85, 258.

Bernard Maupoil's remarks about colonialism in his thesis were mostly confined to his introduction and conclusion, but their content was consistent with what he had written elsewhere. He noted that "since the European occupation, there had been a considerable evolution"—that is, degeneration—of the cult of Fa in Dahomey, which had become "a caricature of itself." Colonialism had cut off the priests from "the current of related civilizations," without whose contact the cult "vegetated." Under the assaults of missionaries, the cult was transforming into black magic, which represented a further loss of social cohesion and of self. *Bokonon*, the traditional diviners, had intervened in family disputes, to "assure the homogeneity of behaviors in the face of the unknowable," and to preserve the indispensable equilibrium of the larger social group confronted with life's vicissitudes. *Bokonon* and their clients alike, through a mastery of the requisite signs and their interpretation, had granted individuals "the illusion of exerting some control over their own destiny." Maupoil hoped that a little more human comprehension would attenuate the sectarianism he was witnessing. "If we do not grasp better the motives that cause so-called primitives to act or think, he added, "it is because we rarely make the effort to ask for explanation, and because they themselves, for reasons that are entirely understandable, do not take the initiative to confide them to us."[124] This Western incomprehension, coming historically in the wake of the slave trade, alcoholism, war, and collective disasters, could only accelerate the ruin of institutions already under siege.

That Maupoil, however, had made the effort to listen to his subjects despite his colonial location became clear in his self-reflexive conclusion. Ethnographic studies, he acknowledged, were now the vogue in European and colonial capitals, and blacks were "being given back" on paper civilizations wasted by white "civilizers." Too often this ethnographic impulse to restore and preserve the African past was just "another way of halting evolution." As if to underscore his role as objective observer rather than colonial preserver, Maupoil insisted that the cult of Fa in Bas Dahomey would continue to evolve: "Fa is surviving itself. The conquest precipitated its destiny and when the last of the old Bokono are gone . . . it will surely undergo other strange metamorphoses."[125] Many blacks, he added, were aware of the political ends of colonial ethnography and thus found scientific investigations humiliating. "May they know," he concluded, "that my contribution is designed only to advance research in Africa, and to devote myself to the study of civilizations as worthy as any other ones of being known."[126] Maupoil's claim to be advancing

[124] Maupoil, *La géomancie*, xiii, 679, 678, 677, 680.
[125] Ibid., xiii. See also 679.
[126] Maupoil, *La géomancie*, 681.

research in Africa was well founded. In his work on geomancy he had—before anyone else in France—decided to study contemporary practices of voodoo in the Caribbean and Brazil for the light they could shed on the disappearing religious and cultural patterns in Dahomey. He had then become a champion not only of the works of the Boasian anthropologist Melville Herskovits on the same subject, but of the pioneering black Haitian ethnographer who was also a student of Mauss, Suzanne Comhaire-Sylvain, encouraging others interested in West Africa to consult both authors.[127] In 1940, Maupoil recommended sending an ethnographic mission "of blacks and whites" to Haiti, Guyana, Cuba, and Brazil so that they might "as a single team, . . . [and as] equals in their work, affirm their contempt for race prejudice" in the spaces once dominated by slavers.[128] Here it is useful to remember that it was Bernard Maupoil who in 1937 had encouraged Alexandre P. Adandé—the graduate of the William Ponty School assigned as secretary to the Institut Français de l'Afrique Noire whom we encountered in chapter 5—to write to Rivet and Mauss about the need to offer the same ethnographic training in Dakar as in Paris.[129]

Tillion and especially Leenhardt discussed colonialism more directly, not surprisingly given that Tillion was required by her fellowship to report on its effects, and that Leenhardt was a missionary. Tillion, in early 1937 after several years in Algeria, wrote in a confidential report to Rivet that the southern part of the Aurès was one of the most backward regions with two characteristics: "the permanence of tradition [and], very surprisingly, a sensitivity to [the] events and movements that appear to be the furthest away, which might seem to be in contradiction with the first tendency." There were women who had never seen a white person, yet shepherds who "followed with interest the events of the Italian-Ethiopian conflict." In the north, in contrast, there were major changes, "so much so that I wonder if the first impression which strikes us, that of the permanence of the past, is not illusory, does not simply come from our European gaze." Politically speaking, she noted that the locals were now resigned to the French, since they could not escape them, but also that the French were sometimes a source of benefits. Algerians, for example, used

[127] Bernard Maupoil, "De Haïti au Dahomey," *Bulletin de l'Institut Français de l'Afrique Noire* 2:3–4 (1940): 423–30. Comhaire-Sylvain had published a landmark volume, *Contes Haïtiens*, in 1937.

[128] Bernard Maupoil, "Ethnographie comparée. Le culte du Vaudou," *Outre-Mer. Revue Générale de Colonisation* 9:3 (1937): 205.

[129] Tellingly, the two had first met when Maupoil criticized Dahomean students at Ponty for producing plays that did not accurately reflect their own history, and challenging them to do better; hence Adandé's letter to Mauss. Bernard Maupoil, "Le théâtre dahoméen," *Outre-Mer. Revue Générale de Colonisation* 9:4 (1937): 301–21. Adandé's response to Maupoil's review is published at the end of the article, 318–21.

French schools readily when provided with road access. There was, however, a "possible divorce" in the making between religious purists and young parliamentarians on the one hand, and the new Muslim elite on the other. "For the moment the masses are docile," Tillion noted, but with characteristic lucidity she wondered if "indigenous life is not in full and relatively rapid evolution, meeting with almost no resistance."[130]

In Maurice Leenhardt's ethnography, the fruit of over fifteen years of cohabitation with the Kanaks and another fifteen years of working with Mauss, the tone was set on the first page: colonization, he wrote, was threatening to annihilate Kanak society when he and his wife had first arrived in 1902; in the end, however, they had come to understand that these people wished "to live. We observed them in order to know them." The pages that followed reconstructed the deep past and chronicled colonial spoliation. Leenhardt noted the destruction of traditional terrace planting and irrigation by "the bovine invasion sustained by the power of the whites"; "the civilized are in the process of transforming a country that the savages had wonderfully irrigated into one that is drying up." In the process, "an inestimable source of cultural data is disappearing"; traditional Kanaks were the rare people who had thrived without any recourse to stimulants, until the introduction of imported alcohol and coffee, which the native now grew and abused. Kanaks used to value the dignity of work well done, he continued, but they were working less and less. The great effort required by colonization incited the young to relax at home; commercialized products were destroying the advantages of artisanal ones, and old techniques were disappearing. For example, the traditional festival known as the *pilou*—"the culminating social moment" of Kanak life—had become too burdensome to maintain under the conditions of colonial immiseration; and with the death of the *pilou*, society itself was disaggregating. Meanwhile colonial authorities were ordering *pilous* on demand during official tours of duty, not realizing that they were seeing the "pale caricature" of the real thing.[131]

Not everything was bleak. Kanak creative capacity was far from depleted, and when conditions were peaceable, "new and superb motifs" were appearing among the elite. Leenhardt himself had seen a statue of a man, and another of a woman holding a child, flanking the doorway of a modern home. These works were fragile signs of renewal, demonstrating that a few individuals were choosing to preserve the old aesthetic while adapting to European tastes. The Kanak of today was thus neither a neophyte Christian nor the

[130] AMH/2 AP 1 B7/Institut International pour l'étude des langues et civilisations africaines/ "Seventh Report on Fieldwork," Mlle. G. Tillion, confidential, Received January 1937.
[131] Leenhardt, *Gens de la Grande Terre,* 1, 17, 61, 63, 88, 170.

dreaded semicivilized (*demi-civilisé*) of colonialist discourse. And as Leen-hardt approached the end of his ethnography, his optimism only increased. Some Kanaks were beginning to distinguish an individual self (person) sep-arate from myth and the body social. This separation, however traumatic, was necessary, because it represented an attempt to rebuild the spirit on a new—that is, Christian basis. Old Caledonia, closed in on itself for millennia, had already begun to degenerate by the nineteenth century. This decadence was hardly surprising: no society could survive without replenishment from outside, which typically took the form of immigration or conquest by close neighbors. The Kanaks had experienced neither. Instead, Europeans with their entirely foreign values had appeared suddenly and brutally, shocking Kanaks in ways before unimaginable. Not surprisingly, many had reacted by clinging to the old ways; others, however, were now beginning to choose in-tegration into the modern world, despite the resistance of the settlers and the colonial administration. In his final pages, Leenhardt made clear that white greed was the single greatest barrier to Kanak renewal on their own terms. In the face of this evolving situation, Leenhardt concluded, the science of ob-serving the human was more relevant than ever.[132]

Leenhardt's work was not technically a thesis, which helps explains his lack of discretion when assessing colonialism's record; he had himself tangled more than once with colonial officialdom in defense of individual Kanaks. Charles Le Coeur's ethnography, especially in the last two sections devoted to Mo-rocco in the 1920s, struck a different note: for him, the recent social fact of the protectorate (created only in 1912) provided the very model of a successful encounter in the Maussian sense, thanks to Resident-General Lyautey's con-scious effort to break with the abusive practices of pre–World War I colonial-ism. At the same time, Le Coeur stressed the continuing need for the French to develop more humane relations with Moroccans—and what would happen if they failed to do so. These views were presented in two different sections of Le Coeur's eclectic thesis. In one section, devoted to the protectorate era, he elab-orated a finely grained ethnography of the Moroccan city of Azemmour un-der colonialism; then in his conclusion, Le Coeur reprinted a piece of prewar political journalism that drew on his sociological findings to praise Lyautey.

While initially jarring, this last section is best understood as of a piece with the earlier section. Together, they represent a highly original synthesis of what Le Coeur had learned not only from Mauss but also from his year studying with Malinowski. Malinowski, to a greater extent than Mauss—and speaking perhaps as the field-worker that he was and that Mauss was not—emphasized

[132] Ibid., 109, 120, 204–5, 209.

the need for the "true scientist of humanity" to not simply accept social diversity, but to *love* this diversity and, better yet, learn from it. Malinowski had put it this way in the conclusion of *Argonauts of the Western Pacific:*

> It is in the love of the final synthesis, achieved by the assimilation and comprehension of all the items of a culture and still more in the love of the variety and independence of the various cultures that lies the test of the real worker in the true Science of Man. There is, however, one point of view deeper yet and more important than the love of tasting of the variety of human modes of life, and that is the desire to turn such knowledge into wisdom. Though it may be given to us for a moment to enter into the soul of a savage and through his eyes to look at the outer world and feel ourselves what it must feel to *him* to be himself—yet our final goal is to enrich and deepen our own world's vision, to understand our own nature and to make it finer, intellectually and artistically.... Nor has civilised humanity ever needed such tolerance more than now, when prejudice, ill will and vindictiveness are dividing each European nation from another, when all the ideals, cherished and proclaimed as the highest achievements of civilisation, science, and religion, have been thrown to the winds. The Science of Man, in its most refined and deepest version should lead us to such knowledge and to tolerance and generosity, based on the understanding of other men's point of view.[133]

Le Coeur took Malinowski's admonition seriously.

In his rich first ethnographic section on Morocco, Le Coeur first assessed the economic and social changes that had affected the approximately 7,745 dwellers of Azemmour and its environs, some thirty miles southwest of Casablanca, since the French occupation. Azemmour's inhabitants, unlike the Téda, did not have a sense of forming an original whole; they knew themselves to be part of larger ensembles: Morocco, Islam, Arab civilization. With the abrupt intrusion of capitalism in the form of imperial power, farmers, artisans, women, shopkeepers, commercial and landed bourgeois, civil servants educated by the French, and a swelling floating populace had all lost ground. European political economists, he noted, had observed similar dislocations in their own society's more gradual transition from a rural economy to a mercantile and bureaucratized one. Independently of Azemmour's economic structures, two civilizations—a thousand-year-old Fassi one for the landlords, merchants, and civil servants, and an even-older agrarian and tribal one for the common people—patterned daily life.[134] Le Coeur concluded with

[133] Malinowski, *Argonauts*, 517–18.
[134] Le Coeur, *Le rite et l'outil*, 57–126.

several policy recommendations. The French should restock the river with fish, extend low-interest loans to farmers and more generous contracts for sharecroppers, secure a minimum wage for workers, and expand the number of schools, since the French and the Moroccan bourgeoisie were now ruling Morocco. The Azemmour elite had to be of its time, or else renounce any ambition for the future and risk being looked down on by those in Fez and Paris. But the French in return had to start teaching Arabic in all of their establishments. In short, the protectorate authorities should adopt a flexible, pluralist understanding of all the interests in Azemmour, from the inside—a policy Le Coeur argued that Marshal Lyautey, Morocco's resident-general from 1912 to 1925, had already inaugurated.[135]

Lyautey, Le Coeur noted in the final, more lyrical section of his thesis, had been no less a revolutionary than Peter the Great, Stalin, or Hitler, and the only one of the four who had built rather than destroyed.[136] On the one hand, he had endowed French Morocco with a modern economy: Casablanca had been transformed in ten years into one of Africa's greatest ports, and its rich phosphate deposits nationalized. But Lyautey had also been a partisan of more ancient forms of civilization, and his modernization had been accompanied by a resurrection of the Moroccan past; more Socialist than the republicans economically, politically Lyautey had rediscovered his royalist roots and made the sultan and the makhzen an essential part of the constitution. This was, in Le Coeur's view, a policy driven not by rational calculation alone, but by "love." All civilized elements in Morocco, he claimed, were breathing this new air; and "as long as the humblest Moroccan, Arab, French, Berber, Jew, and Spaniard keeps alive the flame that pushes each man to love in another that which is most personal, that which makes him 'him' and not some other," he would be preserved from the ravages of nationalism or, worse still, a leveling internationalism that appealed to some faraway "brother" to crush the "foreigner" at home.[137]

While it is tempting to dismiss Le Coeur's reference to "a new air" in Morocco as naive, this final section of his thesis is perhaps best understood as an experiment in using his field encounter to acquire the "wisdom" that Mauss and Malinowski had spoken of—one that might help make sense of the terrifying world of the 1930s in which French ethnologists found themselves. By his own admission, Le Coeur had been an anticolonialist during his student years; becoming a teacher and ethnographer in Africa, however, had transformed his understanding of politics and science, and their relationship to

[135] Ibid., 126–31.
[136] Ibid., 242.
[137] Ibid., 245.

each other. Arriving in 1920s Rabat, he discovered not only the people of Azemmour and the Téda but the urbane, modern nationalism of the Jeune-Marocain Party—whose members spoke (unacceptably in Le Coeur's estimation) of Morocco cleansed of French.[138] One of the primary lessons of the field, Le Coeur noted, was how much time and generosity of spirit were required to learn to value the different social worlds of others, but also how rich the rewards could be.[139] This discovery provided Le Coeur with new insights into the dangers of a politics derived only from "science," whether these politics were Fascist, Communist, imperialist, or nationalist. Stalin and Hitler had already turned to science to justify homogenizing the world in the name of racial or class purity. By comparison, Lyautey's colonial experiment appeared "progressive," premised as it was not on pure scientism, but on an ostensible "love" of Morocco's many communities.

Le Coeur, in "experimenting" with his ethnographic material, of course had his blind spots: the protectorate by the 1930s had made no political concessions to the Moroccan elite, and he knew that most of the local white settlers were not heeding the call to try to love the other—"the more one is an indigenophile (to use that hideous word)," he wrote hopefully to his fellow citizens, "the more one pushes back [Moroccan] nationalism."[140] Yet he also used his training to argue that the colonial shock and the money economy had been the two "cruel and fertile" revolutions of the modern era (the other revolutions, he claimed, had been only cruel).[141] If the "cruel" intrusion of colonial capitalism was evident in Azemmour's balance sheet, its "fertility" in Morocco was not limited to the building of infrastructure. The encounter had made possible Le Coeur's personal "revolution" and Lyautey's political one. Both he and Lyautey had escaped the "eternal contradiction of the colonizer": that of superficially exalting colonial difference, only to Europeanize wherever they went.[142] The lesson was clear for the rest of the empire: French authorities had either to learn genuinely to value the different social choices of each people they colonized, or to continue to destroy everything they touched.

Genealogies of modern French sociocultural anthropology usually wax eloquent about the theoretical breakthroughs of Durkheim and Lévi-Strauss but have considerably less to say about Mauss beyond evoking his landmark essay *The Gift*. Yet the same story can be told quite differently. No human science

[138] Le Coeur, "Le plan de réformes."
[139] Le Coeur, *Le rite et l'outil*, 3–4, 131.
[140] Le Coeur, "Le plan de réformes."
[141] Le Coeur, *Le rite et l'outil*, 245.
[142] Ibid., 236.

develops in isolation, and a particular corpus is always in part the reflection of the distinctive historical moment in which it is produced. After almost a century of industrialization and class conflict, Durkheim with others had been driven to formulate a science that would address the disintegration of society; a half century later, the amplified horrors of the Second World War and genocide would impel a generation of postwar humanists to insist on what all humanity shared. World War I and its aftermath, in contrast, were unsettled and unsettling in every sense for the newer human sciences, and especially for ethnology. What, ethnologists had to ask themselves, were the questions they were seeking to answer? What were the boundaries of their field of investigation? For an innovator like Mauss, attempting to decenter the sociology that his uncle had invented, this meant reconceptualizing an entire discipline. Gifted teacher that he was, he soon involved his students in defining the purpose, methods, and aim of this new science in ways that recalled his own collaborative experience at the prewar *Année Sociologique*.

Given the exploratory nature of the enterprise in its early days, it was hardly surprising that Mauss gave his students an eclectic array of topics to investigate; but he also provided them with an intellectual framework and a method for making sense of the diversity that fascinated them, in which a consideration of race was largely irrelevant. A "Maussian" ethnographer always sought "the whole person in society as a whole"—and this key insight into the role played by symbolic and economic exchanges in every human society helped render the other "familiar," and often admirable in his or her difference from a Western utilitarian individualism run amok, of which classism and racism were by-products.[143] And while ethnology in its formative years did not limit itself to the French empire, the students examined in this chapter discovered the failed exchange that colonialism represented, and anticipated the postcolonial dilemma: how to acquire, in the words of anthropologist Tim Ingold, "a generous, comparative but nevertheless critical understanding of human being and knowing in the one world we all inhabit."[144] In the short term, however, the shock of national defeat was about to pose a very different kind of challenge to how this generation understood the role of reciprocity in any community's moral survival.

[143] Hart, "Marcel Mauss," 3.

[144] Tim Ingold, "Anthropology Is *Not* Ethnography," *Proceedings of the British Academy* 154 (2008): 69.

CHAPTER 7

ETHNOLOGISTS AT WAR

Vichy and the Race Question

Trustworthy sources confirm the recent press reports of the execution by the Germans in April, 1942, of two young French anthropologists, Alexander Levitzky [*sic*] and Vildé, both members of the staff of the Musée de l'Homme (former Musée d'Ethnographie du Trocadéro). Both were arrested in February, 1941, together with Yvonne Oddon, librarian of the museum. . . . Levitzky and Oddon belonged to the small group that . . . turned the antiquated and moth-eaten Trocadéro into the most modern and dynamic anthropological museum in the world. Americans who have carried out researches at the Trocadéro will certainly remember the tall young man who seemed to have in his mind the thousands of uncatalogued objects of the collections. All of us who worked there owe a debt of gratitude to André Levitzky's quiet and unfailing assistance. Because he had temporarily sacrificed his personal scientific ambitions to the enormous task of creating the Musée de l'Homme, few people realized that he was a brilliant student with an unusual knowledge of Siberian ethnology.

—ALFRED MÉTRAUX, *"Notes and News," American Anthropologist,*
 1942

In September 1939, France once again found itself at war. When the horrors of the defeat and Occupation began to recede five years later, the ideas and institutions—and indeed the makeup—of the nation's small community of ethnologists emerged fundamentally changed. The Nazi state throughout Europe politicized the science of man to an unprecedented degree, yoking it to its own murderous ends in ways that had been unthinkable a decade earlier. Vichy, through its collaboration with Hitler, accepted and participated in this process. It not only sent countless Jews to their death but also created France's first university chair in ethnology, as well as more ephemeral ones

in Judaism and the anthropology of races. During these same years, several young ethnologists died defending their country, while others were lost to the discipline because of new commitments awakened during the struggle against fascism. The experience of the war, in short, was a fracturing one for a group of individuals who had up until then believed that they could and should keep politics and science separate. By 1945, many had come to understand that there were times when they had a responsibility as ethnologists to mobilize politically against any misuse of the larger science of humanity.

Thanks to the pioneering work of Robert Paxton, the broad outlines of the French nation's collective ordeal between 1939 and 1944 are well known. In September 1939, France declared war on Germany in response to the Nazi invasion of Poland, only to wait nervously for months for the fighting to begin. When German forces struck in May 1940, more than eight million panicked civilians from Belgium, the north of France, and the Paris region fled before the lightning German advance; military defeat and the signing of a punitive armistice on 22 June ensued with stunning rapidity. As part of the armistice, France was divided into two main zones: a northern zone occupied by the Germans and a southern unoccupied zone. On 10 July a demoralized parliament voted (569–80) full powers to the World War I hero Marshal Philippe Pétain. Pétain immediately swept the deputies aside and replaced the Third Republic with a new authoritarian state located in the spa town of Vichy. The eighty-four-year-old Pétain also initiated a policy of official collaboration with the Germans, hoping to use the Occupation to launch a conservative National Revolution that would cleanse the nation, reform its institutions, and secure France's place in the New Europe that Hitler was building.[1]

The creation of Vichy soon meant professional, social, and civil death for all Jews and eventually, after 1942, nothing less than a death sentence for many foreign-born Jews in France. Vichy also targeted Freemasons, Socialists, and Communists and foreigners in general, holding these groups responsible for all the ills that supposedly plagued France under the Third Republic. Escalating xenophobic legislation had been passed throughout the fraught 1930s, but Vichy went a step further on 4 October 1940 when it promulgated France's first overtly anti-Semitic law, known as the Jewish Statute (Alibert Law), without German prompting. The statute defined anyone in France and

[1] Robert Paxton, *Vichy France: Old Guard and New Order, 1940–1944* (New York, 1972). Paxton was the first to show that Vichy was not an aberration, but a regime rooted in French traditions, and more particularly in the bitter political and intellectual divisions of the 1930s. See also Julian Jackson, *The Dark Years, 1940–1944* (Oxford, 2001); and Philippe Burrin, *France under the Germans: Collaboration and Compromise,* trans. Janet Lloyd (New York, 1996).

Algeria with three Jewish grandparents as Jewish and banned them from public functions.[2] Subsequent legislation would restrict their rights even further. In the course of the Occupation, over 75,000 Jews would be deported from France to German labor and death camps in the East; only some 5,000 ever returned.[3]

Confronted with the unprecedented catastrophe of defeat and Occupation, all French intellectuals faced agonizing choices that no historian can fully understand: resistance and its enormous risks; *attentisme* and accommodation to the new status quo, in all its shades of gray; or outright collaboration. These choices were particularly stark in Paris, where so many writers and scientists lived and worked and which, unlike Vichy, was directly ruled by the Germans during the first two years of the war.[4] Yet ethnologists as a scholarly community dedicated to the science of man faced unique circumstances, which complicated their options compared to those of other intellectuals. In 1940, a cluster of six extremely talented students—five of them working on Africa—had either recently defended or were about to defend their doctoral theses. All of them lacked academic prospects. The four who had finished included Jacques Soustelle and Marcel Griaule, who had defended in 1937 and 1938 respectively, and Charles Le Coeur and Denise Paulme, who defended in April and May 1940—that is to say, after war had been declared and France and Germany had mobilized, and on the verge of the German blitz.[5] Bernard Maupoil was still correcting his thesis proofs when mobilized in September 1939, while Germaine Tillion had returned from her Aurès field site in the midst of the debacle, exodus, and the government's collapse.

For these six and their colleagues also preparing dissertations at the Institut d'Ethnologie and Musée de l'Homme, the humiliation of the defeat and Occupation posed not only the personal dilemma of what attitude to take

[2] On legal exclusion in the 1930s, see Vicki Caron, *Uneasy Asylum: France and the Jewish Refugee Crisis, 1933–1942* (Stanford, CA, 1999); Fette, *Exclusions;* and Weil, *How To Be French,* chap. 3.

[3] Michael R. Marrus and Robert O. Paxton, *Vichy France and the Jews* (New York, 1981).

[4] As a generation of scholarship has demonstrated, the new Vichy state consisted of different factions that competed for influence among themselves and with the Germans. One of the most important divisions occurred between a zealous group of pro-Nazi French leaders in Paris and more traditional Catholic conservatives in Vichy. The first were most concerned with building the Fascist Europe of the future, and the second gave priority to preserving national sovereignty. Several nonconformist intellectuals from the 1930s, such as Marcel Déat and Robert Brasillach, were among the Paris collaborators—with active encouragement from the German ambassador in Paris, Otto Abetz. See Burrin, *France under the Germans,* chaps. 24–29; Karen Fiss, *Grand Illusion: The Third Reich, the Paris Exposition, and the Cultural Seduction of France* (Chicago, 2009), 192–205; Barbara Lambauer, *Otto Abetz et les Français, ou l'envers de la collaboration* (Paris, 2001); and Allan Mitchell, *Nazi Paris: The History of an Occupation, 1940–1944* (New York, 2008).

[5] AMH/IE/2 AM 2/A1/Procès-verbal du Conseil d'administration, 16 Dec. 1944. For Paulme's defense date, see AMH/2 AP 4 2B/2c/Denise Paulme-Schaeffner à Marcel Mauss, 26 May 1940; for Le Coeur's, see IMEC/Fonds Marcel Mauss/MAS 20/Marcel Mauss à Bernard Maupoil, 29 April 1940.

toward the Germans and Vichy.[6] It also created the professional dilemma of how best to protect the fledgling domain in which so many of them had invested years of their lives. As a strictly practical matter, the most important positions then extant in ethnology became available. Mauss as a Jew had to step down from his academic positions in sociological ethnology. Rivet as an ardent patriot reluctantly left the country in February 1941. On an ideological level, Vichy's anti-Semitism cleared the way for an institutionalization of racism, while both Vichy and the Resistance, for different reasons, were willing to promote ethnography that served the empire. Pétain believed that a France reinvigorated by its overseas empire would have a place in Hitler's New Europe, while the leader of the Free French, Charles de Gaulle, wished to carry on the fight against the Nazis from the colonies.[7] Added to these challenges facing individual ethnologists was the moral dilemma that these "scientists of the human" faced more than most: how should they respond to the perversion of their own expertise that Vichy and the occupiers represented.

Confronted with defeat, Occupation, and Vichy's homegrown anti-Semitism, several Maussians joined and died in the Resistance, in the name of the same humanist values and spirit of reciprocity that had made them such superb ethnographers in the first place. Yet other ethnologists saw the demise of the Third Republic and the advent of Vichy as the right moment to continue organizing a sociocultural anthropology in France independently of racial science. And George Montandon represented an extreme case of collaboration with the Germans, in terms of both ideas and actions: he pursued his dream of an ethnoracially pure New Europe purged of Jews, as dictated by his racist understanding of science. Taken together, the years 1940 to 1945 marked the most important turning point in the intertwined histories of sociocultural anthropology and racial science in France since 1900.

EXCLUSION, EXILE, AND SACRIFICE

Over the course of the war, Vichy deemed many ethnologists its enemies, either by virtue of their Jewishness, their prior political activities, or their choice to resist, whether through armed struggle or exile. All of these

[6] Three other students were finishing as well: Jeanne Cuisinier (working on the Muong), André Lerhoi-Gourhon (working on Pacific archaeology), and a student of Griaule's, Germaine Dieterlen (working on the Dogon). Dieterlen wrote to Mauss that her thesis was all but done at the end of May 1940: "I've brought my thesis (to the South of France where I've moved my children and myself) to undertake a few revisions. . . . I will complete the stylistic corrections myself this summer." AMH/2 AP 4 2B/1c/Germaine Dieterlen à Marcel Mauss, 30 May 1940.
[7] Eric T. Jennings, *Vichy in the Tropics: Pétain's National Revolution in Madagascar, Guadeloupe, and Indochina (1940–1944)* (Stanford, CA, 2001).

Anatole Lewitsky on the terrace of a café in the Place du Trocadéro, 1936–37. Lewitsky and fellow ethnologist Boris Vildé were executed by the Germans on 23 Feb. 1942. General Charles de Gaulle awarded them Resistance medals on 3 Nov. 1943. AMH/PH/1998–14265–125. Photo courtesy of the Musée du Quai Branly/Scala/Art Resource, NY.

"enemies" became victims of the regime in one way or another, in contrast to those who chose to accommodate the new Vichy state. Some of these "enemies" managed to leave France. When the Germans arrived in Paris, Paul Rivet took great pride in keeping the Musée de l'Homme open with a skeletal staff, while simultaneously criticizing Pétain. Relieved of his responsibilities at the Musée de l'Homme and the Muséum in the fall of 1940 for political reasons, he decided early in 1941 to go to Bogota, Colombia, where he would continue his research and work for the Free French. Fortuitously, he left his apartment in the Musée de l'Homme on the very night the Germans arrived to search the premises. Tipped off by an informer about certain Resistance activities taking place in the museum, the Gestapo raided its premises in the early hours of 11 February 1941 and arrested the museum's librarian, Yvonne Oddon, the museum's gifted museographer, Anatole Lewitsky, as well as the more recently arrived Estonian student Boris Vildé.

These three were part of a larger Parisian network that had begun printing one of the first clandestine newspapers, *Résistance*, in December 1940 in the Musée de l'Homme's basement. Rivet was not a member of the group, but presumably he knew and approved of it. Oddon, Vildé, and Lewitsky were

imprisoned and then tried seven months later by a German military tribunal. Eager to make an example of these intellectuals, the German authorities (on orders from Berlin) sentenced ten of them to death. Vildé, Lewitsky, and five other members of the network would be executed a year later, despite intense petitioning by France's intellectual, political, and scientific communities for clemency, including Rivet from abroad. No less a person than the Vichy minister of education and youth, the archaeologist Jérôme Carcopino, pleaded their case with the Germans.[8] Plagued with feelings of guilt for the horrific unexpected deaths of his young comrades, a devastated Rivet resolved to work even harder to defeat fascism and preserve the scientific project on which he and his students had collectively worked.[9] For him, the two goals were indistinguishable. He wrote to a friend several months after the executions: "I would like to live long enough to see our triumph, to return to France, to see all those I love, my beautiful museum . . . and I'm afraid of dying before that dream is realized."[10]

Claude Lévi-Strauss would also spend the war in the Americas—in his case, New York—managing in March 1941 to leave from Marseilles on one of the last boats available to Jews. Between 1935 and 1938, he had worked as a professor of sociology at the University of São Paulo and conducted research in the field with his wife and former Institut d'Ethnologie student Dina Dreyfus. This experience had led him to embark on a thesis in ethnology; in 1938 they had lived for over six months among the Nambikwara and Tupi-Kawahib societies, before Lévi-Strauss moved back to Paris and took up a teaching position in a lycée. After serving in the army, he was demobilized in 1940 and returned to teaching until dismissed under Vichy's racial laws.[11] Mauss had been in touch with Lévi-Strauss during the latter's entire time in Brazil, giving him advice on his ideas and projects, but the war ended the correspondence between the "cher maître" and someone Mauss considered one of his most promising new recruits to ethnology. Thanks to the intervention of his fellow Institut d'Ethnologie graduate and Americanist Alfred Métraux—then working in the sociology department at Yale University—Lévi-Strauss was hired by the New School in New York, where he set to work on his thesis on kinship. As of 1942, Lévi-Strauss also served as a speaker for the United States

[8] The history of this resistance network and the subsequent arrest and trial of certain of its members has been meticulously reconstructed by Julien Blanc, *Au commencement de la Résistance du côté du Musée de l'Homme* (Paris, 2010); on the trial, see 428–29.
[9] Laurière, *Paul Rivet*, 543–44.
[10] AMH/2 AP 1 D/Paul Rivet à Mme. Henri Mercier, 4 March 1942.
[11] Eric T. Jennings, "Last Exit from Vichy France: The Martinique Escape Route and the Ambiguities of Emigration," *Journal of Modern History* 74:2 (2002): 289–324. On his war years, see Émmanuelle Loyer, *Paris à New York. Intellectuels et artistes français en exil, 1940–47* (Paris, 2007).

Office of War Information. He wrote to Mauss at the Liberation, somewhat
guiltily:

> During those three years, my justification to myself was unremitting work,
> directed by my desire to be useful and to contribute, as soon as possible, to the
> revival of thought and science in France. So, I worked a lot and I think I made
> a splash: a dozen articles published or forthcoming (several chapters of the
> *Handbook of South American Indians* being put together by the Smithsonian,
> several articles on primitive sociology), a book, completely finished, on family
> and social life among the Nambikwara; another, more substantial and ambi-
> tious, already quite far along.[12]

The Institut d'Ethnologie's other young Americanist and Rivet's *poulain,*
or favorite, Jacques Soustelle, had also been mobilized in 1939, but he was
delegated to the military attaché in Mexico before the German invasion of
France. When news of the defeat reached him, he promptly made his way to
London. Stripped of his citizenship as a resister, Soustelle would spend the
war years serving the Free French in various political capacities. In the wake
of the executions of his colleagues in Paris, he broadcast the news on the
BBC—in terms that emphasized his intense sorrow and the idealism of the
ethnological enterprise of his fallen comrades:

> Fourteen years ago, in 1928, a small young team, with one of the greatest schol-
> ars of our time, Professor Paul Rivet, as guide and inspiration, took on the
> task of creating a center in France for study, research, and education dedicated
> to the science of man. . . . In 1938, when the Musée de l'Homme opened . . .
> the *grand public,* and ordinary people in particular, became aware of the vast
> world community, so diverse and yet one, to which we belong. Yes, that per-
> sistent effort, undertaken and endured through poverty, toil, and the sacrifice
> of personal ambitions, began to bear fruit. . . . I was part of that fervent team,
> I still am, despite distance and war, and nothing in my life makes me more
> proud. . . . And if I speak today, it is because those temporarily triumphant
> barbarians have ravaged that most human and French endeavor. Our *maître,*
> our friend, Paul Rivet, is in exile. And two of our own, among the purest and
> the noblest, have fallen from bullets fired by German soldiers. . . . They were
> neither Jewish nor Communist, since it seems that is what they were accused
> of, and even if they had been, the crime would have been no less odious. They

[12] Bibliothèque Nationale de France/Manuscrits/Fonds Claude Lévi-Strauss/28 150/Claude Lévi-
Strauss à Marcel Mauss, 2 Oct. 1944. I thank Émmaneulle Loyer for this reference. Lévi-Strauss
was in regular contact with Rivet during the war, especially after Rivet left France; most of their
correspondence dealt with practical matters.

were simply young French men full of hope, researchers, *savants*. It is for this reason that they were killed, because the diabolical plan of the invader for the extermination of the French people requires first the destruction of all those who could raise up or lead them. ... My martyred comrades, we will not forget you, and we will avenge you.[13]

Deborah Lifszyc, the brilliant linguist specializing in Amharic and close friend of Denise Paulme, Michel Leiris, and André Schaeffner, did not manage to escape. As a recently naturalized French Jew—whose papers had come through in part through constant efforts on her behalf by Mauss and Rivet—she received news of her termination of salary at the Musée de l'Homme in July 1941. Paul Lester, the assistant director for anthropology, tried to break the news gently, thanking her for her eight years of loyal service and saying she was free to continue to do research in the African department.[14] Leiris reported to Rivet a few months later that "Deborah was making a bit of money" through bibliographical and translating work.[15] In February 1942, she was arrested in Paris and deported. Yvonne Oddon was likewise deported; unlike her colleagues Vildé and Lewitsky, Oddon was spared the death penalty and would spend the remainder of the war in Ravensbrück—and survive the ordeal.

Germaine Tillion was another early resister at the Musée de l'Homme. In October 1939, she had written to Mauss from the Aurès, anguished about receiving almost no news. "I'm working," she wrote, "[but] I do not know when you will receive this letter. I do not know if the Collège de France, the Hautes Études, the Institut d'Ethnologie are still open in Paris."[16] Upon her return to Paris in June 1940, she joined the Resistance immediately; two years later she was betrayed and arrested. Tillion was allowed to bring her thesis in progress and notes to the Fresnes prison where she was incarcerated, only to have to abandon everything when deported a year later, also to Ravensbrück.[17]

[13] Jacques Soustelle, "BBC, Londres, 11 juin 1942," in Jean-Louis Crémieux-Brilhac, ed., *Ici Londres 1940–1944. Les voix de la liberté* (Paris, 1975–76), 2:136–37.
[14] AMH/2 AM 1 K60/c/Paul Lester à Debora Lifszyc, 21 July 1941, no. 185.
[15] AMH/ 2 AP 1 C/Michel Leiris à Paul Rivet, 18 Sept. 1941.
[16] IMEC/Fonds Marcel Mauss/MAS 12.63/Germaine Tillion à Marcel Mauss, 14 Oct. 1939.
[17] Germaine Tillion's extraordinary record of resistance has generated an important literature, including many of her own memoirs. See Germaine Tillion, *Les ennemis complémentaires* (Paris, 1960); Tillion, *Une opérette à Ravensbrück. Le Verfügbar aux Enfers* (Paris, 2005); Tillion, *À la recherche du vrai et du juste. À propos rompus avec le siècle* (Paris, 2001); Tillion, *Ravensbrück* (Paris, 1988). For other perspectives, see Donald Reid, *Germaine Tillion, Lucie Aubrac, and the Politics of Memories of the French Resistance* (Newcastle, 2008); Nancy Wood, *Germaine Tillion, une femme-mémoire. D'une Algérie à l'autre* (Paris, 2003); Christian Bromberger and Tzvetan Todorov, *Germaine Tillion, une ethnologue dans le siècle* (Arles, 2002); Tzvetan Todorov, ed., *Le siècle de Germaine Tillion* (Paris, 2007); and Fabien Sacriste, *Germaine Tillion, Jacques Berque, Jean Servier et Pierre Bourdieu. Des ethnologues dans la guerre d'indépendance algérienne*, foreward by Jacques Cantier (Paris, 2011).

Despite repeated attempts by a friend, Maurice Roy, to recover her precious materials from Fresnes, the thesis was lost for good.[18] Tillion, like Oddon, would manage to survive deportation, and would return to France in 1945.

Charles Le Cœur, a lieutenant in the reserves stationed in Morocco in June 1940, decided once demobilized to apply to the Institut Français de l'Afrique Noire in Dakar for funds to complete his ethnographic research on the Téda, begun in 1934. He could not return to the Tibesti Mountains, the site of his first fieldwork, because the area had ostensibly become too dangerous (the Free French and Italian forces were active in the region); he thus proposed to work with an ethnic group in Niger that was linguistically close to the Téda. In 1942, he headed deep into the Sahara, this time without his wife, Marguerite, who continued to teach in Rabat.[19] In 1943, while still in the desert, he asked to be remobilized by the Free French; it would be another year before he made it back to Morocco and then on to his posting to Italy to participate in the Allied campaign there.[20] In March 1944 he sent to Théodore Monod detailed instructions on the state of his manuscripts, and how they should be completed and published in case of his death. "But let's put aside these macabre provisions, I hope to be able to get back to work at the end of the year."[21] He would be killed in action four months later.

In 1938, the governor-general of French West Africa had relieved Bernard Maupoil of his administrative duties in the colonial administration and reassigned him to the Institut Français de l'Afrique Noire. There he played an important role in launching its scientific journal, the *Bulletin,* in 1939; indefatigable researcher that Maupoil was, his hand is detectable in the journal's many reviews of works on Africa in all languages appearing on the eve of the war.[22] In April 1940, when Maupoil was still trying to keep the Institut going with precarious funding, Mauss had encouraged him to finish correcting the proofs of his thesis so he could defend in the fall. He warned Maupoil about "the fortunes of war . . . you don't have an instant to lose," adding: "The day before yesterday, Le Cœur passed his thesis brilliantly." In a postscript Mauss noted almost optimistically: "So far no losses [*aucune casse*] among my own or my students. . . . Let us hope it continues."[23] Maupoil replied in May 1940:

[18] IMEC/Fonds Marcel Mauss/MAS 8.74/Louis Massignon à Marcel Mauss, 5 Oct. 1944, to which is attached "Copie de la Lettre de Mr. Maurice Roy à Mr. Louis Massignon, 3 Oct. 1944."

[19] IFAN/E 2–3/Charles Le Coeur à Théodore Monod, 23 April 1941.

[20] IFAN/E 2–3/Charles Le Coeur à Théodore Monod, 1 Jan. 1944.

[21] IFAN/E 2–3/Charles Le Coeur à Théodore Monod, 5 March 1944; in May he was complaining of the lack of action and his inability to keep working on his documents, but he had established a "good contact with Italian savants." IFAN/E 2–3/Charles Le Coeur à Théodore Monod, 5 May 1944.

[22] AMH/2 AP 1 C/Théodore Monod à Paul Rivet, 1 Oct. 1938. The reviews appeared in the *Bulletin de l'Institut Français de l'Afrique Noire,* nos. 1–4 in 1939, and nos. 1–2 in 1940.

[23] IMEC/Fonds Marcel Mauss/MAS 20/Marcel Mauss à Bernard Maupoil, 29 April 1940.

"I ask you not to expose yourself for nothing. Many of us love you and need you."[24] He was still in Dakar when the British attempted their abortive landing in September 1940. An "anti-Vichyssois" from the outset, he asked to be repatriated in 1941 and returned to France in 1942, where he joined the Resistance. In September 1942, he became secretary-general of one of the most important Resistance networks of the second half of the war, that of Cahors-Asturie in the department of the Lot. Maupoil gave a talk on the ethnography of the Koniagui-language peoples of Guinea in January 1943 to the Société d'Anthropologie, only to be arrested in May.[25] He was imprisoned for nine months at Fresnes (five of them in secret detention) before being transferred first to Compiègne, and then deported on 2 July 1944 to the slave labor camp of Hersbruck in Germany (Bavaria), where he would die later that same year.[26]

At the age of sixty-eight, Marcel Mauss did not choose flight in 1940; his wife was bedridden before the war, and he insisted on staying in Paris despite the dangers and his own declining health and Jewish origins. In September 1939, weary of teaching, he had already resigned from his chair in religion at the École Pratique, requesting that Maurice Leenhardt (who was sixty-one) take over his courses; Mauss had nevertheless stayed on as director of its Vth Section and continued teaching at the Collège de France. Vichy's anti-Jewish legislation forced him to relinquish these positions, too, and in 1942 he lost his spacious apartment and library. The couple moved into a cramped ground-floor "hovel," as Mauss called it, which they rarely left.[27] Letter writing—Mauss had always been an indefatigable correspondent—and visits from loyal friends, including several students, were Mauss's principal comforts as the Occupation hardened. Michel Leiris sent his New Year's wishes to Mauss in 1941 and noted poignantly: "Thanks to you the young writer that I was . . . has acquired a taste for science and learned to appreciate the admirable grandeur of that thing that only appears simple: the integrity of the true scholar."[28] Leenhardt came by regularly, and so did Denise Paulme. In fact, in 1943, she insisted on working with Mauss to prepare his course on ethnographic methods for publication. Paulme's decision to make sure that this invaluable testimony to his teaching made it into print before it was too late was, however, tied up with something more than filial respect. It was also, implicitly, a reproach against another of Mauss's students, Marcel Griaule, whose wartime choices differed significantly from those of his cohort and his teachers described above.

[24] AMH/2 AP 4 2B/2b/Bernard Maupoil à Marcel Mauss, 13 May 1940.
[25] AMH/2 AM 1 K/90/c/Société d'Anthropologie de Paris/Conférences 1943–1945.
[26] "Nécrologie," *Journal des Africanistes* 15 (1945): 38.
[27] Quoted in Fournier, *Marcel Mauss*, 748.
[28] IMEC/Fonds Marcel Mauss/MAS 7.53/Michel Leiris à Marcel Mauss, 3 Jan. 1941.

Rivet and Mauss had initially pinned great hopes for the future of ethnology on Griaule, the leader of the Mission Dakar-Djibouti in 1931–33. He had nevertheless proven to be a brilliant but difficult recruit from the outset, who typically behaved in his own best interest in a milieu that valued group effort and synthesis. In 1934, Griaule had tried but failed to be appointed director of the Musée des Colonies at Vincennes, while also refusing to become head of the African department at the Musée d'Ethnographie.[29] Rivet had then managed to secure Griaule a research position in the small laboratory that he directed in ethnology in the IIIrd Section of the École Pratique, which was devoted to the natural sciences. With no other options, Griaule had accepted, but he clearly chafed at being in a "hard science" laboratory when his first love was a certain kind of ethnography, initially more descriptive and object-based than sociological and historical in the Maussian sense.[30] When, again through Rivet's efforts, the directorship of the new Institut Français de l'Afrique Noire in Dakar became available in 1937, Griaule refused.[31] The Institut's epistemological model was that of the Musée de l'Homme, that is to say, one in which the natural and human sciences were associated; in retrospect, it is obvious that Griaule never accepted this model for ethnology and aspired instead to make sociocultural anthropology a discipline separate from physical anthropology and prehistory. With the simultaneous disappearance of Soustelle, Mauss, and Rivet from ethnology's commanding posts in 1940, Griaule assumed every available position. In the first two years of the Occupation, he took over from Rivet as director of the École Pratique laboratory and from Mauss as secretary-general of the Institut d'Ethnologie, teaching Mauss's renowned "ethnographic methods" courses, too. In addition, he stepped in for Jacques Soustelle as assistant director of the Musée de l'Homme and began teaching Amharic at the École Nationale des Langues Orientales Vivantes when his other mentor, Marcel Cohen, also fell victim to Vichy's anti-Semitic laws. Finally, Griaule helped orchestrate the creation of

[29] ANF/AJ[16]/6009/M. Charléty [Recteur] à Ministre de l'Éducation Nationale, 27 Oct. 1934.

[30] In the confusing institutional world of French higher education, professors with appointments in one institution nevertheless often directed laboratories housed in others. Rivet as holder of the chair in ethnology at the Muséum directed not only the Musée de l'Homme (with its two laboratories in ethnography and physical anthropology) but also a "laboratoire d'ethnologie" at the École Pratique, IIIrd Section. IMEC/Fonds Marcel Mauss/MAS 5.46/Marcel Griaule à Marcel Mauss, 20 March 1934 and IMEC/Fonds Marcel Mauss/MAS 18/Marcel Mauss à Marcel Griaule, 28 Feb. 1935. Rivet supported many of his and Mauss's students on the laboratory's budget throughout the 1930s. See AMH/2 AM 1 K35/b/École Pratique des Hautes Études, Paul Rivet à M. le Président de la IIIe Section, 9 Sept. 1932; and Jacques Soustelle à M. le Président de la IIIe Section, 5 July 1938, no. 1018. Mauss noted to Le Coeur that Griaule, while in the science section, "would really like to join our section." IMEC/Fonds Marcel Mauss/MAS 19/Marcel Mauss à Charles Le Coeur, 8 Feb. 1937.

[31] Griaule refused to answer letters addressed to him from Dakar about the position. IMEC/Fonds Marcel Mauss/MAS 8.83/Bernard Maupoil à Marcel Mauss, 12 April 1937.

the first chair in ethnology at the Sorbonne, to which he would be appointed in November 1942.

When Mauss sat down in early 1943 with Denise Paulme to transcribe his manual, he wrote testily to his good friend the psychologist Ignace Myerson that at least it "will appear under my own name rather than that of Griaule."[32] In September 1944, certain members of the Musée de l'Homme—almost certainly André Schaeffner and Michel Leiris—accused one of Griaule's closest associates during the war, the anthropologist Jean-Paul Lebeuf, of maintaining close relations with the enemy; Griaule himself was accused of intriguing with Vichy.[33] A temporary suspension of Griaule from the Sorbonne and an inquiry into Griaule's and Lebeuf's wartime records ensued. In a parallel story, Griaule's close associate from the early Musée d'Ethnographie and Mission Dakar-Djibouti days, the equally ambitious Georges Henri Rivière, was also investigated in the fall of 1944 for his ostensibly pro-Vichy efforts during the war years to continue to organize the Musée des Arts et Traditions Populaires. Tellingly, Mauss wrote in support of Rivière but did not do the same for Griaule.[34] Was this a classic falling out of student and mentor? Or under the difficult conditions that the Occupation and Vichy imposed, had Griaule crossed a line that others had not?

[32] Quoted in Fournier, *Marcel Mauss,* 749.

[33] A report signed by five unnamed members of the Musée de l'Homme section of the Comité du Front National Universitaire (FNU) accused Lebeuf of collaboration. The FNU was a resistance group created in 1941, which spawned several satellite organizations, of which the Musée de l'Homme committee was one. These groups coordinated the first investigations into collaboration among academics in the fall of 1944, which were then referred to the purge (*épuration*) councils set up by de Gaulle in late August 1944. Before and during the war Lebeuf had held a CNRS-funded research position at the Musée de l'Homme's anthropology laboratory (which he resigned when accused). His hearing was thus held before the subcommittee "charged with nonuniversity establishments" of the Conseil supérieur d'enquête du Ministère de l'Éducation Nationale. During the proceedings, Lebeuf referred to Leiris and Schaeffner as his accusers. ANF/F[17]/16834/"Rapport du Comité du Front National Universitaire du Musée de l'Homme, transmis à la Commission d'épuration du Muséum National d'Histoire Naturelle." Griaule was officially denounced by a different group than Lebeuf: the Comité du Groupe du Front National de la Faculté des Lettres. While his file does not name the individuals who brought the charges, historians have long assumed—correctly in my opinion—that his estranged colleagues from the Mission Dakar-Djibouti were among those who called for a hearing. As one of his defenders put it, there was a "vicious campaign of calumny" against Griaule at the time of his hearing. ANF/F[17]/16806/handwritten note [author illegible, address of sender is 262 blvd St. Germain], 26 Oct. 1944. Schaeffner, moreover, was the spokesperson for the FNU group responsible for investigating suspected collaborators associated with the Musée de l'Homme at this very moment, i.e., September 1944. As Schaeffner put it, "This task is not pleasant, but I have taken it on in the name of all those who suffered with us and for us." AMH/2 AP 1 C/ André Schaeffner à Mme. Rivet, 29 Sept. 1944. On Griaule's accusers, see also Blanc, *Au commencement,* 278 n. 35; and Fabre, "L'ethnologie française," 359–65.

[34] At least there is no affidavit from Marcel Mauss in Griaule's *épuration* file. For Rivière, see ANF/ F[17]/16946/Conseil d'enquête/pièce 20, Marcel Mauss, 21 Sept. 1944.

Marcel Griaule and the Failure of Reciprocity

The Griaule controversy merits greater scrutiny for the window it provides on the particular choices that a group of hard-pressed academics made in a scientific domain that, in the wrong hands, had life-and-death consequences. The official charge against Griaule in September 1944 read as follows: "M. Griaule, professor of ethnology, owes his nomination [to the chair in ethnology] in part to his intrigues in the governmental milieus of Vichy. His intervention, at the time that assistants were designated for the Sorbonne, should be subjected to a rigorous inquiry."[35] But for Schaeffner and Leiris, and also Denise Paulme, who was married to Schaeffner, Griaule's acquisition of a chair was part of a longer history of self-promotion to advance his own career to the detriment of his coworkers. The original rift dated back to the 1931–33 Mission Dakar-Djibouti, in which Schaeffner, Leiris, and Griaule had participated. In the course of that mission, they had begun working collaboratively on a study of the Dogon people of Mali, each of them picking particular aspects of this ethnic group to study and promising to share their notes as they published articles and worked on their theses. But Schaeffner and Leiris soon found Griaule overbearing, and anything but a team player when they returned to Paris.

In the spring of 1933, the tensions that had formed during the mission continued and deepened.[36] Leiris and Griaule fell out in 1934 when Leiris published his famously experimental autobiographical ethnography of the expedition, L'Afrique fantôme, with its criticism of Griaule's methods and unflattering portrait of colonial officialdom, on whose goodwill they all depended. Griaule began forming his own "school" with new Institut d'Ethnologie students, first Solange de Ganay and Germaine Dieterlen, and later Jean-Paul Lebeuf; Griaule then began traveling regularly with the first two back to the same Dogon field site where he, Schaeffner, and Leiris had originally worked. In early1935, Schaeffner returned with Griaule to Mali for three months for more research on Dogon music and dance; Denise Paulme and Deborah Lifszyc also joined the trip and stayed on for an additional five months on their own to study Dogon social organization and language. Denise Paulme's letters from the field to Schaeffner and Leiris made clear that Paulme, Lifszyc, and

[35] ANF/F¹⁷/16806/Extrait, Président du Conseil supérieur d'enquête, 4 Sept. 1944.

[36] André Schaeffner was already frustrated with Griaule before the mission left; he wrote to Rivet on the eve of his departure to join the mission: "We are all leaving somewhat disappointed by this poor Griaule, the most incredible mix of humanity and egoism, of virility and femininity that I have ever met. Oh well, work in common will make things better." AMH/2 AP 1 C/André Schaeffner à Paul Rivet, 3 Oct. 1931.

Leiris—the Africanists at the Musée de l'Homme—were indeed, along with Schaeffner, a close-knit community working in the cooperative and egalitarian spirit that Mauss and Rivet had intended. These letters also complained discreetly about Griaule: he had completely ignored Paulme and Lifszyc, who had had to travel to Mali on their own, and even in Africa he was constantly seeking publicity for himself alone.[37] Schaeffner's ire with Griaule reached its own boiling point when he read the latter's major and complementary theses (*Masques Dogons* and *Jeux Dogons*) in the fall of 1938; Griaule's theses were the first ones on the Dogon to be published after the Mission Dakar-Djibouti, and Schaeffner reluctantly felt compelled to complain to Mauss about them.

The original letter from Schaeffner regarding Griaule is not in Mauss's archive; it is nevertheless possible to infer from Mauss's reply in December 1938 that Schaeffner had accused Griaule of using material without attribution from the published articles and ongoing research of the other Musée de l'Homme Africanists who had worked on the Dogon with him.[38] Mauss admitted the legitimacy of Schaeffner's complaints, perhaps because he had had a similar experience; a year earlier, Griaule had published one of Mauss's ideas without properly citing him.[39] But, Mauss explained to Schaeffner, "I had to either further delay his defense or to remain silent on a certain number of defects. You will certainly appreciate [my] point of view."[40] The war years aggravated these long-simmering resentments against Griaule, not least because of the latter's own behavior between 1941 and 1943—that is to say, at the same moment that most Musée de l'Homme ethnologists were struggling to make sense of the devastating arrest and execution of Lewitsky and Vildé, and the deportations of Oddon, Tillion, and Lifszyc.

Griaule's wartime career can be retraced through a number of sources, some of them more direct than others in a period that remains a sensitive

[37] Paulme, *Lettres de Sanga,* esp. 39, 73, 79.

[38] IMEC/Fonds Marcel Mauss/MAS 20/Marcel Mauss à André Schaeffner, 12 Dec. 1938. One of the problems that Schaeffner seems to have raised in his letter to Mauss was Griaule's incomplete citations and bibliography. In both *Masques Dogons* (896 pp.) and *Jeux Dogons* (291 pp.), Griaule made scant reference to the articles that had been published on the Dogon since the return of the Mission Dakar-Djibouti by the three other scientific members of the team: Deborah Lifszyc, Michel Leiris, or Schaeffner himself. His introduction to *Masques Dogons* also failed to mention Lifszyc and Paulme's research among the Dogon at Sanga in the mid-1930s. When André Schaeffner's correspondence is opened to researchers in 2050, the specific nature of these grievances will perhaps become clearer.

[39] IMEC/Fonds Marcel Mauss/MAS 18/Marcel Mauss à Marcel Griaule, 1 March 1937. The idea in question involved supposed affinities between a spectacular bronze gazelle head Griaule had found at Midigue on a mission to Chad in 1936–37 and ancient Nubian sculpture. At this point Mauss's and Griaule's relations were still cordial. Mauss, however, brought the incident up four years later with Griaule, when the latter repeated the same offense, suggesting that this ongoing nonattribution rankled. IMEC/Fonds Marcel Mauss/MAS 18/Marcel Mauss à Marcel Griaule, 4 Nov. 1941.

[40] IMEC/Fonds Marcel Mauss/MAS 20/Marcel Mauss à André Schaeffner, 12 Dec. 1938.

and painful one in France.[41] What seems most clear is that, in the absence of Rivet and Soustelle and with the disappearance of Mauss, Griaule attempted a full-scale reorganization of ethnology, at a time when the Vichy authorities were open to such a possibility as part of their larger interest in preserving the empire in the reordered Europe to come.[42] In April 1941, Vichy authorities retired Rivet, opening the way to a replacement.[43] Even before being appointed interim director of the Musée de l'Homme in July 1941, Griaule floated a plan to send its osteological collections back to the Muséum, from which they had been moved in 1937–38.[44] The Musée de l'Homme would revert back to housing only manmade artifacts, as was ostensibly the norm in ethnographic museums internationally. The reorganized Musée de l'Homme would then be recognized as a "national museum" rather than a scientific one; administratively this change in status would mean detaching it from the Muséum and granting the Musée de l'Homme the same budget and status as France's other national museums. The model, Griuale continued, was Rivière's new folklore,

[41] Another possible source is the monograph series in ethnology (Travaux et Mémoires de l'Institut d'Ethnologie) whose editorship Griaule also inherited when he took over Mauss's former position of secretary-general of the Institut d'Ethnologie. A close study of the order in which monographs were published under Griaule—at a time when all scientific publication was slowed because of material shortages and the difficulty of communication—may show a bias toward the works of his students over those of students more closely associated with Mauss, or who were targets of the Vichy regime. For example, Bernard Maupoil's thesis, whose proofs were ready in 1941, was not published by the Institut d'Ethnologie before his arrest in 1943, while Germaine Dieterlen's thesis was published in 1942. IMEC/Fonds Marcel Mauss/MAS 8.83/Marcel Mauss à Bernard Maupoil, 17 June 1941. On the other hand, it might be impossible to prove any such bias, given the many factors that could have influenced editorial decisions in wartime.

[42] ANF/F17/13358/Édouard Galletier, "Note pour le ministre, Musée de l'Homme," n.d. [ca. 1942]; Louis Germain, "Note relative au Musée de l'Homme," 5 Jan. 1942, no. 15.154; and "Note pour l'étude et solutions urgentes en ce qui concerne le Musée de l'Homme," 28 May 1942. Édouard Galletier was le Directeur de l'Enseignement Supérieur at the Ministry of Education under Vichy. It is impossible to tell from these documents who started the conversation about reorganizing French ethnology.

[43] Laurière, Paul Rivet, 538–40. When he left in February 1941, Rivet had secured a promise from Vichy that he could keep his "position and titles," but the new Secrétaire d'État de l'Éducation Nationale, Jérôme Carcopino, retired him in April.

[44] The evidence for Griaule's promoting such a division as early as May is indirect but convincing. According to a note from Mauss to Germain from early July, Griaule had visited all the Muséum professors to sound them out. Several opposed his plan. IMEC/Fonds Marcel Mauss/MAS 5.47/Marcel Mauss, "Note sur l'état actuel du Musée de l'Homme," 1 July 1941; this note is unsigned but on Mauss's letterhead, with "remis à Louis Germain" scribbled across the top. MNHN/MS 2959/pièce 5864/C. Arambourg à L. Germain, 26 May 1941 and pièce 5865/"Texte proposé à l'Assemblée du 24 July 1941." The best account in Griaule's own hand of the division of the Musée de l'Homme appeared in an undated and unsigned "note" written sometime after 10 Aug. 1941. See ARP/IE/Chaire d'Ethnologie/1942/[Marcel Griaule], "Note sur le développement des disciplines ethnologiques en France," nine pages with an organogram attached. Li-Chuan Tai has also attributed this document to Griaule in her study of the Institut d'Ethnologie during the war years. See Tai, L'anthropologie française, 179 n. 10.

or "ethnology of France," museum, which had been made a national museum from the outset in 1937.[45]

When informed of this plan, Mauss immediately objected to it on the grounds "that things should be conserved in their actual state as much as possible, and to the extent that external elements [i.e., the German occupiers] did not intervene." Rivet's tradition, he added, had to be continued; he then pointed out to the director of the Muséum, Louis Germain, that if Rivet had made room for Griaule in his École Pratique laboratory in the natural sciences back in 1935, it was because for Rivet "the nature of things" dictated that "the civilization of humans had to be placed next to their physical structure." But Mauss also recognized that Griaule's suggestions had a certain merit, and he thus proposed a compromise. Given that the ethnographic collections were so much larger than the osteological collections, it would make sense to create a separate chair for their administration; failing that, a full-time curator for ethnography should be appointed, "with whom the Muséum [director] would consult periodically."[46]

The faculty of the Muséum, however, rejected any change in the status quo, although for different reasons than Mauss. Several thought the Musée de l'Homme should perhaps expand the space devoted to physical anthropology, which under Rivet had been—in their eyes—unfairly neglected. Such an overhaul (again!) of the collections would require having only one person in charge of the institution, as Rivet had been; only this time it should be a "real" anthropologist. With no clear vision of the future beyond keeping the Musée de l'Homme part of the Muséum, the latter's faculty voted in the fall of 1941 for a successor to Rivet's empty chair in anthropology (this election will be examined further below). They also made sure that Griaule and the Vichy Ministry of Education overseeing these matters understood that once a replacement had been elected, Griaule's term as interim assistant director of the Musée de l'Homme would be over.[47] In November 1941, Henri Victor Vallois was appointed after a split vote for the vacant chair in anthropology.[48] Vallois was an old-fashioned racial taxonomist and professor of anatomy at

[45] Museums classified as "national" were funded directly by a special state budget that was administered through the Réunion des Musées Nationaux.

[46] IMEC/Fonds Marcel Mauss/MAS 5.47/Marcel Mauss, "Note sur le développement actuel du Musée de l'Homme," 1 July 1941.

[47] MNHN/Ms 2959/Correspondance Arambourg/pièce 5864/C. Arambourg à L. Germain, 26 May 1941 and pièce 5865/"Texte proposé à l'Assemblée du 24 July 1941."

[48] In contrast to the Muséum's decision to replace Rivet, some French institutions of higher learning, such as the Collège de France and the Sorbonne Faculté de Médecine, refused to hold new elections for preexisting chairs that had been "vacated" under Vichy. The Muséum faculty briefly debated the question of not proceeding to a vote in May and June; MNHN/AM 73/Procès-verbal de l'Assemblée des Professeurs du Muséum, 15 May and 19 June 1941.

the Faculté de Médecine of the University of Toulouse, ambitious for himself but with no obvious political affiliations.[49] He immediately relieved Griaule of his duties and began working on refurbishing the Musée de l'Homme's collection of human remains—all, however, on his own initiative; the Germans never showed much interest in the museum's contents.[50] He also published in 1943 a book of interest to the experts at Vichy eager to improve the strength and vitality of the French nation, *Anthropologie de la population française.*[51]

Griaule's stint, then, at the Musée de l'Homme (July to December 1941) was not a long one. While interim director, he nevertheless managed to further shock museum personnel when he asked his close collaborator, Jean-Paul Lebeuf, to help him mount an exhibit on his and Griaule's recent missions to southern Chad. The problem was not the exhibit's *contents*—a spectacular series of bronzes and terra-cotta statues from the Sao civilization (sixth–sixteenth c.) that Griaule and Lebeuf had unearthed—but rather its *presentation.* The two ethnologists broke with the Musée de l'Homme's pedagogical and scientific displays, preferring to adopt what they described as an approach "more accessible" to the public.[52] An article on museography that Lebeuf published in 1942 in Pierre Drieu la Rochelle's collaborationist literary journal, the *Nouvelle Revue Française,* however, made clear that the primary goal of this "new" approach was to pander to Vichy's visceral hatred of the Popular Front, with which Rivet had been associated. Lebeuf wrote that a properly organized museum had to avoid such errors as

[49] There is no biography of Henri Victor Vallois, who by the time of his 1941 election had managed—from Toulouse—to acquire an impressive hold over many of Broca's original institutions. As noted in chapter 4, note 81, in 1932 he became president of the Société d'Anthropologie de Paris, then in 1938 its secretary-general. In 1937 he also became director of the Broca Laboratory, and he had been one of the editors of the major journal *Revue d'Anthropologie* since 1932. For Vallois's vision of the importance of racial science, see Henri Victor Vallois, "L'évolution de la chaire d'ethnologie du Muséum National d'Histoire Naturelle." *Bulletin du Muséum National d'Histoire Naturelle* 16:1 (1944): 38–55. The candidate who won the same number of votes as Vallois was Jacques Millot, a physiologist who wished to preserve Rivet's legacy; this election is discussed in more detail below.

[50] According to Prof. Bourdelle, Vallois was already worrying in Dec. 1941 about a potential dismemberment. The faculty thus voted that their "assesseur," M. Urbain, go immediately to Vichy to "find M. le Professeur Vallois and, once there, take all useful measures so that the Musée de l'Homme will not be severed from the Muséum." MNHN/AM 73/Procès-verbal de l'Assemblée des Professeurs du Muséum, 18 Dec. 1941.

[51] Henri Victor Vallois, *Anthropologie de la population française* (Paris, 1943). Gérard Noiriel argues that this book directly inspired Robert Gessain, an anthropologist trained by Rivet who headed the population "team" at the Fondation Française pour l'Étude des Problémes Humains (Fondation Carrel) under Vichy. Noiriel, *Les origines,* 218. Conceived in a technocratic spirit to regenerate "the individual and the race," the Fondation would survive the war in a new guise, as the Institut National d'Études Démographiques (INED). On this transformation, see Nord, *France's New Deal,* 179–80, 182. Gessain, like many other experts who worked at the Fondation during the Occupation, would have a successful postwar scientific career, eventually becoming head of the Musée de l'Homme.

[52] The display principles and a layout of the "new" presentation adopted by Lebeuf are described in the exhibit catalog, *Les collections du Tchad. Guide pour l'exposition* (Paris, 1942).

an abuse of the "spirit of synthesis" [?], exhibit halls that look like laboratories, systematic display cases, long texts that are pale reflections of the library, a taste for ugliness if it is ritual, a religious devotion to overly visible numbers and labels, inadequate photographs that do not come alive . . . , [and] a hopeless desire to educate the masses regardless of the cost—and in whatever which way, as long as the procedure corresponds to a certain ideology.[53]

The article concluded by noting that a museum visit should be "restful, entertaining, and agreeably educational"; these goals could be met if the museographer brought "his taste, sensitivity, and heart to the enterprise."[54] Leiris, Paulme, and Schaeffner did what they could to contain this threat to Rivet's original lay-out and vision. According to Lebeuf's 1944 testimony, when he himself was temporarily arrested by the Germans and held for a month between mid-October and mid-November 1941 (and then released unscathed), "Messieurs Schaeffner and Leiris took advantage of the fact that I was not [at the museum for a month] to completely change" the (Chad) exhibit. The atmosphere of the museum, he added, "was positively hateful," as if the others alone were responsible for this state of affairs.[55]

 In the end, the election of Vallois to Rivet's chair put an end to Griaule's wartime career at the Musée de l'Homme. By January 1942, however, another possibility for Griaule's ambitions opened up: the professors of the Faculté des Lettres at the Sorbonne voted in favor of creating a chair in ethnology, on the grounds that with only a university "institute" (i.e., the Institut d'Ethnologie) rather than a dedicated teaching line in the field, it had become difficult to find the requisite number of specialists for the juries of doctoral defenses.[56] When the university rector asked the dean for a stronger rationale before passing the measure on to the minister, he eventually received one, based on a single-spaced nine-page report drafted by Griaule. The subject of the report was the future "development of the ethnological disciplines in France," and an organogram was attached.[57] The report recommended not only the breakup

[53] Jean-Paul Lebeuf, "Technique d'une exposition," *Nouvelle Revue Française* 56:338 (1942): 509.

[54] Ibid., 512. The article also reiterated one of Griaule's guiding assumptions about fieldwork: that the first reaction of the "primitive" [Lebeuf's quotation marks] before the European is a "reflex of defense" and refusal to separate from what "he holds most dear." Ethnographic encounters, in short, were always forms of combat. Ibid., 507.

[55] ANF/F17/16834/"Rapport du Comité du Front National Universitaire du Musée de l'Homme, transmis à la Commission d'épuration du Muséum National d'Histoire Naturelle."

[56] ARP/IE/Chaire d'Ethnologie/1942/Doyen à M. le Recteur, 12 Jan. 1942; M. le Recteur à Doyen, 20 Jan. 1942.

[57] ARP/IE/Chaire d'Ethnologie/1942/[Marcel Griaule], "Note sur le développement des disciplines ethnologiques en France." There is no designated recipient for this note, but several of the same arguments appear in three other documents in this file. See Doyen à M. le Recteur, 4 March 1942; Secrétaire d'État, "Création d'un enseignement d'ethnologie," 20 May 1942; and "Rapport à

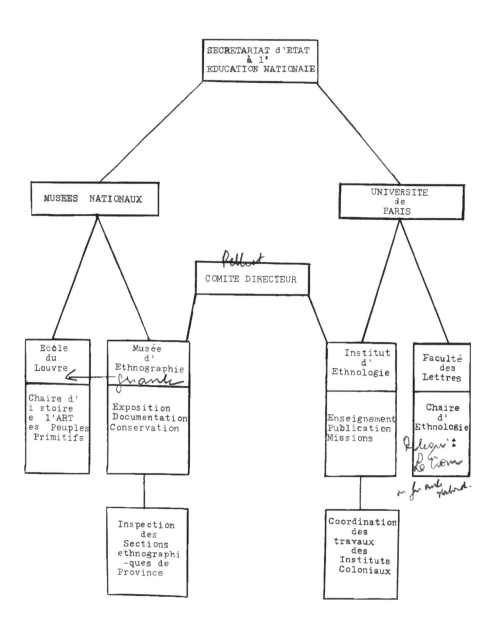

Organogram for a reorganization of the discipline of ethnology in Paris, 1942. [by Marcel Griaule].
ANF/F¹⁷/13358/Note, 28 May 1942, "L'organisation de l'ethnologie en France est à l'étude."

of the Musée de l'Homme, along the lines sketched out above, and renaming it the Musée d'Ethnographie; it also argued for two new chairs in ethnography to supplement the instruction provided by the Institut d'Ethnologie. The first would be at the Faculté des Lettres, in order to prepare doctoral students (here Griaule self-servingly pointed out that the Mission Dakar-Djibouti, which he had led, had alone generated sufficient material for seven doctorates, three finished and four under way). A second, "more modest" chair should be created at the École du Louvre, whose specialty would be "the art of primitive peoples." These innovations represented the logical next step in the growth of a discipline already autonomous in other nations, with their panoply of cultural anthropology departments, institutes, and ethnographic museums. Even more important, it would ensure that the colonies were ruled in the most rational fashion for colonizer and colonized alike, at a moment "when Europe and, for example, Africa—a continent that is the order of the day—are being reorganized."

As this statement suggests, Griaule's report was laced with the same imperial references that had justified the growth of ethnology in the past, altered to accommodate Vichy's acceptance that a German victory in Europe and Africa was inevitable. Its author went on to proclaim that "in the future, nations would be represented in international conferences not only by political experts . . . , but even more by technicians able to specify the nature and the importance of indigenous collaboration in the new economy of continents"— that is to say, "colonial missionaries, doctors, and administrators." Yet Griaule also explained that only the Institut d'Ethnologie and the reconfigured Musée d'Ethnographie would be involved in training these future technicians. Indeed, with the creation of a new chair, the old Institut d'Ethnologie was to have a greater imperial role than ever before. It would become the center for coordinating research empire-wide that the 1937 Congress on Colonial Research had recommended, but that, like so many Third Republic initiatives, had remained a dead letter. Only in Paris, the report insisted (in language lifted verbatim from the 1937 congress), would it be possible to undertake "the immense syntheses that are impossible in the ethnological institutions set up in the territories. . . . In even more practical terms, we call on the Institute to become the seedbed of ethnologists that our colonial empire will draw from, a place to which those specialists will return regularly and where they will develop the documentation collected in the field." These documents would all have one

M. le Recteur sur la création éventuelle d'un enseignement d'ethnologie à la Faculté des Lettres de Paris," [n.a., n.d.]. Taken together, these documents suggest that Griaule put together a persuasive case for the chair to the dean and rector, which then became its official rationale when referred to the Vichy authorities for approval.

goal: that of studying "the populations of the colonies to resolve problems that are as much sociological as practical." The reform of the Institut d'Ethnologie and of the Musée de l'Homme would thus create a unique ensemble that would allow France in a few years to recover "at the head of colonial nations, the place that it occupied in 1877 [*sic*] when it created the first ethnographic museum in the world."[58]

Most of Griaule's lengthy report, then, was taken up with discussing how the reconfigured Institut d'Ethnologie and Musée de l'Homme would serve France's empire, and how the empire would better serve France. It devoted relatively little space (one page out of nine) to the one reform that actually came to fruition late in 1942: the creation of a chair in ethnology at the Sorbonne, which the full professors at the Faculté des Lettres had voted on eight months earlier, and which Vichy presumably financed. What happened between the vote on the chair in January 1942 and the chair's creation and Griaule's appointment to it in November? The official archives are incomplete. They indicate that by the end of February, Griaule—with the approval of Rivet's replacement at the Muséum, Vallois—had renamed Rivet's "ethnology" laboratory at the École Pratique a laboratory in "ethnography."[59] Griaule asked to see the acting rector, Gilbert Gidel, on 16 October to discuss the chair (since the state was creating the chair, it would be up to the minister of education, not the faculty, to make the appointment).[60]

A handwritten anonymous note in the same file four days later indicates that Griaule would present himself as a "candidate," but that he would prefer to "remain" [*sic*] director of the Musée de l'Homme and guarantee the chair for Soustelle.[61] The records also contain a copy of the organogram attached to Griaule's report, with a few names penciled in: his name appears next to the proposed Sorbonne chair with Le Cœur's, where it is written "Griaule first."[62] Then, on 27 November the Vichy minister of education who had replaced Carcopino in April, Abel Bonnard, notified the rector that a decree of 6 November had created not only a chair in ethnology, but also a Jewish chair (Chaire

[58] ARP/IE/Chaire d'Ethnologie/1942/[Marcel Griaule], "Note sur le développement des disciplines ethnologiques en France."

[59] AMH/2 AM 1/D11/e/Procès-verbal de l'Assemblée des Professeurs du Muséum, 26 Feb. 1942. At the same time Vallois created a new laboratory in human paleontology at the Musée de l'Homme.

[60] ARP/IE/Chaire d'Ethnologie/1942/M. Griaule à M. le Recteur, 16 Oct. 1942. An Institut d'Ethnologie report from 1948, most likely by Rivet, made the point that it was the state that appointed individuals to new chairs. AMH/2 AM 2 B3/Institut d'Ethnologie Organisation/[Paul Rivet] à M. le Recteur, "Le passé de l'Institut d'ethnologie," n.d. [1948].

[61] ARP/IE/Chaire d'Ethnologie/1942/handwritten note, 20 Oct. 1942, n.a. The reference to Soustelle is odd, given that he was a member of the Free French.

[62] ANF/F17/13358/Note, 28 May 1942, "L'organisation de l'ethnologie en France est à l'étude." Attached to this note is Griaule's same report and organogram found in ARP/IE/Chaire d'Ethnologie/1942, but the organogram in ANF/F17/13358 is filled in with names.

d'Histoire du Judaïsme); the latter was dated retroactively to 1 October 1942.[63] Three days later a second letter arrived confirming Griaule in the first chair and Henri Labroue, a lycée-teacher-turned-politician and professional anti-Semite, in the Jewish chair. Within days, the Sorbonne professors went on record that they were surprised and sorry that unlike the first chair, which had long been desired, the second one had been created without consultation.[64] Vichy created a second unwanted chair around the same time in "the anthropology of races" at the Faculté de Médecine and appointed the immigration specialist and racial hygienist René Martial.[65] Labroue would give his inaugural lecture on 15 December 1942, with Griaule following on 11 January 1943, and Martial on 25 January 1943.[66] Most students and faculty boycotted all but Griaule's lecture.

Whether Griaule had sufficient connections at Vichy, as he was officially accused, to secure the chair in ethnology, has never been proven; but one in fairness must ask whether such connections were really needed, or if they were, whether in using them, Griaule behaved differently than others around him. To pose these questions is not to exonerate him, but to try to understand what it was about his particular actions that so outraged his colleagues. There was, after all, a widespread determination among ethnologists, and among scholars in general, that French science should go on under the Occupation. The eminent historian Lucien Febvre, for example, continued publishing the journal *Annales* during Vichy, even though it meant striking the name of his Jewish partner, Marc Bloch, from the masthead.[67] Was Griaule, however

[63] ARP/IE/Chaire d'Ethnologie/1942/Secrétaire d'État à M. le Recteur, 27 Nov. 1942 and 30 Nov. 1942. Jérôme Carcopino always claimed to have negotiated with the Germans only to protect the traditional independence of the university, and there is evidence that he treated French colleagues working for the Germans harshly. Bonnard would prove more cooperative. Laurent Mazliak and Glenn Shafer, "What Does the Arrest and Release of Émile Borel and His Colleagues in 1941 Tell Us about the German Occupation of France?" *Science in Context* 24:4 (2011): 607.

[64] ANF/AJ16/4758/Procès-verbal de l'Assemblée des Professeurs, Faculté des Lettres, 21 Nov. 1942. Although he was an *agrégé* in history and geography, Labroue's real credential was his anti-Semitism, awakened with the defeat and advent of Vichy. Louis Darquier de Pellepoix, who had taken over in April 1942 from Xavier Vallat at Vichy's main bureau on Jewish questions, the Commissariat Général des Questions Juives, was behind the initiative and agreed to fund it. See Claude Singer, "L'échec du cours antisémite d'Henri Labroue à la Sorbonne (1942–1944)," *Vingtième Siècle. Revue d'Histoire* 39 (July-Sept. 1993): 3–9.

[65] Claude Singer, *Vichy, l'université et les juifs. Les silences et la mémoire* (Paris, 2004), 203–4. For background on Martial, see chapter 4.

[66] ANF/AJ16/6009/Marcel Griaule, Leçon d'ouverture du cours d'ethnologie; on Martial and Labroue, see Singer, *Vichy*, 202, 203.

[67] Historians remain divided over whether to qualify Lucien Febvre's behavior as collaborationist or accommodationist. The fact that Marc Bloch chose active resistance and died a martyr has made it tempting to simplify the difficult choices that Febvre, like all intellectuals, faced. In Febvre's case we know that he agonized over his decision to go against Bloch's wishes. For the most recent contribution to the Febvre debate, see Denis Crouzet and Élisabeth Crouzet-Pavan, "Postface," in their 2012 edition of a manuscript by Lucien Febvre and François Crouzet that was written in 1950 for UNESCO but never published, *Nous sommes des sang-mêlés. Manuel d'histoire de la civilisation française* (Paris, 2012), 295–318.

personally unscrupulous, being made a scapegoat for acting in ways no different from many others? The Vichy authorities used the chair in ethnology—which the Sorbonne faculty had wanted—to impose a second chair that the hard-line anti-Semites in the new regime desired. As a means for keeping the university as a whole quiescent in the face of moral turpitude imposed from above, this two-chair approach was ingenious.

Griaule's drowning of his rationale for the chair in a sea of colonial patriotic rhetoric surely helped to win its approval. Yet in this domain, too, most of what Griaule argued was within the pale of what ethnologists had been claiming for years about the need to marry good imperial governance and ethnology. On the need for such a marriage there was, in fact, a superficial consensus between Vichy and the Resistance.[68] In 1943, for example, the Free French governor-general of Afrique Équatoriale Française, Félix Éboué, created a Centre des Recherches Ethnologiques in Brazzaville "for the study of the customs of the native populations of the federation" modeled on that of the Institut in Dakar.[69] If the Jewish chair and that in the anthropology of races in Paris would disappear, the ethnology chair would remain at the Liberation as one of the many "overdue" scientific and imperial reforms that republicans and conservatives alike had longed for before the war, and which the arrival of an authoritarian regime in 1940 had made possible. A related Vichy initiative was the creation in 1943 of a new state-funded research organization for the empire, the Colonial Scientific Research Bureau (Office de Recherche Scientifique Coloniale, which after the war would be renamed Office de Recherche Scientifique et Technique d'Outre-Mer).[70]

Moreover, even had Griaule used "Vichy" connections to advance his vision of ethnology, his mentors were also prepared to see their science "grow" institutionally under Vichy, at least early on. Mauss had expressed interest in

[68] Vichy's imperial projects are better known than those of the Resistance, at least before the Brazzaville conference in 1944. Of particular interest for the history of ethnology is Michael Herffernan, "Geography, Empire, and National Revolution in Vichy France," *Political Geography* 24:6 (2005): 731–58.

[69] This center would be transformed after the war into the Institut d'Études Centrafricaines. AMH/2 AP 1 B7/"Rapport à M. le Président du Gouvernement Provisoire,"[n.a., n.d.]; and "Note and Dossier sur l'Institut d'Études Africaines," 26 Jan. 1946.

[70] On the Office de Recherche Scientifique Coloniale, see Bonneuil, *Des savants pour l'empire,* chap. 3, and Tai, *L'anthropologie française,* 187–92. According to Philippe Soulier, in 1943 Griaule and the geographer Émmanuel de Martonne suggested that the Ministry of Colonies create a *maître de conférence* in colonial ethnology, which materialized in May 1944 at the University of Lyon. The post was awarded to the Institut d'Ethnologie/Musée de l'Homme-trained ethnologist André Leroi-Gourhan, who had spent the war years working at the Musée Guimet and the Musée Cernushi, and was just finishing his dissertation; a specialist in early tools and Japanese ethnography, Leroi-Gourhan served the Resistance briefly in the summer of 1944. On the Lyon position, see Soulier, "André Leroi-Gourhan," 4; and André Leroi-Gourhan, "Leçon d'ouverture du cours d'ethnologie coloniale," *Les Études Rhodaniennes* 20:1–2 (1945): 25–35.

an ethnology chair when it was first approved by the Faculté des Lettres pro-fessors—not for himself but for his favorite student. A letter from Le Cœur to Mauss in February 1942 makes clear that the latter had already sounded him out about the possibility of "la Sorbonne." Le Cœur wrote back: "I would be very torn if I had to choose between a chair in Paris and the Sahara"—an allusion to the new fieldwork he was on the cusp of beginning. His prefer-ence, he explained, would be to have a position at the École Pratique later on, either the one Mauss had previously held or another.[71] This deferral was perhaps Le Cœur's polite way of refusing a post tainted by Vichy. Meanwhile Henri Laugier, a prominent biometrician who became one of the first French scientists to relocate to Canada to carry on the fight, chastised Paul Rivet for having tried in early 1941 to bring Soustelle back to Paris from Mexico, where Soustelle was "magnificently" leading the Resistance. "We were shocked, both of us," Laugier wrote to Rivet, "by your desire to see him return and pick up from the hands of Carcopino [Vichy's minister of education from February 1941 to April 1942] and the Nazis, the chair of Rivet, of Mauss."[72] In a follow-up letter, Laugier noted that much as he admired those who had stayed on in France to suffer and keep up the spirit of resistance, it was deeply regrettable for the greater cause of the nation, which urgently needed to be defended in the United States and Great Britain, that so few politicians and intellectu-als "of quality" had chosen emigration.[73] As this letter suggests, certain long-standing habits of intellectual and political sociability in France tragically disarmed many of the elite, when confronted with the unprecedented be-trayal of their values that the Occupation and Vichy state represented. Victor Serge, a Russian émigré intellectual and old acquaintance of Rivet, who was also in exile during the war, caustically described the problem this way:

> [The Occupation] raises for the thousandth time that strange problem that I have never been able to resolve: why such cowardice among the intellectuals and such a sudden and ignoble betrayal of the scientific conscience? They have such an insurmountable fear of swimming against the tide, they always need to be pulled by the current,—"[to be] on the right side of the fence," not too far from official honors and money. Does Paul Rivet not have enough personal authority to assert himself without meekness? . . . He lacks fighting spirit [*le cran*], accustomed as he is to the habits of parliament and the politeness of

[71] IMEC/Fonds Marcel Mauss/MAS 7.42/Charles Le Coeur à Marcel Mauss, 16 Feb. 1942.
[72] AMH/2 AP 1 C/Henri Laugier à Paul Rivet, n.d. [ca. early 1941]. Henri Laugier headed France's recently created CNRS on the eve of the war. He left in June 1940 for Montreal, where he worked to help other scientists get out of France.
[73] AMH/2 AP 1 C/Henri Laugier à Paul Rivet, 19 July 1941.

the salons, where you keep smiling while rubbing elbows with your greatest
enemies. He doesn't know that the Totalitarians only allow this game to go on
in order to profit from it—he does not want to know.[74]

Yet even if Griaule's teachers and cohort wished "science to go on," there
was arguably a difference between working intensively from abroad or in the
frigid basement of the Musée de l'Homme, and accepting a chair of ethnology
at the Sorbonne that was at least indirectly associated with an anti-Semitic
one as well as an overtly racist one. To accept it, Griaule did not hesitate to
invoke in his initial report the "New Europe" and the future redrawing of
boundaries within the African continent, thus pandering to the occupiers'
plans for an "eternal" and "Aryan" Third Reich purged of Jews, Bolsheviks,
and Freemasons. In this same spirit, he, along with Lebeuf and Henri Labo-
uret, agreed to collaborate on a German textbook devoted to African eth-
nography edited by the Austrian ethnologist-photographer (and Nazi Party
member) Hugo Bernatzik.[75] The latter, who had worked in both Africa and
the South Pacific, was a frequent visitor to the Musée de l'Homme early in the
war.[76] It is worth noting here that Griaule was also a member of the "Empire"
commission of Vichy's National Committee on Folklore.[77] And although Gri-
aule never made any allusion to racial hygiene in his work or teaching—in
this sense he was antiracist—he had flattered German learning in another
branch of the human sciences in his 1941 report pleading for professorships
in ethnography:

> Ethnology is the science of man in its entirety (*homo sapiens* and *faber*). It
> rests on two disciplines with distinct methods and subjects, and that have an
> independent existence: anthropology and ethnography. Anthropology, a natu-
> ral science, studies the physical characteristics of man (*homo*). Ethnography, a

[74] Victor Serge, *Carnets* (Paris, 1985), 59.

[75] ANF/F[17]/16834/"Rapport du Comité du Front National Universitaire du Musée de l'Homme,
transmis à la Commission d'épuration du Muséum National d'Histoire Naturelle." Lebeuf defended
this publication on the grounds that "it was absolutely necessary [in 1942] for France to take its
place among colonial nations." Griaule obviously shared this sentiment. Lebeuf also pointed out
that Schaeffner had asked Bernatzik to try to persuade Berlin to grant clemency to Vildé, Lewitsky,
and Oddon. Lebeuf did not see any difference between publishing in Germany under the Occupa-
tion and using a German contact to try to save the lives of colleagues.

[76] Not much is known about Bernatzik. Rivet mentions meeting him in the Musée de l'Homme in
August 1940. AMH/2 AP 1 B1/b/"Un témoinage," n.d. The degree of contact between German and
French Africanists during the war deserves a study in its own right, since there was a long history of
cooperation between them in the 1930s. On the question of Franco-German university and cultural
exchanges before World War II, see Fiss, *Grand Illusion,* chaps. 1–3.

[77] Fournier, *Marcel Mauss,* 740.

moral science, studies the spiritual activities of people and the material prod-
ucts of these activities (*sapiens* and *faber*). . . . It is thus important that the
teaching of ethnography . . . hold an important place in the university. . . . In
Germany . . . there are twenty-six chairs in ethnography and exotic sociology.[78]

In all these ways, the ethnology chair was a poisoned chalice indeed.

But there was another perhaps more potent reason why Griaule was sin-
gled out for investigation by those who had once worked with him. One of
the values of the Maussian school was reciprocity with their mentors and
with each other; the knowledge that they sought depended on practicing
among themselves the systems of solidarity that they were uncovering in
their fieldwork. Griaule had never lived up to this ideal with his original Mis-
sion Dakar-Djibouti companions, either in the field or in the publications
that followed. Such behavior had been bad enough before the war; at a time,
however, when France was still a free and functioning civil society, Griaule's
self-serving choices did not carry the same meaning that they acquired under
the conditions of the Occupation. The Germans had not only extinguished
democracy; they had created a new bastard "science" for their New European
Order, one that promised to become the *only* "science" if the Nazis and those
collaborating with them won. In accepting—in orchestrating—the ethnology
chair, Griaule was thus not only, once again, deserting his former friends and
teachers. He was undermining, or so it must surely have seemed to his profes-
sional colleagues, the possibility of resisting the politicization and deforma-
tion of the science of humanity that the Occupation represented. It is also this
failing of Griaule that set him apart from the Maussians; not all of the latter
resisted actively, but most had learned that they had to protect their science
from the revolting new regime in power. As Schaeffner put it in September
1944, once some in their ranks had paid the ultimate price to defend human-
ity, those remaining had an obligation to make sure their comrades had not
sacrificed in vain.[79]

One final question nevertheless lingers over Griaule's actions. When in-
vestigated in the fall of 1944 for "collaboration," Griaule provided testimony
that he—like so many others—had protected Jews and *résistants* during
the Occupation. But he gave another defense (also corroborated by others)
that pertained directly to his original decision to accept the chair in ethnol-
ogy. He had done so, he claimed, to prevent it falling into the hands of the
one ethnologist in France who was actively collaborating with the German

[78] ARP/IE/Chaire d'Ethnologie/1942/[Marcel Griaule], "Note sur le développement des disciplines ethnologiques en France."
[79] See note 33 above.

occupier, École d'Anthropologie professor George Montandon.[80] Was there any substance to this claim? The question becomes all the more interesting in light of the fact that Montandon's and Griaule's names had already appeared side by side in a related context. Both of them had volunteered their services to the education minister, Abel Bonnard, in the summer of 1942, when he was looking for lecturers for Vichy's École Nationale des Cadres Supérieurs, or training school for the elites of the future. Griaule and Lebeuf were on the list to talk about "primitives," while Montandon was slated to talk about "anthropology."[81]

Active Collaboration and Applied Science

George Montandon, known as one of Vichy's most extreme collaborators, used his "scientific" expertise to decide indeterminate cases of "Jewishness" during the Occupation and made a handsome profit from the many deadly certificates he delivered.[82] Conventional wisdom, as we saw in earlier chapters, attributes this "abrupt" transmutation of a formerly respected scholar to a combination of venality, opportunism, and craving for vengeance against former colleagues whose positions he coveted. Yet a closer look at his wartime record suggests that Montandon's collaboration had another origin: a desire to refound French anthropology according to the principles that he had always espoused, and a willingness to send to their deaths those who obstructed his version of scientific truth, which had long aligned with the principles of Nazi racial hygiene. For Montandon, unlike Catholic and nationalist anti-Semites such as Charles Maurras of the Action Française, whom Montandon despised almost as much as the Jews, the "divine surprise" of the summer of 1940 was not Pétain's conservative and traditionalist government.[83] Rather, it was the

[80] ARP/IE/Chaire d'Ethnologie/1942/handwritten note, 20 Oct. 1942. The record suggests that Griaule was concerned with two possibilities: that Montandon could be appointed to the chair himself; or that if Griaule were appointed, Montandon might be made a "chargé de cours." On Griaule saving the chair from Montandon, see also ANF/F^{17}/16806/G. Bidault à M. Griaule, 30 Sept. 1944; also a handwritten note, 26 Oct. 1944 [signature unreadable], that states that three university professors attested to the fact that Griaule was preventing the "traitor Montandon" from getting the chair.

[81] ANF/F^{17}/13341/Liste des conférenciers. Griaule's and Montandon's names are included.

[82] Laurent Joly has estimated that Montandon delivered 3,800 such certificates, making several million francs' profit from his expertise. Laurent Joly, Vichy dans la "solution finale." Histoire du Commissariat Général aux Questions Juives, 1941–1944 (Paris, 2006), 555.

[83] As an integral nationalist, Maurras rejected the German biological racism that Montandon had embraced. Montandon had begun attacking him for just this reason before the war, sending him excoriating letters in 1938 and 1939. See Billig, L'Institut d'étude des questions juives, 199–201; on antiracist nationalism, see Simon Epstein, Un paradoxe français. Antiracistes dans la collaboration, antisémites dans la résistance (Paris, 2008).

chance to work with those who understood that the future of Europe would be a new racial superstate.

The idea that a late-forming Europeanoid physical type and associated civilization were biologically destined to be superior to all others, once Jews had been removed, had driven all of Montandon's scientific production in the 1930s. Because the larger European *ethnie* was an ostensible mixture of the same three white types (Nordic, Alpine, and Mediterranean) that made up the French *ethnie*, he believed that France had nothing to lose and everything to gain from joining Hitler's New Europe reorganized, finally, according to the infallible laws of heredity. As Montandon put it in 1941, "the Frenchman is more Aryan than he suspects," and "his role consists henceforth of fitting into the bedrock of Europe."[84] The nation-state in this vision of things was a historical dead end, which had produced only fratricide among European peoples with a common "ethnoracial" substrate. According to this delusional vision, true French patriots should be following Montandon's lead: collaborating with Hitler to rid Europe of its one "true" *ethnie allogène*, the Jews. As Bernard Bruneteau has argued, Montandon was not alone in imagining a deep European past and future in these terms—for which the human sciences of the interwar years had, alas, provided ample fodder. Most of those identified by Bruneteau were writers whose literary collaboration, however despicable, did not directly lead individual Jews to their death.[85] Montandon went considerably further, acting out of greed and vindictiveness, but long-standing conviction, too. Viewed through this prism, his collaboration acquires a perverse coherence that scholars until now have missed: he sought to apply the principles of ethnoracism to purge France of its Jews in the present, but also to reorganize French ethnological institutions along ethnoracist lines for the future.

As seen in chapter 4, for most of the 1930s, Montandon had established his scientific credentials with no challenge from within the scientific community; his "science" had turned more and more on the specious scientific claim that while the French were not a race because of a long history of miscegenation, they were an *ethnie* whose future was being destroyed by a "naturally" incompatible Jewish one established throughout the world. Then, in 1938 Montandon had begun to deliver public lectures to openly anti-Semitic and extremist groups, and in November 1939, after France had declared war on Germany, he published his most violent article yet, entitled "L'etnia puttana" in the Italian journal *La Difesa dela Razza*. He followed up with a second article in the same journal on 5 April 1940.[86] In the previous year, Montandon's

[84] "Notre but," *Ethnie Française* 1 (March 1941): 2.

[85] Bruneteau, *"L'Europe nouvelle" de Hitler*, 132–47.

[86] George Montandon, "Trapianti etnici," *La Difesa dela Razza*, 5 April 1940, 6–11.

biological anti-Semitism had not attracted significant attention from France's antiracist press.[87] Now, however, two articles on the Left lucidly accused him not only of bankrupt science but of virtual betrayal—a position that two nationalist newspapers, the right-wing *L'Ordre Nouveau* and the conservative *L'Époque*, endorsed as well.[88] The prominent Jewish journalist Jacques Biélinky in the Zionist *La Terre Retrouvée* entitled his attack on 21 January 1939 "Science in Service of Hatred: Anti-Semitism in the Laboratory." As he put it, "True science . . . has demonstrated the scientific inanity of racism and of its conclusions directed uniquely against the Jews. . . . M. Montandon substitutes the term 'ethnie,' which is even vaguer than that of racism. . . . His learned dissertations are nothing more than a sort of preface, with scientific pretensions, to justify an anti-Semitic program of particular ferocity." Biélinky went on to point out that while the abundance of technical terms was supposed to impress the uninitiated, Montandon's conclusions were rendered in a "language accessible to the crowd." He furthermore insisted on the inconsistency of claiming that Jews, "Mongoloides," and "Negroides" were all *ethnies allogènes,* and then seeing only Jews as impossible to assimilate. The Breton, the Basque, the Corsican, Biélinky wrote, are allowed to stay as they are without posing a threat to the nation. But the Jew who stays Jewish: here is the crime to denounce, to punish, to erase. This, Biélinky concluded, was "a purely imagined classification."[89]

P. E. Gaude, in the left-wing daily *La Lumière* of 24 April 1940, made similar accusations under the headline "The French Professor Already Cited Continues to Defend Nazi Theories in a Hitlerphile Journal." He noted that Montandon's second article in *La Difesa dela Razza*, "Les transplantations ethniques," revealed "an exquisite sense of opportunity" when it applauded Germany's annexation of the Sudetenland on grounds of ethnic compatibility. "Shall we talk science?" Gaude asked. Gaude asserted that Montandon's findings were "absurd" and continued: "I won't insist at length on the incomprehensibility of the term "ethnie," recently forged by M. Montandon and which is far from being accepted in ethnological nomenclature." The bottom line, Gaude concluded, was that these articles had appeared in a journal inspired by Hitler's Germany, alongside articles by Germans that attacked

[87] On the political affiliations of the press in this period, see Claude Bellanger et al., *Histoire générale de la presse française* (Paris, 1969), vol. 4.

[88] Montandon's archives contain a collection of these articles; he saved anything in which his name was mentioned. In addition to the two articles cited, see CDJC/C-18/Émile Huré, "Le meilleur fourrier de l'hitlerisme," *L'Ordre,* 18 April 1940, part of which was reprinted under the same title in *L'Époque* on 24 April 1939; see also Montandon's response, CDJC/CXV-1/George Montandon à Émile Huré, 20 April 1940.

[89] CDJC/XCV-66/J. Biélinky, "La science au service de la haine," *La Terre Retrouvée,* 21 Jan. 1939.

France. Montandon's signature as a professor of anthropology at the École d'Anthropologie, moreover, was leading the German press to claim that he represented French scientific thought, as a recent edition of the *Westdeutscher Beobachter* indicated. Did not M. Louis Marin, the school's director, and the authorities more generally, have something to say on the matter?[90] Oily as always, Montandon took the time to defend himself but refused in either case to "talk science." As he put it to Biélinky, "It is impossible for me right now to enter into a scientific explanation . . . but you have not understood at all the difference between race and *ethnie*."[91] To the director of *La Lumière*, he explained that he was regularly cited in all the works abroad in the field of ethnology, which made certain colleagues jealous.[92] He also stated in a second letter, drafted but not sent, that his statements of the facts regarding the solution to the Jewish question—which neither the Right nor the Left had satisfactorily addressed—had not changed since he had published his book *L'ethnie française* in 1935. Once the Allied victory was assured, he added, they could discuss this solution again. This draft suggests that Montandon believed that his version of science would prevail regardless of who won the war, but for the moment he preferred to keep these sentiments private.[93]

When the Germans defeated France and the Vichy state replaced the Third Republic, this critical scrutiny of Montandon, itself too little and too late, disappeared altogether. He immediately became an extreme collaborator, lashing out on 2 July 1940 in the Fascist newspaper *La France au Travail* at those responsible for the defeat: not only the "Judeo-Masonic clan," but "Maurras' l'Action Marrane (dite française)." He would never look back, always preferring the occupier's racist vision of a New Europe to Vichy's Catholic traditionalism. Vichy authorities and Montandon's colleagues would in return keep their distance from the ethnologist's virulent racism. Indeed, Montandon's difficult personality, former communism, and marginality as a Swiss-born, German-educated ethnologist in French intellectual circles (whether Catholic or republican) all counted against him at Vichy, initially.

On 17 July 1940, citizens born of foreign fathers were banned from the civil service, and on 22 July a law revoking naturalizations effectuated since 1927 was issued. Sometime in November, Montandon was stripped of his naturalization on the grounds of past Bolshevism, effective 1 November 1940. On 14 November, he discovered that his course on "racial and ethnic aspects of

[90] CDJC/C-14/P. É. Gaude, "Le professeur français déjà cité continue de défendre les théories nazies dans une revue hitlerophile," *La Lumière*, 26 April 1940.

[91] CDJC/XCV-66/G. Montandon à J. Bielinsky [*sic*], 10 Feb. 1939.

[92] CDJC/XCV-114/G. Montandon à la Direction de Lumière, 26 April 1940.

[93] CDJC/XCV-115/G. Montandon à la Direction de Lumière, 3 May 1940; at the bottom Montandon has written: "draft, nothing sent."

prehistoric and modern France," which he had been appointed by Vichy to teach at the Sorbonne Faculté de Médecine, had also been canceled at the instigation of professors invoking the foreign-father ban.[94] Protective of their own privileged status and independence, the faculty was probably acting less out of philo-Semitism than outrage that Vichy had forced an outsider on them—the same attitude, as we saw above, that the Sorbonne professors at the Faculté des Lettres had adopted toward Labroue and the Jewish chair.[95] In December 1940, the École d'Anthropologie decided to force his resignation there as well, even though foreigners were not banned from teaching in private schools.[96] In the scabrous and paranoid tones that had cost him a libel suit in Switzerland fifteen years earlier, Montandon blamed Jews and Freemasons as well as particular colleagues at the École d'Anthropologie, including "the couple Raoul Anthony and Madeleine Friant.... We can only refer to this sterile duo in terms of copulation," for his dismissal.[97] He promptly launched a letter-writing campaign to Pétain to regain his nationality, soliciting help from France's most radical right-wing elements: his uncle and publisher Georges Payot, the celebrated author Louis-Ferdinand Céline, and the municipal councilor and hardened anti-Semite Louis Darquier de Pellepoix, whom Montandon had probably known since 1933.[98] In 1942, Darquier de Pellepoix would be appointed to head Vichy's special bureau on Jewish affairs, the Commissariat Général aux Questions Juives, to accelerate Vichy's participation in the Final Solution.[99]

As these events were unfolding, however, Montandon joined the Germans in another venture. In November 1940, he published a pamphlet entitled *Comment reconnaître le juif,* which was part of a series of four texts by

[94] Fette, *Exclusions,*180. In 1939, the École d'Anthropologie was already planning to move out of its existing building, which was in desperate need of renovation. In 1940, the Faculté de Médecine offered it temporary quarters, which is presumably how Vichy became involved in Montandon's teaching there; because it was a public university, state approval would have been needed for Montandon to give a course. Montandon originally wanted to call the course "l'Éthnie Juive," but the École d'Anthropologie had said that such a course, "at least under that name," was not advisable at a time when they were accepting the hospitality of the [Medical] Faculty." AMH/MS 15/3/Procès-verbaux/"Rapport du 31 octobre 1941."

[95] Fette, *Exclusions,* 180.

[96] ANF/AJ40/567/Dossier 8, Memo on G. Montandon, [n.a., n.d.].

[97] Gérard Mauger, "L'affaire Montandon," *Ethnie Française* 3 (May-June 1941): 1–4. See also George Montandon, "Israël et le Grand Orient se vengent," *La France au Travail,* 15 Nov. 1940. In June 1941, the École d'Anthropologie banned him for good because of the first article; then in October 1941 Montandon tried to get reinstated. This time the École d'Anthropologie voted to postpone a decision. Montandon continued to use the title of professor at the École d'Anthropologie after his nationality was restored in July 1941. AMH/MS 15/3/Procès-verbaux/"Rapport du 3 juin 1941" and "Rapport du 31 octobre 1941."

[98] Weil, *How to Be French,* 116. On denaturalizations under Vichy, see also Weil, "Racisme et discrimination," 79–84.

[99] On Darquier de Pellepoix, see Carmen Callil, *Bad Faith: A Forgotten History of Family, Fatherland and Vichy France* (New York, 2010).

different authors commissioned by the occupiers.[100] In these early days, the Germans themselves were divided on how quickly to proceed with French Aryanization; but it is clear that Montandon was already at the disposal of those in Berlin who wanted immediate action. The pamphlet was, tellingly, divided into two parts. The first part was a "scientific" history and morphology of Jews; a second literary part discussed their "moral" traits and compiled quotations from famous French writers, only some of whom could be called anti-Semites. In part 1, Montandon distilled his earlier thesis on the evolution of a specifically Jewish "ethnie," whose racial subtype the science of anthropology could now diagnose despite centuries of racial mixing. Here, he introduced a new specious zoological notion previously absent from his scientific publications: a specifically but nevertheless subtle and variable Jewish *masque*—that is to say, "physical traits" acquired when a particular group intermarried (nose, lip, and eye shapes), which only "an expert" could be sure to identify correctly. In the end, because Jews showed no "consistent" cranial type or blood-type, the *masque* was the critical giveaway:

> But the faces speak more than the numbers. All, no matter what their measurements, no matter what their blood, have the Jewish *masque*. If you were shown them, without being told what they were, you would say: Those are Jews! The Jewish *masque* is, in short, what is most essential, most palpable, most blatant, most betraying, of the Judaic or Jewish [*juifu*] racial type.[101]

Part 2 was devoted to authors who had described in their works Jewish "moral traits." Montandon began with a quotation from Drumont describing the physical characters of Jews. He added pompously:

> These notes from Édouard Drumont agree perfectly with Professor Montandon's scientific exposé. But the portrait would remain incomplete if we did not add the moral description of the Jew. Such a description exists, from our best authors.[102]

The list of "our best authors" that followed included, predictably, Drumont and Céline, but also Renan, whose historical positivism, at least early on, could be

[100] Dr. George Montandon, *Comment reconnaître le juif* (Paris, 1940). The other three pamphlets were Dr. Fernand Querrioux, *La médecine et les juifs*; Lucien Pemjean, *La presse et les juifs depuis la révolution jusqu'à nos jours* (Paris, 1941); Lucien Rebatet [François Vinneuil, pseud.], *Les tribus du cinéma et du théâtre* (Paris, 1941). Their publisher, Robert Noël, was Céline's, too. On the wartime records of writers and editors in France in general, see Gisèle Sapiro, *La guerre des écrivains, 1940–1953* (Paris, 1999).

[101] Montandon, *Comment reconnaître le juif*, 17.

[102] Ibid., 27.

seen to have anti-Semitic undertones. Voltaire was there, too, whose enlightened criticism of religious fanaticism was at moments openly anti-Semitic. Others, such as Zola, are harder to explain.[103] It appears that Montandon was provocatively trying to recast the French literary canon in the clear light of "science"; only those authors who identified the ostensible threat posed by Jewry and reflected French "ethnicity" deserved a place, making ethnoracism Montandon's governing principle of selection. Romantic populists (à la Michelet) and *terroir* or nativist writers (Mistral, a founder of the association Félibrige, which was dedicated to reviving the Occitan language) were mixed in with authors interested in the aristocratic and Catholic traditions of France (O. Havard, La Tour Du Pin), or those who wrote about the Merovingians and the Ancient Constitution (Thiers); to all of these more famous authors were added various riffraff who had made a career out of anti-Semitism. The selections that followed repeated traditional stereotypes about Jewish cupidity, but they also included a long section on the sinuous forms of Jewish solidarity, which were destroying from within *l'ethnie française* (a term used by none of the authors cited except Montandon himself).[104]

Montandon's pamphlet would inform a second German-sponsored initiative, with which he was also associated: the exhibition "The Jew and France." This exhibit ran in Paris's Palais Berlitz from September through December 1941 before traveling through the rest of France and featured many French as well as German materials. The SS-funded Institut d'Étude des Questions Juives organized the exhibit, whose mission was to prepare opinion for the final "cleansing" of Europe in general, and France in particular, of its Jews.[105] The exhibit explained that an overexposure of Jews in film and advertising had rendered them invisible to most French. The person on the street thus had to learn to recognize Jews, and to accept the idea that France's future was now a European Jew-free one—a goal that required visual cues to be "successful." The first gallery was entitled "Europe gets rid of its Jews." The final section of the exhibit reprised this theme by listing French anti-Jewish legislation alongside comparable laws in the rest of Europe.[106] Included was

[103] Ibid. The authors included were "G. Batault; Petrus; Borel; Capefigue; L.-F. Céline; Édouard Drumont; Oscar Havard; René Gontier; La Tour du Pin; Jules Michelet; Mistral; Guy de Maupassant; L. de Poncins; Ernest Renan; J. et J. Tharaud; Thiers; Toussenel; Voltaire; De Vries de Heekelingen; Émile Zola; et de nombreux auteurs Juifs."

[104] Montandon, *Comment reconnaître le juif,* 46.

[105] The Institut d'Étude des Questions Juives (May 1941) was the propaganda branch of Vichy's bureau for Jewish affairs, the Commissariat Général aux Questions Juives (March 1941).

[106] The exhibit took up two floors. The first floor included three sections: one on "The fundamental basis of Jewry," "Origins: A strange mixture of diverse peoples," and "The changing aspect [*le changement d'aspect*] of Jews everywhere"; a second one, four times as large as the first, on "The history of Jews in France and the rest of the world" and the role of Jews in "medicine, economy, justice, press, army, colonies, painting, music, theatre, film, politics"; and a third, smaller section devoted exclusively to Jews in French cinema. The more cramped lower level contained a section on the Talmud and a more expansive chronicle of "Jewish-Bolshevism." Jean Marquès-Rivière, "Exposition Le Juif et la France au Palais Berlitz" (Paris, n.d. [1941]).

a grotesque oversized head with exaggerated so-called "Jewish traits," accompanied by a small "scientific" display case with plaster casts of noses, eyes, ears, and mouths. Also prominent was a huge photograph of Léon Blum, as well as other "French faces." A wall caption that read "Learn to discern a Jew from a French man" led to a life-size poster of Pierre Mendès-France on which was written "French? No!! Jew!" There were similar posters of other "European" figures, with comparable captions: "Russian? No!! Jew!" "German? No!! Jew!"[107] Montandon noted in the margin of a copy of the press releases for the exhibit: "At last, they are awakening." The comment appeared next to a list of "recommended works" for interested readers, in which his *Comment reconnaître le juif* was featured.[108]

As Raymond Bach has argued, the essential message of the exhibit was clear—that the Jew was incapable of assimilating to other peoples. Borrowing from Sander Gilman, Bach points out the central paradox here: Jews were represented as invisible and thus a danger to the *ethnie* wherever they lived, because of their strange power to infiltrate (hence the need to learn to recognize them). Yet they were also clearly identifiable, as the exhibit nauseatingly repeated. The paradox is easily explained: the point of the exhibit, of course, was to create (or reinforce) in the public mind the stereotypical Jew who needed to be eliminated, not to identify "real" ones.[109] The Paris Préfecture de Police had already taken care of this, since its files contained the names and addresses of some 200,000 Jews in February 1941.[110] A year later, under German pressure, Montandon was appointed to the Institut d'Étude des Questions Juives to help adjudicate the more "difficult" cases, and he was soon delivering medical certificates of "nonbelonging to the Jewish race." The model for these certificates once again came from Germany, where two renowned anthropologists, Eugen Fischer at the Kaiser Wilhelm Institute of Anthropology, Human Heredity, and Eugenics in Berlin and Otmar Freiherr von Verschuer at the Institute of Hereditary Biology and Race Biology at the University of Frankfurt, had started issuing them in the late 1930s.[111] Both men had enjoyed distinguished international careers under Weimar and subsequently reoriented their research to fit Hitler's racial goals. Eugen Fischer had traveled to Paris to give a talk at the German Institute (attached to the

[107] Ibid.

[108] CDJC/XCIX-5/*Bulletin de l'Institut d'Étude des Questions Juives* 3, 29 May 1941. The press releases in question were the bimonthly bulletins issued by the Institut between May and July 1941, with recommendations for "anti-Jewish action." Montandon's archives contain seven issues.

[109] Raymond Bach, "L'identification des juifs. L'héritage de l'Exposition de 1941, 'Le Juif et la France,'" *Revue d'Histoire de la Shoah* 173 (2001): 176.

[110] Mitchell, *Nazi Paris*, 39.

[111] Liliane Crips, "Les avatars d'une utopie scientiste en Allemagne. Eugen Fischer (1874–1967) et l' 'hygiène raciale,'" *Le Mouvement Social* 163 (Apr.-Jun. 1993): 18.

German embassy) in the early summer 1941, just after the 21 June opening of the Soviet front, on "the problem of race and racial legislation in Germany."[112]

A description of a typical "racial" examination by Montandon appeared in the collaborationist newspaper *Paris-Midi* in September 1942, suggesting that his particular form of "scientific" collaboration was well publicized. The erudite Prof. Montandon, the reporter Yann Moran wrote, was often called before the courts, as "the only French expert" capable of judging "correctly the ethnic characteristics of a defendant." According to this expert, Moran continued, race obeys the laws of heredity while ethnicity is made up of somatic and mental factors, as well as language, religion, and customs. In Montandon's words, "Heredity is transmitted, tradition is communicated." Montandon then explained to Moran that until he had come on the scene, anthropology had remained an incomplete science, because it had lacked a sure "investigatory procedure" for "diagnosing" Jews. Montandon had remedied the gap, but the interviewer would understand "if he did not explain everything. . . . Jews are lying in wait, and must not be granted the secrets of my method." But he would "allow some clues." First, Montandon claimed, there was the "science of names," then "morphology"; finally, circumcision was "an important consideration." Had not he, Montandon, known "a whole dynasty of Jews" who had convinced "Aryans" that for hygienic reasons their circumcisions, too, should be done in the ritual manner—thus trying to "submerge" their difference? Montandon hinted, however, that his examinations of circumcisions "under black light" always revealed the truth. He "couldn't say more." When Moran asked whether, given the fact that the courts were condemning individuals on the sole basis of biological expertise, the latter was infallible, Montandon replied firmly that "while no one was infallible," the chance of making a mistake was "infinitesimal."[113]

A REORDERING OF FRENCH SCIENCE?

Montandon's ambitions under the Occupation were not limited to applying his "science." He actively worked with the Germans to take control of France's existing ethnological institutions of higher learning; failing that, he sought to erect new ones, also with German help at the highest levels. From May 1941 to September 1942, Montandon was in regular contact with the "Schools and Culture" Fourth Group, a subdivision of the Militärbefehlshaber in Frank-

[112] Eugen Fischer, *Le problème de la race et la législation raciale en Allemagne* (Paris, 1942).
[113] Yann Loranz, "Le problème juif est ethnique, explique le professeur Montandon," *Paris Midi,* 9 Sept. 1942. I thank Vicki Caron for bringing this article to my attention.

reich (German Military Command) created by Hitler to govern occupied France. All divisions of the Military Command were housed in the Hotel Majestic on the Avenue Kléber in Paris; the Fourth Group was in charge of monitoring the politics of French academics in the occupied zone.[114] Montandon turned to the Germans originally to have his nationality restored, but soon he was discussing other matters. Like other collaborators working with the Fourth Group, he had always been convinced that the wrong people had a lock on higher education in France, and he quickly determined that Vichy was proving as negligent in the matter as the regime it had replaced.[115] In another Institut d'Étude des Questions Juives newsletter from summer 1941, an organogram had illustrated how Jews "controlled" parliament, industry, the arts, transportation, and commerce. Montandon had written in the margins: "and also education."[116] As a collaborator, he would denounce individual Jews and Freemasons in the fields closest to his expertise—including at the Faculté de Médecine.[117] But in the fall of 1941, he was especially concerned with the fate of the single most important chair in anthropology in France, Rivet's at the Muséum, and its associated laboratory, the Musée de l'Homme. Was not he, Montandon, the only ethnologist in France truly conversant in physical and cultural anthropology, bones and artifacts, and thus best qualified for the job, which had been vacant since April? As proof, he could offer not only his past scholarly production, but his position as scientific director of a new journal that had begun publishing earlier that year, *L'Ethnie Française*, funded by

[114] Montandon was also in touch with the German Institute. See, for example, ANF/AJ40/567/Dossier 9/George Montandon à Dr. Dahnke, 8 Jan. 1942, in which Montandon discusses his consultation with Dr. Rilke's representative at the German Institute. On the complicated organization of German authorities in Paris, including the respective roles of the Schutzstaffel (SS), the Militärbefehlshaber in Frankreich (MBF) and its Fourth Group, and the German embassy under Otto Abetz in overseeing the purge of undesirable elements in the academy in the first two years of the war, see Mazliak and Shafer, "German Occupation of France," 591–95 and 598–605. The occupiers wanted all Jews to be purged from the university. Non-Jews considered suspect politically, whether on the Right or the Left, posed a greater dilemma, because the various German authorities could not agree initially on the need for their removal. The Germans were always concerned about the effect on public opinion of too much interference in intellectual life; at the same time they relied on spies like Montandon to orient them in a world they did not know well. On the Occupation and the university more generally, see Singer, *Vichy*; and Burrin, *France under the Germans*, chap. 20.

[115] For another case of similar collaboration, see Mazliak and Shafer, "German Occupation of France," 605–8.

[116] CDJC/XCIX-6/*Bulletin Bi-mensuel de l'Institut d'Étude des Questions Juives* 4, 4 June 1941, 5.

[117] Montandon regularly fed the occupiers information on the continued presence of Jews in the ranks of the Medical Faculty's *chargés de cours*, *maîtres de conférence*, and full professors, on which he was very well informed. The full professors deliberately refused to declare the three chairs formerly occupied by Jewish colleagues vacant, protecting them for their holders' return. Bénédicte Vergez has argued that Montandon hoped through such denunciation to acquire one of those chairs for himself. See Bénédicte Vergez, "Internes et anciens internes des hôpitaux de Paris de 1918 à 1945" (Thèse de doctorat, Institut d'Études Politiques, 1995), 413–16, 434–44. I am indebted to Julie Fette for bringing to my attention Vergez's references to George Montandon.

the German Institute and devoted to "everything that touches *anthropologie au sens large.*"[118] Given this "competence," it must have seemed a simple matter of playing his cards right in order to secure Rivet's chair for himself.

Within six weeks of contacting German officials, Montandon had been approved as someone with whom the occupiers could work, and his denaturalization was overturned.[119] Eugen Fischer was consulted on Montandon's politico-scientific credentials and pronounced him to be "one of the most important contemporary anthropologists in the Latin countries. . . . I would consider it a pity if Montandon just disappeared."[120] By then, the Muséum had begun preparations of its own to elect Rivet's replacement, according to the usual rules: a slate of three candidates, on whom the professors would vote, with subsequent ratification by the French Académie des Sciences.[121] Montandon thus had no time to lose. In early September 1941 he wrote to Vichy's then education minister, Jérôme Carcopino, offering his services "dans le domaine scientifique."[122] In a follow-up letter he made clear that he was thinking of "the organization and directorship of the Musée de l'Homme."[123] When Carcopino rebuffed him, Montandon provided his principal German contact at the Hotel Majestic, Dr. Dahnke, with an annotated list of the candidates for the chair: Paul Lester, a "nonentity"; Henri Vallois, a physical anthropologist "with no knowledge of ethnography"; and Jacques Millot, a physiologist who had no knowledge of either anthropology or ethnography, and who would serve, if elected, as a "surrogate" for Rivet (as well as being Vichy's candidate). But he added there was a fourth unofficial candidate: himself, who could "access the chair directly"—if the Germans wished.[124]

Apparently the Germans did not wish, and so once again, Montandon took matters into his own hands. On 11 October, six days before the scheduled election, he sent an anonymous first draft of a soon-to-be-published

[118] "Notre but," *Ethnie Française* 1 (March 1941): 2.

[119] ANF/AJ40/567/Dossier 9/Undated, untitled (apparently lacking cover page) document signed "I. A." concerning Montandon's loss of citizenship. The Germans investigated Montandon's past, and then requested that Ferdinand de Brinon, Vichy's Délégué Général du Gouvernement Français dans les Territoires Occupées, take care of the matter. Montandon's nationality was restored on 3 Aug. 1941, in exchange for "collaboration." ANF/AJ40/567/Dossier 9/G. Montandon à Dr. Dahnke, 4 Aug. 1941.

[120] ANF/AJ40/567/Dossier 9/Eugen Fischer à Dr. Dahnke, 2 July 1941. This dossier containing Montandon's correspondence with the MBF is extensive, with Montandon writing on a variety of anthropological questions in addition to the ones cited below; there are several authorizations as well for meetings with his "handlers" at MBF headquarters at the Hotel Majestic.

[121] The Académie des Sciences was an elected body of France's most eminent scientists; it is one of the five Académies in the Institut de France.

[122] ANF/AJ40/567/Dossier 9/George Montandon à Jérôme Carcopino, 4 Sept. 1941.

[123] ANF/AJ40/567/Dossier 9/George Montandon à Jérôme Carcopino, 18 Sept. 1941.

[124] ANF/AJ40/567/Dossier 9/George Montandon à Dr. Dahnke, 18 Sept. 1941.

article to the director of the Muséum, "confidentially and as a warning." The draft was entitled "Grandeur and Decadence of the Muséum National d'Histoire Naturelle," and the cover letter was signed anonymously by "the president of the academic association for the revival of French science."[125] It began by stating that at a time when "the study of problems relative to the races and the *ethnies* of the world, and the role that these questions play in the life of the New Europe," behooved scientists to collaborate, France's greatest public institution in the realm—the Musée de l'Homme—had become under Rivet's direction "a nest" of Jews, Freemasons, foreigners, recently natural-ized citizens, and other parasites who contributed nothing to science, and certainly nothing to the study of races. The article then identified by name the foreigners, recently naturalized Jews, and Communists still working at the museum; everyone else on the staff was accused of being either a trusted friend or a lover of one these employees. Finally, it listed the three official candidates for the chair, before spending several paragraphs denigrating the current front-runner: Jacques Millot was, Montandon claimed, in fact the "Judeo-masonic-sorbonnard" candidate, supported more for his political credo than for any competence in ethnology. Under Millot the status quo would be preserved, when France needed, Montandon intimated, to embrace ethnoracist science.

If the above summary captures the gist of this letter, several other points are nevertheless worth noting. First, Montandon added a revealing genealogy of the human sciences. He insisted that France was the first modern country to have placed the anthropological and ethnographic sciences on a practical foundation, thus revealing their importance for the future of all humanity: "One only has to cite the names of de Quatrefages, Hamy, Lapouge, Gobineau, etc." Second, it criticized Griaule's plan to sunder the museum in two. Third, it specifically criticized Millot as the candidate of Étienne Rabaud, author of a book on the human races that had failed to take account adequately "of the racial problems in Europe and the world today." And the letter ended with a three-tiered threat: it was in the interest of the Muséum to elect a truly qualified candidate, since the appointment by tradition had to be ratified by the Académie des Sciences; the French government would watch over the nomination of future functionaries in the national education system, making sure that past errors did not repeat themselves; and finally, the "stubborn de-fenders of certain candidates" should not "scorn" the occupying powers, who

[125] MNHN/Ms 2959/Correspondance Arambourg/pièce 5866/Le Président du G.A.R.S.F. à "Cher collègue," 11 Oct. 1941, no. 211. Montandon acknowledged authorship to the Germans; ANF/ AJ40/567/Dossier 9/George Montandon à Dr. Dahnke, 14 Nov. 1941.

had recently made arrests at the Musée de l'Homme.[126] Perhaps Montandon's poisonous pen worked. When the Muséum election occurred on 17 October, Vallois received only four votes, and Millot ten.[127] But when the Académie des Sciences voted on the same two candidates, its members split down the middle. Carcopino then used his authority to appoint Vallois to the chair.[128] Montandon's letter was published with the results of the election in a shorter version under the title "Le Musée de l'Homme Judéo-Maçonnique" in the extreme right-wing newspaper *Au Pilori* on 13 November 1941. At practically the same moment, Montandon was using the columns of the anti-Semitic daily *Je Suis Partout* and his contacts at the Fourth Group to denounce the Jewish professors at the Faculté de Médecine.[129]

German records show that after seeking to capture Rivet's chair, Montandon made one more concerted attempt to align existing French ethnological institutions with superior German "science." This time, however, he chose a different tactic: manipulating the division that had long existed between learned societies associated with the École d'Anthropologie, and those founded by Rivet and Mauss, to his own advantage. Montandon proposed to the Germans that the Société des Océanistes, of which he had been a founding member in 1937, should merge with its rival, the 1938 Centre d'Études Océaniennes at the Musée de l'Homme, which still had no legal standing. If the occupiers authorized the merged society to meet at the Musée de l'Homme and put Montandon in charge, he could keep the occupiers informed of goings-on at the museum, "which was not yet steeped in the new [i.e., German racist] mentality."[130] At the same time Montandon began spying on the meetings of the Société d'Anthropologie, which Vallois had headed since 1938. The Germans had authorized the Société d'Anthropologie to move its meetings to the Musée de l'Homme in 1941. Montandon, however, alerted his German contacts that a double game was in fact going on. Vallois was secretly allowing the Société d'Anthropologie and its longtime rival, the ostensibly unreliable

[126] See also Montandon's report of the voting results to the MBF, ANF/AJ40/567/Dossier 9/George Montandon à Dr. Dahnke, 5 Nov. 1941. Both the first version and the published version of Montandon's anonymous letter prompted an inquiry by Vichy authorities into the Musée de l'Homme's personnel. See ANF/F¹⁷/13385/M. le Directeur du Muséum à M. le Secrétaire d'État à l'Enseignement National et à la Jeunesse, 12 March 1941, no. 13.411 and accompanying note, signed by Louis Germain. This same note was also in German. André Schaeffner wrote Rivet in September 1944 that it was after the publication of this article that Debora Lifszyc "began to be harassed." AMH/2 AP 1 C/André Schaeffner à Paul Rivet, 29 Sept. 1944.
[127] MNHN/AM 73/Procès-verbal de l'Assemblée des Professeurs du Muséum, 17 Oct. 1941.
[128] Jean-Pierre Bocquet-Appel, "L'anthropologie physique en France et ses origines institutionnelles," *Gradhiva* 6 (1989): 30–32.
[129] G. Montandon, "'Faculté' toujours enjuivée," *Je Suis Partout*, 25 Oct. 1941. Cited, along with his correspondence with the MBF regarding medical faculty, in Vergez, "Internes," 539 nn. 196 and 198.
[130] ANF/AJ40/567/Dossier 8/G. Montandon, "Die Angelegenheit des Société des Océanistes betreffend," n.d. Montandon wrote repeatedly about the Society in late 1942 and early 1943. See, in the same file, G. Montandon à Dr. Rilke, 9 Dec. 1941; and G. Montandon à Dr. Rilke, 18 Feb. 1942.

and unauthorized Institut Français d'Anthropologie—founded before World War I by Rivet and Mauss among others—to meet together. As proof, he provided an annotated organogram of the 18 March 1942 session of the Société d'Anthropologie to Dr. Dahnke at the Fourth Group.[131] All the ethnological "contenders" were in attendance (with individual affiliations written in), along with several people whose names were not indicated. Montandon was sitting next to Mauss, and the latter was labeled "Jewish"; Rivet's two sisters were sitting in front of them, and Griaule right behind them; Vallois, Millot, and Lester were there, too, as were Maurice Leenhardt and his wife. This time the members of the Fourth Group nibbled: they soon asked their superiors to consider withdrawing permission for all future meetings of the Société d'Anthropologie, because "Professor Montandon has the objective of raising a new ethnological and anthropological society under his management." While the Germans recognized that Montandon was motivated in part by professional jealousy, "such a new organization would nevertheless be welcome" because Montandon would guarantee work "done in the German way of thinking."[132]

Was this a reference to something grander in the works than a revamped Société des Océanistes—a university chair perhaps? What else, exactly, was Montandon proposing to the Germans in early summer 1942, in the anthropological domain? The record here becomes frustratingly thin. In June 1942 Montandon traveled to Berlin and met with Fischer, with whom he discussed "a renovation of the present state of affairs" regarding race science and race hygiene in France.[133] Consulted on the matter by the German authorities, Fischer reported back to Paris in July that he supported Montandon's proposal for "a new anthropological institute in France."[134] The details of the proposal are not given, but Fischer's comments are revealing. Vallois, he wrote, was pro-German before the war and the first scientist to initiate an exchange of journals after the defeat. But he "cannot give to the young generation a race science education in the modern sense. His work is pure morphology. The racial science questions of race and culture and race hygiene are not at all interesting to him." Germany needs "a rejuvenation of the better French traditions and a dismissal of the old school. . . . I for my part wish . . . to underline the importance . . . of Montandon's plans."[135] The German authorities went on to refer Montandon's proposed institute to the "cultural political expert of the German embassy,"

[131] ANF/AJ40/567/Dossier 8/G. Montandon à Dr. Dahnke, "Der beiliegende Plan bezicht sich auf die Sitzung von Mittwoch de 18. März 1942."

[132] ANF/AJ40/567/Dossier 8/R. [Dr. Rilke] à Group V 2, 14 May 1942.

[133] George Montandon, *La France au Travail*, 10 June 1942.

[134] ANF/AJ40/467/Dossier 8/Eugen Fischer, "Rassenkunde und Rassenhygiene in Frankreich betreffend," 29 June 1942.

[135] ANF/AJ40/567/Dossier 8/"Plan zur Neuorganisierung eines anthropologischen Institutes durch Professor Montandon," 5 Aug. 1942.

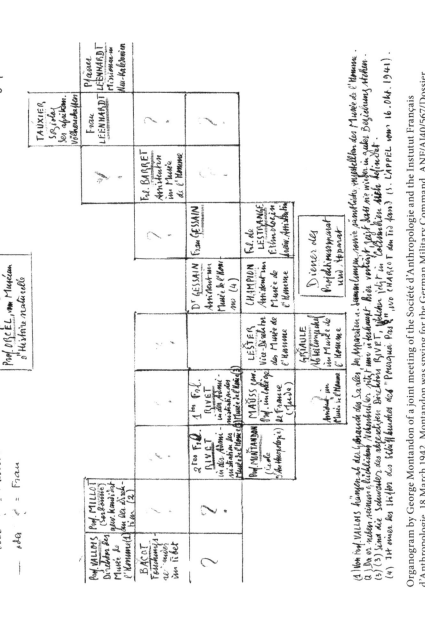

Organogram by George Montandon of a joint meeting of the Société d'Anthropologie and the Institut Français d'Anthropologie, 18 March 1942. Montandon was spying for the German Military Command. ANF/AJ40/567/Dossier 8/G. Montandon à Dr. Dahnke, "Der beiliegende Plan bezieht sich auf die Sitzung von Mittwoch de 18 März 1942."

who decided that, given the political character of the proposal, further consultation was needed.[136] The file was resubmitted to the embassy on 1 September 1942; Montandon contacted Abel Bonnard, Carcopino's more pro-German successor as Vichy education minister, in October, asking him for an interview to discuss the "project for the renewal of anthropology" that he had submitted in June.[137] And here the paper trail ends. Reading between the lines, it seems plausible that the occupying authorities had only been using Montandon to figure out whether the recently elected Vallois posed any real security threat, and not—as Griaule feared—to impose German racial science on the French university, which the professoriate would surely resist. In the end, Darquier de Pellepoix, Xavier Vallat's successor at the Commissariat Général aux Questions Juives, appointed Montandon director of a "private" Institut d'Étude des Questions Juives et Ethnoraciales in 1943, with six teaching chairs attached. Few attended these courses. Montandon was in "close contact" with the German intelligence services in Paris from 1943 on.[138] The last issue of *L'Ethnie Française* appeared in April 1944. With the tide turning in favor of an Allied victory, Montandon spent more and more of his time assessing "dubious cases" of Jewishness, often at Drancy, the major transit camp outside Paris for Jewish deportees. Along with René Martial and Georges Mauco, Montandon's name appeared on the list of international experts who were to be invited to Alfred Rosenberg's Pan-European anti-Jewish congress scheduled first to be held in Cracow in January, then July, 1944.[139]

Was Griaule therefore wrong to have seen in Montandon a possible rival for the chair in ethnology in October and November 1942? Militarily these had been fraught months. Two days after the Vichy decree creating Griaule's and Labroue's chairs, the Allies had landed in North Africa. Local authorities there had switched sides from Vichy to the Allies, and on 10 November Hitler retaliated by invading the unoccupied zone. Montandon had been an accredited member of France's ethnological community before the war, and there he was still, attending the meetings at the Société d'Anthropologie, as well as traveling to Germany, where several prominent academic ethnologists were collaborating with the Nazi racial state.

Under these circumstances, was it not possible that Montandon, given his claim to be both an anthropologist and an ethnographer—an ethnologist in fact, as Rivet had defined the field—could have been appointed through German intervention to the new Sorbonne chair in ethnology in 1942? On the

[136] Ibid.
[137] ANF/F¹⁷/13342/George Montandon à Abel Bonnard, 5 Oct. 1942.
[138] Billig, *L'Institut d'étude des questions juives*, 186. The intelligence service in question was the Sicherheistdienst, or SD.
[139] Max Weinreich, *Hitler's Professors* (New York, 1946), 225.

other hand, scholars in the field have underscored that despite the unquestion-able latent anti-Semitism in all French professional milieus at this time, uni-versity professors in Vichy France elected no overt racists of the likes of Henri Labroue and René Martial to vacant chairs on their own. Not only did students and faculty boycott Labroue's and Martial's inaugural lectures, but the profes-sors at the Faculté de Médecine immediately retired Martial on the grounds that he had reached the university age limit of seventy; the Faculté des Lettres professors and students would no doubt have shunned Montandon as well, had he been appointed. Griaule thus faced the dilemma of whether to accept a brand-new professorship of use to the empire, and which had been voted by his senior colleagues in a different political context, but which was also directly linked with Vichy's rapidly escalating anti-Semitism. The arrest and deporta-tion of his own "team" member Deborah Lifszyc for being Jewish should have left him no illusions about where Vichy was headed. In retrospect it is hard not to be shocked by the cavalier way in which Griaule acted throughout the first two years of the war, failing to register that the occupiers and Vichy were manufacturing new "scientific" orthodoxies to justify a politics of extermina-tion that brooked no dissent, and squandering a meaningful chance to resist by removing himself as a candidate. Reckless as always, Griaule either did not care about or refused to see the dangerous implications of his actions for his compatriots, his nation, or the future of free and open scientific inquiry itself.

Perhaps we will never know what Griaule was actually thinking in No-vember 1942, when he decided to become the Sorbonne's first professor of ethnology in a Europe being remade in the image of Aryan purity. Montan-don, however, left no doubt about his aspirations. In the columns of L'Ethnie Française after Griaule's position was announced, he lamented that the chair at the Faculté des Lettres, which should have been used for "diffusing the teaching of ethnoracial science" to the young, had gone to a man who had no notion, either old or new, of his subject.[140] In a second article entitled "Les gris-gris de Griaule" which appeared in the vicious newspaper Je Suis Partout after Griaule's first lecture, he undermined the new professor more subtly by calling into question Griaule's African and colonial credentials. The article reprinted claims that Griaule had made in 1935 and 1936 when Italy invaded Ethiopia, in which this "Ethiopian expert" repeatedly predicted Italy's defeat. Montandon signed off noting that once again "the very learned M. Griaule" had an audience, thanks to his new university position.[141]

[140] "Échos Universitaires," *Ethnie Française* 7 (January 1943): 7.
[141] G. Montandon, "Les gris-gris de Griaule. Une brillante rentrée," *Je Suis Partout* 597, 15 Jan. 1943. The use of the racist term "gris-gris" was deliberate; it was colonial slang for the talismans that "na-tives" were believed to always wear around their necks.

In June 1944, the Normandy beach landings and the growing Resistance movement brought more suffering to many French in the short term: new Allied air raids, renewed combat, and a spontaneous and violent settling of scores. Several members of France's community of ethnologists died in the last year of the war, while others struggled to return to "normalcy"; still others continued working, as they had throughout the war. On 20 July 1944, four months after joining his battalion to fight for his country, Charles Le Coeur was killed in action in Italy. Bernard Maupoil died of exhaustion on 15 December 1944 in the labor camp of Hersbruck. His two theses had been published in 1943, and after a defense in absentia, the University of Paris conferred a doctorate on him posthumously in 1946. Sometime in late 1944, Michel Leiris learned of the death of Deborah Lifszyc, gassed at Auschwitz either upon her arrival there in 1942 or later, in 1943.[142] A conversation with Céline, recorded in June 1944, indicated that Montandon had no illusions left regarding the outcome of the war or the New Europe, and that he was planning to commit suicide at the appropriate moment. He would never get the chance: in early August 1944, members of the Resistance rang the doorbell at his home in Clamart, killed his wife, and fatally wounded him. He was evacuated to a hospital in Fulda, Germany, where he died on 30 August.[143]

Those who had managed to flee, or to survive their brutal incarcerations, also made their way back to France one by one, to mourn their dead and rebuild. Rivet reclaimed his chair at the Muséum from Vallois on 22 October 1944.[144] Institut d'Ethnologie students Jeanne Cuisinier and André Leroi-Gourhan defended their theses in 1944, Cuisinier on the Muong people of the Vietnamese highlands, Leroi-Gourhan on the tools of the prehistoric peoples of the Pacific Rim.[145] Soustelle briefly resumed his post as assistant director of the Musée de l'Homme, before rejoining de Gaulle in July 1945 to continue a second career in politics. Leroi-Gourhan would replace him at the Musée de l'Homme. Yvonne Oddon and Germaine Tillion returned to France in 1945, Oddon to her library at the Musée de l'Homme, Tillion to the Centre National de la Recherche Scientifique to research the war crimes that she and others had endured. Tillion wrote to Mauss in September 1945, shortly after

[142] Prijac, "Déborah Lifszyc," 169.

[143] Nicolas Chevassus-au-Louis, *Savants sous l'Occupation. Enquête sur la vie scientifique française entre 1940 et 1944* (Paris, 2004), 183. The author interviewed Montandon's daughter about the exact circumstances of her father's death, which like much else in his life remain unclear.

[144] In a December 1944 meeting of the Institut d'Ethnologie council, Paul Rivet noted that among former students (here he was counting all certificate holders, not just *doctorants*) twelve were dead, fifteen had been arrested, and ten were still deportees. AMH/IE/2 AM 2/A1/Procès-verbal du Conseil d'administration, 16 Dec. 1944.

[145] Jeanne Cuisinier, *Les Muong. Géographie humaine et sociologie—Ouvrage publié avec le concours de la recherche scientifique coloniale* (Paris, 1946); and André Leroi-Gourhan, *Archéologie du Pacifique-nord. Matériaux pour l'étude des relations entre les peuples riverains d'Asie et d'Amérique* (Paris, 1946).

arriving in Paris, that as soon as she had been evacuated from Ravensbrück to Sweden, "I immediately sent a telegraph to get your news." It was a great consolation to learn that he had escaped deportation, "miraculously." "I neglected my friends," she reported, "but I was just as busy paying attention to my enemies. . . . Now I'm trying to rest."[146]

By 1945, however, Mauss was a shadow of his former self. His *Manual of Ethnography*, compiled and edited with help from Denise Paulme, would be his last completed work.[147] All of his students' work was amply present in its footnotes. When Claude Lévi-Strauss returned from New York in 1948 to defend his thesis, *The Elementary Structures of Kinship*, Mauss's lucidity and health were fast ebbing. The *maître* died in 1950, the same year that Rivet retired. Lévi-Strauss was appointed to Mauss's old chair at the École Pratique, the one Charles Le Cœur had once dreamed of having, while the sixty-nine-year-old Vallois resucceeded Rivet at the Muséum.[148]

Marcel Griaule (like Jean-Paul Lebeuf and Georges Henri Rivière) was cleared of charges of collaboration and returned to the Sorbonne in 1945, where he would teach until his death in 1956. The split between Michel Leiris, Denise Paulme, and André Schaeffner, on the one hand, and Griaule, on the other, lingered.[149] Griaule would become a tireless defender of "authentic" African civilizations and a councilor (*conseiller*) of the new Union Française (as the French empire was renamed after the war).[150] Leiris would soon join Métraux, Lévi-Strauss, and other scientists who, in the wake of the Holocaust and the Occupation, sought to clarify the proper relationship between politics and science, for themselves and for international opinion. Shocked not only by the genocide, but also by the apparent ease with which racial science had been co-opted to a politics that killed, many intellectuals and "race experts" felt the need to respond, collectively and publicly, as a professional community. The result would be the United Nations Educational, Scientific and Cultural Organization (UNESCO) race statement of 1950—the first political rebuke to scientific racism issued by an international body.

[146] IMEC/Fonds Marcel Mauss/MAS 12.63/Germaine Tillion à Marcel Mauss, Sept. 1945.

[147] Fournier, *Marcel Mauss*, 748–50.

[148] Soustelle was Rivet's preferred candidate for his chair in 1950, but since he had no training in anatomy, his chances of being elected at the Muséum were slim. AMH/2 AP 1 D/Paul Rivet à M. le Directeur du Muséum, Dec. 1949.

[149] Leiris resigned from the Société des Africanistes at its first meeting in 1944, after a public confrontation with Griaule. Aliette Armel, *Michel Leiris* (Paris, 1997), 440. He published his fieldwork from the Mission Dakar-Djibouti in 1948 for a diploma from the École Pratique, under the title *La langue secrète des Dogon de Sanga*. As Andrew Apter has argued, the work was both in dialogue with Griaule's earlier publications on the Dogon and a muted indictment of Griaule. Leiris was haunted by his memories of the Occupation, the loss of Deborah Lifszyc, and his growing unease with colonialism—already manifest in *L'Afrique fantôme*. Apter, "Griaule's Legacy," 104.

[150] For an assessment of Griaule's postwar work, see, in addition to works cited in chapter 5, note 37, Tai, *L'anthropologie française*, 212–19.

EPILOGUE

The abrupt departure of the Militärbefelshaber in Frankreich, including its Fourth Group, from the Hotel Majestic in Paris in the summer of 1944 did not end the association of that building with the race question. By a strange irony, just two years later the Preparatory Commission for UNESCO moved from London into this same hotel, where the organization's headquarters would reside until 1958. In the wake of the Holocaust, one of UNESCO's first initiatives was to mobilize scientists internationally to condemn racism.[1] In December 1949 a group of race experts met at the Majestic Hotel to draft a statement on the scientific facts that could (or so it was believed at the time) remove race prejudice. Several French ethnologists were involved in this landmark initiative, which quickly grabbed world headlines.

UNESCO's interest in educating people everywhere against racism directly reflected the optimistic "one world" sentiment that prevailed at the end of World War II, and had led to the founding of UNESCO in the first place. In November 1945, the Conference of Allied Ministers of Education (which had been meeting since 1942) hammered out UNESCO's charter in London. The overall purpose of the organization was "to contribute to peace and security by promoting collaboration among the nations through education, science, and culture in order to further universal respect for justice, for the rule of

[1] This program in turn was of a piece with the landmark adoption of the Universal Declaration of Human Rights by the United Nations General Assembly in 1948, which required UN agencies, including UNESCO, to develop policies aimed at protecting ethnic and racial minorities. On the history of the Charter individual human rights movement that emerged in the 1970s, see Samuel Moyn, *The Last Utopia: Human Rights in History* (Cambridge, MA, 2010), prologue and chap. 3.

law, and for human rights and fundamental freedoms, which are affirmed for the peoples of the world without distinction of race, sex, language, or religion, by the Charter of the United Nations." Three objectives were proposed: to advance "mutual knowledge and understanding through all means of mass communication;" to "give fresh impulse to popular education and to the spread of culture" through increasing access to education; and to "maintain, increase, and diffuse knowledge" through "the conservation of the world's inheritance of books, works of art, and monuments of history and science."[2] Thanks to extensive lobbying by the French delegate to the 1945 meeting, the Conference agreed to headquarter the new organization in Paris.[3]

Julian Huxley, an influential antiracist biologist, served as UNESCO's first general director; the Mexican diplomat Jaime Torres Bodet succeeded him in 1948. Huxley set up UNESCO's Secretariat on the basis of professional disciplines, and program activities were grouped into staff departments representing education, the natural sciences, the social sciences, the humanities, and journalism. In 1949 the United Nations Economic and Social Council requested that the Department of Social Sciences convene "a commission of experts to draw up a statement defining the notion of race and setting out in clear and simple terms the present state of our knowledge on the oft-disputed problem of race equality."[4] Brazilian cultural anthropologist Arthur Ramos was initially put in charge of the meeting, but he died in late 1949 before the first deliberations could be published. In early 1950 UNESCO created a new division for the study of racial questions, and asked Alfred Métraux—a former student of Rivet and Mauss—to head it. Métraux would oversee the publication of UNESCO's first race statement.

When Métraux came on board, a small but impressively diverse international panel of cultural anthropologists, sociologists, and one biologist had already met in Paris to begin drafting the statement in question. The eight participants included three Jews (Claude Lévi-Strauss from France, Morris Ginsburg from Great Britain, and Ashley Montague from the United States), one African American (E. Franklin Frazier), one Brazilian (Luiz de Aguir Costa Pinto), one Indian (Humayun Kabir), one New Zealander (Ernest Beaglehole), and one Mexican (Juan Comas). No women sat on the committee. Their conclusions, made public in July 1950, listed among other major

[2] Article I, Constitution of the United Nations Educational, Scientific and Cultural Organization, cited in Michel Conil Lacoste, *The Story of a Grand Design: UNESCO 1946-1993* (Paris,1994), 450–51.
[3] Walter R. Sharp, "The Rôle of UNESCO: A Critical Evaluation," *Proceedings of the Academy of Political Science* 24:2 (January 1951): 251. See also William R. Pendergast, "UNESCO and French Cultural Relations, 1945–1970," *International Organization* 30:3 (Summer 1976): 453–83.
[4] Alfred Métraux, *American Anthropologist*, n.s., 53:2 (Apr.-June 1951): 298.

points, that the mental capacities of all humans were similar; that there were no superior or inferior races; that there was no evidence for either the existence of pure races, or for biological deterioration as a result of hybridization; that there was no correlation between national or religious groups and any race; that biological groups overlapped, so that no single trait could distinguish one group from another; that races constitute dynamic, not static groups, that reflect the evolutionary processes that lead to change over time; and that races are deciphered inside laboratories, not in society. Perhaps their most revolutionary claim was that "the biological fact of race and the myth of 'race' should be distinguished. For all practical social purposes 'race' is not so much a biological phenomenon as a social myth."[5] As Michelle Brattain has argued, this last clause was remarkable for implying that "race had once been one thing and now it was another"—a social constructivist perspective that is usually associated with the postcolonial turn in the academy in the 1970s, rather than the postwar moment.[6]

The claim that race was "a social myth," as we shall see in a moment, provoked a storm of controversy among certain biologists and physical anthropologists and would be dropped in a second UNESCO race statement issued a year later. Yet this claim would live on in another set of UNESCO antiracist publications from the early 1950s. As head of the new division studying racial questions, Métraux sought to disseminate the scientific data that he believed could fight racism through an even broader educational campaign. To reinforce the conclusions of the 1950 statement, he commissioned a series of more detailed—but still popularizing—pamphlets on different aspects of modern science and the race question. Social rather than natural scientists authored all but three of these pamphlets, and Métraux turned to his colleagues from the Musée de l'Homme, Claude Lévi-Strauss and Michel Leiris, to write two of them: *Race and Culture* (1951) and *Race and History* (1952).[7]

These pamphlets made clear that Métraux, Lévi-Strauss, and Leiris were not satisfied only to have the known facts about the heredity of traits and the unity of the species laid out by their colleagues in the natural sciences. The three ethnologists had another goal: to democratize science itself, by taking such consequential concepts as "race" out of the hands of experts alone, and asking public opinion to weigh in on a question upon which scientists

[5] UNESCO/SS/1, "Statement by Experts on Racial Problems," Paris, 20 July 1950.
[6] Brattain, "Race, Racism and Antiracism," 1413.
[7] Leiris, *Race and Culture*; Lévi-Strauss, *Race and History*. The other pamphlets were Otto Klineberg, *Race and Psychology* (Paris, 1951), L. C. Dunn, *Race and Biology* (Paris, 1951), Arnold Marshall Rose, *The Roots of Prejudice* (Paris, 1951), Juan Comas, *Racial Myths* (Paris, 1951), Kenneth Lindsay Little, *Race and Society* (Paris, 1952), G. M. Morant, *The Significance of Racial Differences* (Paris, 1952), and Harry Lionel Shapiro, *Race Mixture* (Paris, 1953).

disagreed. Observed differences between groups, Leiris and Lévi-Strauss argued, were the result not of inherited racial capacities but of cultural and social factors, themselves the effect of different paths of historical development. Ethnologists had not publicly argued this point in 1930s France, to combat either scientific racism or the racial science of many anthropologists in their midst. But the rise of Nazi Germany and the behavior of certain of their colleagues under the Occupation had awakened several ethnologists to the fact that the general science of man was not, in fact, neutral.[8] If ideologues under the Occupation had been able to harness the science of man to such devastating political ends, then ethnologists had a moral obligation to mobilize in return, in the name of the better science that they wished to advance. And not only ethnologists: the discovery in 2011 of an unpublished manuscript by the historian Lucien Febvre and his younger colleague François Crouzet, originally written in 1950 as part of the larger UNESCO initiative against racism, suggests that colleagues in allied fields were also attempting to come to terms with the race question. The title of their book, *Nous sommes des sang-mêlés. Manuel d'histoire de la civilisation française* (*We are all Mixed-Bloods. A Manual on the History of the French Civilization*), is revealing in and of itself.[9]

Here it is useful to turn to the first race statement, and the accompanying pamphlets written by Leiris and Lévi-Strauss. In 1950 UNESCO's race experts had made the following claim: "The scientific material available to us . . . does indicate that the history of the cultural experience which each group has undergone is the major factor explaining such [observed] differences." Leiris, in his 1951 pamphlet *Race and Culture* attempted to explain the primordial role of "culture" rather than "race" in human affairs. "Racism, overt or covert," he wrote, "continues to be a baleful influence, and the majority of people still regard the human species as falling into distinct ethnic groups each with its own mentality transmissible by heredity." The reason for this error, he insisted, was that we "all too often fail, ignorantly or willfully, to distinguish social heritage from racial heritage."[10] The differences between contemporary human societies, he continued, were cultural variations first and foremost, dependent on these societies' contacts with others throughout human history. All societies were dynamic, although some more than others, because of these interconnections. Current Western achievements were no greater than those of other peoples who had gone before them, and

[8] In the United States, on the other hand, Boas's student Ruth Benedict actively lobbied against racist anthropology during the war. Teslow, *Anthropology and the Science of Race*, chap. 5.
[9] The book sought to combat an essentialist view of French history. UNESCO rejected the manuscript for its series, but it finally appeared in print in 2012 with a postface by Denis Crouzet and Élisabeth Crouzet-Pavan.
[10] Leiris, *Race and Culture*, 7.

these same so-called primitives had made decisive cultural contributions to the technological achievements of the West. It was vain "to judge a culture by our own ethical standards, for—apart from the fact that our ethics are too often no more than theoretical—many non-European societies are in certain respects more humane than our own."[11] Leiris concluded that it was one of UNESCO's missions to convince the world that race prejudice "far from being the more explicit expression of something instinctive" was "itself cultural in origin and barely three centuries old," and "had grown up and taken the form we know today for economic and political reasons"—and principally because of the desire of Westerners to enrich themselves at the expense of peoples they had either enslaved or colonized.[12]

Leiris' intervention was one of the most impassioned of those published at the time, and one senses the pain of professional and personal wartime wounds that had not healed. Claude Lévi-Strauss took up the theme of "cultural" differences in cooler tones in his pamphlet *Race and History*. Keeping away from any lengthy disquisition on colonialism, he emphasized, instead, the need to "investigate" the "nature of diversity":

> It would be useless to argue the man in the street out of attaching an intellectual or moral significance to the fact of having black or white skin . . . unless we had an answer to another question, which experience proves he will ask immediately: if there are no innate racial aptitudes, how can we explain the fact that the white man's civilization has made the tremendous advances with which we are all familiar, while the civilizations of the coloured [sic] peoples have lagged behind?[13]

Before the war, Lévi-Strauss had held that colonialism could benefit the colonized—a position that Maupoil, Leenhardt, Tillion, Le Coeur and Paulme, working in the African parts of the empire, were already questioning. By the 1950s, he too had broken with such residual evolutionary thinking. There were, Lévi-Strauss now insisted, no *peuples enfants*, that is, peoples at an earlier stage of evolution. All were adults, all of them products of deep histories comparable in grandeur—only some were more ignorant of their history than others. Societies everywhere had had to respond to the same problems, and each answered these problems in slightly different ways; diversity itself, moreover, was not the result of isolation, but of contacts that brought cultures together. He conceded that human societies could be divided

[11] Ibid., 36.
[12] Ibid., 8.
[13] Lévi-Strauss, *Race and History*, 6.

between those that progressed by accumulating technical inventions through intra-cultural contact, and those that remained stationary because they did not synthesize their discoveries. The rare occurrence of technologically cumulative societies—the Neolithic and modern West—nevertheless proved to Lévi-Strauss that these successes were arbitrary, the result of a high level of interaction between different cultures over a long period of time. Lévi-Strauss then sounded a warning. Without continued cultural diversity, he insisted, the world risked stagnation, because societies needed each other's difference to continue to create: "The need to preserve the diversity of cultures in a world which is threatened by monotony and uniformity has surely not escaped our international institutions. They must also be aware that it is not enough to nurture local traditions and to save the past for a short period longer. It is diversity itself that must be saved." And, he continued,

> We must also be prepared to view without surprise, repugnance or revolt, whatever may strike us as strange in the many new forms of social expression. Tolerance is not a contemplative attitude, dispensing indulgence to what has been or what is still in being. It is a dynamic attitude consisting in the anticipation, understanding and promotion of what is struggling into being.[14]

As these quotations suggest, the pamphlets of Leiris and Lévi-Strauss reflected many of the ideas that Mauss in particular had developed in the interwar years, and whose impact on his students we have followed throughout this book. Both Mauss and Rivet posited that a true science of humanity could never emerge from the classificatory charts so meticulously constructed by physical anthropologists, with their fixed trajectories for different groups. Human societies were valuable not because of their racial inheritance, but because they elaborated complex and holistic webs of life, each one unique and some more "wise" than contemporary Western ones. Ethnologists had to decode the always complex lifeways of social groups, whether in the past or the present, and then learn from them. In this new science of humanity that Mauss helped to shape, individuals and societies progressed only through the creation of rituals of reciprocity that bound them to each other and allowed them to live in relative peace with outsiders. These ties emerged historically through constant borrowings and contacts, and each culture that resulted was as different as the material and historical circumstances that conditioned but never determined the choices of humans.

In hindsight, it is difficult to exaggerate the novelty of Mauss's thinking, compared to that of the "human" scientists who came before him, whether

[14] Ibid., 49.

the disciples of Durkheim or the descendants of Broca. As a sociologist living in the second half of the nineteenth century, Durkheim had been most interested in discovering universal social laws. He had optimistically believed that the ongoing capitalist division of labor would result in new forms of solidarity, and that it was the sociologist's job to identify and help foster the nascent directions toward which society should be developing. In this worldview, forged largely in the study, society shaped people rather than the other way around, and priority should be given to preserving "civilization." Brocan racial evolutionism was racist in a way Durkheimian sociology never was, but Broca nevertheless anticipated Durkheim's late nineteenth-century faith that certain laws—in the former case biological rather than social ones—determined human potentialities, and that scientists in their laboratories could unravel these laws, to humanity's ultimate benefit. As a sociologist-turned-anthropologist, Mauss, in contrast, was more interested in people than in biology or society; at the risk of simplifying, by the interwar years he had come to believe not only that race had nothing to do with civilization but also that it was people who created society, rather than the other way around. He was also more pessimistic than Durkheim or Broca, more skeptical about the desirability, or indeed possibility, of uncovering universal laws of any kind, and thus more historically minded than his nineteenth-century predecessors. Having survived the cataclysm of World War I only to endure its vicious aftermath, Mauss determined that it was the "human" and the "person," rather than the "race" or "civilization," that had to be defended against the rapidly escalating inequalities and hatreds of his times.

In the wake of these insights, Mauss's science and politics developed into a new humanism that his closest students came to incarnate, not as active Socialists or progressives (none were that), but in the personal and professional choices they made in the 1930s, 1940s, and 1950s. In this context, the private musings of another Institut d'Ethnologie student, André Leroi-Gourhan, further demonstrate the range of Mauss's impact in these critical decades. Leroi-Gourhan was one of the few members of the 1930s cohort to have begun his studies as a physical anthropologist.[15] In 1940 he had recently returned to France from studying the Ainu in Japan, and was already wrestling with the

[15] André Leroi-Gourhan completed his doctorate in 1944, published later as *L'archéologie du Pacifique-nord*. Although a student of Mauss's throughout the 1930s, he considered the younger Chinese specialist at the École Pratique, Marcel Granet, his closest mentor. Leroi-Gourhan's primary interest was in material culture and the evolution of technicity among early humans, and he did not hesitate to criticize some of Mauss's conclusions for underestimating the importance of milieu in human evolution. When Leroi-Gourhan dedicated his first book, *La civilisation de la renne*, to Mauss in 1936, the latter's purported only response was to say that he (Mauss) was "a hen who had hatched a duckling." Leroi-Gourhan, *Les racines du monde*, 35, and also 31–35. On Leroi-Gourhan's career, see Soulier, "André Leroi-Gourhan."

race question in terms that anticipated those that emerged at UNESCO in 1949-1952. As he wrote to his friend and fellow Asianist Jean Buhot,

> The conscientious anthropologist expresses himself in fairly byzantine terms and spends his life on specific problems to avoid committing suicide or changing professions. Race exists and we know of no pure races. Race does not exist and yet the Australian has a unique skull whose origin we cannot trace, the races have a single source and we do not know its confluences. No conscientious [scientist] has ever escaped this circle, not one. Those that have made positive assertions have done so while hiding half of one of the preceding philosophical propositions.

As his work had matured in the 1930s, Leroi-Gourhan had not hesitated to challenge some of Mauss's premises. Mauss and Montandon, Leroi-Gourhan wrote to Buhot, had each gotten the question of human origins and evolution (physical and cultural) wrong: Montandon because of his flawed premises, Mauss because of his failure to recognize that the material world or "milieu" imposed constraints on human groups in their quest for survival. Perhaps, Leroi-Gourhan ventured, human groups were formed by both their drive to seek the best possible solution to every material and social challenge *and* the limits of the milieu. This combination of forces produced a movement toward "the formation of a type (and not a racial type)," one accentuated by individual unions, but also diluted by *métissage*. *Métissage* posed "new terms," pushed toward a new type that is never perfectly realized. "Race then is perpetually virtual, there is no race but a tendency toward race," because humans are always choosing among any number of possible combinations of "man, milieu, *mélanges*." The study of anthropology, Leroi-Gourhan concluded, should consist of the pure observation of these phenomena, "without interpretation of the future, without a hypothetical reconstruction of the past. You see, however, that such a path is not possible for researchers hypnotized by their conclusions."[16] Leroi-Gourhan had just completed a manuscript on these questions, but he had already shelved it, realizing how politicized the question of race had become. As he put it in this manuscript, which he would never publish, "The word 'race' is a flaw in the science of humanity, and from the moment [this word] left the laboratory to enter politics, its meaning again lost much of its clarity."[17]

[16] André Leroi-Gourhan à Jean Buhot, 20 Feb. 1940, in André Leroi-Gourhan, *Pages oubliées sur le Japon* (Grenoble, 2004), 101–2.

[17] André Leroi-Gourhan, "Texte général sur le Japon, sans titre, tapuscrit inédit" (1939), cited in Philippe Soulier, "André Leroi-Gourhan et l'anatomie humaine. De la craniologie à la fouille des sépultures," *Revue Archéologique de Picardie*, special issue, 21 (2003): 36.

André Leroi-Gourhan's letters in 1940 offers further evidence that all of Mauss's students—even those who disagreed with him—eschewed the search for either social or natural laws in their own developing science. Instead, they embraced like him certain anthropological constants, one of which was that people throughout history have always created, preserved, and negotiated their own values. These values alone made life worth living, because of the dignity that they bestowed on the individuals who participated in them. Between 1930 and 1945, Institut d'Ethnologie students learned the hard way that murderous consequences—whether those of communism, fascism, or imperialism—could fester underneath an allegedly neutral scientific discourse; but they also came to realize, because of their fieldwork, that good scientific knowledge could come from direct contact with profoundly dark realities, such as those engendered by French colonialism. In the euphoric postwar moment, when it seemed that making a better world was possible, both insights moved certain French ethnologists to take a radical public stance against racism and its root causes, and others to set aside the study of race as too dangerous.

In many ways, however, this mobilization proved to be short-lived, as the world surrounding the surviving Maussians changed again in ways they had not predicted. After the war, the students of Rivet and Mauss no longer formed a single community; several members quickly moved on to new commitments—some scientific, some political. Racism, of course, did not end in the 1950s; nor did racial science wither away, far from it. No sooner had UNESCO's first race statement been issued, then several biologists and physical anthropologists protested the assertion that race was less a biological fact than a social myth. As one typical critic, W.C. Osman Hill of the Zoological Society of London, bluntly put it in February 1951, "That race is more than a social myth is endorsed by the plain facts of physical anthropology and ethnography."[18] His words were echoed by Henri Victor Vallois, the racial taxonomist elected under Vichy to replace Paul Rivet in the anthropology chair during the war and then again in 1950 at Rivet's retirement. Vallois explained that the goal of racial science had always been to counter perceptions of difference based on prejudice by developing "a precise method" for objectively establishing "the differences between the races."[19] As sociologist Jenny Reardon has pointed out, such objections revealed that many biologists, geneticists, and physical anthropologists continued to believe that race was meaningless *only* for the particular purpose of creating hierarchical distinctions

[18] W.C. Osman Hill, ["U.N.E.S.C.O on Race,"] *Man* 30 (Feb. 1951): 17.
[19] UNESCO/323.12 A 102/Statement on Race Part I, Nov. 1949–Sept. 1951/Dr. H.V. Vallois, untitled response, Paris, n.d. [1950–1951].

among human beings in society. They very much wanted to hold onto the concept of race for studying the origin and evolution of the human species and continued to take for granted that it was possible to use the "rationality" and "neutrality" of racial science to fight the "ideology" of racism—a position about which Leroi-Gourhan already had his doubts in 1940.[20] At their urging, the race statement was amended in 1951, and the clause about race's socially constructed nature was removed altogether on the grounds that it had not been proven.[21] In the 1950s and beyond, scientists who saw themselves as antiracist thus succeeded in constructing a new expert space in which studies of race formation, whether in the traditional realms or at the molecular level, could continue—and continue to be misappropriated for non-scientific ends.

On the colonial front, antiracist anthropology and anti-imperialism did not necessarily go hand in hand in the 1950s and 1960s, particularly since many French ethnologists remained dependent on the empire for jobs. As the Cold War heated up, claims about racial and ethnic difference once again played primary roles in the reconstruction and maintenance of national and global political orders. Policymakers who had grown up in the race-saturated 1930s soon openly described the brewing anticolonial or Third World movements as an international race war pitting the peoples of African and Asia against the "white" West. In the face of this continuing racism, many anthropologists—Marcel Griaule and his school comes to mind—accepted that cultural relativism would suffice to remove misunderstandings between peoples. Following UNESCO's lead, these anthropologists sought to shift the explanation of racism from misperceptions about biology to the level of individual prejudice, born of ignorance of other cultures and solvable through education about them (in which social scientists would lead the way). This culturalist antiracism quickly elided the very thing that Leiris at least had identified as an important root cause perpetuating racism: state-level discrimination by colonial regimes that had to be challenged through political engagement. Cultural relativism as antiracism encouraged instead a view of the world as made up of discrete and homogeneous cultural groups of equal value, which reified new group identities and diminished the possibilities for political solidarity across groups in the fight against racist discrimination.[22]

At the same time, the almost immediate popularity of Lévi-Strauss's structuralism points to another kind of fracturing of the Maussian

[20] Jenny Reardon, *Race to the Finish: Identity and Governance in an Age of Genomics* (Princeton, NJ, 2005), 25–31.

[21] The second statement was titled "Statement on the Nature of Race and Race Differences by Physical Anthropologists and Geneticists—June 1951." See UNESCO, *The Race Concept, Results of an Inquiry* (1952; Westport, CT, 1970), 11–16.

[22] Alana Lentin, *Racism and Anti-Racism in Europe* (London, 2004), 74–85.

legacy. Structuralism represented a different universalism—and a different antiracism—than that achieved by the interwar generation. In *Les formes élé-mentaires de la parenté* (1949), Lévi-Strauss argued that the whole of social life could be understood as a system of transactions between groups and between individuals, whose rationale was established by techniques analogous to those of structural linguistics.[23] Exposed to linguistic theory during his wartime exile in New York, he never returned to the fieldwork on which Mauss and Rivet had insisted. Lévi-Strauss' brilliant premises fit well with the Manichean dichotomies and universal absolutes that characterized the Cold War, as well as the European superstate in construction. Europeans were determined to celebrate what they had in common without succumbing again to either the old nationalist shibboleths or reinvented forms of ethnoracism, and there can be no doubt that structuralism proved the fundamental sameness of all human groups. Yet if Lévi-Strauss opened a new way of seeing the world as one, his success came at the cost of encountering individuals from other cultures first-hand, in order to learn from them in the way Mauss had first taught.[24]

Not all postwar anthropologists in France, of course, were swept up by either cultural relativism or structuralism. In the 1950s the pioneering sociologist of urban Africa Georges Balandier—whom Denise Paulme, Michel Leiris and André Schaeffner had all helped to mentor—continued the tradition of a Maussian-inflected on-site and in-depth fieldwork in France's imperial domain. In another continuity between the Maussians and Balandier, the latter republished Charle Le Coeur's thesis in 1969. Balandier acknowledged his intellectual debt to Mauss in his landmark 1951 essay, "La situation coloniale," noting that only an analysis that recognized the inherent conflicts and tensions of social relations under colonialism permitted "that concrete and complete approach recommended by Marcel Mauss."[25] Rather than evacuate

[23] Claude Lévi-Strauss, Les formes élémentaires de la parenté (Paris, 1949).

[24] Wictor Stoczkowski has persuasively argued that Lévi-Strauss would further develop the antiracist ideas expressed in *Race and History* in his revised 1971 pamphlet, also commissioned by UNES-CO—*Race and Culture*—although this continuity was not recognized at the time. More and more convinced that the world's cultural diversity was endangered by overpopulation, Lévi-Strauss now openly blamed not only industrialization for continued racism in the world, but also (among other things) the West's excessive reverence of the individual. A rapidly expanding global population was competing for ever scarcer resources, which Lévi-Strauss saw as a recipe for continued racialized hatreds among peoples; the same demographic pressures were producing excessive homogenization, which rendered humans—according to Lévi-Strauss—less capable of the creativity that made life worth living. Finally, the arrogant philosophies that since the Renaissance had placed man at the center of the universe were leading to a cavalier destruction of the planet upon which human life depended. In the face of this impending catastrophe, Lévi-Strauss recommended moving toward a genuinely universal humanism, in which each of us achieves "wiser relations with the universe," in imitation of the so-called "primitive" peoples of the globe, whose respect for nature we have lost. Quoted in Stoczkowski, *Anthropologies rédemptrices*, 99.

[25] Georges Balandier, "La situation coloniale. Approche théorique," *Cahiers Internationaux de Sociologie* 11 (1951): 73.

history or consider African societies in some pure authentic state, Balandier innovatively examined how the unequal power relations of colonialism were altering "traditional" solidarities. Yet, as Gregory Mann has demonstrated, Balandier was also influenced by his "field" encounter with the anticolonial politics of Mamadou Madeira Keita; the two men met while working for the Institut Français d'Afrique Noire in Conakry, Guinea in 1946-1947. The result of this collaboration was, briefly, a new, politically engaged, sociology, in which Balandier's scientific conclusions began to incorporate the agendas of African nationalists regarding labor and land reform.[26] Mann's research suggests that Balandier—and there are surely others—carried the Maussian socio-cultural method of studying individual groups *in situ*, concretely and dynamically, forward into the 1950s, and perhaps beyond.

French intellectual life has always boasted a strong universalistic tendency. During the interwar and war years, a small group of French ethnologists involved themselves in the world, rather than seeking "neutrality" in the laboratory, the museum, and the library. In the process, they produced a more humanist anthropology than what came before, one that repudiated race and promoted the study of a unified humanity. Mauss and Rivet had the unusual generosity of spirit needed to encourage this cohort to go beyond the armchair ideas and methods in which they themselves had been trained. These two *maîtres* understood that the experience and experiment of interacting with people in the field would change, for the better, the methods and content of a still renovating science of humanity in France. The extraordinary convergence of new Fascist, Communist, and imperialist ideologies in the 1930s and 1940s provided further possibilities for the Maussian generation to react against a resurgent racial and racist science even more decisively than their mentors—in spite of, or perhaps because of, the colonial situations in which they worked. In today's post-Cold War and postcolonial world, where learning to respect differences among diverse peoples within the confines of the nation-state has again become a pressing political problem, the global moral and scientific ethos that crystalized in Paris in 1950, and the striking emergence of anthropologists from the academy to the center of public life, surely has something still to teach us.

[26] Gregory Mann, "Anti-Colonialism and Social Science: Georges Balandier, Madeira Keita, and 'the Colonial Situation' in French Africa," *Comparative Studies in Society and History* 55:1 (2013): 103, 111–14.

SELECTED BIBLIOGRAPHY

ARCHIVAL SOURCES

Archives de l'Institut d'Ethnologie, Rectorat de l'Académie de Paris, Paris

ARP/IE/25 Procès-verbaux.
ARP/IE/25 Personnel.
ARP/IE/26 Rapports Annuels.
ARP/IE/26 Statuts.
ARP/IE/Chaire d'Ethnologie/1942.

Archives Nationales de France, Paris

ANF/AJ15/737/MNHN/Procès-verbaux des Assemblées de Professeurs et pièces jointes.
ANF/AJ15/740/"Projet de mission ethnographique et linguistique Dakar-Djibouti."
ANF/AJ16/4758 Université de Paris, Faculté des Lettres, Registre des Actes.
ANF/AJ16/6009 Commission d'épuration/Dossier de Marcel Griaule.
ANF/AJ40/567 Archives Allemandes, 1940–1944, Dossier 8.
ANF/AJ40/567 Archives Allemandes, 1940–1944, Dossier 9.
ANF/F^{17}/13341 Dossier "Cycle de conférences à l'École nationale des cadres supérieurs."
ANF/F^{17}/13342 Correspondance Abel Bonnard.
ANF/F^{17}/13358 Ethnologie et Anthropologie.
ANF/F^{17}/13560/MNHN/Procès-verbaux des Assemblées de Professeurs, 1923–1934.
ANF/F^{17}/13567/MNHN/Musée d'Ethnographie du Trocadéro, 1923–1928.
ANF/F^{17}/13385 Académie de Paris, Affaire du Musée de l'Homme.
ANF/F^{17}/16806 Commission d'épuration/Dossier de Marcel Griaule.
ANF/F^{17}/16834 Commission d'épuration/Dossier de Jean-Paul Lebeuf.
ANF/F^{17}/16946 Commission d'épuration/Dossier de Georges Henri Rivière.
ANF/317/AP 138 Papiers Louis Marin.

Archives, Toledo Museum of Art, Toledo, Ohio

Archives, Världskulturmuseet, Gothenburg

Alfred Métraux Correspondance.

Beinecke Library, Yale University, New Haven, Connecticut

GM 350/Alfred Métraux-Yvonne Oddon Correspondance.

Bibliothèque Centrale du Muséum National d'Histoire Naturelle, Paris

Archives du Musée de l'Homme
AMH/2 AM 1 A1–A14: Administration du MET/MH.
AMH/2 AM 1 B1–B11: Coupures de presse sur le musée et ses activités de 1929 à 1949.
AMH/2 AM 1 C1–C9: Manifestations organisées par le musée de 1930 aux années 1980.
AMH/2 AM 1 D1–D14: Courier administratif entre le MNHN et le musée, 1928–1969.
AMH/2 AM 1 E1–E5: Courier administratif entre différents ministères et le musée, 1928–1958.
AMH/2 AM 1 F1–F2: Grandes expositions (coloniales et internationales) auxquelles a participé le musée.
AMH/2 AM 1 G1–G3: Exposition universelle de 1878 et création du MET; le débuts de son administration; l'administration Rivet/Rivière; la réorganisation de 1935/1938 en MH.
AMH/2 AM 1 J1–J2: Ordres et notes de service, 1928–1974.
AMH/2 AM1 K1–K99: Correspondance reçue et envoyée, 1928-années 1970.
AMH/2AM1 M1–M3: Missions ethnographiques du musée, 1932–1941.
AMH/2 AP 2: Fonds Yvonne Oddon.
AMH/2 AP 4: Fonds Marcel Mauss.
AMH/2 AP 5: Fonds Anatole Lewitsky.
AMH/MS 15/3/Procès-verbaux de l'Association pour l'enseignement des sciences anthropologiques (École d'Anthropologie).

Archives de l'Institut d'Ethnologie at the Musée de l'Homme
AMH/IE/2 AM 2/A1: Procès-verbaux du Conseil d'administration.
AMH/IE/2 AM 2/B3: Certificats.
AMH/IE/2 AM 2/C2: Articles/Paul Rivet.

Fonds Paul Rivet
AMH/2 AP B1–B23: Archives Paul Rivet.
AMH/2 AP 1 C: Lettres à Paul Rivet.
AMH/2 AP 1 D: Lettres de Paul Rivet.

Archives du Muséum National d'Histoire Naturelle
MNHN/AM 50–73/Procès-verbaux des Assemblées de Professeurs, 1932–1941.
MNHN/MS 2959/Correspondance Camille Arambourg.

Bibliothèque Nationale de France

BNF/Manuscrits/Fonds Claude Lévi-Strauss.

Centre de Documentation Juive Contemporaine, Fonds George Montandon, Paris

CDJC/XCV.
CDJC/XCIX.

Institut Français de l'Afrique Noire, Dakar

IFAN/E 2–3/Dossier Charles Le Coeur.

Institut Mémoires de l'Édition Contemporaine, Caen

IMEC/Fonds Georges Devereux.
IMEC/Fonds Lévy-Bruhl.
IMEC/Fonds Marcel Mauss.

International African Institute Archives, London

IAIA/1/19/Minutes of the Executive Council.
IAIA/8/10/Rockefeller Felllowship.
IAIA/13/91/"Publications envisagées par Mlle. T. M. H. Rivière et Mlle. G. Tillion, Aurès, 1935–1936."
IAIA/39/196/Le Coeur.

Musée du Quai Branly, Paris

Archives du Musée des Arts d'Afrique et d'Océanie (formerly Musée des Colonies)
AMAAO/15.
AMAAO/20.
AMAAO/50.

Photothèque, Musée de l'Homme

UNESCO Archives, Paris

UNESCO/SS/1, "Statement by Experts on Racial Problems," Paris, 20 July 1950.
UNESCO/323.12 A 102/Statement on Race Part I, Nov. 1949–Sept. 1951.

Published Primary Sources

Articles, Books, Legislation

Anthony, Raoul. "L'Anthropologie. Sa définition, son programme, ce que doit être son enseignement." *Bulletins et Mémoires de la Société d'Anthropologie de Paris* 8:4 (1927): 227–45.

Balandier, Georges. "La situation coloniale. Approche théorique." *Cahiers Internationaux de Sociologie* 11 (1951): 44–79.

Berr, Henri. *La synthèse en histoire. Essai critique et théorique.* Paris, 1911.

Billig, Joseph. *L'Institut d'étude des questions juives, officine française des autorités nazies en France. Inventaire commenté de la collection de documents provenant des archives de l'Insitut conservés au C.D.J.C.* Paris, 1974.

Bouteiller, Marcelle. "Les races de l'Asie." *Races et Racisme. Bulletin du Groupement d'Étude et d'Information* 16–17–18 (Dec. 1939): 11–13.

Broek d'Obrenan, Charles van den. "Les races de l'Océanie." *Races et Racisme. Bulletin du Groupement d'Étude et d'Information* 16–17–18 (Dec. 1939): 18–19.

Capart, Jean. "Le rôle social des musées." *Mouseion* 12:3 (1930): 219–38.

Christie, Francis A. "*Morales et religions nouvelles en Allemagne. Le Néoromantisme au delà du Rhin* by Ernest Seillère." *American Historical Review* 33:2 (1928): 399–401.

Coiffier, Christian, and Michel Panoff. "Quelques aspects de l'histoire de la Société des Océanistes. Un entretien avec M.-C. Laroche." *Journal de la Société des Océanistes* 100–101:1–2 (1995): 41–55.

Comhaire-Sylvain, Suzanne. *Contes Haïtiens.* Paris, 1937.

Congrès de la recherche scientifique dans les territoires d'outre-mer. Paris, 1938.

Cuisinier, Jeanne. *Les Muong. Géographie humaine et sociologie—Ouvrage publié avec le concours de la recherche scientifique coloniale.* Paris,1946.

Cunard, Nancy. "The Musée de l'Homme." *Burlington Magazine for Connoisseurs* 88:516 (1946): 66–71.

Deniker, Joseph. *The Races of Man: An Outline of Anthropology and Ethnography.* London, 1900.

Dieterlen, Germaine. "Marcel Mauss et une école d'ethnographie." *Journal des Africanistes* 60:1 (1990): 109–17.

Dorsey, George Amos. "Notes on the Anthropological Museums of Central Europe." *American Anthropologist* 1:3 (1899): 462–74.

Do Xuan Hop, and Pham Bieu Tam. "Étude anatomique et anthropologique de l'omoplate chez les Annamites." *Institut Indochinois pour l'Étude de l'Homme. Bulletins et Travaux pour 1942* 5:1 (1942): 41–48.

——. "L'humerus chez les Annamites (résumé)." *Institut Indochinois pour l'Étude de l'Homme. Bulletins et Travaux pour 1942* 5:2 (1942): 49–56.

Durkheim, Émile. "Compte-rendu de Albert Cahuzac, *Essai sur les institutions et droit malgache.*"*L'Année Sociologique* 4 (1901): 342–45.

——. "De la définition des phénomènes religieux." *L'Année Sociologique* 2 (1899): 1–28.

——. "La prohibition de l'inceste et ses origines." *L'Année Sociologique* 1 (1898): 1–70.

Éribon, Didier, and Claude Lévi-Strauss. *Conversations with Claude Lévi-Strauss.* Chicago, 1991.

Falck, Roger. "Technique de présentations des vitrines au Musée de l'Homme." *Museum International* 1:1–2 (1948): 70–74.

Febvre, Lucien, and François Crouzet. *Nous sommes des sang-mêlés. Manuel d'histoire de la civilisation française*, ed. Denis Crouzet and Élisabeth Crouzet-Pavan. Paris, 2012.

Firth, Raymond. "The Study of Primitive Economics." *Economica* 21 (Dec. 1927): 312–35.

Fischer, Eugen. *Le problème de la race et la législation raciale en Allemagne.* Paris, 1942.

Fleure, H. J. "Review 13." *Man* 35 (Jan. 1935): 14–15.

——. "Review 109." *Man* 36 (May 1936): 86.

——. "Review 110." *Man* 36 (May 1936): 87.

Griaule, Marcel. *Les flambeurs d'hommes.* Paris, 1934.

——. *Masques Dogons.* Paris, 1938.

——. *Méthode d'ethnographie.* Paris, 1957.

Haddon, A.C. *The Races of Man.* Cambridge, 1924.

——. "Review 104." *Man* 29 (Aug. 1929): 144–46.

Hamy, Ernest-Théodore. "Introduction." *Revue d'Ethnographie* 1 (1882): ii–iii.

——. *Les origines du Musée d'ethnographie. Histoire et documents.* 1890. Paris, 1988.

Heydrich, Martin. "La réorganisation du musée ethnographique de Munich." *Mouseion* 11:2 (1930): 128–37.

Hill, W. C. Osman. ["U.N.E.S.C.O on Race."] *Man* 30 (Feb. 1951): 17.

Hubert, Henri. "Compte-rendu de Capitaine Maire, *Étude sur la Race Man du Haut Tonkin*." *L'Année Sociologique* 9 (1906): 208–9.

——. "Compte-rendu de E. Lunet de Lajonquière, *Ethnographie du Tonkin Septentrional*." *L'Année Sociologique* 10 (1907): 241–43.

Huxley, Julian S., and A. C. Haddon, with a contribution by A. M. Carr-Saunders. *We Europeans: A Survey of Racial Problems*. London, 1935.

"Introduction." *Institut Indochinois pour l'Étude de l'Homme. Comptes Rendus des Séances de l'Année 1938* (1938): 7–15.

Jamin, Jean. "André Schaeffner (1895–1980)." *Objets et Mondes* 20:3 (Fall 1980): 131–35.

——. *Leiris. Miroir de l'Afrique*. Paris, 1996.

Labouret, Henri. *Ethnologie coloniale*. 3 vols. Paris, 1932.

Lameere, Jean. "La conception et l'organisation modernes des Musées d'Art et d'Histoire." *Mouseion* 12:3 (1930): 239–311.

Lebeuf, Jean-Paul. *Les collections du Tchad. Guide pour l'exposition au Musée de l'Homme*. Paris, 1942.

——. "Marcel Griaule." *La Revue de Paris* 63 (May 1956): 131–36.

——. "Technique d'une exposition." *Nouvelle Revue Française* 56:338 (1942): 506–12.

Le Coeur, Charles. *Carnets de Route 1933–1934*. Paris, 1969.

——. "La révolution de Lyautey." *L'Homme Nouveau*, 1 Nov. 1935.

——. "Le plan de réformes du nationalisme jeune-marocain." *L'Homme Nouveau*, 1 Oct. 1935.

——. *Le rite et l'outil. Essai sur le rationalisme social et le pluralisme des civilisations*. 1939. Paris, 1969.

——. "Méthode et conclusions d'une enquête humaine au Sahara nigéro-tchadien." In *Gens du roc et du sable, les Toubous. Hommage à Charles et Marguerite Le Coeur*, ed. Catherine Baroin, 190–99. Paris, 1988.

——. "Socialistes humanistes." *L'Homme Nouveau*, 1 Oct. 1936.

Leenhardt, Maurice. *Documents néo-calédoniens*. Paris, 1932.

——. *Gens de la Grande Terre*. Paris, 1937.

——. "Marcel Mauss (1872–1950)." *Annuaire* (1950–51): 22.

——. *Notes d'ethnologie néo-calédonienne*. Paris, 1930.

——. *Vocabulaire et grammaire de langue houailou*. Paris, 1935.

Leiris, Michel. *La langue secrète des Dogon de Sanga*. Paris, 1948.

——. "Les races de l'Afrique." *Races et Racisme. Bulletin du Groupement d'Étude et d'Information* 16–17–18 (Dec. 1939): 13–15.

——. "L'Exposition. L'Encyclopédie à la portée de tous." *Avant-Garde*, 14 Aug. 1937.

——. *Race and Culture*. Paris, 1951.

Leroi-Gourhan, André. *La civilisation du renne*. Paris, 1936.

——. *L'archéologie du Pacifique-nord. Matériaux pour l'étude des relations entre les peuples riverains d'Asie et d'Amérique*. Paris, 1946.

——. "Leçon d'ouverture du cours d'ethnologie coloniale." *Les Études Rhodaniennes* 20:1–2 (1945): 25–35.

——. *Les racines du monde. Entretiens avec Claude-Henri Rocquet*. Paris, 1982.

——. *Pages oubliées sur le Japon*. 1940. Grenoble, 2004.

Lester, Paul. "Bibliographie africaniste, anthropologie, généralités." *Journal de la Société des Africanistes* 9:2 (1939): 227–86.

Lester, Paul, and Jacques Millot. *Les races humaines*. Paris, 1936.

Lester, Paul, Paul Rivet, and Georges Henri Rivière. "Le laboratoire d'anthropologie du Muséum." *Nouvelles Archives du Muséum d'Histoire Naturelle* 6:12 (1935): 507–31.

Letourneau, Charles Jean Marie. *La sociologie d'après l'ethnographie*. 2nd ed. Paris, 1884.

Lévi-Strauss, Claude. *Introduction to the Work of Marcel Mauss*. 1950. London, 1987.

———. *Les formes élémentaires de la parenté*. Paris, 1949.

———. *Race and History*. Paris, 1952.

Lévy-Bruhl, Lucien. *La morale et la science des moeurs*. Paris, 1903.

———. *Les fonctions mentales dans les sociétés inférieures*. Paris, 1910.

———. "L'Institut d'Ethnologie de l'Université de Paris." *Revue d'Ethnographie et des Traditions Populaires* 23–24 (1925): 233–36.

———. "L'Institut d'Ethnologie pendant l'année scolaire 1925–1926." *Annales de l'Université de Paris* 2 (1927): 90–94.

Lewitsky, Anatole. "Quelques considérations sur l'exposition des objets ethnographiques." *Mouseion* 29–30 (1935): 253–58.

Lips, Julius. *The Savage Hits Back*. New Haven, CT, 1937.

Loranz, Yann. "Le problème juif est ethnique, explique le professeur Montandon." *Paris Midi*, 9 Sept. 1942.

Louis, Jean-Paul. *Lettres à Albert Paraz, 1947–1957*. 2nd ed. Paris, 2009.

Malinowski, Bronislaw. *Argonauts of the Western Pacific. An Account of Native Enterprise and Adventure in the Archipelagoes of Melanesian New Guinea*. 1922. New York, 1961.

———. "Ethnology and the Study of Society." *Economica* 6 (Oct. 1922): 208–19.

Manouvrier, Léonce. "L'indice céphalique et la pseudo-sociologie." *Revue de l'École d'Anthropologie* 9 (1899): 233–59.

Marquès-Rivière, Jean. "Exposition Le Juif et la France au Palais Berlitz." Paris, n.d. [1941].

Martelli, Maurice. "Rapport sur l'activité de l'Association Colonies-Sciences en 1931." *Actes et Comptes-Rendus de l'Association Colonies-Sciences* 82 (April 1932): 84–96.

Martial, René. *La race française*. Paris, 1934.

Mauco, Georges. *Les étrangers en France. Leur rôle dans l'activité économique*. Paris, 1932.

Mauger, Gérard. "L'affaire Montandon." *Ethnie Française* 3 (May-June 1941): 1–4.

Maupoil, Bernard. "De Haïti au Dahomey." *Bulletin de l'Institut Français de l'Afrique Noire* 2:3–4 (1940): 423–30.

———. "Ethnographie comparée. Le culte du Vaudou." *Outre-Mer. Revue Générale de Colonisation* 9:3 (1937): 203–5.

———. *La géomancie à l'ancienne côte des esclaves*. 1943. Paris, 1988.

———. "Le théâtre dahoméen." *Outre-Mer. Revue Générale de Colonisation* 9:4 (1937): 301–21.

Mauss, Marcel. "A Category of the Human Mind: The Notion of the Person; the Notion of Self." In *The Category of the Person: Anthropology, Philosophy, History*, ed. Michael Carrithers, Steven Collins, and Steven Lukes, 1–25. Cambridge, 1985.

———. "Compte-rendu de Commandant Delhaise, *Les Warega*, Joseph Halkin, *Les Ababua* et Fernand Gaud, *Les Mandja*." *L'Année Sociologique* 12 (1913): 138–42.

———. *Écrits politiques*, ed. Marcel Fournier. Paris, 1997.

———. *Essai sur le don,* foreward by Florence Weber. Paris, 2007.

———. "Essai sur les variations saisonnières des sociétés eskimo. Étude de morphologie sociale." *L'Année Sociologique* 9 (1906): 39–132.

———. "Fait social et formation du caractère." *Sociologie et Sociétés* 36:2 (2004): 135–40.

———. *The Gift: The Form and Reason for Exchange in Archaic Societies,* trans. W. D. Halls, foreword by Mary Douglas. New York, 1990.

———. "L'enseignement de l'histoire des religions des peuples non civilisés à l'École des Hautes Études. Leçon d'ouverture." *Revue de l'Histoire des Religions* 45 (1902): 36–55.

——. "Les civilisations. Éléments et formes." In Lucien Febvre et al., *Civilisation. Le mot et l'idée*, 81–108. Paris, 1930 [1929].

——. "L'état actuel des sciences anthropologiques en France." *L'Anthropologie* 30 (1920): 153–54.

——. "L'ethnographie en France et à l'étranger I-II." *La Revue de Paris* 20:5 (1913): 537–60 and 815–37.

——. *Manuel d'ethnographie.* Paris, 1947.

——. *The Nature of Sociology,* trans. William Jeffrey, introduction by Mike Gane. New York, 2005.

——. *Oeuvres.* 3 vols., ed. Victor Karady. Paris, 1968–69.

——. "Remarques." *Revue de Synthèse Historique* 1 (March-Sept. 1931): 202–3.

——. *Techniques, Technology, and Civilization*, ed. Nathan Schlanger. New York, 2006.

Mélanges de préhistoire et d'anthropologie offerts par ses collègues, amis et disciples au Professeur Comte H. Begouën. Toulouse, 1939.

Merleau-Ponty, Maurice. *Signs.* Evanston, IL, 1964.

Métraux, Alfred. "De la méthode dans les recherches ethnographiques." *Gradhiva* 5 (1988): 57–71.

——. "French Anthropology and the Resistance to German Rule." *American Anthropologist* 44:4 (1942): 728.

——. *La civilisation matérielle des tribus Tupi-Guarani.* Paris, 1928.

Métraux, Alfred, and Georges Henri Rivière. *Les arts anciens de l'Amérique, exposition organisée au Musée des Arts Décoratifs, Palais du Louvre, Pavillon de Marsan mai-juin 1928.* Paris, 1928.

Monod, Théodore. "Historique de l'Institut Français d'Afrique Noire." *Notes Africaines* 90 (April 1961): 31–63.

Montandon, George. "Camille Spiess et ses commentaires sur les théories raciales de Gobineau." *La Revue Contemporaine* 11:25 (1917): 589–93.

——. *Comment reconnaître le juif.* Paris, 1940.

——. "Des tendances actuelles de l'ethnologie à propos des armes de l'Afrique." *Archives Suisses d'Anthropologie* (May 1914): 102–35.

——. "Échos universitaires." *Ethnie Française* 7 (January 1943): 7.

——. "'Faculté' toujours enjuivée." *Je Suis Partout*, 25 Oct. 1941.

——. "Israël et le Grand Orient se vengent." *La France au Travail,* 15 Nov. 1940.

——. *La race, les races. Mise au point d'ethnologie somatique.* Paris, 1933.

——. "Les gris-gris de Griaule. Une brillante rentrée." *Je Suis Partout*, 15 Jan. 1943.

——. "L'état actuel de l'ethnologie raciale." *Scientia* 65 (1939): 32–46.

——. *L'ethnie française.* Paris, 1935.

——. "L'etnia puttana." *La Difesa della Razza*, 5 Nov. 1939, 18–22.

——. *L'ologenèse culturelle. Traité d'ethnologie culturelle.* Paris, 1934.

——. *L'ologenèse humaine (Ologénisme).* Paris, 1928.

——. "L'origine des juifs." *L'Humanité*, 15 Dec. 1926.

——. "Notre but." *Ethnie Française* 1 (March 1941): 2.

——. "Revue d'ethnologie." *La Revue Générale des Sciences Pures et Appliquées* 47 (1936): 448–55.

——. "Trapianti etnici." *La Difesa dela Razza*, 5 April 1940, 6–11.

Neuville, Henri. "La race est-elle une réalité?" *La Revue de Paris* 44:20 (1937): 847–70.

——. *L'espèce, la race et le métissage en anthropologie.* Paris, 1933.

——. "Peuples ou races." In *L'Encyclopédie française*, ed. Lucien Febvre, vol. 7, *L'Espèce humaine*, 7.44-1–7.64-14. Paris, 1936.

Oddon, Yvonne. "Une bibliothèque universitaire aux États-Unis. La bibliothèque de l'Université de Michigan." *Revue des Bibliothèques* 36 (1928): 129–55.

O'Reilly, Patrick. "Le Centre d'études océaniennes du Musée de l'Homme durant la guerre." *Journal de la Société des Océanistes* 1:1 (1945): 129–32.

"The Ossendowski Controversy." *Geographical Journal* 65:3 (1925): 251–54.

"The Ossendowski Controversy." *L'Humanité* 12 April, 9 Aug., 15 Sept., and 26 Nov. 1924.

Panoff, Michel, and Christian Coiffier. "Quelques aspects de l'histoire de la Société des Océanistes. Un entretien avec M.-C. Laroche." *Journal de la Société des Océanistes* 100–101:1–2 (1995): 41–55.

Patte, Étienne. "Le problème de la race. Le cas de l'Europe passé et présent." *Cahiers de la Démocratie* 52 (Nov.-Dec. 1938): 1–63.

Paulme, Denise. *Lettres de Sanga à André Schaeffner, suivi des lettres de Sanga de Deborah Lifchitz et Denise Paulme à Michel Leiris.* Paris, 1992.

——. *Organisation sociale des Dogons (Soudan Français).* Paris, 1940.

Pemjean, Lucien. *La presse et les juifs depuis la révolution jusqu'à nos jours.* Paris, 1941.

Polin, Raymond. "L'ethnologie." In *Les sciences sociales en France. Enseignement et recherche,* ed. Raymond Aron et al., 78–99. Paris, 1937.

Querrioux, Fernand. *La médecine et les juifs selon les documents officiels.* Paris, 1940.

Rebatet, Lucien [François Vinneuil, pseud.]. *Les tribus du cinéma et du théâtre.* Paris, 1941.

Rivet, Paul. "Ce qu'est l'ethnologie." In *L'Encyclopédie française,* ed. Lucien Febvre, vol. 7, *L'Espèce humaine,* 7.06-1–7.08-16. Paris, 1936.

——. "Compte-rendu de la séance. Intervention du Dr. Rivet." *Revue de Synthèse Historique* 1 (March-Sept. 1931): 202–3.

——. "Deux mots d'un ami de la jeunesse, le professeur Paul Rivet sur le problème des 'races.'" *L'Oeuvre,* 13 Sept. 1938.

——. "L'ethnologie." In *La science française,* 2:5–12. Paris, 1934.

——. "Le Musée de l'Homme." *Vendredi,* 26 July 1937.

——. "Les données de l'anthropologie." In *Nouveau traité de psychologie,* ed. George Dumas, 1:55–101. Paris, 1930.

——. "Les Indiens Jíbaros. Étude géographique, historique et ethnographique." *L'Anthropologie* 19 (1908): 69–87 and 235–59.

——. "Les Malayo-Polynésiens en Amérique." *Journal de la Société des Americanistes* 18 (1926): 141–278.

——. "Les origines de l'homme américain." *L'Anthropologie* 35 (1925): 293–319.

——. "Les peuples d'Indochine vus par un ethnographe." *Monde Colonial,* 1 Sept. 1932.

——. "L'ethnologie en France." *Bulletin du Muséum National d'Histoire Naturelle* 12:1 (Jan. 1940): 38–52.

——. "L'étude des civilisations matérielles. Ethnographie, archéologie, histoire." *Documents* 3 (1929): 130–34.

——. "L'origine des races humaines." *Races et Racisme. Bulletin du Groupement d'Étude et d'Information* 16-17-18 (Dec. 1939): 5–8.

——. "Nous ne pourrons conserver l'Afrique du Nord que si nous faisons une grande réforme agraire." *L'Oeuvre,* 8 May 1937.

——. "Organisation des études ethnologiques." *Actes et Comptes-Rendus de l'Association Colonies-Sciences* 78 (Dec. 1931): 251–53.

——. "The Organization of an Ethnological Museum." *Museum* 1:1–2 (January-December 1948): 68–70 and 112–13.

——. "Recherches sur le prognathisme." *L'Anthropologie* 20 (1909): 35–49 and 175–87 and *L'Anthropologie* 21 (1910): 505–18 and 637–99.

——. "Réponse à Jean Cassou." *France Observateur,* 26 July 1956.

——. *Titres et travaux scientifiques de P. Rivet.* Paris, 1927.

Rivet, Paul, and Henri Arsandaux. *La métallurgie en Amérique précolombienne*. Paris, 1946.

Rivet, Paul, and Georges Henri Rivière, "La réorganisation du Musée d'Ethnographie du Trocadéro," *Bulletin du Muséum National d'Histoire Naturelle* 2 (1930): 478–87.

Rivet, Paul, and René Verneau. *Ethnographie ancienne de l'Équateur*. 2 vols. Paris, 1912–22.

Rivière, Georges Henri. "De l'objet d'un musée de'ethnographie comparé à celui d'un musée des beaux-arts." *Omnibus, Almanach aus das Jahr 1932* (1932): 113–17.

——. *La muséologie selon Georges Henri Rivière. Cours de muséologie, textes et témoignages*. Paris, 1989.

——. "Le Musée d'Ethnographie du Trocadéro." *Documents. Doctrines, Archéologie, Beaux-Arts, Ethnographie* 1 (1929): 54–58.

——. "Les musées de folklore à l'étranger et le futur Musée des Arts et Traditions Populaires." *Revue de Folklore Français et de Folklore Colonial* 3 (May-June 1936): 59–71.

——. "L'exposition de Bénin et les transformations du Musée d'Ethnographie du Trocadéro." *Les Nouvelles Littéraires*, 6 July 1932.

——. "Témoinage." In *Ethnologiques. Hommages à Marcel Griaule*, ed. Solange de Ganay, Annie Lebeuf, Jean-Paul Lebeuf, and Dominique Zahan, 131–32. Paris, 1987.

Rivière, Joseph, ed. *Camille Spiess. Sa vie, son caractère et sa pensée*. Paris, 1919.

Roberts, W. J. "The Racial Interpretation of History and Politics." *International Journal of Ethics* 18:4 (1908): 475–92.

Rosa, Daniele. *L'ologenèse. Nouvelle théorie de l'évolution et de la distribution géographique des êtres vivants*. Paris, 1931.

Royer, Paul. "Review of *L'ethnie française*." *Revue Anthropologique* 46 (1936): 102–3.

Schreider, Eugène. "Comment on étudie les races humaines. Anthropologie et biotypologie." *Races et Racisme. Bulletin du Groupement d'Étude et d'Information* 16–17–18 (Dec. 1939): 20–24.

——. [M. V. Fleury, pseud.]. "Le Musée de l'Homme." *Races et Racisme* 16–17–18 (Dec. 1939): 2–5.

Seillère, Ernest. "Séance du 20 juin 1936." *Revue des Travaux de l'Académie des Sciences Morales et Politiques et Comptes Rendus de Ses Séances* 96 (1936): 599–601.

Serge, Victor. *Carnets*. Paris, 1985.

Sharp, Walter R. "The Rôle of UNESCO: A Critical Evaluation." *Proceedings of the Academy of Political Science* 24:2 (1951): 249–62.

Soustelle, Jacques. "BBC, Londres, 11 juin 1942." In *Ici Londres, 1940–1944. Les voix de la liberté*, ed. Jean-Louis Crémieux-Brilhac, 2:136–37. Paris, 1975–76.

——. *The Four Suns: Recollections and Reflections of an Ethnologist in Mexico*, trans. E. Ross. New York, 1971.

——. *La famille Otomi-Pame du Mexique Central*. Paris, 1937.

——. "Les races indigènes de l'Amérique." *Races et Racisme. Bulletin du Groupement d'Étude et d'Information* 16–17–18 (Dec. 1939): 15–17.

——. *Mexique, terre indienne*. Paris, 1936.

——. "Musées vivants, pour une culture populaire." *Vendredi*, 26 Aug. 1936.

Spalding Stevens, Nina. *A Man and a Dream: The Book of George W. Stevens*. Hollywood, n.d. [ca. 1940s].

Spiess, Camille. *Impérialismes. La conception gobinienne de la race. Sa valeur au point de vue bio-psychologique*. Paris, 1917.

——. *Mon Autopsie. Éjaculations autobiographiques*. Nice, 1938.

Starr, Frederick. "Anthropological Work in Europe." *Popular Science Monthly* 41 (May 1892): 54–72.

Stern, Philippe. "La réorganisation du Muséee Guimet et les problèmes muséographiques." *Mouseion* 33–34 (1936): 101–12.

Sudre, René. "Review of *L'ologenèse culturelle.*" *Le Journal des Débats,* 22 Nov. 1934.

Tillion, Germaine. *À la recherche du vrai et du juste. À propos rompus avec le siècle.* Paris, 2001.

———. *Il était une fois l'ethnographie.* Paris, 2000.

———. *Les ennemis complémentaires.* Paris, 1960.

———. *Ravensbrück.* Paris, 1988.

———. *Une opérette à Ravensbrück. Le Verfügbar aux Enfers.* Paris, 2005.

Tischner, Herbert. "Les collections océaniennes d'ethnographie en Allemagne après la guerre." *Journal de la Société des Océanistes* 3 (1947): 35–41.

Tubiana, Joseph. "Regard dans le rétroviseur." *Journal des Africanistes* 69:1 (1999): 247–53.

UNESCO. *The Race Concept: Results of an Inquiry.* 1952. Westport, CT, 1970.

Vacher de Lapouge, Georges. *L'Aryen et son rôle social.* Paris, 1899.

———. *Les sélections sociales.* Paris, 1896.

Vallois, Henri Victor. *Anthropologie de la population française.* Paris, 1943.

———. "Interview de Henri Victor Vallois (le 15 février 1981)." *Bulletins et Mémoires de la Société d'Anthropologie de Paris* 8:1–2 (1996): 81–103.

———. "L'évolution de la chaire d'ethnologie du Muséum National d'Histoire Naturelle." *Bulletin du Muséum National d'Histoire Naturelle* 16:1 (1944): 38–55.

———. "Rapport moral pour l'année 1938." *Bulletins et Mémoires de la Société d'Anthropologie de Paris* 9:4–6 (1938): 112–14.

———. "Review of *La race, les races.*" *L'Anthropologie* 44 (1934): 381–82.

———. "Review of *L'ethnie française.*" *L'Anthropologie* 46 (1936): 442–44.

Van Gennep, Arnold. "Review of *La race, les races.*" In "Anthropologie," *Mercure de France,* 1 June 1934, 367–70.

———. "Review of *L'ologenèse culturelle.*" In "Ethnographie," *Mercure de France,* 15 Sept. 1935, 604–8.

Verneau, René. "L'Institut Français d'Anthropologie." *L'Anthropologie* 22 (1911): 110–11.

Victor, Paul-Émile. *La mansarde (Vents du nord, vents du sud).* Paris, 1981.

Vignaud, Henry. "Discours de rentrée de M. Vignaud, séance du 4 novembre 1913." *Journal de la Société des Américanistes* 11 (1919): 1–12.

Vildé, Boris. "Les races de l'Europe." *Races et Racisme. Bulletin du Groupement d'Étude et d'Information* 16–17–18 (Dec. 1939): 8–10.

Wallis, Wilson D. "Review of *L'ologenèse culturelle.*" *American Anthropologist* 37:3, pt. 1 (July-Sept. 1935): 521.

Wassen, Henri. "Le musée ethnographique de Göteborg." *Revista del Instituto de Etnología de la Universidad de Tucuman* 2:2 (1932): 237–62.

SECONDARY SOURCES

Adler, Karen H. *Jews and Gender in Liberation France.* Cambridge, 2003.

Apter, Andrew. "Griaule's Legacy." *Cahiers d'Études Africaines* 177 (2005): 95–130.

Armel, Aliette. *Michel Leiris.* Paris, 1997.

Asad, Talal. *Anthropology and the Colonial Encounter.* New York, 1973.

Augé, Marc. *A Sense for the Other: The Timeliness and Relevance of Anthropology,* trans. Amy Jacobs. Stanford, CA, 1998.

Avez, Renaud. *L'Institut Français de Damas au Palais Azem (1922–1946) à travers les archives*. Damascus, 1993.

Bach, Raymond. "L'identification des juifs. L'héritage de l'Exposition de 1941, 'Le Juif et la France.'" *Revue d'Histoire de la Shoah* 173 (2001): 170–92.

Baker, Lee D. *From Savage to Negro: Anthropology and the Construction of Race, 1896–1954*. Berkeley, 1998.

Barkan, Elazar. *The Retreat of Scientific Racism: Changing Concepts of Race in Britain and the United States between the World Wars*. Cambridge, 1992.

Bayly, Susan. "French Anthropology and the Durkheimians in Colonial Indochina." *Modern Asia Studies* 34:3 (2000): 581–622.

Bellanger, Claude et al. *Histoire générale de la presse française*. Vol. 4. Paris, 1969.

Belmont, Nicole. *Arnold Van Gennep, the Creator of French Ethnography*, trans. Derek Coltman. Chicago, 1979.

Bernault, Florence. "L'Afrique et la modernité des sciences sociales," *Vingtième Siècle. Revue d'Histoire* 70 (April-June 2001): 127–38.

Besnard, Philippe. "La formation de l'équipe de l'*Année Sociologique*." *Revue Française de Sociologie* 20:1 (1979): 7–31.

Blais, Hélène. "Les enquêtes des cartographes en Algérie ou les ambiguïtés de l'usage des savoirs vernaculaires en situation coloniale." *Revue d'Histoire Moderne et Contemporaine* 54:4 (2007): 70–85.

Blanc, Julien. *Au commencement de la Résistance du côté du Musée de l'Homme*. Paris, 2010.

Blanckaert, Claude. *De la race à l'évolution. Paul Broca et l'anthropologie française, 1850–1900*. Paris, 2009.

——. "La création de la chaire d'anthropologie du Muséum dans son contexte institutionnel et intellectuel (1832–1855)." In *Le Muséum au premier siècle de son histoire*, ed. Claude Blanckaert, Claudine Cohen, Pietro Corsi, and Jean-Louis Fischer, 85–124. Paris, 1997.

——, ed. *Les politiques de l'anthropologie. Discours et pratiques en France (1860–1940)*. Paris, 2001.

——. "Of Monstrous Métis? Hybridity, Fear of Miscegenation, and Patriotism from Buffon to Paul Broca." In *The Color of Liberty: Histories of Race in France*, ed. Sue Peabody and Tyler Stovall, 42–70. Durham, NC, 2003.

Blay, Michel. "Henri Berr et l'histoire des sciences." In *Henri Berr et la culture du XXe siècle. Histoire, science et philosophie. Actes du colloque international, Paris, 24–26 octobre 1994*, ed. Agnès Biard, Dominique Bourel, and Éric Brian, 121–37. Paris, 1997.

Bloom, Peter. *French Colonial Documentary: Mythologies of Humanitarianism*. Minneapolis, 2008.

Bloor, David. *Knowledge and Social Imagery*. London, 1976.

Bocquet-Appel, Jean-Pierre. "L'anthropologie physique en France et ses origines institutionnelles," *Gradhiva* 6 (1989): 23-34.

Bondaz, Julien. "L'exposition postcoloniale. Formes et usages des musées et des zoos en Afrique de l'Ouest (Niger, Mali, Burkina Faso)." Thèse de doctorat, Université Lumière Lyon 2, 2009.

Bonneuil, Christophe. *Des savants pour l'empire. La structuration des recherches scientifiques coloniales au temps de "la mise en valeur des colonies françaises," 1917–1945*. Paris, 1991.

Bonneuil, Christophe, and Patrick Petitjean. "Recherche scientifique et politique coloniale. Les chemins de la création de l'ORSTOM, 1936–1945." In *Les sciences coloniales. Figures et institutions*, ed. Patrick Petitjean, 131–61. Paris, 1996.

Bourdieu, Pierre. "Le champ scientifique." *Actes de la Recherche en Sciences Sociales* 2:2 (1976): 88–104.

——, ed. *Le mal de voir. Ethnologie et orientalisme. Politique et epistémologie, critique et autocritique.* Paris, 1976.

Bowd, Gavin, and Daniel Clayton. "Tropicality, Orientalism, and French Colonialism in Indochina: The Work of Pierre Gourou, 1927–1982." *French Historical Studies* 28:2 (2005): 297–328.

Bowler, Peter J. *Evolution: The History of an Idea.* Berkeley, 2003.

Brattain, Michelle. "Race, Racism, and Antiracism: UNESCO and the Politics of Presenting Science to the Postwar Public." *American Historical Review* 112:5 (2007): 1386–1413.

Bromberger, Christian, and Tzvetan Todorov, eds. *Germaine Tillion, une ethnologue dans le siècle.* Arles, 2002.

Brown, Alison, Jeremy Coote, and Chris Gooden. "Tylor's Tongue: Material Culture, Evidence, and Social Networks." *Journal of the Anthropological Society of Oxford* 31:3 (2000): 257–76.

Bruneteau, Bernard. *"L'Europe nouvelle" de Hitler. Une illusion des intellectuels de la France de Vichy.* Paris, 2003.

Bunzl, Matti, and H. Glenn Penny, eds. *Worldly Provincialism: German Anthropology in the Age of Empire.* Ann Arbor, MI, 2003.

Burguière, André. *L'école des Annales. Une histoire intellectuelle.* Paris, 2006.

——. "De la psychologie des peuples à l'histoire des mentalités. La controverse de Paul Lacombe et d'Alexandre Xenopol" (unpublished paper).

Burian, Richard M., Jean Gayon, and Doris Zallen. "The Singular Fate of Genetics in the History of French Biology, 1900–1940." *Journal of the History of Biology* 21:3 (1988): 357–402.

Burke, Edmund, III. "France and the Classical Sociology of Islam, 1798–1962." *Journal of North African Studies* 12:4 (2007): 551–61.

Burrin, Philippe. *France under the Germans: Collaboration and Compromise.* New York, 1996.

Buschmann, Rainer F. *Anthropology's Global Histories: The Ethnographic Frontier in German New Guinea, 1870–1935.* Honolulu, 2009.

Carbonell, Bettina Messias, ed. *Museum Studies: An Anthology of Contexts.* 2nd ed. Chichester, UK, 2012.

Caron, Vicki. *Uneasy Asylum: France and the Jewish Refugee Crisis, 1933–1942.* Stanford, CA, 1999.

Carson, John. *The Measure of Merit: Talents, Intelligence, and Inequality in the French and American Republics, 1750–1940.* Princeton, NJ, 2007.

Chailleu, Luc. "Histoire de la Société d'Ethnographie. La revue orientale et américaine (1858–1879). Ethnographie, orientalisme et américanisme au XIXe siècle." *L'Ethnographie* 86 (1990): 89–107.

Chandler, David, and Christopher Goscha, eds. *L'espace d'un regard. L'Asie de Paul Mus.* Paris, 2006.

Chappey, Jean-Luc. *La Société des Observateurs de l'Homme (1799–1804). Des anthropologues au temps de Bonaparte.* Paris, 2002.

Charle, Christophe. *La République des universitaires.* Paris, 1994.

——. *Les élites de la République.* Paris, 1987.

——. *Naissance des "intellectuels"(1880–1900).* Paris, 1990.

Charle, Christophe, and Éva Telkes. *Les professeurs du Collège de France, dictionnaire biographique (1901–1939).* Paris, 1988.

Chevassus-au-Louis, Nicolas. *Savants sous l'Occupation. Enquête sur la vie scientifique française entre 1940 et 1944.* Paris, 2004.

Chimisso, Christine. "The Mind and the Faculties: The Controversy over 'Primitive Mentality' and the Struggle for Disciplinary Space at the Inter-war Sorbonne." *History of the Human Sciences* 13:3 (2000): 47–68.

———. *Writing the History of the Mind: Philosophy and Science in France, 1900–1960s*. London, 2008.

Chiva, Isac. "Georges Henri Rivière, un demi-siècle d'ethnologie de la France." *Terrain* 5 (1985): 76–83.

Ciarcia, Gaetano. *De la mémoire ethnographique. L'exotisme au pays des Dogons*. Paris, 2004.

Cinnamon, John M. "Missionary Expertise, Social Science, and the Uses of Ethnographic Knowledge in Colonial Gabon." *History in Africa* 33 (2006): 413–32.

Clark, Terry N. *Prophets and Patrons: The French University and the Emergence of the Social Sciences*. Cambridge, MA, 1973.

Clifford, James. *Person and Myth: Maurice Leenhardt in the Melanesian World*. Berkeley, 1982.

———. *The Predicament of Culture: Twentieth-Century Ethnography, Literature, and Art*. Cambridge, MA, 1988.

Clifford, James, and George E. Marcus, eds. *Writing Culture: The Poetics and Politics of Ethnography*. Berkeley, 1986.

Cohen, William B. *The French Encounter with Africans: White Response to Blacks, 1530–1880*. Bloomington, IN, 1980.

Cohn, Bernard. *Colonialism and Its Forms of Knowledge*. Princeton, NJ, 1996.

Cole, Douglas. *Franz Boas: The Early Years, 1858–1906*. Vancouver, 1999.

Cole, Joshua. *The Power of Large Numbers: Population, Politics, and Gender in Nineteenth-Century France*. Berkeley, 2000.

Colonna, Fanny. "Elle a passé tant d'heures." In *Aurès, Algérie, 1935–1936, photographies de Thérèse Rivière*, 121–91. Paris, 1987.

Comaroff, Jean, and John Comaroff. *Ethnography and the Historical Imagination*. Boulder, CO, 1992.

Comiscoli, Elisa. *Reproducing the French Race: Immigration, Intimacy, and Embodiment in the Early Twentieth Century*. Durham, NC, 2009.

Condominas, Georges. "Marcel Mauss, père de l'ethnographie française," pts. I and II. *Critique* 28:297 (1972): 118–39, and 28:301 (1972): 487–504.

Conn, Steven. *Museums and American Intellectual Life, 1876–1926*. Chicago, 1998.

Coombes, Annie. *Reinventing Africa: Museums, Material Culture, and Popular Imagination in Late Victorian and Edwardian England*. New Haven, CT, 1994.

Copans, Jean, ed. *Anthropologie et impérialisme*. Paris, 1975.

Crips, Liliane. "Les avatars d'une utopie scientiste en Allemagne. Eugen Fischer (1874–1967) et l'"hygiène raciale.'" *Le Mouvement Social* 163 (Apr.-Jun. 1993): 7–24.

Crouzet, Denis, and Élisabeth Crouzet-Pavan. "Postface." In Lucien Febvre and Francois Crouzet, *Nous sommes des sang-mêlés. Manuel d'histoire de la civilisation française*, ed. Denis Crouzet and Élisabeth Crouzet-Pavan, 295–318. Paris, 2012.

D'Anglure, Bernard Saladin. "Mauss et l'anthropologie des Inuit." *Sociologie et Société* 36:2 (2002): 91–131.

Darnell, Regna. *And Along Came Boas: Continuity and Revolution in Americanist Anthropology*. Amsterdam, 1998.

Dartigues, Laurent. "La production conjointe de connaissances en sociologie historique. Quelles approches? Quelles sources? Le cas de la production orientaliste sur le Vietnam (1860–1940)." *Genèses* 43 (June 2003): 53–70.

Daughton, J. P. "When Argentina Was 'French': Rethinking Cultural Politics and European Imperialism in Belle-Époque Buenos Aires." *Journal of Modern History* 80 (December 2008): 831–64.

Debaene, Vincent. *Adieu au voyage. L'ethnologie française entre science et littérature*. Paris, 2010.

———. "Étudier des 'états de conscience,' la réinvention du terrain par l'ethnologie, 1925–1939." *L'Homme* 179 (2006): 7–62.

———. "Les 'Chroniques éthiopiennes' de Marcel Griaule. L'ethnologie, la littérature et le document en 1934." *Gradhiva* 6 (2006): 87–103.

Decock, Sophie. "Le Centre de Documentation en sciences humaines entre passé et futur." In *Africa-Museum Tervuren, 1898–1998*, 115–19. Tervuren, 1998.

De l'Estoile, Benoît. "Africanisme et *Africanism*. Esquisse de comparaison franco-britannique." In *L'africanisme en questions*, ed. Anne Piriou and Émmanuelle Sibeud, 19–42. Paris, 1997.

———. "'Des races non pas inférieures mais différentes': de l'Exposition Coloniale au Musée de l'Homme." In *Les politiques de l'anthropologie. Discours et pratiques en France (1860-1940)*, ed. Claude Blanckaert, 391–473. Paris, 2001.

———. *Le goût des autres. De l'exposition coloniale aux arts premiers*. Paris, 2007.

———. "Science de l'homme et 'domination rationnelle.' Savoir ethnologique et politique indigène en Afrique coloniale française." *Revue de Synthèse* 4:3–4 (July-Dec. 2000): 291–323.

———. "Une petite armée de travailleurs auxiliaires." *Les Cahiers du Centre de Recherches Historiques* 36 (2005): 1–25.

Diallo, Youssouf. "L'africanisme en Allemagne. Hier et aujourd'hui." *Cahiers d'Études Africaines* 161 (2001): 13–44.

Dias, Nélia. *Le Musée d'ethnographie du Trocadéro (1878–1908). Anthropologie et muséologie en France*. Paris, 1991.

———. "Looking at Objects: Memory, Knowledge, in Nineteenth-Century Ethnographic Displays." In *Travellers' Tales: Narratives of Home and Displacement*, ed. George Robertson, Melinda Mash, Lisa Tickner, Jon Bird, Barry Curtis, and Tim Putnam, 164–77. London, 1994.

———. "Séries de crânes et armée de squelettes. Les collections anthropologiques en France dans la seconde moitié du XIXe siècle." *Bulletins et Mémoires de la Société d'Anthropologie de Paris* 1:3–4 (1989): 203–30.

Dimier, Véronique. *Le gouvernement des colonies. Regards croisés franco-britanniques*. Brussels, 2004.

Dirks, Nicholas, ed. *Colonialism and Culture*. Ann Arbor, MI, 1992.

Doquet, Anne. *Les masques dogons. Ethnologie savante et ethnologie autochtone*. Paris, 1999.

Duchet, Michèle. *Anthropologie et histoire au siècle des Lumières*. Paris, 1995.

Dumoulin, Olivier. "Les sciences humaines et la préhistoire du CNRS." *Revue Française de Sociologie* 26:2 (1985): 353–74.

Duncan, Carol G. *A Matter of Class: John Cotton Dana, Progressive Reform, and the Newark Museum*. Pittsburgh, 2010.

Dzimira, Sylvain. *Marcel Mauss, savant et politique*. Paris, 2007.

Edison, Paul N. "Conquest Unrequited: French Expeditionary Science in Mexico, 1864–1867." *French Historical Studies* 26:3 (2003): 459–95.

———. "Latinizing America: The French Scientific Study of America, 1830–1930." PhD diss., Columbia University, 1999.

El-Shakry, Omnia. *The Great Social Laboratory: Subjects of Knowledge in Colonial and Postcolonial Egypt*. Stanford, CA, 2007.

Embree, John F. "Anthropology in Indochina since 1940." *American Anthropologist* 50:4 (Oct.-Dec. 1948): 714–16.

Epstein, Simon. *Un paradoxe français. Antiracistes dans la collaboration, antisémites dans la résistance*. Paris, 2008.

Evans, Andrew D. *Anthropology at War: World War I and the Science of Race in Germany*. Chicago, 2010.

———. "Race Made Visible: The Transformation of Museum Exhibits in Early Twentieth-Century German Anthropology." *German Studies Review* 31:1 (2008): 87–108.

Fabre, Daniel. "D'Isaac Strauss à Claude Lévi-Strauss, le judaïsme comme culture." In *Claude Lévi-Strauss, Un parcours dans le siècle*, ed. Philippe Descola, 267–93, Paris, 2012.

———. "L'ethnologie française à la croisée des engagements (1940–1945)." In *Résistants et Résistance*, ed. Jean-Yves Boursier, 319–400. Paris, 1997.

Ferembach, Denise. "Le laboratoire d'anthropologie à l'École pratique des hautes études." *Bulletins et Mémoires de la Société d'Anthropologie de Paris* 7:7–4 (1980): 307–18.

Fette, Julie. *Exclusions: Practicing Prejudice in French Law and Medicine, 1920–1945*. Ithaca, NY, 2012.

Fiemeyer, Isabelle. *Marcel Griaule, citoyen Dogon*. Paris, 2004.

Fischer, H. *Völkerkunde im Nationalsozialismus. Aspekte der Anpassung, Affinität und Behauptung einer wissenschaftlichen Disziplin*. Berlin, 1990.

Fiss, Karen. *Grand Illusion: The Third Reich, the Paris Exposition, and the Cultural Seduction of France*. Chicago, 2009.

Foucault, Michel. *L'ordre du discours*. Paris, 1971.

———. *Surveiller et punir. Naissance de la prison*. Paris, 1975.

Fournier, Marcel. "Introduction." In Marcel Mauss, *Écrits politiques*, ed. Marcel Fournier, 7–58. Paris, 1997.

———. *Marcel Mauss*. Paris, 1994.

Fraiture, Pierre-Philippe. *La mesure de l'autre. Afrique subsaharienne et roman ethnographique de Belgique et de France (1918–1940)*. Paris, 2007.

Frémeaux, Jacques. *Le Sahara et la France*. Paris, 2010.

———. *Les bureaux-arabes dans l'Algérie de la conquête*. Paris, 1993.

Fuller, Steve. *Thomas Kuhn: A Philosophical History for Our Times*. Chicago, 2000.

Gaillard, Gérald. "Chronique de la recherche ethnologique dans son rapport au CNRS, 1925–1980." *Cahiers pour une Histoire du CNRS* 3 (1989): 85–126.

———. *Dictionnaire des ethnologues et des anthropologues*. Paris, 1997.

Gaulmier, Jean. "Dossier Gobineau." *Romantisme* 37 (1982): 81–100.

Gelfand, Toby. "From Religious to Bio-medical Anti-Semitism: The Career of Jules Soury." In *French Medical Culture in the Nineteenth Century*, ed. Ann Elizabeth Fowler La Berge and Mordechai Feingold, 248–79. Amsterdam, 1994.

Gemelli, Giuliana. "Communauté intellectuelle et stratégies institutionelles. Henri Berr et la fondation du Centre International de Synthèse." *Revue de Synthèse* 108:2 (April-June 1987): 225-259.

Giddens, Anthony. *Capitalism and Social Modern Theory: An Analysis of the Writings of Marx, Durkheim, and Max Weber*. Cambridge, 1971.

Goldstein, Jan. *Console and Classify: The French Psychiatric Profession in the Nineteenth Century*. 1987. Chicago, 2002.

———. "Foucault among the Sociologists: The 'Disciplines' and the History of the Professions." *History and Theory* 23:2 (May 1984): 170–92.

Gorgus, Nina. *Le magicien des vitrines. Le muséologue Georges Henri Rivière*. Paris, 2003.

Gould, Stephen Jay. *The Mismeasure of Man*. New York, 1996.

Grognet, Fabrice. "Le concept de musée. La patrimonisalition de la culture 'des Autres' d'une rive à l'autre, du Trocadéro à Branly. Histoire de métamorphoses." Thèse de doctorat, École des Hautes Études en Sciences Sociales, 2009.

Grove, Richard. *Green Imperialism: Colonial Expansion, Tropical Island Edens, and the Origins of Environmentalism, 1600–1860*. Cambridge, 1995.

Guyer, Jane I. "The True Gift: Thoughts on *L'Année Sociologique* Edition of 1923–24." *Revue du M.A.U.S.S.* 36 (Nov. 2010), http://www.editionsladecouverte.fr/catalogue/index-Marcel_Mauss_vivant-9782707166555.html.

Hale, Dana. *Races on Display: French Representations of Colonized Peoples during the Third Republic*. Bloomington, IN, 2008.

Hall, Bruce S. *A History of Race in Muslim West Africa*. Cambridge, 2011.

Hammond, Michael. "Anthropology as a Weapon of Social Combat in Late Nineteenth-Century France." *Journal of the History of the Behavioral Sciences* 16:2 (1980): 118–32.

——. "The Expulsion of Neanderthals from Human Ancestry: Marcellin Boule and the Social Context of Scientific Research." *Social Studies of Science* 12:1 (1982): 1–36.

Hart, Keith. "Marcel Mauss: In Pursuit of the Whole; A Review Essay." *Comparative Studies in Science and History* 49:2 (2007): 1–13.

Harvey, Joy. *Almost a Man of Genius: Clémence Royer, Feminism, and Nineteenth-Century Science*. New Brunswick, NJ, 1997.

——. "Evolutionism Transformed: Positivists and Materialists in the Société d'Anthropologie de Paris from Second Empire to Third Republic." In *The Wider Domain of European Evolutionary Thought*, ed. David Oldroyd and Ian Langham, 289–310. Dordrecht, 1983.

Hauschild, Thomas. *Lebenslust und Fremdenfurcht. Ethnologie im Dritten Reich*. Berlin, 1995.

Hecht, Jennifer Michael. *The End of the Soul: Scientific Modernity, Atheism, and Anthropology in France*. New York, 2003.

Heffernan, Michael J. "A State Scholarship: The Political Geography of French International Science during the Nineteenth Century." *Transactions of the Institute of British Geographers* 19:1 (1994): 21–45.

——. "Geography, Empire, and National Revolution in Vichy France." *Political Geography* 24:6 (2005): 731–58.

Heilbron, Johan. "Les métamorphoses du durkheimisme, 1920–1940." *Revue Française de Sociologie* 26:2 (1985): 202–37.

Hellman, John. *Émmanuel Mounier and the New Catholic Left, 1930–1950*. Toronto, 1981.

——. "The Opening to the Left in French Catholicism: The Role of the Personalists." *Journal of the History of Ideas* 34:3 (1973): 381–90.

Henley, Paul. *The Adventure of the Real: Jean Rouch and the Craft of Ethnographic Cinema*. Chicago, 2011.

Herbert, James D. *Paris 1937: Worlds on Exposition*. Ithaca, NY, 1998.

Herle, Anita. "The Life-Histories of Objects: Collections of the Cambridge Anthropological Expedition to the Torres Strait." In *Cambridge and the Torres Strait: Centenary Essays on the 1898 Anthropological Expedition*, ed. Anita Herle and Sandra Rouse, 77–105. Cambridge, 1998.

Herle, Anita, and Sandra Rouse, eds. *Cambridge and the Torres Strait: Centenary Essays on the 1898 Anthropological Expedition*. Cambridge, 1998.

Herrnstein, Richard J., and Charles A. Murray. *The Bell Curve: Intelligence and Class Structure in American Life*. New York, 1994.

Hinsley, Curtis M. *The Smithsonian and the American Indian: Making Moral Anthropology in Victorian America*. Washington, DC, 1981.

Hirsch, Francine. *Empire of Nations: Ethnographic Knowledge and the Making of the Soviet Union*. Ithaca, NY, 2005.

Hodeir, Catherine, and Michel Pierre. *L'exposition coloniale*. Paris, 1991.

Holt, Thomas C. *The Problem of Race in the Twenty-First Century*. Cambridge, MA, 2000.

Hoyt, D. L. "The Reanimation of the Primitive: Fin-de-siècle Ethnographic Discourse in Western Europe." *History of Science* 39:125 (2001): 331–54.

Hurel, Arnaud. *L'abbé Breuil. Un préhistorien dans le siècle*. Paris, 2011.

———. *La France préhistorienne de 1789 à 1941*. Paris, 2007.

Hutton, Christopher M. *Race and the Third Reich: Linguistics, Racial Anthropology, and Genetics in the Dialectic of the Volk*. London, 2005.

Ingold, Tim. "Anthropology Is *Not* Ethnography." *Proceedings of the British Academy* 154 (2008): 69–92.

Jackson, Julian. *The Dark Years, 1940–1944*. Oxford, 2001.

James, Wendy. "The Treatment of African Ethnography in *L'Année Sociologique* (1–12)." *L'Année Sociologique* 48:1 (1998): 193–207.

James, Wendy, and N. J. Allen, eds. *Marcel Mauss: A Centenary Tribute*. New York, 1998.

Jamin, Jean. "André Schaeffner (1895–1980)." *Objets et Mondes* 20:3 (1980): 131–35.

———. "De l'identité à la différence. La personne colonisée." *Journal de la Société des Océanistes* 58–59:34 (1978): 51–56.

———. "La Mission d'ethnographie Dakar-Djibouti 1931–1933." *Cahiers Ethnologiques* 5 (1984): 1–179.

———. *Leiris. Miroir de l'Afrique*. Paris, 1996.

———. "Le savant et le scientifique. Paul Rivet (1876–1958)." *Bulletin et Mémoires de la Société d'Anthropologie de Paris* 1:3–4 (1989): 277–94.

———. "L'ethnographie mode d'inemploi. De quelques rapports de l'ethnologie avec le malaise dans la civilisation." In *Le mal et la douleur*, ed. Jacques Hainard and Roland Khaer, 45–79. Neuchâtel, 1986.

———. "Objets trouvés des paradis perdus. À propos de la Mission Dakar-Djibouti." In *Collections Passion*, ed. Jacques Hainard and Roland Khaer, 69–100. Neuchâtel, 1982.

Jarnot, Sébastien. "Une relation récurrente. Science et racisme. L'exemple de l'Ethnie française." *Les Cahiers du Cériem* 5 (May 2000): 17–34.

Jennings, Eric T. "Last Exit from Vichy France: The Martinique Escape Route and the Ambiguities of Emigration." *Journal of Modern History* 74:2 (2002): 289–324.

———. *Vichy in the Tropics: Pétain's National Revolution in Madagascar, Guadeloupe, and Indochina (1940–1944)*. Stanford, CA, 2001.

———. "Writing Madagascar Back into the Madagascar Plan." *Holocaust and Genocide Studies* 21:2 (2007): 191–202.

Joly, Laurent. *Vichy dans la "solution finale." Histoire du Commissariat Général aux Questions Juives, 1941–1944*. Paris, 2006.

Joly, Marc. *Le mythe Jean Monnet. Contribution à une sociologie historique de la construction européenne*. Paris, 2007.

Jolly, Éric. "Des jeux aux mythes. Le parcours ethnographique de Marcel Griaule." *Gradhiva* 9 (2009): 165–87.

———. "Écriture image et dessins parlants. Les pratiques graphiques de Marcel Griaule." *L'Homme* 200 (2011): 43–82.

———. "Marcel Griaule, ethnologue. La construction d'une discipline (1925–1926)." *Journal des Africanistes* 71:1 (2001): 149–90.

Jones, Robert Alun. *The Development of Durkheim's Social Realism*. Cambridge, 1999.

———. *The Secret of the Totem: Religion and Society from McLennan to Freud*. New York, 2005.

Karady, Victor. "Durkheim et les débuts de l'ethnologie universitaire." *Actes de la Recherche en Sciences Sociales* 74 (1988): 23–32.

———. "French Ethnology and the Durkheimian Breakthrough." *Journal of the Anthropological Society of Oxford* 12 (1981): 165–76.

——. "Le problème de la légitimité dans l'organisation historique de l'ethnologie française." *Revue Française de Sociologie* 23:1 (1982): 17–35.

Karsenti, Bruno. *L'homme total. Sociologie, anthropologie et philosophie chez Marcel Mauss*. Paris, 1997.

Keller, Richard. *Colonial Madness: Psychiatry in French North Africa*. Chicago, 2007.

Klauptke, Egbert. "German 'Race Psychology' and Its Implementation in Central Europe: Egon von Eickstedt and Rudolf Hippius." In *Blood And Homeland: Eugenics And Racial Nationalism in Central And Southeast Europe, 1900–1940*, ed. Marius Turda and Paul Weindling, 23–40. Budapest, 2007.

Kleingen, John. "Tropicality and Topicality: Pierre Gourou and the Genealogy of French Colonial Scholarship on Rural Vietnam." *Singapore Journal of Tropical Geography* 26:3 (2005): 339–58.

Knobel, Marc. "George Montandon et l'ethnoracisme." In *L'antisémitisme de plume, 1940–1944*, ed. Pierre-André Taguieff, 277–93. Paris, 1999.

——. "L'ethnologue à la dérive. George Montandon et l'ethnoracisme." *Ethnologie Française* 18:2 (1988): 107–13.

Kohlstedt, Sally Gregory. "Thoughts in Things: Modernity, History, and North American Museums." *Isis* 96 (2005): 586–601.

Kubler, George. *The Art and Architecture of Ancient America: The Mexican "Maya" and Andean Peoples*. Harmondsworth, UK, 1962.

Kuhn, Thomas S. *The Structure of Scientific Revolutions*. 1962. Chicago, 1970.

Kuklick, Henrika, ed. *A New History of Anthropology*. Oxford, 2008.

——. "Personal Equations: Reflections on the History of Fieldwork, with Special Reference to Sociocultural Anthropology." *Isis* 102:1 (2011): 1–33.

——. *The Savage Within: The Social History of British Anthropology, 1885–1945*. Cambridge, 1991.

Lacoste, Michel Conil. *The Story of a Grand Design: UNESCO 1946–1993*. Paris, 1994.

Lacouture, Jean. *Le témoinage est un combat*. Paris, 2000.

Lambauer, Barbara. *Otto Abetz et les Français, ou l'envers de la collaboration*. Paris, 2001.

Latour, Bruno. *Science in Action: How to Follow Scientists and Engineers in Society*. Cambridge, MA, 1988.

Laurière, Christine. "Georges Henri Rivière au Trocadéro, du bric-a-brac à la sécheresse d'étiquette." *Gradhiva* 33 (2003): 57–66.

——. *Paul Rivet. Le savant et le politique*. Paris, 2008.

Leacock, Seth. "The Ethnological Theory of Marcel Mauss." *American Anthropologist* 56:1 (1954): 58–71.

Lebovics, Herman. *True France: The Wars over Cultural Identity, 1900–1945*. Ithaca, NY, 1992.

Leclerc, Gérard. *Anthropologie et colonialisme*. Paris, 1972.

Lemaire, Marianne. "La chambre à soi de l'ethnologue. Une écriture féminine en anthropologie dans l'entre-deux-guerres." *L'Homme* 200 (2011): 51–73.

Lentin, Alana. *Racism and Anti-Racism in Europe*. London, 2004.

Leroux-Dhuys, Jean-François. "Georges Henri Rivière, un homme dans le siècle." In *La muséologie selon Georges Henri Rivière. Cours de muséologie, textes et témoinages*, 11–32. Paris, 1989.

Lévi-Strauss, Claude. "L'anthropologie devant l'histoire." *Annales. Économies, Sociétés, Civilisations* 15:4 (1960): 625–37.

Liebersohn, Harry. *The Return of the Gift: European History of a Global Idea*. Cambridge, 2011.

Limoges, Camille. "The Development of the Muséum d'Histoire Naturelle of Paris, 1800–1914." In *The Organization of Science and Technology in France, 1808–1914*, ed. Robert Fox and Georges Weisz, 211–40. Cambridge, 1980.

Lorcin, Patricia. *Imperial Identities: Stereotyping, Prejudice, and Race in Colonial Algeria.* London, 1995.

Lowie, Robert H. *The History of Ethnological Theory.* New York, 1937.

Loyer, Emmanuelle. *Paris à New York. Intellectuels et artistes français en exil, 1940–47.* Paris, 2007.

Lucas, Philippe, and Jean-Claude Vatin. *L'Algérie des anthropologues.* Paris, 1975.

Lukes, Steven. *Émile Durkheim: His Life and Work; A Historical and Critical Study.* New York, 1973.

Lumley, Robert, ed. *The Museum Time Machine: Putting Cultures on Display.* London, 1988.

Luzzato, Michele, Claudio Palestrini, and Pietro Passerin d'Entrèves. "Hologenesis: The Last and Lost Theory of Evolutionary Change." *Italian Journal of Zoology* 67:1 (2000): 129–38.

Maack, Mary Niles. "Americans in France: Cross-Cultural Exchange and the Diffusion of Innovations." *Journal of Library History* 21 (Spring 1986): 315–33.

MacDonald, Sharon, ed. *The Politics of Display: Museums, Science, Culture.* London, 1998.

Mallard, Grégoire. "The Gift Revisited: Marcel Mauss on War, Debt, and the Politics of Nation." Working Paper 10–004, Buffet Center for International and Comparative Studies, Working Papers, November 2010, 1–49.

Mann, Gregory. "Anti-Colonialism and Social Science: Georges Balandier, Madeira Keita, and 'the Colonial Situation' in French Africa," *Comparative Studies in Society and History* 55:1 (2013): 92–119.

Maresse, François. "The Family Album." *Museum International* 50:1 (1998): 25–30.

Marrus, Michael R., and Robert O. Paxton. *Vichy France and the Jews.* New York, 1981.

Massin, Benoît. "Anthropologie raciale et national-socialisme. Heurs et malheurs du paradigme de la 'race.'" In *La science sous le Troisième Reich: victime ou alliée du nazisme?* ed. J. Olff-Nathan, 197–262. Paris, 1993.

——. "From Virchow to Fischer: Physical Anthropology and 'Modern Race Theories' in Wilhelmine Germany (1890–1914)." In *Volksgeist as Method and Ethic: Essays on Boasian Ethnography and the German Anthropological Tradition*, ed. George W. Stocking, Jr., 79–154. Madison, WI, 1996.

Mazliak, Laurent, and Glenn Shafer. "What Does the Arrest and Release of Émile Borel and His Colleagues in 1941 Tell Us about the German Occupation of France?" *Science in Context* 24:4 (2011): 587–623.

Mazon, Brigitte. "La Fondation Rockefeller et les sciences sociales en France, 1925–1940." *Revue Française de Sociologie* 26:2 (1985): 311–42.

McBride, Bunny. *Molly Spotted Elk: A Penobscot in Paris.* Norman, OK, 1997.

McCarthy, Conal. *Exhibiting Maori: A History of Colonial Cultures of Display.* New York, 2007.

Michaud, Jean. *"Incidental" Ethnographers: French Catholic Missions on the Tonkin-Yunnan Frontier, 1880–1930.* Leiden, 2007.

Mills, David. *Difficult Folk: A Political History of Social Anthropology.* New York, 2008.

Mitchell, Allan. *Nazi Paris: The History of an Occupation, 1940–1944.* New York, 2008.

Monnais-Rousselot, Laurence. *Médecine et colonisation. L'aventure indochinoise, 1860–1939.* Paris, 1999.

John Warne Monroe, "Surface Tensions: Empire, Parisian Modernism, and 'Authenticity' in African Sculpture, 1917–1939," *American Historical Review* 117:2 (April 2012): 445–75.

Morton, Patricia. *Hybrid Modernities: Architecture and Representation at the 1931 Colonial Exposition, Paris.* Cambridge, MA, 2000.

Moyn, Samuel. *The Last Utopia: Human Rights in History.* Cambridge, MA, 2010.

——. "Personalism, Community, and the Origin of Human Rights." In *Human Rights in the Twentieth Century,* ed. Stefan-Ludwig Hoffmann, 85–106. Cambridge, 2010.

Mucchielli, Laurent. *La découverte du social. Naissance de la sociologie en France (1870–1914).* Paris, 1998.

——. "Sociologie *versus* anthropologie raciale. L'engagement des sociologues durkheimiens dans le contexte 'fin de siècle' (1885-1914)," *Gradhiva* 21 (1997): 77–95.

Murphy, Maureen. *De l'imaginaire au musée. Les arts d'Afrique à Paris et à New York (1931–2006).* Paris, 2009.

Murray, Alison. "Film and Colonial Memory. La Croisière noire." In *Memory, Empire, and Postcolonialism: Legacies of French Colonialism,* ed. Alec Hargreaves, 81–97. New York, 2005.

——. "Le tourisme Citroën au Sahara (1924–1925)." *Vingtième Siècle. Revue d'Histoire* 68 (Oct.-Dec. 2000): 95–107.

Noiriel, Gérard. *Immigration, antisémitisme et racisme en France.* Paris, 2007.

Nord, Philip. *France's New Deal: From the Thirties to the Postwar Era.* Princeton, NJ, 2010.

——. *The Republican Moment: Struggles for Democracy in Nineteenth-Century France.* Cambridge, MA, 1995.

Nordman, Daniel, and Jean-Pierre Raison, eds. *Sciences de l'homme et conquête coloniale. Constitution et usage des sciences humaines en Afrique (XIX–XXe siècles).* Paris, 1980.

Nye, Robert. "Heredity or Milieu: The Foundations of Modern European Criminological Theory." *Isis* 67:3 (1976): 335–55.

Oliver, Georges, and Claude Chippaux. "Pierre Huard (1901–1983)." *Bulletins et Mémoires de la Société d'Anthropologie de Paris* 10:2 (1983): 155–57.

Osborne, Michael. *Nature, the Exotic, and the Science of French Colonialism.* Bloomington, IN, 1994.

Osborne, Michael, and Richard S. Fogarty. "Eugenics in France and the Colonies." In *Oxford Handbook of the History of Eugenics,* ed. A. Bashford and P. Levine, 332–46. Oxford, 2010.

Pajon, Alexandre. *Lévi-Strauss politique. De la SFIO à l'UNESCO.* Paris, 2011.

Parkin, Robert. "The French-Speaking Countries." In *One Discipline, Four Ways: British, German, French, and American Anthropology,* ed. Frederick Barth, 157–253. Chicago, 2005.

Parkin, Robert, and Anne de Sales, eds. *Out of the Study and into the Field: Ethnographic Theory and Practice in French Anthropology.* New York, 2010.

Paudrat, Jean-Louis. "Les classiques de la sculpture africaine au Louvre." In *Sculptures, Afrique, Asie, Océanie, Amérique,* ed. Jacques Kerchache and Vincent Bouloré, 45–55. Paris, 2000.

Paul, Harry W. *From Knowledge to Power: The Rise of the Science Empire in France, 1860–1939.* Cambridge, 2003.

Paxton, Robert. *Vichy France: Old Guard and New Order, 1940–1944.* New York, 1972.

Pedersen, Jean Elisabeth. "Sexual Politics in Comte and Durkheim: Feminism, History, and the Social Scientific Canon." *SIGNS: A Journal of Women in Culture and Society* 27:1 (Fall 2001): 229–63.

Pels, Peter, and Oscar Salemink, eds. *Colonial Subjects: Essays on the Practical History of Anthropology.* Ann Arbor, MI, 2000.

Pendergast, William R. "UNESCO and French Cultural Relations, 1945–1970." *International Organization* 30:3 (1976): 453–83.

Penny, H. Glenn. *Objects of Culture: Ethnology and Ethnographic Museums in Imperial Germany.* Chapel Hill, NC, 2001.

Penny, H. Glenn, and Matti Bunzl, eds. *Worldly Provincialism: German Anthropology in the Age of Empire.* Ann Arbor, MI, 2003.

Petch, Alison. "Notes and Queries and the Pitt Rivers Museum." *Museum Anthropology* 30 (2007): 21–39.

Poncelet, François. "Regards actuels sur la muséographie d'entre-deux-guerres." *CeRO-Art* 2 (2008), http://ceroart.revues.org/565.

Pouillon, François, and Daniel Rivet, eds. *La sociologie musulmane de Robert Montagne.* Paris, 2000.

Prakash, Gyan. *Another Reason: Science and the Imagination of Modern India.* Princeton, NJ, 1999.

Prijac, Lukian. "Déborah Lifszyc (1907–1942): Ethnologue et linguiste (de Gondär à Auschwitz)." *Aethiopica: International Journal of Ethiopian Studies* 11 (2008): 148–72.

Rabinow, Paul. *French Modern: Norms and Forms of the Social Environment.* Cambridge, MA, 1989.

Raj, Kapil. *Relocating Modern Science: Circulation and the Construction of Knowledge in South Asia and Europe, 1650–1900.* London, 2007.

Reardon, Jenny. *Race to the Finish: Identity and Governance in an Age of Genomics.* Princeton, NJ, 2005.

Reid, Donald. *Germaine Tillion, Lucie Aubrac, and the Politics of Memories of the French Resistance.* Newcastle, UK, 2008.

Reubi, Serge. *Gentlemen, prolétaires et primitifs. Institutionalisation, pratiques de collection et choix muséographiques dans l'ethnographie suisse, 1880–1950.* Bern, 2012.

Reynaud-Paligot, Carole. *La République raciale. Paradigme racial et idéologie républicaine.* Paris, 2006.

——. "Naissance de l'antisémitisme scientifique en France." *Archives Juives* 43:1 (2010): 66–76.

——. *Races, racisme et antiracisme dans les années 1930.* Paris, 2007.

Reynolds, Larry T., and Leonard Lieberman, eds. *Race and Other Misadventures: Essays in Honor of Ashley Montagu in His Ninetieth Year.* Dix Hills, NY, 1996.

Richard, Natalie. *Inventer la préhistoire. Les débuts de l'archéologie préhistorique en France.* Paris, 2008.

——. "La revue *L'Homme* de Gabriel de Mortillet. Anthropologie et politique au début de la Troisième République." *Bulletins et Mémoires de la Société d'Anthropologie de Paris* 1:3–4 (1989): 231–56.

Richards, Graham. *"Race," Racism and Psychology: Towards a Reflexive History.* London, 1997.

Richardson, Michael. "An Encounter of Wise Men and Cyclops Women: Considerations of Debates on Surrealism and Anthropology." *Critique of Anthropology* 13:1 (1993): 55–75.

Rival, Laura. "Paul Rivet, vie et oeuvre." *Gradhiva* 26 (1999): 109–28.

——. "What Sort of Anthropologist Was Paul Rivet?" In *Out of the Study and into the Field: Ethnographic Theory and Practice in French Anthropology,* ed. Robert Parkin and Anne de Sales, 125–50. New York, 2010.

Riviale, Pascal. "L'américanisme français à la veille de la fondation de la Société des Américanistes." *Journal de la Société des Américanistes* 81 (1995): 207–29.

——. *Un siècle d'archéologie française au Pérou (1821–1914).* Paris, 1996.

Rodrigue, Aron. "Totems, Taboos, and Jews: Salomon Reinach and the Politics of Scholarship in Fin-de-Siècle France." *Jewish Social Studies* 10:2 (2004): 1–19.

Rolland, Anne-Solène. "Art ou ethnologie? Questions de présentation dans les *Museen für Völkerkunde* en Allemagne après 1900." *Histoire de l'Art et Anthropologie* (2009), http://actesbranly.revues.org/155.

Roque, Ricardo. *Headhunting and Colonialism: Anthropology and the Circulation of Human Skulls in the Portuguese Empire, 1870–1930.* London, 2009.

Rosa, Frederico. *L'âge d'or du totémisme. Histoire d'un débat anthropologique (1887–1929)*. Paris, 2005.

———. "Le movement anthropologique et ses représentants français (1884–1912)." *Archives Européennes de Sociologie* 37:2 (1996): 375–405.

Rosenberg, Clifford. "Albert Sarraut and Republican Racial Thought." *French Politics, Culture, and Society* 20:3 (2002): 97–114.

Rossetti, Carlo. "Malinowski, the Sociology of 'Modern Problems' in Africa and the 'Colonial Situation.'" *Cahiers d'Études Africaines* 100 (1985): 477–503.

Saada, Émmanuelle. *Les enfants de la colonie. Les métis de l'Empire français entre sujétion et citoyenneté*. Paris, 2007.

———. "Race and Sociological Reason in the Republic: Inquiries on the Métis in the French Empire (1908–1937)." *International Sociology* 17:3 (2002): 361–91.

Sachse, Carol, and Mark Walker, eds. *Politics and Science in Wartime: Comparative International Perspectives on the Kaiser Wilhelm Institute*. Osiris 20. Chicago, 2005.

Sacriste, Fabien. *Germaine Tillion, Jacques Berque, Jean Servier et Pierre Bourdieu. Des ethnologues dans la guerre d'indépendance algérienne*, foreword by Jacques Cantier. Paris, 2011.

Salemink, Oscar. *The Ethnography of Vietnam's Central Highlanders: A Historical Contextualization, 1850–1990*. Honolulu, 2003.

Sánchez Durá, Nicolás, and Hasan G. López Sanz, eds. *La misión etnográfica y lingüística Dakar-Djibouti y el fantasma de África*. Valencia, 2009.

Sapiro, Gisèle. *La guerre des écrivains, 1940–1953*. Paris, 1999.

Schafft, Gretchen E. *From Racism to Genocide: Anthropology in the Third Reich*. Urbana, IL, 2004.

Schiebinger, Londa. "The Anatomy of Difference: Race and Sex in Eighteenth-Century Science." *Eighteenth-Century Studies* 23 (1990): 387–405.

Schiller, Francis. *Paul Broca: Founder of French Anthropology, Explorer of the Brain*. Berkeley, 1979.

Schlanger, Nathan. "Introduction." In Marcel Mauss, *Techniques, Technology, and Civilization*, ed. Nathan Schlanger, 1–30. New York, 2006.

Schmuhl, Hans-Walter. *The Kaiser Wilhelm Institute for Anthropology, Human Heredity, and Eugenics, 1927–1945*. Dordrecht, 2008.

Schneider, William H. "Henri Laugier, the Science of Work, and the Working of Science in France, 1920–1940." *Cahiers pour l'Histoire du CNRS, 1939–1989* 5 (1989): 7–34.

———. *Quality and Quantity: The Quest for Biological Regeneration in Twentieth-Century France*. Cambridge, 1990.

Schumaker, Lynn. *Africanizing Anthropology: Fieldwork, Networks, and the Making of Cultural Knowledge in Central Africa*. Durham, NC, 2001.

Schweber, Libby. *Disciplining Statistics: Demography and Vital Statistics in France and England, 1830–1885*. Chapel Hill, NC, 2006.

Scott, Joan W. *Gender and the Politics of History*. New York, 1999.

———. *Only Paradoxes to Offer: French Feminists and the Rights of Man*. Cambridge, MA, 1997.

Segalen, Martine. *Vie d'un musée*. Paris, 2005.

Segalla, Spencer D. *The Moroccan Soul: French Education, Colonial Ethnology, and Muslim Resistance, 1912–1956*. Lincoln, NE, 2009.

Servi, Sandro. "Building a Racial State: Images of the Jew in the Illustrated Fascist Magazine *La Difesa della Razza*, 1938–1943." In *Jews in Italy under Fascist and Nazi Rule, 1922–1945*, ed. Joshua D. Zimmerman, 114–57. Cambridge, 2005.

Sharp, Walter R. "The Role of UNESCO: A Critical Evaluation." *Proceedings of the Academy of Political Science* 24:2 (1951): 1–3.

Shelton, Anthony Alan. "Museums and Anthropologies: Practices and Narratives." In *A Companion to Museum Studies*, ed. Sharon Macdonald, 64–80. Oxford, 2006.

Sherman, Daniel J. *French Primitivism and the Ends of Empire.* Chicago, 2011.

Sibeud, Émmanuelle. "L'Afrique d'une société savante. Les Africanistes et leur mémoire." In *L'africanisme en questions*, ed. Anne Piriou and Émmanuelle Sibeud, 71–88. Paris, 1997.

——. *Une science impériale pour l'Afrique? La construction des savoirs africanistes en France 1878–1930.* Paris, 2002.

——. "Un ethnographe face à la colonisation. Arnold Van Gennep en Algérie (1911–1912)." *Revue d'Histoire des Sciences Humaines* 10 (2004): 79–104.

——. "A Useless Colonial Science? Practicing Anthropology in the French Colonial Empire, circa 1880–1960." *Current Anthropology* 53:S5, The Biological Anthropology of Living Human Populations: World Histories, National Styles, and International Networks (April 2012): S83–S93.

Sibeud, Émmanuelle, and Jean-Loup Amselle, eds. *Maurice Delafosse. Entre orientalisme et ethnographie, l'itinéraire d'un africaniste (1870–1926).* Paris, 1998.

Silverman, Debora L. "Art Nouveau, Art of Darkness: African Lineages of Belgian Modernism, Part I." *West 86th: A Journal of Decorative Arts, Design History, and Material Culture* 18:2 (Fall-Winter 2011): 139–81.

——. "Art Nouveau, Art of Darkness: African Lineages of Belgian Modernism, Part II," *West 86th: A Journal of Decorative Arts, Design History, and Material Culture* 19: 2 (Fall-Winter 2012): 175–95.

Singaravélou, Pierre. *L'École Française d'Extrême-Orient, ou l'institution des marges (1898–1956). Essai d'histoire sociale et politique de la science coloniale.* Paris, 1999.

——, ed. *L'empire des géographes. Géographie, exploration, et colonisation.* Paris, 2008.

——. *Professer l'empire. Les "sciences coloniales" en France sous la IIIe République.* Paris, 2011.

Singer, Claude. "L'échec du cours antisémite d'Henri Labroue à la Sorbonne (1942–1944)." *Vingtième Siècle. Revue d'Histoire* 39 (July-Sept. 1993): 3–9.

——. *Vichy, l'université et les juifs. Les silences et la mémoire.* Paris, 2004.

Sirinelli, Jean-François. *Génération intellectuelle. Khâgneux et normaliens dans l'entre-deux-guerres.* Paris, 1988.

Solange, Thierry. "Paul Lévy (1909–1998)." *Bulletin de l'École Française d'Extrême-Orient* 86 (1999): 6–9.

Soulier, Philippe. "André Leroi-Gourhan (25 août 1911–19 février 1986)." *La Revue pour l'Histoire du CNRS* 8 (2003), http://histoire-cnrs.revues.org/554.

——. "André Leroi-Gourhan, de la muséographie à l'ethnologie." In *Du folklore à l'ethnologie*, ed. Jacqueline Christophe, Denis Michel, and Régis Meyran, 205–15. Paris, 2009.

Spencer, Frank. "Ales Hrdlicka, M.D., 1869–1943: A Chronicle of the Life and Work of an American Physical Anthropologist." 2 vols. PhD diss., University of Michigan, 1979.

Staum, Martin S. *Labeling People: French Scholars on Society, Race, and Empire, 1815–1848.* Montreal, 2003.

——. "Nature and Nurture in French Ethnography and Anthropology, 1859–1914." *Journal of the History of Ideas* 65:3 (2004): 475–95.

——. *Nature and Nurture in French Social Sciences, 1859–1914 and Beyond.* Montreal, 2011.

Steiner, Philippe. *Durkheim and the Birth of Economic Sociology.* Princeton, NJ, 2010.

Steinmetz, George. *The Devil's Handwriting: Precoloniality and the German Colonial State in Qingdao, Samoa, and Southwest Africa.* Chicago, 2008.

Stepan, Nancy. *The Idea of Race in Science: Great Britain, 1800–1960.* London, 1982.

Stern, Alexandra Minna. "From Mestizophilia to Biotypology: Racialization and Science in Mexico, 1920–1960." In *Race and Nation in Modern Latin America*, ed. Nancy P. Appelbaum, Anne S. Macpherson, and Karin Alejandra Rosemblatt, 187–210. Chapel Hill, NC, 2003.

Stocking, George W., Jr. *After Tylor: British Social Anthropology, 1888–1951.* Madison, WI, 1995.

——, ed. *Bones, Bodies, Behavior: Essays in Biological Anthropology.* Madison, WI, 1988.

——, ed. *Colonial Situations: Essays on the Contextualization of Ethnographic Knowledge.* Madison, WI, 1991.

——. "Franz Boas and the Culture Concept in Historical Perspective." *American Anthropologist* 68:4 (1966): 867–82.

——, ed. *Objects and Others: Essays on Museums and Material Culture.* Madison, WI, 1985.

——. "Qu'est-ce qui est en jeu dans un nom? La 'Société d'Ethnographie' et l'historiographie de 'l'anthropologie en France.'" In *Histoires de l'anthropologie*, ed. Britta Rupp-Eisenreich, 421–31. Paris, 1984.

——, ed. *Race, Culture, and Evolution: Essays in the History of Anthropology.* Chicago, 1982.

——. "Racial Capacity and Cultural Determinism." In *A Franz Boas Reader: The Shaping of American Anthropology, 1883–1911,* ed. George W. Stocking, Jr., 219–54. 1974. Chicago, 1989.

Stoczkowski, Wictor. *Anthropologies rédemptrices. Le monde selon Lévi-Strauss.* Paris, 2008.

Stoler, Ann Laura. *Carnal Knowledge and Imperial Power: Race and the Intimate in Colonial Rule.* Berkeley, 2010.

——. "Colonial Aphasia: Race and Disabled Histories in France." In "Racial France," ed. Janet Roitman, a special issue of *Public Culture* 23:1 (2011):121–56.

——. "Racial Histories and Their Regimes of Truth," *Political Power and Social Theory* 11 (1997): 183-206.

Strenski, Ivan. "Henri Hubert, Racial Science, and Political Myth." *Journal of the History of the Behavioral Sciences* 23:4 (1987): 353–67.

Sturtevant, William. "Does Anthropology Need Museums?" *Proceedings of the Biological Society* (1969): 619–49.

Suremain, Marie-Albane de. "L'Afrique en revues. Le discours africaniste français, des sciences coloniales aux sciences sociales (anthropologie, ethnologie, géographie humaine, sociologie)." Thèse de doctorat, Université de Paris VII, 2001.

Taguieff, Pierre-André. "Catégoriser les inassimilables. Immigrés, métis, juifs. La sélection ethnoraciale selon le Docteur Martial." In *Intégration, lien social et citoyenneté*, ed. Gilles Ferréol, 101–34. Paris, 1998.

——. *La couleur et le sang. Doctrines racistes à la française.* Turin, 1998.

——. "Racisme aryaniste, socialisme et eugénisme chez Georges Vacher de Lapouge (1854–1936)." *Revue d'Histoire de la Shoah* 183 (2005): 69–134.

Tai, Li-Chuan. *L'anthropologie française entre sciences coloniales et décolonisation (1880–1960).* Paris, 2010.

Tamagne, Florence. *A History of Homosexuality in Europe.* 2 vols. New York, 2006.

Tarot, Camille. *De Durkheim à Mauss. L'invention du symbolique.* Paris, 1999.

——. *Sociologie et anthropologie de Marcel Mauss.* Paris, 2003.

Teslow, Tracy Lang. *Anthropology and the Science of Race in America, 1900–1960*. Cambridge, forthcoming.

Thomas, Nicholas. *Colonialism's Culture: Anthropology, Travel, and Government*. Princeton, NJ, 1994.

Thomas, Philippe, and Jean Oster. *Le Musée de l'Homme*. Rennes, 1982.

Tilley, Helen. *Africa as a Living Laboratory: Empire, Development, and the Problem of Scientific Knowledge, 1870–1950*. Chicago, 2011.

Tilley, Helen with Robert J. Gordon, eds. *Ordering Africa: Anthropology, European Imperialism, and the Politics of Knowledge*. Manchester, UK, 2007.

Todorov, Tzvetan, ed. *Le siècle de Germaine Tillion*. Paris, 2007.

Tournès, Ludovic. "La fondation Rockefeller et la construction d'une politique des sciences sociales en France (1918–1940)." *Annales. Histoire, Sciences Sociales* 63:6 (2008): 1371–1402.

Trumbull, George, IV. *An Empire of Facts: Colonial Power, Cultural Knowledge, and Islam in Algeria, 1870–1914*. Cambridge, 2009.

Urry, James. "*Notes and Queries on Anthropology* and the Development of Field Methods in British Anthropology, 1870–1920." *Proceedings of the Royal Anthropological Institute of Great Britain and Ireland* 1972 (1972): 45–57.

Valensi, Lucette. "Le Maghreb vu du centre. Sa place dans l'école sociologique française." In *Connaissances du Maghreb. Sciences sociales et colonisation*, ed. Jean Claude Vatin et al., 227–44. Paris, 1984.

Valette, Jean. "L'Académie Malgache," *Journal of Modern African Studies* 5:1 (May 1967): 125–29.

——. "The Organisation of Research in the Malagasy Republic." *Journal of Modern African Studies* 6:1 (1968): 97–101.

Van Beek, W. "Dogon Restudied: A Field Evaluation of the Work of Marcel Griaule." *Current Anthropology* 32:2 (1991): 139–67.

——. "Enter the Bush: A Dogon Mask Festival." In *Africa Explorers: 20th-Century African Art*, ed. Susan Vogel, 56–73. New York, 1991.

Van Beek, W., and J. Jansen. "La mission Griaule à Kangaba (Mali)." *Cahiers d'Études Africaines* 158 (2000): 363–76.

Van Beurden, Sarah. "Authentically African: African Arts and Postcolonial Cultural Politics in Transnational Perspective (Congo [DRC,] Belgium and the USA, 1955-1980)." PhD diss., University of Pennsylvania, 2009.

Vatin, Jean-Claude, et al. *Connaissances du Maghreb. Sciences sociales et colonisation*. Paris, 1984.

Vergez, Bénédicte. "Internes et anciens internes des hôpitaux de Paris de 1918 à 1945." Thèse de doctorat, Institut d'Études Politiques de Paris, 1995.

Wartelle, Jean-Claude. "La Société d'anthropologie de Paris de 1859 à 1920." *Revue d'Histoire des Sciences Humaines* 10:1 (2004): 125–71.

Weil, Françoise. "Yvonne Oddon (1902–1982)." *Objets et Mondes. Revue du Musée de l'Homme-Muséum National d'Histoire Naturelle* 22:1 (Spring 1982): 3–6.

Weil, Patrick. "Georges Mauco, expert en immigration. Ethnoracisme pratique et antisémitisme fielleux." In *L'antisémitisme de plume 1940–1944. Études et documents*, ed. Pierre-André Taguieff, 267–76. Paris, 1999.

——. *How to Be French: French Nationality in the Making since 1789*, trans. Catherine Porter. Durham, NC, 2008.

——. "Racisme et discrimination dans la politique française de l'immigration, 1938–1995." *Vingtième siècle. Revue d'Histoire* 47 (July-Sept. 1995): 77–102.

Weindling, Paul. *Health, Race, and German Politics from National Unification to Nazism.* Cambridge, 1989.

Weinreich, Max. *Hitler's Professors.* New York, 1946.

Weisz, George. *The Emergence of the Modern Universities in France, 1863–1914.* Princeton, NJ, 1983.

White, Owen. *Children of the French Empire: Miscegenation and Colonial Society in French West Africa, 1895–1960.* Oxford, 1999.

——. "The Decivilizing Mission: Auguste Dupuis-Yakouba and French Timbuktu." *French Historical Studies* 27:3 (2004): 541–68.

Wilder, Gary. *The French Imperial Nation-State: Colonial Humanism, Negritude, and Interwar Political Rationality.* Chicago, 2006.

Williams, Elizabeth A. "Anthropological Institutions in Nineteenth-Century France." *Isis* 76:3 (1985): 331–38.

——. *The Physical and the Moral: Anthropology, Physiology, and Philosophical Medicine, 1750–1850.* Cambridge, 1994.

Wolfe, Patrick. *Settler Colonialism and the Transformation of Anthropology: The Politics and Poetics of an Ethnographic Event.* London, 1999.

Wood, Nancy. *Germaine Tillion, une femme-mémoire. D'une Algérie à l'autre.* Paris, 2003.

Zantop, Suzanne. *Colonial Fantasies: Conquest, Family, and Nation in Precolonial Germany, 1770–1870 (Post-Contemporary Interventions).* Durham, NC, 1997.

Zerilli, Filippo M. *Il lato oscuro dell' etnologia. Il contributo dell' antropologia naturalista al proceso di istituzionalizzazione degli studi etnologici in Francia.* Rome, 1998.

Zimmerman, Andréw. *Anthropology and Antihumanism in Imperial Germany.* Chicago, 2001.

INDEX

CPSIA information can be obtained
at www.ICGtesting.com
Printed in the USA
LVHW030937281221
707329LV00004B/583